RUBENS
Selected Drawings

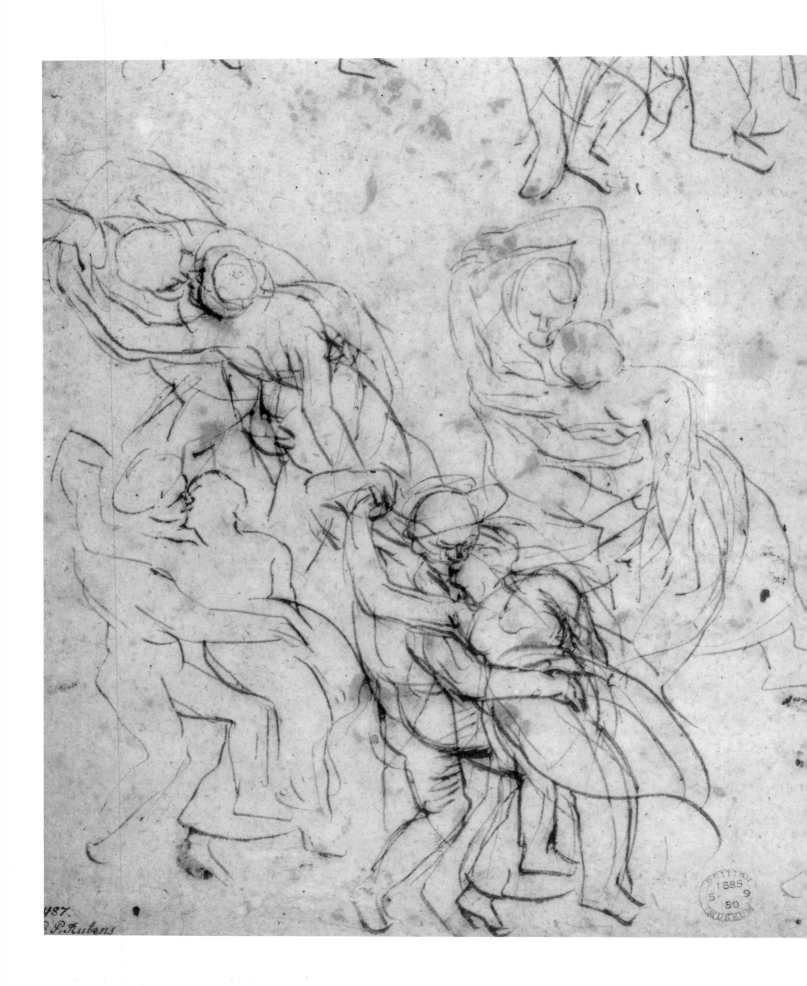

487.
P. Rubens

RUBENS
Selected Drawings

With an Introduction
and a Critical Catalogue by

JULIUS S. HELD

MOYER BELL LIMITED

*Additional photographic material for the new edition
has been supplied by:*

Royal Library Windsor Castle. Reproduced by gracious permission of
Her Majesty The Queen: 77; 78

Graphische Sammlung Albertina, Vienna/Lichtbildverstätte
'Alpenland': 129; 141; 163; colour plates 1 & 3

Fratelli Alinari, Florence: 168

Amsterdam Historical Museum: colour plate 6

Ashmolean Museum, Oxford: 200

British Museum, London: 22; 23; 26; 31; 37; 90; 143; 149; 150; 167;
colour plates 2 & 7

Sterling and Francine Clark Art Institute, Williamstown MA: colour
plate 4

Courtauld Institute Galleries, London: 191

Fondation Custodia (Collection F. Lugt) Institut Néerlandais, Paris: 192

Devonshire Collection, Chatsworth/Derrick Witty. Reproduced by
permission of the Chatsworth Settlement Trustees: 18

Fitzwilliam Museum, Cambridge: 114

The J. Paul Getty Museum, Malibu: colour plate 5

Hessisches Landesmuseum, Darmstadt: 166

Nationalmuseum, Stockholm: 10

Réunion des Musées Nationaux, Paris: colour plate 8

This edition first published by Moyer Bell Limited.

Revised edition Copyright © 1986 Julius S. Held

All rights reserved. No part of this publication
may be reproduced, stored in a retrieval system or
transmitted, in any form or by any means, electronic,
photo-copying, recorded or otherwise, without the
prior permission of Moyer Bell Limited,
Colonial Hill/RFD 1, Mt. Kisco, New York 10549.

Library of Congress Cataloging-in-Publication Data

Rubens, Peter Paul, Sir, 1577–1640.
 Rubens—selected drawings.

 Includes index.
 1. Rubens, Peter Paul, Sir, 1577–1640—Catalogs.
2. Rubens, Peter Paul, Sir, 1577–1640—Criticism
and interpretation. I. Held, Julius Samuel, 1905–
II. Title.
NC266.R8A4 1986 741.9493 86-5226
ISBN 0-918825-48-2

This edition was designed and produced by
John Calmann & King Ltd, London
Designer: Trevor Vincent

Phototypeset by Tradespools Limited, Frome, Somerset
Printed in Singapore by Toppan Ltd

FRONTISPIECE
Detail from Dancing Peasants (Plate 185),
London, British Museum

Exhibitions

LONDON, 1835 A Catalogue of one Hundred Original Drawings by
Sir P. P. Rubens, Collected by Sir Thomas Lawrence, S. and A.
Woodburn Galleries, London, 1835

LONDON, 1927 Loan Exhibition of Flemish and Belgian Art, Royal
Academy, Burlington House, London, 1927

ANTWERP, 1927 P. P. Rubens, 1577–1927, Museum, Antwerp,
1927

DÜSSELDORF, 1929 Ausstellung alter Malerei aus Privatbesitz,
Kunstverein, Düsseldorf, 1929

ANTWERP, 1930 Tentoonstelling van Oud-Vlaamsche Kunst,
World Exhibition, Antwerp, 1930

VIENNA, 1930 Drei Jahrhunderte Vlämische Kunst, Wiener
Sezession, 1400–1700, Vienna, 1930

AMSTERDAM, 1933 Rubens Tentoonstelling, Gallery J.
Goudstikker, Amsterdam, 1933

BRUSSELS, 1935 Cinq Siècles d'Art, World Exhibition, Brussels,
1935

BRUSSELS, 1937 Esquisses de Rubens, Musées Royaux des Beaux-
Arts de Belgique, Brussels, 1937

LONDON, 1938 Seventeenth Century Art in Europe, Royal
Academy of Arts, London, 1938

ROTTERDAM, 1938 Meesterwerken uit vier eeuwen, 1400–1800,
Museum Boymans, Rotterdam, 1938

BRUSSELS, 1938–1939 Dessins de Pierre-Paul Rubens, Palais des
Beaux-Arts, Brussels, 1938–1939

ROTTERDAM, 1939 Teekeningen von Peter Paulus Rubens, Museum
Boymans, Rotterdam, 1939

ZÜRICH, 1946–1947 Meisterwerke aus Österreich, Kunsthaus,
Zürich, 1946–1947

ROTTERDAM, 1948–1949 Tekeningen von Jan van Eyck tot Rubens,
Boymans Museum, Rotterdam, 1948–1949

PARIS–BRUSSELS, 1949 De Van Eyck à Rubens, Les Maitres
Flamands du Dessin, Bibliothèque Nationale, Paris, 1949

LONDON, 1950 A Loan Exhibition of Works by Peter Paul Rubens,
Wildenstein and Co., Kt. London, 1950 (Catalogue by L. Burchard)

ROTTERDAM, 1952 Choix de Dessins, Expos. organisée à l'occasion
du XVIIme Congrès International d'Histoire de l'Art, Rotterdam,
1952

HELSINKI–BRUSSELS, 1952–1953 P. P. Rubens, Esquisses, Dessins,
Gravures, Ateneum, Academie des Beaux-Arts de Finlande,
Helsinki, 1952–1953 (With some changes, this exhibition was
repeated in the Musées Royaux des Beaux-Arts, Brussels, 1953)

STOCKHOLM, 1953 Dutch and Flemish Drawings in the
Nationalmuseum and other Swedish Collections, Nationalmuseum,
Stockholm, 1953

LONDON, 1953–1954 Flemish Art, 1300–1700, Royal Academy,
Burlington House, London, 1953–1954

ROTTERDAM, 1953–1954 Olieverfschetsen van Rubens, Museum
Boymans, Rotterdam, 1953–1954 (Catalogue by E. Havercamp
Begemann)

PARIS, 1954 Anvers, Ville de Plantin et de Rubens, Bibliothèque
Nationale, Paris 1954

CAMBRIDGE–NEW YORK, 1956 Drawings and Oil Sketches by P. P.
Rubens from American Collections, Fogg Art Museum, Harvard
University, Cambridge and The Pierpont Morgan Library, New
York, 1956 (Catalogue by Agnes Mongan)

ANTWERP, 1956 Tekeningen van P. P. Rubens, Rubens House,
Antwerp, 1956 (Catalogue by L. Burchard and R.-A. d'Hulst)

ANTWERP, 1977 Schilderijen-Olieverfschetsen-Tekeningen,
Koninklijk Museum voor Schone Kunsten (Catalogue by A.
Montballieu and others)

ANTWERP, 1977 P.P. Rubens als Boekillustrator, Museum Plantin-
Moretus (Catalogue by R. Judson)

COLOGNE, 1977 Rubens in Italien (Catalogue by J. Muller Hofstede)

LONDON, 1977 P.P. Rubens' Drawings and Oil Sketches
(Catalogue by J. Rowlands)

VIENNA, 1977 Rubenszeichnungen der Albertina (Catalogue by
Mitsch)

PARIS, 1977–1978 Rubens, Ses Maîtres, Ses Elèves (Catalogue by
A. Sérullaz)

Contents

Preface

TO THE FIRST EDITION

'An endless amount has already been published about Peter Paul Rubens; much of it is worth knowing but an extraordinary lot of it is rubbish.' With these words P. Génard, the Antwerp archivist to whom we owe so much concrete information about Rubens, in 1877 opened a book on the master. More than eighty years and many books and articles later, any author who adds to the flood of Rubens literature should feel obliged to justify his undertaking.

The present study has been directed towards the one field of Rubens' activity which from the point of view of historical research can still be characterized as a 'frontier' region of our knowledge. As recently as 1942, H. G. Evers admitted that 'a critical study about Rubens as draftsman is still missing'. It is obvious that only a complete critical catalogue of all Rubens' drawings can fill this gap. The time has not come yet for such an undertaking. I have tried, however, to lay the groundwork. For years I have examined the drawings said to be by Rubens in order to find criteria for distinguishing the genuine ones from those wrongly attributed to the master. I studied Rubens' technical procedures and the place which drawing occupies within his total activity. I have tried to determine the date of his drawings in order to see the development of his style in this particular medium. The results of these studies are presented here, accompanied by a selection of outstanding and characteristic examples chosen from all the categories into which Rubens' drawings can be divided.

Only one previous publication, in German and never translated into any other tongue, had a comparable aim. This is a book published in 1928 by the Viennese scholars Gustav Glück and Franz Martin Haberditzl. Both writers were eminently qualified for their task. Both had made extensive studies in the field of Flemish seventeenth-century art and of Rubens in particular. Their volume was a major achievement, remarkable for its scholarship and the sensitivity of its insight. Ever since its appearance that book has formed the basis for all the discussions of Rubens' drawings, and it will not be superseded until a complete publication of the master's drawings is made in the form of a *catalogue raisonné*.

When they published their book, Glück and Haberditzl actually thought they were publishing a complete list of at least all the unquestionably authentic drawings by the master. Admitting that by the rigorous exclusion of any drawing in the slightest degree doubtful they risked a marginal incompleteness, they believed firmly that they had not left out any original drawings of real historical or aesthetic significance. These claims were immediately challenged by various reviewers. Some pointed out that several drawings accepted by Glück and Haberditzl were at least doubtful if not actually by other hands. Not all of these criticisms were justified, but a few drawings accepted by Glück and Haberditzl must indeed be eliminated from Rubens' oeuvre. More important was the publication by the reviewers of additional drawings of great merit and unquestionable authenticity which Glück and Haberditzl had overlooked. Since then so much new material has been added in books, articles, and exhibition catalogues that no one could today consider Glück and Haberditzl's book even remotely as a complete presentation of Rubens' drawings.

If any one group of Rubens' drawings was insufficiently represented by Glück and Haberditzl, it was that in which the artist was most himself: his first ideas for compositions. On the other hand, of the 241 drawings which they reproduced, nearly one-sixth were copies which Rubens had made of other artists' work. It is true that Rubens made many copies—many more, indeed, than the Viennese scholars had realized; yet it seemed to me self-evident that for the modern beholder the original effort was more important than the copy. In this study, therefore, the emphasis has been placed on those productions in which the artist's creative genius is most clearly revealed. None of the major categories that can be distinguished among Rubens' drawings has been omitted, including even the group in which the master's contribution consisted only in retouching somebody else's work, and this has been duly discussed in the text. The number of plates, however, was not chosen in proportion to the actual number of drawings that happens to be preserved in each group, but in relation to the importance of these groups for our understanding of Rubens' art. Thus the largest group consists of

projects for compositions, ranging from sketchy first drafts to more elaborate designs. The second are Rubens' drawings from life, done in the studio or out of doors; they include, in his large portrait studies, the most famous and the most popular works of the master in this medium. The third group comprises drawings which Rubens made as models for other artists, to be 'translated' into sculpture, engraving, or woodcut. Copies and retouched drawings follow at the end. Each of these groups, except the last, has been arranged in loose chronological sequence; too rigid an adherence to this order seemed neither necessary nor in all cases possible. At the present state of research, many conclusions in regard to dates of Rubens' drawings are still tentative and subject to revision.

It goes without saying that in dividing the material in this way into functional categories there were inevitably a few borderline cases which might have qualified equally well for more than one group. I considered it nevertheless the most appropriate system because it does justice to one basic aspect of Rubens' art. As will be shown more fully below, Rubens' working process was at least in principle regulated methodically, with the various categories of drawing playing a well defined rôle in the total sequence. What at a first glance may seem to be an almost bewildering technical and stylistic variety becomes comprehensible and meaningful if seen in this perspective.

A drawing which cannot be dated cannot be said to have been properly integrated in an artist's work. For this reason no drawing has been included in this selection to which a date cannot be assigned with a fair degree of certainty, except for a few special categories like landscape drawings and copies, where the problem is too complex. The temptation to assign a date arbitrarily because of the desire to accept the drawing has been resisted and the danger

perhaps diminished because of this awareness.

For the final and often painful decision which drawing in each category to include, which to omit, many factors have been taken into account. Drawings were not selected for the sake of novelty alone. The fact that a piece had never been published before did not in itself give it an advantage over one reproduced many times over. The guiding consideration was always the desire to give the best possible account of Rubens' draughtsmanship in all its aspects as far as the extant material permitted. Since only a fraction of Rubens' total output in this field has survived, a certain inadequacy was inherent in the effort from the beginning. I am also conscious of the fact that subjective elements and preferences could not, and perhaps should not, be eliminated completely. In other words, the choice of material also reflects the author's personal taste.

Ludwig Burchard once wrote that 'there is perhaps no other draughtsman whose work suffers more from reduction than that of Rubens.' While it has been possible to reproduce a number of drawings near their actual size and to include a few large details, it was inevitable that many of the finest of Rubens' drawings had to be considerably reduced in scale. To offset this disadvantage, an effort has been made to obtain good photos: several drawings have been photographed specially for this publication.

The text of this book was completed when the large exhibition of Rubens' drawings was held in Antwerp in the summer of 1956. Wherever appropriate, I have added references to that exhibition in the critical catalogue. In a few cases I also made additions to the text of the catalogue using information contained in the detailed notes provided for that show.

New York, September 1st, 1958 *J. S. H.*

PREFACE TO THE SECOND EDITION

As I am laying the last hand on this second edition of my 1959 book on Rubens' drawings, I am conscious of the enormous changes that have come to this area of research. When I began my work in the early 1950s, the only book dedicated exclusively to Rubens' drawings was the volume by Gustav Glück and F. .M. Haberditzl, published in 1928. During the preparation of my undertaking, an exhibition of Rubens' drawings, with a catalogue by L. Burchard and R. A. d'Hulst, was held in Antwerp in 1956. Yet in the last thirty years, the situation has changed dramatically. We are faced

now with a veritable avalanche of learned studies, many of them dedicated to Rubens' drawings; it crested in 1977 in connection with the world-wide celebration of the 400th anniversary of the master's birth.

It is obvious that the results of this huge scholarly output could be absorbed only in part in the framework of this relatively modest publication, containing, like its predecessor, only a selection of drawings by the master. It seemed desirable, however, to enlarge to some extent the total number of drawings to do justice, in some small measure, to

the many discoveries which have been made in these decades. Thus, whereas the old book contained 179 Rubens' drawings fully discussed in the catalogue, and an additional eight at least reproduced, the present volume consists of 236 entries; it also contains eight colour plates rather than five in the old volume. The comparative material, however, has been reduced, from a total of sixty-two to only nineteen.

Bibliographical references, too, had to remain highly selective, preference being given to a small number of relatively comprehensive publications. Foremost among them were a number of volumes from the *Corpus Rubenianum Ludwig Burchard*. Of the enterprises similar to my own I made specific reference to Burchard-d'Hulst's book of 1963, an enlarged version of their 1956 catalogue, and Y. Kuznetsov's Russian volume of 1974 (whose text, unfortunately, remained a closed book to me). (I omitted Bernhard's 1977 compilation since it relied entirely on previously published material.) Of the publications of the Rubens year those regularly cited are M. Jaffé's *Rubens and Italy*; H. Mielke and M. Winner's catalogue of the Berlin holdings, E. Mitsch's of those of the Albertina, and the exhibition catalogues of J. Rowlands (London), J. Müller Hofstede (Cologne), A. Montballieu (and others, Antwerp), and A. Sérullaz (Paris, published 1978). Of my own studies I cite regularly only the 1980 book on Rubens' oil sketches, and the collection of essays, published 1982.

I found little reason to change my introductory text, save for some necessary corrections and amplifications. As far as I can see, it still remains the only study available analysing Rubens' drawings technically, functionally and stylistically, besides dealing with the tricky problem of connoisseurship.

In two respects, however, this publication departs from the old one. I dissolved the several categories into which the material had been divided, and tried to present it more or less in chronological sequence, so as to show the many different projects Rubens had to deal with simultaneously. Such an arrangement evidently depends on our ability to give at least an approximate date to all drawings, an ability which I now feel is less dependable than one could wish for.

The balance, too, between the different categories of drawings has somewhat shifted. While I still feel that emphasis should be given to those drawings 'in which the artist's creative genius is most clearly revealed', I now include a larger number of Rubens' 'copies', particularly of ancient sculpture, and of models for engravers, mainly done for the embellishment of books.

The task of bringing the material up-to-date involved checking the present location of those drawings that have changed hands, generally to enter public institutions, as did, for instance, the entire collection of Count Seilern, which as The Princes Gate Collection has entered the Courtauld Institute Galleries, London. In one instance (No. 17) the identification of the subject matter had to be changed, thanks to the perspicacity of Elizabeth McGrath.

To her, to Anne-Marie Logan, and to David Freedberg I owe a special word of thanks, for having encouraged me to proceed with this revised edition of a book long out of print. May it help to win new friends for an artist whose works continue to enrich our lives.

Bennington, Vt. June 7, 1986 *J. S. H.*

I

The Problem of Critique

OFTEN in the course of my studies I have been asked how many drawings there are by Rubens. In the more sophisticated phrasing of the scholar this question would read: how many of the drawings commonly attributed to Rubens are really works by his hand?

For those who think it ought to be easy enough to answer this question I should like to tell of a typical instance. In the winter of 1775–1776 one of the largest and finest collections of Old Master drawings ever gathered in private hands was sold at auction in Paris. It was the collection of P.J. Mariette, one of the great connoisseurs of drawings of all time. The catalogue had been prepared by the dealer and expert Basan. Even the greatest masters were represented by such large groups of drawings that most of them had to be sold in lots. If a drawing was singled out to be sold alone, it was a sure sign that Basan, and Mariette before him, had thought highly of the piece. Such a drawing was No. 1000 of Basan's catalogue. Basan himself bought it, possibly for a collector who did not want to be mentioned, for the very large amount of 1300 livres. It was with considerable interest and some amusement that I came across the following marginal note in a copy of the catalogue now preserved in the Albertina in Vienna—a note evidently written by a man of knowledge and experience who had attended the sale: 'Il y a eut de grands debats sur l'originalité de ce dessin, savoir s'il étoit de Rubens ou de Diepenbeeck. On prétend que le prince de Conti en possède l'Original.'

Thus we are confronted, only 135 years after Rubens' death, with the situation of an important drawing, coming from one of the finest collections and accepted by well-known experts, that was seriously doubted by others. To judge from the wording of the note, with its reference to another famous collection and to a painter whose work indeed is often confounded with that of Rubens, these negative critics were anything but ignorant laymen. The plain fact is that one no longer knew with any degree of certainty whether this drawing was or was not by Rubens. No guarantee, no hard and fast proof of its authenticity had come with it. That did not prevent its being accepted as genuine by many collectors and scholars. First Lagoy, then Sir Thomas Lawrence—no mean connoisseurs—

bought it for their collections; in 1850 it was purchased for the British Museum. Rooses spoke of it in the highest words of praise, and Hind included it in his catalogue of Flemish drawings in the British Museum. Yet Glück and Haberditzl, who may have been familiar with the marginal note in the Albertina copy of Basan's catalogue, excluded it from their book and by this act took their stand with the unknown critics of the eighteenth century.

Mariette's drawing has been included in this volume (Pl. 99) because I firmly believe that it is a work by Rubens. Yet the question is not whether this individual drawing is genuine or not. Since it is a very prominent work that has gone through many famous collections, it highlights the situation of most of the drawings attributed to Rubens. Not a single drawing was actually ever signed by the master, though many carry his name in handwriting of the seventeenth and eighteenth centuries.

Fortunately, the situation is less hopeless than might appear at first. Although there are no real signatures on Rubens' drawings, there are often found inscriptions which on graphological and internal evidence can safely be claimed for Rubens (see below, p. 38 ff.); a few drawings are on letters which Rubens wrote, and in two cases the text refers directly to the drawing. If the stylistic evidence supports the graphological, the authenticity of the drawing is fairly well established.

Another group of well authenticated drawings is formed by Rubens' designs for book-illustrations, especially designs for frontispieces (Pls. 150, 219, 220, 221, 222). Here documentary evidence, such as entries of payment and other kinds of business records, give solid proof in favour of the attribution. Inscriptions by other hands, provided they are early and are corroborated by additional evidence, have considerable value; a group of beautiful portrait drawings, mostly in Vienna, has been established as Rubens' work in this manner (see Pl. 160, Colour Pl. 3).

Most important is, of course, stylistic comparison which establishes a contact between the drawing and authentic works in other media (oil-sketches and paintings in particular). These connections must be evaluated properly; the degree of variation from the finished product, the technique, and the 'quality' of the piece play a rôle in the decision. A good

provenance is important, but—as the case of the Mariette drawing proves—is insufficient by itself to establish a drawing as genuine.

Centuries of testing and selecting with all the means at our disposal (except the so-called 'scientific' ones which would analyse the materials themselves but which, I regret to say, are of little use in problems of this kind) have established the authenticity of certain drawings which no reasonable person would question. These drawings naturally form a touchstone by which new attributions are judged. The methodical procedure in studying Rubens' drawings is in principle the same as that applied in the study of other great draughtsmen such as Leonardo, Michelangelo, Dürer, Rembrandt, and Watteau. In practice, however, as O. Benesch aptly put it,[1] it is more difficult with Rubens. For once, differences of function result in striking differences of style and technique. Since Rubens used drawings for many different purposes, the variety of his style is at first bewildering. These functional variations must be kept in mind, especially when one tries to arrange the drawings chronologically. Pieces which technically and stylistically differ greatly may nevertheless have been done at the same time, though for very different purposes.

Yet we must also consider the changes due to the artist's development. To know an artist's development it is essential to establish a correct chronology of his works. Some of Rubens' drawings can indeed be dated reliably by circumstantial evidence. For the chronological distribution of many others we depend largely upon our concept of the artist's development. This sounds like going around in circles. Actually, the critical process resembles more the weaving of a fabric in which the many isolated strands of the warp are fastened together by shuttling the weft first from one side and then from another. Each work fixed in Rubens' oeuvre by external evidence is apt to modify our general concepts of his style and development; these concepts, so improved, will in turn allow us to consider and to put into their proper place other drawings omitted before. The possibility of error is always present. Yet as the fabric grows larger, and as the pattern emerges more clearly, the 'foreign' elements are more likely to be revealed.[2]

Nevertheless, the chronology of Rubens' drawings—as indeed of all his works—is unusually difficult to establish. It is an indication of these difficulties that specialists can differ so radically in the dates which they assign to individual works. Our Pl.77 was dated 1630 by Glück and Haberditzl; Evers dated it 1611. Pl.184 was dated 1635–38 by the Viennese scholars, 1620–23 by Evers. Hind's date for Pl.216 was 1600–1608; Glück and Haberditzl placed it 'after 1620' (which seems to me to be still too early). Parker believed that Pl.214 was made around 1615–20, while I consider it to be a work of about 1634–35. It would be easy to extend that list.

The difficulty in assigning dates to Rubens' works (to his paintings as well as to his drawings) is no modern predicament. When Roger de Piles, one of the first biographers of the master, wrote to Rubens' nephew Philip Rubens for information about the dates of the major works of his uncle, he found that practically nothing was known about them. His uncle, Philip answered, had not been in the habit of keeping records and most of his students were now dead. The best he could do was to point to dates found on engravings after Rubens' works which could be used as *termini ante quos* for the pictures themselves.[3] Thus, only one generation after Rubens' death, a method still often used today had to be applied by those who wanted to date Rubens' works.

Drawings which can safely be attached to a dated work acquire in this way a date for themselves. Yet even here one must beware of a number of fallacies. The use of a drawing in one of Rubens' paintings does not necessarily mean that it was made for this particular picture. Rubens dealt with the same themes many times in his career; he often fell back upon an older drawing, especially in cases where for one reason or another he had not made use of that drawing before (see Pl.129). Individual poses were used many times over and in very different contexts.[4] While it is natural to assume that drawings of these poses were made for pictures where they occur for the first time, this is by no means certain. A drawing of a nude man leaning back (G.-H. No.45) was first dated 1601–2 by Haberditzl, because he connected it with the Raising of the Cross of 1602 in Grasse; when he published his book with Glück he admitted that it might be a drawing of *c.* 1609–10, copied from a lost early one; it was made use of at that time in the Antwerp Raising of the Cross. Oldenbourg and Burchard assigned it to 1615 because of its similarity with a figure in the Munich Last Judgment. Burchard, however, also called attention to the fact that the same pose is still found in pictures of the 1630's.

A specific problem has to be kept in mind for drawings which are evidently studies for compositions of paintings datable on the basis of contracts. An artist usually got a commission only after he had submitted a satisfactory drawing or oil-sketch in which the layout of the design was more or less determined. Accordingly those drawings in which the artist appears to be still groping for the general composition are likely to have been made before, not after, the date of the contract.

Another problem is raised by drawings which are

found on different sides of the same sheet of paper. While *recto* and *verso* normally date from the same period, there is no assurance that this *must* be so. There are, indeed, several examples where the weight of evidence seems to favour different dates for *recto* and *verso* (see Pls.82, 128, 154, 176 and 210). Since Rubens kept his drawings precisely for the purpose of using them again at later opportunities, there must have been instances when he found a blank space on an older drawing coming in handy for a quick sketch at a later date.

Title-pages were generally printed soon after the drawing had been delivered; thus the date of the book furnishes a date for the drawing. Yet there is a drawing for one title-page which was not published until 1666, twenty-six years after Rubens' death! If we did not have a correspondence which was carried on between author and publisher and which permits us to date the drawing in the year 1638, we would have to rely on stylistic evidence alone. The delay in the use of Rubens' drawing is all the more astonishing as Rubens had kept the author waiting for three years; when he finally delivered the drawing, together with a Latin explanation of its allegorical content, the author, Frédéric de Marselaer, acknowledged the receipt with a polite anecdote about the French writer Pierre Mathieu. Reproached by King Henry IV for having taken so long 'en bonne foy, vous écrivez longtemps,' Mathieu is supposed to have punned 'Ouidà, Monsieur, mais c'est pour longtemps'.[5] Did Rubens procrastinate because he knew that the publisher had no serious intention of bringing out a new edition of de Marselaer's book for some time?

For a complete count of Rubens' drawings it is not only necessary to establish the authenticity of each sheet; one must also define the lines of demarcation between his drawings and other categories of his work. This is not as simple as it may sound. The boundaries are fluid in several respects. There are oil-sketches by Rubens which differ from drawings in pen or in chalk only because they are done in another medium and on wood instead of on paper (Held, 1980, Nos.253 and 300). In these sketches the artistic effect is conveyed chiefly by line. Such sketches, indeed, are essentially drawings and it is only a relatively arbitrary, though traditional, practice of terminology which keeps them in a different technical category. On the other hand, there are gouache paintings on paper which, like water-colours, are generally included among the drawings although they resemble paintings much more than the oil-sketches just mentioned (see No.229 and Colour-Plate 8).

A special problem, finally, is posed by those drawings where Rubens drew on top of the work of other artists, a practice which seems to have been fairly common with him. He also improved in this manner drawings by assistants and he corrected proof-prints by graphic artists (see also p.41 note 32). While he obviously 'drew' on all these pieces, do they all equally qualify as drawings by him? Where the reworking has been extensive, there is no doubt that they must be so classified, but it seems advisable to draw the line where only a few strokes were made by the master.

One way to determine what the artist actually drew is to identify the real authors of drawings falsely attributed to him. This method has been successfully applied in the case of Rembrandt and it yields results for Rubens also. It involves crystallizing the styles of those artists who were near enough to the master for their drawings to be confounded with his. Jacob Jordaens is probably the one Antwerp painter whose drawings are easy to detach from those of Rubens, partly because there are so many of them and partly because Jordaens' style is rather distinct; yet some of Jordaens' earliest drawings are uncomfortably close to those by Rubens and have occasionally been attributed to him. Abraham van Diepenbeeck is the author of a very large number of drawings of markedly Rubenesque character. In his mature work, such as the large cycle of drawings for the *Temple des Muses* published by the Abbé de Marolles many years after they had been made, Diepenbeeck has well defined peculiarities. He nevertheless seems to deserve a special study as there is good reason to suspect that the real range of his drawing style has not yet been determined. The same holds true for Erasmus Quellinus, whom we know as a close associate of Rubens in the 1630's when he drew several frontispieces under Rubens' direction and in a very Rubenesque style. Small groups of drawings are known by Cornelis Schut, Adriaen Sallaert, Peter van Lint, Jan Cossiers, and Jan Boeckhorst which give a fairly distinct idea of their styles, but of course they all may have had a period in which they were closer to Rubens than we know today. A particularly intriguing case is that of Theodoor van Thulden, one of Rubens' most gifted pupils. A magnificent group of cartoons for stained glass windows, all but unknown, gives a high opinion of his ability as a draughtsman (Musée du Cinquantenaire, Brussels). A special study on this master is one of the most urgent tasks of the Rubens critique. The situation is even more confusing with artists like Abraham Janssens, Gaspar de Crayer, Jan van Egmont, Theodoor Rombouts, Jan van de Hoecke, and Gerard Seghers, although drawings have been attributed to all of them.

We must always remember that all through the history of art, minor men have been forgotten and their products associated with the names of the

more famous artists in whose circle they worked. This is understandable in cases where the 'forgotten' artist was strongly influenced by the one remembered. One might consider another possibility in connection with a group of landscape drawings (perhaps not even all by the same hand) which have been attributed to Rubens chiefly on the strength of a clearly later 'signature' found on several of them. They are also inscribed on the back with the names of the villages and farms represented and with dates ranging from 1606 to 1610. The handwriting of these notes is not that of Rubens; besides, Rubens was still in Italy in 1606 and could not have drawn a Flemish farm in that year. This is also the view of H. Mielke (Mielke-Winner, 1977, Nos.45, 46) who recently has devoted a thoughtful analysis of the pros and cons to the problem. The only author who insists on Rubens' authorship remains W. Adler (*Corpus Rubenianum* XVIII, 1, 1982, Nos.2–12).

The case is puzzling since none of the authors who rejected the attribution to Rubens has come up with a plausible alternative (I myself have long withdrawn my tentative attribution to Jan Wildens). Nor has anyone been able to discover any of these landscape settings in the background of a painting whose author is known, or recognized the same hand in drawings—either inscribed or dated—that postdate the last year—1610—found on drawings of this group. This is what I had written in the earlier edition of this book—a thought perhaps still worth pondering:

Perhaps the author of the better ones among them (Berlin; New York, Morgan Library; London) was a gifted artist who died young. The disappearance of drawings in this style after 1610 makes us think of the epidemics which ravaged Antwerp in the early seventeenth century, particularly that of 1612, which was so severe that it drove many people away—among them, incidentally, Rubens. I mention this theory primarily to point out how many possibilities a cautious historian ought to keep in mind.

Far and away the most important, and in some respects the most difficult task confronting the scholar intent on deciding which drawings are Rubens' own is the task of distinguishing between Rubens and Van Dyck. For several years, particularly between 1617 and 1620, Van Dyck was Rubens' closest collaborator. He was the only one of Rubens' followers who possessed real genius, and he had also an astonishing gift for artistic osmosis. It will probably never be determined exactly what form the collaboration between the two artists took. A view held by such scholars as Bode, Oldenbourg, Glück and Burchard gives to Van Dyck the execution of many large paintings designed by Rubens. There are early records which seem to substantiate this theory. Van Dyck, as we shall see below, has also been given credit for some drawings after Rubens' compositions, made as preparations for engravings. Many of these drawings were formerly considered works by Rubens, or at least pieces largely reworked by the master.

There is also, however, a trend in the opposite direction. A number of drawings which tradition and old inscriptions had given to Van Dyck have more recently been recognised as works of Rubens. It is particularly in the field of creative effort, of drawings quickly done in pen or chalk, that the list of Rubens' works has been enlarged at the expense of Van Dyck.

The task of distinguishing between the works of Rubens and Van Dyck, especially during the years of their closest artistic association (*c.* 1617–1620) is made so difficult because of the peculiar human relationship between the two men. Rubens was twenty-two years older and a famous artist when Van Dyck entered his studio. Van Dyck, a youth of eighteen, highly gifted and ambitious, had had his first training elsewhere and came as an assistant rather than a pupil. Psychologically the two artists represented very different types. Rubens was the born leader, a man of high intelligence, imaginative, resourceful and emotionally mature. Van Dyck, the prodigy, was less stable and perhaps less certain of himself; all his life he felt a need to please and to ingratiate himself. He must have admired the assured balance of Rubens, but his voluntary subordination to the older artist was probably charged with a desire to equal, if not excel, the master. Rubens, on the other hand, must have welcomed the eager and skilful efforts of his young protégé who was so quick in assimilating his style; at a time when commissions were coming to him from all sides, an assistant of Van Dyck's talent was surely a godsend. Rubens made no secret of the help he received from Van Dyck. Van Dyck's name is mentioned in the contract which Rubens signed in 1620 for the decoration of the church of the Antwerp Jesuits. In the same year, and while Van Dyck still lived in Rubens' house, a correspondent of the Earl of Arundel (see Pl.144 and p.32) reports that Van Dyck's works are hardly less appreciated than those of his master.

Collaboration of the kind that can no longer be analysed did not of course extend to drawings, at least not to rapid sketches or to studies from the model. Yet the number of drawings which scholars push back and forth between the two men is surprisingly large. Unhappy migrants, they seem to cross forever a kind of no-man's land between the two artistic continents, without being admitted to permanent residence anywhere. Indeed, one scholar proposed to create a '*zone neutre*' where these

homeless commuters could come to a temporary rest (Delacre, *Van Dyck*, p.210). The younger artist evidently followed his great model not only in the more general traits, but he mimicked also some personal peculiarities of sketching, such as short-hand devices of drawing human figures with the pen, or the relation between outline and shading in drawings done with chalk. I even suspect that Van Dyck's handwriting was influenced by that of Rubens, but there is still a very revealing difference between their hands, which I feel has not sufficiently been taken into account in the critical discussions. Important too is the fact that Van Dyck signed his drawings occasionally, something that Rubens, as we have seen, never did.

Despite the considerable difficulties of the task, I believe it possible to distinguish the drawings of one man from those of the other. This is not the place to go into the problem in detail, but it is permissible to make a few generalizations. (See Fig.1.) In compositional sketches Van Dyck tends to draw more hastily, with a less balanced sense of proportion and of anatomical structure. Rubens paid more attention than Van Dyck did to the extremities, such as hands, feet, or horses' hoofs. Van Dyck, at least in his most rapid sketches, either omits these details or suggests them by a vague flourish. In his more careful drawings they tend to be elongated and flat. When Rubens draws hair, his lines suggest a soft tangible mass. Van Dyck prefers the decorative effect of undulating lines as such, without creating the sensation of a three-dimensional object. In places where Rubens uses a spiral with its spatial implications, Van Dyck draws a meandering line which remains in one plane. There are many dense and chaotic passages in the first drafts made by Rubens but they are clearly the result of his intensive search for the 'right' form. Similar areas in Van Dyck's drawings do not result from the same kind of almost organic growth but are introduced to promote the effect of sudden contrasts of light and dark. It is characteristic that Van Dyck was very fond of ink made out of gall-nuts which yields powerful effects of deep shadow. Apt to be also highly acid, this ink has eaten through the paper of many of Van Dyck's drawings. Rubens almost always used the traditional bistre, made of oven-soot; his washes are a light, sometimes slightly reddish brown, and perfectly innocuous as chemical substances. One of Van Dyck's favourite graphic devices, the use of rows of small dots in addition to lines and washes, is only rarely found with Rubens.

In chalk-drawings, Van Dyck's outlines have a keener edge, as it were, and the forms do not give a sensation of swelling forward in smooth rotundity. The lengthening of all proportions, well-known from Van Dyck's paintings, is often seen here too.

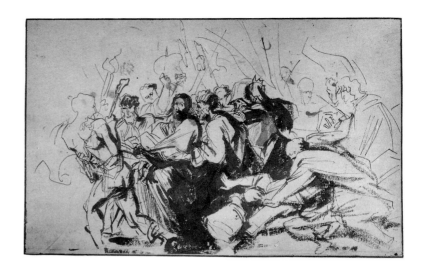

Fig. 1 A. van Dyck: Study for a *Taking of Christ*. Vienna, Albertina

These few remarks, admittedly far from complete, are meant to show that it is not an impossible job to distinguish between the drawings of the two artists. Yet the problem of Van Dyck–Rubens will always plague the scholars concerned with their drawings. A study of the drawings of either can never claim to be taken seriously if it does not include a thorough consideration of those of the other.

The Van Dyck-Rubens problem carries over even into the last question which the criticism of Rubens' drawings must consider, the tedious and vexing one of the copies. Modern students are apt to forget how common the practice of copying was and how adept the artists of the past were in producing striking replicas. Inventories of seventeenth-century collections (see Denucé, *Inventories*, passim) prove that many collectors owned as many copies as they did originals. Nor was it only the minor artist who copied: Rubens himself (as we shall see below), throughout his life, made many copies with the brush and the pen. Rubens' own drawings were naturally copied too; where the original drawing is lost, there is always the danger that a good copy may go as the master's own work. For the recognition of copies made in the eighteenth, and even more of those from the nineteenth century, stylistic and material analysis provide fairly effective weapons of detection, but the copies made in Rubens' own time or shortly thereafter are much harder to spot. There are a few instructive cases which contain a healthy warning against over-confidence.

One of them is the famous drawing with cattle, which was engraved by Pontius in his so-called *Livre à Dessiner* (R., V, No.1229), containing 20 designs by Rubens. Four nearly identical drawings of this composition are known to exist. One, in the

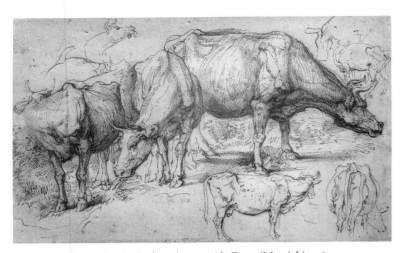

Fig. 2 Study for *Landscape with Cows* (Munich). 1620. Chatsworth, Devonshire Collection

British Museum (Hind, No. 118) was accepted as the original by Glück and Haberditzl; Rooses, and more recently Popham (*The Burlington Magazine*, LXXII, 1938, 20), as well as other scholars, stressed the superiority of a version at Chatsworth (Fig. 2); Hind believed that both were from Rubens' hand, although there is no case known where the artist repeated himself so literally. Two other drawings, one also in the British Museum (Hind, No. 122), the other formerly in the Northwick collection, are very similar but obviously inferior; both, according to Hind, seem to have been copied from the Chatsworth version, and the one in the British Museum appears to have been the model for Pontius' engraving. Suppressing the mischievous thought that the real original, like the 'real' ring of Lessing's fable in *Nathan the Wise*, may be lost, we must evidently choose between the first drawing in London and the example in Chatsworth. Of the two, the Chatsworth one seems to be the more spirited; it has a certain intensity and excitement in its lines which is absent from the more placid forms of the London page. Its shadows have greater depth, aided partly by the splotchy absorption of the ink into the paper. There is only one thing 'wrong' with the Chatsworth drawing: it is signed 'Ant. van dyck' and comparison with genuine Van Dyck signatures would seem to lead to the conclusion that this, too, is his own signature. The date fits well: the drawing must have been done around 1618–1620 as it is clearly connected with Rubens' Munich Landscape with Cattle (*KdK*. 187) of that period. It has, besides, the stylistic peculiarity mentioned before of rows of little dots which is quite characteristic of Van Dyck. The elimination from Rubens' oeuvre of the Chatsworth drawing would let the London piece win the race as it were by default. It is not unworthy of being called a Rubens, but an uneasiness remains; would Van Dyck have signed a copy he had made after a Rubens drawing or could it be that for his painting Rubens made use of studies by Van Dyck? In a close workshop affiliation this is not inconceivable. And since Pontius worked clearly from an album of copies, he might well have thought that this was Rubens' invention, seeing its close connection with a famous painting. Finally, the drawing may not be a study from nature at all, but a collection of animal poses, taken from various sketches of Rubens or from his paintings; it does have somewhat the character of a sample sheet. I do not consider the problem fully solved; it certainly illustrates the difficulties created by contemporary copies (see also text to Pl. 99).[6]

There is another case where the original may indeed be lost—if it ever existed. It concerns the portrait of a young woman, known from several nearly identical versions; one is in the British Museum (Fig. 3), another in the collection of Baron Rothschild (G.-H. No. 231); a third is at the Fogg Museum, Cambridge (Mongan-Sachs, 1940, No. 487), a fourth in the Louvre (Lugt, *Catalogue*, No. 1173). Watteau made a copy of it (Coll. S. Kramarsky, New York)[7] and a *contre-épreuve* of *his* drawing is in the Albertina (G.-H. No. 228). Why this piece was such a favourite with copyists I am unable to say. Nor do I believe that any one of the examples preserved is *the* original. (See also commentary to No. 37.)

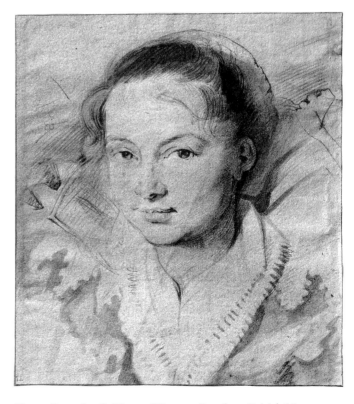

Fig. 3 Portrait of a Young Woman. London, British Museum

It is clear from the foregoing that the copyists did not make life any easier for the critics of Rubens' drawings. Yet we do owe them a debt of gratitude, too. The 'Copenhagen Copyist', for instance, so called from a large group of anonymous drawings in the Museum of Art in Copenhagen, has preserved for us the memory of a vast number of Rubens' drawings which without him would be completely lost. He is also responsible in my opinion for a pen-drawing which up to the present day has passed as an original drawing by Rubens. I refer to the so-called Self-Portrait of Rubens in Vienna, which Glück and Haberditzl accepted with the reservation that it had been reworked by a pupil. Yet a close examination of the piece makes it obvious that there is no drawing of any artistic significance below the parts done in pen and ink—and these parts are identical in style with many of the sheets in Copenhagen; the case is clinched by the inscription in which the same ink was used as in the head, while revealing the unmistakable hand that inscribed several of the Copenhagen pieces. The copyist worked either from a lost drawing or, more likely, from the painted self-portrait, formerly in the d'Arenberg

collection, now in the Rubenshuis in Antwerp.[8] Another drawing by him—also accepted in part as a Rubens original by Glück and Haberditzl—is, however, surely a copy of a lost work of the master himself. It is the portrait of Rubens' son Albert (G.-H. No.158), taken from the drawing which had served for the double portrait of Albert and Nicolas in the Liechtenstein collection (see also Pl.162).

While some copies were probably made with the aim to deceive, the vast majority surely were made in good faith, for practice or for future use. Whatever the original function, it was inevitable that many of these drawings would be labelled originals by later generations, from ignorance or wishful thinking as much as for fraudulent purposes. For the critic who wants to separate Rubens' own work from copies and imitations, the honest copies—unless they show clearly the hand of their makers as do those done by Watteau and Fragonard—are of course as much of a nuisance as the fraudulent ones. They becloud the genuine oeuvre of the master and are a constant invitation to lower the standards of quality by which Rubens' work is measured.

[1]*Kunstchronik*, VII, 1954, 199.
[2]For this 'methodical circle' see E. Panofsky, *Studies in Iconology*, New York, 1939, 11, note 3 (reprinted in E. Panofsky, *Meaning in the Visual Arts*, Anchor Books, Garden City, N.Y. 1955, 35) and the literature mentioned there.
[3]See C. Ruelens, *Bulletin-Rubens*, II, Antwerp, 1883, 166. By not signing, let alone dating his paintings (except a small number in 1614) Rubens may have consciously followed the major Italian masters, contemporary as well as past, as an assertion of his originality as an artist.
[4]An interesting example for this economy is furnished by the drawing of a man, seen from the back, who helps raising the Cross of Christ (Burchard-d'Hulst, 1963, No.58).
Rubens used the same pose for one of the child angels in the Munich painting of Children with a Garland of Fruits (*KdK*.132) which was made at least 6 years later.
[5]De Marselaer apparently was not aware that in applying Pierre Mathieu's *bon mot* to Rubens, he paid the artist an even handsomer compliment than he had thought. For Mathieu had only paraphrased a very similar saying found in Plutarch's little essay 'On Having Many Friends' (Plutarch's *Moralia*, The Loeb Classical Library, II, London–New York, 1928, 55, 5). There Zeuxis is quoted as having said, when charged with working slowly, 'I admit to paint a long time, but it is for

a long time'. With his great knowledge of classical authors, Rubens probably was familiar with this passage, just as was Reynolds who in His Third Discourse (1770) made a passing reference to it (see E. Wind, *Journal of the Warburg and Courtauld Institutes*, x, 1947, 160).
For de Marselaer's letter see *Correspondence*, VI, 198.
[6]The most recent literature remains divided: John Rowlands (*Catalogue*, Exhibition 1977, 152) appears to accept Van Dyck as the author of the Chatsworth drawing and follows Popham who thought that Jan Brueghel did the one at the British Museum. L. Burchard, as quoted by Adler (*Corpus Rubenianum*, XVIII, 1, 105), considered all versions copies, claiming that Rubens' original is lost. Renger (*Kunstchronik*, XXXI, 1978, 135) stressed the superiority of the Chatsworth sheet—and gave it again to Rubens.
[7]See K. T. Parker and J. Mathey, *Antoine Watteau*, T. I., Paris, 1957, No.282. Parker and Mathey, the last authors to express themselves in this matter, apparently accepted Ludwig Burchard's opinion that the London example is Rubens' original, and that all the others, including the Rothschild drawing which Sachs and Morgan had also accepted as authentic, are copies.
[8]Since Panneels made an etching of this picture (V. S. 160, 46), it was probably he, too, who drew the Vienna drawing; if so, those drawings in Copenhagen that have the same kind of inscription would have to be considered also as Panneels' works.

15

II

Types and Techniques of Rubens' Drawings

THE FUNCTION OF DRAWINGS

IF WE WANT to understand the rôle which drawing played in Rubens' art, we must always keep in mind one basic truth. The only productions which Rubens recognized as finished work were his paintings in oil, either of the 'easel' size or the still larger ones made for the decoration of walls and ceilings in palaces and churches, for altars, or for the temporary structures erected in the great pageants of his time; to these must be added tapestries and portraits, the latter mostly of the large, formal kind. No matter how much we may admire today the brilliance of his oil-sketches or the beauty and variety of his drawings, we ought to realize that these works were almost never produced as ends in themselves, but as preparations for the more finished products. It is interesting that a contemporary of Rubens—and one of his early admirers—admonished young painters 'to consider all drawing but as a servant and attendant, and as the way of painting, not the end of it'.[1]

That does not mean that Rubens was unaware of the special attraction which these unfinished, or intermediate, solutions may have; it is well known that once when Rubens in a contract was given the choice of either delivering the preparatory sketches (which, to be sure, were very numerous) or to paint an additional large altar-piece, he painted the large canvas and kept the sketches. That a drawing was for Rubens an object of beauty as well as one of specific usefulness can be inferred from a passage in the famous letter to Sustermans explaining the significance of every figure and every object in his Allegory of War in the Palazzo Pitti in Florence. 'If I remember correctly,' he wrote, 'you will find on the ground under the feet of Mars a book and a drawing on paper to indicate that he tramples on literature and on other things of beauty.'[2] It has apparently never been noticed that on that drawing is a clearly recognizable sketch—visible only as a fragment—of the Three Graces (Fig.4). While thus using a time-honoured image for 'things of beauty' destroyed in war, it is surely significant that he introduced it in the shape of a crumpled drawing which in times of peace presumably would be honoured and preserved as much as the book on which the foot of Mars is actually resting. It can hardly surprise us to find that Rubens collected drawings by old masters, for their historical and aesthetic interest surely as much as for study and imitation.[3]

The fact remains, nevertheless, that for Rubens drawings had to fulfil first of all specific functions in the production of paintings and in the organization of his studio. Nothing could reveal better Rubens' conception of the value of drawings than the disposition of his own drawings provided for by him in his will. While the actual words of the will are lost, we are well informed about many of its provisions.[4] It is worth while to quote the pertinent passage literally: 'But the drawings which he had collected and made he ordered to be held and preserved for the benefit of any of his sons who would want to follow him in the art of painting, or, failing such, for the benefit of any of his daughters who might marry a recognized painter; thus they should be kept until the youngest of his children should have reached his eighteenth year. If by that time none of his sons should have followed him in his art and none of his daughters should have

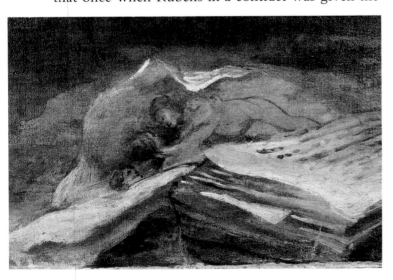

Fig. 4 The Three Graces. Detail from *The Horrors of War.* Florence, Palazzo Pitti

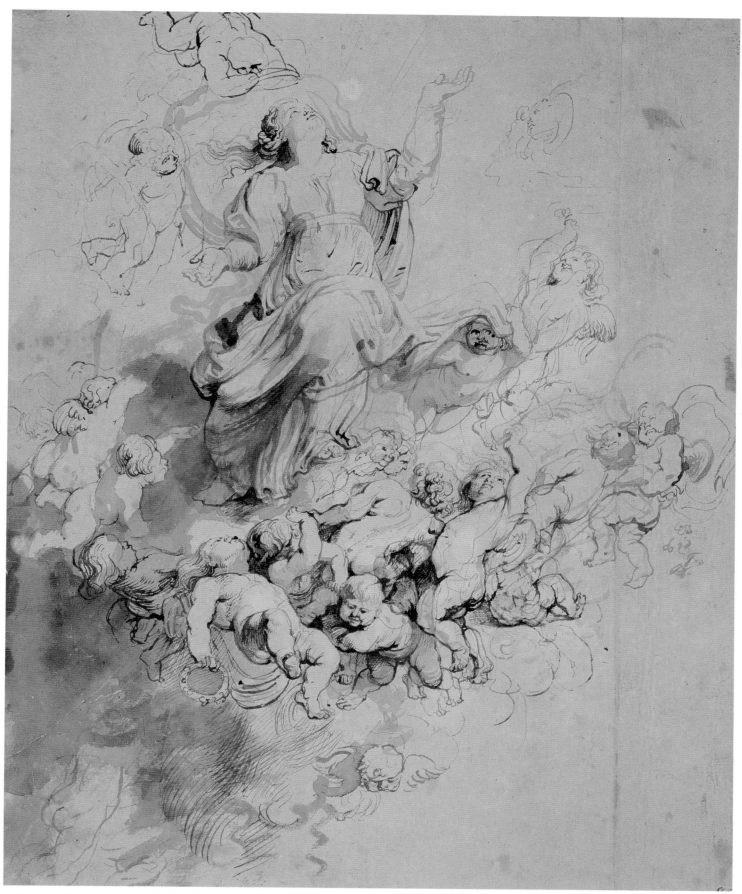

1 (Cat. 85) The Assumption of the Virgin. *c.* 1614–15. 290 × 230 mm. Vienna, Albertina

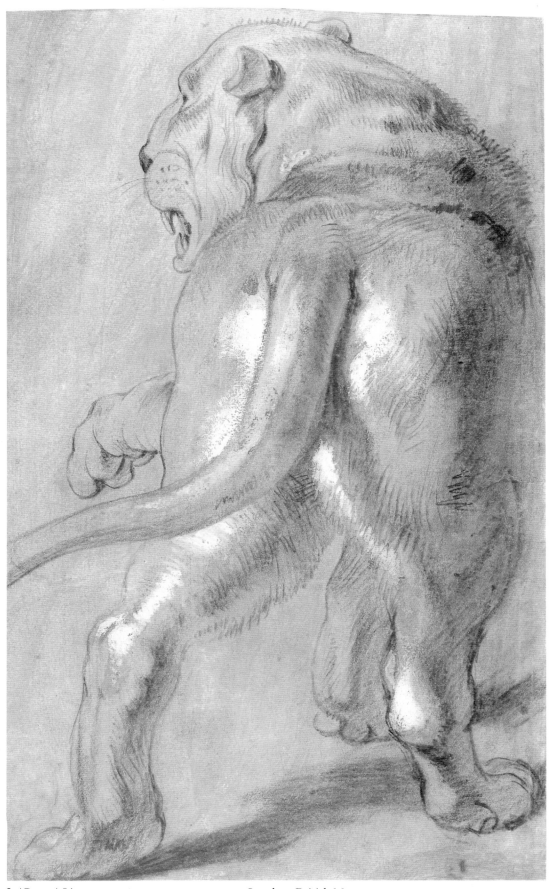

2 (Cat.93) Lioness. *c.* 1614–15. 390 × 235 mm. London, British Museum

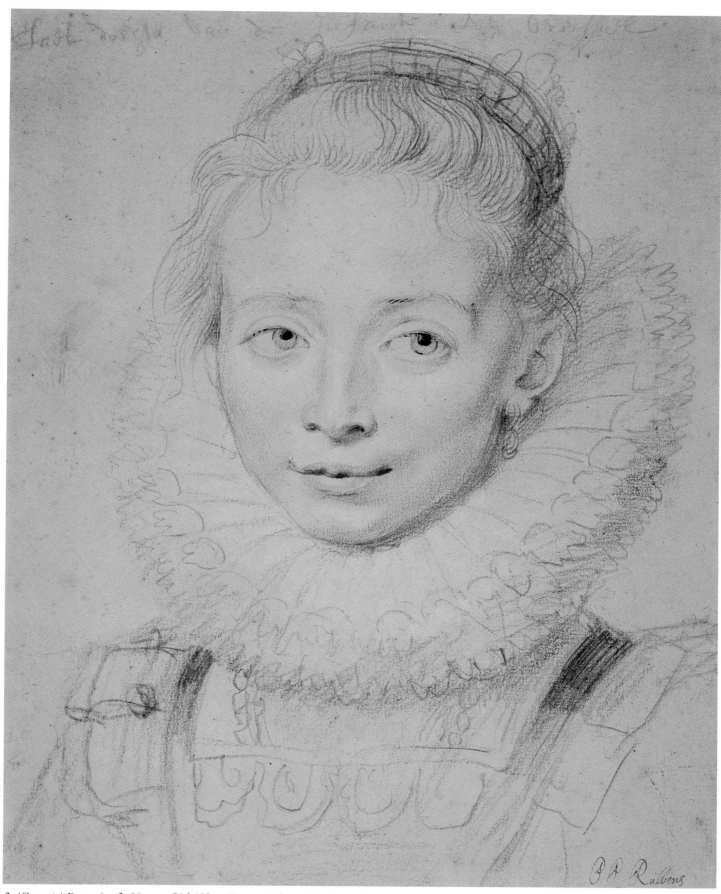

3 (Cat.162) Portrait of a Young Girl (Clara Serena Rubens (?) 1611–23). *c.* 1623. 350 × 283 mm. Vienna, Albertina

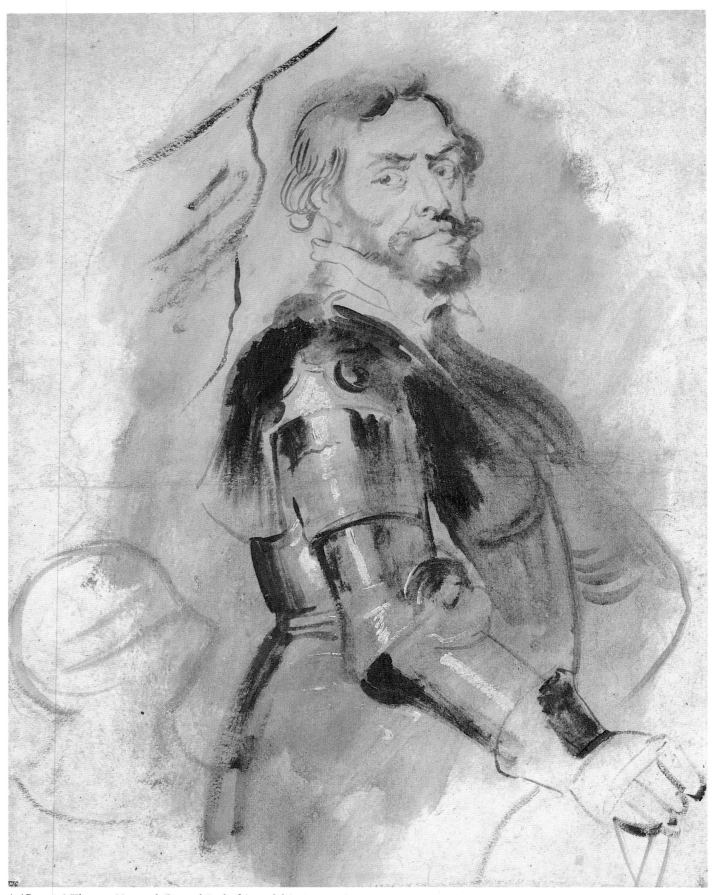

4 (Cat. 180) Thomas Howard, Second Earl of Arundel (1585–1646). *c.* 1629–30. 460 × 355 mm.
Williamstown, Mass., Sterling and Francine Clark Art Institute

married a recognized painter, the drawings should be sold and the receipts divided in the same manner as his other assets...'[5]

Rubens could hardly have had any illusions about the artistic talents of his older children, but when he died those by Hélène Fourment were still very young, and one was not yet born. Was he motivated by a secret hope for an artistic successor, or is his will a veiled expression of disappointment at the absence of such a child at the time of his writing? This is most unlikely. Sir Peter Paul Rubens, 'Secretary of His Catholic Majesty, in his Privy Council', and the Manor-Lord of the Property of Steen, must have known full well that by his own social advancement he had made it practically impossible for any of his sons or sons-in-law to return to the status of a painter. He himself had never forgotten—no matter how brilliant his career as diplomat and statesman had been—that he was primarily an artist. His children, however, were surely conscious of their father's social position and probably regarded the profession of painter as unsuitable for themselves.

The stipulation about the disposal of his drawings, in other words, was only an evidence of his customary good sense. One of Rubens' most significant characteristics was his ability to attend to his affairs in an orderly and business-like way and to make proper use of his faculties and of his resources. Since drawings were useful tools in the routine of a workshop and, as such, assets potentially of greater value than they would be as mere objects of a collector's curiosity, it would have been improper and unwise to sell them as long as there was a chance that they might be used again in the studio. They were to be dispersed only when it was clear beyond any doubt that no other benefits could be derived from them; until then Rubens felt it his duty to protect them.[6]

Thus the importance of the master's will lies in the clarity with which it expresses the view that the primary function of drawings is to serve as models for study, possibly also for the instruction of pupils, and as reference material. Rubens himself used his own drawings again and again; indeed, it would be of great interest if we knew how he filed them, for it was surely done so that a desired motif could be found quickly among hundreds, if not thousands, of items.

While the usefulness of a drawing was by no means exhausted once it had served its original purpose, it is of course necessary first to see it in the context of its origin. This involves a knowledge of the whole working process of the master. A widespread but nonetheless questionable theory holds that the greatness of an artist is measured chiefly by the degree of his originality. It is often silently assumed that his main concern should be the avoidance of tradition. Whenever we see a great artist turning to the past we are inclined to assume that he did it only 'pour mieux sauter'. Yet the freedom of action implied in Cézanne's famous 'Il faut refaire Poussin sur nature,' was possible and valued only after the middle of the nineteenth century. It is admittedly difficult for people who have come to equate traditional art with poor, or at least with dull art, to do full justice to an artist for whom there was no greater goal than to continue a great tradition.

Rubens was such an artist. Perhaps it would be a more adequate statement if we were to say that he carried on two traditions. The heritage of Flanders remained strong in his art to the very end. But it is certain that he preferred to think of himself as the heir to a longer and greater tradition reaching across the great masters of the Renaissance back to the culture of the Ancients. His real teachers were not Adam van Noort or Otto van Veen, and not even Pieter Bruegel, but Leonardo and Michelangelo, Raphael and Giulio Romano, Titian and Tintoretto, and the great sculptors of classical antiquity. There is probably more than justifiable pride and self-confidence in the famous phrase with which he solicited, long before he actually obtained it, the commission to decorate Whitehall Palace. By asserting that by nature he was 'more gifted for the very large works than for the little curiosities,' he claimed confidently membership in the only school and tradition which until then had been recognised as capable of working on a monumental scale, the Italian, and he may have chosen this very formulation as an answer to Michelangelo's quip (reported in Francisco de Hollanda's first Dialogue) that the artists of the North were good at painting small details ('masonry ... grass ... rivers and bridges ... with many figures' ...) but that they lacked boldness, substance, and vigour.

As a painter in the monumental tradition, Rubens follows the technical procedures which the Italian artists had evolved before him. The various classifications that we can make among his drawings, which have their fixed rôles in the preparation of paintings, can all be found in Italian art of the sixteenth century. It is true that the painted oil-sketch was used far more frequently by Rubens than by any earlier Italian painter, but even this is not a novel element (nor, for that matter, a Northern tradition) but the development of a practice first introduced, it seems, in the studios of Tintoretto and Barocci.[7]

Much has been written about the rôle of these oil-sketches in Rubens' art. One of the most extreme theories, repeatedly expressed by Van Puyvelde, claims that oil-sketches completely replaced com-

positional drawings after Rubens' return from Italy. '*Rubens pensait le pinceau à la main*'[8] is a charming formulation, but it is not true if it is meant to exclude other methods of creative 'thought'. The chief function of the oil-sketch, though not its only one, as Van Puyvelde himself said correctly, was to submit the artist's ideas to his clients and to his collaborators (*Esquisses*, 14, 55). Van Puyvelde's contention, however, that Rubens *started* the working process with oil-sketches, or that he painted his small easel pictures without any preparation, is not borne out by the evidence. Everyone will agree that Rubens must have been a speedy worker. But to call Rubens' speed, as Van Puyvelde does repeatedly (*Esquisses*, 15, 58), a facility for improvisation comparable to the 'eloquence of a born orator' is to do an injustice to one of the most deliberate of artists, who probably abhorred the idea of rhetorical 'improvisation' as much as Poussin did.

If Rubens was ever tempted to rely on improvisation and on what Bellori called his 'furia del pennello' it was in November, 1634, when he received the commission to make sketches for the elaborate decoration of the city of Antwerp for the triumphal entry of Cardinal Infante Ferdinand, scheduled to take place the following January.

Fig. 5 Design for the title-page of the *Pompa Introitus Ferdinandi*. Oil-sketch. Cambridge, Fitzwilliam Museum

(Actually it was delayed until April.) If we look attentively at the sketches which have been preserved we see plainly that Rubens drew the outlines of the compositions in black chalk on the light ground of his panels. These lines have disappeared where oil-paint was subsequently applied, but where there is no covering layer other than varnish they still stand out as clearly as if they were drawn on paper. That this was a common practice with Rubens, and that he drew with chalk on the prepared panels even when he was not pressed for time, can be observed in several sketches, especially the fine one he made for the title-page of the *Pompa Introitus Ferdinandi* in the Fitzwilliam Museum in Cambridge (Fig. 5). In the centre of the sketch where later the title of the book was engraved, he had originally drawn in chalk the same scene which appears in oil-colours in the pediment above. Closer inspection shows that the pediment itself and even the caryatids were first started lower down on the panel. For some reason, as he worked, he moved the whole design upward. Where the first lines were not later covered up by layers of colour it is still possible to study them with ease; they are very similar to the first chalk-lines which we can distinguish in some late pen-drawings (see Pl.184). Chalk lines of the first rough draft, and even inscriptions in chalk, can be clearly seen on the Antwerp sketch of the Victory Chariot of Calloo (Held, 1980, No.289).

In view of these observations there is no reason to question the veracity of the often quoted report by the young Danish physician Otto Sperling about a visit he had made to Rubens' house in 1621.[9] The house and studio of Rubens were evidently 'musts' on sight-seers' lists of Antwerp attractions; like other travellers, Sperling included it in his tour, and he had the good fortune of being introduced to the artist and to watch him at work. Without stopping work, Rubens answered questions, listened to a reader, and dictated letters. In one room Sperling saw 'many young painters who worked on different pieces on which Sr. Rubens *had drawn with chalk* and put a spot of colour here and there; the young men had to execute these paintings which then were finished off with lines and colours added by Rubens himself.' That we can no longer detect these preliminary chalk drawings under their later coats of colour does not prove that they did not exist. It so happens that we know from a contemporary source—and one close to Rubens, at that—that artists were wont to take good care that these first drawings would not show later on. In his notes on painting, Dr. Theodore Turquet de Mayerne warned the artists that 'auant que paindre, il fault bien essuier le tableau nettement a fin que ladicte pierre ne tache et macule les couleurs'.[10] No matter how thinly Rubens painted, the chances of finding

traces of his first outlines on the canvases are evidently slim.

PRELIMINARY STUDIES

Although occasionally Rubens may have made no other drawings than those he traced directly on his panels or canvases, as a rule he prepared his pictures carefully in drawings on paper and in oil-sketches on panel. We can reconstruct the normal procedure in principle, although it is unlikely that we have for any of Rubens' works a record of the preliminary phases as complete as we have for Géricault's Raft of the Medusa, for instance, or for Seurat's Grande Jatte, or Picasso's Guernica. Incomplete though the material may be, it contains representative examples of all the stages through which any of Rubens' thoughts might have passed on the way to their final pictorial realization. Needless to say, only pedantry would expect Rubens to have proceeded always in the same manner; but no matter how flexible his procedure was and how many short-cuts he may have chosen in individual cases, there was a basic pattern which we can still perceive with great clarity.

Like all artists of his time, Rubens used sketch-books, and the pages of one of these are still preserved in London (see p.45 and Pls.65–68). Three sketchbooks by Rubens were listed in the inventory of his pupil Erasmus Quellinus, made in 1679.[11] A copy of a sketchbook which contained theoretical writings was still extant in the late nineteenth century (see p.43). It is certain, however, that most of Rubens' drawings were not made in sketchbooks but on single sheets. The evidence for this statement is quite simple, and I believe incontrovertible. When there are drawings on both sides of a sheet, the top of one side nearly always coincides with the bottom of the other. In other words, when Rubens turned a leaf, it was not turned horizontally as one turns the pages of a book, but vertically. He may have turned the pages either towards himself, or away, but never from right to left. Only a draughtsman using loose sheets would have developed this habit.

Most of these sheets have been preserved only as fragments; the size of the original sheets can be seen in a few pieces which evidently have not been cropped, such as the Kermesse (Pl.184), which is on a paper of about 50 by 58 cm. The portrait of Hélène Fourment (Pl.191) measures 61 by 55 cm. (and although now cut out, was probably about the same size originally). The sheets of the Garden of Love (Pls.203, 204) are 71 cm. wide (though one has been added to in order to make this width). Rubens used these sheets full size only in the most unusual cases. Even at half the size they were still large.

Rubens normally began by drawing hardly more than the barest outlines of his figures in thin lines with quill or chalk. There is no marked preference as far as I can see for either of these tools. Both are found in examples from all periods of Rubens' activity, though in his youth he seems to have used the pen more frequently when starting his drawings. That chalk was used as freely and easily as pen to give form to his first thoughts has not generally been realized. The reason for this lies in the fact that the first thin lines made in chalk have become well-nigh invisible in many cases, either because they were wiped off on purpose, or because of abrasion. It often takes a very attentive scanning of the surface to detect the traces of the first drawing in chalk. The beautiful study of Carousing Soldiers in the collection of Frits Lugt, for example, which in the literature is described only as a drawing in pen and ink, was actually first sketched in black chalk (Pl.208). In some instances Rubens seems also to have used lead pencil. In pure pen-drawings the lightness of the first outlines is often hidden beneath the coarser lines made later; a good example to gauge the difference in thickness between the first lines and those made slightly later—even though both kinds are still within what may be termed the trial-and-error phase of a work—is the Stockholm drawing with Studies of the Virgin and Child (Pl.170).

Rubens rarely left the first thin sketch without making changes. Generally he continued drawing on top of it, developing some figures or groups more thoroughly, repeating certain sections, trying out alternatives, and frequently using wash to bring order into the chaos. Rubens never hesitated to draw into and over figures which he had outlined before. Some of his drawings are in multiple layers that recall palimpsests. In the Silenus and Aegle (Pl.77) Rubens had drawn in the upper right corner the same reclining nymph which one sees clearly in the centre and the lower left; but her body is barely recognizable among the swirling lines of other figures drawn over her. The Descent from the Cross (Pl.121) was drawn twice in versions which partly overlap. In the Stockholm Virgin and Child (Pl.170) there are at least four different versions of the theme in the right half of the sheet, overlapping and interpenetrating each other.

There are many sheets on which elaborately drawn figures and groups stand beside roughly outlined ones; the Raising of Lazarus in Berlin (Pl.126) is a particularly instructive example, since all its parts deal with the same theme. There are some almost amorphous chalk-lines, belonging to the first sketch, most clearly visible in the centre under the large layer of bistre wash. A tiny pen-sketch, long on spirit but short on detail, is in the

upper right corner. Even in the main group there is considerable variation in degree of finish, from the barely indicated apostles to the strongly modelled figure of Lazarus.

Lazarus himself is a good example of Rubens' habit of multiplying the limbs or the head of a figure until it resembles an idol of Buddhist mythology. Lazarus' head was drawn in three different positions; Bathsheba, in a pen-sketch in Berlin, was drawn with alternate positions of her legs and right hand (Pl.135); Hercules, in a chalk drawing in Antwerp (Pl.89) seems to have three right and two left legs which partly overlap; the lion, too, has several paws too many. The figure which served for Mercury in the Education of Marie de Médicis (Pl.153), a drawing which fits into two different categories, apparently has three pairs of legs. The victor in the Berlin drawing of a Roman Triumph has one left arm up, another down; and Jupiter's head, like Lazarus', is shown in three positions (Pl.131). A particularly charming instance is the little angel who hovers over St. Gregory Nazianzen (Pl.146): he has been endowed with two complete bodies, one flying towards the right, the other towards the left, but he has only one head and one pair of arms.

Outlines are sometimes drawn in single strokes of pen or chalk with a neatness reminiscent of Ingres. At other times the figures almost disappear in a cloud of rushing and whirling lines which fail to define form but suggest movement more convincingly than the lines of Balla's scottie (Pl.47). For greater speed, Rubens developed certain graphic abbreviations. He often drew eyes and nose together in one continuous line which breaks in four right angles; mouths are rendered by a very short line, if at all. When seen in profile, noses are fairly long, and sharply pointed. The shoulder is always a very conspicuous round form in the construction of Rubens' figures. However, for a master who has been said to think in rounded forms, he drew surprisingly often in straight lines and sharp angles, especially in his first sketches; in subsequent stages he would round off the angular rhythms of his first lines. (I have mentioned a few other peculiarities before in contrast to Van Dyck.) It is clearly impossible, however, to draw up a complete list of Rubens' personal shorthand devices which, to be sure, underwent certain changes during the forty years of his activity. The master's style was surprisingly flexible. His graphic formulae are distinguished by variety rather than consistency. A student who knew only Morelli's method would have a hard time demonstrating that one artist did all the different pieces.

The chief appeal of these preliminary studies lies in the insight which they furnish into Rubens' creative process in general and into the genesis of individual works in particular. It is exciting to watch the artist as he skilfully woos his mental image in ever new attempts at visualization. There is never anything laboured in these efforts. New possibilities present themselves quickly and the hand is limited only by its physiological speed, not by a scarcity of ideas. Like Dürer, from whom we also borrow the phrase, Rubens must have been 'inwendig voll Figur' (full of forms within). We think of Dürer's sheet with nine different images of St. Christopher (Berlin) when looking at the six different poses of Thisbe's suicide (Pls.24, 25); St. Christopher himself was drawn twice by Rubens on one sheet (Pl.87) and also formed the subject of one of his finest oil-sketches (Held, 1980, No.359). The studies for the Visitation with their increasingly large and flowing forms (Pl.72) or the sheet with the various deeds of Hercules (Pl.216) are of this same sort. One of the most beautiful of these drawings is the sheet with seventeen pairs of dancers in the British Museum (Pl. 185 and Frontispiece); here we no longer witness an effort to find a single solution. His imagination fired by the subject, Rubens seems to have continued drawing for the sheer delight of mentally watching a couple of dancers whose dance expresses their love and whose love lends wings to their dance.

The sketchy freedom of these first 'thoughts' Rubens owes to Italy. As E. H. Gombrich has shown in a fascinating study, the 'unfinished' and sometimes chaotic character of designs for compositions may well have been consciously created by Leonardo.[12] This was the visible expression of Leonardo's belief in the superiority of invention, or imagination, over execution. Since invention results from an intense action of the creative faculties, drawing, the visual equivalent of this process, was the more convincing, the less it had the appearance of neatness and finality. Indeed, from the indefiniteness itself may spring new mental stimuli, 'keeping alive' the flow of imagination. By Rubens' time, the particular overtones of conscious novelty and psychological justification were surely no longer connected with this manner of drawing. A century of practice by Italian artists had firmly established the custom and had demonstrated its usefulness. Yet it was still primarily an Italian method; and it was only through eight years of close association with the Italian tradition on the very soil of the peninsula that Rubens could assimilate it fully.

As we can never be sure of knowing all the drawings made for any one project, it is impossible to say how many preliminary sketches on the average Rubens made before he found a satisfactory solution. For the Presentation in the Temple we have three rough sketches, two of them close

together and placed in such a way that one seems to be almost the mirror-image of the other (Pl.73). During these first stages in the genesis of a picture reversing a design in order to test new possibilities was apparently not unusual. The best example is furnished by the two drawings of the Continence of Scipio (Pls.123, 124), though in this case the second version contains also many significant advances over the first. (The finished painting followed neither of these plans.) Two quick studies are known for the Last Communion of St. Francis (Pl.128); three drawings have for their subject Venus lamenting Adonis (Pls.56, 57), but we do not know if a painting corresponding to the scheme of these drawings was ever executed.[13] In other cases, though we have only one drawing, the main group or action is sketched several times on the same sheet. From all this it would appear that Rubens was quick to find a satisfactory form for his ideas; from the drawings of the Continence of Scipio we can also learn how easily he introduced variations into compositional patterns and how rapidly his second versions acquired precision and descriptive detail. What seems to be fairly certain is that for any new project Rubens made at least one first draft in the media of pen or chalk. This gives us a measure of the losses. What has been preserved is evidently but a tiny fraction of what must once have existed.

While we deplore this loss, we can readily account for it. It was precisely this kind of drawing which was least likely to be preserved. In the daily routine of the studio these early and often amorphous scribbles played only a minor rôle. Their loss meant less than losses in other categories. The sketchiness that makes them so fascinating to us must have been in Rubens' eyes their chief shortcoming. Any subsequent drawing or oil-sketch diminished their value. Once they had fulfilled their function they could easily be discarded like the first draft of a manuscript. For other types of drawing there was a continued usefulness in the studio; not so for them, or at least not for the most tentative of them. Those preserved may owe their survival more to the devotion of ardent disciples than to any care given to them by Rubens himself.

It is obvious that the amusingly descriptive term 'crabbelinge' or 'crabbeleye' (scribble) which occurs in seventeenth-century inventories applies to this kind of preliminary drawing. We should remember, however, that these 'scribbles' may range from first hasty notations to fairly elaborate drawings which could well have been submitted to patrons for their approval. Normally Rubens seems to have made an oil-sketch for that purpose since it would also give an idea of the appearance the work would have in colour. (Rubens himself surely did not need the sketches to study colour effects, any more than a composer needs to hear sounds for his instrumentation.)

To patrons who lived out of town, and surely to those abroad, he probably sent a drawing for the sake of speed and safety. Two such drawings with inscriptions by Rubens have been preserved in the Louvre, Paris (G.-H. Nos.40, 41); they have been dated in the Italian years by many scholars, because the text is in Italian. Since, however, Rubens almost always corresponded in that tongue, we are free to date the pieces by their style. They were probably done between 1612 and 1615. On one of them Rubens explains to the recipient 'you must remember that the work will turn out very different from these sketches (scizzi) which have been drawn only lightly at the first try to show you the general idea (il pensiero); the drawings (dissegni) and the picture, too, will be made with all possible care and diligence.' (Despite these reassuring words, he does not seem to have obtained the commission.) It shows how familiar he was with the language of Italian studios to find him using the characteristic term 'pensiero' in connection with these preparatory drawings; we should not, however, take too literally his statement that he had made the drawings 'da primo colpo.' They were done rather neatly, almost like models for engravers, in pen and ink with the addition of some slight wash. What he meant by the 'dissegni' which he would do with great care is not quite clear. Oldenbourg thought that he referred to large-scale cartoons. It is more likely that what he had in mind were large oil sketches or modelli. Both designs illustrate old-testament subjects (the three patriarchs, Abraham, Isaac and Jacob, and King David playing the harp)— subjects rather unusual for large-scale religious paintings.

Sometimes he provided drawings for other artists to use in their work. One such drawing, evidently the central group for a Feeding of the Five Thousand (G.-H. No.103), he mailed with some others to a 'Mons. Felix', who probably was a Flemish painter since the accompanying letter was written in Flemish. Rubens wrote: 'You must be content with these drawings no matter how weak and pale they be, since I am prevented because of other occupation to do more with them. You will have to make shift with them and you can make the composition wider or narrower to suit the proportion of your work.' He signed 'your friend and servant Pietro Paulo Rubens' and by adding the date made this the only drawing still preserved which is dated exactly: January 18, 1618, done in Antwerp. We do not know whether 'Mons. Felix' ever used the drawing (if he did, it was probably for a picture in which still-life and landscape elements prevailed); we are grateful to him, though, for having preserved this

document—and for not having made his alterations on top of Rubens' drawing.

The process of change and of growth of Rubens' compositions extended occasionally into the sketches painted in oils. While the majority of them show evolved compositions, there are not a few in which Rubens was still experimenting; some, indeed, look as if Rubens had started them without previous drawings. The sketch for the lion hunt in the collection of The Marquess of Cholmondeley is such a piece (Fig.6). Several figures in the upper half of the panel are indicated only in outlines, and a still earlier phase, corresponding to the very first rapid sketches in pen or chalk, is visible in the lower half of the panel. Here for once there is no functional distinction between drawing and oil-sketch.[14] Other sketches in oil, belonging clearly to the formative stage in the development of compositional ideas, are the Adoration of the Trinity by All Saints in Rotterdam (Held, 1980, No.399) or the Conversion of St. Paul in the Princes Gate Collection (Held, 1980, No.421), both so full of changes made during the execution that it is very difficult to 'read' the design. The Rotterdam sketch represents an unusual situation where an oil-sketch preceded a more finished drawing. The reason for this irregularity may lie in the fact that the 'end-product' in this case was an engraving—one of the illustrations which Rubens designed and C. Galle engraved for the new edition of the Breviarium Romanum of 1614 (G.-H. No.70). We shall return to Rubens' preparation of engravings in a separate section.

Fig. 6 Study for a Lion Hunt. Oil-sketch. Collection Marquess of Cholmondeley, Houghton Hall, Norfolk

DRAWINGS FROM THE MODEL AND PORTRAITS

The 'neat' drawings and the oil-sketches mark the end of the first phase in the preparation of Rubens' paintings. Yet they were not like blue-prints, from which Rubens or his assistants would produce the large pictures by the mere process of scale-enlargement. With the basic plan of the whole thus fixed, Rubens turned to the clarification and the improvement of the details. F. M. Haberditzl deserves credit for having observed that the chalk drawings from the living model—the magnificent pages which today form such an impressive group among Rubens' drawings—were mostly made *after* Rubens had painted the oil-sketches. Before they were done Rubens had determined the character of each figure and the place it occupied in the ensemble. Then he had models assume the various poses in order to check the flights of his imagination against the stubborn facts of reality. There is a wonderful concreteness about these drawings, but nothing pedestrian. Impressive as they are by sheer size, they owe their effect to something more than mere bigness. The true secret of their beauty lies in the fact that each form seems to be animated by a spirit commensurate with its majestic shape. Whether it is a man in physical and mental agony (Pl.74), a placid peasant woman crouching on the ground (Pl.129), a pair of hands (Pl.59) or arms flexed in combat (Pl.70)—all these forms and figures have in common an inner dignity, a grandeur less of size than of bearing.

It was not only a guarantee of correctness which Rubens obtained from these studies. Through them he frequently found also a more telling gesture, a more meaningful expression, than he had sketched before. The very clarity of these drawings, besides, was useful in a workshop where a good many labour-saving devices must have been practised. If Rubens employed assistants in the execution of his large canvases, as I think he did, certain modern theories to the contrary notwithstanding, these large and precise drawings of details must have been an invaluable aid to guide his helpers.

One aspect of Rubens' talent is particularly well demonstrated by these drawings: the truly marvellous coordination between the observation of his eyes and the action of his hand. In contrast to his first sketches in which the lines may occasionally remind us of the dense growth of wild underbrush, the chalk-drawings are lucidity itself. Their forms stand freely in space like the trunks of tall trees in a well-kept forest. No image is superimposed upon another. Corrections are rare, though there may be experiments with alternate positions of individual limbs. Most of the time Rubens hits the target at the first try. Without hesitation, but also without hurry,

he recorded what seemed to him essential in each particular case, the smooth flow of an outline or the flickering light that plays over a silken material. With a few lines and lightly applied shadows Rubens indicated the relationship of a figure to space. Details like arms, hands, and feet were often repeated. Rather than scaling down his figures, Rubens preferred to draw separately, next to the body, an arm or a leg which otherwise would have extended beyond the paper's edge.

For a painter whose popular fame—rightly or wrongly—rests on his female nudes, there are, as Glück and Haberditzl already noticed, surprisingly few drawings from the nude female model in Rubens' work.[15] Of the small number which they list, one used for a figure of Psyche (G.-H. No.96) was drawn, I believe, from a male model, a practice frequent with Michelangelo and Raphael. Another (G.-H. No.238) has been doubted by Lugt, but even if not original it may record a Rubens drawing, especially as the pose is identical—though seen from the back—with that of Pallas in the London Judgment of Paris (KdK.344).[16] There remain, first, a drawing in the Princes Gate Collection (G.-H. No.239)—a drawing generally dated much too late; it can hardly be later than 1620; two drawings—not known to me in the original—which were exhibited in Amsterdam (1933, Nos.105, 106). of which only the second one clearly was done from nature; and a drawing in the Louvre (Lugt No.1032), which Evers probably correctly identified as a study of Hélène Fourment and which, hence, is a special case. Even if we add to these the few pen-sketches of female nudes (Pls.136, 137, 178), there remains the suspicion that female models were none too common in Rubens' studio.[17] (They were one of the chief attractions of Rembrandt's.)

Male figures indeed dominate this group of drawings, especially up to the early 1620's. They are athletic types and full of energy, whether they run, fight, or lift heavy loads; even when they suffer from man's cruelty or under a wild beast's attack, they remain physically intact and impressive. Small accents of deep shadow give to all forms a powerful plasticity. Hands and feet receive special attention, in drawings of all periods. Rubens is specially attentive, in such studies, to the action of light, stressed in highlights and reflections, and to the problem of foreshortening. In one extraordinary drawing of an elderly man he depicts a gigantic pot-belly, without any intimation of helplessness or freakish anomaly.[18]

Draped figures tend to be shown more stationary than nudes. In some of the sketches the boldly arranged masses of material look as if they could almost stand up by their own strength. For farm women and ladies in elegant finery he makes concise, though never minute, observations of the characteristic elements of their dress. Foreign costumes occur occasionally in studies made from life (Pls.133, 134). In most of these drawings except those in which Rubens concentrated on a single feature, such as hands, the human face assumes the leading rôle. This involved the problem of balance between the features of the face and those of the body. We are hardly ever aware with Rubens that such a problem exists, so right and so natural is the relationship. Where the drawing of the body is detailed, this interest carries through into the face (Pl.84); where the arms and shoulders of a girl are sketched with a few lines only, the same economy extends to her features (Pl.112).

In his drawings of heads Rubens always starts with the simple silhouette of the skull. Hair for him is an incidental element to which he pays only scant attention. It may either flow smoothly along the solid form underneath, or it may play around it in fluffy, undulating curls, but unless there is a special feature which interests him, such as the braids of peasant women or the bangs and buns of the ladies of fashion, Rubens draws hair quickly with a minimum of detail.

When we come to the study of heads alone, we cannot always be sure whether a drawing was made for a figure in a larger composition or more specifically for a portrait. The boundaries here are somewhat fluid, but one can tell in general the study-heads from the studies for portraits by the poses and expressions which are not in accordance with portrait conventions. As a rule, portraits turn towards the beholder; thus drawings of heads in which the figure does not turn towards us most likely were not meant to serve for portraits. The few exceptions to this rule are found in some drawings of children and in portrait studies made in connection with larger compositions where the individuals (such as Queen Mother Marie de Médicis) had to be fitted into a wider context and had to conform to predetermined attitudes (G.-H. Nos.150–152, 180; Pl.162, 175). There are drawings which look as if the same model had posed for them—as for instance the Study for a Crucified Christ (Pl.84) and that for Daniel (Pl.85). While this does not prove that they were done simultaneously, it is not likely that more than a few years lie between them. On the other hand, drawings made evidently at the same session and from the same model were often used in paintings of quite different dates (see Pl.129, and G.-H. Nos.108, 114).

There is still another problem involved in the question of Rubens' models. We have taken it for granted that all these drawings were made from living models, and most of them may well have been done in this way. But even where his model

was an inanimate object, Rubens had an almost magic gift for suggesting the immediacy and spontaneity of an observation from life. In the Hermitage in Leningrad there is a beautiful chalk drawing of a bearded man looking up, with another head seen in profile and a hand appearing near the lower edge (Pl. 88)—the type of drawing normally made from the live model. In this case, however, it is easy to demonstrate that Rubens made the drawing of the foreshortened head from the classical bust of the so-called 'Seneca' which he owned,[19] and which for the sake of this study was simply tilted backward. Rubens used this study from a sculpture in the same way he did those made from life.[20] He introduced the 'Seneca' into his picture of the Miracles of St. Ignatius of Loyola in Vienna just above the women possessed (*KdK*.204). The drawing of a lioness (Colour Plate 2), so full of *brio* and vitality, may also have been made from a plastic model. It is a matter of record that for his portrayals of Henry IV for the Cycle for Marie de Médicis Rubens used a plaster cast which had been sent to him from Paris; one drawing made from it has been preserved (Exh. Amsterdam, 1933, No.111). Rubens' well-known statement recorded for us by his great admirer in the seventeenth century, Roger de Piles, about the imitation of classical statues comes to mind: 'They [the sculptures] are to be made use of judiciously, so as to avoid any suggestion of stone . . . Even the best statues . . . show peculiarities which the painter must notice, and indeed avoid. To some painters it is very useful [to copy antique statues], to others so harmful as to destroy their art.'

The standard medium for the studies from the model was black chalk, heightened with white. Rubens preferred the slightly greyish 'Steinkreide' (natural stone-chalk) to oiled chalk or to coal, although they too were occasionally used. He liked red chalk, in combination with black and white, for faces and hands; he retained black chalk for such features as hair, eyebrows, eyelashes, and of course for the costume. Only during the later period do we find heads which were started and largely finished in red chalk, with black and white used only for additional emphasis (Mitsch, 1977, Nos.49–51). In a few instances, chalk in other colours was employed (Pl.134). Once in a while Rubens reinforced the modelling with bistre wash, or as in some of his drawings for actual portraits, he used lines in pen and ink to strengthen the effect of mouth, nostrils, and especially of eyes.

In these studies Rubens preferred to draw on rough textured paper which helps to break the harshness of line in favour of granular effects implying light and atmosphere. The paper evidently came in different colours, though it is hazardous today to say exactly what the original shade may have been unless a microscopic inspection is made in each case. Many of the drawings have been exposed to light for long periods, which evidently affected the colour of the papers. Most common are shades of tan, ranging from yellow to medium brown; blue, green, and grey papers are also found, as are some that are still perfectly white.

In the preparation of actual portraits, Rubens appears to have made two types of preliminary study in drawing. In one kind, he sketched the pose, with special attention to the costume, and occasionally the setting. In these drawings the features were indicated only in a more or less general way. The head was then drawn separately with great care and in the position which had been determined by the previous plan.

We happen to have a contemporary report about a portrait session which deserves to be quoted. Alethia Talbot, the wife of the Earl of Arundel, passed through Antwerp in the summer of 1620, accompanied by the Count's secretary acting as her marshal, by a jester, a dwarf, and a large greyhound, white with black markings. Arundel had sent a letter along, introducing her to Rubens and requesting that he paint her portrait. On July 17, 1620, Francesco Vercellini, the Count's Venetian secretary,[21] wrote to the Count: 'Immediately after arriving in this town I presented the letter of your Excellency to Sr. Ribins the painter who received it with a joyful face, but he displayed still greater pleasure after he had read it and he gave me this answer: "Although I have refused to paint the portraits of many princes and gentlemen, particularly here at the court of her Highness [the Archduchess Isabella] I cannot refuse the Count the honour which he does me by giving me this commission, inasmuch as I consider him to be one of the four evangelists, and patron, of our art," following these words with many other polite ones. He then requested that her Excellency the Countess should come the following day to pose, which she did, and he with great courtesy, has finished her likeness, that of Robin the dwarf, the jester, and the dog, with only a few minor things still missing which he will finish tomorrow. Her Excellency will depart the day after tomorrow with the intention of spending the night in Brussels. Because the said Sr. Ribins lacked a picture-canvas sufficiently large for his purpose, he portrayed the heads as they should be, and drew on paper the postures and the costumes; he portrayed the dog in full length. But in the mean time he will have a canvas made to order and will copy with his own hand what he has done. The picture will be perfect and he will send it to your Excellency together with the original portraits. And the said Sr. Rubins promised my Lady not to

paint the portrait of any person whatever except those who would be ordered of him by your Excellency.'[22]

The portrait of Alethia Talbot is still preserved in Munich (*KdK*.200). It shows, on a canvas 2.61 by 2.65 m., the Countess, the dwarf, the jester, the dog, and more in the background a man who formerly was thought to be either Arundel himself, or Vercellini, but who according to L. Burchard is Sir Dudley Carleton, the English Ambassador at The Hague(?)[23]

We learn from this letter that Rubens determined the poses in drawings and made a record of the costumes. One of these drawings is still preserved (Pl.144). In addition he either painted or drew the heads separately, the word '*ritrarre*' allowing either interpretation. We may ask whether this procedure was normal with Rubens, or was caused in this case by the circumstance, specifically mentioned, that he did not have a large enough canvas on hand. Had he had one, would Rubens have dispensed with all intermediary steps and painted directly on it? This is not likely; he would probably have sketched on the canvas in chalk the poses and the details of the costumes with brief colour notes, just as he did with other paintings, according to Dr. Sperling's report (p.26); he would surely have made separate studies of the faces 'come devono essere,' i.e., in the positions determined by the sketch.

Of the 'compositional' sketches for portraiture relatively few have been preserved (Pls.32, 110, 173 and Colour-plate 4). And whereas the few sketches of poses that have come down to us are done in a great variety of techniques and sizes, the drawings of the heads were almost invariably done in chalk, close to or in actual life size; he occasionally accented them lightly in pen and ink. Rubens drew these portrait-heads practically without corrections, with that seemingly automatic sureness that we have mentioned before; concentrating on the face, he always indicated a few details of the costume—just enough to suggest the organic connection of the head with a body; since the body is usually turned in a direction slightly different from the head, these portrait drawings produce a distinct impression of movement, an effect further strengthened by a few escaping strands of hair in portraits of women, or some unruly curls in those of boys and men.

Fewer drawings of this kind may be lost than others. To begin with, portrait-painting—contrary to Van Dyck's practice—was a subordinate activity with Rubens. In addition, if any drawings were apt to be well taken care of by later owners it was these, where aesthetic attractiveness and human interest were so intimately linked. Yet there are some deplorable gaps. Since we know that Rubens made many paintings of Genoese nobles in 1606, the total

absence of any portrait drawing (save for a costume study like Pl.32) from that period is a keenly felt loss. There must have been many portrait drawings of individuals whom Rubens included as donors, or in the actual narrative context, of some of his larger compositions. This holds true particularly for a group of pictures from the cycle of Marie de Médicis, like the Marriage by Proxy (*KdK*.247) and the Coronation scene (*KdK*.252), both of which contain figures with distinct portrait-likeness.[24]

The finest group of portrait drawings is in the Albertina in Vienna; they are among the most popular works of the artist. The interpretation of his models is characterized by a skilful blending of realism and idealization, of informality and the reticence of good manners. Some of the most charming are portraits of members of Rubens' own family, of his children, of Isabella Brant, his first wife, and of Hélène Fourment, his second. A drawing which shows his second son Nicolas at a tender age is all chubby cheeks and silky hair, as if it had been produced by a caressing hand (Pl.156). We can now follow the growth of the boy by looking at a later drawing in which the hair, done with incredible economy, is appropriately wild and the expression both slightly quizzical and truculent (Pl.162). The features of a daughter, who died before she had reached her thirteenth year, may be preserved in a drawing, perhaps done shortly before her death, in which a wistful, though seemingly anaemic girl with large liquid eyes and narrow shoulders looks at us from above her huge, formal lace collar (Colour-plate 3). The slightly irregular features of her mother, Isabella Brant, who died three years later, are transfigured by a faint smile (Pl.154). Hélène Fourment's placidly healthy figure is shown frontally in the large and unusually elaborate drawing in the Princes Gate collection (Pl.191).

Rewarding as these drawings are from a human point of view, they also are a good yardstick to measure the social changes in Rubens' household. No matter how generously she displays her sensuous charms, Hélène Fourment is every inch the gracious lady, where Isabella had been primarily the loving wife. Hélène's nobly relaxed gesture as she draws her veil away from the high pompon of her skull-cap was derived, not surprisingly, from a classical motif of which Rubens had always been exceedingly fond and with which he usually invested figures in whom he wanted to combine dignified grace with maidenly modesty. The children of his second marriage are also rendered much more elegantly than those of his first. Frans Rubens, especially, appears in several drawings in splendid attire, including a feather-trimmed beret (Pl.212), and his bearing is as proud as that of any prince. The famous self-portrait of the master in the Louvre

(Pl.207) sums up eloquently the social distinction which Rubens had acquired by the 1630's. It was made for the painting in Vienna in which the sword of Rubens' knighthood is prominently displayed. He drew himself in full dress, as it were, with the hat, the gloves, the large cloak, all marks of the cavalier. From within the flamboyant sweep of his costume and his hat, the Secretary of the Secret Council of the King of Spain looks down at us with all the conscious dignity of his position.

There exists only one other authentic drawing— also rather late—which Rubens made of himself (see below, p.61). Yet he surely had made more, as there are several painted self-portraits from his early years. It is likely that all these drawings shared with the one in Paris the tendency to give to the master's image an air of formality and restraint. Certainly Rubens was not prompted by either vanity or introspection to draw his own features. He painted self-portraits for the simple reason that people whom he could not well have denied had asked him for them. In 1623 Charles I, then Prince of Wales, asked for Rubens' portrait. Rubens himself tells the story in a letter to Valavez, January 10, 1625:[25] 'The Prince of Wales . . . is the greatest lover of painting among the princes of the world. He already owned something from my hand when he asked me, through the English representative in Brussels, for my portrait with such insistence that I saw no way to refuse it to him. And although it did not seem proper for me to send my portrait to a prince of such quality, he prevailed over my modesty.' A few years later it was Nicolas-Claude Peiresc (1580– 1637) who repeatedly requested a self-portrait of Rubens and finally received one in the summer of 1630.

LANDSCAPES AND FARM LIFE

The landscape drawings from Rubens' hand which we know are not strictly speaking drawings of 'landscapes' but of landscape motifs. A country lane, a fallen tree, a gnarled willow, a small bridge across a brook, surrounded by young trees, or a pond in which a few trees are reflected—these are the themes of Rubens' landscape drawings.[26] We also find other rural subjects, such as farm wagons, and a farmer on horseback (Pl.190), farm women doing their chores or working in the fields. Some, though by no means all, of these motifs can be found in paintings by Rubens, but unlike his other drawings, which were made with a definite picture in mind, Rubens seems to have drawn his rural motifs as the occasion arose, without knowing exactly when and how he would use them. Of the two drawings of the fallen tree (Pls.113, 117), one was probably used soon after it had been done, but the other only many years later.

The special character of this category of drawing can be accounted for if we consider the rôle which the painting of landscapes occupied in Rubens' activity. The beauty and historical significance of his landscape paintings notwithstanding, Rubens was, after all, not a professional landscape artist. He surely never painted a landscape on commission, and probably rarely sold one; they were done as a diversion and, in a deeper sense, as a token of his love and affection for the Flemish soil to which he was attached with his whole being. Less exclusively than the old Bruegel, but with equal understanding, Rubens observed the life of the farmer and the beasts which contribute to his sustenance. As the owner of rural property long before he became the squire of Château Steen, Rubens had every opportunity to make these studies, not to mention the fact that town and country life in the seventeenth century were not as separate as they are with us. On his daily outings on horseback Rubens must almost invariably have passed farms in full activity and must have looked often at the polders with their water systems and their scattered herds of cattle.

It is most unlikely therefore that Rubens deliberately went out into the country to make studies *ad hoc*. Over the years he created a collection of sketches which served him as reference material when he began to paint his landscapes, or stories with landscape backgrounds. No matter which studies were used for them, these paintings were always essentially the products of his imagination rather than portrayals of concrete settings and localities. Rubens painted his landscapes, as Oskar Fischel was fond of saying, with his back to nature. That does not mean that he may not have made on occasion a faithful portrait of a specific site. When they appear, they were inserted for iconographic reasons rather than for pictorial interest. A view of the environs of the castle of Mantua has been identified in an early painting showing Rubens among some friends of his Italian period (Evers, II, 321 ff.). The ruins of the Palatine Hill appear in a landscape painting (*KdK*.188) and as background in two pictures with specific Roman references (*KdK*.45 and Exh. Rotterdam, 1953, No.3).[27] In his portrait of Philip IV he included a view of the Manzanares valley[28] and he must have brought home with him from Spain a panoramic drawing of St. Lawrence in Escorial from which a landscape specialist, Pieter Verhulst, made a large picture.[29] In this case we have Rubens' own word that he had made the drawing himself. Yet it gives us pause for reflection that not one such drawing has ever been identified. We should remember that wherever Rubens went he travelled in style, with a personal retinue which may have included a trained assistant. In Italy he had already been accompanied by a

young artist, Deodat Delmont (1582–1644). Rubens may have more than once entrusted to assistants the task of making topographical records. It is different with the motifs from Castle Steen which crop up in his late landscape paintings, and perhaps also in some drawings (Pl.225): these he always did himself.

Depleted though it surely is, this group of landscape drawings, if seen in connection with Rubens' landscape paintings, permits some conclusions about his choice of motifs. In contrast to the landscapes painted by Rubens' Dutch contemporaries (Bloemaert, de Gheyn, Seghers, van Goyen), we never see the shabby, if picturesque, farm houses and barns, the broken-down implements, the suggestion of poverty and decay. Nor are we shown peasants loafing or gaming in smoky inns (Brouwer). As Rubens sees the countryside it is a setting for healthy and useful human activities. The farmers thresh, gather sheaves of grain, milk cows (Pl.103), make butter (Pl.119). Animals are rendered in forms of strength and imposing calm (Pl.109). In the scenery itself—at least in his drawings—Rubens pays little heed to the vast panoramas which Bruegel drew so beautifully; he is even less concerned with the close-ups of flowers and of grass which had fascinated Dürer and which were still drawn by specialists. Rubens drew the 'middle-ground' as it were, the trees, paths, bridges, fences, and water, endowing these things with the special beauty which they assume for those who spend most of their lives away from them.

DRAWINGS FOR ENGRAVINGS

Distinct in style from Rubens' drawings for paintings are those which he made for engravings.

Two types of engravings were produced from Rubens' designs. There are first the numerous engravings which Rubens himself published (and over whose copyright privileges he watched jealously); they were made by engravers whom Rubens hired and whose work he supervised to a certain degree so that they would do justice to his designs. Much of his international fame was due to these prints, which also provided a steady source of income. It is easy to understand that he took great care in the production of works that were so important for him in many ways. They were made from exact drawings, most of them quite large, which were supplied to the engraver. The engraver's job was difficult enough as it was; he could not be expected also to make the working drawings.[30]

But these working models for the engraver were not made by Rubens himself, or at least only in exceptional cases. Since they themselves were based on other works of Rubens, particularly on paintings, it was neither artistically rewarding nor economically justified for the master to expend much time on what amounted to a more or less literal repetition of his own compositions. This job he left to pupils, and he confined himself to final corrections in which he gave the right values to light and shade and pointed up the details to give them the necessary crispness and strength (see Pl.226). Where this reworking of his pupils' drawings (which he usually performed with washes in bistre and lead-white) was extensive, he transformed them to such a degree that he could have said of them, as he said of the more extensively retouched paintings, that they could pass as works of his hand.[31] How highly such drawings were valued in former centuries appears from a revealingly wistful remark by Mariette, who wrote about one of them (*Abecedario*, v, 115): 'I have seen the drawing on which this piece [an engraving by Paul Pontius] was engraved. It was done in black chalk, by one of Rubens' disciples, and the great master had contented himself with adding a few lines with pen and ink in the heads. This would have been a priceless piece if he had continued the same kind of work across the whole design, for he was going in great style' ('car il était alors bien en verve'). On the authority of Bellori (1672), a number of these drawings for engravings, most of them used by Vorsterman in prints bearing the dates 1620 and 1621, have been attributed to Van Dyck (see F. Lugt, *Catalogue*, II, 36, No.1126 and the literature listed there). The attribution is tempting because this group shows no traces of having been reworked by Rubens, though they are of undeniable quality. There is, however, no definite proof that this attribution is correct, and unless some new evidence appears—which is not likely—Van Dyck's authorship will remain a matter of conjecture.

At times, however, as has been said before, Rubens made such drawings himself. That these drawings are so much neater and more detailed than his other drawings is no valid argument against their attribution to the master, as has occasionally been asserted. His drawings for book illustrations, to which we will come below, show that he could be as precise as any of his pupils when he wanted to guide the engraver. It is Ludwig Burchard's opinion, with which I agree, that a small group of drawings for the woodcuts of Christoffel Jegher are authentic works of Rubens (Pls.203, 204, 218). Apart from the fact that these drawings were not copied literally from any existing work by the master, they combine sensitivity with breadth in such an impressive manner that any other authorship but Rubens' own seems inconceivable. Some of Jegher's woodcuts may have been cut, in accordance with an old practice, from drawings made on the wood-block itself.[32]

The lack of regard for these highly finished

drawings reflects no doubt a modern aesthetic prejudice against all 'finished' work, particularly in drawings. This is a blind spot of the modern critic which did not, however—indeed, could not—extend to one category of Rubens' drawings: the drawings for book-illustrations which Rubens furnished to Antwerp publishers, above all to his close friend Balthasar Moretus, the head of the house of Plantin. There is a good reason for accepting these drawings. They are unusually well documented. The archives of the house of Plantin in Antwerp's unique Musée Plantin-Moretus still preserve letters written about them as well as the accounting books with the original entries of payment both for the drawings and for the engravings made from them. Moretus himself left us an interesting comment on these drawings in a correspondence with Balthasar Cordier (Corderius), a Jesuit theologian in Vienna, who tried to obtain an emblematic design for some 'theses' written by one of his students. Rubens is unwilling, so Moretus tells Cordier, to do such a design unless he is given three months to think about it. Normally, he continues, the artist expects to be given half a year's warning for each title; 'he makes these drawings in free moments on holidays for he does not squander workdays on such trifles; else he would have to ask 100 florins for a single drawing.'[33] Moretus did pay, of course, for these products of a busman's holiday, but at a reduced rate, and strictly according to size. Rubens received twenty florins for a folio page, twelve for one in quarto, and eight for drawings in octavo. For the smallest pieces (see Pl.221), Rubens received five florins. The engravers, whose work was less creative but took much longer, were paid between 75 and 100 florins for the folio prints, 30–40 for quarto, and 25 for still smaller pages.

Except for a few pieces commissioned during the last years of his life, Rubens himself attended to these drawings for title pages and book illustrations. Besides being unquestionably authentic they have the advantage of being well dated (with the qualification mentioned before, see p.11). They also allow us to follow closely the interchange between artist and patron. For the title-page of the Breviarium Romanum of 1614 Balthasar Moretus submitted to Rubens a simple diagram of the layout of the page, together with the scriptural texts which he had chosen for it. It was probably Moretus, too, to judge from the character of the writing, who wrote the texts into Rubens' drawing for the benefit of C. Galle, the engraver. Before the final design was made, a draft was generally submitted to the author of the book for his approval, or for suggestions of changes. In the search for appropriate allegorical images, Rubens' part was probably more decisive than that of anyone else involved in the undertak-

ing. The deference shown to his judgment respected not only his artistic talent but his intelligence and his scholarship. 'D. Rubenus divino illo ingenio suo inveniet scio aliquid appositurum et lauro meae conveniens, et ordini in quo sum, et Pietati' (With his divine genius, Rubens, I know, will invent something appropriate, fitting my poetry, the order to which I belong, and Piety) wrote one hopeful author, Bauhusius, 1617.[34] The first edition of Bauhusius' epigrams had appeared in 1616 without any design; and despite his plea, nothing was done for the second edition, either. Only for the posthumous edition of 1634 did Rubens design a title. In a note which accompanied the drawing the artist shows an almost boyish pleasure at having found a concise image for the title of the tiny volume: 'I do not know,' he writes to Moretus, 'if you will like my idea; I myself am quite pleased with it and almost congratulate myself upon it' (Pl.221). Balthasar Moretus apparently agreed; the title was printed without change. It seems to have been quite common for Rubens to write explanations of the meaning of his designs. The most elaborate of these explanations which has been preserved is that of the title-page of De Marselaer's book, of which we have spoken before (p.11).

Since not all of Rubens' title-pages bear his name, there are differences of opinion as to how many he designed; it is safe to say that the number is no less than forty-four and no more than forty-eight. By contrast there is only a small number of books which contain illustrations designed by the master, and they all belong to the early part of his career. The first is a book of philological studies by Rubens' brother Philip, Electorum Libri II, Antwerp 1608, with six plates rendering classical sculpture. None of the drawings for these engravings has as yet been found. Two drawings have been identified for the Vita B. Ignatii Loiolae, which appeared in Rome in 1609 (see Pl.41). Two drawings have also been discovered for the vignettes—there are six of them—which Rubens contributed to Franciscus Aguilonius' Opticorum Libri VI of 1613 (see Pl.80). The most important publications containing prints from Rubens' design are the Missale Romanum of 1613 and the Breviarium Romanum of 1614. At present five full-page drawings and the copy of another one (Judson-van de Velde, Pl.54) are known, as well as the drawings for two marginal decorations (see Pls.71, 76, 79 and Judson-van de Velde, Pl.48). The etchings which so lavishly decorate Gevartius' Pompa Introitus Ferdinandi of 1641–1642 were made by Van Thulden from Rubens' oil-sketches for the triumphal entry of the Cardinal-Infante of 1635. Rubens appears to have planned, in collaboration with Peiresc, an edition of engravings of ancient cameos based on drawings by him. Three such drawings are still preserved (see

Pls. 148, 149) but the book was not published in Rubens' lifetime. Of eight engravings made for it, two were printed in 1665 in a book of essays by Rubens' son Albert, entitled *De Re Vestiaria Veterum*.

Reflecting fairly accurately the editorial policy of the Plantin Press and the others for which Rubens occasionally worked, the titles Rubens designed were mostly for books on theology and church history (20); next in number came politics and history (13), archaeology and philology (9), and poetry and emblems (5). Science (1) comes last. The chief problem in designing the frontispieces consisted in bringing together and arranging in an orderly pattern the multitude of emblematic and allegorical images and allusions which to Rubens as well as the publisher seemed necessary and appropriate as an introduction to their authors' texts. Together with his designs for the various large projects of 'secular apotheoses' such as the Cycle of Marie de Médicis, the Whitehall Ceiling, and the Triumphal Entry of the Cardinal-Infante, the book-titles are a convenient means for studying how Rubens approached the allegorical mode of expression. One can see plainly that he took pleasure in giving life to the abstract conceits of the theological and humanist traditions and in combining them into new configurations. Only rarely do we feel that he tried to pack too much meaning into one of these images (as he may have done for instance in the Bauhusius title mentioned before [Pl. 221]). What usually characterizes his titles is the clarity with which their themes have been expressed. Rubens used either a simple architectural framework (Pl. 150) around which he arranged his figures and emblems, or devised a common action in which they were involved (Pl. 219).[35] In both ways he achieved an impression of unity which is generally lacking in the book-titles Northern artists had designed before him. (The notion of richly decorated book-titles was never popular in Italy, and no major Italian artist made any contribution to this problem.) Rubens shared, and perhaps contributed to, the preference of artists of the Baroque for codified and easily understood personifications and symbols. He favoured the lucid expression over the obscure, the sanctioned image over the one newly contrived. Contrary to the far-fetched hieroglyphics of the Renaissance mythographers and emblematists, Rubens' allegories abound in such time-honoured objects as laurel and palm branches, lyres and trophies, rudders and trumpets, and the familiar menagerie of doves and serpents, lions and eagles. These objects and figures gain under his hands a compatibility which makes us forget their heterogeneous nature. In the frame which Rubens designed for the portrait of his admired mentor, the classical philologist Justus Lipsius, wreaths, cornucopiae, ribbons, and serpents' tails, oil-lamps and burning torches form a harmonious and gracefully integrated whole beneath the winged hat of Mercury and a faintly radiant face of the sun (Pl. 102).

The standard technique of these models for engraving is as follows: On thin preliminary lines, sometimes done in chalk and in one case definitely done in lead-pencil (the title of 'Gelresche Rechten' in the collection of J. Q. van Regteren Altena)[36] Rubens drew the design in pen and ink in firm, clear lines, with 'open' cross-hatchings which suggest to the engraver the most desirable direction (but not the exact number or placing) of his burin-grooves. The areas where Rubens expected the engraver to use denser layers of shadow he indicated with bistre washes. (The design for Oliver Bonartius' *In Ecclesiasticum Commentarius*, of 1634, doubted by Judson-van de Velde, No. 70a, is exceptionally heightened with oil paint.)[37]

The problem of reversing the design, unavoidable in engraving, does not seem to have bothered Rubens much. Except for taking care that his characters would come out right-handed (and there are even exceptions to that: Christ lifts the palm branch with his left hand in the Resurrection of the Breviary of 1614), almost all the drawings appear reversed in print. Only the drawing for H. Hugo's *Obsidio Bredana* (1626) (Judson-Van de Velde, Pl. 191) was engraved so that the print corresponds to the drawing. This drawing, besides, is also technically different from most others. While done with the pen, it has been washed extensively, in shades of grey, green, and brown of great density. Rubens evidently used these washes in body-colour to make thorough changes—which points to a hastier execution of the drawing than was normal with him. It was perhaps because of this speed that Rubens had neglected to let his main figures, *Labor* and *Vigilantia*, use their right hands—a fact which necessitated a special treatment by the engraver.

The work of those engravers who were employed by Rubens himself was closely supervised by the master. His control was less strict with engravers who worked from his designs but who were under contract with a publisher. In a third category of works where Rubens' drawings were translated into another medium, his influence upon the shape of the end-product was even more restricted. I refer to those incidents—by no means rare, as we are beginning to see—where Rubens furnished designs to sculptors and architects. It is still a moot point to what extent Flemish architecture was indebted to Rubens for ideas of a purely structural nature. There can be no question, however, that he made important contributions to the character of the surface design of the Flemish Baroque, and to the patterns

of its interior decoration. His own house, after all, was one of the most prominent examples of 'modern' architectural design in Antwerp in the second decade of the seventeenth century, and he must have prepared every detail of it carefully in drawings and sketches. The sculptor with whom he collaborated most closely in these years was Hans van Mildert, a German artist from Königsberg and a protégé of Rubens' friend C. van der Geest, who may have been instrumental in bringing the two men together.[38] Three drawings of allegorical figures (Pl.104) may be the first documents of this collaboration, provided the traditional attribution to Van Mildert of the corresponding wood sculptures in the Musée Plantin is correct. Hans van Mildert was the author of three large sculptures in white alabaster from Rubens' design (Held, 1980, 576–578), originally placed in the church of St. Michael, three of which are now in the small St. Trudo Church at Zundert just over the Dutch border north of Antwerp. Rubens' part in the decoration of the Antwerp Jesuit church was not confined to his paintings for the altar and the ceiling. The very shape of the frame for the altarpiece as well as the sculptures which were to decorate it were designed by Rubens (see G.-H. Nos.130, 132). (He made drawings for altar-frames in other cases too.)[39] The stucco decoration of the Chapel of the Virgin—the only original piece of the interior decoration of St. Charles which has been preserved—was executed from Rubens' design (G.-H. No.129). For the sculptural decoration of the façade, too, Rubens is known to have furnished designs.[40] Particularly beautiful are the drawings for the big central cartouche (Pl.125) and two trumpet-blowing angels for the main portal (Pls.106, 107). The sculptors responsible for the execution of these works seem to have been the brothers de Nole.

To these works must be added the designs Rubens made for tombs (like the imposing, but never executed Richardot tomb, Pl.54) and for epitaphs, a category of work that only recently has attracted attention.[41]

Another German sculptor came into contact with Rubens in the 1620's. Unlike Van Mildert, who lived in Antwerp, Georg Petel was there only for shorter periods of time, but apparently always in close contact with Rubens.[42] It is even likely that some of the pieces which he carved from Rubens' design were actually made on Rubens' order. This is probably true of the beautiful salt-cellar in Stockholm (see text to Pl.165) which figured in Rubens' estate, along with two other works possibly by Petel. Besides working in more conventional materials, Petel seems to have had a special talent for making sculptures in ivory, the material from which the salt-cellar was fashioned, and he captured the sensuous quality of Rubens' art much better than the sober Van Mildert—too well, indeed, for the taste of Sandrart, who thought that his works had a somewhat licentious character.

The last sculptor who worked extensively from designs by Rubens was one of his own pupils, the young Lucas Faid'herbe of Mechlin. Faid'herbe lived for more than three years (1637–1640) in Rubens' house, and it is not inconceivable that Rubens at that time may have contemplated setting up his own school of sculpture to multiply his compositions in three-dimensional form. It is an intriguing idea to imagine the gout-stricken Rubens 'dictating' sculpture as the aged Renoir did when crippling arthritis had made painting excruciatingly painful. The circumstances of each case were very different, though, and not favourable for such a far-reaching parallel. Sculpture had been too close to Rubens' interests throughout his life to mean as much to him emotionally as it did to Renoir, whose style only at the end of his career had come to a point when it almost demanded transference into the third dimension. If anything, Rubens considered sculpture another branch of the great enterprise which he was conducting. And while he may have taken an interest in the work of Faid'herbe or other young sculptors, he surely did not hover over them or follow the progress of their work in every detail.

That Rubens' influence on sculpture extended also to the iconographic sphere is documented by letters sent to him on May 26 and June 9, 1622, by Peiresc, in which Peiresc asked Rubens' advice concerning the subject of a figure about to be included in the sculptural decoration of the Luxembourg Palace.[43] In such cases Rubens may occasionally have sent sketches and written instructions as we find on the sheet for the statues in the Museum Plantin (Pl.104).[44]

INSCRIPTIONS ON DRAWINGS

In a discussion of the functional categories of Rubens' drawings brief mention ought to be made, finally, of the many 'incidental' drawings which he must have made but of which only a few traces have come down to us. In a lifetime of creative activity there must have been many situations to which Rubens responded by making a drawing. We read in one of his letters that he would send a drawing to suggest remedies when two of his pictures were found to be wrongly proportioned.[45] In letters to Peiresc about archaeological or scientific questions he would amplify his words by making a quick sketch.[46] Even though Rubens, one of the most literate and articulate artists, expressed himself freely and easily in several tongues, he found, upon occasion, that nothing could illustrate a point better than an illustration.

The kinship of word and image worked both

ways with Rubens. If in his letters he clarified his text by adding a drawing, he often emphasized and strengthened some aspects of his drawings by writing on them a few words in his uncluttered and harmoniously flowing script. We find on his drawings inscriptions in Latin, Italian and Flemish; a French word is exceptional (see No.158).[47] Flemish texts are in Gothic script, while others are in the cursive so familiar from Rubens' letters.

Rubens added words to his drawings for a great many different reasons. Some inscriptions, like those on the design for a title-page (Pl.221) or for sculptures (Pl.104), are messages to a third person, and thus—like the notes accompanying the drawings sent to 'Mons. Felix' and to the unknown patron for whom he made the drawings G.-H. Nos.40 and 41—are essentially brief letters. Most of the other inscriptions are notes for himself. They may be no more than a hasty indication of a figure or a specific action. In one of the sketches for the cycle of Marie de Médicis (Pl.157) he identified some of the figures as 'Force,' 'Constancy,' 'Prudence,' or 'Kingdom of France'; the rudder is accompanied by the words 'Government of France' (Governo G[alie]). 'Cupido Captivus' (Captive Cupid) was inscribed on a late drawing (Pl.217), and similar identifications are found on a few designs for double-headed herms (G.-H. Nos.81–83), one of them with the delightful amplification that the profile of Cupid had been derived from Rubens' son Albert ('ex Albertuli mei Imagine'). Notes on colours and materials are found on portrait-studies and wherever special costumes were involved. In the drawing of Robin the Dwarf (Pl.144) Rubens adds a note about the 'red satin Doublet' and the 'red velvet pants' besides a number of other colour-notes; in the drawing of an old peasant woman in Berlin (Pl.82) he recorded the colour of every part of the costume and the materials (for instance, of the 'white scarf', which was worn below the 'canvas' vest). In the London sketchbook of medieval and Oriental costumes to which we will come below there is an abundance of inscriptions of this kind; one can vividly sense the optical delight with which Rubens recorded a Turkish fashion for women (Belkin, *Corpus Rubenianum*, XXIV, 1978, 180): 'a skirt made out of thin material over a thin pair of trousers so that the naked legs shine through' and sleeves of 'thin material so that the naked flesh is visible throughout' (see also Pls.67, 68). When he copied a classical cameo (G.-H. No.24) he added notes about the materials, the colours, and some small iconographic details (in an inscription in which after some Italian phrases he fell back on his native Flemish), and indicated a restored part tersely as 'pezzo moderno'. Words can take the place of figures or of objects which are either not at all or only vaguely indicated in the drawings: 'cornucopiae,' 'diverse arms,' and 'he holds the thunderbolt' (Pl.131), 'an old woman enjoying herself' (Pl.77), 'with a large flat landscape' (Pl.208), and the famous lines 'Here are missing beggars with their wives . . . and children' (Pl.184). In the Princes Gate Collection there are two drawings from the Book of Genesis (Seilern, *Catalogue*, No.55) on which Rubens indicated in an Italian inscription where there would appear—presumably very small—the Creation of Man on one, the Fall and Expulsion from Paradise on the other.

Explanatory notes are sometimes added to his copies. When he drew Augustus and the Sibyl from a fresco by Pordenone (G.H.1) he added a note about the intricacies of the location; on two of his copies after woodcuts by Stimmer he inscribed comments on a particular aspect of the action: 'he waits on the angels with reverence' (*reverenter Angelis ministrat*), referring to a servant of Abraham waiting on the heavenly visitors, or 'she gropes for it in the dark' (*sy taster into doncker naer*), for Judith who is about to sever Holofernes' head (see Lugt, 1943, Fig.10) and Pl.5. And when he drew his early Descent from the Cross (Cat. No.15) he recalls how Daniele da Volterra had organized one part of the action.

Rubens even expressed criticisms of his own drawing, as when he wrote next to a figure in the Last Supper (Pl.19) that the gesture should be larger 'with the arms stretched out,' or when he simply added 'more space' to one of his late compositions (Pl.205). How thoroughly Rubens considered phenomena of light, even in the earliest stages of the creative process, is shown by the inscriptions on the rapid sketch of the Last Communion of St. Francis in the collection of L. Burchard (Burchard-d'Hulst, 1963, No.122, verso). He apparently planned the scene to take place in an interior illuminated from a stained glass window (this, at least, would be the meaning of the inscription 'geschildert venster' which M. Jaffé and F. Baudouin read in preference to 'geschloten venster' given by Burchard and d'Hulst). At the bottom of the sheet Rubens noted—rather surprisingly in Italian—'Tutto il gruppo in umbra et una luce resonante del sole bastante per la fenestra' (the whole group in shadow and a reflected (?) light of the sun through the window). The often quoted text on the London landscape, finally ('The reflection of the trees in the water is darker (?) and much more perfect in the water than the trees themselves' [Colour-plate 7]) is also concerned with an optical phenomenon and was surely meant to be no more than a notation supplementary to his drawing. He made it perhaps because it would have been difficult to render the correct values in so rapid a sketch. He also must

have realized that at the time of day when the sun is just disappearing behind the trees, changes such as he recorded take place from one minute to the next.[48] (For a connection of this inscription with F. Aguilonius' book on Optics see Held, 'Rubens and Aguilonius: New Points of Contact', *The Art Bulletin*, LXI, 1979, 257 ff.)

It is well known that in the manner of humanist writing, Rubens' letters abound with quotations from ancient authors. There are several instances in which he enriched his drawings too, by learned allusions. When he drew the she-wolf and the infants Romulus and Remus (a detail of the large marble group of the Tiber, now in the Louvre) he added five lines from the *Aeneid* (VIII, 630–634) that describe not only that the animal suckled the little boys, but 'with sleek neck bent back, licked them by turns and shaped their bodies with her tongue'. Moreover, he exchanged the two children so that the animal's solicitude so vividly described by the poet is also visually convincing.[49] Though it may not be an actual quotation the words 'spiritum

morientis excipit ore' (she draws out the soul of the dying with her mouth) (see Pl. 57) unmistakably alludes to Bion's tender dirge on the death of Adonis which Rubens may have known from a Latin adaptation. And when—perhaps for the amusement of his own brother—he made a jocular mis-interpretation of the relief on a Roman sarcophagus, he spiced it with an allusion to Plautus' *Miles Gloriosus* (see Pl. 21).

Unfortunately, many inscriptions have been so badly rubbed or damaged in other ways that it is difficult, if not impossible, to read them (Pl. 211). Some are clear in some words, but abraded in others (Pl. 13). Added to the physical impairments are the difficulties inherent in Rubens' script when he wrote in Flemish. He must have written rapidly, thus slurring his letters; even words which at first glance look very clear may on closer study be difficult to decipher. The whole question of Rubens' inscriptions, both on drawings and on sketches, evidently deserves to be taken up in a special study.

[1] Edward Norgate, *Miniatura*, or the *Art of Limning*, Oxford, 1919, 83. G. Glück expressed this idea, perhaps a little too drastically, when he said: 'There are absolutely no drawings by Rubens' hand without a particular purpose, either in connection with the origin of or the plan for a picture, or an illustration.' (*Essays*, 180, footnote.) See also Held, 1980, I, 3–6.

[2] '*Credo, sebben mi ricordo, che V. S. trovera ancora nel suolo, di sotto in piedi di Marte, un libro, e qualche disegno in carta, per inferire che egli calca le belle lettere et altre galanterie*' (*Correspondence*, VI, 208). Miss Magurn's recent translation of this passage ('. . . to imply that he treads underfoot all the arts and letters' in *The Letters of Peter Paul Rubens*, Cambridge, 1955, p. 409) does not quite do justice to the distinction Rubens was making between the meaning of the book and the drawing. Indeed, although Rubens speaks in his letter diffidently only of '*qualche disegno in carta,*' he was much more specific in the painting itself.

[3] Rubens may well have been familiar with the allegorical representation of the three 'arte di disegno' in the guise of the Three Graces, first introduced on the *Porta al Prato* in Florence on the occasion of the marriage of Francesco de' Medici and Johanna of Austria, 1565 (Vasari-Milanesi VIII, 530; see also Matthias Winner, *Die Quellen der Pictura-Allegorien in gemalten Bildergalerien des 17. Jahrhunderts zu Antwerpen*, Diss., Cologne, 1957, 96 and 106).

[4] See P. Génard, 'De Nalatenschap van P. P. Rubens' ('La succession de P. P. Rubens'), *Antwerpsch Archievenblad*, II (1865). 69–179 (in part reprinted in J. Denucé, *De Antwerpsche 'Konstkamers'*, Antwerp, 1932, 71–85).

[5] The sale of the drawings took place in August 1657 (supposedly on the 28th of August, though I have been unable to find documentary evidence for this date). It fetched 6557 *guilders* and 16 *stuivers*. Strictly speaking, Rubens' youngest child, Constantia-Albertina, born posthumously on February 3, 1641, reached her eighteenth year only in February 1659. As she had been in a convent since the middle of 1657, there was no reason to wait any longer with the sale, the less so since her brother Petrus-Paulus had reached his eighteenth year on March 1, 1655. These data were first published by Rooses (*Rubens Bulletin*, v, 1897, 56–57). In an earlier and more accessible publication (R. v, 3 ff.) he had written that the sale took place in 1659 and that date is still occasionally cited in the literature (see for instance *The Burlington Magazine*, XCIII, 1951, 17).

[6] Rubens was not the only Flemish artist who took these precautions. According to F. Jos van den Branden, *Geschiedenis der Antwerpsche Schilderschool*, Antwerp, 1883, 282, Frans Pourbus made a similar stipulation in his will of September 17, 1581. He left to his two sons, Frans and Moses, all his drawings with the proviso that if Moses should not become an artist, Frans, who was then only twelve years old, should have them all. As it turned out, Frans indeed followed his father's trade. Rubens' care for the proper disposal of his drawings evidently accords with established practice, though he appears to have been unusually circumspect and mindful of all possible future conditions where the drawings might be of use.

[7] See Meder, 180, 292, 532, 553; B. Degenhart, *Europäische Handzeichnungen*, Zürich, 1943, 24; H. Tietze, Arte Veneta, v, 1951, 55, and Held, 1980, I, 6–8.

[8] See Van Puyvelde, *Revue Belge*, XXI, 1952, I, 53.

[9] See *Correspondence*, II, 1898, 156.

[10] E. Berger, *Quellen für die Maltechnik während der Renaissance und deren Folgezeit*, Munich, 1901, 278. Berger thinks that most of these preliminary drawings were made with white chalk which is more easily absorbed by the oil (p. XXXVIII). Van Mander (ed. Floerke, I, 320) explicitly mentions chalk (crijt) as the medium used by Frans Floris for the preliminary drawings which he made for the benefit of his students. It is likely, however, that coal was also used a great deal for reasons which Cennino Cennini already had given (*Il Libro del Arte*, transl. by D. V. Thompson, New Haven, 1933, 75). See also Meder, 296–297.

[11] Denucé, *Inventories*, 291: '*Teecken boeck van Rubbens; Een cleyn teeckenboecken van 71 bladeren, met root cryt; Noch een cleyn boecken van Rubbens, met architectuer*' (Drawing book by Rubens; a small drawing book with 71 leaves, done in red chalk; another small drawing book, by Rubens, with architecture.) Although the author of the second book is not mentioned, I believe that the context makes it most likely that it too was by Rubens.

[12] E. Gombrich, Conseils de Léonard sur les esquisses de tableaux, *L'Art et la Pensée de Léonard de Vinci*, Actes du Congrès Léonard de Vinci, Paris-Alger, 1954, p. 3 ff.

[13] For another composition of the subject see Held, 1980, No. 267.

[14] For the functional distinctions within the oil sketches see two very instructive articles by E. Haverkamp Begemann, *Bulletin Museum Boymans*, Rotterdam, v, 1954, 2 and *ibid*, VIII, 1957, 83. In the first one of these articles the author distinguishes no less than seven different types. See also Held, 1980, I, 1–6.

[15] See also Meder, 394.

[16] For this drawing and an ivory carving (by Artus Quellinus the Elder?) based on it, see K. Feuchtmayr-A. Schädler, *Georg Petel, 1601/2–1634*, Berlin, 1973, 180–181, under No. 140.

[17] In the inventory of Erasmus Quellinus, 1678 (Denucé, *Inventories*, 286) one item is described as '*Half ontcleede vrouwkens, naer tleven, Rubbens*' (Half undressed women, from life, Rubens). This was probably a drawing, but it is impossible to make any deductions from so scant an entry.

[18] Rotterdam, v, 82, see Evers, II, Fig. 241 and Exhibition, Antwerp, 1956, No. 56.

[19] See B. Moretus in his foreword to the Seneca edition of 1615; Bouchery-Wijngaert, 135–136, No. 48.

[20] He did the same thing with a portrait head of Emperor Galba: see James Byam Shaw, *Drawings by Old Masters at Christ Church, Oxford*, Oxford, 1976, No. 1372, Pl. 808. No exact use of this head has so far been identified in Rubens' oeuvre.

[21] See Mary F. S. Hervey, *The Life, Correspondence and Collections of Thomas Howard, Earl of Arundel*, Cambridge, 1921, 172 ff. The letter, written in Italian, is not signed and hence 'either draft or copy of a

vanished original' (Hervey, 174). All the evidence, however, points to Vercellini as its writer.
[22]All publications of this letter (except that by Miss Hervey), including the translations into French (by L. Hymans, reprinted in *Correspondence*, II, 250) and into German (by Evers, I, 88) contain a good many errors. It is this letter, incidentally, which also has the important passage about Van Dyck's staying with Rubens. In connection with a report about the visit of the Countess to the Church of the Jesuits ('la trova cosa maravigliosa'), it also contains a reference to Inigo Jones.
[23]See L. Burchard, *Catalogue*, Exh. Antwerp, 1956, 81. For an engraved portrait of Sir Dudley (W. Delff, after M. Mierevelt) see *Correspondence*, II, 136. This evidently supersedes Burchard's earlier identification of the model with Vercellini (*Catalogue*, Alte Pinakothek, Munich, 1936, 226).
[24]The Marriage by Proxy, indeed, contains what I believe to be an unrecognized self-portrait of Rubens in the man with the large cross, behind the future queen. Rubens had good reasons for including himself in this scene since he had attended the event, though not in this role, in his first year in Italy. None of these heads have been found in drawing, though several seem to have been in Crozat's collection (see Lugt, 1925, 179).
[25]*Correspondence*, III, 320.
[26]In Basan's catalogue of Mariette's collection (see above, p.9) was listed the following item: '1014. *Autre paysage en travers, ou se trouve une charette embourbée, comme par l'Estampe de Bolswert, qui s'y trouve jointe.*' This drawing, evidently much esteemed, since it was sold alone, disappeared from sight after the sale and has remained completely unknown (and unpublished), although for many years now it has been in no less public a place than the Metropolitan Museum of Art (Fig.7). From Mariette's collection it passed into that of Walpole, who also owned Rubens' corresponding picture Landscape with a Mired Wagon (*KdK*.185, now in Leningrad). Done in pen and ink and in blue, green, ochre, and grey water colour, measuring 190 × 271 mm., the drawing now forms part of the Scrapbook Aedes Walpolianae (fol.53v°), still accompanied by Schelte a Bolswert's engraving. Indeed, it is still inscribed: 'The Original Drawing bought at the sale of Mr. Mariette's Collection at Paris, 1776'. Yet despite Mariette's, Basan's, and Walpole's confidence in its authenticity I cannot accept it as an original by Rubens. It is too fuzzily drawn and lacks the structural clarity one would expect from Rubens in such a sketch. The small figures of men and horses are particularly strange, done as they are in nervous and hasty flourishes. The colouristic treatment is reminiscent of the drawings by Lucas van Uden and its greater freedom than that found in Van Uden's own drawings may be credited to its close dependence on Rubens. The case proves that drawings of 'complete' landscapes attributed to Rubens in the earlier literature ought to be considered with a good deal of scepticism.
[27]For this painting see now Jan Kelch, *Peter Paul Rubens, Kritischer Katalog der Gemälde im Besitz der Gemäldegalerie Berlin*, Berlin–Dahlem, 1978, 7–13.
[28]E. Kieser, *Münchener Jahrbuch der Bildenden Kunst*, N.F. VIII, 1931, 287.
[29]*Correspondence*, VI, 257–259, and R., IV, 386–387.
[30]It goes without saying that the engravers were trained artists and as such perfectly capable of making drawings. Lucas Vorsterman, for instance, unquestionably did some drawings, but these drawings, mostly portraits, executed in minute detail, are rather dry and pedestrian. The question of engravers' drawings probably needs still further study.
[31]For this complex of questions see now Konrad Renger, RUBENS DEDIT DEDICAVITQUE, Rubens' Beschäftigung mit der Reproduktionsgrafik', *Jahrbuch der Berliner Museen*, XVI, 1974, 122–175, and XVII, 1975, 166–213.
[32]Of some of Jegher's woodcuts there exist several different proof-impressions, each one retouched by Rubens (Amsterdam, Antwerp, and Paris). A very good idea of the pains Rubens took to edit prints for publication may be derived from an album filled with proof-prints of engravings as well as woodcuts in the Bibliothèque Nationale at Paris (Cc34j, réserve). There one can follow how Rubens strengthened outlines, gave emphasis to facial expression, or changed proportions. Again and again he took out unnecessary hatchings to clarify contrasts of light and dark. He even went so far as to suggest changes in the slant of a few lines of shading (No.1 of the volume, the early 'Large Judith') when he felt it would improve the effect.
[33]This statement, while generally true, should not be taken too literally. Not only do we know that at times Rubens furnished such designs fairly quickly, but in this particular case Father Cordier had sent a design in the hope that Rubens would improve on it—something Rubens never was willing to do. Moreover, the letter was written on September 13, 1630 (*Correspondence*, V, 335–336), about two and a half months before Rubens' marriage to Hélène Fourment—at a time when he must have had other things on his mind than decorating some theses by a young theologian from Bratislava.

Fig. 7 L. van Uden (?) after Rubens: Landscape with Mired Wagon. Drawing. New York, Metropolitan Museum of Art

[34]*Correspondence*, II, 112 ff. Another author, Philippe Chifflet, in a letter of 1639 to B. Moretus modestly agreed to be satisfied with anything that Moretus and 'le docte Monsieur Rubens' would suggest, 'préférant son invention et vostre jugement à mes pensées' (*Correspondence*, VI, 247).
[35]See also Held, *Rubens and the Book* (prepared by students in the Williams College Graduate Program in the Arts), Williamstown, Mass., 1977 and Held, 1982, 166–184.
[36]J. G. van Gelder, *Nederlands Kunsthistorisch Jaarboek*, 1950–51, The Hague, 1951, 137.
[37]Rubens deviated occasionally, and particularly in his later period, from this standard procedure by submitting to the engraver oil-sketches in grisaille. For four of these sketches for book-titles see now Held, 1980, Nos.303, 304, 305 and 306. A fifth grisaille was made—before 1629—for the charming printer's mark of Jan van Meurs, ibid. No.307.
[38]For Van Mildert see M. Konrad, *Mitteilungen des Vereins für die Geschichte von Ost- und Westpreussen*, VI, 1932, 53 ff.; Is. Leyssens, *Gentse Bijdragen tot de Kunstgeschiedenis*, VII, 1941, 73 ff.
[39]See his letter of March 19, 1614, addressed to Archduke Albert, Correspondence II, 69.
[40]See Exh. Antwerp, 1956, No.68 and M. Jaffé, *The Burlington Magazine*, XCVIII, 1956, 314.
[41]For epitaphs see Held, *Rubens and his Circle*, 1982, 80–93; David Freedberg, 'Rubens as a Painter of Epitaphs, 1612–1618', *Gentse Bijdragen*, XXIV, 1976–1978, 51–71; and Frans Baudouin, 'Het epitaaf van Jan Gevaerts: een Prent van Adriaen Lommelin, naer Pieter Paul Rubens of naar Erasmus Quellin?' *De Gulden Passer*, LXI–LXIII, 1983–1985, 485–504.
[42]See K. Feuchtmayr-A. Schädler, *Georg Petel, 1601/2–1634*, Berlin, 1973.
[43]*Correspondence*, II, 416–417 and 435.
[44]For the question of Rubens' connection with sculpture in general see Glück, *Essays*, 188 ff., and Oldenbourg, 1922, 194 ff. For the design of a tomb (apparently never executed) see Cat. No.50.
[45]See *Correspondence*, II, 252.
[46]See *Correspondence*, III, 216; V, 310–311 (illustrating the statement that all utensils, such as tables, stools, candelabras, pots etc. were called *tripods* if they rested on three feet); VI, 49 (though the drawing of a spoon reproduced on that page is not by Rubens). For a reproduction of the marginal illustration in Rubens' letter of August 3, 1623 (*Correspondence*, III, 216) and an interesting discussion on the object rendered in it see A. A. Barb, *Journal of the Warburg and Courtauld Institutes*, XVI, 1953, 194 ff.
[47]In a letter written on February 26, 1611, Nicolas Rockox asked Jacques de Bie (himself an engraver) to pay heed to a note Rubens had attached to a drawing for the frontispiece of Hemelaers' book on Roman coins (*Correspondence*, II, 1898, 28). (See also Judson-Van de Velde, Fig.114.)
[48]For the equally celebrated inscription on the landscape with brambles in Chatsworth (Pl.116) see text to Pl.113.
[49]See Held, *Rubens and his Circle*, Princeton, 1982, 100.

III

Copies made by Rubens

'Chacun copie comme il peint, avec son sentiment, son esprit et sa main,
avec sa manière de voir et sa nature individuelle. Si cette nature est personelle et puissante,
la copie vaudra l'original, non pas par l'exactitude, mais par une sorte de compensation
qui s'établira entre ce que l'auteur aura perdu et ce que le traducteur lui aura donné . . .'[1]

ALL through his life, Rubens made copies of other artists' work. When the inventory of his estate was drawn up, there were listed no less than thirty-two paintings after Titian, nine after Raphael. Others had been made from works of Tintoretto, Bruegel, Leonardo, Vermeyen (though his model then was thought to be a picture by Moro), and Elsheimer. We may take it for granted that Rubens had painted these copies with the intention of keeping them for himself. During his sojourn in Italy he is known to have painted copies upon commission. In 1605 he made two copies after Correggio for Emperor Rudolf II;[2] part of his services for the Duke of Mantua seems to have been furnishing copies which were sent as gifts to other courts. Many of these painted copies are known still to exist; in addition to the masters mentioned in his estate, Rubens is known to have painted copies after Mantegna, Parmigianino, Primaticcio, Caravaggio, Massys, Key, and others. Not all of these copies were based on the originals: the two beautiful copies after Titian's Andrians and Sacrifice to Venus in Stockholm were painted by the master from copies which could very well have been available to him in Antwerp; in an Antwerp inventory of 1649 there is mention of such copies after Titian (see No.138).[3]

Numerous as these painted copies are, they are vastly outnumbered by those made in the form of drawings. Even today, when only a fraction of the material is preserved which we know once existed, the drawings which are copies run up into the hundreds; the Louvre alone has ninety of them, according to the count of F. Lugt. In addition to those preserved, we can reconstruct many more, thanks to the curious collection of drawings in the Print Room of the Museum of Art in Copenhagen.[4] Willem Panneels (1600–after 1632), a pupil of Rubens who, during the master's absence in the second half of the 1620's, took care of his affairs, is generally believed to be their author. The drawings, however, show such differences in style that they cannot all have been made by one artist. Panneels probably did the majority. One should perhaps also consider the possibility of Willem van Haecht's having been the author of some others. Willem van Haecht (1593–1637) is well known as a specialist in copying; he painted two of the largest and most detailed gallery-pictures of the seventeenth century (in the Mauritshuis at The Hague, and in the Rubenshuis in Antwerp, the latter dated 1628). He is all the more likely to have made some of the Copenhagen copies as his name appears on one of them, together with that of Panneels, in contemporary writing.[5]

The majority of these drawings are copies of works by Rubens, and many of them were done from sketches and drawings no longer preserved in the original. Since the copyists were apparently eager to make a record of those drawings in which Rubens himself had studied works of art of the past, our knowledge of Rubens as copyist is greatly increased by the Copenhagen evidence.[6]

When we find a great artist of the past engaged to such an extent in an activity like making copies that to us seems to have little merit, we can understand his motivation only by remembering two facts. Copying was, first of all, a basic device in art education. There may have been different attitudes to this activity in different schools and some masters may have been more independent than others. (A study of the rôle of copying in the training of artists since the Renaissance, a task that should prove rewarding, has apparently not yet been undertaken.) But no one before the twentieth century would have questioned the value of copying, or would have substituted for it the kind of 'creative dabbling' which in recent years has often been deemed sufficient for the training of an artist. While disciplining eye and hand, copying helped to broaden the mind.

There was, however, a second reason which helps to explain the continuing interest which Rubens took in this routine. Surrounded as we are by a vast body of photographic renderings of works of art we have difficulty in imagining a time when only a relatively small number of works was available in

reproduction, and when many of these reproductions—mostly copper-engravings—were made by insensitive hands. They were, besides, fairly expensive. The wider the range of an artist's interests, the more strongly must he have felt the need to supplement the material available in engravings with copies of his own, or made for him by others. Rubens seems to have employed other artists systematically for the purpose of making copies. One of twelve copies which Paul de Vos drew after pictures presumably by Snyders is inscribed: 'Ick, Pauwels de Vos hebbe voor Peter rubbens ghewrocht 6 daaghen' (I, Paul de Vos, have worked for Peter Rubens six days). These twelve drawings (two in Amsterdam, the rest in Antwerp) are done in pen and ink, washed, and are fairly large; they follow their models in considerable detail. To make two such, and possibly more, drawings in one day, as the text seems to indicate, would be a remarkable achievement by modern standards; but such was the skill and experience of seventeenth-century artists that this was probably a normal day's work. A collection of these copies took the place of an art reference library; we may be sure that the group amassed by Rubens was unusually large and comprehensive. Its function for his own art was expressed, in the nice rhetoric of the seventeenth century, by Roger de Piles when he reported that although Rubens had 'copied many things in Italy and elsewhere' and had a large collection of engravings, he still set young artists to work copying for him in Rome and in Lombardy 'all that was most beautiful which he later made use of according to the occasion, to stimulate his humour and to heat up his genius' (pour exciter sa veine et pour échauffer son genie).[7] In addition to objects which he copied as possible sources of artistic inspiration, Rubens also made records of other artists' works for what may be called their documentary interest; the drawings after classical sculpture and Italian masters, finally, which he included in two manuscripts, both lost, though one of them, preserved in a copy and in an incomplete edition of the eighteenth century,[8] was clearly made for theoretical demonstrations; indeed, the chief Copenhagen copyist inscribed several of his drawings as having been taken from Rubens' book on anatomy.

It goes without saying that Rubens' copies always betray his own style. Whatever his motives for making them, he did not try to be painstakingly literal. That is true even of the drawings which he made in his youth from illustrations in German woodcut books. There are few artists whose copies illustrate more fittingly Ephrussy's thoughtful statement quoted at the outset of this chapter. Each copy by Rubens makes up for what the original has lost by the powerful imprint of his own personality.

COPIES AFTER ANCIENT AND ITALIAN WORKS

Rubens' selection of the things he chose to copy gives a clear picture of the fields he preferred to study. One of the most discerning and best informed of the modern Rubens critics, H. G. Evers, once wrote that 'from the very beginning Rubens aimed to gather in and to master the whole artistic culture of the Western world.' This may be true in principle, but it stands to reason that Rubens was more interested in some masters and artistic traditions than in others. Classical antiquity, as one would expect, looms large in these studies. A true son of humanism, Rubens was filled above all with admiration for the culture of Rome; we have no way of telling whether he was aware of the distinction between Roman and Greek art, but if he was, he certainly did not consider the former inferior to the latter. A passionate archaeologist, he took interest in all relics of the ancient past, no matter how small. He must have made many careful studies of decorative sculpture and of all sorts of objects used in military activities, religious rites, or in domestic life. Altars, trophies, armour and weapons, furniture, clothing, vehicles, and musical instruments—whatever threw light on the Roman way of life excited his interest. A few of these drawings from Roman relics were used in Philip Rubens' book of 1608[9] which is best described as a collection of footnotes on ancient costumes and customs, revealing clearly the influence of Justus Lipsius, who himself had written extensively on the military equipment and practice of the Romans. A series of copies from classical heads, mostly portrait-busts, appears to have been destined for another project. They resemble the illustrations of classical busts by an unknown artist which Theodor Galle had published in 1598 (and in a second enlarged edition in 1606), and like many of the heads on Galle's series render examples from the collection of Fulvio Orsini in Rome. Lugt pointed out correctly (*Catalogue*, II, 30, before No. 1086) that none of Rubens' drawings was used in any of the editions of Galle's *Illustrium imagines ex antiquis marmoribus numismatibus et gemmis expressae.* Yet in the commentary to Galle's publication, written by Rubens' friend and physician, Dr. Johannes Faber of Bamberg, there is a description of a twin-bust of Menander of which Rubens made a drawing (Louvre, L. 1097).[10] This supports Evers' hypothesis that Rubens' drawings of these busts may have been destined for a projected supplement to, or a new and enlarged edition of, Galle's work. The large group of drawings from Roman coins in London and Chatsworth may also have been made for some publication.[11] It has been noted before (see p. 36) that Rubens planned a major publication of Roman cameos.

During his stay in Italy Rubens' attention, quite naturally, turned to the most famous pieces of monumental sculpture above all else and he studied them intensely, as a whole series of drawings attests. Besides those known from Rubens' own hand—greatly augmented in recent years (see text to No. 34 and a number identified by Jaffé in *Rubens and Italy*, Oxford, 1977) must be added many from the Copenhagen collection, among them additional ones after the Laocoön group, six of the Centaur Fettered by Love (Louvre), and five pen sketches of a most undignified pose of Hercules, two of which are indeed from Rubens' own hand.[12] A list of the drawings after classical sculpture of which we still have Rubens' originals, augmented by those of which we have copies or which are recorded in old inventories, reads indeed like a roll call of all the celebrated marbles known in his time.[13] The Farnese Bull, the Pompeian Fisherman (believed to be a statue of Seneca), the so-called Ares and Aphrodite (formerly in the Palazzo Borghese, now in the Louvre), the Flora Farnese, the Hercules Farnese, the Gaul killing his wife and himself (in the Terme Museum), the Apollo Belvedere, the Belvedere Torso, Hercules and the Telephus child, the Boy with the Goose, the Hermaphrodite, the Barbarian Prisoners of the former Cesi collection, and many others are among them. To these must be added drawings of reliefs from sarcophagi, and from such monuments as triumphal arches and columns.

In the collection of Erasmus Quellinus, who seems to have owned a considerable number of these drawings by Rubens, there are twelve listed as having been made from the column of Trajan alone.[14] From one of Rubens' letters we know that he must have been well acquainted with the Roman painting known as the Aldobrandini Wedding.[15]

It is only natural that such a constant and thorough preoccupation with ancient art must have left deep traces in Rubens' own work; the influence of specific monuments has been well studied in articles by Haberditzl and Kieser,[16] among others, but we should keep in mind that Rubens had so thoroughly absorbed into his system the artistic language of the ancients that he could speak it with only a trace of Flemish accent; his art had sunk its roots deeply in the rich soil of classical antiquity and never ceased to draw nourishment from it. From the passage quoted before (p. 32), in which Rubens advocated the use of discretion in the imitation of classical sculptures, we may also derive an explanation for the almost exclusive use of soft drawing materials, chiefly chalks, for the copies he made of them. Only these media would permit the suggestion of soft flesh and of pliable materials which he considered desirable; when Rubens added washes, or when he did some of the shading with the brush (as he did in his copy of Montorsoli's Faun (Pl. 29), a Renaissance sculpture, but an object related in principle to the classical statues he copied) he used reddish tints, made of diluted sanguine, and bistre so that the result is a convincing and tenderly modulated rendering of human skin and hair.

Their vibrancy distinguishes Rubens' copies of ancient sculpture from those made by Flemish artists before him. Jan Gossart, Marten van Heemskerck, Lambert Lombard, and Frans Floris had made such studies most of them in pen and ink. Goltzius had engraved the Hercules Farnese in famous prints. Only in Rubens' drawings do these statues look as if they had really come to life.

The study of classical art was natural for a man with Rubens' humanistic training; with equal assiduity he recorded the works of the great artists of the Renaissance, but he showed little interest in the quattrocento painters.[17] (Only Mantegna was studied and copied by him extensively, perhaps because of his Mantuan connections.)[18] His abiding interest belonged to the artists of the High Renaissance. Besides the ten drawings after the Sistine Ceiling published by Glück and Haberditzl (Nos. 12–21), there are two more in London which show with minor changes the same figure—one of the *ignudi*—as seen in the original, and in reverse (Pl. 22).[19] There is no evidence here that Rubens worked from engravings; this is certainly the case, however, with the figure of Haman in the Louvre (Lugt, *Catalogue*, No. 1039) which was taken from Lafreri's engraving of 1565. The drawing of Michelangelo's Notte (G.-H. No. 22) was probably made from a small copy in sculpture. Two drawings after Michelangelo's relief of the Battle of Lapiths and Centaurs were probably done from the original, which was turned so that the light fell on it first from the right, and then from the left, side (Jaffé, 1977, Pls. 14, 16). There are drawings copied after Raphael, Leonardo, Titian, Correggio, Del Sarto, Polidoro, Giulio Romano, Pordenone, Tintoretto, Muziano, Barocci, and other masters not yet identified. Of his contemporaries, Rubens was aware of Annibale Carracci, Caravaggio, and Elsheimer.[20] Rubens appears to have avoided the arch-mannerists like Rosso, Pontormo, Salviati, Vasari, and Bronzino, less perhaps from a dislike of the elements of distortion and caprice in their works than from the lack of sensuous appeal of their colours. Of later Florentine artists, only Cigoli seems to have interested him.[21] Rubens was attracted to Primaticcio and made copies of his work;[22] for the drawing of three of Primaticcio's lithe and long-limbed caryatids from Fontainebleau (Pl. 152) he actually used the back of a sheet on which a Fontainebleau artist had drawn an allegorical composition in the characteristic calligraphic manner of that school.

COPIES AFTER NORTHERN WORKS

More astonishing than Rubens' study of classical and Italian art is his pervasive interest in the Northern tradition. Many observations made in recent years show that Rubens was well aware of the achievements of the German and Flemish artists of the fifteenth and sixteenth centuries. His attachment was neither sporadic nor superficial. Indeed, at the end of Rubens' career, it came to the fore with renewed vigour (see below, p.59). To some extent it must have been implanted in the artist at an early age. Tobias Verhaecht, his first master, who probably did not teach Rubens more than the rudiments of art, nevertheless must have brought him in contact with the Bruegel-tradition from which he himself stemmed. Van Noort and Van Veen, with whom Rubens studied later, were primarily interested in assimilating Italian art and were probably no great admirers of Northern 'primitives', but they surely knew that their own aims continued those of a long line of Northern painters from Massys and Gossart, through Floris and Vermeyen to Heemskerck and Marten de Vos. It may well have been upon a suggestion from his teachers that Rubens copied the woodcuts of Tobias Stimmer's Bible of 1576 (Pl.5) and Jost Amman's Flavius Josephus of 1580. There were, after all, traces of Michelangelo even in Stimmer, and a good deal about the proportion, anatomy, and the perspective foreshortening of human figures could be learned from the prints of these masters. Rubens, indeed, seems to have preferred and selected from their works figures bending down, stepping forward, or lying on the ground in various patterns of foreshortening[23]. Credit for having identified some of Rubens' early copies of woodcuts belongs to Frits Lugt, who remembered that Rubens himself told Sandrart on a boat between Utrecht and Amsterdam that he had made many copies after Stimmer's prints.[24] In addition to Amman and Stimmer, it is certain that Rubens also studied Stradanus and copied engravings after him. What attracted him to these men may be seen from a copy after Stradanus, a sheet with pen-drawings of two tuba players (Rotterdam, Burchard-d'Hulst, 1963, No.4). The figures were copied from two prints (Nos.12 and 13) belonging to a series entitled *Encomium Musices* (published by Philip Galle).[25] These prints surely appealed to Rubens because of the archaeological interest which they had as examples of ancient military musicians; Stradanus himself no doubt had derived them from classical sources. Thus the same interests that led Rubens to Italian and classical models prompted him to copy Northern masters of the late sixteenth century.

This explanation does not hold good, however, for copies from Northern models of an earlier time, like those preserved in the London Costume Book and in a few isolated pieces of similar character (Pl.64). Several of these drawings were copied from prints by Burgkmair, von Meckenem, and Weiditz. Some were apparently taken from the so-called Arras Codex, a collection of sixteenth century copies of earlier French and Flemish portraits. The majority (except for the oriental figures, see Pls.67, 68) were taken from the *Mémoriaux* of Antoine de Succa, parts of which have been preserved in the Royal Library at Brussels. Hind (*Catalogue*, No.119) had already referred to this manuscript without realizing how many of Rubens' drawings were indeed derived from De Succa's work. Perhaps at the request, and certainly with the approval of Archduke Albert and Archduchess Isabella, Antoine de Succa had travelled to various towns and ecclesiastical institutions to gather from seals, funerary monuments, and painted portraits iconographic and documentary evidence of genealogical value. Since the first edition of this book, De Succa's album has been studied carefully.[26] His aim appears to have been to bring together and illustrate faithfully all the relevant material for a dynastic history of Brabant and Flanders.

Rubens' purpose evidently differed from De Succa's. When De Succa drew these figures in his timid and fussy way he took good care to show them completely with all the details which he considered important for his undertaking. If he copied a tombstone he included the borders and the inscriptions; in figures from epitaphs he showed their praying hands, often in monotonous repetition; *pleurants* are faithfully rendered with the little pedestals below their feet. When he had finished he often had the correctness of his renderings attested to by the local guardians of the relics. Rubens invariably changed those aspects which would indicate fixed settings. He eliminated the references to bases or backgrounds. He often changed praying hands into casually occupied ones. Thus his figures always give the impression of being alive and of moving freely in space. In other words, he was not interested in making an accurate record of individual monuments. While he did care for the identity of the figures and in most cases copied their names along with their appearance, he wanted to visualize them as living persons, not as painted or carved images. Here too we see a tendency to 'animate' his models like that observed in his rendering of classical sculptures.

But what exactly was his aim? The London sketchbook carries on its fly-leaf an eighteenth-century note in French that it was drawn by Rubens 'for his history of the Counts of Flanders.' While it was indeed customary to show princes in genealogi-

cal chronicles in 'living' poses—as may be seen from H. Barlandus' *Ducum Brabantiae Chronica* of 1600 and 1612 and similar works—the London sketch-book is hardly a preparation for such a book; it contains a great deal of material that has nothing to do with a genealogical programme: hunting scenes, with dogs or falcons; dancing couples; figures from life; men with grotesque hats; not to mention the series of Turkish and Persian figures which have no place whatever in such a project. Mariette probably had the right idea when he finished his description of the volume for the catalogue of Crozat's collection by saying: 'Cette suite qui a été apportée de Flandres par M. de Piles est curieuse et montre avec quel soin Rubens faisoit des recherches, pour être en état d'observer le Costume dans ses tableaux' (Paris, 1751, 97, No.845). It is, indeed, a book of costumes, and thus related to such drawings as the peasant woman in Berlin (Pl.84) and even the Dwarf of the Countess of Arundel (Pl.144) where Rubens also made detailed notes in writing on the materials and colours, as he did with many of the costume studies.

Yet it is significant that Rubens' costume drawings were only rarely taken from the contemporary scene; it was not picturesqueness as such that interested him, but costumes which might help to evoke past ages or exotic countries. He was motivated by a combination of historical and romantic tendencies. It is certain that he wanted to make sure that the figures in his paintings of medieval subjects, from sacred as well as secular history, were attired in costumes established as authentic by early works of art. When he drew the Tiburtine Sibyl from the Bladelin Altar (Pl.64) it was hardly meant as a tribute to its master, though he may have known that it was the work of the famous Rogier van der Weyden. It was as 'source material' for late medieval costumes that he copied this graceful figure from one of the masterpieces of early Flemish painting.

It would be wrong, however, to overestimate Rubens' 'historical' sense. Just as he was guided by a desire to reconstruct the 'Roman' way of life from ancient monuments without considering the changes appearing in successive epochs, so he never hesitated to mix in the same 'medieval' representation costumes taken from many centuries, nor paused to weigh such niceties as whether they were contemporary with the action itself. Anachronisms abound in Rubens' work as much as they do in the works of other masters of his time (like Goltzius, N. de Bruyn, Adam Elsheimer, and his own teacher, O. van Veen) who were also interested in late medieval costumes. What mattered to him, as to them, was the effect of romantic excitement that came with feather-berets, slit doublets, veil-crested henins, and all the other colourful accoutrements found in early Flemish paintings and German wood-cuts. A newly awakened interest in one's own national past, noticeable also in contemporary literature and symptomatic of the growing nationalism of the century, may have affected Rubens as it did Dutch poets and painters, including Rembrandt.[27]

The impact of these costume studies on Rubens' painting, while clearly noticeable, is never felt as a foreign element. Rubens was too urbane and had derived too great a sense of balance and harmony from his well assimilated study of the classical tradition to lose himself in romantic make-believe or 'nationalistic' masquerade. Indeed, his great gift for absorbing the most diverse influences without spoiling the unity of his style appears never more happily than when he painted *dans le goût médiéval*. The ripe beauty, the gracious gesture, the supple movement are the same whether his figures wear Roman armour or Burgundian dress. One need only examine the Arch of Philip in the series of triumphal porticos which Rubens designed for the Entry of Cardinal Infante Ferdinand into Antwerp (best studied in Th. van Thulden's etchings from the *Pompa Introitus Ferdinandi* of 1641–1642) to see the transformation of historical costume figures into princes of nobility and baroque opulence. In the two wedding scenes which are depicted in front and in back of this arch, Cybele and Juno Pronuba, Chronos and Hymenaeus appear alongside Maximilian and Mary of Burgundy, Philip the Handsome and Isabella of Portugal. This intermingling of figures from different worlds is common with Rubens; it is also found in other secular apotheoses, like the Medici cycle and the Whitehall ceiling. His classical gods and Christian saints, as has often been observed, were practically interchangeable in their outward appearance. The historical, legendary, mythological, and allegorical figures were all moulded in the same form, heated by the same fire. They all had to renounce part of their specific nature and to absorb some of the generous and well-bred vitality of Rubens' own ideal before they could be combined harmoniously in the same frame.

For the sake of clarity, Rubens drew most of his records of costumes in pen and ink; thin washes were applied to several sheets, but it is only the two Spanish costumes, evidently drawn from life (Costume Book, 32a and 32b), which were touched up more heavily in three tones of chalk. The speed with which Rubens must have made these copies is belied by their appearance. There is hardly a correction anywhere; no unnecessary lines clutter up the design. The sureness of his hand is all the more remarkable as he evidently drew here with the pen 'da primo colpo.' No preliminary drawing in pencil or chalk can be seen anywhere.

We have seen that Rubens was attracted by works of earlier Northern masters because he found in

them information useful in his own work. To assume, however, that he was motivated solely by archaeological curiosity when he made these studies would be taking a very narrow view of his personality. Another factor quite clearly must be taken into consideration. Along with the general increase in national self-consciousness, of which we spoke, there had developed also a growing esteem for the 'old masters' themselves. Van Mander's book on the Lives of Flemish, Dutch and German painters (1604) had been an eloquent tribute. Lucas van Leyden's fame was confirmed by Rubens himself in a drawing made evidently for an engraving (Pl.223) where the head of the Dutch artist, copied from his famous self-portrait now in Brunswick, is surrounded with various emblematic devices. A veritable wave of enthusiasm for Quentin Massys had swept Antwerp at the beginning of the seventeenth century, strongly encouraged by one of Rubens' earliest patrons who remained a life-long friend, the collector Cornelis van der Geest.[28] Van der Geest's collection, of which we have a record in a 'gallery painting' of 1628 (Rubenshuis, Antwerp), contained several pictures by Massys, along with other paintings of the sixteenth century, and one curious panel by Jan van Eyck, now unfortunately lost. This collection of 'primitifs' is vastly outnumbered, however, by the one Rubens himself owned. Listed separately in the inventory of his estate as 'pieces by old masters' (in contrast to contemporary Flemish ones, including Rubens' own), it contained paintings by, or attributed to, Jan van Eyck, Hugo van der Goes, Quentin Massys, Lucas van Leyden, Joos van Cleves, and many other masters of the sixteenth century. Most significant was Rubens' collection of works by Pieter Bruegel the Elder. While he owned at most two or three pieces by any one of the earlier masters, Rubens had a collection of no less than twelve paintings by Bruegel, among them several which are known today. It surely was more than his personal friendship with Bruegel's son, Jan Brueghel the Elder, that prompted him to collect the paintings of the father. Committed though he was to the classical tradition, Rubens must have felt a deep kinship with the most Flemish of all Flemish painters before him. In him he found that sense of reality and animal vigour, which he too cherished as artistic goals. He paid homage to this great predecessor in several paintings, above all in his magnificent Kermesse in the Louvre (see Pl.184). That he made also copies after Bruegel is demonstrated by a drawing and two paintings which all three are based on a lost composition of the older master.[29] (See also Pl.4.) It is not without significance that the interest in Bruegel and the recollections of the earlier Northern traditions are particularly noticeable in the 1630's. After his long absence in diplomatic affairs

Rubens had returned to Antwerp in 1630 and had married the daughter of a respected Antwerp patrician. He settled down a second time, and this time it was a spiritual as well as a physical homecoming. The man who had been honoured by the most powerful princes and whose reputation as artist, scholar, and diplomat shone brightly across Europe now rediscovered the beauty of his own country. Paintings such as the Kermesse, the Garden of Love, even the Carousing Soldiers (see Pl.208), as well as his late landscapes (Pls.200, 225) are the visible tokens of his reawakened love of Flanders.

DRAWINGS RETOUCHED BY RUBENS

We have already mentioned the curious practice, not known with other masters (as for instance with Jordaens) but particularly frequent with Rubens, of drawing directly over other artists' works. It has always been acknowledged that Rubens practised this kind of 'face-lifting'; in Crozat's collection, according to Mariette's catalogue, were '10 Italian drawings retouched by Rubens.' Two such Italian drawings retouched by Rubens were specifically mentioned in a ms. catalogue of the collection of Valerius Roever (Delft, c.1739). One was a Flight into Egypt by Carracci, the other a 'Beheading' by Pordenone.[30] (Early inventories also list paintings which had been gone over by Rubens, as for instance, a small Descent from the Cross by Lucas van Leyden, 'retouched by Rubens' [Denucé, 312] or 'a small brothel scene, repainted by Rubens' [ibid., 314].) In recent years a fair number of drawings retouched by Rubens have been identified, ranging from pages to which the master added only a few highlights to others where one may wonder whether there is indeed a drawing by another hand under the characteristically Rubens-like surface. In a profile head of a youth, for instance (Museum Boymans, Rotterdam, see Exh. Amsterdam, 1933, No.115) Rubens' retouches dominate the effect to such an extent that chiefly the presence of silverpoint on greenish prepared paper induces us to assume that an Italian drawing, presumably by Ambrogio da Predis, lies underneath. Rubens commonly used the brush, with bistre and lead white, for this kind of work, but occasionally pen and ink occurs too. Obviously it is difficult to be sure who the first artist was where Rubens' reworking has been very extensive and there are some cases where the original artist will probably always remain unknown. Among those identified as 'victims' of Rubens' retouching (we could also call it an honour) are Van Orley, Vermeyen, Hans von Kulmbach, Niklas Manuel Deutsch, Martin Caldenbach, and D. Hopfer (?). Of Italian artists, besides Da Predis,

there are Farinati, Giuseppe Porta, called Il Salviati, and two anonymous artists (Albertina, Vienna).[31] One of the finest examples is the graceful woman with an armorial shield in Chatsworth (Pl.224), where a precisely outlined drawing of the early sixteenth century was brilliantly brought to life by Rubens' magic. In the hands of lesser men this practice might have amounted to vandalism. With Rubens it is invariably an artistic gain, even though a severe historian might deplore his tampering with 'documentary' evidence.

What was it that prompted Rubens to modify and edit these older drawings? In a number of cases he was clearly motivated by a desire to preserve and to restore. (In the Van Orley and the Giuseppe Porta, for instance, pieces of the original drawings were missing and were replaced by Rubens.)[32] Contrary to modern practice, however, according to which restorers are supposed to respect every line of the original, conservation in Rubens' time, in all fields, was controlled by nothing but the personal taste of the restorer, who was always an artist. And what artist is not convinced that, given a free hand, he could improve on what someone else had done before him? In the case of the Porta drawing, Rubens indeed, contrary to what Mariette thought, had worked over the original itself considerably. There may also have been cases in which Rubens was asked by collectors to touch up drawings which they owned, in the belief that he would bring out beauties not realized in the original formulation. The majority of the drawings gone over by the master were, however, probably also owned by him, and many of them were in perfectly sound condition. What he did, hence, is not so much a restoration as an editing of a quaint old text; the closest parallel, perhaps, is found in the notorious transcriptions of the music of Bach and Handel by later nineteenth- and twentieth-century conductors and virtuosi. These transcriptions betray no lack of respect but a certain insensitivity to style. Yet what one may hesitate to condone in a Busoni or a Stokowski, one accepts unquestioningly with Rubens. Where they sacrificed the character of the original in favour of a certain superficial brilliancy of decoration or orchestration, Rubens always reveals

a respect for the basic structure of the work under his hands. It is clear, however, that he set a higher value on the invention, and the general design of these drawings, than on what may be called the personal calligraphy of their masters. We are confronted here with a contrast not unlike that which Panofsky neatly characterized in speaking of the exchange of drawings between Raphael and Dürer.[33] What mattered to Raphael in a drawing was its conformity to a super-individual style; Dürer, on the other hand, respected it as the manifestation of 'an individual chosen by God.' Rubens, as one would expect, is nearer to the views of Raphael. He felt justified in retouching freely other artists' drawings because he was not at all interested in their linear idiosyncrasies. Indeed, it may well be one of the reasons that it is so difficult to distinguish between Rubens' own drawings and those of his school that he never consciously cultivated an individual manner clearly his own.

While drawing on top of some of these older sketches, Rubens may have conceived new artistic ideas. The enchanting drawing of a Garden Party, which seems to have been originally a work of Vermeyen but is now largely Rubens' own (Pl.227), may well have a place in the genesis of the painting of the Garden of Love in Madrid; several of the couples show similar attitudes and relationships. Like copying, this activity, too, may have served, in the words of De Piles, 'pour échauffer son génie.'

There were times when Rubens expressly refused to draw over another artist's work, but in these cases his refusal was not out of respect for the piece involved or the rank of the artist who had created it.[34] In 1630, an emblematic drawing had been submitted to Balthasar Moretus for publication, with the request to have it first edited by Rubens. Moretus' answer deserves to be quoted: 'Rubens,' he writes, 'praises the ingeniousness of the drawing, but declines to lay his hand on somebody else's work. He would rather make a new design than rework this drawing.' Damning with faint praise, Rubens asserted here unmistakably that his art was not for hire to improve the work of an incompetent artist, especially when the credit-line, as would have been the case here, was to name the first designer.[35]

[1]Ch. Ephrussy, Les Dessins de la Collection His de la Salle, *Gazette des Beaux-Arts*, Paris, XXV, 1882, 308.
[2]A. Luzio, *La Galleria dei Gonzaga*, Milan, 1913, 113.
[3]See also C. Nordenfalk, *Jahrbuch der preussischen Kunstsammlungen*, LIX, 1938, 43–47.
[4]A few of the Copenhagen drawings have been recognized as originals by Rubens, see note 12 below.
[5]Copenhagen, Box, I, 32. Partial copy of Rubens' Obsequies of Decius Mus, *KdK*.147.
[6]Many of the Copenhagen drawings carry inscriptions identifying the model (in a few cases it is actually stated that the model was a drawing) and the copyist repeatedly notes that he fetched his model from Rubens' 'cantoor', i.e., from a locked closet or chest used for the keeping of paper and valuables. On one of the copies, for instance, appears the statement: 'This is Laocoon and it is very well copied and I have fetched the model also from Rubens' *cantoor*.' If one of the copies succeeded well, the draughtsman liked to give himself a pat, but he occasionally

admitted that something did not come out quite right. 'This is not quite correct'; 'This figure is rather a little too long and from the navel to the knee somewhat too short,' etc.
[7]De Piles' statement, first published in *Conversations sur la connaissance de la peinture* (Paris, 1677, 218), precedes by one year S. van Hoogstraeten's *Inleyding tot de Hooge School der Schilderkonst . . .* Rotterdam, 1678, Book V, 193. Hoogstraeten told it in this way: 'Rubens was criticised by some of his competitors for borrowing whole figures from the Italians, and that, to do this more easily, he kept at his expense draughtsmen in Italy who copied for him all the beautiful things ("alle fraeyicheden") and sent them to him. But when this great man ("deeze groote geest") heard this he answered that they (his critics) were free to do likewise if they found that they could benefit by it. By this he indicated that not everybody was capable of deriving benefit from these copies.' Hoogstraeten continues with the idea which for his age always sanctioned the practice of using other artists' figures—by calling such uses 'quotations' rather than 'copies' (as Reynolds later did): 'Surely the

works of our forerunners are for us as free (to be used) as are the books of the ancients for scholars.'
[8]Charles-Antoine Jombert, *Théorie de la figure humaine*, Paris, 1773. This is a translation from the original Latin. The engravings were made by P. Aveline. See also G. Pawlowski, *L'Art*, XXXVI, T. 1, 1884, 214. The problem of Rubens' notebooks has been carefully explored by Michael Jaffé in *Anthony van Dyck's Antwerp Sketchbook*, London, 1966.
[9]Philip Rubens, *Electorum libri II*, Antwerp 1608, with six engravings after Rubens' design.
[10]For Dr. Faber, see K. Gerstenberg, *Zeitschrift für Kunstgeschichte*, I, 1932, 107; Evers, II, 117–118; Weizsäcker, *Adam Elsheimer*, Berlin, 1936, Text, 84 ff.
[11]In his comment on a series in London of thirty heads drawn by Rubens after antique coins, etc., Hind (*Catalogue*, No.55–82) pointed out that ten of the drawings were taken from medals by Valerio Belli, a Renaissance sculptor (1468–1546) 'whose imitations of antique coins and medals seem to have passed almost among his contemporaries as original antiques and to have been regarded as such by Rubens.' To what extent Rubens was capable of distinguishing Renaissance imitations of ancient sculpture from originals is difficult to say. He may have made the drawing after Montorsoli's reclining satyr (see Cat. No.40) (Montorsoli's sculpture is now in St. Louis) under the impression that it was a classical work, though we cannot be sure that this was so. The drawings after Belli, at any rate, contribute nothing to the question since it is precisely this group of the set in London which is not from Rubens' hand.
[12]All five are reproduced in Müller Hofstede's catalogue of the Cologne exhibition of 1977, but only those marked K44d (which should actually be K44a) and K44e (should be K44b) are originals. (I had suggested 1959, 51, that some might indeed be original.)
[13]In copying these statues Rubens followed a practice which was not only common among Italian artists (as may be seen from the charming drawings about the education of Taddeo Zuccari, by his brother Federico, in the album in the Philip H. and A. S. W. Rosenbach Foundation, Philadelphia, No.17 of the series), but which had already been codified in theoretical writings. Giovanni Battista Armenini (*De' veri della pittura*, Pisa, 1823, 68–69) had suggested this list of models: Laocoon, Hercules, Apollo, 'il Torso grosso', Cleopatra, Venus, Nile, 'con alcune altre pure di marmo che tutte sono poste in Belvedere'; further, Marcus Aurelius, the 'Giants' of Monte Cavallo, the Pasquino, etc.
[14]For this group see Mitsch, 1977, Nos.134–151.
[15]*Correspondence*, IV, 406–407.
[16]F. M. Haberditzl, *Jahrbuch der kunsthistorischen Sammlungen des Allerhöchsten Kaiserhauses*, XXX, 1911–12, 257; E. Kieser, *Münchner Jahrbuch der Bildenden Kunst*, N.F. X, 1933, 110. For the use of classical subject matter in Rubens' work see Goeler von Ravensberg, *Rubens und die Antike*, Jena, 1882.
[17]For an isolated borrowing from Gentile Bellini, see text to Pl.205.
[18]See H. Kauffman, *Köln und der. Nordwesten*, Cologne, 1941, 99 ff.; also J. Q. van Regteren Altena, *The Burlington Magazine*, LXXVI, 1940, 194.
[19]Another copy after Michelangelo, showing the figure of God the Father surrounded by angels from the Creation of Adam, was published by M. Jaffé, *The Burlington Magazine*, XCIX, 1957, 376.
[20]The free copy in oils which Rubens painted of Caravaggio's Entombment, now in the National Gallery of Canada, Ottawa (*KdK*.81), would presuppose the existence of a drawing if it was indeed, as I believe with most scholars, painted by Rubens after his return to Antwerp. Contrary to the prevailing opinion, I am inclined to date the picture no later than 1609–10. Since stylistically it is still very close to the works painted by Rubens in Rome at the end of his stay, E. Kieser's doubts about the authenticity of the painting in Ottawa—he called it a school-repetition (*Zeitschrift für Kunstgeschichte*, XIII, 1930, 135–36)—I consider unjustified. For Rubens' interest in the works of Carracci see M. Jaffé, 1977, *passim*.
[21]Evers, II, 137 ff.; W. Stechow, *Jahrbuch der Preussischen Kunstsammlungen*, L, 1929, 217 ff. See also H. Olsen, Cigoli og Rubens, *Kunstmuseets Aarskrift*, XXXVII, 1950, 55–73; W. Friedländer, 'Early to Full Baroque: Cigoli and Rubens', *Festschrift für Ludwig Heinrich Heydenreich*, Munich, 1964, 65–82; M. Jaffé, 1977, 51–52.
[22]Burchard-d'Hulst, 1963, No.163.
[23]From a scene of the Baptism of Christ by J. van Scorel, in the Frans Hals Museum at Haarlem, Rubens copied two muscular men striking complex poses while undressing (Louvre, L. 1109). F. Lugt, who first recognized Rubens' hand, was understandably induced to suspect that Rubens had made the drawing in Italy after Michelangelo (see the first edition of this book, Figs.30, 31).
[24]The only drawings attributed to Rubens' youth by Lugt which seem to me doubtful are four small pieces in the Louvre (L. 1111–1114) copied after Weiditz' illustrations to 'Von der Artzney beyder Glück' of 1532. Their style is markedly different from that of the other copies and for that matter different from anything we know of Rubens. Although they were attributed to Rubens by Mariette, they may be early attempts of A. Sallaert, with whose little known drawings they show some similarity. (The drawings v. 100 and v. 101 in Rotterdam, to which Lugt refers, are different and are more likely to be by Rubens.)
[25]The set was engraved by Adriaen Collaert, Galle's son-in-law (see

F. W. H. Hollstein, *Dutch and Flemish Etchings, Engravings, and Woodcuts*, The Hague, III, 1949, 201). The dependence of Rubens on Stradanus was observed independently by M. Jaffé (*Burlington Magazine*, XCVIII, 1956, 318) and myself.
[26]See Micheline Comblen-Sonkes and Christiane Van den Bergen-Pantens, *Les Mémoriaux d'Antoine de Succa*, Brussels, 1977, in two volumes. The nature of his undertaking is discussed separately by A. M. Bonenfant-Feytmans, pp.15–41.
[27]See for these questions H. van de Waal, *Drie Eeuwen Vaderlandsche Geschied-Uitbeelding*, The Hague, 1952, *passim*.
[28]See J. S. Held, *Gazette des Beaux-Arts*, XLVIII 1957, 53 ff. enlarged with new documentary material in Held, *Rubens and his Circle*, Princeton, 1982, 35–64.
[29]For this case see Burchard and d'Hulst, *Catalogue* Exh. Antwerp, 1956, No.88. Of the three works, the drawing in Rotterdam makes the least convincing impression; I consider it likely that it was reworked at a later time.
[30]The catalogue is now in the University Library in Amsterdam, see J. Q. van Regteren Altena, *The Burlington Magazine*, LXXVI, 1940, 194.
[31]See A. E. Popham, *Old Master Drawings*, I, 1926–1927, 45 (Kulmbach, Van Orley); E. Schilling, *Nürnberger Handzeichnungen des XV und XVI. Jahrhunderts*, Freiburg, 1929, Pl.31 (Kulmbach); E. Schilling, *Zeitschrift für Schweizerische Archäologie und Kunstgeschichte*, XI, 4, 1950, 251 (Niklas Manuel Deutsch, M. Caldenbach, D. Hopfer[?], and Il Salviati); O. Benesch, *Alte und Neue Kunst*, III, 1954, 18 (Vermeyen and two anonymous Italian drawings); M. Jaffé, *The Art Quarterly*, 1955, 331 (Il Salviati and Farinati). This list is by no means complete. The British Museum has an anonymous Italian (not Flemish) drawing (NG853–K853–M) to which Rubens added two new figures besides some generous retouchings (Popham, *Brit. Museum Quarterly*, X, 1935, 10). In his article of 1926–7 Popham also listed drawings after Bellini, Polidoro and even some fifteenth century Flemish drawings as having been retouched by Rubens. I may finally mention that in the collection of Mariette (Catalogue, 1775, No.1022) there was a drawing by Giulio Clovio after Michelangelo's Abduction of Ganymede, retouched by Rubens, and a 'superbe composition' by Raphael (Jacob and Esau, No.1020), equally restored by the master. For this question see now also M. Jaffé, 'Rubens as Collector of Drawings', *Master Drawings*, II, 1964, 383 ff.; III, 1965, 21 ff.; IV, 1966, 127 ff.
[32]Mariette wrote on the back of the Porta drawing, after referring to the painting for which the drawing had been made: 'Ce dessein qui apparemment avoit souffert, ayant passé entre les mains de Rubens, ce grand Peintre a pris la peine de le restaurer dans ce qui y manquoit, sans toucher au travail du Salviati en a fait un dessin de la première consideration' (see Jaffé, loc. cit., Fig.8). Another example of a restoration of a damaged sheet is the drawing 'after Carracci', in the Victoria and Albert Museum (see Van Regteren Altena, *The Burlington Magazine*, LXXVI, 1940, 300). The wedge-shaped piece in the lower left with the figure of Leda is all by Rubens; the larger fragment was gone over by the master but contains a base—in black chalk—which appears to be by a different hand. That Rubens restored damaged paintings, too, is seen from letters written by various agents to Sir Dudley Carleton (*Correspondence*, II, 219–225, 261–264, 314; III, 134). They refer to a painting of the Creation by Bassano which had been badly damaged and which Rubens, to quote one of the writers, 'mended very well.' In 1603, faced with an embarrassing emergency, Rubens restored, largely by repainting, a number of paintings that had been sent as gifts to Count Lerma and had been ruined by rain in transit (*Correspondence*, I, 139–183).
[33]E. Panofsky, *Albrecht Dürer*, Princeton, 1945, 284.
[34]As early as 1603 (*Correspondence*, I, 145) Rubens had proudly declined to collaborate with painters whom he considered inferior when it was a question that they might help him in the restoration of some damaged works (see note 32 above) 'avendo avuto sempre per raccommandato il confondermi con nessuno qual si voglia grand huomo' (having always had the principle not to get myself confused with anyone no matter how great).
[35]Unfortunately, some of Rubens' own drawings did not escape the fate of being tampered with by later hands. Glück and Haberditzl occasionally went too far in assuming such re-working but their No.118 is surely a case in point. Another one, not observed hitherto, is seen in the standing Apostle in the collection Fodor, Gemeente Musea, Amsterdam (R., V, No.1485, Exh. Amsterdam, 1933, No.118). Here a later owner evidently tried to strengthen the original lines, especially in the face, which had been abraded. These pedantic retouchings can be spotted by the slightly darker shade of chalk in which they were made. In the sales catalogue of the eighteenth century painter Jacob de Wit (March 10, 1755, Amsterdam) we find drawings by Rubens, Van Dyck and Jordaens actually described as having been retouched by de Wit (p.45, No.8: 'Christus, zyn wonden toonende aan de Apostelen, door P. P. Rubens; en opgetekend door Jacob de Wit'; *ibid*. No.13: 'Een Crucifix, door Rubens; en opgetekend door Jacob de Wit'; p.46, No.22: 'Twee Stuks Vrouwshoofdjes, door Rubens; en opgetekend door Jacob de Wit' etc.). See also *Catalogue*, Exh. Antwerp, 1956, No.36. P. H. Lankrink has also been 'credited' with re-touching of drawings by Rubens (see M. Jaffé, *The Burlington Magazine*, XCVIII, 1956, 318).

IV

Rubens' Development as Draughtsman

THE FIRST PERIOD [BEFORE 1612]

IN the study of artists of the past it is generally their earliest works which are hardest to identify. Our mental image of their style is formed by their mature works; it requires not only ingenuity but at times a good deal of critical daring to push the frontiers of our knowledge back into those shadowy years when the works of a young genius are still linked by close bonds to those of his teachers and when success and failure still appear very close to each other. Yet it is axiomatic that the formative years of great artists are likely to be as full of creative activity as any of their later ones. The results of their labour may not have been preserved so well as their later ones when every scrap from their hands was eagerly gathered up. They themselves may have destroyed some which they felt to be unworthy of their talent. It is very unlikely, nevertheless, that most of these early works should have disappeared.

With this in mind one could demonstrate almost statistically that for the youthful years of Rubens there must be extant more original drawings, in contrast to copies he made from other artists' works, than Glück and Haberditzl admitted. If we omit four drawings dated by the Austrian scholars before 1608, but which actually were done later (G.-H. Nos. 40, 41, 45 and 56), there remain in their catalogue no more than *fifteen* original inventions preserved in drawings for the first thirty-one years of Rubens' life. Since Glück and Haberditzl themselves counted at least 37 copies from the same period—a number which as we have seen before (p. 42) can easily be multiplied—we would have to assume a strangely one-sided depletion of the records to account for this curious proportion between copies and original inventions.

Most scholars, indeed, agree that Glück and Haberditzl were too restrictive, particularly for the first years of Rubens' activity. Many more original efforts have come down to us, and while there may be differences of opinion in a few cases, and almost certainly disagreements about some of the dates, I believe there will be little objection to the drawings published here as early works of the master. Together they form a coherent group characterized by certain technical peculiarities which may also be observed in the early copies after Stimmer and Amman. Most of them are done in pen and ink, in a style which stresses the outlines, no matter how thinly they may be drawn; sometimes, indeed, the pen seems to be just skimming across the paper. Shading is occasionally done with washes, but more often with layers of cross-hatchings produced by means of straight or only slightly curved parallel lines. This system of shading appears to reflect practices common in engravings of the somewhat schematic, impersonal character that prevailed in the middle and second half of the sixteenth century. One characteristic of Rubens' use of these shadows is that they form little units attached here and there to the silhouettes of figures, setting them off without giving concrete spatial or textural indications (see Pls. 8, 9). No drawings of his own invention exhibit the neat thoroughness of his copies; his own forms are more simplified, some being barely indicated. The draperies generally cling more closely to the bodies. Hands and feet are abbreviated, though never slurred over, while such motifs as human hair and the tails and manes of horses provide elegantly undulating breaks in the general dryness of the design.

Although at this time Rubens was already concerned with physiognomic expression, his emotional range was severely limited. Apprehension, grief, fear, even madness are rendered in stereotyped facial patterns which betray his study of antique formulae. The focal points of expression are the eyes and the mouth which are frozen into shapes of accepted meaning not unlike the masks of Roman actors. Physiognomically there are striking parallels between these drawings and the engravings in Philip Rubens' book of 1608 (see p. 36); contrary to the opinion of Oldenbourg (1922, 45), who dates the—lost—drawings on which these engravings were based as late as 1607, I believe that most of them were made during Rubens' first visit to Rome in 1601–1602.

A drawing which may well go back into the pre-Italian years is the Berlin Discovery of Callisto (Pl. 8)—a subject which Rubens treated nearly forty years later in the magnificent painting of the Prado (*KdK*. 433). In the early drawing there is little of the psychological subtlety of that late work; the story is rendered with more frankness than feeling. Because of its obvious unevenness the work has hitherto not been attributed to Rubens, although this unevenness manifestly reflects immaturity rather than weak-

ness. Side by side with awkward passages are highly successful ones, such as the heads of Callisto and of the lovely nymph right above her; there are infelicities in the anatomical structure, for instance in the rump and shoulder of Callisto, but the nymph who holds on to Callisto's left arm is again a striking figure full of tense energy and worthy of a great, if still youthful, master. The shortcomings, understandable in such an early work, cannot blind us to the merits of the piece, the variety of the poses, the skilful grouping and interlacing of the figures, and the forthright and highly original conception of the whole action. In the juxtaposition of figures rendered in considerable detail with others barely outlined, the drawing introduces a feature that was to remain a characteristic of such studies; and it is precisely in these marginal figures, treated in a very sketchy way, that Rubens' talent for making succinct statement is already in full evidence.

It is seen again in the London Battle of the Amazons (Pl.9). Although lacking the clear organization of space and the wealth of dramatic incident that belong to the Munich painting of the same subject (KdK.196), the drawing is nevertheless a bold effort to show man and beast entangled in fierce combat; the unleashed fury built up to a great climax in the centre of the composition contains the germ of one of the finest passages in the Munich picture.[1]

The Rotterdam Anointing of Christ's Body (Pl.13) and the Leningrad Descent from the Cross (Pl.14) can easily be connected with the drawings of this earliest period of activity. Rubens conceived the figure of Christ in the Descent in the image of a dying Niobid—an instructive example of the easy transference of figural types from the pagan to the religious sphere which Rubens like all humanist artists practised throughout his life. Impressions from works of Italian artists are united with those received from classical art; but it is characteristically the Michelangelo and Raphael traditions in Rome (carried on by masters like Marcantonio, Sebastiano del Piombo, Daniele da Volterra, Battista Franco) which attracted him first. And nothing is ever lost: while there are no early paintings which correspond to these drawings, Rubens used them later when the opportunity presented itself: individual figures from the Anointing appear in other works, some as different in theme as the Lot with his Daughters (KdK.42). The drawing of the Descent from the Cross served about ten years later as Rubens' point of departure when he designed the large painting for the Antwerp Cathedral. The contrast between the drawing and the painting is illuminating. In the early drawing Rubens still follows a favourite compositional plan of the mannerists: the action revolves around two neutral areas (often permitting

vistas into depth) which are formed by a central and two lateral figure-groups. This pattern is used for an intricate combination of two themes. The Descent from the Cross is represented as the prelude to the Lamentation. The Virgin, sitting on the ground, has a long drapery spread out before her, ready to receive the body of Christ; the young women in the centre of the drawing are both taking part in the lowering of the body but they are conspicuously placed on either side of the sheet on which Christ will be deposed for the next act in the drama. The energetic contrapposto of the girl seen from the back expresses vividly this duality of impulse. Ten years later all the complexity of compositional design and of narrative action has been abandoned in favour of a grand unity of purpose. All figures take part in *one* action, and they all form one group which dominates the centre of the stage. Mannerism has been left behind; the Antwerp painting is Rubens' baroque solution of the theme.

In both the Leningrad Descent from the Cross and the Rotterdam Anointing we notice a figure which is almost a hallmark of Rubens' early works, a young woman with flowing hair that curls away from a central part to fall in solidly massed waves down either side of her face. It is a type which occurs also in the Hero and Leander in New Haven, in the Antwerp Baptism of Christ of 1604–1606 (KdK.14), and in an etching by Buytewech which must be based on one of Rubens' early drawings as it has their characteristic system of crosshatchings.[2] This type appears for the last time on the left wing of the Elevation of the Cross in the Cathedral in Antwerp (KdK.36). Whether the figure is Rubens' invention or whether it was derived from other sources I do not know; I consider it possible, at any rate, that classical models had some influence in shaping it. The Medea which Rubens drew from a Roman sarcophagus (Pl.16) seems related to it despite her much shorter hair. The drawings in Leningrad and in Rotterdam are also the first of his own invention which bear inscriptions. Similar inscriptions are found in a drawing copied from a fresco by Pordenone (G.-H. No.1),[3] in one of those copied from Stimmer (Lugt, 1943, Fig.10), and in the drawings for the Last Supper and a Raving Medea in Malibu (Pls.19, 20). All these inscriptions are in Latin, in a small, neat hand; their graphological appearance corresponds well with the careful use of the pen in most of the drawings.

Only a few drawings of the first Italian period can be connected with finished paintings. Thanks to L. Burchard's keen eye, the Brunswick study of a Crowning with Thorns (Pl.12) has been identified as a project for one of the paintings which Rubens did between 1601 and 1602 for Sta. Croce in Gerusalemme; it was Evers who recognized a chalk

study of two men holding poles (Fig. 8) as belonging to the same commission. This drawing, hence, is the first one made in chalk which can be dated and as such deserves special attention.

In contrast to the pen-drawings of the same period, the study in chalk gives the impression of having been done somewhat haltingly. This can hardly have been because the medium itself was unfamiliar to Rubens. While Northern artists of the later sixteenth century, including Rubens' masters, seem to have preferred drawing in pen and ink, with or without wash, they surely were acquainted also with chalk and taught its use to their students. Hendrik Goltzius, one of the most prominent draughtsmen of the North immediately before Rubens, made many portrait drawings in chalk.[4] Neatness and smooth precision are characteristic of these drawings in chalk, and we find the same qualities in many of Rubens' early drawings in this medium, such as his copies of Renaissance paintings (Pl. 22); his studies of classical sculpture (Pls. 34–37), and his 'cartoon' for the Baptism of Christ (Pl. 28). The Baptism of Christ, indeed, is a veritable *tour de force* in which chalk, sharpened to a pencil-like point, is used with incredible patience for the rendering of the smallest details. The contours are as well-defined as if they had been done by a pen, and the shadows, as in the pen-sketches, are drawn in layers of parallel lines.

The studies for the Raising of the Cross (Fig. 8), on the other hand, reveal an awareness of other possibilities, of broader strokes, and more indefinite shadow areas. The reason, as often with Rubens' work, may well be found in the special function of the drawing. What was new here for Rubens, in other words, was not the medium as such but the use to which it was to be put. To make large drawings of single figures from life in poses which had been determined by previous studies was rarely found in Flemish art before Rubens, while it was a well established tradition of Italian studios. As we have seen before, it was practised particularly in the school of the Carracci in Bologna and Rome, resulting in drawings of impressive size and beauty. We may thus attribute the appearance in Rubens' work of this kind of drawing to his contact with contemporary Italian art. Together with the assimilation of a new technical procedure, Rubens learned to derive new stylistic possibilities from his tools. The ultimate fruits of this study are seen thirty years later in Rubens' drawings of cavaliers and ladies for his Garden of Love (Pls. 198, 199, 201, 202, Colourplate 6).

Rubens' rapid progress in handling drawings in this way can be gauged by the beautiful piece of a Halberdier in the Bibliothèque Royale, Brussels (Pl. 30). It was probably drawn around 1604 in connection with the work for the sadly mutilated canvas showing the Gonzaga family adoring the Trinity. We notice that Rubens draws with increased boldness, occasionally bearing down on the paper with quick straight movements of the hand. Shadows are deep and wash has been added to create a colouristic brilliance which anticipates that of the finished canvas. The variety of tonal modulation and the lively manipulation of drapery folds is indeed vaguely reminiscent of Grünewald's exciting studies in black and white.

This striving for 'rich' effects in chalk is still found in the studies from the nude for the Prado Adoration of the Magi of 1609 (Pl. 55). With endless variety of technical means, Rubens rendered a surface rippled by bulging flesh and muscles. We watch him, now smudging chalk into smoothly textured layers, now pressing down hard for deep shadows, now adding a white highlight for extra sparkle. At the same time we notice, particularly in contrast to the early drawing in Bayonne, a new strength and firmness in the conception of the human body. Whereas the men in the earlier drawing seem to cling to the pole rather than to lift or guide it, the figure in the Rotterdam sheet is the very image of controlled and purposefully applied power.

A tendency toward greater precision in the definition of form can be seen in the pen and ink drawings which belong to the later years of this period. This is particularly evident in two drawings which are certainly works of Rubens but which have puzzled some of the critics (Pls. 46 and 47). Evers must be credited with recognizing that Rubens was the author of this group, but even he assumed that the Death of Creusa in Bayonne must have been reworked by another hand in order to explain the awkward passages which this drawing undeniably shows. Yet if we compare the Death of Creusa with the Rotterdam Entombment scene (Pl. 13), we perceive the great strides which Rubens had made in a few years. There is more articulation in hands and feet; the heads are trim and compact, and the salient features are rendered with greater economy. The Amsterdam Abduction scene (Pl. 47) is a most instructive piece for our understanding of what went on in these years: on the left side of the sheet we see a first sketch executed in apparently uncontrolled flourishes from which—thanks to a few thin washes—we can just barely make out the action: a woman is struggling against the attack of a figure (a centaur?) who attempts to lift her up while another figure, nearer the ground, either helps in, or tries to prevent, the rape. This wild, almost chaotic section represents a new boldness in the representation of violence. On the right half of the paper Rubens drew another action in the precise and well-defined

manner seen also in the Creusa drawing; a few thin preliminary pen lines like those of the group at the left can still be distinguished, but over them Rubens drew the group delineated clearly in every detail. With calm assurance he emphasizes the deep shadows around the eyes and fingers, or the silky softness of flowing hair.

In the drawings of this series we notice also the beginning of a new facility in the use of washes. Not only does Rubens make use of wash more frequently but he handles it more freely, occasionally drawing directly with the brush, and using these lines to indicate form as well as light and shade. It is surely not accidental that around 1606–1607 he made—perhaps as an experiment—what may be his only *pure* brush-drawing: the St. Catherine in the Metropolitan Museum, New York (Pl. 33). In place of the careful blending of thin washes found in some earlier drawings (Pl. 13 for instance) Rubens now applies the bistre in broad strokes, so that an effect of either sunlight or striking nocturnal illumination is suggested (Pls. 48, 52). Whereas in the chalk-drawings he tended toward greater complexity and subtlety, in the pen-drawings, especially when washed, Rubens strove to gain contrast and dramatic force. The principal advantage which Rubens derived from this loosening up of the technique was an increase in speed in quick sketches; one rapid stroke of the brush now takes the place of many laborious cross-hatchings. The long shadows on and around the frightful coils of the monster in the Bayonne Death of Hippolytus (Pl. 58) were evidently produced in a few seconds. The shadow lending relief to the frightened witness who, arms outstretched, runs towards the right, was made by a few strokes with the brush, one of which, in one sweep, suggests also the shadow he casts on the ground.[5]

With increased speed Rubens also gained in effect. Many of the scenes portray subjects of violence and disaster. The slashing or undulating strokes of the brush sustain a mood of excitement appropriate to stories of fear and sudden death. In the Susanna drawing (Pl. 52) the figure is placed before a large shadowy area, presumably of trees, which carries with it an ominous suggestion of terror. The hasty flashes at the right—probably meant to render nothing more harmful than slender bullrushes—echo Susanna's movement and thereby intensify the emotional character of the situation. Evers (I, 108) spoke of the years of 1609–1611 as a period of 'Deeds of Violence' (Gewalttaten), using the term primarily to denote brutal conflicts between the sexes. Yet there is an air of violence and excitement in most of the projects which attracted Rubens in these years. Peaceful subjects like the Adoration of the Magi of 1609 (Sketches in Chicago and

Groningen, see Held, 1980, No. 325 and under 313) also reflect this trend. That this violence is due more to stylistic preference than to subject matter is demonstrated by the sketch of Philopoemen in the Louvre (Held, 1980, No. 278) where a table prosaically laden with fruits, vegetables, and dead game is rendered in violent brush strokes and with melodramatic effects of light. The oil-sketches of these years show, indeed, the same combination of straight slashing strokes and serpentine undulations so common in the drawings in pen and wash.

The pen-drawings reveal a development of the master in still another direction. Rubens' ability to visualize the human body in complex movements, foreshortened, or in contrapposto, and in interaction with other figures, now approaches a perfection which he clearly had lacked in the early Italian years. His incessant drawing from classical sculptures and from the painters of the Renaissance was bearing fruit. If one wants to understand why themes of violence attracted Rubens in these years, one should not overlook the fact that they offered him opportunities for trying his skill in drawing the human body in difficult positions. In drawings of this period it is not so much the contorted poses which distinguish the figures from those he drew earlier as it is the flowing rhythm with which these contortions are displayed. Bodies have a new softness and pliability (see for instance Pl. 51); the limp figure of the dying Adonis (derived from a classical model) together with that of Venus, who sadly leans over him, form a group of unforgettable lyrical harmony (Pls. 56, 57). David's sword, ready for the final blow, rises above his head as the climax of a grandly spiralling diagonal movement. A few lines swirling round his body are there primarily to convey that upward movement and only incidentally to suggest a flying drapery (Pls. 61, 62).

Although the painting of portraits was one of Rubens' major activities while he was abroad, only a few drawings of portraits have been preserved from the years spent in Italy and Spain. Two heads of young Gonzaga princes, carefully done in chalk (Pls. 10, 11), the study for the equestrian portrait of Count Lerma of 1603 (Pl. 38), and a study for one of his Genoese portraits of 1606 (Pl. 32) are all that remain of dated or datable drawings; to these should be added a few (such as G.-H. Nos. 42 and 44) which are early too. The first one, indeed, may still belong to Rubens' Antwerp time, before 1600. Psychologically, these portraits give little. But in the heads of the two Gonzaga princes one can observe the first manifestation of Rubens' stress on clear outline in constructing the architecture of a head. He still had to go over the contours several times, but when he had found the proper shape he marked it by a stronger line and by a few touches of shading. The

portrait drawings that he must have made in Genoa would surely have told us still more about his early development, and it is regrettable that save for the one full-length study in the Morgan Library (Pl. 32) not one of these Genoese drawings has been found.

THE SECOND PERIOD [c. 1612–1620]

The disappearance of large bodies of drawings which we can be quite sure did exist at one time imposes a severe limitation on our efforts to trace Rubens' development as a draughtsman. In 1604–1605 he painted three canvases for the Jesuit church in Mantua, but no compositional sketch for any of the three has come to light. (The Baptism in the Louvre [Pl. 28] evidently sums up many preliminary sketches.) The genesis of the pictures Rubens painted in 1607–1608 for the Chiesa Nuova in Rome is easier to reconstruct, especially as there are several oil-sketches which supplement the drawings.[6] For the triptych of the Raising of the Cross of 1610–1611 there are studies for details in chalk, but no drawing for the composition as a whole. It is therefore a welcome accident that some drawings for the wings of the triptych of the Descent from the Cross of 1611–1614 have been preserved (Pls. 72, 73). They are clearly first thoughts, but their apparent roughness still comes as a surprise. Even in the sketchiest of the earlier drawings (such as the Sts. Gregory and Domitilla of the collection of L. Burchard, Burchard-d'Hulst, 1963, No. 26a) the lines swayed gently as if feeling their way into and around the figures and their draperies, but here they are drawn with utter unconcern for the niceties of a silhouette. The figures are blocked out, as it were, and they impress the beholder with their mass before he perceives their action or expression. Thus the change to a sculptural style which is clearly noticeable in Rubens' paintings of this period, is paralleled in the very first jottings of compositional ideas.

We find this reduction of figures to block-like simplicity in many drawings of the years that follow the Antwerp triptych; the first outlines often describe the forms in such abbreviation that they approach the simplicity of rectilinear, tubular, or spherical objects (see Pls. 77, 92, 126). In full possession now of the knowledge of the human body, Rubens could suggest the most complex actions in a few hurriedly dashed-off lines. In the study of the Apostles around the tomb, for an Assumption of the Virgin (Pl. 127), one man is leaning backward, hands folded in prayer; his head, seen in a foreshortened view from below, is perfectly convincing although it consists only of three little lines for the face, one for the chin, and one arch-like curve to outline the whole. Other figures, done with equal economy, lean forward, or turn about with eloquent gestures of their hands. In the sketch for the

last Communion of St. Francis (Pl. 128), the physical feebleness of the Saint and the tender solicitude and veneration by which he is surrounded are beautifully suggested in the same apparently haphazard artlessness of a quick sketch. The little pen-sketch of the Raising of Lazarus which Rubens drew in one corner of a page showing a large drawing of the same subject (Pl. 126)—although it apparently displeased the master, who crossed it out with two or three angry lines—is nevertheless perfectly readable in each of its major figures. To measure the artist's progress one need only compare any of these sketches with the group at the left in the early drawing of Lapiths and Centaurs (Pl. 47). Not even the added bistre wash could give to the maze of swirling lines in that earlier drawing anything like the clarity of action obtained with fewer strokes at the later date.

Moreover, as the blocked-out stone does for the sculptor, these geometrically simplified figures suggested to Rubens' eyes the full range of bodily motion. In the Berlin sketch of Bathsheba (Pl. 135) the figures in the upper left corner (as well as those on its back) almost have the appearance of an accumulation of parallelograms. Immediately below, Rubens drew Bathsheba's figure again with a most sensitive and subtle modulation of her youthfully firm body. In the drawings of Scipio and the Spanish Bride, the figure of a standing young woman can be seen in three stages of transformation. In the Berlin version (Pl. 123) she appears twice near the left edge of the composition. Rubens first blocked her out in a few lines. When he had realized that the composition would gain by concentration, he repeated the figure in greater detail alongside, nearer the centre of the sheet. She appears for a third time in the drawing in Bayonne (Pl. 124), but now in reverse and invested with many details of costume and anatomy. All these changes Rubens surely made without recourse to a posing model. He had arrived at a point where both his memory and his imagination provided him with movements and configurations of great complexity and with an untold number of colourful and realistic details.

It was in the period from 1612 to 1620 that Rubens established and systematically organized the full range of his activity. With sovereign assurance he staked out his realm as the most versatile artist of his country. His close association with the publishing firm of Plantin began in these years, and his first book-titles were then drawn (1611, 1613, 1614).[7] He began to make drawings for sculpture and, prompted perhaps by the building of his own house, he took an active interest in architecture. He began to hire professional engravers for the multiplication of his designs, and he developed appropriate methods

for the preparation of their works. All the different subjects that he was ever to treat now make their appearance: beside conventional religious subjects he painted huge mythological pieces, hunting scenes, landscape and genre. If any one subject is relatively infrequent during these years it is portraits, a fact which bears out Rubens' statement, made in 1620 to the secretary of the Earl of Arundel, that he had turned down many such commissions (see p.32). The drawings preserved from this decade give an adequate and impressive idea of Rubens' activity. Beside the sketches for the Altar of the Descent from the Cross there are the spirited study for the Conversion of St. Paul (Pl.60), and another one, rather similar in style, possibly for the so-called 'Coup de Lance' (Pl.97).

The dramatic Entombment (Pl.98), the Descent from the Cross (Pl.121), and the gracefully exuberant Assumption of the Virgin (Colour-plate 1) are characteristic studies for big altar-pieces, such as Rubens and his studio produced in large numbers during these years. It is a particularly fortunate circumstance that we are so well informed from drawings about the genesis of one of his most admired religious paintings of these years, the Last Communion of St. Francis, Antwerp (Pls.128, 130). Fewer drawings have survived for his numerous mythological compositions; for the Battle of the Amazons in Munich (*KdK*.196), one of his most ambitious, and most celebrated, works, belonging to the middle of the decade, no preparatory work of any kind seems to have been preserved. If there were any pen-sketches for that picture they would probably look somewhat like the fighting scene preserved on the reverse of the drawing for an Assumption in Oslo (No.104), where one figure indeed resembles strongly the foremost Greek foot-soldier fighting on top of the bridge in the painting. Nor are there any compositional drawings for the first of Rubens' great cyclical narratives, that devoted to the life of the Consul Decius Mus. All these losses strengthen the importance of a study for one of the key-paintings of the mythological group, the Drunken Silenus (Pl.111). This drawing permits us to see the emergence of a motif which Rubens still considered many years later worthy of rendering in a large woodcut (see Pl.218)—the heavy forward staggering of Silenus, whose form, unlike the forms of the accompanying figures, Rubens drew even in the first sketch with some of the majestic curves that in the painting are still more overpowering. A study for Venus and Cupid (Pl.137) presents the female ideal of this period, a long-limbed, though rather muscular figure, familiar from many paintings of nymphs and goddesses.

The series of drawings of nature and of farm-life begins with the striking sketch of a farm girl (Pl.83),

seen from a low eye-level where the monumental conception of the whole compensates for a certain crudeness in the treatment of the shadows and a seeming hesitation in the tracing of the lines. A few years later, Rubens drew a girl milking a cow with far greater assurance and precision in details, rendering the shadows in an almost transparent fashion (Pl.103); the pen-strokes were added only after the forms had been fixed in chalk, a procedure which Rubens also followed in drawings of landscape motifs like the fallen tree (Pl.113) and the country lane (Pl.114).

The most prominent group of drawings from this decade, however, are evidently large chalk-drawings, made from a model posing in Rubens' studio, of whole figures or of details, such as arms, hands, and legs. It is surely no accident that most of these studies were made when Rubens established the routines that enabled him to cope efficiently with large undertakings. Part of the purpose, as has been said before, of such drawings may have been to give guidance to Rubens' assistants. Thus the emphasis on large studies from life may reflect Rubens' conscious assumption during this period of his rôle as teacher and head of a big studio.

Yet it is also obvious that in making these studies Rubens sought to obtain for each pose, each gesture, each expression a maximum of clarity and effect. In this respect the drawings demonstrate well a trend in Rubens' art that is general during this decade. In all fields of his activity he insisted on maintaining the utmost lucidity of organization, no matter how dramatic the subject or how grandiose the scale of the work. Whether or not he had at the beginning of the decade an 'academic' phase, as claimed by Oldenbourg but denied by Evers, there can be no question that, starting with such works as the Descent from the Cross in the Antwerp Cathedral, Rubens consistently developed a style in which balance and clarity are perfectly compatible with baroque rhetoric. His settings are made up of rational elements like stairs, platforms, bridges; an easily comprehensible equilibrium is established from figure to figure and from group to group; broad areas are filled with brilliant saturated colours that carry distinctly across large spaces. His figures, above all, perform their rôles with a new eloquence. They had gained control over their bodies long before, but only now, one feels, do they assume in each rôle the most appropriate stance and the most telling expression; the slight changes which Rubens made in the position of the arms of the blind man in the Miracles of St. Francis Xavier between the oil-sketch and the chalk-drawing (Pl.139) made a world of difference for the expression he tried to convey. Evers (I, 140) aptly spoke of this period as one in which the artist's chief aim was 'Verkörperlichung'

(giving bodily form); the spiritual was served by making it 'above all visible and tangible.' It is significant that the large chalk-studies of single figures are found more frequently in this period than at any other time.

If we compare studies from the beginning of the decade with those from its end, we observe a distinct development. The technically more complex pieces come first, like the moving study for the crucified Christ (Pl. 84), whose richly highlighted body is reminiscent of gleaming ivory. Studies like the blind man (Pl. 139), the monks (Pl. 130), the man with ladder (Pl. 141) and the girl with a bowl (Pl. 112) belong to the end; in their very simplicity they achieve an incomparably happy fusion of gentleness and monumentality.

Since the discovery of studies like the St. Catherine (Pl. 33) and the Halberdier (Pl. 30), it can no longer be said, with Glück and Haberditzl, that Rubens made no single studies of clothed figures before 1615. If there is a difference between studies from life done before and after that date, it is a difference that has to do with a basic concept of the human body. In the beginning Rubens seems to have been interested especially in the articulation of each part of the body; later he stresses more the rhythmic unity of movement and the impression of solid mass. A jagged silhouette like that of the nude man (Pl. 74), who flings his legs and arms in all directions, would be unthinkable around 1620. One might compare the nude figure with the study of Mercury descending (which admittedly belongs already to the beginning 1620's); in the latter piece (Pl. 153) the radiating members only serve to emphasize the strong pull of the solid core.

Rubens had reached this stage several years before, as may be seen from the massive dignity of a crouching farm-girl (Pl. 129). What Rubens had achieved by 1620 is probably seen nowhere better than in the superb drawing of St. Gregory Nazianzen for the ceiling of the Antwerp Jesuit church (Pl. 146). It is a compositional drawing which in an unusual way combines the imaginativeness of a first study with the precision and the clarity of studies from life. The angel and the first demon, undoubtedly, were based on life-studies and they well represent the masterly balance, achieved in these years, between dynamic force and sculptural cohesion; for the last time we perceive the shade of Michelangelo. It is almost symbolic that it was just these two figures which Rubens eliminated when he painted the final version, in order to concentrate on the Saint. In the figure of this embattled Saint, in the agitation of the lines of his gown, we see the birth of a new ideal that will dominate the following decades.

THE THIRD PERIOD [c. 1621–1630]

When we come to the 1620's the situation changes in several respects. During this decade Rubens was engaged in projects which must inevitably have affected his activity as an artist. Political affairs began to make demands on his time and necessitated a far-reaching and lengthy correspondence; he must have had close contacts with the court at Brussels; and finally he travelled as the special envoy of his sovereign (not, as in 1603, as a subordinate member of a Mantuan Embassy) to Spain and, after a brief stop-over at home, to England. The many deliberations, the official audiences, the reading and writing of dispatches, the gathering of information pertinent to his aims and to the goal of his mission, not to speak of the importunities of petitioners, must have taken up much of his time, no matter how prodigiously active and how skilled in the organization of his work he may have been. When it was all over Rubens himself spoke of the labyrinth in which he had been caught up during these years.

Whatever time he had left, he naturally gave to the main interest of his life. In Spain, where his public affairs moved slowly and where his commissions did not keep him fully occupied, he painted large copies after canvases by Titian in the collection of King Philip IV—a magnificent group of works, many of which the king later acquired from Rubens' estate. Working directly from the originals, Rubens had evidently no need to make any drawings except the sketches in chalk he may have made directly on the canvas. Nevertheless, we do have a sheet with studies of single heads taken from three of Titian's 'poesie' (No. 175; Colour-plate 5).

Even granting that there were times when he was too busy to draw, or when because of the nature of his work he could dispense with making drawings, there is no denying that the number of drawings seems to fall off more than might be explained by these circumstances. After all, Rubens was occupied in the 1620's with some of the largest undertakings of his career. First there are the cycle of Constantine and the decoration of the Luxembourg Palace for Marie de Médicis. To the second half belongs the cycle of the Triumph of the Eucharist. Soon after 1630 he designed the series of the Life of Achilles and the various compositions for the ceiling of the Banqueting House at Whitehall. There were plans for a cycle of the life of Henry IV, and several pieces were fairly advanced when the project was abandoned. In the 1630's we have the plans for the Triumphal Entry of Cardinal Infante Ferdinand in Antwerp and the huge commission for the Torre de la Parada near Madrid. Along with these major projects Rubens painted many altar-pieces and other types of monumental decoration.

Only a surprisingly small number of drawings can be connected with these large undertakings. One or two drawings of compositions for the Constantine cycle, three rapid sketches for the Medici series, some studies for the High-altar of the St. Augustine church in Antwerp and for the painting of St. George and the Princess are all there is from the 1620's; it is about the same for the 1630's, with hardly any drawings known for the major projects just cited.

Whereas the number of drawings seems to drop, the number of oil-sketches known to exist rises steeply. Starting around 1620 with the sketches for the decoration of the Jesuit church at Antwerp, we have a nearly complete record in oil-sketches of all the great cycles, and not infrequently more than one sketch for a single picture. These sketches were painted on a light ground (and invariably on wood); as we have said before it was Rubens' habit to make rough preliminary drawings in chalk on this ground before painting on it; some of the sketches, besides, especially those which were demonstrably done first, were themselves 'drawn' with a fine brush, in brown or thin crimson lines made with 'la laque commune,' as Dr. Mayerne calls it in his treatise (see p. 26). Thus, while drawing is still a basic procedure, the sequence of events is often telescoped, so that technical steps formerly taken separately could now overlay each other on the same ground.

Particularly significant in this connection is the disappearance, at least for a period of time, of studies from the nude model. Except for portrait studies, which form a special category to which I shall return, not one drawing of a single figure had hitherto been identified as coming from the Medici series with its hundreds of characters. The only one which I believe belongs to that cycle (Pl. 153) is—not surprisingly—a study for an unusually compli-cated pose. There are few figures in the cycle for the Luxembourg palace which Rubens could not have drawn freely from his imagination and from the enormous stock of poses previously studied by him from life or taken from classical and Renaissance masters. The Medici series, indeed, is notoriously full of 'quotations' from classical statuary.

The only explanation which seems to make sense—short of again assuming a strangely one-sided depletion of our records—is that Rubens either did not need, or did not care to make the kind of study from the model which had occupied him so much during the second decade. Indeed, the prob-lems which attracted him in the 1620's, judging from all the categories of his works, did not require the same concentrated observation of nature so characteristic of the earlier periods. What concerned him now was the integration of all the formal elements of design into a colouristically and rhyth-mically unified whole, with more attention to tying forms together than to separating them. To insure the effect of a continuous flow of action and of the impression that air was circulating between his figures, he frequently relied on non-stable forms like fluttering draperies, clouds, transparent foliage, rays of light. By giving a suggestion of vagueness he evoked infinity. Colours, formerly identified indi-vidually and employed to isolate figures, are now more broken up and more fused, thus binding together the design in a harmonious luminosity.

It is obvious that aims like these were better served by oil-sketches than by drawings. Even such drawings as there are from this period seem to bear out the change in Rubens' style. At first we notice a new delicacy in the use of the pen, as in the drawing of the Roman triumph (Pl. 131), where the strokes, drawn over a rapid study in chalk, transform the whole surface into a network of subtly vibrating lines. In the late 1620's appear pen-drawings in which Rubens drew figures with a new fluency and sinuous grace, suggesting at the same time, by merely varying the pressure of the hand, the play of light and shade which he had formerly indicated by actual shading (Pl. 176). Though still serving to accentuate plastic volume, his washes tend to lose the sharply defined shapes they had during the previous decade and assume a shaggy, irregular appearance, sometimes giving the impression of having been scattered at random rather than for a definite purpose. The Stockholm drawing for the high altar of the Augustines (Pl. 169) beautifully foreshadows the waves of colouristic and physical movement in the finished painting, surging up and spending themselves against the Virgin's throne. There is, finally, a certain logic in the fact that it was precisely in the late 1620's that Rubens again ex-perimented with new technical procedures. Gouache—although never very popular with Rubens—makes its appearance in his oeuvre at about this time.

The only kind of drawing which does not de-crease in number after 1620, but actually shows an extraordinary increase, is that of portraits in chalk, or large study-heads. The preservation of these drawings may be due to accident; yet, given on the one hand the general changes which we notice after 1620, and on the other the style of these drawings in particular, it is more likely that they are evidence of a shift in Rubens' interests. It would probably be going too far to say that Rubens' attitude towards portraiture as such had changed. Though there are more portrait-paintings from this period than from any other, the explanation is simple enough. Now in close touch with the royal houses of France, Spain and England, and dependent upon their goodwill for the success of his diplomatic missions, Rubens

was in no position to say no to official requests for likenesses; he could not easily turn down members of the court or of the diplomatic world who could favourably or adversely influence his affairs. Rubens' art in these years became to some extent another tool in the hands of Rubens the political emissary. Nor could he forget that precisely from these circles could he obtain the kind of commission he liked best. When he made the drawings of George Villiers, Duke of Buckingham (Pl. 160), and of his Duchess, Catherine Manners, he portrayed not only a man who until his murder in 1628 was the most influential figure of the English court, but also potentially one of the most important patrons of the arts. The Spanish diplomat Don Diego Messia, Marquis of Léganès, was, in the words of the painter Pacheco, Rubens' great admirer—and responsible for one of the few commissions outside portraiture which Rubens had while in Spain. It was to be expected that Rubens would paint the Earl of Arundel when he finally made the acquaintance of that great Maecenas (Colour-plate 4).

Thus his close contacts with the courts of Europe forced Rubens into the field of portraiture which he had before treated with reluctance, except during the Italian period when he had also not been a wholly free agent. Yet there is another factor involved which would seem to have been of deeper significance. A very large number of the portrait-drawings of the 1620's and early 1630's are of members of Rubens' own family and of close personal friends; many of them are of women and of children. Studying these drawings, we suspect that the close association of family life, particularly the observation of his own children, may have suggested to Rubens thoughts about portraiture which had eluded him before. In his earlier portraits Rubens had stressed the physical presence and the social identification of his models, as for instance in his Genoese portraits. In the portrait-drawings of the 1620's and 1630's we sense Rubens' awareness of a new dimension. It is only now that we find the psychological variety of which I have spoken before (p. 33). The tender smile of his wife (Pl. 154), the slightly pouting lips of his son (Pl. 162), even the faint tenseness in the face of the Marquis of Léganès (G.-H. No. 164) indicate a subtler psychological insight into human nature than Rubens commanded before. Rubens knew that there are nuances of expression which a portrait painter must catch if he wants to be successful; he expressed it well in a letter written in August 1630 to Peiresc, acknowledging a portrait of Peiresc which had been sent to him by the French scholar (in return for one of himself): '*ma io confesso non mi parere di relucere in questa faccia non so che di spiritosa, et una certa emphasi nel sembiante che mi pare propria del Genio di V.S. laquale però non si acerta*

facilmente in pittura da ogniuno' (. . . but I confess that there does not seem to be reflected in that face a certain spirited quality, and a certain emphasis in the countenance which seems to me appropriate to your genius but which cannot easily be captured in painting by everyone).[8]

In its richness and delicacy the technique of these drawings itself might be interpreted as a token of respect for that invisible element which Rubens now discovered as the true measure of individuality. The interplay of the three chalks has lost what it had before of the schematic and stereotyped. Red and black chalk, particularly, are worked into each other with great imaginativeness and sensitivity. Rubens shows now a special fondness for the warm, glowing quality of red chalk (G.-H. Nos. 194, 195, 196). He uses linear divisions less frequently or noticeably. The surface modulation of these drawings sometimes assumes the pictorial quality of paintings (Pl. 168). The final spark of life, the '*certa emphasi nel sembiante*,' is often added by touches of the pen.

Perhaps it is the mellowing of Rubens' own nature that is mirrored in the faces of his models, especially the young women and the children. The same mood seems to be reflected in the colouristic and compositional style of his later years. Just as there is nowhere now a colouristic break or a spatial chasm in his designs, so none of his figures is ever 'an island entire by itself'; they are surrounded by sympathy—not the least the master's own—and if there is one pervasive feeling which they all share, in varying degrees, it is the feeling of deep happiness, born of security and physical and mental equilibrium. 'Mens sana in corpore sano' is one of two mottos from Juvenal that Rubens had caused to be inscribed on the outside of his house. It is only during these later years that he found the most convincing visual equivalent for this idea.

THE FOURTH PERIOD [*c.* 1630–1640]

'Using the opportunity of a short, secret trip, I threw myself at her Highness' feet and asked her, as the sole reward of my labours, to free me of these missions and to permit her to serve her from my home.' Thus Rubens wrote in December 1634 to his friend Peiresc, informing him that he had managed finally to lay down the burdens of official duty. He continues: 'I am now, as you may have heard from Mr. Piquery, united with my wife and my children and have no other wish than to live in peace.'[9] His marriage to Hélène Fourment in 1630 did not mark the beginning of a new phase in his artistic development, but it was an opportunity to bring to full fruition the artistic ideas which had occupied him for years before. He had had enough of honours and of responsibilities. Now the artist claimed his rights. How his drawings were affected can be seen from

two magnificent sets: the studies for the Garden of Love (Pls. 198, 199, 201, 202, Colour-plate 6) and for the Flemish Kermesse (Pls. 184, 185, Frontispiece). No oil-sketch is known to exist for either of these paintings.

In connection with the Garden of Love, large chalk-studies of single figures reappear again; indeed, there are more such studies known for this work than for any of his others. No less than nine large drawings have been preserved for eight of the main figures in the foreground. Is it an 'optical illusion,' induced by the unexpected emergence of a category which had seemed almost abandoned by the master, or does Rubens here really relish the pleasure of observing nature again as he used to do long before, by drawing from the model? There is no doubt that these drawings and the several which follow them make a very different impression than the studies from life which Rubens had made between 1610 and 1620. They are almost all costume figures and contrary to the earlier ones the great majority are of women.[10] Yet the deeper difference, of which these facts are no more than symptoms, consists, I believe, in a change in Rubens' attitude toward drawing as such. In former years, the appearance of Rubens' drawings had been largely determined by the rôle they played in the crystallization and the clarification of his ideas. Their beauty was primarily a functional one. In Rubens' drawings of single figures from the 1630's we encounter an attitude best described perhaps as a delight in the pictorial appeal of the drawing itself. It still holds true that Rubens made no drawings which did not contribute to the preparation of paintings, but he treated these studies of young ladies and cavaliers, of kitchen-maids (Pl. 192) and of despairing mothers (Pl. 215) with such ardour and enthusiasm that while making them he seems to have become oblivious to their specific purpose. He grows enchanted with the play of light on silky surfaces; he endows an essentially cumbersome fashion with lightness and flowing grace. All the sensuous splendour which he had absorbed in his studies of Titian's paintings in Spain, all the joy and happiness which he experienced in his second marriage reappear in these studies. Indeed, 'studies' is an inadequate term for these drawings. Rubens projected into them—quite unconsciously, one may be sure—feelings which he never expressed in words. By nature discreet, and especially reticent when it came to speaking of himself, it is only through this new pictorial enthusiasm, felt strongly also in his paintings of the early 1630's, that Rubens makes us aware of the deep satisfaction which possessed him when he had once more become the master of his own fate. It was one of these late studies, showing Hélène Fourment seated on a chair (Pl. 193) which, when exhibited

with the Lawrence collection at the Woodburn Gallery in London in 1835, prompted W. Mayor—a dealer hardly given to sentimental reflections—to write spontaneously on the margin of his catalogue, now in the Frick Library in New York: 'The most delicate and tender drawing of the master I ever saw.' Similar expressions of admiration of these pieces fill the literature on Rubens. We may recall in this connection Rubens' letter to Sustermans (see above, p. 16), written a few years later, in which he explains the symbolism of the drawing in his painting 'The Horrors of War.' It is unlikely that he would have been so conscious of, and so articulate about, the aesthetic values of drawing before he had made those pieces whose beauty centuries after still delights our eyes and warms our hearts.

The studies for the Kermesse are very different from those for the Garden of Love, but equally significant of the new attitude of the master. On the front of the large drawing in London (Pl. 184) Rubens drew, at first in the angular staccato of a preliminary chalk-sketch and then in the more flexible curves of the pen, a Bruegel-like view of peasants assembled for a feast. There are about eighty figures on this sheet, more than Rubens had ever before assembled on one piece of paper. It is not, as Evers thought, a coherent study for a composition. Several groups and figures were repeated, some in quite different places. Nor is it, as it has also been said, a study from life. Rubens must have seen peasants innumerable times, sitting heavily on benches, drinking from huge mugs, supporting drowsy heads on lumpy arms, or leaning across tables in deep intoxication. He must have watched them as they rolled helplessly on the ground, with well-meaning friends or an anxious wife trying to get them up; he surely had observed children learning from their elders to guzzle beer, or the jolly greeting between friends and the start of a rustic dance. He remembered the initial shy friendliness of one couple and the gross demonstration of passion of another. He must have noticed the silent onlookers and the gossips and he well knew the characteristic poses of fiddlers standing on their platforms or walking through the crowd. He surely had seen all these things in life, but he had also seen German sixteenth-century woodcuts of *Kirchweih* celebrations, paintings of peasant feasts by Bruegel and Gillis Mostaert, and the brutal pictures of peasant life by his younger compatriot Brouwer, whose works he is known to have valued highly. From all such stores of knowledge he now poured forth an inexhaustible wealth of images, drawing a seemingly endless variety of people and actions across his page as densely and effortlessly as one might do in writing. Just as he was carried away in his chalk-studies for the Garden of Love by the sheer pleasure

of drawing, so with gay abandon he gave himself up here to the flow of images crowding, but not cluttering, his imagination.

The reverse of the sheet (see Frontispiece) is perhaps the most amazing projection of creative fury found anywhere in Rubens' drawings. Seventeen times he sketched on this page a pair of rustic lovers, dancing in a wild frenzy, their arms interlocked or raised overhead, their bodies writhing excitedly while executing their intricate figures. As the dancers twist around each other, obeying the rhythm of the music and the rules of the dance, they are possessed by the desire to embrace, and indeed their lips meet, no matter how complicated the pose. This basic theme Rubens drew again and again in ever new variations, far more often than he was to use it in his projected painting. We do meet some of the couples in the picture later; the pair in the upper right, for instance, in which the girl half evades, half swoons in, the arms of her aggressive partner, was taken over into the Louvre painting with only minor changes. Yet here in the sketch the very act of drawing seems again to have exercised a strange, almost obsessive fascination upon the master. Aided by the rough preliminary chalk-lines underneath, his pen seems to fly across the paper, bent only on catching the sensation of intense and passionate movement. The lower left corner contains perhaps the most striking groups, and surely the most extraordinary graphic equivalent of dynamic motion. The lines themselves here seem to meet, to interweave, and to embrace, with the same orgiastic abandon that motivates the dancers.

Different though they may be, the studies for the Garden of Love and for the Kermesse both manifest the creative exuberance which breaks forth in the master's art in the early 1630's. In his development as a draughtsman they mark a climax. The happy coincidence of his personal feelings with the demands of the themes gave rise to a creative spiral of an intensity unusual even for Rubens. The heat of these very productive years could not last, but their impetus carried through to the very end of Rubens' life. The inventive faculty of the master remained unimpaired even in the years of increasing physical disability and suffering. In the drawings of Rubens' last years there appears occasionally a curious harshness, as if some nervous controls had been relaxed, noticeable particularly in some 'first' sketches, among them the Berlin sheet with Cupido Captivus (Pl.217), the thickly inked Feast of Herod in Cleveland (Pl.205), and the somewhat erratic though fascinating Bath of Diana in the Princes Gate Collection (Pl.210).[11] The figures in these drawings seem to be treated rather carelessly in parts, especially when traced in pen, though there is no reason to think that the reworking in pen was not Rubens' own.

The drawings Rubens made in these years for Jegher's woodcut version of the Garden of Love, marvels of graphic discipline and diversity of line (Pls.203, 204), certainly prove that if he felt it necessary he could still draw as delicately as ever. Yet even with drawings made as models for engravers one notices now what seems to be a growing preference for heavy broad lines. The penwork for the title page of the Poems of Urban VIII (Pl.222), as of the Lipsius frontispiece of 1634 (G.-H. No.214), is unusually broad. This is true also for the vigorous, almost brutal, fragment of carousing soldiers (Pl.208), where the graphic style well fits the crudeness of the characters. It is of interest to see how much less Rubens now uses geometric patterns which for so long were his favourite device for 'blocking out' the first outlines of his figures. In rapid chalk sketches such as the intensely emotional Adoration of the Magi of c. 1633 (Pl.211), we meet once more those undulating contours and slightly 'formless' shapes which characterize some of the early drawings done during his stay in Italy (see p.52). But whereas in his youth Rubens aimed to generate an essentially optical impression of excitement by using flamboyant lines and violent contrasts of light and dark, he now combines the sensation of action and drama with a strong suggestion of bodily substance. Though he gave up using the geometric shorthand devices to indicate mass, he did not abandon the concept of mass itself. It is significant that the figures keep their arms close to their bodies and that their shoulders are drawn so close to their heads that the necks almost disappear (Pl.211). On the title page for the poems of Urban VIII (Pl.222) the huge form of Samson and of the Lion tower above but remain closely tied to the rusticated arch below, an architectural form which is in itself essentially a solid mass. Equally significant is an obvious trend away from action in depth. Not that Rubens abandoned his interest in suggesting distance in space; but he renounced sudden contrasts in depth, diagonal compositions, and sharply foreshortened bodies. He had now learned to achieve the same effect in a quieter, less obvious way.

This becomes particularly apparent when we turn to the late landscape drawings. Instead of the typical motifs of his earlier landscapes, such as a path leading straight into depth, a country wagon seen in a strikingly foreshortened view, or a fallen tree pointing inward, we have now rows of trees, fences, or a water's edge extending horizontally across the paper (Colour-plate 7). Furthermore, while Rubens previously had stressed the individual object, the plastic unit, as it were, he now observes less tangible things such as light breaking through foliage, a haze blurring the contours, and trees

vaguely reflected in still water. Without the obvious means which he had employed formerly, there is more atmosphere and more depth in the landscape drawings which he made toward the end of his life.

In 1635 Rubens had bought the large and lordly estate of Castle Steen, and he withdrew more and more to its peace and freedom. Yet there was no let-up in his activity. Large commissions, like the decoration of the Hunting Lodge of King Philip IV of Spain, still demanded his attention. The series for this lodge, the Torre de la Parada, was what we would call a rush job, and Rubens took only a limited part in the actual painting of the big canvases.[12] It is however significant that he delegated now also other tasks to assistants, tasks he formerly had handled himself. The last book-titles which he contracted were actually drawn by Erasmus Quellinus, though they were based on Rubens' ideas. Rubens must have felt the need to husband his strength.

It is a self-portrait that I feel tells us more than paintings or even letters about the master's physical and spiritual condition toward the end of his life. I refer to the remarkable, much too little known drawing in Windsor (Pl.206). Here Rubens is no longer portrayed as the *grandseigneur*, the man of the world, of position and of means. It is quite evidently a casual piece, quickly made and not considered very important, since Rubens himself crossed its outlines in several places with strokes in ink, drawn in the typical rough manner of the late pen-drawings. We look into a large face, impressive in its quiet dignity and mature wisdom. We see also, however, in its ageing and slightly flabby forms the signs of fatigue, of a lassitude that at the end of the road may at times have overcome even this man of boundless energy and physical endurance. For once with Rubens we seem to approach something comparable to the 'confessional' nature of Rembrandt's self-portraits. But precisely because we see how much control and propriety of deportment he still commanded even in a moment of candid, almost merciless self-appraisal, this drawing, unique in all of Rubens' work, turns out to be a particularly moving human document.

[1]For a still earlier treatment of that subject see Held, 'Thoughts on Rubens' Beginnings', *Journal of the Ringling Museum of Art*, Sarasota, 1983, 14–35.
[2]See J. G. van Gelder, *Oud Holland*, XLVIII, 1931, 49 ff., *Catalogue*, No.7.
[3]Pordenone's fresco at Treviso (now destroyed) is reproduced in G. Fiocco, *Giovanni Antonio Pordenone*, Udine, 1939, Pl.73. Fiocco identified the subject as Augustus and the Sibyl of Tibur. Rubens copied another section of that fresco in a drawing now in the Princes Gate Collection, London.
[4]See Otto Hirschmann, *Hendrik Goltzius*, Leipzig, 1919, pp.143–144.
[5]The Descent from the Cross in the Musée des Beaux-Arts in Rennes (Burchard-d'Hulst, 1963, No.71) most likely belongs also to this period rather than the years after the Antwerp Painting of the Descent from the Cross, as most scholars seem to be thinking (see also Held, 1980, 496).
[6]For the oil sketches and the history of the project see now Held, 1980, 537–545.
[7]The small and mainly architectural title page of the *Vita B. Ignatii Loiolae* of 1609 may also be his work, see No.44.
[8]*Correspondence*, V, 312.
[9]*Correspondence*, VI, 82.
[10]The only unquestionable drawing of a nude from life of this late period is a study in chalk, showing Hélène Fourment seated (Paris, L. 1032). It served for the famous painting in Vienna that goes by the name 'Het Pelsken' which is not, as is generally assumed, merely a portrait of Hélène, but a glorification of Hélène in the role of Aphrodite at the Bath (see Held, *Rubens and his Circle*, Princeton, 1982, 106–113). Evers (I, 454–455) was the first author to accept the Louvre drawing as genuine.
[11]The large sheet in Berlin with bathing women (G.-H. Nos.186–187) dates probably also from the very last year of the master, instead of the period of c. 1630 as Glück and Haberditzl thought. The peculiar aspects of that drawing—which prompted some scholars to question its authenticity—are less surprising if we give it so late a date. I should like to state that I do not accept as Rubens' works such supposedly late studies in chalk as G.-H. Nos.240 and 241; like G.-H. No.174, which Lugt (*Catalogue*, No.1185) doubted on good grounds, they were probably made after the corresponding paintings.
[12]The total number of pictures sent to Spain in 1638 was 112. Of these sixty were done by Snyders who presumably had designed them himself. That leaves 52 mythological scenes designed by Rubens. Van Puyvelde (*Esquisses*, 40–41) lists 62 titles, but several of these were demonstrably not part of the commission, and others may have been contemplated but were never executed. For this project see Svetlana Alpers, *Corpus Rubenianum Ludwig Burchard* IX, Brussels, 1971 and Held, 1980, 251–301.

Conclusion

RUBENS' late self-portrait strikes us as unusual because of its intimacy. This fact points to a limitation which the artist consciously imposed upon his art and which is particularly evident from a study of his drawings. We have seen that his drawings provide an opportunity to watch the variety of processes which Rubens went through in the preparation of his works. Drawing was a tool, but the artist would have been less dedicated to the ends if he had not constantly worked on improving and perfecting that tool. The result of this is the creation, almost incidentally, of a body of drawings which by its scope and because of the beauty of the individual pieces places Rubens among the greatest draughtsmen of the past.

What we lack almost entirely, however, in Rubens' drawings is an 'intimate' revelation which would permit us to share the emotional fluctuations to which he, like other mortals, must have been subject. Here and there perhaps the curtain lifts a little. It is with great tenderness that he drew the portraits of his children—but even there we sense a

remnant of formality. We have noticed how his deep happiness in the early 1630's is reflected in some of the drawings made during these enchanted years. All this makes it only more evident that Rubens kept his private life to himself; his drawings, at any rate, hardly ever furnish a view which the master denied us also, with very few exceptions, in his letters.

From all the available records emerges what we may call the 'official' image of Rubens. This is not a façade behind which the 'real' man lies hidden. Rubens was all this, the man of knowledge, of taste, of tact, and above all the celebrated artist, the 'Apelles of our Age' (B. Moretus). Yet we should like to have a few more personal features for a rounded picture. It is surprising with a man who all his life stood in the full limelight of publicity that there are hardly any anecdotes which might illuminate the 'unofficial' side. Rubens' letters, as far as they have been preserved, are full of information about his works, his interests and scholarly hobbies, his activity as man of affairs and as statesman. They are magnificent examples of the art of saying the proper thing at the right time and in the correct way.

In his answer to a letter of condolence at the death of Isabella Brant (July 15, 1626)[1] Rubens admits his feeling of bereavement, but his words are controlled. 'I have no pretensions about ever attaining the impassiveness of the stoics, nor do I believe that any human emotion congruous with its object is unbecoming to man's nature.' He then goes on to quote Tacitus and Virgil and he praises his late wife for not having shared 'any of the faults of her sex.' I am certain that Rubens felt deeply the loss he had suffered, yet in obedience to a law of his nature he maintained his composure. There is nothing anywhere in the large body of writings left by Rubens that could be compared to the intensity of personal feeling revealed in Michelangelo's sonnets. Nowhere do we find an outcry of anguish like that which Dürer at the news—untrue, at that—of Luther's death, managed to put into the pages of a diary that was mainly a prosaic record of daily doings and expenses. Occasionally we meet with humour or gentle banter, but no words of passion, of desire, of hostility ever break through the civilized surface of Rubens' letters. They are invariably polite; their language is as controlled as the feelings they express.[2]

Many factors had concurred to make it Rubens' second nature to be reserved and sage. His father had been imprisoned, sentenced to death for adultery, and only paroled through his wife's devoted efforts. Growing up in a household overshadowed by this social stigma, and in a foreign country, Rubens may never—not even as a boy—have

known the relaxed unconcern of a normal situation. When his mother returned to Antwerp after his father's death (1587), he stayed with her only a short time and at the age of thirteen left home to fend for himself. For a brief period he entered a noble household as a page. This contact probably meant for him an early training in the social taboos of the aristocratic world. Perhaps the deepest influence on him came from his acquaintance with the intellectual current of Renaissance stoicism, of which Justus Lipsius, the editor of Seneca's works (see Pl. 102), was the leading representative. We know, not the least from the celebrated group portrait in the Pitti Palace, in which Rubens portrayed himself in the company of his brother Philip, the humanist Woverius, and of Lipsius, that he considered himself a disciple of the great scholar. From stoicism, modified by Epicurean thought, Rubens adopted the ideal of equanimity and contentment, an ideal which he disclaimed in the letter just quoted, but which nevertheless clearly dominated his whole existence. This ideal had been epitomized in the well-known sonnet Le Bonheur de ce Monde by Christopher Plantin, a French émigré ('domter ses passions, les rendre obeissantes . . .'). The full text of one of the quotations from Juvenal which Rubens inscribed on his house (and which I have cited before) reads: 'We should pray to have a healthy mind in a healthy body, to possess strength of soul, and to be free of the fear of death: to be incapable of anger and to desire nothing.' In a letter to Peiresc[3] the artist said: 'I think it ought to be the first wish of every gentleman to be able to live with a tranquil mind.' The philosopher's ideal is not by accident joined here to the estate of the gentleman. To be unable to check one's emotions is not only unworthy of the educated mind, it is also a sign of social inferiority. Here lies the clue for the understanding of the emotional difference in the relation of the two sexes as shown in the brutally frank Kermesse and in the well-mannered Garden of Love.

The scholar's duty and the gentleman's breeding require measure and restraint; whatever passions Rubens may have felt—and we may be sure that the emotional range of his figures reflects his own potential for strong feelings—he seems to have kept well in check. Yet there was another factor that prevented Rubens from occupying himself with themes and situations that would have given him a chance to reveal more about himself.

We only need to think briefly of Rembrandt's drawings to realize that a whole class of subject matter is absent from those of Rubens. Rubens almost never sketched domestic subjects or scenes from everyday life.[4] In Rembrandt's drawings we find crying babies, picturesque actors, ragged beg-

gars. He drew the ruins of a burned building and the interior of his own studio. Like many other Dutch painters, Rembrandt was fascinated by the life that went on around him; drawing it in all its aspects, even the most humble and the most intimate, Rembrandt revealed himself as part of that life, conscious of all its pleasures, its temptations, its tragedies. Rubens kept the common world at arm's length, even where it concerned him most deeply. The greatest painter of Antwerp nowhere gave us a view of the town he lived in; for our knowledge of Rubens' studio we must rely on a few scattered remarks by occasional visitors. Domestic life is depicted by men like Jordaens and Coques, not by Rubens; even in the very restricted sense in which Rubens cultivated genre art, it was at best a marginal interest.

Rubens' art—continuing the classical tradition—is an ideal art. There is no place in it for the common, the accidental, the imperfect. His peasants, as I have written elsewhere, resemble pagan Gods more than Flemish boors. Heroes and martyrs, devils and angels, grizzled men and blond children, the trees and animals themselves, all belong to a world in which perfection is the prerequisite of existence. This fundamental fact is well illustrated in Rubens' drawings. When Mathis Gothard Nithard (the so-called Grünewald) made studies from the model, he drew the plain people he saw before him with ruthless honesty; only in his paintings were they transformed into the timeless symbols of humanity with its sorrows and its triumphs. When Rubens drew his models they were transmuted at the earliest stage, even in the very process of drawing. Anything accidental and irregular was automatically eliminated. To what I said before that the drawings from the model were made 'to check the flights of his imagination against the stubborn facts of reality,' should now be added that this reality was in Rubens' eyes already cleansed of impurities.

We know that the ancients and the Italian masters had taught Rubens to see as he did. A deeply religious man, he may also have found satisfaction in the thought that in creating a world of ideal shapes he might approach the intentions of the Creator and recover, at least in images, that perfection which through 'the weakness of decadent and spoiled ages has been lost' (*quod nunc saeculorum senescentium defectu ab accidentibus corruptum nihil sui retinuit*) as Rubens himself put it in *De imitatione statuarum*—the only original part of his theoretical writings that has survived.[5]

Like God's world, this one too could not be without animation. The supreme beauty of Rubens' drawings lies in the clarity with which they demonstrate that the ideal is not found in perfect shapes alone. Form must be filled with vitality. This vitality manifests itself in physical motion, whether it concerns people fighting in mad fury or trees gently swaying in a soft breeze. To bodily movement is joined a multitude of emotional expressions, from the smile of a girl in love to the bitter agony of death. Most important, it is the lines themselves which seem to be in motion, the interplay of shadows and highlights which gives the effect of flux and change. With his pen, his chalk, and his brush Rubens thus evokes the image of a world that is consistent in itself and endowed, like the one it mirrors, with the force to generate and to perpetuate life.

[1]*Correspondence*, III, 444–445. The recipient of this letter was Pierre Dupuy, Keeper of the King's Library in Paris, with whom Rubens began a long correspondence precisely in that year; that may explain to some extent the 'literary' character of this letter.
[2]See also Bellori's characterization of Rubens (*Le Vite*, I, 251): 'Erano in lui modi gravi, ed accorti, e fu egli saggio quanto ciascuno del suo tempo, godendo le sue doti naturali, do bontà, e di prudenza affinata con l'uso de' Grandi e nelle Corti...'
[3]*Correspondence*, VI, 127. In another letter, of August 1630 (*Correspondence*, V, 312), he expressed his admiration for Peiresc's ability to continue his studies of antiquities 'in tanta calamita publica'—a sure sign of an orderly and truly philosophical mind ('specimen animi bene compositi et vera philosophia imbuti').
[4]The delightful drawing of a domestic scene in the Louvre (Lugt,

Catalogue, No. 1027) is both exceptional and problematical. It depicts a mother seen from the back and sitting near a fireplace, two children, a cat, and a maid with a basket standing behind the woman. Done in two shades of red chalk, some lines in ink, and some white gouache, mainly in the central portion, which was enlarged all around, it was strongly defended as Rubens' work by Lugt and accepted by others; some doubts mildly expressed by me (1959) have been reinforced by Logan (*Master Drawings*, XVI, 1978, 430), who suggests that the central portion may be Italian 'from the circle of Carracci' and only the additions from Rubens' hand. Unobserved seems to be the awkwardness in the connection of the—added—legs with the seated woman's body, which would strongly argue against the view that the drawing was planned from the beginning essentially as it appears today.
[5]Goeler von Ravensburg, *Rubens und die Antike*, Jena, 1882, 196.

Catalogue

1,2 [Plates 1,2]

TWO DRAWINGS AFTER HOLBEIN'S SO CALLED 'DANCE OF DEATH'

(Bilder des Todes). Before 1600.
1: The Knight; 2: The Noblewoman. Pen and ink.
1: 100 × 73 mm. 2: 104 × 76 mm.
Amsterdam, Mrs. H. D. Pfann.

COLLECTIONS J. Boeckhorst; P. Crozat; Fleischmann; Ch. von Mechel; D. A. Galitzine; A. Firmin-Didot; The Princes of Liechtenstein; Sale Amsterdam (Mak van Waay) September 23, 1969.
EXHIBITIONS Antwerp, 1977, No.110 (two drawings reproduced).
LITERATURE P. J. Mariette, *Description Sommaire des Desseins . . . du Cabinet de Feu M. Crozat*, Paris, 1841, 89, No.796; *Idem, Abecedario*, II, Paris, 1853–54, 360; F. Douce, *Holbein's Dance of Death*, London, 1890, 118–20; J.Q. van Regteren Altena, 'Het vroegste Werk van Rubens', *Mededelingen van de Koninklijke Academie voor Wetenschappen, Letteren en Schone Kunsten van België*, Klasse der Schone Kunsten, XXXIV, 1972, No.2; *idem: Peter Paul Rubens tekeningen naar Hans Holbeins Dodendans*, Facsimile, Amsterdam, 1977.

In his *Teutsche Academie* (Nuremberg, 1675, 252) Joachim von Sandrart reported that he had it from Rubens himself (whom he accompanied on a boat trip from Utrecht to Amsterdam) that as a youth he had copied Holbein's book of the 'Todten-Tanz' (as well as one by Stimmer, see Nos.5, 6). While the copies after Stimmer have been scattered and many are lost, of the forty-six copies after Holbein which were bound in a small volume in the eighteenth century, forty-two are still together and have been rendered in facsimile in Regteren Altena's publication of 1977. Rubens' drawings are slightly larger than Holbein's woodcuts; they also differ in many small, but significant ways, from their models. Spatial relationships which the 'Formschneider' (Hans Lützelburger) could not always completely clarify are more explicit, and physiognomic details made more subtle. These and other observations justified Regteren Altena in giving these drawings, which in the earlier literature had been attributed to Holbein himself, to the youthful Rubens. It is anybody's guess at what age Rubens drew them. Since Regteren Altena was surely justified in calling them the earliest drawings preserved by the master, I see no reason why one cannot put them to the years 1591–1592, when Rubens was entering the studio of his first teacher at the age of fourteen. Regteren Altena, however, followed Burchard-d'Hulst in placing the London Costume Book (see Nos.68, 69) into the same period, an opinion which is clearly untenable.
This is not the place to investigate whether, and to what extent, these early studies reverberate in some of Rubens' later works. There is, however, one unmistakable echo of his copies of the Dance of Death in one of his paintings for the ceilings of the Antwerp Jesuit church, known today only from an oil sketch in the Národní Galerie in Prague (Held, 1980, No.6, Pl.7). As Adam and Eve are expelled from Paradise, a skeletal figure of Death, drawn in a most dramatic pose, grabs Adam's arm with his right hand and Eve's hair with his left. Although not directly copied from Holbein, that figure was clearly inspired by the viciously attacking skeletons in such woodcuts as *Der Ritter* (our No.1), *Der Edelmann*, or *Der Krämer* in Holbein's series. One may ask, too, whether Rubens—among other sources—also had the print of the Noblewoman in mind (No.2) when he planned the pair walking at the left in his Garden of Love (see Nos.210, 211).

3 [Plate 3]

A BATTLE OF NUDE MEN, AFTER B. BEHAM

Before 1600. Pen and brown ink over black chalk.
142 × 252 mm.
Two irregularly cut out fragments are pasted on a larger sheet on which the composition was enlarged by two figures (upper left) and some weapons and pieces of armour (lower right). All four corners have been cut, but without loss of figures. Remnants of a water mark (fleur de lys).
Washington, The National Gallery of Art (1984.3.57). Julius S. Held Collection, Ailsa Mellon Bruce Fund.

COLLECTIONS Janos Scholz; Julius S. Held.
EXHIBITIONS Binghamton 1970, No.39; Williamstown–Hanover, N.H.–Brunswick, Ma.–Toronto–Sarasota, Fl., 1979, No.9.
LITERATURE M. Jaffé, *Van Dyck's Antwerp Sketchbook*, London, 1966, I, pl. CXLIX (as by Van Dyck, an attribution reflected also in the 1970 exhibition); A.-M. Logan, 'Some Early Drawings by Rubens', *Gentse Bijdragen*, XXIV, 1976–1978, 105, Fig. 1.

All the figures of this drawing have been taken from two prints by Barthel Beham (B.16 and 17, see E. Waldmann, *Die Nürnberger Kleinmeister*, Leipzig, 1911, plates 33 and 34) but they have been arranged quite freely. Moreover, the figures drawn on the two fragments are done in a drier manner than the additions on the sheet to which these pieces were applied. Rubens evidently wanted to salvage some parts of an earlier copy (while surely discarding some others he disapproved of); thus one can observe a rapid growth of facility in the still very young artist since even the later parts must have been done at an early age—I suspect even before 1598, the year Rubens was admitted to the artists' guild.
The subject—battling nude men—was introduced into Renaissance art by Antonio Pollaiuolo in a famous print (1465), possibly as a reconstruction of Roman gladiatorial combats. Rubens' interest, however, seems to have been directed towards the purely formal rather than the iconographical aspects of the subject. He selected figures in difficult foreshortening and dramatic poses, some of which still occur much later in his work, as for instance in his Conversion of St. Paul and the Stoning of St. Stephen (see Held, 1980, Nos.421 and 426).

4 [Plate 4]

THREE PEASANT SCENES. AFTER PIETER BRUEGEL (?)

Before 1600. Pen and ink in brown. 247 × 198 mm.
A horizontal fold runs across the sheet slightly above the centre. An irregularly cut piece, 87 × 76 mm at its greatest extensions, is pasted at the left on the upper portion. Inscribed 'geel' (yellow) on the lower section.
Bakewell, Chatsworth Estates, Devonshire Collection (675).

COLLECTIONS N. A. Flinck.
EXHIBITIONS Nottingham, 1960, No.35; Antwerp-Rotterdam, 1960, No.3.
LITERATURE H. Vey, 'Einige unveröffentlichte Zeichnungen Van Dycks', Bulletin, *Musées Royaux des Beaux Arts*, Brussels, VI, 1957, 175–210; L. Münz, *Bruegel, The Drawings*, London, 1961, 239, No.A57, Fig.204; H. Vey, *Die Zeichnungen Anton van Dycks*, Brussels, 1962, No.144.

Three distinct actions are depicted on this sheet. At the upper right a group of people, done on a small scale and only in outline, are fighting, though no weapons seem to be involved.

At the right a man is choking another one who has fallen on his back; to the left of this pair, a woman (?) tries to take something a man seems to be holding; she is assisted by another man who attacks her opponent from behind. Several people appear to be restraining a man with outstretched arms, while his 'victim' tries to escape towards the left. The action on the sheet that was pasted on the main paper is much clearer. It consists of three figures, a fat, and apparently drunk man who is led away by a woman (his wife?) and another man, both supporting him under his arms; he may have been involved in a fight since the woman carries the sword he may have been wielding. On the lower half of the paper a ragged group of people seems to try to get warm near a fire, as does a dog sitting on the ground. A man standing alone at the right and seen from the back might be relieving himself.

In Vey's publication of the drawings by Van Dyck, the Chatsworth sheet is preceded by a very similar drawing with copies from Bruegel's Massacre of the Innocents (F. Grossmann, *Pieter Bruegel, Die Gemälde*, Cologne, 1955, Plates 110–111), belonging to the collection Wicar at the Palais des Beaux-Arts, Lille; it was exhibited as Rubens' work in the exhibition of Rubens' drawings in Antwerp in 1956, No.5. Yet the authors of the catalogue withdrew that attribution in a Supplement having decided that it really was by Van Dyck. In a note on p.18 of the first edition of this book I had accepted Burchard's change of mind but have had second thoughts since then. The Lille drawing was reproduced by Jaffé in his review of the Antwerp show, but again as by Rubens.

In fact, it seems to me now very difficult to uphold the attribution to Van Dyck. There are, to begin with, some very simple technical observations. Both drawings are done with a very fine pen, with a clear and deliberate definition of all forms. The drawings in the so called Antwerp sketchbook, which Jaffé published (London, 1966) are done with a very broad pen, and in a very loose, occasionally almost careless manner. The control and accuracy that characterize the Lille and Chatsworth drawings are familiar from Rubens' early works; Van Dyck's early drawings are bold and done almost impatiently, at the expense of precision and balance. Where shading is added, as in the lower scene and the fragment at the upper left, it is done with fine parallel lines that often cross each other; this is precisely the manner of shading I have described in my introduction and that can be observed in several of the earliest drawings in this volume (Nos.5, 8, 9). To this should be added the fact that the single word inscribed on the lower half of the Chatsworth drawing is written quite differently from that which Jaffé has called 'Van Dyck's Flemish script', which is more widely spaced and inclined to flourishes, as well as being written with the same broad pen lines he applied to his figures. Since the several groups on the Chatsworth sheet—no matter what their immediate model—are rather 'Bruegelian' in character, it is useful to see how Van Dyck copied a Bruegel design (Jaffé, II, pl.18, verso and 19, recto): in his sketch the typical Bruegelian angularity of forms is totally lost, replaced by a concept that sees everything in smoothly flowing curves. Yet that is precisely what is still captured in the Chatsworth sheet. This brings up the question of what models the artist followed here. The model for the group of fighting people, above right, is still unidentified. Burchard, as quoted by Vey, claimed that the drunk man and his two companions have been derived from a painting by Lucas van Valckenborch of which two versions are known (Leningrad, Hermitage No.523 and Wawra sale, Vienna, 1931). Yet the group is strongly reminiscent of Bruegel types: the spread legs and bent knees of the drunk fellow are found again and again in country dances of the Bruegel school, derived chiefly from a print by Pieter van der Heyden after a design by the master himself (see Marlier, *Pierre Breughel le Jeune*, Brussels, 1969, pp.186 ff.).
For the larger group below, the only prototypes hitherto

identified have been Pieter Balten's Feast of St. Martin in Antwerp and the same artist's Ecce Homo in the same collection. Yet the group also occurs in a signed painting by Pieter Brueghel the Younger (Marlier, Fig.197) so that one is again led back to the elder Bruegel himself. The indication of at least one colour (yellow) probably indicates that Rubens' model was a painting rather than a drawing.

5 [Plate 5] *(1959: No.156)*

TWO COPIES AFTER TOBIAS STIMMER

Before 1600. Pen and ink. 188 × 127 mm.
Inscribed: 'sy taster int doncker naer' (she gropes for it in the dark).
New York, J. Pierpont Morgan Library (1984.46)

COLLECTIONS C. Fairfax Murray; E. Schilling.
LITERATURE F. Lugt, *The Art Quarterly*, VI, 1943, 109; *Idem, Catalogue*, II, under No.1116. For this topic see also E. Maurer, 'Stimmer in Rubens' Sicht', *Zeitschrift für schweizerische Archäologie und Kunstgeschichte*, XLII, 1985, 82–95.

This sheet—surely one of the earliest drawings by the master still preserved—belongs to a set in which Rubens copied woodcuts by T. Stimmer and J. Amman and a small group of prints by Goltzius and Vicentino. Nine of these drawings are in the Louvre (L. Nos.1116–1124). One is in Rotterdam (Exh. Antwerp, 1956, No.1), and three were in the Fairfax Murray collection. When Lugt published his important article, he knew only two of these three. The third sheet became known when the whole group appeared at an auction in London in 1956.
The models for the present drawing—as for many of the others—are found in woodcuts by Stimmer published in Basel in 1576 under the title *Neue Künstliche Figuren Biblischer Historien* (reprinted in 1923 in a modern facsimile edition by G. Hirth in Munich). The lower scene—evidently drawn first on the sheet—represents Judith about to cut off Holofernes' head; it is based on Stimmer's woodcut on p.108 of the Bible of 1576. The woman above is taken from Stimmer's illustration on p.111 and shows Job's wife berating her husband. Rubens drew her skirt as far as the figure of Judith would permit, adding separately at the side that part of the skirt for which there was no room. This additional sketch, together with the inscription, may have prevented Rubens from adding another figure in the upper right corner, contrary to his practice, seen in the other sheets of this group, to fill all the available space with figures. (Judith's figure is incomplete in the lower left corner because the kneeling maid occupies that place in Stimmer's woodcut. Stimmer's woodcuts are also reproduced in Lugt's article, as Figs.17 and 18.)
Even at this early stage in his career, Rubens' own personality clearly asserts itself in his copies. The outlines of his figures are more undulating than those of Stimmer's; his treatment of light and shade is subtler and more complex. The manner of shading still reflects the mechanical regularity of the late sixteenth-century techniques of engraving and woodcut found in his model; yet there is more variety in the direction of lines and in the transition of one area to the next. There is also an evident desire to clarify all forms and to give precision to human expressions.
The attribution to Rubens of these drawings, warranted by their style and by the inscriptions found on them, is strongly supported by Rubens' own words. In 1627 he told Joachim von Sandrart that he admired Holbein's and Stimmer's woodcuts and that he had copied them in his youth (*Joachim von Sandrarts Academie der Bau-, Bild- und Mahlerey-Künste*, ed. A. R. Peltzer, Munich, 1925, 106). F. Lugt deserves special credit for having identified these drawings and thus substantiated Rubens' words. By describing them as works of his 'youth' Rubens permits us to date them before 1600 but the question remains of how far

back one is entitled to go. My hesitation to push them very far back is due above all to the character of the inscriptions. Graphologically they are written in a fully developed hand, formed with the fluency and ease of an adult; the content, which in one case ('reverenter Angelus ministrat' in the drawing in Rotterdam) reveals a tender insight into character; in the other, the present drawing, an interest in the mechanics of an intensely dramatic action, also seems to be characteristic of a mature man rather than of a youth. Thus I doubt that Rubens could have done these drawings much before his twentieth year, which he had reached in 1597. Moreover, two of the prints by Goltzius copied by Rubens (L. Nos.1121, 1123) are dated 1597.

6 [Plate 6]

NINE FIGURES, AFTER TOBIAS STIMMER

Before 1600. Pen and ink (bistre). 187 × 127 mm.
Hilversum (The Netherlands), Private Collection.

COLLECTIONS C. Fairfax Murray; V. Ezekiel; sold Sotheby's, February 9, 1956.
LITERATURE *J. Pierpont Morgan Collection of Drawings by the Old Masters Formed by C. Fairfax Murray*, London (unnumbered plate). F. Lugt, *The Art Quarterly*, VI, 1943, 109, Fig.19; Burchard-d'Hulst, 1963 (under No.6).

This is a good example of the seemingly random selection of individual figures from woodcuts in Stimmer's 'Bible' of 1576. Rubens took the two figures at the top from the Expulsion of Adam and Eve from Paradise (Stimmer, p.4); Rubens also copied Eve, but on a separate sheet (Paris, Lugt, No.1116) together with three other copies of nude women, one of which he took from a woodcut by Amman. The two small figures centre left come from the woodcut of The Flood (Stimmer, p.8); below them is a group—a faint man comforted by a woman—from the Brazen Serpent (Stimmer, p.58); the man kneeling and seen in profile was copied from Moses Exhorting the People (Stimmer, p.60), but while it seems that he turns to the two standing men at the lower right, they have been derived from a very different context, being bystanders in Esther's Reception by Ahasuerus (Stimmer, p.106). (All these woodcuts have been reproduced in Lugt's article of 1943.)
While Rubens may have enjoyed occasionally assembling randomly chosen figural types in what looks like new and seemingly meaningful combinations (something that has also been claimed for another early drawing, see No.7), his main purpose, I believe, was the study of the greatest possible variety of bodily motions as carriers of expression; and by removing them in most cases from the original context, they became available (Maurer's word was 'verfügbar') in new combinations, but not necessarily within the pages of the sketchbook themselves.

7 [Plate 7]

SKETCHBOOK SHEET, WITH FIGURES COPIED FROM RAPHAEL AND HOLBEIN AND NOTES TAKEN FROM QUINTUS CURTIUS RUFUS'S HISTORIAE ALEXANDRI MAGNI MACEDONIS

Before 1600 (?). Pen and ink (bistre). 202 × 159 mm.
Berlin-Dahlem, Staatliche Museen Preussischer Kulturbesitz, Kupferstichkabinett (3240).

COLLECTIONS M. Merian the Younger; The Great Elector; King Frederic William I; the Royal Library; the Academy of Art; since 1831 in the Kupferstichkabinett.
EXHIBITIONS Cologne, 1977, No.25A.
LITERATURE Rooses, *Bulletin Rubens*, V, Antwerp, 1897, 99–

102; Bock-Rosenberg, 1930, 252; Jaffé, *Van Dyck's Antwerp Sketchbook*, London, 1966, I, 18, 82, and 302; *idem*, 1977, 25 L; Müller Hofstede, 1977, 50–62; Mielke-Winner, 1977, No.5.

On the verso is The Judgment of Solomon, after Raphael's fresco in the Stanza della Segnatura, Vatican; above this scene Rubens inscribed six lines taken from a Latin edition of Dürer's Four Books of Human Proportions (*Vier Bücher von menschlicher Proportion*). (This page is disfigured by an old stamp of the collection.)
The small drawing in Berlin has been treated twice at great length, first by Müller Hofstede in the catalogue of the Cologne exhibition and, to a certain extent based on this study, by Matthias Winner in the Berlin catalogue of the same year.
There is good reason to assume that the sheet originally was part of a sketchbook by the master which was mentioned by Bellori and was owned, for some time, by Roger de Piles. It changed hands several times and was burnt on August 30, 1720 in a fire in the studio of André-Charles Boulle, the royal *ébéniste*, in the Louvre. It is not known how and when this particular sheet had been removed from that sketchbook. De Piles' description of the sketchbook deserves to be quoted at least in part since it helps to understand the combination of word and image in the present drawing:
'J'en ay veu un livre de sa main fait de cette manière, où les demonstrations et les discours étoient ensemble. Il y avoit des observations sur l'Optique, sur les lumières et les ombres, sur les proportions, sur l'Anatomie et sur l'Architecture, avec une recherche très curieuse des principales passions de l'ame, et des actions tirées de quelques descriptions qu'en ont fait les Poëtes avec des demonstrations à la plume d'après les meilleurs Maistres et principalement d'après Raphaël, pour faire valoir la Peinture des uns par la Poësies des autres . . .' ('I have seen a book in his hand done in this fashion, in which the demonstrations and discussions were together. There were observations on optics, on light and shade, on proportions, on anatomy and on architecture, with a singular study of the principal passions of the soul and of the actions drawn from some descriptions made by the poets, accompanied by pen drawings after the best masters and especially after Raphael, so as to enhance the painting of the ones by the poetry of the others . . .')
What de Piles saw so clearly as the central purpose of that sketchbook, the demonstration of the kinship of Painting and Poetry in accordance with Horace's *ut pictura poesis*, can indeed be observed on the Berlin sheet.
The 'theme' of the sheet, if it can be so called, is 'figures in agitation'. At the upper left and only lightly sketched are three figures every one of which lifts both arms up in gestures of astonishment or despair; Rubens clearly was interested only in the gesticulation of the arms, since for two of the figures he skipped the lower half of the body, and treated it only very lightly in the third. Hans Mielke was able to identify the source: all three come from woodcuts of Holbein's *Dance of Death* ('Death and the rich man'; 'Death and the sailor'; and 'Death and the Abbess'). The other figures also gesticulate excitedly: the seated figure at left spreads both arms widely, a gesture which seems to be answered by that of a young woman at the lower right seen from the back, who raises both arms high. To her left is another woman, seated on the ground and holding a small child, who raises her left hand; and there are two more figures, of whom only the heads and shoulders are seen, each also gesticulating with one arm and outstretched fingers. The seated man and the one partially seen next to him are taken from Raphael's cartoon of the Blinding of the sorcerer Elymas (*Acts* XIII, 6–12), the main character being the Roman proconsul Sergius Paulus who 'believed, being astonished at the doctrine of the Lord.' The source of the helmeted man with the huge uplifted hand at the upper right is a relatively minor figure in the grisaille below Parnassus in the Stanza della Segnatura, who

expresses astonishment seeing Alexander depositing Homer's Iliad in a large 'chest'. Rubens may have taken that figure from a print by Marcantonio Raimondi (B.207). The two women and the child, finally, come from Raphael's fresco of the Fire in the Borgo, also in the Stanza della Segnatura; being in reverse of Raphael's composition, they may have derived from the engraving by Marco da Ravenna (B.XV, p.33).

The inscriptions on the sheet, explained in detail by Müller Hofstede, come from three different passages of Quintus Curtius Rufus's *History of Alexander the Great*. The first is from Book VII, Ch.2: *iuvenis erat primo aetatis flore pubescens/Is tum flere coepit et os suum converberare.* (He was a lad in the first flush of youth who then began to cry and to beat on his face.) The story is about three brothers who feared for their life when a close friend of theirs, Philotas, had been executed by Alexander for having kept secret a conspiracy against his life. They were eventually acquitted. The passage here inscribed is about the youngest of the three, Polemon, and his state of intense agitation when he was captured after an effort to flee. The second passage, inscribed at the right, consists of two texts which come from different sections of Quintus Curtius Rufus's book. The first describes Alexander's shock when he realized that Philemon, whom he had trusted, had been silent about the conspiracy: *Post illatum Dimni Cadaver/Rex in Concionem procedit vultu/praeferens dolorem animi Amicorum/quoque Moestitia Expectationem haud/parvam fecerat. Diu Rex demisso in Terram vultu/attonito stupendique similis stetit.* (When Dymnus's corpse had been brought, the King went before the assembly, his face expressing his anguished mind, and the sadness of his friends only increased the (sense of) expectation. The King stood a long time, his face lowered to the ground, like one stunned and stupefied.)

This inscription ends with a short passage from Book VII, Ch.7, above which Rubens inserted, in explanation, *scilicet reus* (to wit, the accused): *Ille exanguis attonitoque similis/stabat per metum etiam/voce suppressa* (He stood pale and like one stunned, made wordless by fear). This sentence, so similar to the previous one, refers, however, to a very different event, when Alexander harshly criticized a soothsayer for having passed on his predictions to an officer before informing the king.

The common denominator of all three texts is again an extreme mental agitation, whether it is fear or profound anguish. The sketches—featuring figures taken from very different contexts—demonstrate how bodily motions and particularly gestures of the arms provide the artist with a visual vocabulary comparable to the verbal one of the poet, describing intense emotion.

Müller Hofstede and Winner carried the analysis of the Berlin sheet still further, assuming that by distributing the various figures across the sheet, Rubens proceeded from 'imitazione' to 'invenzione'—linking them up in a common action, as 'Rohmaterial' (raw material) for a Judgment of Solomon—the subject actually rendered (after Raphael) on the reverse. While the idea is intriguing, I find it too speculative, and too little borne out by the attitudes of the several figures (why should Solomon express himself in such a dramatic manner?) to carry complete conviction. Yet both authors link Rubens' concern for the rendering of emotional situations in both literature and art with the broad currents of aesthetic theory as expressed by writers of the later *cinquecento*, particularly G. P. Lomazzo in his *Trattato dell'arte della pittura* of 1584.

Both authors also agree in dating the Berlin sheet circa 1602–1603, though Winner qualifies his opinion by adding 'wenn es nicht noch früher denkbar wäre' (if one could not think of it as done earlier). He mentions particularly the fact that Rubens derived the figural part of his drawing from printed material which evidently had been accessible to him at an earlier date as well. Despite the fact, to which Winner alludes, that Rubens

added verses from Virgil to his drawing of the Roman lupa in Milan (Fubini-Held, 1946, pl.7) the cases are not really comparable since in that drawing image and text support each other closely, as do other inscriptions found on Rubens' drawings (see Nos.15, 19). In fact a programme such as that described by de Piles as a collection of words and images drawn from many sources to illustrate the interdependence of science, literature and art seems to me more characteristic of a young and intellectually ambitious master than of one recognized and active on many fronts. At any rate, I see no strong reason to assume that the sketchbook was not begun 'until some time after Rubens set out from Antwerp . . . on May 9, 1600' (Jaffé, 1966, 301), even if he continued making notes in it later. There were, after all, two years before 1600 (after he had been formally received in the artists' guild in 1598) about which we know very little; there can be no doubt that he had acquired by that time a fairly intimate knowledge of Italian art, primarily through the medium of engraving, long before he saw those works themselves. Nor can one draw chronological conclusions from the character of Rubens' script as found in his textual additions. The handwriting of the twenty-two-year-old was hardly less formed by practice than the same man's at twenty-five or twenty-six. At least for this particular sheet, I am inclined to plead for a date before Rubens left for Italy.

8 [Plate 8] *(1959: No.1)*

THE DISCOVERY OF CALLISTO

Before 1600. Pen and ink. 179 × 139 mm.
On the reverse: A standing figure, two nude women seated on the ground, seen from the back, and two heads of women.
Berlin-Dahlem, Staatliche Museen Preussischer Kulturbesitz, Kupferstichkabinett (3239).

COLLECTIONS M. Merian the Younger; King Friedrich Wilhelm I of Prussia.
LITERATURE Bock-Rosenberg, 124 (Van Dyck); Helma Konow, *Berichte aus den Preussischen Kunstsammlungen*, LXI, 1940, 58, Fig.4; Lugt, *Catalogue*, I, 53, under No.589; Burchard-d'Hulst, 1963, No.49; Mielke-Winner, 1977, No.4; Jaffé, 1977, Fig.67; Müller Hofstede, 1977, No.23

Bock and Rosenberg hesitantly attributed this drawing to Van Dyck. Lugt accepted the attribution, finding similarities with the Actaeon drawing by Van Dyck in the Louvre. Konow called the drawing 'from the circle of Van Dyck'. The attribution to Rubens has not previously been suggested. Yet stylistically it forms a consistent group with other drawings (Nos.9, 16) which have strong claims to be early studies by Rubens.

The figures on the back were probably intended for a different subject. They have been drawn in rather conventional mannerist contrapposto movements which better fit a date of 1600 or before than one of fifteen years later, which it would have to be if the drawing were by Van Dyck.

The attribution to Rubens is supported by the fact that in the Merian collection the drawing went under this master's name,—as did five others. Of these five, several had since been attributed to other masters, but in recent studies they have again been firmly established as the work of Rubens (Berlin Nos.3235, 3240, 3234, 3241, 12256). There is a good likelihood that Merian's judgment, or the tradition on which it was based, vindicated in the other cases, was right in this one too.

9 [Plate 9] *(1959: No.2)*

A BATTLE OF GREEKS AND AMAZONS

1600–1602. Pen and ink, over thin pencil. 252 × 430 mm.
London, British Museum (1895, 9.15, 1045).

COLLECTIONS J. Richardson, Sen.; E. Bouverie; J. C. Robinson; Malcolm.

EXHIBITIONS London, 1977, No.50.

LITERATURE R., V. No.1458; Hind. *Catalogue*, No.24; Burchard-d'Hulst, 1963, No.50; Jaffé, 1977, 70R; Müller Hofstede, 1977, No.24.

This striking sketch, despite its prominent place, has been neglected by most writers on Rubens' drawings. The reason probably lies in the silent assumption that the drawing has some connection with the famous painting of the same subject in Munich (*KdK.196*), although Hind quite sensibly had suggested an early date. The drawing, indeed, forms a well-defined group with such studies as the Berlin Callisto (No.8), the Crowning with Thorns (No.13), the Medea after a Roman sarcophagus (No.16), and the Rotterdam tuba-blowers after Stradanus (Exh. Amsterdam, 1933, No.109). These are the drawings that have the somewhat schematic system of hatchings that has been discussed above (Introduction, p.50); the artist may have derived this method from pen-drawings of the circle of Michelangelo as well as from engravings.

The London drawing reveals not only a knowledge of Classical battle scenes but of such engravings as Vaccarius' so-called *Drusus* and *Battling Amazons* (both then in the Farnese collection; see P. G. Hübner's *Quellenstudien zu einem Katalog der Antikensammlungen Roms in XVI. Jahrhundert*, Halle, 1911, 45, Nos.19, 20); the falling Amazon with loose hair in the centre and the stylization of the horses' heads particularly vividly recall these engravings. The comparison also reveals the superior quality of Rubens' drawing. Despite its evident shortcomings it is the work of an imaginative and sensitive artist. There are many connections with other works of the master. The horse at the left, kicking backward with both hindlegs, is a frequent type, occurring later in such pictures as the Conversion of St. Paul formerly in Berlin (*KdK.155*) and in the Princes Gate Collection, Courtauld Institute Galleries. The horse which tumbles forward at the right also appears in the picture. The horse above the falling Amazon, jumping into the picture, can be found in the Munich Sennacherib (*KdK.156*) and again in the Conversion of St. Paul in the Princes Gate Collection. Several of these types of horses' movements have a classical origin, as Pinder has shown (*Münchner Jahrbuch der Bildenden Kunst*, N.F., V, 1928, 360–61). Rubens' immediate source of inspiration, however, probably was Leonardo's Battle of Anghiari known to him, perhaps, from a print (see No.49). The motif of two horses fighting each other which appears in the London drawing and many times in Rubens' later work surely comes from his study of Leonardo's composition.

One of the human figures appears in a drawing in the Louvre (Lugt, *Catalogue*, No.643) that has been attributed to Rubens by Evers (II, Fig.264, p.250–51). It is the figure of a man, at the left of the falling Amazon, who from a half-kneeling position tries to hold on to the horse leaping away. The Louvre drawing, I believe, is neither an original by Rubens (as Evers maintains) nor by a pupil of Van Dyck (Lugt), but a copy of a lost Rubens drawing. The original was probably done for a Rape of the Sabine Women rather than the Rape of the Daughters of Leucippus (Evers); the similarity of the kneeling figure at any rate is an additional argument for the retention of the London drawing in Rubens' work.

10, 11 [Plates 10, 11] *(1959: No.80)*

TWO PORTRAITS OF YOUNG GONZAGA PRINCES
c. 1601–1602.
a) *Francesco Gonzaga* (1586–1612). Black and red chalk.
226 × 161 mm.
b) *Ferdinando Gonzaga* (1587–1625). Black and red chalk.
224 × 160 mm.
Stockholm, Nationalmuseum (A: 1918/1863; B: 1917/1863)

COLLECTIONS Comte A.C.P. de Caylus; P. Crozat; Comte C. G. Tessin.

EXHIBITIONS (*b*): Brussels, 1938–39, No.23; Rotterdam, 1939, No.15; Rotterdam, 1948–49, No.109; Paris, 1949, No.97; Stockholm, 1953, No.95.

LITERATURE R., V, Nos.1508, (*b*) and 1509, (*a*); Glück, *Essays*, 6; J. Wilde, *Jahrbuch der Kunsthistorischen Sammlungen in Wien*, X, 1936, 212; L. van Puyvelde, *Pantheon*, XXIII, 1939, 75 ff.; N. Lindhagen-P. Bjurström, *Catalogue, Exhibition Stockholm*, 1953, Nos.95, 96; Burchard-d'Hulst, 1963, No.27 (*b*); Jaffé, 1977, 76R; Müller Hofstede, 1977, under No.89 (*a*); No.90 (*b*). F. Huemer, *Corpus Rubenianum*, XIX, I, 1977, 28–31; U. Bazzotti, 'La Pala della Trinità', in *Rubens a Mantova*, Milan, 1977, 45; E. McGrath, in *Splendours of the Gonzaga*, London, 1981–1982, Nos.232, 233; M. Jaffé, 'Rubens's Gonzaga altarpiece: another portrait rediscovered', *Apollo*, June 1985, 379–82.

INSCRIBED (probably by Tessin):
a) 'Francesco Gonzaga Principe di Mantova fù da poi Duca. Fatto in presenza di S.A. da P. P. Rubens. Mr. le Comte de Cailus a donné ce Portrait a Mr. de Crozat 1727.' ('Francesco Gonzaga Prince of Mantua was later Duke. Done in the presence of His Excellency by P. P. Rubens. M. Le Comte de Cailus gave this portrait to M. Crozat 1727'.)
b) 'Ferdinando Gonzaga Cardinale di Mantova or Duca, fatto in presenza sua da P. P. Rubens. Ce portrait a eté donné a M. Crozat par M. le Comte de Cailus.' ('Ferdinando Gonzaga Cardinal of Mantua now Duke, done in his presence by P. P. Rubens. This portrait was given to M. Crozat by M. le Comte de Cailus.')

These two drawings have the same provenance and evidently have never been separated. A certain preference has been given in the literature to b), and in the first edition of this book, it alone was illustrated, though the other piece was mentioned. Against earlier views it is now generally assumed—as Lindhagen and Bjurström first suggested—that the drawings were done considerably earlier than the large, but sadly dismembered canvas of the Adoration of the Trinity by the Gonzaga Family, which Rubens executed between August, 1604 and May, 1605. Lindhagen and Bjurström suggested a date of 1600–1601, but a slight shift to 1601–1602 may be preferable. In addition to Francesco and Ferdinando, the third, and youngest, son, named Vincenzo like his father, was also depicted in the large canvas, at the left, while the two daughters, Margherita and Eleanora Gonzaga, were seen behind their mother at the right. The heads of all the children were cut from the canvas in 1801, during the French occupation. One fragment (Vienna) has long been recognized; another (Fondazione Magnani-Rocca, Reggio Emilia) was discovered and published by Christopher Norris (1975); the last one to appear was found and published by Jaffé (1985, 'private collection'). Of the daughters only one has been recovered, Margherita; that picture was found and acquired by L. Burchard. Its identity is beyond question; but there has been a good deal of controversy about the identity of two of the fragments of the young princes.

The case is complicated by the fact that X-ray photography of the Vienna fragment has revealed a head in a slightly different position, corresponding, however, closely to the Stockholm drawing of 'Francesco'. Believing that the difference in the position of the heads must be the result of a major change of plan in regard to the placing of at least two of the sons, some scholars, while retaining the name of Francesco for the Stockholm drawing, felt compelled to find another name for the face seen on the surface of the Vienna fragment. Since the X-ray had also revealed part of the white Maltese cross on a figure above and behind the one in front, and since that cross also appears in the Stockholm drawing of Ferdinando, who in fact was a *cavaliere gerosolomitano*, the only son who could be substituted for 'Francesco' was the youngest of the princes, Vincenzo.

Indeed, a fairly large number of scholars have called the curly-headed youth of the Vienna fragment Vincenzo, among them Glück (1915), Oldenbourg (1921), Norris (1975), Bazzotti (1977), Schütz (1977), Fredlund (1977), McGrath (1981-2) and Jaffé (1985). Jaffé, in fact, had twice before (1961 and 1977) identified the Vienna fragment as a portrait of Francesco but in *Apollo*, June 1985 he gave that name to the head he had just discovered and thus joined those who called the Vienna fragment Vincenzo.

Another group of scholars, however, drew a different conclusion from the seeming discrepancy of the two heads seen in the Vienna fragment. Keeping to the name 'Francesco' for the 'surface' head, they assumed that the Stockholm inscription, though very firmly expressed, was mistaken, and that Vincenzo not Francesco was depicted in it. This view was taken by Wilde (1936), Burchard and d'Hulst (1963), Jaffé (1977) and Huemer (1977). Müller Hofstede, who in 1965 had agreed to this view, came to another conclusion in 1977, which was similar to the one I had taken in the first edition of this book. He not only accepted the inscription on the Stockholm drawings at face value but also retained the name of Francesco for the visible part of the Vienna fragment, implying that the change of plan revealed by the X-ray applies to only one of the sons (Francesco) and should not be taken as evidence for an exchange of place between the oldest and the youngest son. I am now in full agreement with Müller Hofstede on this question, and can refer the reader to this thorough and persuasive treatment of the problem in the catalogue of the Cologne exhibition of 1977. The portrait of Francesco Gonzaga by F. Pourbus the Younger in the California Palace of the Legion of Honor (inscribed 'FRANC. PRINC. MANTVAE') to which I had called attention in 1959 supports the identification of the Vienna fragment, as well as the Stockholm drawing, as a portrait of Francesco. As for the 'Ferdinando' drawing, although I had concluded that the identifying inscription was probably correct, I had pointed out that a natural son of Duke Vincenzo, called Silvio (1592-1612) had been a *cavaliere gerosolomitano* (since 1598). I did not suggest that he might have been included in the mutilated painting (although several critics thought that I did) but only that the Stockholm drawing might be his portrait. Jaffé, however, twice called the boy in the Stockholm drawing Silvio, without qualification (1961 and 1977, Pl. 267).

The latest discovery made by Jaffé enables us to reconsider the problem. He is surely correct when he connects the head of the boy he found in the (unnamed) private collection with the mutilated Mantuan canvas and recognizes it as the last of the three missing portraits of Vincenzo's sons. Yet it is hard to understand why he now identifies this fragment as Francesco despite the fact that the youth looks not only rather immature for one eighteen years old, and indeed noticeably younger than his brothers in the other two fragments, but that he is also squeezed into a severely limited space.

The importance of Jaffé's discovery lies in the contribution it makes to our ability to reconstruct the placing of the three princes. Kneeling in front is Francesco (Vienna fragment); behind him and slightly above is Ferdinando, holding a prayer book in his hands (the fragment in Reggio Emilia); placed still further back is Vincenzo, the cadet son (Private Collection). Arranged in a diagonal in depth, parallel to the alignment of their father and grandfather, they follow each other precisely in the order to be expected. Francesco, the oldest and first in succession, is nearest to the beholder and the only one not overlapped by any other figure; with marked self-assurance he looks out of the picture. The pious Ferdinando, next in line, and soon to be made a Cardinal (1607) follows behind him; Vincenzo, a boy of twelve, brings up the rear.

A relatively subordinate role in the problem of the identity and placing of the three Gonzaga princes is played by a portrait, also first made known by Jaffé (1961), in Saltram House, National Trust, Plympton (see Exhibition Antwerp, 1977, No. 13). I believe Jaffé was correct when he identified the youth as Francesco Gonzaga, though Rubens' authorship of the painting has been questioned by some scholars. The face, at any rate, impresses me as good enough to qualify as Rubens' work.

In the first edition of this book, I also rejected the view that a portrait formerly in Mr. Henry Goldman's collection, now part of the Putnam Foundation in San Diego and traditionally identified as a 'Duke of Mantua' could be any of the three princes dealt with here; in *Rubens in America* (1947) I had followed the traditional view without being specific. Burchard's proposal (Exhibition Catalogue, London, 1950, No. 30) that the sitter might be Francesco Gonzaga can now be considered untenable.

12 [Plate 13] (1959: No.4)

ANOINTING OF CHRIST'S BODY

c. 1600–1602. Pen and ink, washed in gray and brown bistre, over black chalk. 324 × 408 mm.
Rotterdam, Museum Boymans-van Beuningen (Rubens 7).

COLLECTIONS F. J. O. Boymans.
EXHIBITIONS Antwerp, 1956, No. 31; Antwerp, 1977, No. 133.
LITERATURE Van Regteren Altena, *The Burlington Magazine*, LXXVI, 1940, 199; Burchard-d'Hulst, 1963, No. 36; Jaffé, 1977, 29, 31, 62; Müller Hofstede, 1977, No. 22.

In the catalogue of the Boymans collection of 1825 and 1869 this drawing was listed as 'School of van Dyke'. Van Regteren Altena was the first to recognize in it the hand of Rubens. There are remnants of an inscription in two lines at the lower right; of the Latin text only a few words can be made out: '. . . *focus hic ad miscendum et mirram et aloen . . .*' (read by Müller Hofstede under ultraviolet light). In the lower right corner is the number 84. The writing is very similar to that on the Descent from the Cross in Leningrad (No. 15), with which the Rotterdam drawing has close stylistic affinities. Both drawings must belong to a very early period of Rubens' career; it is possible that they go back to the pre-Italian years; if not, they were done shortly after 1600. The physiognomic type of Christ of the Rotterdam drawing is familiar from Rubens' painting of the Crowning with Thorns in Grasse, of 1602 (*KdK*.2). The position of His body, the motif of the shroud covering part of His head, and the torch, occur again in the sketch of a Lamentation in Berlin, Held, 1980, No. 361 (1609–1610). The pose of the fainting Virgin is found again in the young woman in the centre of the painting of the Brazen Serpent (see Glück, *Essays*, 26, Fig. 19 and A. Seilern, *Catalogue*, No. 15, where the picture is dated 1609–10). There are two interesting motifs in this drawing which tie the picture to Italian models. One is the man who looks through spectacles at Christ's arm. Elderly men with spectacles occur in other early works of the artist (see No. 19 recto), but they disappear after his painting of the Church Fathers in St. Paul in Antwerp of 1609 (*KdK*.28), where, as far as I can make out, this idea was used for the last time in Rubens' oeuvre. Rubens may have derived the motif from Caravaggio (see for instance, the old man in the Calling of Matthew in San Luigi dei Francesi); and, if so, this would be an argument for a date after, rather than before, 1600 for the drawing. (Caravaggio's lateral paintings 'were not affixed to the walls until December 1600', see W. Friedländer, *Caravaggio Studies*, Princeton, 1955, 177). As a typical 'genre' motif, it was very popular with most Caravaggesque painters, but perhaps for that very reason it did not please Rubens at a more advanced state of his development. The pose of Christ's left arm, held by the man with the spectacles, is apparently derived from Titian's Entombment in Paris (see H. Tietze, *Titian*, Pl. 83), an observation I owe to Mr. L. Goldscheider.

The second motif of unusual interest is the idea of letting one of the men hold the shroud with his teeth. It is most likely that Rubens derived this idea from an engraving by Gio. Battista Franco which may also have influenced the general pattern of his composition. (Van Regteren Altena, *loc.cit.*, suggested a connection with Sebastiano del Piombo's Lamentation at Viterbo; since Franco's print was surely influenced by Sebastiano's famous painting, this observation would retain its value even if the connection were only an indirect one.) Franco himself did not invent the idea, as it occurs as early as 1512 in L. Lotto's Entombment in the Civica Pinacoteca at Jesi (see L. Coletti, *Lotto*, Bergamo, 1953, p.39. Miss Helen Franc called my attention to Lotto's painting). It is found furthermore in an Entombment designed by G. Groningus ('Paludanus'), engraved by Philip Galle and published in 1573 in a series 'Vita Salvatoris' as No.59. Rubens was rather fond of the idea and used it in the Leningrad drawing of the Descent from the Cross (No.15), in the Rennes drawing of the Descent (see No.121), and the great triptych of the Descent from the Cross in Antwerp Cathedral (*KdK.* 52).

I am indebted to E. Haverkamp Begemann for the reference to Franco's print and for the photograph.

13 [Plate 12] *(1959: No.5)*

CHRIST CROWNED WITH THORNS

c. 1601. Pen and ink. 208 × 289 mm.
On the reverse: A kneeling woman, seen in profile, probably a study for a Penitent Magdalen after a print by Marcantonio Raimondi. Inscribed on the reverse, by later hands, 'Rubens' and 'P. P. Rubens'; on the front, 'No.270'.
Brunswick, Herzog Anton Ulrich-Museum.

EXHIBITIONS Antwerp, 1956, No.8.
LITERATURE E. Flechsig, *Zeichnungen Alter Meister in Braunschweig*, Frankfurt, 1925, No.72 (as Van Dyck). L. Burchard, *Sitzungsberichte der Berliner Kunstgeschichtlichen Gesellschaft*, Jan.15, 1932, 10; *idem*, in Glück, *Essays*, 374 i; M. Delacre, *Le Dessin*, 1934, 43 ff. (as Van Dyck); O. Benesch, *Die Graphischen Künste*, N.F.III, 1938, 19 ff.; Evers, II, 98; Vlieghe, Vlieghe, *Corpus Rubenianum* VII, 1973, II, No.111a; Jaffé, 1977. 59–60.

Burchard was the first to observe that the drawing is closely related to the painting Rubens executed in 1601–1602 for Sta. Croce in Gerusalemme in Rome (*KdK.*2). The picture which is now in the Hospices at Grasse was commissioned by Archduke Albert in 1601, with Jean Richardot acting as intermediary. (See also M. de Maeyer, *Gentse Bijdragen*, XIV, 1953, 75 ff.) The two figures behind Christ are essentially alike in both the drawing and the painting, except that in the painting the man with the oil lamp is bearded and looks away from Christ, towards the left. The postures of Christ differ more. The posture Rubens gave Him in the painting reflects his study of the Torso of the Belvedere and perhaps also of the Laocoön. His proportions are more majestic; He sits straighter, and His hands are tied in His lap. The man who presents Him with the reed kneels on the other side of Christ, but his pose seems to be about the same as in the drawing.

Rubens made use of the discarded pose of Christ of this drawing in one of his oil sketches for the Elevation of the Cross in Antwerp Cathedral (Held, 1980, No.349). However Rubens decided a second time against using this pose: the figure was not taken over into the finished picture.

A figure not unlike the Magdalen on the reverse was sketched by Rubens on the paper which now has five drawings of the suicide of Thisbe (No.24); one of the Thisbe figures was drawn on top of it, but the general outlines are still visible.

For another drawing connected with the commission for Sta. Croce in Gerusalemme, see No.14.

14 [Fig.8] *(1959: No.70)*

A MAN HOLDING THE SHAFT OF THE CROSS

(Study for the Raising of the Cross).
c. 1601. Black chalk. 360 × 265 mm.
Bayonne, Musée Bonnat (1438v°).

LITERATURE G.-H. No.75; L. Burchard, in Glück, *Essays*, 382; Evers II, 102; A. Seilern, *Catalogue*, 90, Fig.52.

This drawing is on the reverse of the Visitation studies (No.71). The Bayonne drawing is only the right half of the original sheet; the other half was again cut into two, but both pieces have been found and a reconstruction of the complete drawing is possible (see Fig.8). The whole sheet must have measured at least 510 × 380 mm. Evers (*loc.cit.*) was the first to attempt a reconstruction, but both he and Seilern were hampered by being unaware of the third piece, which is now in the Metropolitan Museum in New York. Evers was the first to suggest that these studies were not made at the same time as those for the Visitation (*i.e.*, circa 1611) but about ten years before, in connection with the Raising of the Cross for Sta. Croce in Gerusalemme (now probably lost; the example in the Hospices in Grasse, which hitherto had been considered the original, is only a copy, see M. de Maeyer, *Gentse Bijdragen*, XIV, 1953, 75 ff.). Rubens executed the three paintings for the Roman church late in 1601 and early in 1602. No other early drawing from the model is preserved; G.-H. No.45 probably dates from the period of Rubens' work for the Antwerp Raising of the Cross. It is precisely a comparison with the studies made from the nude in about 1609–1611 (see Nos.54, 55) that makes the early date for the Bayonne drawing so persuasive; its style is very different, the outlines are wavy, as if groping, the shading much more haphazard; the figure lacks muscular control, and the movement as a whole is much more awkward than in figures done ten years later. The heads in an early style on the Visitation studies strengthen the early date for the present drawing.

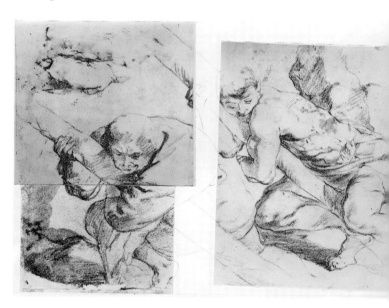

Fig. 8 Studies for a Raising of the Cross. Reconstruction of original sheet

15 [Plate 14] *(1959: No.3)*

THE DESCENT FROM THE CROSS

c. 1600–1602. Pen and ink over black chalk, washed.
437 × 380 mm.
Leningrad, Hermitage (5496)

COLLECTIONS Count Cobenzl.
EXHIBITIONS Rubens and his school in drawings and
engravings, Leningrad, Hermitage, 1940, No.7; Antwerp,
1956, No.31a.
LITERATURE R. Weigel, *Dessins de l'Ermitage*, 1865, No.7757;
M. Dobroklonsky, 1930, 31, No.1; Evers II, 144 (footnote
based on information obtained from E. Trautscholdt); H.
Robels, *Die Niederländische Tradition in der Kunst des Rubens*,
Diss. Cologne, (ms.) 1950, 24–25; M. V. Dobroklonsky,
Risunki Flamandskoi Skolni XVII–XVIII Vekov, Moscow, 1955,
No.633. Burchard-d'Hulst, 1963, No.37; Jaffé, 1977, 29, 31, 51,
62, 75, 82; Müller Hofstede, 1977 No.26A.

Inscribed in the upper left corner, in Rubens' hand:
*Vide(n)tur (?) ex Daniele Volterrano/Unus qui quasi tenens tamen
relinquit/Item alius qui diligentissime/descendit ut laturus opem*
('One sees (?) with Daniele da Volterra/one who, as if holding,
nevertheless lets go/and another who carefully/descends to
support the (precious) weight (?)')

Of the preliminary drawing in chalk some figures in the upper
right corner can still be seen. One man stretches out both arms
toward Christ; another seems to busy himself above the cross-
bar (pulling one of the spikes?). Several changes made in the
course of the execution are noticeable, particularly in the
woman standing at the left. Rubens first outlined her somewhat
nearer the centre of the composition. A second version of her
face, slightly more inclined, is visible in the shaded area of the
mantle that covers her head.
This drawing has not received the attention which it deserves.
Dobroklonsky and, following him, Robels believe that it was
retouched by a later hand; they make this assumption because
they connect it with Rubens' painting of the Descent from the
Cross of 1611–14 in Antwerp Cathedral (*KdK.*52) and need
some explanation for the rather evident shortcomings of the
design.
For these, there is, however, a different explanation. While
Rubens made use of some ideas of this drawing when he
prepared the Antwerp painting, there is good reason to assume
that the drawing itself had been made long before that time. It
should be clear that stylistically it does not belong to the group
of drawings which can be dated in the years 1610–12 (see
Nos.71, 72). On the other hand, it has close affinities to the
earliest group of drawings that we have by Rubens (see Nos.8,
9, 13). The man on the ladder wearing a turban is the same type
as the one who examines Christ's arm through his spectacles in
the Rotterdam Anointing (No.12). The figure of a man holding
the shroud with his teeth is found here too, as well as the young
women with flowing hair (see Introduction, p.51). The hand-
ling of the brush in the figure of St. John is strongly reminiscent
of a Rubens drawing inspired by Leonardo's Battle of Anghiari
(G.-H.No.8). That the position of Christ's body is very similar
in the Antwerp Descent is of little significance for the date, since
it also occurs with only minor variations in one of the children
of the early Medea drawing (No.7v°). This pose, indeed, is not
Rubens' invention. He took it over as a characteristic 'pathos
formula' from a classical source. It is found as the motif for
some of the dying daughters of Niobe, on Roman sarcophagi of
that theme, as for instance on the sarcophagus now in the
Museo Archeologico in Venice (see C. Roberts, *Roman Sar-
cophagi*, III, 3), a piece which Rubens probably knew, since in
the seventeenth century it was in Rome at the Villa Borghese.
(For the popularity of this sarcophagus in the Renaissance see
also Otto J. Brendel, *The Art Bulletin* XXXVII, 1955, 11;

Michelangelo used a rather similar pose for a figure in drunken
torpor [see L. Goldscheider, *Michelangelo Drawings*, London,
1951, Fig.92]; the pose was adopted for the body of Christ in B.
Franco's Lamentation, in Lucca, see Goldscheider, *loc.cit.*,
Fig.10.) Rubens' Christ seems to be nearer the daughter of
Niobe on the left side of the sarcophagus, while Medea's child
in the Chatsworth drawing resembles more closely the corres-
ponding figure at the right.
The young woman with raised arms may well echo a young
woman near the centre in Raphael's Fire in the Borgo (G.
Gronau, *Raphael*, *KdK.* IV ed. 1908, 111). For the motif of
holding on to the shroud with the teeth, see No.12. The
crouching man on the ladder and perhaps some general
compositional ideas may have been inspired by Gossart's
Descent from the Cross in Leningrad (as suggested orally by
Professor Van Regteren Altena). Rubens' inscription with its
reference to Daniele da Volterra is of particular interest. The
points of contact with Daniele's famous painting of the theme in
SS. Trinità dei Monti are admittedly only of a very general
nature (but it should be remembered that the figure of a youth
who helpfully, though somewhat ineffectually, leans over the
crossbar in the Antwerp painting comes straight out of
Daniele's painting); it is quite possible, however, that Rubens
knew another formulation of the theme by Daniele, possibly a
drawing. In this connection it is perhaps not without interest to
note that in one of the richest early collections of Rubens'
drawings—that of G. Huquier, sold in Antwerp in 1761—there
was a small drawing listed as 'the first thought of a Descent
from the Cross by Daniele da Volterra' (No.2520). It may well
have been a drawing by Daniele which came from Rubens' own
collection. (A Descent from the Cross—now no longer known
to exist—was formerly in Genoa, see Marie Louise Mez,
Daniele da Volterra, *Rassegna Volterrana*, VII, 1933, 58; the
painting in Novalesa, sometimes listed as a work of Daniele's, is
only a copy of a painting by V. Campi, acc. to Mez, 62).
The nature of the inscription is quite evidently the same as in
Rubens' copy after Pordenone (G.-H.No.1) and other such
inscriptions in the early drawings (Nos.12, 19).
When Rubens, ten to twelve years later, was given the
opportunity to represent the Descent from the Cross in a large
painting, he understandably used his early drawing as a starting
point. This is made quite clear when we compare the finished
painting with the panel formerly in the collection of the
Viscountess Lee of Fareham (see Held, 1980, No.355). This
picture—one of the large-scale *modelli* in Rubens' oeuvre—
differs from the finished painting in several ways, as has been
correctly pointed out by E. Haverkamp Begemann in his
catalogue of the exhibition. Yet it is precisely these differences
(the outstretched arm of Magdalen, the appearance of the right
knee of the man on the ladder, etc.) which connect it with the
early drawing.
Since this was written, the drawing has been shown as a genuine
work of Rubens in the Antwerp Exhibition though still dated
1611–1612. M. Jaffé, however, in his review of the exhibition
(*Burlington Magazine*, XCVII, 1956, 318) suggested an earlier
date ('second Roman period') and in 1977, 51, stressed its
dependence on Cigoli.

16 [Plate 16] *(1959: No.159)*
THE FLIGHT OF MEDEA

1601–1602. Pen and ink. 157 × 157 mm.
Rotterdam, Museum Boymans-van Beuningen (8).

COLLECTIONS F. J. O. Boymans.
EXHIBITIONS Antwerp, 1956, No.17.
LITERATURE D. Hannema, 1931, No.10; Burchard-d'Hulst,
1963, No.14; Kuznetsov, 1974, No.15; Müller Hofstede, 1977,
No.4.

In the catalogue of the Boymans collection of 1852 (No.821) this drawing was said to represent Ceres, abducting Trip- tolemus. Actually it represents Medea on a chariot, drawn by two dragons, after she has killed her two sons; one of the children is carried on her shoulder, the other lies in the chariot so that only his legs are visible. Rubens copied this composition from a famous classical sarcophagus of the second century, which at his time was exhibited in the Belvedere in the Vatican and which, when described by Robert, was in the Stamperia Reale, in Rome (C. Robert, *Die Antiken Sarkophagreliefs*, Berlin, 1890, II, No.199, p.212); it is now in the Museo delle Terme (information provided by Mrs. Phyllis Pray Bober). This sarcophagus was drawn in several of the Renaissance codices that record classical sculptures and was engraved by the Master with the Die and by Giulio Bonasone. Rubens, however, surely worked from the original; in his drawing he tried to reconstruct the original appearance of the damaged figures; the outstretched right arm of Medea and the second leg of the child in the chariot belong to this reconstruction. According to Burchard-d'Hulst, Rubens' model was a sarcophagus in the Palazzo Ducale in Mantua (see *Dedalo*. VII, 1926, 209).

The drawing is closely connected with the earliest group of Rubens' drawings (see Introduction, p.51). It is likely that he did it soon after his arrival in Rome, in 1601. It differs sensibly from a drawing showing the Rape of Proserpina (after a sarcophagus now in the Palazzo Rospigliosi in Rome) in the Rubens House in Antwerp (Exh.Antwerp, 1956, No.16), which is probably by a different hand.

17 [Plate 15] *(1959: No.6)*

ALCIBIADES INTERRUPTING THE SYMPOSIUM

c. 1601–1602. Lead pencil and pen and ink. 260 × 350 mm. On the reverse: Several light sketches in pen and ink for a Baptism of Christ, and a seated youth seen from the back. Inscribed, in Rubens' hand: 'Plato' 'Socrates'; of a third word only 'A' and 'S' (for Alcibiades) can be made out.
New York, Metropolitan Museum of Art (40.91.12).

COLLECTIONS P. H. Lankrink; J. Richardson, Sr.; Th. Hudson; Ch. Rodgers; Von S. (Sale Berlin, Henrici, VI. 12.1919, No.55); Harold K. Hochschild.
EXHIBITIONS Cambridge–New York, 1956, No.4.
LITERATURE H. W. Williams, *Metropolitan Museum Bulletin*, XXXV, 1940, 156 (as van Dyck); J. S. Held, *Magazine of Art*, XLIV, 1951, 2; *Idem, The Burlington Magazine*, XCVIII, 1956, 124; Müller Hofstede, 1977, No.27; E. McGrath, 'The Drunken Alcibiades, Rubens' Picture of Plato's Symposium', *Journal of the Warburg and Courtauld Institutes*, XLVI, 1983, 228–35.

Besides the main scene two figures are faintly visible, one reclining and one standing, both done in lead-pencil.
The drawing, like so many others, had been attributed to Van Dyck. First connected with Rubens by P. Wescher (in a ms. note), it forms a close group with the drawings for a Last Supper in Chatsworth and Malibu (nos.18, 19), and, like them, reflects the influence of the school of Raphael, especially of Marcantonio Raimondi. The seated youth on the back, though nude, is very similar in pose to the Caravaggesque youth in Chatsworth. He is also related to the seated figure on the reverse of the Thisbe drawing in the Louvre (No.24); repr. Lugt, *Catalogue*, I, Pl.LIV, No.591, as Van Dyck. The Baptism evokes thematically the subject of one of Rubens' large paintings for the Jesuit church in Mantua (now in Antwerp, *KdK*.14) of 1604– 1605. The interpretation of the theme is so different, however, that there is little reason to connect the two works. Here instead of the strong Michelangelesque character of the Mantuan work, the influence of Venetian representations of the subject is more noticeable.

On the authority of Erwin Panofsky I had identified the subject as *The Return of the Victorious Horatius* (Livy I, 26). McGrath was the first to notice the inscriptions which actually are more clearly visible in the photograph than on the original. The drawing illustrates a moment towards the end of Plato's Symposium, when Alcibiades, accompanied by revellers who, like he, are inebriated, bursts into the room, greeting first Agathon—the young man who extends his arms in greeting— and then offering wreaths to both that youth and to Socrates. She identifies the men at the right as Eryximachus and Aristophanes, while Plato is the long-haired youth in the centre. McGrath realizes that Plato was not present at the Symposium but plausibly suggests that Rubens did not want to omit the author of the dialogue. She also assumes that the design was not intended for a larger work, but—probably like the humorous drawing with 'Socrates' and 'Xantippe' in Chicago (No.21) was meant to amuse an erudite friend (perhaps his brother?) in recollection of a 'memorable dinner party when the conversa- tion turned to philosophy and love'.

18 [Plate 18]

STUDIES FOR A LAST SUPPER

c. 1600–1604. Pen and ink (bistre), lightly washed.
283 × 444 mm.
Chatsworth, The Devonshire Collection (1007 A).

COLLECTIONS N. A. Flinck (?); the second Duke of Devonshire (?).
EXHIBITIONS Antwerp, 1899, No.116 (as Van Dyck); London, 1950, No.40; Antwerp, 1956, No.25; London, 1977, No.24.
LITERATURE Rooses, *Rubens Bulletin*, V, 1897, 202–3; Held, *Magazine of Art*, 1951, 288–9; Burchard-d'Hulst, 1956, No.25; Burchard-d'Hulst, 1963, No.35; Jaffé, 1977, 29L; Müller Hofstede, 1977, No.26.

On the reverse: Two heads of apostles(?) and several studies for a St. Sebastian.

While in this sheet as well as the following one Rubens centred on the excitement that grips the apostles as Christ announces the betrayal, Christ himself appears only in this drawing. Raising his right hand high as if pointing to heaven he seems to address the beholder more than his disciples. (Rubens had first sketched the arm in a lower and less emphatic position.)
Burchard-d'Hulst as well as Müller Hofstede believe that Rubens began with the other sheet, placing this one second. Müller Hofstede gave both drawings a more penetrating analysis than anyone had given them before; yet I do not see, as he does, the intensification of the apostles' expression, which is his chief argument for placing this sheet second. Without putting too much emphasis on a chronological differentiation between drawings which clearly belong to the same working process (one might ask with equal justification which group of figures was drawn first on each of the sheets) I see no reason for changing my view expressed in 1959 (under No.7). Stressing the character of these drawings as free 'Ideenskizzen', Müller Hofstede also rejects the notion that the drawings were prepared for a painting, an interesting but hardly verifiable thought.

19 [Plate 19] *(1959: No.7)*

STUDIES FOR A LAST SUPPER

c. 1600–1604. Pen and ink (bistre), 293 × 435 mm. Paper torn at the upper left.
Malibu, J. Paul Getty Museum (84.GA.959).

COLLECTIONS N. A. Flinck (?); the second Duke of Devonshire (?); sold Christie's, London, 3 July, 1984.
EXHIBITIONS Antwerp, 1899, No.116 (as Van Dyck); London,

1950, No.39; Antwerp, 1956, No.24; London, 1977, No.25.
LITERATURE Rooses, *Rubens Bulletin*, v, 202–3; Held, *Magazine of Art*, 1951, 288–9; Burchard-d'Hulst, 1963, No.34; Jaffé, 1977, 29L; 30R; 57L; Müller Hofstede, 1977, No.25.

Inscribed in Rubens' hand: *Gestus magis largi longi(que) brachijs extensis* ('The gestures [to be] larger and broader, with arms extended')
On the reverse: Medea and her Slain Children (see No.20)

The two drawings must have been made in quick succession since several figures appear similarly in both of them. Some of these figures are more developed in this sheet which may indicate that it came later. Several of the figures are clearly derived from Italian sources. The youthful apostle holding both hands in front of his chest as if asseverating his innocence who appears twice in this sheet and once in the earlier one is borrowed from Marcantonio's engraving of the Last Supper after Raphael (see H. Delaborde, Marc-Antoine Raimondi, Paris, 1888, 103).
The old man in the upper right was taken (in reverse) from the Ezechias spandrel of the Sistine Ceiling which Rubens himself had copied (G.-H.No.13). The young man at the left, seen from the back, is probably derived from the youth in Caravaggio's Calling of Matthew in San Luigi dei Francesi, who in turn was inspired by an apostle in the Last Supper in Raphael's Loggie (cf. G. Gronau, *Raffael*, KdK.192); the motif of the spectacles (on the apostle at the extreme left) is Caravaggesque, too (see the Calling of Matthew in S. Luigi dei Francesi for instance); it appears quite frequently in early works of Rubens (see No.12). There are only very tenuous contacts with the most famous representation of the Last Supper, that of Leonardo da Vinci (copied by Rubens in a lost drawing, after which Soutman made an engraving). The gesture of the old apostle in the centre who raises both hands in astonishment may have been inspired by Leonardo's St. Andrew. Leonardo's group of Peter and John seems to be echoed in two figures near the top centre of the 'earlier' sketch.
There is no evidence that Rubens painted a Last Supper at this early date. The two heads which Burchard (1963, 62) connected with such a project (as a 'fragment' of an unfinished painting or a study for it) have no demonstrable contact with either these drawings nor the theme of the Last Supper in general. (For that picture see Held, 1980, No.440; the painting has since been sold, Christie's, New York, 9 January, 1981.)
Some of the types drawn in these sheets are found in other early works of the master, as, for instance, in the Transfiguration in Nancy of 1604 (KdK.15).
In an article published in 1965 in the *Jaerboek, Koninklijk Museum voor Schone Kunsten*, Antwerp, 183–205 ('P. P. Rubens en het Nachtmael voor St.-Winoksbergen, 1611, een niet uitgevoerd schilderij van de meester') A. Monballieu connected the two Chatsworth drawings for a Last Supper with a project for a painting of that subject which the magistrate of St.-Winoksbergen planned to donate to the Benedictine Abbey of that town. The project, for which Rubens apparently was approached, foundered, presumably because Rubens' price was too high. Monballieu was encouraged to connect the drawings with this project of 1611, since Burchard and d'Hulst had dated the drawings to 1611–12. I do not believe that the drawings can be dated that late; nor has that date been accepted by either Jaffé or Müller Hofstede.
Rubens did paint a Last Supper in 1631–32 (now in Milan, KdK.203). In it he used some of the ideas of his early drawings, e.g., the 'caravaggesque' youth. In view of the fact that some of the participants in that scene, notably Christ himself, are reminiscent of Rubens' first style, I suggested in the first edition of this book that the Milan painting be X-rayed to see if traces of an earlier composition can be identified on it. To the best of my knowledge this has not yet been done.

20 [Plate 20] *(1959: No.7 verso)*

MEDEA AND HER SLAIN CHILDREN

Inscribed (in Rubens' hand): *vel Medea respiciens Creusam ardentem et Jasonem velut Insequens* . . . (?) At the right, again, in chalk *Creusa arden(s?)*. ('or Medea looking back at the burning Creusa and at Jason as if [?] pursuing . . . [?]; Creusa burning [?]') *Malibu*, J. Paul Getty Museum.

LITERATURE Jaffé, 1977, 29R; Müller Hofstede, 1977, No.25.

That Rubens was interested in the Medea myth may be seen from a drawing in Rotterdam (No.16) and another in Bayonne, which apparently renders the Death of Creusa (No.59). Since he was an admirer of Lipsius, the Seneca specialist, he was probably familiar with Seneca's tragedy *Medea*.
Contrary to the classical renderings of Medea's flight, where Medea always mounts a chariot drawn towards the right by serpents (see No.16), Rubens shows the crazed mother rushing towards the left and gives no indication of her magic powers. Twice she appears in full figure; between the two poses Rubens drew once again Medea's left arm and one of the dead children. He derived the pose of this child from a classical sarcophagus, where it showed one of Niobe's daughters (see also No.15). The expression on Medea's face is very similar to that found in an apostle in the upper right group of the Last Supper, on the obverse. For her movement Rubens may have used a classical maenad (see Evers II, Fig.249, after Cavalieri). Rooses (see No.19) assumed mistakenly that the figure of Medea belonged to a composition of the Massacre of the Innocents, an interpretation which is impossible in view of the inscription, but understandable since Rubens gave the scene an element of plain human anguish which it does not have in the classical models.
Stylistically the drawings both of the Last Supper and of the Medea myth belong to a group of pen-drawings which Rubens must have done during the first period of his stay in Italy (see No.13). They occupy a prominent place in that group. (The authors of the catalogue of the Antwerp exhibition (1956) first placed the drawing in Rubens' Italian period but in a supplement to the catalogue changed the date to 1611–1612.)

21 [Plate 21] *(1959: No.160)*

THREE FIGURES FROM A ROMAN SARCOPHAGUS

1601–1605. Black chalk. 281 × 416 mm.
Inscribed, in pen, apparently in Rubens' hand: '*Socrates procul dubio*' (Socrates without doubt): '*Xantippe quae stomachatur*' (who is in a bad mood), '*vide os columnatum*' (notice the 'pillared face' [see below]). The signature 'Rubens' near the lower edge is by a different hand.
Chicago, The Art Institute of Chicago, The Leonora Hall Gurley Memorial Collection.

COLLECTIONS Dr. Ginsburg; William F. Gurley.
EXHIBITIONS Cambridge–New York, 1956, No.5.
LITERATURE Goris-Held, No.109; W. Stechow, *Rubens and the Classical Tradition*, Cambridge, Mass., 1968, 32–4; Jaffé, 1977, 83; Müller Hofstede, 1977, No. 62 ('1606–1608'); E. McGrath, *Journal of the Warburg and Courtauld Institutes*, XLVI, 1983, 232n. (with a corrected reading of the inscription, here adopted).

When I first published this drawing I was unable to identify Rubens' model, though I recognized the female figures as corresponding to well-known types of the Muses Urania and Polyhymnia. I owe to Mrs. Phyllis Pray Bober the reference to the beautiful sarcophagus formerly in the Villa Mattei, now in the Museo delle Terme in Rome (inv. No.80711) where the three figures of Rubens' drawing are seen in the same sequence, though separated by columns, on the right end (see Fig.9 and W. F. Stohlman, *American Journal of Archaeology*, 2nd series,

XXV, 1921, 229, Fig. 5).

It is not very likely that Rubens should have misinterpreted the figures in the way he 'explained' them. Even the vague relationship of the man's head with the traditional Socrates type (see M. Bieber, *The Sculpture of the Hellenistic Age*, New York, 1955, p. 47) does not satisfactorily explain his mistaking the muse Polyhymnia for the peevish Xantippe. While he may indeed have erred, one should perhaps seriously consider the possibility that the inscription was added in a jocular vein. The phrase 'vide os columnatum' (which in the catalogue of the Cambridge–New York exhibition was translated 'look how the bone resembles a column [?]') is almost certainly meant to be humorous. It alludes to a passage in Plautus' *Miles Gloriosus* in which Periplectomenus, the neighbour of the vainglorious Pyrgopolynices, describes the attitudes struck by the wily slave Palaestrio as he invents the plan that will succeed in freeing Acroteleutium and punishing her abductor. 'Ecce autem aedificat: columnam mento suffigit suo. Apage, non placet profecto mi illaec aedificatio; nam *os columnatum* poetae esse indaudivi barbaro, cui bini custodes semper totis horis occubant' ('He's building—supporting his chin with a pillar. None of that! I don't fancy that sort of building, not for a minute. For I happen to have heard that a foreign poet has a pillared face and a couple of custodians always lying on him hour after hour'; Loeb Classical Library, *Plautus* III, London, 1924, pp. 209–212, 142–143). The foreign poet is the Roman Naevius, imprisoned for his attacks on the nobility, especially the Metelli. The Muse supporting her chin with her hand may have reminded Rubens of Plautus' amusing phrase which appears to be unique in classical literature, and which he surely knew well; Plautus is frequently quoted in the book *Electorum Libri Duo* which Philip Rubens was then writing and for which Rubens furnished drawings of classical sculptures (see Introduction, p. 36). Could the whole inscription have been added in a mockingly 'scholarly' vein for the amusement of his own brother?

F. Cumont (*Recherches sur le symbolisme funéraire des Romains*, Paris, 1942, 314) identified the man with the club as a cynic, perhaps Diogenes. Even in the original the unusually protruding chin, which Rubens stressed in his drawing, gives the head a striking appearance. It is likely that Rubens also made studies of the other sides of the sarcophagus, but no such drawing has yet been found.

Fig. 9 A Poet and Two Muses. Roman sarcophagus. Rome, Museo delle Terme

22 [Plate 22] *(1959: No. 158)*

IGNUDO, AFTER MICHELANGELO

1601–1605. Red chalk, accented with the brush. 387 × 277 mm. The number '19' appears in red chalk in the lower centre. *London*, British Museum (1870.8.13.882).

COLLECTIONS P. H. Lankrink; E. Bouverie.
EXHIBITIONS London, 1977, No. 37; Cologne, 1977, No. 67.
LITERATURE M. Jaffé, *The Burlington Magazine*, XCIX, 1957, 376, Fig. 22; Burchard-d'Hulst, 1963, No. 18; Jaffé, 1977, 21, 56; Müller Hofstede, 1977, 274.

The drawing renders the last of the *ignudi* on the right (north) side of the Sistine Chapel, marking the corner between Jonah and the Libyan Sibyl (see Charles de Tolnay, *The Sistine Ceiling*, Princeton, 1945, Figs. 105 and 125). Though somewhat smaller than they, the drawing belongs clearly to the copies Rubens made of the prophets and sibyls (G.-H. Nos. 14–21 and Lugt, *Catalogue*, Nos. 1040–1047). Like them, it must have been done very early in Rubens' career. Lugt, indeed, ventured to date them '1601 or soon thereafter', assuming that Rubens must have made them from the originals in Rome. I agree with this view since to the best of my knowledge none of the Italian engravings made of these figures could have served as models but this question needs still further study.

As in the copies of the prophets and sibyls, one notices some subtle but highly characteristic differences between Michelangelo's figure and Rubens' version of it. In Michelangelo one senses a discrepancy, surely meaningful, between the smoothly expansive pose of the body and the tensely introverted, almost dreamy expression of the face. In Rubens' version the head of the figure is inclined towards the right (whereas it was strictly vertical in Michelangelo) which helps to harmonize it with the flowing forms of the body. Moreover, the expression, rather than being withdrawn, is alert, outgoing, and sensuously expectant.

In the British Museum the drawing is accompanied by a second version of this figure, which also came from the Lankrink and Bouverie collections (1870.8.13.883, placed as 50 A; 322 × 199 mm., irregularly cut out). Here the *ignudo* is rendered in reverse and altered in so many ways that it can be called only a free variation of Michelangelo's model. It differs technically, too, from the present copy, as Rubens used the brush much more freely, 'washing' the red chalk and adding even small amounts of white. Originally, this drawing must have been a counterproof (a fact kindly verified for me by Christopher White) which was thoroughly reworked by Rubens, possibly at a much later time. Some of the brushwork, indeed, is very similar to that used by Rubens on the Blosius-title of 1631 (No. 213).

23 [Plate 27] *(1959: No. 12)*

THE BIRTH OF THE VIRGIN

c. 1603–1607. Pen and ink, on greyish paper. 253 × 365 mm. *Paris*, Petit Palais (Coll. Dutuit, No. 65).

COLLECTIONS Eugène and Auguste Dutuit.
EXHIBITIONS Rotterdam, 1948–1949, No. 115; Antwerp, 1954, No. 333; Antwerp, 1956, No. 50; Antwerp, 1977, No. 155.
LITERATURE F. Lugt, 1925, 193; G.-H. No. 76; Burchard-d'Hulst, 1963, No. 128 (1621–1622).

The attribution to Rubens was first made by Lugt, who also identified the subject. Formerly its title had been 'Moses drawn from the water'. The smiling old woman who hands the child to Joachim while sitting in one of the long wicker-baskets (which were standard nursery equipment in the seventeenth century) is probably St. Anne herself. A bed is visible at the extreme left.

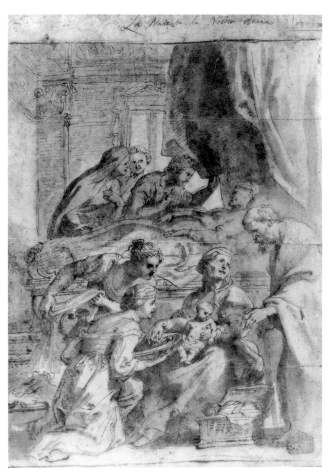

Fig. 10 The Birth of the Virgin. Pen and brown ink and wash.
310 × 207 mm. Private collection

No painting is known of this subject. Glück and Haberditzl dated the drawing 1613–1614. Lugt thought it had been done 'about ten years before the Vestal Tuccia' (No.156), which would point to 1612. The similarity of the prophetess Hanna on the right wing of the Descent from the Cross with the smiling woman above St. Anne in the drawing and the kinship of the young woman at the left with the Virgin of the left wing (see Phaidon *Rubens*, Pl.223) speak in favour of such a date. The style of the drawing, however, is still closely related to drawings which belong to Rubens' Italian period (see Nos. 18, 20). It shares with them many graphic conventions in rendering outlines and shading. The schematized design of facial features and hands and the lack of spatial clarification of the figures are also found here. The smooth long necklines and the big round shoulders are reminiscent of the so-called 'large' Judith (KdK.30), a work generally dated 1608–1610. Evers (I, 110) tentatively placed it into the later Italian years. A still earlier date, proposed by me (Miscellanea Prof. Dr. D. Roggen, Antwerp, 1957, 130), should be corrected.
The subject of the Birth of the Virgin appears also in an interesting drawing sold at Sotheby's-Monte Carlo, June 13, 1982 (114). (Pen and brown ink, washed, 310 × 207 mm., Fig.10.) The drawing is inscribed at the top in what I have no doubt is Rubens' own handwriting 'La Nativita di Nostra donna.' I know the drawing only from a good photograph (kindly provided by Julien Stock) which shows that the condition of the sheet is less than perfect: it seems to have been folded horizontally (and possibly torn) in three places. There are unquestionably connections with Rubens' work but some

details (hands!) are rather weakly done. The composition seems to have been derived from Annibale Carracci's Birth of the Virgin of *c.* 1600 (Louvre, see Posner, *Annibale Carracci*, II, Pl.110a). The character of the piece recalls Rubens' designs for engravings, but no such engraving is found in the literature; nor is the subject mentioned in Rooses' still basic oeuvre catalogue.

24 [Plate 24] (1959: No.8)

STUDIES FOR THE SUICIDE OF THISBE

1602–1605. Pen and ink. 193 × 208 mm. On the reverse: A seated youth, nude, seen from the back.
Paris, Louvre, Cabinet des Estampes (L.591 as Van Dyck).

COLLECTIONS P.J. Mariette.
EXHIBITIONS Antwerp, 1956, No.40; Paris, 1978, No.2.
LITERATURE Lugt, *Catalogue*, I, No.591, Pl.LIV; *Catalogue*, Exh. Cambridge–New York, 1956, under No.2; O. Benesch, *Alte und Neue Kunst*, III, 1954, 10; Burchard-d'Hulst, 1963, No.77; Jaffé, 1977, 29R, 64R; Müller Hofstede, 1977, No.29.

Despite the authority of F. Lugt, who accepts the old attribution to Van Dyck, this drawing must be given to Rubens because of the close analogies which it shows to his other early drawings. The nude figure on the back appears similarly on the reverse of the New York Alcibiades Interrupting the Symposium (No.17) and in the Last Supper drawings in Chatsworth (Nos.18–19). It was used by Rubens in an early painting of a Judgment of Paris (Vienna, Academy; see R. Eigenberger, *Catalogue*, 1927, No.644, Fig. 90 as Van Dyck), a picture which was attributed to Rubens by Evers (II, 268–271, Fig.289).
Stylistically, the drawing of Thisbe in Paris and the related one in Brunswick, Maine (No.25), are connected with the earliest known group of Rubens' drawings, though they should evidently be dated slightly later. No painting of Thisbe by Rubens is known to exist, but there is a figure near the right edge of the Transfiguration in Nancy of 1604–1606 (KdK.15) which looks like the fruit of the Thisbe studies. In the same picture there is another figure in a pose reminiscent of the figure of Thisbe in the lower right corner of the Louvre sheet. This is the prophet Elijah, who appears in the clouds, at the right of Christ, pointing at the Saviour. The drawing of Thisbe, indeed, fits the style of the Mantuan works. The excited actions, realized in depth, with expansive gesturing and fluid contrapposto, the flickering light, especially of the Transfiguration, provide many analogies. Some of the poses occur, however, in later paintings, such as the *Coup de Lance* (KdK.216)—the Magdalen—and the sketch of the Ascension in the Academy in Vienna (KdK.214). 'The most lamentable comedy, and most cruel death of Pyramus and Thysbe'—evidently one of Ovid's most popular tales—was not infrequently rendered in art; Baldung's painting in Berlin comes to mind first, but Rubens is more likely to have known a painting of the Tintoretto school showing Thisbe falling upon the sword, which forms part of a series of Ovidian subjects now in Modena (see S. Ricci, *La R. Galleria Estense di Modena*, I, Modena, 1925, 91, Nos.220–233); the central figure in the upper row of Rubens' drawing comes nearest to the Thisbe in Modena, who also turns to the left and raises both arms as she falls upon the sword). Müller Hofstede called attention to Rubens' faithfulness to Ovid's text (Met.IV, 162–3): '... *aptato pectus mucrone sub imum incubuit ferro*' ('having put the point of the sword under her breast she threw herself on the iron'). Several paintings of Pyramus and Thisbe are listed in Antwerp art inventories of the seventeenth century (Denucé, *Inventories*, 142, 164, 305, 352), one of them being described as a copy after Van Dyck. This reference is hardly sufficient to give any support to the attribution of the Thisbe drawings to Van Dyck.
Beneath the figure in the lower left corner Rubens seems to have

drawn another, seen nearly in profile, kneeling towards the right. The lines which look, at a first glance, like a flowing veil actually describe the back of the figure; it is possible that the two sharply pointed forms which emerge from Thisbe's head and could almost be interpreted as a crown, belonged to that first figure who may not have been a Thisbe at all.

In 1982 Elizabeth McGrath took this observation one step further ('Rubens, the Gonzaga and the "Adoration of the Trinity"', *Splendours of the Gonzaga, Catalogue*, Victoria & Albert Museum, London, 214) and suggested that this and the following drawing depict the suicide of Dido, not of Thisbe. The 'crown' on which she bases her argument is seen, however, on only one of the six figures, and the few lines in the lower right corner (if they are indeed made by Rubens) can hardly be read as a 'funeral pyre'. Her interpretation, however, has been accepted by David P. Becker (see No.25).

25 [Plate 25] *(1959: No.9)*

THISBE COMMITTING SUICIDE

c. 1602–1605. Pen and ink. 95 × 115 mm.
Brunswick (Maine), Bowdoin College Museum of Art.

COLLECTIONS J. Richardson, Sr.; Prof. Henry Johnson; Mrs. Stanley P. Chase.
EXHIBITIONS Cambridge–New York, 1956, No.2.
LITERATURE F. J. Mather, Jr., *Art in America II*, 1913–1914, 115, Fig.18; Jaffé, 1977, 64; Müller Hofstede, 1977, No.29; David P. Becker, *Old Master Drawings at Bowdoin College*, Bowdoin Museum of Art, Brunswick, Maine, 1985, No.13.

Describing it as 'far too good for Rubens', Mather attributed the drawing to Van Dyck; it had been under Rubens' name before. The connections with the studies for Thisbe's suicide, now in the Louvre (No.24), are obvious. In addition, there is a great similarity between the foreshortened view of Thisbe's left hand and the hand of Susanna in Rubens' painting in the Villa Borghese (*KdK.* 19), which was dated 1605 by F. M. Haberditzl (*Jahrbuch der Kunsthistorischen Sammlungen des Allerhöchsten Kaiserhauses*, XXX, 1912, 257 ff.). The sketchily drawn head of a man in the lower centre is similar to figures which may be seen on the back of the New York drawing of Alcibiades Interrupting the Symposium (No.17).

There is a drawing in the collection of F. Lugt of a meeting (or parting?) of apostles (?), which has on its back some sketches of frantically fleeing women, some of whom seem to be standing in water; it may, therefore, have been drawn for a rendering of the Diana and Actaeon myth. The drawing is closely associated with the Thisbe drawings and must have been done about the same time.

26 [Plate 38] *(1959: No.71)*

A GENTLEMAN IN ARMOUR ON HORSEBACK

Study for the Portrait of the Duke of Lerma. 1603 (Summer).
Pen and ink washed (some parts drawn with the brush) over black chalk. 300 × 215 mm. The head has been drawn on a separate piece of paper of irregular shape.
Paris, Louvre, Cabinet des Estampes (20.185).

COLLECTIONS Robert de Cotte.
EXHIBITIONS Brussels, 1938–1939, No.15; Rotterdam, 1939, No.17; Rotterdam, 1948–1949, No.108; Paris, 1949, No.95; Brussels, 1949, No.91; Antwerp, 1956, No.18; Paris, 1978, No.1.
LITERATURE R., V. No.1503; Michel, 110, Pl.IX; F. Boix, *Retrato ecuestre del Duque de Lerma*, Madrid, 1924; Muchall-Viebrook, No.17; Glück, *Essays*, 32; G.-H. No.46; Lugt, *Catalogue*, No.1018; Burchard-d'Hulst, 1963, No. 30;

Kuznetsov, 1974, No.16; Jaffé, 1977, 69, 75; Huemer, *Corpus Rubenianum*, XIX, No.20a.

Formerly listed as a portrait of Charles V, this drawing was recognized by Glück as a study for the equestrian portrait of the Duke of Lerma which Rubens painted in 1603 in Madrid, and has since 1968 been in the Prado (Catalogue, I, 1975, No.3137) (*KdK.* 5). The features of the face, however, are not those of the Duke; Glück and Lugt account for this discrepancy by suggesting that one of the Duke's equerries served as the model. (The fact that the head is on a separate piece of paper is not explained by this assumption.) There is a second version of this composition in a drawing formerly owned by the Grand Duke of Saxe-Weimar-Eisenach (according to Jaffé, 1965, 380, owned by the exiled Grand Duchess of Weimar). It is almost twice the size of the one in Paris and in many respects much closer to the painted version, except that it too does not show the head of Lerma but a somewhat idealized version of the man in the Louvre drawing. This is sufficient reason against the theory (originally held but then abandoned by Glück) that it was copied from the painting. Of the several small features which prove that it is closer to the painting and may have served as the working sketch, one might point out the strap hanging loosely from the corner of the saddle cloth which is not found in the Louvre drawing. Still more obvious is the larger display of branches and foliage overhead, which the Weimar drawing shares with the painting. Yet, there is one striking feature which so far has not attracted sufficient attention: the upper extension in the Weimar drawing is on an added strip of paper, and the painting, too, to judge from the available reproductions, has been added to at the top in the very same way. Thus, the genesis of the painting can be reconstructed in this way: first came the Louvre drawing (in which the preliminary chalk drawing reveals a gradual clarification of the idea). The Weimar drawing was an enlarged copy, made probably after the approval of the first sketch, in order to serve for the execution. Originally it ended at the top like the Louvre drawing, and the painting did so too. Only after (or at best during) the execution of the painting was it found necessary to enlarge the canvas. In order to test the new format, the paper strip with the foliage was first added to the Weimar drawing and adopted in the picture.

It does not seem to be likely in view of these observations that the two drawings were done by Rubens after the painting, possibly as a preparation for an engraving, as Lugt tentatively suggests. I agree even less with M. Lorente (*Miscellanea Prof. Dr. Roggen*, Antwerp, 1957, 184) who thinks that the drawings render the features of Archduke Albert.

A. L. Mayer (*El Greco*, Berlin and Leipzig, 1931, 104) pointed out that Rubens may have borrowed the idea for his portrait from El Greco's St. Martin (now in the National Gallery in Washington, Widener Collection), which was painted between 1597 and 1599. The horse, indeed, has surprising similarities. L. Burchard (in Glück, *Essays*, 377) suggested that both El Greco and Rubens may have worked from the same model, possibly a lost work by Tintoretto. Another possibility, overlooked so far, is a painting of St. Martin by Pordenone in San Rocco (Fiocco, *Pordenone*, Pl.130) and a drawing of a cavalier by Pordenone in Chantilly (Fiocco, Pl.132). The influence of Pordenone upon Rubens is well known (see G.-H. No.1, and A. E. Popham, *Old Master Drawings*, 1933–1934, 43, Pl.46; also A. Seilern, *Catalogue*, No.50). Whatever the sources, it remains Rubens' merit—as Burchard has already said—to have adopted a pattern only found before in religious painting to formal equestrian portraiture. I should like to suggest, however, that in doing so, Rubens may have been prompted by his recollection of another source. In his *Natural History* (XXXV, 96), Pliny mentions that Apelles painted a portrait of Antigonos in armour, advancing with his horse (*fecit ... Antigonum thoracatum cum equo incedentem*), a painting which was greatly admired by the experts (see K. Jex-

Blake, *The Elder Pliny's Chapters on the History of Art*, London, 1896, 130). In introducing a new pattern into equestrian portraiture, Rubens may well have followed the lead of the most famous painter of antiquity.

27 [Plate 30] *(1959: No.72)*

A YOUNG SOLDIER WITH HALBERD

1604 (after the month of August). Black and white chalk; some red chalk on head and hand only; washed. On light grey paper. 404 × 258 mm.
Brussels, Cabinet des Estampes, Bibliothèque Royale Albert I.

COLLECTIONS P. H. Lankrink; J. von Haecken; M. Jaffé.
EXHIBITIONS *Drawings by Old Masters*, Saville Gallery, London, 1930, No.23 (repr); Antwerp, 1977, No.122.
LITERATURE Müller Hofstede, 1977, No.39; Jaffé, 1977, 73 R; U. Bazzotti, in *Rubens a Mantova*, 1977, 46.

Inscribed, in pen and ink, by later hand, 'Rubens'.

This drawing is of considerable importance since it is probably connected with the biggest commission Rubens obtained while in Italy, the decoration with three large canvases of the Church of the Holy Trinity in Mantua. The story of this project has been told many times (see A. Luzio, *Archivio Storico Italiano*, 1911, p.406 ff., and most recently Bazzotti, 28–53). The central canvas, which contained the Gonzaga family in Adoration of the Trinity, also contained several halberdiers, on each side of the picture. The fragment of one at the left has been found and is now again in the Palazzo Ducale in Mantua. Another fragment, presumably of one at the right side, was in the collection of Alessandro Nievo in Mantua and was sold about 1870; its whereabouts is unknown. It is permissible to assume as a working hypothesis that the present drawing is a study for one of these figures.
Hardly any drawings have been found which belong to this great undertaking. The Louvre has a working drawing for the Baptism of Christ (No.28), which may owe its survival to the circumstance that it was *not* used for the purpose intended. Two drawings of young Mantuan princes have been connected with the commission, but they may have been made several years earlier (see Nos.10, 11). The head of a small child, however, may belong to this period (see Exh. Amsterdam, 1933, No.125). Under the circumstances, the appearance of the present drawing is most welcome. It is not only of value in the reconstruction of the dismembered and mutilated canvas, but it also provides an example of a category of drawing of which no others are known from this period (see Introduction, p.52).
The execution of the Mantuan paintings must lie between August, 1604, when Rubens left Rome for Mantua, and May 25, 1605, when the pictures were reported to be finished. The drawings, evidently, must belong to the second half of 1604.

28 [Plate 28] *(1959: No.11)*

THE BAPTISM OF CHRIST

c. 1604. Black chalk. 477 × 766 mm. Squared. Two pieces of paper, irregularly shaped, were inserted near the upper edge after the squaring; they are still within the crown of the tree in the centre; a small piece was inserted near the groin of the seated youth in the centre and another in the thigh of the young man at the right who pulls his shirt over his head.
Paris, Louvre, Cabinet des Estampes (20.187).

COLLECTIONS E. Jabach.
EXHIBITIONS Brussels, 1938–39, No.8; Rotterdam, 1939, No.8. Antwerp, 1977, No.121; Paris, 1978, No.4.
LITERATURE R., V, No.1343, Pl.384 ('by an engraver?'); F. M.

Haberditzl, 1912, 264; G.-H. No.50; Lugt, *Catalogue*, No.1009. Exh. Rotterdam 1953, under No.13; Burchard-d'Hulst, 1963, No.29; Jaffé, 1977, Fig.245.

Although depreciated by Rooses, the drawing has been accepted by all scholars who have written about it since, and Lugt termed it 'le plus important (dessin) qui nous soit conservé de la première période du maître'. It was made in connection with Rubens' work for the Church of the Holy Trinity in Mantua, consisting of three large canvases finished in May, 1605. The painting for which the Louvre drawing was made is now in Antwerp (*KdK*.14). Despite the fact that the squaring of the drawing would point to its representing the final plan on which the execution was to be made, there is actually a considerable number of differences between the drawing and the painting. The changes seem to have been motivated by the artist's desire to fill the area and to enlarge his figures. He achieved this by eliminating the youth in front of the tree, thereby gaining enough space to pull all the other figures closer to the front and make them accordingly larger. He also added two child angels in the upper left and thoroughly redesigned the figure of St. John the Baptist. The tree was moved further to the right and another was added; this, in turn, required some changes in the group of women in the background. Thus it is practically certain that Rubens must have made another drawing to serve as a model for the transfer of the composition into the large format of the Antwerp painting; the preservation of the Louvre drawing, then, was due precisely to the fact that it did *not* serve as the cartoon. (See also Introduction, p.52.) The figure of the youth whom Rubens left out in the final version reappears several times later on; Lugt lists his occurrence in the St. Sebastian in the Galleria Corsini (Glück, *Essays*, 17, Fig.12, with slight changes), in the drawing for the All Saints page in the *Breviarium Romanum* (G.-H.No.70) and in the Raising of Lazarus in Turin (*KdK*.1st ed., 457). To these should be added the fine oil sketch which preceded the drawing G.-H.No.70, now in Rotterdam (Held, 1980, No.399), and the painting of the Feast of Achelous in the Metropolitan Museum in New York (*KdK*.117, see J. S. Held, *The Art Quarterly*, IV, 1941, 122 ff.). That this figure was derived from a sculptural model, probably a classical figure, can be deduced from a drawing by one of the Copenhagen copyists (W. Panneels?) showing the figure without arms and inscribed: 'dit manneken hebbe ick oock gehaelt vant cantoor ende is redelijck wel gecopieert' ('I also fetched this figure from the closet and it is fairly well copied'). The sculpture has indeed been identified by Dr. H. M. van der Meulen-Schregardus as a marble that was, until its destruction by fire in 1776, in the Medici Collections in Florence; it had been restored to represent a seated Bacchus, evidently only after it had been drawn by Rubens. (See also Müller Hofstede, 1977, 144.) It is easily seen that the second seated figure from the right is an adaptation of the famous *Spinario* type. Rubens' interest in this motif is apparent from a drawing now in London (see No.38), in which he drew the figure twice, with variations in the attitude of the head. The idea, found in the Louvre drawing, of turning the youth's head in the opposite direction to the raised foot is seen also in the London drawing, though in reverse. The old man at the right is related to the Belvedere 'Torso' which Rubens drew several times (Exh. Amsterdam 1933, No.93, and Copenhagen III, 56–58).
The influence of Michelangelo is obvious and has been mentioned by all the writers who discuss the Louvre drawing. There are connections with the Last Judgment in the Sistine Chapel and with the cartoon of the Battle of Cascina, especially the figures of men putting on, or taking off, their clothes at the right. The figure of Christ was derived from Sebastiano del Piombo's Flagellation of Christ in San Pietro in Montorio (L. Dussler, *Sebastiano del Piombo*, Basel, 1942, No.45, Fig.35 and

No.156, Fig.102), which in turn drew its inspiration from drawings by Michelangelo. The female figures in the background look like mannerist transformations of classical types, and the angels at the left are Correggiesque rather than Michelangelesque. Besides the connections with works of earlier periods and other masters, the ties which bind the Louvre drawing to some of Rubens' own earlier works should not be overlooked. The position of the head and shoulders of the angel in the centre of the group of three at the left repeats almost literally the Virgin of the Rotterdam Anointing (see No.12). The facial type of the old man undressing at the right has a strong affinity with that of the man on top of the ladder in the Leningrad Descent from the Cross (see No.15), where there is also the exaggerated foreshortening (on the second man on the ladder) that can be seen in the lower right of the Louvre drawing.

29 [Plate 32] (1959: No.73)

PORTRAIT OF A LADY

c. 1606. Pen and ink, over black chalk. 315 × 185 mm. Several tears in the paper have been repaired, but there is some damage round the edges and a piece is missing in the lower right corner.
New York, J. Pierpont Morgan Library (1975.28).

COLLECTIONS M. Uzielli; E. Schilling; O. Manley.
EXHIBITIONS London, 1950, No.55; Cologne, 1977, No.39; London, 1977, No.2; Paris–Antwerp–London–New York, 1979–1980, No.12.
LITERATURE L. Burchard in *Catalogue*, Exh. London, 1950, No.55; Ch. Norris, *The Burlington Magazine*, XCIII, 1951, 7, Pl.5; J. S. Held, 1951, 286.

Inscribed 'gout' (gold) on cornice; 'goudt' (gold) below first capital; 'Root' (red) on curtain.

This sketch served for the portrait of Brigida Spinola-Doria of 1606 who in that year, at the age of 22, married Giacomo Massimiliano Doria; the painting, known from a lithograph of 1848, has unfortunately been cut down since. There is a striking difference between the appearance of the lady in the present drawing and that of Brigida Spinola in the painting. Whereas in the painting she looks very youthful and exceedingly pretty, the drawing shows a woman of much sharper and older features. It was normal in formal portraiture to flatter the model, but the differences in the present case go far beyond what one might expect of such an improvement upon nature. Christopher Norris' suggestion therefore, that for the purpose of the drawing Rubens worked from a 'stand-in' model, probably one of the ladies-in-waiting of Brigida Spinola, has much to recommend it. Norris correctly points out that a similar case can be observed in Rubens' drawings for the portrait of the Duke of Lerma (see No.26). A drawing of the same figure (done with the brush and *encre de Chine*, on grey paper, 345 × 189 mm) in the Ecole Nationale Supérieure des Beaux-Arts, Paris (Inv. No.628), exhibited as a second, original version in Cologne, 1977, No.40, has been rejected by most critics and in my opinion, too, can only be considered as a somewhat coarsened copy of the large painting.

30 [Plate 31]

ALLEGORY OF BRESCIA, AFTER TITIAN

1605–1608. Pen and ink (bistre). 316 × 384 mm.
London, British Museum (1897–4–10–12).

COLLECTIONS R. Cosway.
EXHIBITIONS London, 1977, No.17; Cologne, 1977, No.71.
LITERATURE Hind, II, No.25; E. Tietze-Conrat, 'Un Soffitto di

Tiziano a Brescia, Conservato in un disegno del Rubens', *Arte Veneta*, 1954, 209–10; H. Vey, *Die Zeichnungen Anton van Dycks*, Brussels, 1962, No.155 (as Van Dyck); R. Baumstark, 'Ikonographische Studien zu Rubens Kriegs- und Friedensallegorien', *Aachener Kunstblätter*, XLV, 1974, 169–70; Müller Hofstede, 1977, 282; Logan, *Master Drawings*, XV, 1977, 412 ('more likely by Van Dyck'). (According to Vey, *loc.cit.*, the attribution to Van Dyck was also shared by Burchard.)

The true subject of this drawing (which Hind had interpreted as derived from a passage in Homer's Iliad) was identified by Tietze-Conrat on the basis of a description by B. Zamboni (*Memorie intorno alle pubbliche fabbriche della Citta di Brescia*, Brescia, 1778, 139). Zamboni described in considerable detail an octagonal field in the centre of a ceiling of the town-hall of Brescia which had been commissioned in 1565 to be done by Titian; the whole decoration was finished in 1568, and was destroyed by fire only seven years later, in 1575. Zamboni apparently had access to the contract which in fact is all that remains of the work—with the exception of an engraving by Cornelis Cort, depicting the smithy of the Cyclopes, and the drawing by Rubens. Vasari also made reference to the decoration (ed. Milanesi, VI, 509 ff.), mentioning elsewhere that Titian had begun the paintings by the time he visited Vasari in the spring of 1566.
According to the contract, the female figure in the centre above is the city of Brescia personified, turning her back on Mars (war) while gladly welcoming Minerva—in her role as *pacifera*, the peace-loving—extending to her a golden statuette of *Fides*, a motif derived from coins of Vespasian. Minerva holds the olive branch of peace in her right hand; her owl is at her feet. Below are three partly nude naiads, holding reeds and other plants growing near water; they represent three rivers, a meaning reinforced by large urns (made, as the contract stipulates, of iron, lead, and crystal) from which broad streams of water are pouring. In the centre, directly below Brescia, one can discern a lion's skin, perhaps associating the idea of strength with that of love of peace.
Since the painting by Titian (according to another source largely executed by assistants of Titian) was lost, Rubens worked either from a preliminary drawing or a copy. Müller Hofstede dated the drawing very early (1600–1601) but the relaxed fluency of the lines seems to point to a somewhat later date.
While I can understand why several experienced scholars have preferred an attribution to Van Dyck rather than to Rubens, the drawing seems to be more characteristic of the older master. I do not find in Van Dyck the sustained control that extends here to every detail of the work, giving substance and clarity to all forms; the argument is essentially the same as I make in the case of the peasant scene (No.4) which was also given to Van Dyck by Vey, and which—despite the great difference of time and nature of the model—exhibits the same qualities of precision and consistency typical of Rubens, but foreign to Van Dyck.

31 [Plate 26]

THE SULTAN AND HIS RETINUE

c. 1606–1608. Pen and ink (bistre), grey wash and touches of red and yellow chalk. 271 × 213 mm.
London, British Museum (Oo.9–30).

COLLECTIONS R. Payne Knight bequest, 1824.
EXHIBITIONS Frankfurt, *A. Elsheimer*, 1966–7, No.250; London, 1977, No.41.
LITERATURE Hind, II, 44; I. Jost, 'A Newly Discovered Painting by Adam Elsheimer', *The Burlington Magazine*, CVIII, 1966, 3–6; Keith Andrews, *Adam Elsheimer, Paintings–Drawings–Prints*, Oxford, 1977, Pl.118; Jaffé, 1977, 53L; Logan, *Master Drawings*, XV, 1977, 412.

This drawing was etched by Pieter Claesz. Soutman (F. van den Wijngaert, *Inventaris der Rubeniaansche Prentkunst*, Antwerp, 1940, No.643; Logan suggested that Soutman also drew the London drawing, a view I cannot share).

The London drawing is a rather unusual work, since all figures, with one exception, are based on a painting by Elsheimer (The Stoning of St. Stephen), now in the National Gallery of Scotland in Edinburgh (see Andrews), but does not render that subject at all. Rather it is an assembly of several figures from Elsheimer's painting, some from the foreground and many from various groups in the background, to form a completely new composition. That was done with great ingenuity, since one of the tasks had been to adjust the scale of the figures which means that several of the smallest ones in Elsheimer's painting had to be enlarged greatly to appear as equal companions to the turbaned horseman who in Elsheimer's painting was the pagan commander in the Stoning of the Saint. As it stands now, the drawing renders a group of Oriental warriors, without any reference to a Christian theme. Was that only an idle exercise? Or a somewhat unusual tribute to Elsheimer, whom, as we know, Rubens esteemed highly? (See the letter he wrote at the news of Elsheimer's death, Magurn, *Letters*, 53–54.) An answer, of sorts, may be found in Soutman's etching. In eight lines of Latin poetry (the source of which I have not located) the speaker tries to arouse a complacent populace to fight a powerful enemy and to re-establish their own authority (*Ac nos supino semper in otio/Perdemus aevum. surgite Dardani/Cives triumphantumque captis/Imperium reparate Graijs*). In terms of the contemporary world of Rubens' own time, the well-armed hordes referred to in the first four lines (*Heu quantus armis quantus adest Equis/…*) were easily identifiable as the Turkish soldiery menacing the European heartland, though the danger in the early seventeenth century was more part of a traditional conceit than justified by an actual threat.

The difficulty lies in the chronological relationship of Rubens' drawing and Soutman's print. Rubens' contact with Soutman is generally placed in the middle of the second decade, but may have begun somewhat earlier. Still, it is unlikely that Rubens would have excerpted so many figures from a painting by Elsheimer many years after his return from Italy only to make a—less than urgent—political statement. But he may have thought of it—possibly with Elsheimer's agreement—while he was still in close contact with the German painter; or else Dr. Faber—a friend both of Rubens and Elsheimer—may have suggested such a composition as a warning against the Turkish danger.

In fact, there is good reason to retain the early date for Rubens' drawing, since he incorporated several of its elements in the sketch for the *Adoration of the Magi* of *c.* 1609–1610 (Groningen, see Held, 1980, No.325 and p.451), and precisely at the scale he had given them in the London drawing. There remains, of course, the simple or simplistic explanation (which hitherto appears to have been assumed silently) that he treated Elsheimer's painting as a convenient model for costume studies, to be used wherever they may be appropriate.

32 [Plate 33] *(1959: No.74)*

ST. CATHERINE

1606–1607. Brush and bistre over black chalk, reinforced in a few places with pen and ink. 470 × 315 mm. The paper is torn at the top; a jagged piece of paper is missing above the head.
New York, Metropolitan Museum of Art (Rogers Fund 65175)

COLLECTIONS L. Burchard
EXHIBITIONS Amsterdam, 1933, No.84; Brussels, 1938–39, No.9; London, 1950, No.43; Antwerp, 1956, No.26.
LITERATURE L. Burchard, in Glück, *Essays*, 375; Kieser,

Münchner Jahrbuch der Bildenden Kunst, 1933, 112; Evers, II, 114; 119; L. Burchard, *Catalogue*, Exh. London, 1950, 51; Chr. Norris, *The Burlington Magazine*, XCIII, 1951, 4, 7; Haverkamp Begemann, in *Catalogue*, Exh. Rotterdam, 1953, under No.3; Burchard-d'Hulst, 1963, No.28; Jaffé, 1977, 96; Vlieghe, *Saints II (Corpus Rubenianum VIII)*, 1973, No.109b.

Inscribed in upper left corner: Antonius van Dyck; in lower left: A.V.D.150. A few lines in chalk (of another figure) are visible at the left.

The drawing was made at the same time as Rubens' studies for the decoration of the high altar at Sta. Maria in Vallicella in Rome, with which he was occupied between 1606 and 1608 (see also Nos. 33, 41, 42). Rubens first painted a single picture, finished in June, 1607, which was found unsuitable and is now in Grenoble (*KdK.23*); it was replaced in 1608 by three pictures, painted on slate, which are still *in situ* (*KdK.24–25*). Evers, the first author since M. Rooses to make a thorough investigation of the sequence of events, assumed that in February, 1608, Rubens made an intense effort to redesign the work, and he placed the present drawing among the studies made then, together with two others which are very close to it: a drawing in the collection of L. Burchard, showing the same figure in sketchy outlines, together with other saints (Burchard-d'Hulst, 1963, No.26 recto), and a large *modello* (146 × 119 cm.) formerly in Potsdam and now Berlin–Dahlem, Staatliche Museen Preussischer Kulturbesitz (Held, 1980, No.396). The connection between these three works cannot be denied. The saint is virtually the same in both drawings. A study of the drapery shows, as Evers has correctly observed, that the corresponding figure in the *modello*, too, although seen in profile rather than turned inward as in the drawing, is based on the same model. Evers suggested that Rubens worked from a plastic model; I see no compelling reason to accept this theory.

The question then would be whether the three works were indeed done in preparation for the final solution, or before the first one. Despite Evers' strong plea for the former alternative, the latter seems to be preferable. Evers' chief argument lies in the observation that the *modello* does not provide a place for the miraculous image of the Virgin, an essential part of the project (see No.42), and hence must date from a period when the division into several panels was already contemplated. He himself, however, suggests that at this stage the image of the Virgin was to be placed in a separate panel—the general idea of which is preserved in a drawing in the Pushkin Museum, Moscow (see Jaffé, 1977, 98, 1)—above the central piece with the various saints. If this was possible in 1608, there is no reason why such a solution could not already have been envisaged in 1606–1607. Indeed, there are good reasons for assuming that the group of works lay before the first version, just as Burchard avers.

While appearing as a St. Catherine (so identified because of the sword she is holding) in the present drawing, the figure was used for St. Domitilla in the pen-drawing and in the *modello*; this saint was essential to the hagiographic programme of the altar of the Chiesa Nuova.

Technically, the drawing is rather unusual, having been produced almost entirely by brush-work. For Rubens' interest in brush-techniques at this time, see the Introduction, p.53.

There is an engraving by Schelte a Bolswert (Evers, II, Fig.19) in which the figure of St. Domitilla from the Grenoble altarpiece was taken almost literally, though in reverse, for a representation of St. Catherine. It is perhaps not accidental that the figure which had been developed from a St. Catherine in turn served as a model for this saint.

For this entire complex of questions see now also Held, 1980, 537–45, where I have redefined and to some extent modified my position and made detailed reference to the extensive literature published since the above was written.

33 [Plate 39]

SAINTS GREGORY, DOMITILLA, MAURUS AND PAPIANUS

1606 (before September 25). Pen and ink, washed, over black chalk. 735 × 435 mm.
Montpellier, Musée Fabre (3704).

COLLECTIONS Convent of the Oratorians in Pezenas; Bonnat-Mel, Pezenas; given to the museum in 1864.
EXHIBITIONS Cologne, 1977, No. 32.
LITERATURE J. Claparède, Inventaire, 1943 (as Anonymous, Flemish, 17th century); M. Jaffé, 'Peter Paul Rubens and the Oratorian Fathers' (advance extract, *Proporzioni*, IV, 1959); *ibid.* 1963; J. Müller Hofstede 'Rubens' first Bozzetto for Sta. Maria in Valicella', *The Burlington Magazine*, CVI, 1964, 442 ff.; Vlieghe, *Saints* II (*Corpus Rubenianum*, VIII) 1973, under No. 109; Jaffé, 1977, 96, Pl. 322; Logan, *Master Drawings*, XIV, 4, 1978, 422; Freedberg, *Revue de l'Art*, XXXIX, 1978, 90, note 19; Held, 1980, 541, under No. 396.

The attribution of this important and surely authentic drawing is due to Jaffé. (I cannot follow the negative judgments by Vlieghe, Freedberg, and Logan.) It may well be the 'disegno o sbozzo' (Jaffé) mentioned in the contract for the altarpiece of September 25, 1606. The history of the entire project has been discussed at great length by various authors, chiefly Jaffé, Müller Hofstede, and Warnke; a summary of the historical data has been given by me, 1980, 537–45.
Although the Montpellier drawing foreshadows the general disposition of the figures as they were eventually painted in the canvas now in Grenoble, there is hardly a single detail that was left unchanged. The main difference, at any rate, seems to be in the proportions of the entire work: in the drawing height is stressed considerably over width, in contrast to the panel in Grenoble which permits the figures to spread out more comfortably sideways. This change of proportions also gave Rubens the chance to revert to some aspects of the 'demonstration-piece' (now in Berlin, Held, 1980, No. 396) particularly for the figure of St. Gregory with the expansive movement of his arms and the grand sweep of his gown. Although the central arch was greatly enlarged and extends higher up, the area reserved for the miraculous image (left open in the Montpellier drawing) and the putti draping garlands around it is considerably reduced in size, so that the figures dominate the composition much more forcefully.
Together with two other drawings done in a similar technique and also datable to *c.* 1606 (see No. 32), the Montpellier drawing is of considerable importance for the chronology of washed pen-drawings done before Rubens' return to Antwerp.

34 [Plate 34]

LAOCOÖN, SEEN FROM THE BACK

c. 1605–1608. Black chalk. 440 × 283 mm. A small piece of paper has been cut away at the right, just below the centre.
Milan, Biblioteca Ambrosiana (F.249 inf.Folio 5; see also No. 34).

COLLECTIONS Padre Sebastiano Resta.
EXHIBITIONS Cologne, 1977, No. 55.
LITERATURE Held, 'Padre Resta's Rubens Drawings after Ancient Sculpture', *Master Drawings*, II, 1964, 2, 123–41, reprinted Held, *Rubens and his Circle*, Princeton, 1982, 94–105; M. Winner, 'Zum Nachleben des Laokoön in der Renaissance', *Jahrbuch der Berliner Museen*, XVI, 1974, 83 ff; Müller Hofstede, *Catalogue*, Cologne Exhibition, 1977, 252.

Both Winner and Müller Hofstede made the point that Rubens must have worked from a plaster cast since the niche in the Belvedere Gardens where the Laocoön group was displayed was too shallow to permit drawing the figures from behind. One plaster cast of the group is, in fact, documented: made by Primaticcio for King François I of France and then cast in bronze, it is now in the Louvre (see A. von Salis, *Antike und Renaissance*, Erlenbach-Zürich, 1947, 139). The theory that Rubens drew the Laocoön group from a plaster copy, rejected by me in my 1964 study (note 14), still fails to convince me fully.
The Laocoön group was discovered in Rome on 13 January 1506 and immediately became the most celebrated work of ancient statuary known to the Renaissance. Missing at that time were the right arm of Laocoön, the right arm of his younger son, some fingers on the right hand of the elder one, and parts of the serpents. When Rubens drew the group and its individual figures, the missing forms had been in part restored, albeit incorrectly. On the basis of the six original drawings currently known (five in Milan and one in Dresden) and the copies of lost drawings (in Copenhagen) we can ascertain that Rubens must have made at least fifteen drawings of the Laocoön group, looking at it from various angles, including the back. The drawing in Milan that shows the entire group (Held, 1982, pl. VIII, 1) must be counted as two drawings since the older son (at the right) was drawn separately and only later silhouetted and superimposed on the main sheet (by Padre Resta?). As he always did, Rubens reinterpreted the ancient work in terms of his own style and sentiment. In my first publication of the Milan drawings I summed this up in these words: 'Rubens' figures are less heroic in the grand manner but more human than their models. Their plight is more touching because they are less idealized, and the intimate angles of vision, so foreign to the traditional manner of drawing from the antique, bring them still closer to our sympathetic attention.'
It is not clear how Padre Resta obtained the nine drawings now assembled in the album at the Ambrosian Library. (One of the nine, depicting the story of the Brazen Serpent, is a copy of Rubens' original, now in the British Museum, see Hind, II, No. 4). They may have come into Resta's possession together with an original drawing by Michelangelo of which he speaks in a lengthy preface to the album in Milan. That drawing, so Resta says in that 'letter', addressed to the *Signori Pittori e Virtuosi di Milano*, had been in Rubens' own collection and had been acquired by 'Monsù Habé' after Rubens' death—presumably in the great dispersal sale of 1657—and had later belonged to 'il fiamingo' which I take to be François Duquesnoy, the famous sculptor. Resta identified 'Monsù Habé' as a former (and favoured) student of Rubens and Van Dyck and gave some additional information in the so-called Lansdowne manuscript of the British Museum (see A. E. Popham, 'Sebastiano Resta and his Collections', *Old Master Drawings*, XI, 1936, 1ff.): 'Questo Habé fu un Fiamingo discepolo di Vandyck che venne anco per la Lombardia a nostri giorni, fu d'Enthusiasmo feroso' ('This Habé was a Fleming, a pupil of Van Dyck, who came to Lombardy in our time, he was fiercely enthusiastic'). Popham thought 'Monsù Habé' might have been the painter Hendrick Abbé, who, however, was not born until 1639 and hence could not have been a pupil of either Rubens or Van Dyck. I had submitted that he might have been Gilles Hallet, born in 1620 in Liège, a painter who is known to have worked in Rome, where he died in 1694. Burchard-d'Hulst (1963, 183) identified 'Monsù Habé' with a Brussels art dealer Gelande Habert who is mentioned twice in the 1680s; and Jaffé accepted this theory (1977, 102), but was in error when he said that Resta himself identified the vendor of the Ambrosiana drawings as 'Monsù Habé'. Even this theory remains purely conjectural, especially as it is not known whether Gelande Habert ever was in Italy.
Van Dyck copied one of the drawings that show Laocoön from the back but not necessarily the one discussed here, unless one assumes that he took great liberties with the model (see Jaffé, *Van Dyck's Antwerp Sketchbook*, London, 1966, II, Pl. 28 verso).

35 [Plate 35]

LAOCOÖN'S YOUNGER SON, SEEN FROM THE FRONT

c. 1605–1608. Black chalk. 411 × 260 mm.
Milan, Biblioteca Ambrosiana (F.249 inf. Folio 6).

COLLECTIONS Padre Sebastiano Resta.
EXHIBITIONS Cologne, 1977, No. 56.
LITERATURE Held, 'Padre Resta's Rubens Drawings after Ancient Sculpture', *Master Drawings*, II, 1964, 2, 123–41; reprinted Held, *Rubens and his Circle*, Princeton, 1982, 94–105; Müller Hofstede, *Catalogue*, Cologne Exhibition, 1977, 254.

When Rubens drew this figure, all the fingers of the right hand and four toes of the right foot were missing. Although not actually drawn, the father's knee is clearly silhouetted near the youth's left hip. The pose of this son of Laocoön recurs much later in Rubens' painting of the Abduction of Ganymede by the Eagle of Zeus (Madrid, Prado, *KdK*.392) though almost certainly taken from a drawing taken from the youth's right side. The pose of the older son was used by Rubens in a seemingly very different context (as Burchard-d'Hulst observed, 1963, 32) for Nicodemus standing on a ladder in the Antwerp Descent from the Cross (*KdK*.52, see also Held, 1980, II, Pl.351). Yet as in most of those cases where Rubens shifted a figural motif from the pagan to the Christian sphere, he acted from a true recognition of the expressive content of the ancient model. In this case, for instance, both figures are involved in a heartrending event: Laocoön's son sees the cruel suffering of his father while Nicodemus watches the sad duty of the lowering of Christ's lifeless body. (For other uses of Laocoön, see Burchard-d'Hulst, 1963 33.)

36 [Plate 36]

LAOCOÖN'S YOUNGER SON, SEEN FROM THE BACK

c. 1605–1608. Black and some white chalk. 443 × 265 mm.
Milan, Biblioteca Ambrosiana (F.249 inf. Folio 5).

COLLECTIONS Padre Sebastiano Resta.
EXHIBITIONS Cologne, 1977, No.57.
LITERATURE J. S. Held, 'Padre Resta's Rubens Drawings after Ancient Sculpture', *Master Drawings*, II, 1964, No.2, 123–41, reprinted Held, *Rubens and his Circle*, Princeton, 1982, 94–105; Müller Hofstede, *Catalogue*, Cologne Exhibition, 256.

Müller Hofstede—following Winner's argument (see No.34)—points out that this drawing, too, was probably made from a plaster cast, since it was impossible to draw any of these figures from behind.

37 [Plate 17]

SILENUS

c. 1605–1608. Black chalk. 413 × 262 mm. (It may originally have been higher, to show also the feet of the sculpture which, however, were restored from the knees down.)
London, British Museum (5211–58).

COLLECTIONS William Fawkener (bequeathed 1769).
EXHIBITIONS London, 1977, No.13.
LITERATURE Hind, II, No.51; Fubini-Held, 'Padre Resta's Rubens Drawings after Ancient Sculpture'. *Master Drawings*, II, 1964, 2, 141 (note 39) reprinted: Held, *Rubens and His Circle*, Princeton, 1982, 104–5, note 39; Jaffé, 1977, 82L and 117, note 51.

The original marble drawn by Rubens on this sheet is a

sculpture now in the Dresden *Skulpturensammlung*; it had come to Dresden in 1728, with the collection of antiquities belonging to Prince Agostino Chigi of Rome. (Fig. 11; another version is in the Glyptothek in Munich, see Emil Kieser, 'Rubens' Münchner Silen und seine Vorstufen', *Münchner Jahrbuch der Bildenden Kunst*, N.F.1938–39, 185–202.) The drawing exists in a very good copy in Copenhagen (Held, 1982, Fig.VIII.13), which might very well have been taken to be Rubens' original, if we did not have the London sheet.

Rubens drew the same figure a second time, but seen from the front (Jaffé, 1977, pl.293); it is now in the Musée des Beaux-Arts, Orléans. (Its dimensions were not given by Jaffé.) The London drawing, in style as well as format, is closely linked to the drawings in Milan and probably dates from the same period—the last years of Rubens' stay in Rome.

Rubens clearly made use of the drawing in one of his early bacchanals (Leningrad, *KdK*.82). Rather than leaning against a tree trunk, Silenus here has the support of a goatlegged satyr woman and a satyr with a goat's face. The staggering god holds an apparently empty tankard in his left hand—a logical object given the pose of that hand. That arm and hand, however, like the lower parts of the legs, were a sixteenth-century restoration and (like the legs) have been removed in modern times.

Fig. 11 Drunken Silenus with Tankard. Marble, 103 cm high. Dresden, Skulpturensammlung

38 [Plate 37]

SLEEPING HERMAPHRODITE

c. 1608. Black chalk. 310 × 437 mm. Some outlines seem to have been redrawn by another hand.
Inscribed lower left (in an early script): A. V. Dÿck, and Van Dyck.
London, British Museum (1946–7–13–1005).

COLLECTIONS Comte de Fries; Sir T. Lawrence; S. Woodburn; Sir T. Phillipps; T. Fitzroy Fenwick.
EXHIBITIONS London, 1977, No.18.
LITERATURE A. E. Popham, *The Phillipps Fenwick Collection of Drawings*, London, 1935, 184, No.3; Logan, *Master Drawings*, XV, 1977, No.4, 412 (Van Dyck); Renger, *Kunstchronik*, XXXI, 1978, 135.

A majority of scholars have rejected the attribution to Rubens while not necessarily accepting the old inscriptions which give it to Van Dyck. Popham called it too weak and colourless for

Rubens, an opinion repeated by Renger. John Rowlands, however, included it in his 1977 exhibition as Rubens' own work, and I, too, find it less incompatible with Rubens' studies after ancient sculpture than severer critics have held. The extreme tenderness of modelling is somewhat unusual though not unparalleled. It is found also, for instance, in the drawing after the Bacchic Vase in the Louvre (Dresden, Kupferstich-kabinett, black chalk, 292 × 383 mm., first attributed to Rubens by M. Jaffé, 1967). It certainly would be exceptional in Van Dyck's oeuvre. Van Dyck never seems to have shared Rubens' sustained interest in the sculptural remains of classical antiquity. In his book on Van Dyck's drawings Vey included only three that were done from ancient sculpture, and they are very different in style and technique (Nos.156, 158, 159). The only major work of ancient art Van Dyck copied in his Italian sketchbook (now National Gallery, London; see Adriani, folio 50v° and 51r°) is a painting—the Aldobrandini Wedding.

Pliny (xxxiv, 80) mentions Polycles as the sculptor of Hermaphrodite. Rubens' model seems to have been the Sleeping Hermaphrodite which is now in the Louvre (Bieber, *The Sculpture of the Hellenistic Age*, 2nd ed., New York, 1961, Fig.623). That sculpture was discovered only in 1608, which furnishes an unusually precise date for the London drawing. It, too, was part of the Borghese collection, like the Bacchic Vase mentioned before, which may account for the stylistic similarity between the two drawings. (For Rubens' familiarity with Roman collections of ancient sculpture see M. van der Meulen, *Gentse Bijdragen tot de Kunstgeschiedenis*, xxiv, 1976–8, 147–58.) There is another drawing of a sleeping Hermaphrodite, attributed to Rubens (red chalk, 228 × 372 mm.), which came to the Metropolitan Museum from the collection of Walter C. Baker, New York. Its connection with the former Borghese version of the theme is less close than that of the British Museum piece. The question of its model is in need of further study.

39 [Plate 23]

A YOUTH IN THE POSE OF THE SPINARIO

c. 1605–1608. Red chalk with touches of white highlights; the grey wash covering the background was added by another hand. 260 × 360 mm.
London, British Museum (5213–1).

COLLECTIONS G. Hugnier; William Fawkener. Bequeathed 1769.
EXHIBITIONS London, 1977, No.14.
LITERATURE Hind, *Catalogue*, No.52; G.-H. No.27; Burchard-d'Hulst, 1963, No.16.

The drawing shows the same model in two similar, though not identical poses, modelled after one of the most celebrated ancient sculptures, known as *spinario*—a boy pulling a thorn from his foot. The bronze figure, now in the Palazzo dei Conservatori in Rome, had survived above ground all through the Middle Ages and had exerted a vast influence on artists of the Renaissance as early as the fifteenth century. (For that history see A. von Salis, *Antike und Renaissance*, Erlenbach-Zürich, 1947, 124–34, and H. Ladendorf, *Antikenstudium und Antikenkopie*, Berlin, 1958, 23–4 and 45.) The London drawing (and two others which I shall refer to later) are of unusual interest since they demonstrate a studio practice that later was not uncommon in the French Academy but for which this is the only example we have from the Rubens studio.

The slender youth Rubens drew is seen from his left side in the pose drawn at the left; while turning his head towards the beholder, his eyes even seem to look up. Instead of acting as if pulling a thorn he appears to be drying his left foot with a towel. His thigh was drawn once more separately in the lower centre of the sheet. The second pose at the right follows the

spinario motif more faithfully, but the figure is seen slightly from the back. Unlike the boy in the ancient sculpture, whose hair remains neatly arranged around cheeks and neck, in Rubens' drawing some locks fall down over the youth's forehead. Although a drawing after a live model could have been done at any time, the drawing stylistically belongs to those Rubens did from ancient sculpture while in Italy; in fact, it seems to be rather close to his drawings of the Laocoön group and should hence be dated to the second Roman period of the master.

Alerted to its existence by Ann Sutherland Harris, Anne-Marie Logan published a similar drawing now in the museum in Dijon (red and traces of black chalk, 244 × 379 mm.), *Master Drawings*, xv, No.4, 1977, 412 and Pl.47b. Here, too, the pose is drawn twice; on the left the youth is seen from the back; on the right, from his right side. His face is not visible in either pose. I do not remember having seen the original and admit that most likely it was done in the same session during which Rubens sketched the London sheet. I do, however, see some differences, even in the shape of the model, who seems to be more compactly built in the Dijon drawing.

A third drawing, depicting the pose of the *spinario* studied from a live model, though only once, is in a private London collection (Jaffé, 1977, 73L, 80L, Pl.273; black and white chalk, 277 × 186 mm.). It shows the youth again from his left side, but slightly more from the front. I know that drawing also only from the reproduction. (See also above, No.28.)

40 [Plate 29]

PAN RECLINING

c. 1605–1608, reworked at a later date. Counterproof of an early drawing in red chalk. 309 × 493 mm. The reworking is done with the brush, with red and grey washes, heightened with body-colour; some traces of black chalk. The vines belong to this phase of the work.
Washington, National Gallery of Art (B.30.457), Ailsa Mellon Bruce Fund.

COLLECTIONS J. Richardson, Sr.; B. West; Sir Charles Greville; the Earl of Warwick; Sir John Robinson; Charles A. de Burlet; L. Burchard; W. Burchard. Sale Christie's, April 9, 1970 (63).
EXHIBITIONS Amsterdam, 1933, No.101; Brussels–Rotterdam, 1938–39, No.7; London, 1953–4, No.521; Antwerp (Rubenshuis), 1956, No.121; London, 1977, No.38a.
LITERATURE G.-H. No.25; Burchard-d'Hulst, 1963, No.161; Jaffé, *The Burlington Magazine*, CVII, 1965, 381 (161); Stechow, 1968, 40.

Pan lies on the ground in a drunken stupor, his back supported by a wine bag, his head resting on a goat's skin; with his left hand he still holds the syrinx, while his goat's legs are spread, one of them resting on a branch of a vine.

When Rubens drew this figure, he probably took the sculpture of *giallo antico*, on which it is based, for a work of antiquity. It belonged at that time to the Barberini collection (Palazzo Barberini) but since 1947 it has been in the City Art Museum, St. Louis (Mo.). Most scholars attribute that marble to Giovanni Angelo Montorsoli (1507–1563). Jaffé suggested that the sculptor worked over an ancient core. (In the 1933 exhibition another Italian sculptor, Vincenzo Rossi, was mentioned as the author of the work.)

The method of a reworking (at a later date) of a counterproof of an earlier drawing was observed by me in the first edition of this book, p.156, under No.158; see above, No.22.

For an ancient source of the pose, see A. von Salis, *Antike und Renaissance*, Erlenbach-Zürich, 1947, 118–21, pl.27b and 27d.

41 [Plate 40] *(1959: No.16)*

ST. GREGORY, ST. MAURUS, AND ST. PAPIANUS

1608. Pen and ink, washed; traces of white body-colour.
158 × 140 mm.
Chantilly, Musée Condé (V.329).

COLLECTIONS Revil; Duc d'Aumale
LITERATURE R., V, No.1450; J. Guiffrey, *Antoine van Dyck*,
Paris, 1882, 94; Glück, *Essays*, 21, 375; G.-H. No.53; Evers, I,
59–60; Held, 1980, p.544.

Inscribed, by a later hand, in the lower right corner: P. P. Rubens.

Between May and October, 1608, Rubens replaced the painting
on the high altar of the Chiesa Nuova of the Oratorians at
Rome, which he had finished the year before, with three
independent pictures, two of them to be hung on the side walls.
They were painted on slate to avoid the reflections that had
hindered appreciation of the earlier work. The Chantilly
drawing is a draft for the picture on the left wall of the choir.
The dominant figure in it is St. Gregory, whose tiara is carried
by a small angel; in the first painting, which is now in Grenoble
(*KdK.*23), St. Gregory had been the main figure of the whole
altar. His appearance remained fairly constant after Rubens had
developed the basic pattern; the main difference between the
Chantilly drawing and the last painting on the one hand, and the
Grenoble canvas on the other, consists in a more graceful
curvature of the Saint's body in the two later works, and in the
gathering up of one end of the pluvial so that it falls across, and
is held by, the book in the Saint's left hand. St. Maurus,
standing in armour on the left, had appeared in profile in the
Grenoble painting. While he is seen frontally in both the
Chantilly drawing and the final painting, there are still con-
siderable differences between the two versions, since in the
finished painting he looks at the beholder and rests his left hand
on his shield instead of holding a piece of drapery. There are
also two putti flying overhead with his martyr's wreath instead
of only one in the drawing. The poses of all the putti are
different from the drawing. St. Papianus and the little angel
who carries the tiara are fairly similar in both drawing and
painting; the latter figure, incidentally, is the only one whose
pose was altered by Rubens while he made the drawing; his
body was first drawn in a more upright position to which
Rubens reverted in the finished picture. Some of the changes
from drawing to painting may have been prompted by changes
in plan concerning the proportion of the picture; the height of
the final version is greater than the width, while in the drawing
Rubens apparently counted on a nearly square format. Thus he
was forced to move the figures closer together so
that the angel with the tiara came to stand directly beneath
St. Gregory's outstretched hand. When Rubens drew the Lon-
don sketch containing Sts. Domitilla, Nereus and Achilleus
(G.-H.52), he seems to have known the desired dimensions,
for the proportions of the drawings agree much more closely
with those of the final work.
There is a drawing in the British Museum that shows the same
three Saints as the Chantilly sheet. Glück and Haberditzl
considered it to represent an earlier phase in the development of
Rubens' ideas for the altar (G.-H.No.51); Hind, following the
old inscription, had published it as a work of Van Dyck's).
Despite the fact that it has been a companion piece to the draw-
ing of Sts. Domitilla, Nereus and Achilleus from Mariette's
time on, and that it has the almost square format which was
apparently contemplated at one time, there are doubts in my
mind as to whether it really is an autograph drawing by Rubens.
It has technical and stylistic aspects which, at the present state of
our knowledge, rather isolate it among Rubens' early drawings.
For the entire project, including an oil-sketch in the Barock-
museum in Salzburg see Held, 1980, Nos.396–98, pp.537–45.

42 [Plate 43] *(1959: No.17)*

THE IMAGE OF THE VIRGIN ADORED BY ANGELS

1608 (beginning of the year). Pen and ink, washed, heightened
with white (especially in the sky) on a light preliminary pencil-
drawing. 268 × 152 mm. The image of the Virgin inside the
frame was done with the brush only. The design was extended
by Rubens on both sides by about 5 mm.
Vienna, Albertina (8231).

COLLECTIONS P. J. Mariette; L. Lempereur.
LITERATURE F. M. Haberditzl, 1912, 271 (Pl. XXVII); Glück,
Essays, 21–22; G.H. No.54; Evers, I, 59; *idem*, II, 115–117;
Müller Hofstede, 1977, No.19; Jaffé, 1977, p.98, Pl.329;
Mitsch, 1977, No.5.

This drawing was made by Rubens early in 1608 when it had
been decided that the first altarpiece for the High Altar of the
Chiesa Nuova was to be replaced by three individual paintings,
one to grace the altar, two others to flank it lower down on the
walls of the apse (see the comment to No.41). The Vienna
drawing was made for the central picture on the altar. Icon-
ographically it is related to an altarpiece by Federico Zuccari, in
the third chapel at the right, the 'Capella degli Angeli', in Il
Gesù. (See L. Van Puyvelde, *La Peinture Flamande à Rome*,
Brussels, 1950, 150. Zuccari's painting was done after 1590 and
before 1603, see Giulio Manconi, *Considerazioni sulla Pittura*,
Rome, 1957, 88, note 740, [Luigi Salerno].)
The original project had combined two themes: the glorification
of the old patron saint of the church, St. Gregory the Great, and
the veneration of the miraculous image of the Virgin, which had
been preserved from the original church. It was to be exhibited
above the altar on special occasions, while the artist had to
include a reasonable facsimile in his picture. In Rubens' first
solution both themes are united in one canvas (*KdK.*23). In the
second, the veneration of the image took precedence over that
of St. Gregory as the sole theme of the main picture.
The Vienna drawing gives an interesting insight into the
development of the second version. Instead of showing the
miraculous image as part of the architecture, as he had done in
the first version, Rubens now painted it held aloft by a large
number of flying child-angels while bigger angels, kneeling on
clouds, adore it from below. The proportions of the drawing do
not quite agree with either the first or the second painting, being
higher and narrower than they. It was easy, however, to cut the
composition down to the required proportions, since the design
does not reach either to the lower or to the upper margin. The
Vienna drawing was followed by an oil-sketch, now in the
Vienna Academy (Held, 1980, No. 397). The decisive changes
lie between the drawing and that sketch; the final painting
follows the sketch fairly closely. The main changes concern the
relative size of the figures and their distribution in space.
Whereas in the drawing the arrangement is strikingly asymmet-
rical, the sketch introduced a higher degree of symmetry into
the placing of the groups of angels. All the figures, furthermore,
are larger in the oil-sketch, with the result that the beholder feels
closer to the picture as a whole and particularly to the
miraculous image. The frame of the image, which Rubens had
designed with a semicircular top in the Grenoble canvas, and as
a highly decorative *cartouche* shape approaching the oval in the
drawing, became a clear ellipse in the oil-sketch; in the final
painting it was flattened at the sides and the frame, which was
already simpler in the oil-sketch than in the drawing, was finally
no more than a perfectly regular, unadorned moulding, inserted
bodily into the painting. Of the putti who hold the painting,
several survived all transformations and were taken over into
the final painting; of the larger angels, only the one kneeling in
the lower left corner is still found in the finished version; the
second from the left, used in the oil-sketch, was given a
different and more restrained pose in the large picture; the one

in the right corner was already transformed in the sketch, and in that pose but with more chastely draped shoulders entered the last version.

The effect of the finished picture is rather heavy and lacks the imaginative gaiety of the drawing; there is more fervour in the angels' attitudes in the drawing and even in the oil-sketch. It is possible that this general emotional reduction of the work reflects the interference of Rubens' patrons rather than Rubens' own intentions. It was perhaps the price which Rubens had to pay to the *genius loci*, the majestic though somewhat heavy Roman early Baroque, so well represented by F. Rughesi's façade of the Chiesa Nuova of 1605. (Evers, in contrast to the view presented here, believes that the changes were all due to Rubens' personal development without any interference from outside.) A drawing in Moscow (red chalk, 440 × 370 mm.) depicting only the framed image of the Virgin surrounded by child-angels must be placed between the Albertina drawing and the oil-sketch in the Academy in Vienna. It was first published by Jaffé (*Proporzioni*, VI, 1959, Pl.51) and again in his book *Rubens and Italy*, 1979, p.98(I) and Pl.328. (See also Kuznetsov, 1965, No.11.) A copy of this drawing is in the Louvre (G.-H. No.55 and Lugt, *Catalogue*, No.1008).

43 [Plate 42] *(1959: No.18)*

TWO SHEPHERDS AND A MAN WITH TURBAN

1608. Pen and ink, washed. 139 × 150 mm.
Amsterdam, Fodor Collection, Gemeente Musea (1936–126).

EXHIBITIONS Antwerp, 1977, No. 127.
LITERATURE J. S. Held, *Magazine of Art*, 1951, 291, Fig.10; Burchard-d'Hulst, 1963, No.41; Kuznetsov, 1974, No.26; Jaffé, 1977, 98R; Mitsch, 1977, under No.6.

The shepherds are studies for the Adoration of the Shepherds in Fermo (cf. R. Longhi, *Vita Artistica*, I, 1926, 191; *Pinacothea*, I, 1928, 169; *Bollettino d'Arte*, XXVI, 1932, 387). The drawing accords more closely with the sketch for this picture which is now in Leningrad (Held, 1980, No.321); in the finished picture the hands of the shepherds are changed and also, to a lesser extent, their faces. The head of the oriental was used in the Conversion of St. Paul, formerly in Munich, now in the Princes Gate Collection, Courtauld Institute Galleries, London, where it appears near the right edge. Rubens may have derived the idea for this head from Elsheimer, since a very similar head appears in the composition which Rubens drew after Elsheimer (see No.31; see also No.61).

Longhi had thought that the Fermo painting was a 'sample' ordered by the Oratorians before giving Rubens the commission for the paintings in the Chiesa Nuova. This would date the work in the year 1606. According to Francesco Maranesi (*La Natività di P. P. Rubens*, Fermo, 1954), however, the painting was executed between February and June, 1608. It is most likely, therefore, that the drawing was made early in that year.

44 [Plate 41]

ST. IGNATIUS OF LOYOLA CONTEMPLATING THE HEAVENS

c. 1606–1608. Pen and bistre wash. 114 × 98 mm.
Paris, Louvre, Cabinet des Estampes (22.239).

COLLECTIONS P. J. Mariette?
EXHIBITIONS Paris, 1978, No.10.
LITERATURE F. Lugt, Inventaire . . . II, Paris, 1949, No.1614 (Anonyme); Held, 'Rubens and the Vita Beati P. Ignatii Loiolae of 1609', *Rubens before 1620* (ed. J. R. Martin), Princeton, 1972; Held, 'Some Rubens Drawings—Unknown or Neglected',

Master Drawings, XII, 1974, 249 ff.; Ursula König-Nordhoff, *Ignatius von Loyola*, Berlin, 1982, 280 and 300–4; Held, Review of König-Nordhoff's book, *Kunstchronik*, 1984, 46–53.

The small drawing is Rubens' sketch for plate 68 of the *Vita Beati P. Ignatii Loiolae*, published in Rome, 1609, the year of the saint's beatification. With its 79 numbered engravings (excluding the title-page and the portrait of the saint) the slim volume is the largest illustrated *vita* of the Founder of the Jesuit order. (An 80th print depicting the canonization was prepared from the beginning but could be added only to the second edition of 1622, when Ignatius had indeed been canonized.) König-Nordhoff found evidence that the work on this publication had begun around 1605–1606, but contrary to her view I believe that Rubens entered the enterprise only at a somewhat later date. The engraver was probably Jan Baptist Barbé (1578–1649); the extent of Rubens' participation in the project can no longer be determined. I suggested (1972) that a minimum of ten prints were made from Rubens' design, but that another nine might conceivably also be by him. Mariette owned four drawings by Rubens for the *Vita Ignatii*; one of these drawings is owned by the National Gallery of Scotland, Edinburgh (see K. Andrews, *Catalogue of Netherlandish Drawings in the National Gallery of Scotland*, I, Edinburgh, 1985, D. 1965).

The basic *vita* of Ignatius of Loyola was written by Pedro de Ribadeneyra, an early follower (1527–1611); its first edition came out in 1572, but when a concerted effort was made by the order around 1600 to obtain the canonization of its founder, that *vita* was greatly enriched by tales of miraculous appearances, interventions, cures and similar events that would substantiate the claim of sanctity. The *vita* published in 1609 is rich in such incidents.

The action depicted in the Louvre drawing does not belong to such legendary miracles. It is clearly described in the five lines of text added to the (reversed) image of the engraving. Ignatius, so it says, often shed heavy tears at the marvellous sight of the sky and used to exclaim: 'How paltry is the earth when I behold the heavens.' (HEV QVAM SORDET TELLVS, CVM COELVM ASPICIO.) And when the flood of tears caused him to almost lose the sight of his eyes, he obtained from God the special favour of being able to control the gift of tears. The sickle of the moon indicates the scene as a nocturnal one; the engraver, in fact, added a fair number of stars to further stress that point.

The *Vita Beati P. Ignatii Loiolae* is the first book to which Rubens contributed illustrations of narrative subjects. (Philip Rubens, the artist's brother, had published a book of philological studies the year before [1608] which contained a number of plates of Roman sculptures engraved from Rubens' designs.) The modest drawing in the Louvre contains what is apparently the earliest preserved landscape drawing by the master. As such, it contributes an important argument against the attribution to Rubens of a series of landscape drawings of Flemish farms some of which bear identifying inscriptions and dates ranging from 1606 to 1610. They have, however, been upheld again as Rubens' work by Adler (*Corpus Rubenianum*, XVIII, I, 1982).

45, 46 [Plates 44, 45] *(1959: under No.10)*

CAIN SLAYING ABEL

c. 1608–1609. Black and red chalk and pen and ink, washed. 267 × 184 mm. Some parts were drawn directly with the brush. On the reverse: Samson slaying the Philistines (?), done without the red chalk, otherwise the same. A small strip of paper added at the bottom; on it, by a later hand: PPR.
Amsterdam, Fodor Collection, Gemeente Musea (1936–124).

COLLECTIONS J. Richardson, Sr.; The Hudson; H. Oppenheimer (sale Christie's, London, July 10–14, ('Van Dyck').

EXHIBITIONS Jerusalem, 1960, No.75; Antwerp, 1977, No.126.
LITERATURE Held, *Miscellanea Prof. Dr. D. Roggen*, Ghent, 1957, 125ff.; *Idem*, 1959, No.10 (only the reverse illustrated); Burchard-d'Hulst, 1963, 48 (Samson Slaying a Philistine); Jaffé, *The Burlington Magazine*, 1965, 380 (Samson); Müller Hofstede, *Wallraf-Richartz-Jahrbuch*, 1965, 260; Held, 1980, 427, under No.308.

The action on the recto of this drawing is closely related to an oil-sketch formerly in the collection of Louis Jay in Frankfurt (Held, 1980, No.308). Although Burchard-d'Hulst and Jaffé believe it to represent Samson Slaying a Philistine I still take it (as I did in 1959 and 1980) to represent Cain Slaying Abel, while I have an open mind about the action on the reverse, which indeed may represent Samson; as I pointed out before, the man who does the killing is a very different type as seen on the front and back, youthful and slender with long hair on the front, stocky, bald and middle-aged on the back. The jawbone of an ass as the weapon used is traditional for both figures (for Cain's use of the bone see M. Schapiro, *The Art Bulletin*, XXIV, 1942, 205–12).

The drawing is reminiscent of, but not directly connected with, a painting in the Princes Gate Collection at the Courtauld Institute Galleries. It was extensively discussed by Count Seilern in the volume of *Addenda* to his collection of Flemish paintings and drawings (London, 1969, 8–10). Before that painting appeared in the London art market, the composition had been known from an etching by Buytewech, and an early copy in the museum of the Château at Blois.

As various scholars, quoted by Count Seilern, have pointed out, Rubens was heavily indebted to several Italian sources when he painted the panel now at the Courtauld Institute. Both figures seem to be derived from Italian prototypes. This cannot be said of the figures on both sides of the present drawing. I still insist, as I did in 1959, that the action in the drawing (as well as the oil-sketch formerly in Frankfurt) is more developed and dramatically more effective than in the Princes Gate panel, which cannot be much later than 1600–1602. In fact, a greater chronological time span than I suggested in 1959 should be inserted between the Courtauld picture and the present drawing; the date of *c.* 1608–1609 which I assigned to the oil-sketch formerly in Frankfurt should also be given to the drawing.

In the Oppenheimer sale, the present drawing formed a lot with one called 'Judith' (pen and ink, washed, 184 × 130 mm.) drawn on both sides. Both drawings were attributed to Van Dyck, but the 'Judith'—now also in the Fodor Collection (1936–125)—is as typical a Rubens as the Cain and Abel. The subject, however, is not Judith but Salome, as may be seen from a large painting in the museum of Wyk auf Föhr (No.557), known to me only from a photo in the Rijksdocumentatie-bureau at The Hague. It was exhibited (and erroneously attributed to G. Seghers) at Flensburg, June–July 1954, No.23.

47 [Plate 47] *(1959: No.14)*

THE BATTLE OF LAPITHS AND CENTAURS

c. 1608–1610. Pen and ink, washed. 159 × 182 mm.
Amsterdam, Rijksmuseum (A4302).

COLLECTIONS W. Pitcairn Knowles (as Van Dyck).
EXHIBITIONS Antwerp, 1956, No.42 (dated there *c.* 1612).
LITERATURE Burchard-d'Hulst, 1963, No.52; Müller Hofstede, 1965, p.261 (1615–1616); Mielke-Winner, 1977, p.66.

The figure of the young woman is probably Hippodamia, who at her wedding to Pirithous was attacked by the Centaur Eurytus, but was freed from his clutches when Theseus killed him with one blow. The story (Ovid, *Metamorphoses*, XII, 210ff.) is told by Nestor, who took an active part in the ensuing battle between the Lapiths and the Centaurs, which ended in the total defeat of the latter. Since the rescuer of Hippodamia in Rubens' drawing is an elderly man, it is possible that the artist intended him to be Nestor—although, strictly speaking, Nestor himself was still young when the event actually happened.

The drawing forms a close group with a number of pen-drawings which I now date shortly after Rubens' Italian period (cf. Nos.48, 60, and Exh. Antwerp, 1956, No.25, where an apostle greatly resembles old 'Nestor'). The drawing offers the unusual spectacle of combining on one sheet what at first look like two completely different styles. The left half is drawn in fluid, disconnected lines that rush apparently at random or haphazardly across the paper, so that the action can only vaguely be perceived. In the jumble of penstrokes, clarified only slightly by washes, a woman (Hippodamia) can be discerned; she is seen from the back, struggling against an attacker who apparently tries to carry her off. It is not clear whether the figure nearer the ground, who looks up at her, is trying to defend her or help the attacker. The group at the right, by contrast, is drawn with great precision, and while there are evident changes of plan, it does not look as if it had ever been prepared in quite the same 'chaotic' way.

48 [Plate 48] *(1959: No.15)*

JUDITH KILLING HOLOFERNES

c. 1608–1610. Pen and ink, washed. 205 × 160 mm.
Frankfurt, Städelsches Institut (15690).

COLLECTIONS J. Barnard; Sir Thomas Lawrence.
LITERATURE J. S. Held, *Magazine of Art*, 1951, 290 (Fig.7); Burchard-d'Hulst, 1963, No.47.

Inscribed on mat: 'One of the selected fifty for Woodburn's Exhibition in 1853.'

The drawing had been attributed to Van Dyck. The attribution to Rubens, first suggested by Van Regteren Altena, cannot seriously be doubted. The drawing brings to mind the painting (and engraving by C. Galle) of the so-called 'large' Judith of *c.* 1608–1610 (see No.23). The Frankfurt drawing shows a more fluid and more dramatic action and might be connected with another version of the theme. The pose of Holofernes, however, especially his outstretched arms, is found in other early works, such as Cain and Abel in London (see under Nos.45, 46).

49 [Plate 50] *(1959: No.161)*

THE FIGHT FOR THE STANDARD, AFTER LEONARDO DA VINCI

1612–1615. Black chalk, pen and ink, washed, heightened with grey and white body-colour. Enlarged all around, most noticeably at the right. 452 × 637 mm.
Paris, Louvre, Cabinet des Estampes (20.271).

COLLECTIONS Comte C. G. Tessin; Queen Ulrika Lovisa of Sweden; Princess Sophia Albertina of Sweden; Count Stenbock; Count Nils Barck. In the Louvre since 1852.
EXHIBITIONS Brussels, 1938–1939, No.1; Rotterdam, 1939, No.1; Antwerp, 1977, No.118; Paris, 1978, No.79.
LITERATURE R., V, No.1395; G.-H.No.9; K. F. Suter, *Das Rätsel von Leonardo's Schlachtenbild*, Strasbourg, 1937 (subsequently quoted as 'Das Rätsel'); Lugt, *Catalogue*, No.1084. (The drawing figures frequently in the extensive literature on Leonardo, some of which will be quoted below.) Jaffé, 1977, 29–30.
Copy: Fogg Art Museum, Harvard University, Cambridge, No.473 (there attributed to G. Edelinck); a painted version (with slight variations), attributed to Rubens himself by Suter

(*The Burlington Magazine*, LVI, 1930, 266, and *Das Rätsel*, 1937, 84 ff.) is in the Museum of the Academy in Vienna; a copy of that picture is in the collection of P. J. Zeman, Seattle, Wash. Engraved: G. Edelinck (van den Wijngaert, No.170).

Two other drawings, in addition to the one in the Louvre, have been attributed to Rubens, as copies of Leonardo's Battle of Anghiari. One is a large sheet in the British Museum (Hind, *Catalogue*, II, No.21) which was accepted as a copy of Leonardo's work by Glück and Haberditzl (No.24); it is, however, only remotely related to Leonardo's painting. As surmised by Hind, and stressed more explicitly by Suida (*Leonardo und sein Kreis*, Munich, 1929, 261), Suter (1930, 266, and *Das Rätsel*, 1937, 16), and Maria Lessing (*Die Anghiarischlacht des Leonardo da Vinci*, Diss., Bonn, 1935, 28), the drawing is an original composition in which Rubens used ideas derived from Leonardo's work. (The London drawing deserves to be studied more thoroughly, perhaps with the help of infra-red photographs so that the inscription on it can be more clearly deciphered.)

The second drawing is in the Koninklijk Huisarchiv in The Hague (pencil [?], pen and ink, washed, 435 × 565 mm.). It was published by J. Q. van Regteren Altena (*The Burlington Magazine*, LXXVI, 1940, 194), who expressed the opinion that it was the first copy made by Rubens, possibly from Leonardo's own cartoon. He considered the Louvre drawing a later version, freely reworked by the master. The priority of the drawing in The Hague was accepted by J. Wilde (*The Burlington Magazine*, XCV, 1953, 69) and L. H. Heydenreich (*Leonardo da Vinci*, London, New York, Basel, 1954, note to Pl.64), but with the distinction that Heydenreich assumes as Rubens' model 'an exact copy' of Leonardo's painting, while Wilde tends to share van Regteren Altena's opinion that Rubens still had access to Leonardo's original cartoon. A less favourable view was expressed by Lugt (*loc.cit.*), who calls the drawing in the Koninklijk Huisarchiv *plus sec* than the one in the Louvre and suggests cautiously that it might have been done by an assistant such as Deodat del Monte (p.21).

Before the question of the relationship of these drawings to each other can be considered, it is necessary to survey briefly the history and pictorial tradition of Leonardo's work. (The most thorough treatment—though unfortunately marred by an insistence on the hardly tenable theory that Leonardo's painting was never meant to contain more than the Fight for the Standard—is found in Suter's book *Das Rätsel*; Suter is the only author who reproduces virtually every one of the known copies of Leonardo's composition, with the exception of a painting in the collection of the Principe D'Angri in Naples, which has been reproduced in the commemorative volume of the Leonardo exhibitions of 1936, Berlin 1936, and the drawing in the Koninklijk Huisarchiv, which was not known at that time. For other recent literature see M. Herzfeld, *Kritische Berichte*, VII, 1938, 33—a spirited attack on Suter's book which leaves untouched, however, the author's deductions from the later copies—J. Wilde, the *Journal of the Warburg and Courtauld Institutes*, VII, 1944, 65 ff.; G. Neufeld, *The Art Bulletin*, XXXI, 1949, 170 ff.; C. Gould, *The Art Bulletin*, XXXVI, 1954, 118 ff.) It is generally agreed that Leonardo executed on the wall of the Council chamber no more than the group of four riders battling for the possession of a flag, accompanied by three figures on the ground. There are differences of opinion, however, about Leonardo's cartoon. The majority of scholars seem to think that Leonardo had finished a complete cartoon by the time he abandoned the project; they point to the statement of the Anonymo Magliabecchiano (Gaddiano) of *c.* 1537–42 that Leonardo's cartoon was preserved in sections, one part being in the Palazzo Vecchio, the other in the Ospedale of S. Maria Nuova. Neufeld, citing the text of a document of 1504, expresses doubts that the cartoon was ever finished, though he also believes that Leonardo planned a very large painting. Suter

claims, as did Dvořak in *Die Geschichte der Italienischen Kunst im Zeitalter der Renaissance* (Vienna, 1927, 187), that nothing more than the battle for the flag was ever planned; he explains the presence of parts of the cartoon in different places by its early and rapid disintegration, and he believes that it had completely disappeared by the middle of the sixteenth century, when Cellini wrote his autobiography (*Das Rätsel*, 15, 26). (That the cartoon was never finished might be inferred, too, from the admittedly late statement of Borghini, who says in his *Il Riposo* of 1584 that Leonardo '*cominciò* un cartone . . .'.) It must always remain puzzling for the proponents of the theory that Leonardo had finished a complete cartoon—parts of which were still extant around 1540—that no contemporary copy exists which contains more than the battle for the flag, and that there does not seem to be a reflection of anything more in other works of the period. If these parts ever existed, they must have disappeared in one way or another at an early date. Nor does there seem to be any evidence in support of the opinion, held by many scholars (A. Venturi, *L'Arte*, XXV, 1922, 129–133; W. von Seidlitz, *Leonardo*, Phaidon edition, Vienna, 1935, 296; G. Pauli, Thieme-Becker, XXIII, 1929, 78; van Regteren Altena, *loc.cit.*), that the section of the cartoon which contained the battle for the flag survived until the seventeenth century. Needless to say, Rubens' copy cannot be cited in support of this theory; neither the drawing in the Louvre nor the one at The Hague—as we shall see—can possibly render any original version of Leonardo's work. The painting in the Palazzo Vecchio was either completely destroyed by 1557, or covered up when Vasari painted his battle-scenes in its place.

The following are the copies, in whole or in part, of the Battle of the Flag (unless another reference is given, each work is found reproduced in Suter's book):

(1) Silver point drawing by Raphael, Christ Church, Oxford. According to Suter (*Das Rätsel*, 35–8) a copy, made around 1505, of the unfinished cartoon.

(2) Painting, Uffizi. Generally accepted as an early and reliable rendering of the painting in the Palazzo Vecchio. Some differences of opinion (whether the evident incompleteness of the design reflects a temporary obstacle, such as a wooden frame [Herzfeld] or seats [? Heydenreich], or is due to the actual condition of the original [Suter]) need not concern us here.

(3) Painting, Collection of Principe Doria D'Angri, Naples. Similar to the copy in the Uffizi, this picture contains the crouching man in the lower left, absent from the copy in Florence.

(4) Engraving by Lorenzo Zacchia, 1558. Inscribed: *Ex Tabella Propria Leonardi Vincii Manu Picta. . . .* The only dated copy. Suter assumes that it combines elements from both the painting and the cartoon. It was probably the recent destruction of the wall-painting that prompted Zacchia to make the engraving.

(5) Painting, last reported in the collection of Emile Dunan. It had once belonged to Vicomte de Laborde and was at that time engraved by W. Haussoullier. It passed later into the collections of Charles Timbal and Charles Jacques (see *L'Art Vivant*, V, 1929, 520).

(6) Painting, Casa Horne, Florence.

(7) Drawing from the Casa Rucellai, now Uffizi. Engraved by A. Fedi and M. Carboni and published in Marco Lastri's *Etruria Pittrice*, Florence, 1791–1795, Pl.XXIX.

(8) The rider on the extreme right of the group. Drawing, London, British Museum.

(9) The rider on the extreme left of the group. Drawing, Louvre, Paris, Cabinet des Estampes.

(10) Head of the second rider from the left. Piece of a cartoon, Oxford, Ashmolean Museum. Considered by some scholars, especially Suter and Lessing, to be a fragment, reworked at a later time, of Leonardo's original cartoon. K. T. Parker, in his

recent catalogue of the drawings of the Ashmolean Museum (Oxford, 1956, No.20), denies that anything in the drawing is by the master's own hand.

A relief in Berlin, also reproduced by Suter, is too free to be useful for the reconstruction of the original.

Suter (*Das Rätsel, passim*) made an effort to distinguish between those copies which rendered the cartoon and those which were taken from the painting in the Palazzo Vecchio. According to him, Raphael's drawing (No.1) and the painting in the Timbal collection render the cartoon; Zacchia's print is based on both the painting and the cartoon. Without going into the merits of this thesis, one fact can be clearly determined: that Rubens' drawing in the Louvre, which for chronological reasons cannot have been copied from the painting in the Palazzo Vecchio, cannot be a faithful copy of the cartoon either. First of all, it has one feature which occurs nowhere else and is probably an addition by Rubens himself: a sword held in the raised arm of the second figure from the right. (Zacchia's print comes nearest to Rubens in showing this arm raised and holding a battle-axe.) Suter's suggestion, that Rubens interpolated this detail into the scene in an effort to make it agree with Vasari's somewhat confused description (where 'uplifted *swords*' are mentioned), has much to recommend it.

In copies Nos.2, 3, 5, 6 and 7, the same rider wears a very fanciful helmet crested by a coiled and winged dragon; it is evident that this was a feature of either the cartoon or the painting, and possibly of both. Only in Zacchia's print is he given another kind of headgear, but that, too, differs from Rubens', which corroborates the idea that Rubens here used his own imagination. Rubens' drawing lacks the dagger in the hand of the man who fights another on the ground beneath the riders; this motif is also missing in Zacchia's print, which increases the likelihood that Rubens knew this engraving. Rubens also left out the horse's head in the left rear. The motif of the broken shaft of the standard and the tip of a lance which appears—out of nowhere—near the breaking point is most important. That spear-head originally belonged to a shaft held by the first warrior at the right. Since Rubens reinterpreted that shaft as the upper part of the flag for the possession of which the fight rages, the spear-tip is no longer connected with a shaft, or with a soldier's hand. (It is one of Suter's strongest arguments for the genuineness of the Vienna oil-painting that this incongruous feature was eliminated there. It does occur again in Edelinck's print, which was naturally made long after Rubens' death by a craftsman who simply intended to follow Rubens' Louvre drawing faithfully in every detail.)

While perhaps more than any of the earlier copies, Rubens' Louvre drawing captures the spirit of Leonardo's picture of embattled fury, it is evidently of only limited documentary value for the reconstruction of Leonardo's composition.

It is precisely documentary value that has been claimed for the drawing in the Koninklijk Huisarchiv. Wilde (*loc.cit.*, 1953) called it 'the best of the copies after [Leonardo's] cartoon which we possess' though adding that it, too, was not completely faithful. The drawing in The Hague admittedly does not contain the sword-wielding arm of the rider in the rear; on the other hand, it does contain the head of the horse in the upper left, which was probably also visible in the original. It lacks, however, the dragon-helmet of the rider in the rear and it gives a helmet which is found nowhere before to the first rider from the right. In the Louvre drawing this helmet has a visor in the shape of a bearded human face, turned upwards in a long concave curve. In this form the helmet appears in copies Nos.2, 3 and 5; how thoroughly Leonardesque it is, may be seen from the studies for a similar helmet in Windsor (K. Clark, *A Catalogue of the Drawings of Leonardo da Vinci at Windsor*, New York, 1935, Nos.12590 and 12588). The visor of the helmet in the drawing at The Hague, which shows a slightly tilted face in a convex curve, is without analogy in Leonardo's work and in

this form does not appear in any of the known copies of the battle of Anghiari. It is important to note that in the drawing at The Hague also appear the broken flag-shaft and the disconnected spear-head next to it, features it shares with the Louvre drawing but which certainly could not have appeared in Leonardo's composition at any stage of its development. Furthermore, the man on the ground, like the same figure in the Louvre drawing, lacks the dagger; his left arm seems to disappear in the earth as it does in some of the copies of Leonardo's painting, but as it surely did not in any of Leonardo's original versions.

Thus it is manifestly impossible to call the drawing at The Hague a reliable source for our knowledge of Leonardo's composition. It was certainly not copied from Leonardo's cartoon, but was itself based on one or more copies.

The situation is still more complicated by the existence of a drawing which has been completely ignored in the Leonardo and Rubens literature, except for a brief reference in Lugt's catalogue entry about the Louvre drawing. This is a drawing in the collection of E. Reynaud in Paris, published in a small and unsatisfactory reproduction in *L'Art Vivant*, v, 1929, 518. Lugt thought that it might possibly be identical with the drawing in Cambridge, which is not the case. This piece is very similar to the drawing in the Koninklijk Huisarchiv, and as far as one can judge from the reproduction, not inferior. Indeed, it contains one feature which would speak in favour of its superiority, i.e., the visor with the upturned face, which surely is more Leonardesque than the one in the drawing in The Hague. In the accompanying note by Léo Larguieur, it is praised as a fine sixteenth-century Italian copy after Leonardo. Yet enough can be seen from the reproduction to state that it is clearly Rubenesque.

Having seen neither the Reynaud nor the drawing at The Hague in the original, I hesitate to go any further than admitting that one or the other might indeed be an original drawing by Rubens. (I might add that the drawing at The Hague is said to be identical with one mentioned in the Collections Dimsdale, Sir T. Lawrence, and King William II of the Netherlands; the question of its provenance is not entirely clear, however.) Neither of them can be considered a copy of the Louvre drawing (whereas the one in Cambridge clearly is such a copy). Both drawings lack the parts which are seen on the added strips of the Louvre sheet; in both the lifted arm with the sword which crosses the other is missing; both contain the horse's head above the shoulder of the first rider at the left. Thus it is highly probable that the original of the two—whichever it is— preceded the drawing in the Louvre. It is probably the greater precision in details such as the carefully delineated curls of the horses' hair and the very precise modelling of their bodies, seen in the drawings in The Hague (and presumably also in that of the collection Reynaud), which caused van Regteren Altena and Wilde to stress the Leonardesque character of this earlier drawing.

When he first published the drawing in the collection of the Koninklijk Huisarchiv, van Regteren Altena stated that 'in many respects ... the drawing is even more important for our knowledge of Leonardo than for that of Rubens.' While its importance for our knowledge of Leonardo may be somewhat less than he (and Wilde) think, the drawing at The Hague (and the Reynaud) are probably not so important for our knowledge of Rubens as the one in Paris. It is the latter which shows an original development beyond a mere copying of an earlier work, whatever *that* was. In the Louvre drawing we meet all the brilliancy of Rubens' style, especially in the work in ink and in water-colour which gives the surface an inimitable sparkle and life. It is incomprehensible that Suter (alone of all scholars) maintained that precisely this reworking is of post-Rubensian origin. While there cannot be any doubt that the present surface of the drawing is most characteristic of Rubens' work, the

possibility that the *preliminary* chalk drawing was the work of a pupil could be considered. This would explain the presence of the embarrassing lance-head which was taken over from Rubens' first drawing (Reynaud or The Hague) and eliminated in the painting in the Vienna Academy. Yet there is no real evidence to support any such theory.

Rubens may well have planned to use the Paris drawing as the model for an engraving. The only engraving known of it, by Edelinck, belongs, however, to the later seventeenth century. Edelinck was born several months after Rubens had died.

50 [Plate 54] *(1959: No. Additional 171)*

DESIGN FOR A TOMB

c. 1609. Pencil, pen and ink, washed. 272 × 171 mm.
Amsterdam, Rijksprentenkabinet (57:345).

EXHIBITIONS Cologne, 1977, No.33.

This sketch, discovered by Professor J. Q. van Regteren Altena, is a work of unusual interest, both for its subject and its style. It is by no means the only sepulchral monument that Rubens designed. Rooses lists three monuments, two of them known from engravings, the last from a description of the eighteenth century (R., V, 187–188). None of them has been preserved. It is for good reasons therefore that we welcome the appearance of an authentic drawing made for a tomb, even though this one never seems to have been built.

The drawing shows the tomb proper as an elaborate structure placed inside a wide niche that opens with a round arch on pilasters; the underside of the arch is coffered. The tomb itself has the form of an aedicula in which Corinthian columns on high bases support a broken segmental pediment. On the right base is an emblematic design consisting of an ear of wheat (Müller Hofstede) and a caduceus, joined by a wreath. Filling the space between these bases and rising to the same height is the sarcophagus. Above it appears a portal with two doors, each one decorated with reliefs (two at the left and three at the right to provide a choice of design) and a lion's head from whose mouth a ring is suspended. The doors, slightly ajar, are being opened on either side by a winged figure holding with one hand the nearest ring. A large tablet over the portal was designed to contain the commemorative text. The only words inscribed on it are 'D. M. JOANNES RICHAR ...'. Garlands, suspended from two horn-like scrolls, frame this field which still higher up is overlapped by an oval cartouche inscribed (in Rubens' hand) 'Arma'. Continuing the central axis behind this cartouche there rises a short pedestal accompanied by lateral volutes and carrying on its plinth the bust of the deceased, foiled by a large shell. The portrait is of a bearded man wearing a wreath on his head. A thin line, pointing at the head from the upper right, may originally have issued from an explanatory text that is now lost. Remnants of another inscription, now completely illegible, are seen at the bottom of the sheet.

Stylistically the drawing is related to drawings done by Rubens after his return from Italy. The nearest formal analogies are found in such book-illustrations as the six delightful pen and ink sketches for the Roman Missal which Rubens must have drawn before the 25th of September, 1612, since Th. Galle, who engraved them, was paid for his work on that day (see No.70). The ornamental details of the commemorative tablet and the cartouche above it show analogies with the framing forms of these prints as well as with cartouches found on the title-pages of F. Aguilonius' book on optics (1613) and the Roman Breviary (1614). Yet the best evidence for dating the drawing is found in its inscription.

It is obvious that a tomb as sumptuous as that projected in Rubens' drawing must have been intended for a person of considerable eminence. Keeping this in mind, and examining

Fig. 12 Roman Tomb. Vatican, Belvedere Collection

the clearly fragmentary inscription on the commemorative tablet, the conclusion seems to me inescapable that the tomb was designed for no one else but one of the most famous men of the age, Jean Grusset, called Richardot (1540–1609), who after a distinguished career served at the end of his life as the powerful President of the Privy Council of the Spanish Netherlands.

Jean Richardot died on September 3, 1609 in Arras, after having negotiated successfully the twelve-year truce between Spain and the Northern provinces. He was buried in the Chapelle du Saint-Sacrement des Miracles of the church of Ste. Gudule in Brussels (see V. Brants, *Bulletin, Académie Royale de Belgique*, Classe des lettres, No.8, 1901, 914). A tombstone, made in 1595, after the death of his wife, was at the time of his death replaced by another one, the inscription of which started with: D. O. M. JOANNES RICHARDOTVS ... (see F. Sweertius, *Monumenta Sepulcralia . . .* etc, Antwerp, 1613, 280, and M. de Hauteclocque, *Mémoires de l'Académie des sciences, lettres, et arts d'Arras*, II.ser., X, Arras, 1878, 166.ff.).

Jean Richardot had been no stranger to Rubens. In the 1590s Rubens' brother Philip had been Richardot's secretary and the tutor of his sons. When they were sent to study at Louvain, Philip went with them. Between 1601 and 1604 Philip accompanied Guillaume Richardot, one of the sons, on his travels in Italy. The other son, Jean Richardot, was in Italy about the same time, serving as the representative of Archduke Albert at the Holy See. He appears to have played an important role in obtaining for Rubens the commission for the paintings in Sta. Croce in Gerusalemme (see *Correspondence*, I, 43ff.). Thus Rubens' contacts with the Richardot family had been sufficient-

ly close for him to be concerned with the plans for a tomb for the elder Richardot. He may well have made the design on his own initiative, or at the suggestion of his brother. This at least seems to me more likely than the assumption that he had been charged by the family with making such a plan, seeing that nothing, apparently, came of it. No tomb of Richardot's is found today at Ste. Gudule (see F. Lefèvre, *La Collégiale des Saints-Michel-et-Gudule à Bruxelles*, Brussels, 1949) and I have found no reference anywhere to a major monument erected in his honour. The conclusion that Rubens' plans were never executed finds support in other observations to which I come below. (The inscription 'JOANNES RICHAR[DOT]' would fit also the younger Richardot who indeed died only a few years after his father, in 1614. At that time, however, he was Archbishop of Cambrai, and it is unthinkable that Rubens would have made a sketch for his tomb without indicating anywhere his ecclesiastic rank.)

Assuming then that the design was made in 1609 for the tomb of the elder Richardot, one can easily see that it is apt to play a considerable role in discussions of the old and vexing problem of Rubens' part in the development of Baroque architectural design in Flanders. One need not go deeply into this question to observe that despite some traces of sixteenth-century ornamental traditions (for instance in the shape of the inscription tablet) the design is deeply indebted in feeling and detail to the rudimentary Roman baroque of the late sixteenth and early seventeenth centuries. Few, if any, other Flemish artists could have produced in 1609 anything equally 'advanced' and equally integrated in terms of the 'modern' architectural idiom. The artist coming nearest to doing so in his own projects was Jacques Francart (1583–1651). Francart had been in Rome in the early years of the seventeenth century and may have known Rubens there. He was, however, not only six years younger than Rubens but his architectural interests apparently developed slowly. It is only in 1616, when he published his *Premier Livre d'Architecture* that we find him using an architectural language similar to that of Rubens' project of 1609 (see J. H. Plantenga, *L'Architecture Religieuse dans l'Ancien Duché de Brabant, 1598–1713*, The Hague, 1926, Fig. 63).

While its architectural vocabulary is largely derived from Roman contemporary sources, the iconographic elements of Rubens' design stem from sepulchral motifs he had found in ancient Roman works. Doors as a central theme of tombs are a frequent motif in classical art. I owe to Dr. L. D. Ettlinger the observation that in this case Rubens took his inspiration from a specific monument, a first-century A.D. Roman cinerary altar for two children, now in the Belvedere collection of the Vatican (Fig. 12), which in Rubens' time formed part of the Mattei collection (see W. Altmann, *Die Römischen Grabaltäre der Kaiserzeit*, Berlin, 1905, Fig. 85, and W. Amelung, *Die Skulpturen des Vatikanischen Museums*, II, Berlin, 1908, No. 80, Pl. 21). Rubens adopted from this work the idea of the half-open doors (of Hades) and the two winged figures (Victories) opening them by taking hold of rings in the mouth of lion-masks. Rubens considerably ennobled these two figures, not unmindful perhaps of the graceful angels who are often similarly placed in Renaissance tabernacles and tombs. The idea of resurrection and of immortality evidently contained already in the classical work (see F. Cumont, *Recherches sur le symbolisme Funéraire des Romains*, Paris, 1942, 481) was given a specifically Christian turn by this angelic transformation of the Victories. Rubens emphasized it more strongly still by adopting the motif of the scalloped shell behind the bust of the deceased symbolizing to the ancients the soul's journey into the hereafter. (For this motif see W. S. Heckscher's *Rembrandt's Anatomy of Dr. Nicolaas Tulp*, New York, 1958, 119.) If I read rightly the scribbles in the spandrel at the upper right corner Rubens may have contemplated putting allegorical figures there which would have helped to create associations with triumphal arches.

The best argument in support of the thesis that Rubens' design was never carried out is found in the fact that he used two of its most striking motifs soon after in different works, though in a similar context. The two 'Victories' standing before sepulchral doors and holding rings in order to open them reappear in surprisingly similar form on the outside of the triptych which Rubens painted in 1610–1611 for the tomb of Jean Moretus in the Cathedral of Antwerp (see R., II, 145–150, Nos. 337–8 and *KdK*. 50, right). The central panel of this altar has as its subject the Resurrection of Christ and it is obvious that in this context the 'Victories' have indeed been changed into angels, though they still sport the distinctively classical *coiffure* they had in the Roman altar and in Rubens' drawing for Richardot's tomb. It hardly needs stressing that Rubens, no matter how economical he may have been with some of his ideas, would not have repeated in quick succession a motif so easily recognized. The reappearance of the angels on Moretus' tomb on the contrary contains a strong hint that the Richardot tomb had not been executed in the projected way.

To this can be added another argument. The scalloped shell behind the bust at the top of the drawing is found in virtually the same shape, the same relationship to a bust, and doubtlessly expressing the same idea, in a print based on Rubens' design and dedicated to the memory of his brother Philip (inscribed: PIIS MANIBUS PHILIPPI RVBENII SACR., see R., V, No. 1302, pl. 375). It was done by C. Galle the elder and was paid for in the beginning of 1615. Again it is most unlikely that Rubens would have used the identical form of the shell for the image of his brother if it had been employed for President Richardot only a few years before. On the other hand, by associating with his brother one of the symbolical elements originally conceived in honour of Richardot, Rubens may have admitted, perhaps subconsciously, the part which Philip had played in the genesis of the project that never had progressed beyond the planning stage.

J. Müller Hofstede twice dealt with the problems of this design of a tomb since its publication in 1959, first in the *Wallraf-Richartz Jahrbuch*, XXVII, 1965, 261, and most thoroughly in the catalogue of the Cologne exhibition of 1977. He recognizes two scenes from the life of John the Baptist on the left door of the tomb, and correctly identifies what I had thought was a torch (on the base of the column at right) as an ear of wheat. He also believes that Richardot himself ordered the tomb, and that Rubens may have made the design in 1608, while still in Italy. He also gives a detailed biography of Richardot.

51 [Plate 53] *(1959: No. 24)*

SAMSON AND DELILA

c. 1610. Pen and ink, washed. 164 × 162 mm. On the reverse: Indistinct sketches in pen.

Amsterdam, Collection J. Q. Van Regteren Altena.
EXHIBITIONS Amsterdam, 1933, No. 67; Antwerp, 1956, No. 32; Antwerp, 1977. No. 129.
LITERATURE A. Scharf, 1933, 249; Evers, *Pantheon*, IV, 1942, 84; Evers II, p. 151, 162, Fig. 51; D. Rosen and J. S. Held, *Journal of the Walters Art Gallery*, XIII–XIV, 1950–51, 77ff.; Burchard-d'Hulst, 1963, No. 46; Kuznetsov, 1974, No. 27; Tilmann Buddensieg, 'Simson und Dalila von Peter Paul Rubens', *Festschrift für Otto von Simson*, Berlin, 1977, 328–45; Held, 1980, under No. 312.

Inscribed V.D.

The drawing is a preliminary sketch for the painting of the same subject formerly in the A. Neuerburg collection in Hamburg, now in the National Gallery, London. Its similarity to a composition by Tintoretto (a workshop version of which is preserved in the Ringling Museum in Sarasota, Fla.) was

observed by Oldenbourg (1922, 83, Fig.43), who only knew Rubens' composition from the engraving by J. Matham (V.S.6, 41).

The pose of Samson was used again by Rubens at a much later date for a Sleeping Argus. The composition exists in two versions, a sketch formerly in the collection of Frank T. Sabin (Exh. Brussels, 1953, No.17) and a medium-sized painting in Dresden (No.962C; R., III, No.644). See also Haverkamp Begemann, *Catalogue*, Exh. Rotterdam, 1953, No.109, and Held, 1980, No.A6 (627).

52 [Plate 52] *(1959: No.20)*
SUSANNA

c. 1608–1612. Pen and wash. 215 × 158 mm. On the reverse: David and Goliath (No. 63).
Montpellier, Bibliothèque Universitaire, Collection Atger (247).

COLLECTIONS X. Atger.
EXHIBITIONS Antwerp, 1956, No.38.
LITERATURE Van Regteren Altena, in *Catalogue*, Exh. Amsterdam, 1933, under No.39; Burchard-d'Hulst, 1963, No.70; Kuznetsov, 1974, No.34.

Inscribed (by a later hand): 'Rubens fecit—Susanne au bain.'

Study for the painting of Susanna and the Elders in the Academia San Fernando in Madrid (*KdK.*32). The painting in Madrid shows the scene in reverse, but the figure of Susanna is obviously developed from that of the drawing in Montpellier; the main difference concerns the position of the near arm, which reaches back in the drawing to pull up the garment while it crosses the body in the Madrid painting. The outstretched hand of one of the elders, which barely reaches the gown in Montpellier, touches Susanna's body in the finished painting. On the analogy of the Madrid painting, the vague forms at the right in the drawing must be interpreted as the rim of a fountain and water overflowing from it. This is the second composition of Susanna in her bath which Rubens executed during his early years. The first is the small canvas in the Villa Borghese, which dates from the early years of Rubens' stay in Italy (*KdK.*19; see also No.83). The Madrid painting was dated by Oldenbourg after Rubens' return from Italy, but it is not impossible that it still belongs to the end of Rubens' Italian period.

53 [Plate 51] *(1959: No.19)*
A BACCHANAL

c. 1608–1610. Pen and ink, washed, heightened with white. 140 × 125 mm.
Antwerp, Cabinet des Estampes (A. XV, 2).

COLLECTIONS Comte Caylus; Dr. C. Otto ('Van Dyck'); sold Boerner, Leipzig, 7 November 1929 (55).
LITERATURE Smith III, 1831, 463; J. Guiffrey, Antoine van Dyck, Paris 1882, 266; *L'Arte*, 1897, III, 293; Delen, *Catalogue*, 1938, No.188; Evers II, 223–225 and 230–231.

The drawing was etched by Comte Caylus while it was in his collection. The etching is reproduced on p.200 of Guiffrey's book. Evers, who discussed the drawing in great detail, recognized that the central figure of the reclining Silenus has two faces, one of which is turned towards the figure at the left (in whom Evers sees a Bacchante) and another turned up and seen in sharp foreshortening to receive the juice which a satyr presses from grapes. (Evers calls the latter face a 'mask' though it might very well be an alternate possibility in a drawing which is so clearly still in the experimental stage.) Whether the figure at the left who seems to push the satyr away is really a woman and not a man (Bacchus?) is hard to say. In the lower right

corner a leopard is playing with grapes which fall from a basket; there is a child (a young satyr?) behind the basket.

No painting based on this drawing has been identified so far. Evers, however, believes that the drawing represents a preliminary phase in Rubens' preparation of the Dreaming Silenus in the Academy in Vienna (see also No.81). There are contacts with such drawings as the Death of Creusa (No.59) and Venus and Adonis (No.57). All this points to a relatively early date, though not before Rubens' return from Italy.

54 [Plate 55] *(1959: No.75)*
A NUDE MAN, KNEELING

c. 1609. Black and white chalk. 520 × 390 mm. Paper torn at left, so that a part of the left forearm is missing.
Rotterdam, Museum Boymans–van Beuningen (V.52).

COLLECTIONS P. H. Lankrink; G. Bellingham Smith; F. Koenigs; D. G. van Beuningen.
EXHIBITIONS London, 1927, No.580; Antwerp, 1927, No.14; Amsterdam, 1933, No.70; Brussels, 1938–39, No.30; Rotterdam, 1939, No.29; Rotterdam, 1948–49, No.114; Brussels, 1949, No.84; Paris, 1949, No.87; London, 1950, No.53; Helsinki–Brussels, 1952–53, No.43; Antwerp, 1956, No.50.
LITERATURE L. Burchard, *Old Master Drawings*, 1927, 39; G.-H.No.60; Lugt, *Catalogue*, II, under No.1030; L. Burchard in *Catalogue*, Exh. London, 1950, 59; Burchard-d'Hulst, 1963, No.92; Kuznetsov, 1974, No.69.

L. Burchard alone (*Cat. Exh.* London, 1950) seems to doubt the early date of this drawing, which always has been connected with the Adoration of the Magi of 1609 in the Prado (*KdK,*26). He believes that it may have been done together with a similar drawing in the Louvre (Burchard-d'Hulst, 1963, No.91) for the painting of Abraham and Melchisedek in Caen (*KdK.*110), which he dates—rather surprisingly—about 1618. Not only is this date for the painting in Caen probably too late by two or three years, but there is every reason to assume that the drawing in Rotterdam, as well as the one in the Louvre, was made in 1609 when Rubens prepared the Madrid Adoration. (This opinion seems to have been shared by the author of the catalogue of the exhibition of 1933, as well as by Evers, who reproduces the Louvre drawing with the Epiphany [I, Fig.46], and by Lugt [*loc.cit*]; Glück and Haberditzl, dating the Louvre drawing '1610–16', left the question open.) Burchard himself mentions that the drawing was used for a satyr in the Allegory of Nature in Glasgow 'of circa 1615–1616' (*KdK.*61), which would advance its date. (In the exhibition 'l'Art Flamand dans les Collections Britanniques', held at the Musée Communal at Bruges, 1956, the Glasgow painting was indeed dated—more convincingly—*c.* 1613–1614.) Yet the fact that the drawing occupies a position between the Groningen sketch for the Epiphany (Held, 1980, No.325) and the Madrid painting is still more important. The right foot, for instance, in the Madrid picture, corresponds exactly to the separately drawn foot of the Rotterdam drawing, while it is hardly visible in the Groningen sketch; furthermore, the figure in the sketch is seen in greater profile, while in the painting it turns inwards exactly as in the drawing; finally, while the sketch deals with the skin and muscles in rather general terms, the painting follows in all details the careful observation of these parts in the drawing. It would have been highly uneconomical for Rubens to make a careful study of a nude in a pose virtually identical with a figure like the porter in the Madrid painting.

To these reasons must be added those of style. Chalk-studies from the model dating from the second half of the second decade (see Nos.111, 134) are done more simply, with less modulation in light and shade and greater reliance on line. They

are also drawn with greater assurance. In the Rotterdam drawing there are not only corrections such as the repetition of the left hand, but also changes in the light and dark pattern which were effected by using white chalk to cover up undesired shadows. In all these aspects the drawing in Paris is so similar to the one in Rotterdam that it was probably made at the same time, and, not having been used then, was taken over into the painting in Caen, just as Lugt assumed. Both drawings, thus, occupy an important place between the earliest known studies from the nude (see No.14) and the well-known group of the following decade.

55 [Plate 49] *(1959: No.76)*

A NUDE MAN WITH RAISED ARMS

(Study for the Raising of the Cross) *c.* 1610. Black and white chalk. 488 × 315 mm. At the right large pieces of paper have been cut away across the corners.
The Hague, Koninklijk Huisarchiv.

COLLECTIONS King William II of the Netherlands.
EXHIBITIONS Rotterdam, 1939, No.63 (Supplement); Rotterdam, 1948–49, No.113a; London, 1950, No.58 (Addendum); Antwerp, 1956, No.35; Antwerp, 1977, No.131.
LITERATURE Burchard-d'Hulst, 1963, No.56; Kuznetsov, 1974, No.30.

This study was made in connection with Rubens' painting of the Raising of the Cross of 1610 in Antwerp Cathedral (*KdK*.36). Its genesis demonstrates in exemplary fashion how Rubens combined the study of antiquity with that of nature. It is almost certain that he had studied in Rome the front of a small sarcophagus with scenes from the life of Dionysos (2nd cent. A.D., now in the Art Museum of Princeton University; see L. Curtius, *Jahreshefte des Österreichischen Archäologischen Institutes in Wien*, Vienna 1946, 62ff.), which on its left end shows the raising of a Dionysos Herm (Fig.13). (A similar scene is found on a Roman lamp, published by Bellori, see Curtius, *loc.cit.*, note 15.) Like Caravaggio before him, whose Crucifixion of Peter in S. Maria del Popolo was probably inspired by this work, Rubens derived ideas from it for his Raising of the Cross. The pose of the figure in the present drawing manifestly repeats that of a woman who pushes up the Dionysos Herm from behind by placing her left hand on its shoulder and her right on the back of its head. Thus the basic outlines of the figure were given to the master. What he needed was control of the details of muscles, bones, and epidermis on the living form. He therefore had a model to pose for him in the given position, of which the present drawing is the record. It hardly can be accidental that the only place where he studied two alternatives of the pose (in the placing of the left leg) concerns a limb which had been largely hidden by a drapery in the Roman relief.
A fine oil-sketch formerly in the collection of L. Gauchez (Held, 1980, No.349) now in the Louvre was made in preparation for the Antwerp triptych. In this sketch, as well as in the finished painting, the figure corresponding to that in the present drawing is shown in armour. The position of the left leg, which as we saw was still in doubt when Rubens made the drawing, had been decided when he painted the sketch. The latter, indeed, might very well have formed the basis for the contract, notwithstanding the great differences that can be noticed between sketch and final version. In any case, the sketch would have to be dated before June, 1610, when Rubens met the pastor and the churchwardens of St. Walburgis church to sign the contract, a formality which traditionally took place after the sketch had been approved. The present drawing consequently also lies before that date.
The drawings for the figure of Christ, on the other hand (G. H. No.61 and No.62), are definitely later than the oil-sketch since

Fig. 13 Raising of a Dionysos Herm. Roman sarcophagus. Princeton, University Art Museum

they presuppose the change of plan for the centrepiece which gave Christ and the Cross a much more dominant position. The same is true of the drawing of the man at the foot of the Cross in the collection of Mr. Chr. P. van Eeghen, Amsterdam (Burchard-d'Hulst, 1963, No.58). Another drawing from the nude, for the bald man supporting the Cross with his body as well as his arms, is in Oxford (Exh. London, 1950, No.52). I see no reason to doubt its connection with the Antwerp painting (nor of the similar one in Rotterdam [Exh. London, 1950, No.51]), especially as one sees from the oil-sketch that Rubens originally planned this man as a youthful figure.

56 [Plate 59] *(1959: No.77)*

STUDIES OF HEADS AND HANDS

c. 1610. Black and white chalk on light chamois paper. 392 × 269 mm.; the sheet consists of two pieces of paper which have been joined. The seam lies above the hands at the right, then follows the curve of the man's ruff before swinging out to the left half-way up the neck of the profile figure.
Inscribed by a later hand: P. P. Rubens.
Vienna, Albertina (8306).

EXHIBITIONS Zürich, 1946–47, No.81; London, 1948, No.64.
LITERATURE R., V, No.1578; Haberditzl, 1912, 7–8; G. Glück, *Marées Gesellschaft*, No.9; G.-H.No.64; Kuznetsov, 1974, No.32; Mitsch, 1977, No.7

The pair of hands, drawn twice from slightly different angles, are studies for the hands of the Virgin in the Raising of the Cross of Antwerp Cathedral (*KdK*.36). (Neither pair was adopted exactly as it appears in the drawing, but the pair at the left seems to be nearer the final pose.) They are drawn in rich dark crayon, whereas the two heads are done in the greyer tone of chalk. The profile head looks as if it has been drawn from a sculpture.
The head of a man deserves special attention since he is clearly a portrait of a contemporary of Rubens, on the evidence of his collar. There is even a faint physiognomic resemblance to Cornelius van der Geest (cf. for instance the portrait by Van Dyck, London, *KdK*.[Van Dyck], 4th ed., 125) if we make allowance for the time interval that separate the two portrayals; that Rubens should have made a drawing of Van der Geest at the time of his work for the Raising of the Cross is highly probable. As one of Antwerp's prominent art patrons, Van der Geest was responsible for Rubens obtaining the commission for the high altar of the St. Walburgis church, of which he was warden. At an early stage Van der Geest's portrait was perhaps meant to be included, as a donor, somewhere in the great

triptych. The very pose of the head in the drawing—turned, as it is, to face the beholder yet implying a connection with something behind the picture-plane—is very typical of donors' portraits in baroque altarpieces.

57 [Plate 56] *(1959: No.22)*

VENUS LAMENTING ADONIS

c. 1608–1612. Pen and ink, washed. 217 × 153 mm.
London, British Museum (1895.9.15.1064).

COLLECTIONS Ch. G. Vicomte Morel de Vindé; Sir Th. Lawrence; J. H. Hawkins; J. Malcolm.
EXHIBITIONS London, 1835, No.48 (as Van Dyck); London, 1977, No.61.
LITERATURE Hind, *Catalogue*, 58, No.24 (Van Dyck); A. J. J. Delen, 1932–33, 34; Evers II, 135–36, Fig.37; Erna Mandowsky, *The Art Bulletin*, XXVIII, 1946, 115; *Catalogue*, Exh. London, 1950, under No.44; L. van Puyvelde, *Van Dyck*, Brussels–Amsterdam, 1950, 56 (as Van Dyck); Burchard-d'Hulst, 1963, No.66; Kuznetsov, 1974, No.37; Jaffé, 1977, 65R.

One of three closely related drawings of this subject (all three reproduced in Evers II, Figs.35–37). The other two are in the National Gallery, Washington (see No.58), and in the Stedelijk Prentenkabinet, Antwerp (Delen, *Catalogue*, No.193). Bellori (*Le Vite*, Rome, 1672, 223) mentioned a painting of the subject in the collection of Gio. Vincenzo Imperiale. L. Burchard (*L'Amour de l'Art*, XVIII, 1937, 293) traced the history of the picture to 1727 and expressed the opinion (*Catalogue*, Exh. London, 1950, No.44) that the three drawings were made for it. A painting which may be either this lost picture or a copy thereof has been found (exhibited in 1953 in the Rubens House in Antwerp); there is, however, no connection between the painting and these drawings. The beautiful sketch of the Lament of Adonis in Dulwich is also very different (see Held, 1980, No.267).

Hind referred to the classical group of Menelaus and Patroclus in the Loggia dei Lanzi in Florence as a source for the composition. This reference has been made specific by Miss Mandowsky, who pointed out that two versions of this group existed in Florence from about 1570, the other being in the courtyard of the Palazzo Pitti. The latter was restored on the basis of a Mantuan frieze (Mandowsky, note 11) possibly by Giovanni Caccini (d.1644), and it was this restored group which influenced Rubens. The group has since been altered by additional restorations.

58 [Plate 57] *(1959: No.23)*

VENUS LAMENTING ADONIS

c. 1608–1612. Pen and ink. 305 × 198 mm.
Washington, National Gallery of Art (B.25.283).

COLLECTIONS T. J. Bell (Sotheby's, Nov. 26, 1929 'Van Dyck'); L. Burchard.
EXHIBITIONS Amsterdam, 1933, No.103; London, 1950, No.44; Antwerp, 1956, No.46; London, 1977, No.60.
LITERATURE Evers II, 135; Burchard, *Catalogue*, Exh. London, 1950, No.44; Chr. Norris, *The Burlington Magazine*, XCIII, 1951, 7; Burchard-d'Hulst, 1963, under No.66; Kuznetsov, 1974, No.38; Jaffé, 1977, 65.

Inscribed in Rubens' hand; '*Spiritum morientis excipit ore*' ('she draws out the spirit of the dying youth through his mouth'). This inscription has also been read as '*Spiritum morientis exceptura*' (Evers) and as '*Spiritum morientis exceptans*' (Burchard). See No.57.

The inscription clearly belongs only to the small sketch in the upper right where Venus indeed approaches the face of the dying youth as if prepared to suck his soul from his mouth. In the large group she sadly contemplates the head of Adonis, supported by one of the two cupids, while the other tries to dress his mortal wound. The reading 'Spiritum morientis excipit ore' is not only more in keeping with the graphological evidence but also makes better sense in view of the literary source to which Rubens evidently alludes. There can be little doubt that Rubens had in mind one of the most celebrated poems of classical antiquity, Bion's beautiful dirge on the death of Adonis, in which Venus embraces the dying youth and tries with kisses to suck his breath into her own body. Though Rubens frequently added Latin inscriptions of his own to his drawings, it is not impossible that in this case his text is quoted from a Latin adaptation of Bion's Greek original. For such adaptations (none of which contains an identical phrase), see *Theocriti, Bionis et Mosschi Carmina Bucolica*, ed. L. C. Valckenaer, Leyden, 1810, pp.525 and 551. The beautiful image still fascinated Shelley, whose fragment of the 'Elegy on the Death of Adonis' contains this passage: 'and mix my lips with thine/ Wake yet a while, Adonis—oh but once, / That I may kiss thee now for the last time – / But for as long as one short kiss may live – / Oh, let thy breath flow from thy dying soul / Even to my mouth and heart, that I may suck / That . . .' (*The complete Poetical Works of Percy Bysshe Shelley*, London, 1935, p.714).

The Antwerp drawing is the sketchiest of the three versions, the London one the most finished. Evers accepted this factor as a criterion for their sequence and considered the London drawing the last of the three. Mandowsky, judging them in their relative proximity to the classical group, put the London drawing in the beginning, the Antwerp one at the end. Both considered the drawing in the L. Burchard collection to have been the one in the middle of the sequence.

Without the evidence of a finished painting, it is difficult to decide such a problem. A good case, it seems to me, could be made for the Burchard drawing's having been the last of the three, with the one in Antwerp as an intermediary, rather tentative, and never continued solution. (It should be noted that the pencil lines, indicating drapery, over the body of Venus and the abdomen of Adonis in the Antwerp drawing were probably added later, by another hand.)

L. Burchard (London Exh. 1950) placed the group of drawings 'not later than 1615'. Burchard and d'Hulst (Antwerp Exh. 1956) date all three drawings *c.* 1612. Evers had dated them '1611–1612'. It is possible that the drawings were done still earlier, in the first few years after Rubens' return to Antwerp but hardly as early as 1602, as has been suggested by Jaffé. The substitution of the theme of Venus and Adonis for that of Menelaus and Patroclus is not novel. It is found before Rubens in a washed pen-drawing by Luca Cambiaso in the Uffizi (see Licia Collobi Ragghianti, *La Critica d'Arte*, III, 1954, Fig.172).

59 [Plate 46] *(1959: No.13)*

THE DEATH OF CREUSA

c. 1608–1610. Pen and wash in bistre, over black chalk, heightened with white. 224 × 281 mm.
Bayonne, Musée Bonnat (1432).

COLLECTIONS R. Houlditch.
LITERATURE Evers, II, 131–133; Burchard-d'Hulst, 1963, p.66 ('Porcia proving her Courage'); Müller-Hofstede; 1965 (*c.* 1615–1616).

The connection of this drawing with the Creusa myth was made by E. Panofsky, who pointed out in a communication to the author that the appearance of flames is not indispensable to a rendering of this story. Creusa was consumed by a fire which

took hold of her when she put on a gown or an ornament that Medea had sent her. Of the various versions of the story, those of Seneca (*Medea*, 570ff.) and of Horace (*Fifth Epode*, 65) are particularly relevant here, since they stress that Creusa was killed by a poison which burned or corroded her flesh. The painfully writhing body of the nude woman and the solicitous actions of the bystanders, some of whom try to soften the pain by pouring water over her arm, seem to support this interpretation. That Rubens was interested in the Creusa myth at a very early date is proved by the inscription on the Medea drawing in Malibu (No.20).

Evers was the first to attribute this drawing to Rubens, calling it 'Death of a Martyr'. Before his publication it had been attributed to Van Dyck, like most of the drawings of this group (cf. Nos.47, 48). Evers' attribution was not made without hesitation. He thought it possible that it was either a copy or that it had been reworked by a later owner. I do not see the need for making such assumptions. The drawing is well connected with other works of the master. The position of Creusa's body appears with minor variations in such later pictures as the Entombment in St. Géry at Cambrai; a sketch for it in Munich (Held, 1980, No.366, see also No.111) and Death of Eurydice (Rotterdam, Museum Boymans-van Beuningen, see Held, 1980, No.188). The pose was ultimately derived from a design by Giulio Romano (Death of Procris, see *Münchner Jahrbuch der Bildenden Kunst*, N.F. VIII, 1931, 57, Fig.9), also known from an engraving by G. Ghisi (Bartsch, XV, 409.61). An echo of this pose is found in one of the woodcuts by Stimmer which Rubens copied in his youth (see F. Lugt, *The Art Quarterly*. VI, 1943, 108 and Fig.10).

The woman pouring water at the left is very similar to a figure in the drawing of the Anointing in Rotterdam (No.12) and one of the daughters of Lot in the painting in Schwerin (*KdK*.42). The woman standing next to her at the left resembles one standing at the right in the Circumcision in Genoa (*KdK*.21).

There are many corrections in the Bayonne drawing lending support to the view that it is an original project and not a copy. The head of the woman above Creusa's shoulder, for instance, was first drawn inclined to the left and was covered up by a flying drapery when Rubens changed its position.

60 [Plate 58] *(1959: No.21)*

THE DEATH OF HIPPOLYTUS

c. 1610–1612. Pen and ink, washed. 220 × 321 mm. On two pieces of paper.
Bayonne, Musée Bonnat (1441).

COLLECTIONS Marquis de Chennevière.
LITERATURE L. Burchard, *Sitzungs-Berichte der Kunstgeschichtlichen Gesellschaft*, Berlin, Oct. 8, 1926, 3; G.-H.No.65; A. Seilern, *Catalogue*, 32; Burchard-d'Hulst, 1963, No.39; Kuznetsov, 1974, No.24; Held, 1980, under No.245.

The Death of Hippolytus, the Death of Phaeton, and the Conversion of Paul, despite their differences, have certain narrative elements in common. Whether or not one of them suggested the other to Rubens we cannot say. The fact remains that he occupied himself with these themes at about the same time, *i.e.,* shortly after his return from Italy, and that he took figural motifs over from one composition into the other. He certainly made more versions than are now preserved. For some which are recorded in one form or another, see Seilern, *loc.cit.* The Bayonne drawing must be one of Rubens' first drafts of the Hippolytus myth. Hippolytus, the son of Theseus, accused by his stepmother Phaedra of an attempt on her honour, was destroyed by a sea-monster which Poseidon sent at Theseus'

request. In the drawing the hapless youth, fallen from his chariot, is dragged along the shore by his shying horses against which the full fury of the monster is directed. In the foreground a few frightened figures take flight.

On the basis of a photograph preserved at the Rijksdocumentatiebureau in The Hague, some scholars assume that Rubens painted a picture which corresponds closely to the Bayonne drawing (Seilern, *loc.cit.*, and footnote). A second, slightly later, version of the theme is known from a sketch in the Princes Gate Collection (Held, 1980, No.245) and from a painting on copper formerly in the collection of Lord Plunket, now Fitzwilliam Museum, Cambridge. The Princes Gate picture was engraved by Maria Cosway (V.S., No.101), while Lord Plunket's version was engraved by R. Earlom (V.S., No.99 and No.100; see Oldenbourg, 82, Abb.39). The two pictures differ from each other in that the Lord Plunket picture has two fleeing figures in the background at the right and sea-shells in the left foreground as well as the main figures. They both, however, omit the long tail of the monster and the waves which fill the left side of the Bayonne drawing, and give more prominence to the figure of Hippolytus. In the paintings Hippolytus lies towards the right in a pose which Rubens derived from Michelangelo's Tityus drawing in Windsor (Oldenbourg, *loc.cit.*, p.83). Rubens had made a chalk drawing of Michelangelo's figure, now in the Louvre (L.1029). He also used this pose in the Death of Argus in Cologne (*KdK*.33) and in the Prometheus in Philadelphia.

The Phaeton composition, one example of which was on the London market in 1953, shows great similarities in the design of the horses. The rearing horse at the right is found there in an identical pose, and in the same relationship to the chariot. There are also motifs which connect the Hippolytus group with the Conversion of Paul (see No.61), such as the kicking horse in the last one of Rubens' early versions of that theme (see A. Seilern, *Catalogue*, No.21). That animal had first appeared in Rubens' work in the London drawing of the Battle of the Amazons (see No.9).

The shape of the sea-monster shows Rubens' assimilation of such ancient snake-tailed dragons as those which appear in the Medea-sarcophagi (see No.16) and the Claudius and Agrippina Cameo (G.-H.No.24).

61 [Plate 60] *(1959: No. 31)*

THE CONVERSION OF ST. PAUL

c. 1610–1612 (not 1612–1614 as in the 1959 edn.) Pen and ink, washed; some corrections made in white chalk. 222 × 329 mm. The right half consists of three pieces of paper, skilfully superimposed on each other, probably for the sake of corrections in the design.
London, Princes Gate Collection, Courtauld Institute Galleries.

COLLECTIONS (Left half of sheet) P. H. Lankrink; Sir Joshua Reynolds; Sir Thomas Lawrence; S. Woodburn (?); The Ashmolean Museum, Oxford. (Right half of sheet) P. H. Lankrink; Sir Joshua Reynolds.

EXHIBITIONS (Left half) London, 1950, No.42.
LITERATURE L. Burchard, in *Catalogue*, Exh., London, 1950, 50, 51; Held, 1951, 290 (left half only); Ch. Norris, *The Burlington Magazine*, XCIII, 1951, 4ff; A. Seilern, *Catalogue*, 92, 93, No.57; Burchard-d'Hulst, 1963, No. 54; Kuznetsov, 1974, No.43.

Inscribed on verso (left half) 'Conversion of S. Paul, Vandyck, Lawrence coll[n].' (according to A. E. Popham in the hand of Samuel Woodburn); (right half) 'The picture is at Düsseldorf' (in the hand of Sir Joshua Reynolds).

This important drawing was cut in half at an early date. It formed two separate sheets in P. H. Lankrink's (d.1692) collec-

tion. It is therefore not impossible that it came originally from the collection of Joh. Phil. Happart, Canon of the Cathedral of Antwerp, in whose estate are listed three drawings by Rubens, each consisting of two pieces (Denucé, *Inventories*, 336). Another of these 'divided' drawings may be the Love-garden (see Nos.210, 211). Was it the Canon himself who separated them? It is fortunate that the two halves of the Conversion of St. Paul, which were evidently separated from each other when Reynolds' collection was dispersed, are now again reunited (see Seilern, *loc.cit.*).

Because of the fact that 'all lines end just short of the inner edge' A. Seilern surmises (*Catalogue*, p.35) that the drawing had been done 'on the opposite pages of an open sketch-book' and that on finding 'the right half unsatisfactory' Rubens 'tore that page out of the book' and drew 'the present right half on the page underneath'. This assumption does not really account for the interruption of the lines short of the sheet's centre. A simpler explanation would seem to be that the original double sheet was bound in the sketchbook in such a way that an inaccessible valley remained in the middle. As anyone would do in such a situation, Rubens drew right across this crease, thus skipping a small area of paper which was exposed later, when the sketchbook was taken apart.

The drawing is part of a group of three works, all of which are now in the Princes Gate collection. Besides the drawing, there is an oil-sketch (Held, 1980, No.421; panel, 56 × 79 cm.) and a 'finished painting' (panel, 95.2 × 120.7 cm.). Reviewing the relationship to each other of these three works, Count Seilern (*loc.cit.*, p.34ff.) came to the conclusion that chronologically the oil-sketch came first. It was followed by the drawing which forms a bridge, as it were, to the 'finished painting'. He accounts for the changes made from drawing to final painting by suggesting that Rubens had planned to make of the Conversion of Paul a companion-piece to the Defeat of Sennacherib in Munich (*KdK*.156).

That the sketch and the drawing are closely related to each other is evident, and Count Seilern may well be right in placing the oil-sketch first. It is clearly one of those 'working sketches' like the All-Saints sketch in Rotterdam (Held, 1980, No.399) in which the artist tried out several possibilities one on top of another so that in the end it was difficult to tell the forms apart. For the reconstruction of the last phases of the development of the theme the X-rays of the finished picture, published by Count Seilern, offer interesting evidence. As in the drawing, Rubens first sketched the kneeling, half-naked man in the foreground with his left arm raised, before giving him the pose that he assumes in the last layer of the painting. St. Paul also seems to have lifted his left arm in the stage recorded by X-rays, although his body was already turned to 90 degrees. The most important argument in favour of Count Seilern's sequence of events is the position of St. Paul's horse which is the same in the drawing as well as both stages of the 'finished painting'.

Weighty though these arguments are, those which favour the sequence *drawing—sketch—finished painting* should not be overlooked. The drawing is a much more sprawling composition than either sketch or painting. The complex structure of the oil-sketch could be due to Rubens' effort to concentrate on the main theme by eliminating the agitated group which fills the lower left corner of the drawing (supplanting it by a dog) and by bringing the group of Saul closer to the foreground, thus giving to it approximately the same place and weight as it has in the finished painting.

Chr. Norris dates the drawing 1610–12, L. Burchard 1613–14, and Count Seilern 1615–17. (The two-year span of Count Seilern's date is rather generous, since his date for the finished painting is '*c.* 1615 or slightly later'.) In the rather 'outré' actions of the figures and the spotty treatment of light, the drawing is related to works done around 1610–12, such as the Miraculous Draught of Fishes at the Wallraf-Richartz Museum, Cologne

(Held, 1980, No.335), and the Raising of the Cross itself. That the woman with two children on a camel echoes the Asa-Josaphat-Joram lunette of Michelangelo's Sistine Ceiling (*KdK*.85) and was probably derived from an engraving by C. Cort after F. Floris may be taken as support for an early date. The same is true of the position of the horse of St. Paul which Rubens may have derived from a painting by Elsheimer (see W. Heil, *Miscellanea Leo van Puyvelde*, Brussels, 1949, 221). Other Elsheimer reminiscences are found in the 'finished picture' where the group of Orientals at the right edge recalls Rubens' drawing after Elsheimer in London (see No.31). The fact that a study of one of these heads is found on the same sheet on which Rubens sketched some heads for his altar at Fermo (see No.43) finally speaks for an early date of the 'finished picture'. The pose of the kneeling young shepherd at Fermo, indeed, may have played a role in the genesis of the striking figure of a young man in the right half of the 'finished picture' who shields his eyes with a curling drapery. The next step in the development of this figure was reached with the rope-swinging tormentor of Christ in the Flagellation of *c.* 1614 (Ghent, see Held, 1980, No.342; and Antwerp, St. Paul, see *KdK*.87).

Even if we follow Count Seilern in assuming that the Conversion of Paul once formed a companion piece to the Munich Sennacherib, it is of course by no means certain that they were painted at the same time, let alone that the Sennacherib came first. The Sennacherib is generally dated *c.*1615, though there is no definite evidence for it; it was certainly painted before the Death of Decius Mus of about 1617. I see no reason why even the 'finished picture' of the Conversion of Paul could not have been painted somewhat earlier. Thus Christopher Norris' date for the Count Seilern drawing does not seem to be unreasonable. For this question see also Held, 1980, I, p.579.

62 [Plate 61]

DAVID AND GOLIATH

c. 1610–1612. Pen and ink. 219 × 164 mm.
Rotterdam, Museum Boymans-van Beuningen (V.41).

COLLECTIONS P. Dubaut; F. Koenigs; D. G. van Beuningen.
EXHIBITIONS Amsterdam, 1933, No.68; Brussels, 1938–39, No.10; Rotterdam, 1952, No.66; Antwerp, 1956, No.39.
LITERATURE Chr. Norris, *The Burlington Magazine*, LXIII, 1933, 230; Burchard-d'Hulst, 1963, No.69.

This drawing is related to the one in Montpellier (No.63) and like it belongs to the beginning of the second decade of Rubens' career. The severing action of David, as he cuts off Goliath's head, is still reminiscent of the painting of Judith cutting off the head of Holofernes, which Rubens had painted in Italy (*KdK*.30; see also C. Galle's engraving known as the 'large' Judith). The head of Goliath has been drawn in a foreshortened pose like that of St. Christopher in the drawing in London (No.73). For the connection of the pose of David with that of Samson in the Chicago sketch see comment under No.63. Rubens came back to the somewhat forced relationship of the head to the shoulders and arms in the figure of a husky man who holds Christ's legs in the Entombment in Amsterdam (No.98). He solved this movement more successfully in the Amsterdam drawing which dates a few years later, by avoiding the artificiality of a completely profile view of the head.

63 [Plate 62] *(1959: No.26)*

DAVID AND GOLIATH

c. 1610–1612. Pen and ink. 215 × 158 mm. (On the reverse: Susanna, No.20.)
Montpellier, Bibliothèque Universitaire, Collection Atger (247).

COLLECTIONS X. Atger.

EXHIBITIONS Antwerp, 1956, 38.
LITERATURE Exh., Amsterdam, 1933, mentioned under No. 68; M. Jaffé, *The Burlington Magazine*, XCVIII, 1956, 318; Burchard-d'Hulst, 1963, No.70; Kuznetsov, No.40.

Inscribed (by later hands): 'David et Goliath', and 'P.P. Rubens fecit'.

This drawing and the one in Rotterdam (No.62) seem to be the earliest formulations of this theme in Rubens' work. In the Montpellier drawing David is shown in two poses, each rendering the moment when he lifts the sword with both hands, ready to deliver the blow which will sever Goliath's head. In the Rotterdam drawing he bends down, holding Goliath's hair with his left hand while cutting his victim's neck with the sword held in his right.

David's pose in the Montpellier drawing is very reminiscent of that of Samson in the Capture of Samson in Chicago of *c.* 1610 (see Held, 1980, No.313), except for the action of the arms. The movement of the arms as they appear in the pose nearer the right edge was used by Rubens before, in the very early painting of the Massacre of the Innocents in Brussels (see G. Glück, *Annuaire des Musées Royaux des Beaux-Arts de Belgique*, I, 1938, 151, and J.S. Held, *Miscellanea Prof. Dr. D. Roggen*, Ghent, 1956, 129); it occurs again, much later, in a sketch of Hercules killing the Hydra of the Torre de la Parada series (Held, 1980, No.192).

No painting of the David and Goliath story is known from the period to which these two drawings seem to belong. A painting formerly in the Leuchtenberg collection and now in the collection of Norton Simon, Pasadena, shows both figures in a different pose again. David's movement in that picture closely resembles that of the tormentor of Christ near the right edge in the Flagellation sketch in Ghent (Held, 1980, No.342) of *c.* 1614. The Leuchtenberg canvas seems to belong to the period of around 1615. Rubens dealt with the subject again in 1620, when he included it in his series of paintings for the ceiling of the Jesuit church in Antwerp. The composition is known from several copies and from an original sketch in the Princes Gate Collection, Courtauld Institute Galleries (Held, 1980, No.11).

It can easily be seen that many influences assimilated by Rubens during his Italian travels are incorporated here. For the figure of David (just as for his Samson in Chicago), Rubens made use of his studies of the Torso in the Belvedere, one of the antiques he admired most. He was certainly familiar with the various treatments of the David and Goliath theme by Italian masters, such as Michelangelo's fresco of the Sistine Ceiling, Raphael's painting in the Loggie (where Goliath is very like that of the Montpellier drawing), the Louvre painting by Daniele da Volterra, Pordenone's picture in the Cloisters of Santo Stefano in Venice (see G. Fiocco, *Giovanni Antonio Pordenone*, Udine, 1939, Pl.176) and such graphic renderings as Ugo da Carpi's print after Raphael and Picino's after Pordenone. Most of these versions of the theme have the traditional motif of triumph, which Rubens also adopted in the early drawings, in which David steps across the body of Goliath and rests one knee solidly on the giant's back. When he painted the Leuchtenberg version, Rubens no longer followed this pattern, but only in 1620 did he find the most forceful and personal solution, though even there an Italian influence is discernible: that of Titian's Cain from Santa Maria della Salute in Venice (O. Fischel, *Tizian*, KdK.III).

64 [Plate 64] *(1959: No.162)*

ELEVEN HEADS OF WOMEN

c. 1608–1612. Pen and ink. 203 × 313 mm.
Brunswick (Braunschweig), Herzog Anton Ulrich-Museum (D.60–C.1711).

EXHIBITIONS Antwerp, 1956, No.6; Antwerp, 1977, No.124.
LITERATURE Held, 'Rubens' Designs for Sepulchral Monuments', *The Art Quarterly*, XXIII, 1960, 264–66; Burchard-d'Hulst, 1963, 16, under No.3; K.L. Belkin, *Corpus Rubenianum*, XXIV, 1978, No.45.

The nature of these studies and their arrangement on the page follow patterns familiar from costume books, and indeed might indicate that this sheet was originally part of Rubens' own Costume Book in the British Museum; this, at any rate, is the view of Kristin Lohse Belkin, the author of the most thorough discussion of that collection of costume studies. One of the heads, as had been observed by several authors before, is clearly derived from the Tiburtine Sibyl on the left wing of Roger van der Weyden's Bladelin Altarpiece in Berlin. The nearest correspondence of most of the other heads is found in Heinrich Vogtherr's *Kunstbüchlin*, first published 1537 (but reprinted many times later). Belkin, however, is probably correct in assuming that Rubens had before him a sketch- or model-book in which these heads had been assembled by an earlier artist. The nearest analogies to this sheet are found in No.6 of the London Costume Book (a drawing which was acquired separately in 1841 and inserted in the book) and a drawing in the Louvre (Lugt, *Catalogue*, No.1115, Pl.LIV); both drawings, in fact, share one head, though in reverse.

65 [Plate 63] *(1959: No.157)*

A YOUNG COUPLE (AFTER ISRAHEL VAN MECKENEM)

1608–1612. Pen and ink. 199 × 139 mm.
Berlin, Kupferstichkabinett (3243).

COLLECTIONS M. Merian the Younger; Kurfürst Friedrich Wilhelm of Brandenburg; King Friedrich Wilhelm of Prussia; Berlin Akademie der Künste; since 1831 in the Kupferstichkabinett.
LITERATURE J. Rosenberg, 1928, 64; Bock-Rosenberg, *Catalogue*, 253; Burchard-d'Hulst, 1963, No.8; Mielke-Winner, 1977, No.17; K.L. Belkin, *Corpus Rubenianum*, XXIV, 1978, 58, 125 ('done in his early youth').

This graceful drawing was copied from Meckenem's engraving B.182. It is the only instance in which a definite connection can be established between Rubens and a fifteenth-century print. (For a copy from a fifteenth-century painting see No.64.) Rubens' drawing is considerably larger than the original print, but otherwise follows it fairly closely except for the omission of a scroll. Traces of the young woman occur in several later works. She was taken over literally in a drawing in Vienna (of doubtful authenticity) showing a group of young women and monks (Mitsch, 1977, No.101). It seems possible that Rubens also remembered her when he made the final draft of the Virgin in his painting of the Visitation on the left wing of the Descent from the Cross in Antwerp of 1611–1614 (*KdK.*52). In the first edition of this book I dated the drawing 'before 1600' but with a question mark added. Since my late dating of the London Costume Book has now generally been accepted, I am happy to change the date of this drawing also, accepting the one Mielke (in Mielke-Winner) has proposed.

66 [Plate 65]

SEVERAL STUDIES OF SIXTEENTH-CENTURY ARMOUR

c. 1610–1614. Pen and brown ink in two tones. 232 × 336 mm.
London, British Museum (folio 22 of the Costume Book) (1841–12–11–8).

COLLECTIONS R. de Piles (who may have obtained it from

Philip Rubens, the artist's nephew); Pierre Crozat; P.-J. Mariette (?); J. Boon (?) or H. G. Boon (?); acquired by the British Museum 1841.

EXHIBITIONS London, 1977, No.2.

LITERATURE Hind, II, 119 (22); Burchard-d'Hulst, 1963, I, 13 (under No.1). Belkin, *Corpus Rubenianum*, XXIV, 1978, No.22; Held, Review of Belkin's book, *The Burlington Magazine*, 1982, 245-46.

This sheet (and part of the one preceding it) differs from the majority of drawings in the Costume Book in that it concentrates on armour worn by men as well as horses, and that apparently all details have been derived from woodcuts by German artists of the early sixteenth century. Hind was the first to identify rider and horse seen at the left and the hand above it as copies from Burgkmair's chiaroscuro woodcut of St. George, and the horse at the lower right as a copy from its companion piece, the woodcut of Emperor Maximilian, both done in the same year (1508). Burgkmair was also the author of the head of a horse in the lower centre, though Belkin, who recognized it, found that woodcut only in a 1679 edition of the *Theuerdank*. The *Theuerdank* book provided also the model, as Belkin found, for the two heads at the upper right, one coming from a woodcut by Burgkmair, the other from one by Leonard Beck. The other details have not been identified yet, but they, too, must derive from similar German sources.

Although Belkin was in general agreement with the late date for most of the drawings in the Costume Book which I had proposed, she excepted several sheets, among them precisely the one shown here, assigning to it a date before 1600 (p.44). In my review of her book I argued that this sheet (and folio 21 which has two similar figures) should also be dated at least as late as the rest, if not even somewhat later. I take it from a letter she wrote to me soon after that she now shares this view.

67 [Plate 66]

YOLANDE DE BARBANÇON, GUILLAUME DE JAUCHE AND THREE OTHER FIGURES

1610-1611. Pen and brown ink, grey wash. 304 × 105 mm.
Watermark: Briquet 1368.
London, British Museum (1841.12.11.8).

COLLECTIONS De Piles; P. Crozat.
LITERATURE Hind, *Catalogue*, II, No.119; K. L. Belkin, *Corpus Rubenianum*, XXIV, 1978, No.10 (Fig.42).

Inscribed: Jolant de Barbanson femme de Otto Seig^r de Lalaing (the standing lady at left); Guillaume de Jausse s^r de Mastain; Caterine heritiere de Molenbais femme de Guillebert de santes (the pair upper right); Margerite de briffey femme de Guillaume de Jausse (the lady lower right).

The three half-lengths were copied from the Recueil d'Arras; Yolande de Barbançon may have been copied from a drawing by de Succa; her ultimate source (Belkin) may have been a statuette from the tomb of Louis de Mâle in the Collegiate Church of St. Peter at Lille which de Succa visited in 1602. As she did throughout her volume on the Costume Book, Belkin described the costumes in great detail, even noting whether they were of the period in which the individuals here portrayed lived. (They were not for Marguerite de Brifeul and her husband Guillaume de Jauche.) The head-dress of Yolande de Barbançon appears similarly in Pontius's engraving of Queen Thomyris having Cyrus's head dipped in blood and the preparatory drawing, partly reworked by Rubens, in a private collection, Munich (see Müller Hofstede, *Wallraf-Richartz-Jahrbuch*, XXVII, 1965, fig.244).

This sheet from the London Costume Book is a good example of Rubens' intention to animate the rather lifeless models from

which he worked. The half smile on Yolande de Barbançon's face, her sideways glance, and the play of her fingers almost suggest a living model. Rubens also introduced one of his favourite devices—a shadow falling over the forehead and eyes, which thereby gain a delightful luminosity.

For Rubens' sources in general see the following number.

68, 69 [Plates 67, 68] (1959: No.163)

FOUR FIGURES IN ORIENTAL DRESS

1610-1614. Pen and ink. 308 × 388 mm.
London, British Museum (1841.12.11.8).

COLLECTIONS De Piles; P. Crozat.
LITERATURE Hind, *Catalogue*, No.119 (40); R. A. Ingrams, *The Burlington Magazine*, CXVI, 1974, 190-97; Kuznetsov, 1974, No.49 (the 'King of Persia' only); K. L. Belkin, *Corpus Rubenianum*, XXIV, 1978, No.40.

This is a double page from a sketchbook containing costume-studies, most of which seem to have been taken from drawn or painted sources rather than from life. The overwhelming majority of these costumes are late medieval in character (fifteenth to sixteenth centuries), and it can be demonstrated that the most important single source for Rubens was the *Memoriaux* of Antoine de Succa, fragmentarily preserved in the Brussels Library. De Succa's album was a compilation of iconographic and epigraphic material which may have been made for a contemplated history of the houses of Brabant and of Flanders, probably at the special request of Archduke Albert and his wife Isabella. The London album itself has been inscribed in an eighteenth-century hand '*Un volume d'etudes dessinées par P. P. Rubens pour son histoire des Contes de Flandre*' ('A volume of studies drawn by P. P. Rubens for his history of the Counts of Flanders') Hind, *Catalogue*, No.37, but Hind is probably correct in assuming that it was compiled by Rubens more for costume references in the studio than for any such special purpose. Besides the forty leaves listed by Hind (many of them double folios) there are two more which were acquired by the British Museum in 1949 (*Philip le Bel* and *Johanna Aragonia*) and a similar sheet, which originally may also have been part of the album, was in 1951 in the New York art market (J. S. Held, *The Magazine of Art*, 1951, 287). If the New York drawing was indeed a part of the album, it may have been the last leaf or even a part of that leaf when the album was still in Crozat's collection. As Mariette described it (Paris, 1741, No.845), the album consisted of 'Quarante-trois Desseins de Rubens, d'après de vieux monuments qui conservent la forme des anciens habits, qui étoient en-usage en France & dans les Pays-Bas, en remontant jusqu'au douzième siècle; ensemble quelques modes Turques & du Levant.' (See also Introduction, p.46.)

Hind's notes on the individual folios and his reference to the possible models of Rubens are very incomplete.

In 1972 H. and O. Kurz published a volume with watercolour drawings of Turkish costumes they had found in the L. A. Mayer Memorial in Jerusalem (*Nederlands Kunsthistorisch Jaarboek*, XXIII, 275-90). Another such album is at the Veste Coburg. A book of that kind seems to have been the source for most of the Turkish drawings in the London Costume Book. No such models have as yet been found for the Persian figures. Dr. R. Ettinghausen kindly informed me that he considers it likely that Rubens based his design on the records of a Western traveller rather than on Islamic miniatures. A man who might have played a role in the transmission of oriental motifs was N. de Respaigne, who had a collection of 'Turkish costumes' (see *Rubens Bulletin*, V, 1900, 103ff.).

Inscribed (in Rubens' hand): 'Coninck van Persia' (top of left-hand part of sheet) 'groen' (green), 'purper', 'root', 'purper',

'wit' 'root' (counterclockwise) on young woman at left; 'blauw' 'gout' 'Gout den gront met root en groen werk', 'root' (twice); 'Witte schoenen' (white shoes) 'zee groen med goude blome' (sea-green with gold flowers); 'sabel' (sable); 'wit met goude strepen' (white with gold stripes) (counterclockwise on seated man). 'Blauw', 'root gouwe laken (?)' on a seated man in the right half of paper; 'Persiaensche Jonghe dochter' above the girl with a mirror at right; 'Gout', 'roo[t] strepen', 'gout', 'de vingeren root geschildert', 'gout', 'met root', 'gout, bruin blau flouweel met goude bloemen' 'groen', 'Gout groen met blau', 'root werck op blaw', 'witte schoen', 'Turcks werck met velderley coleuren'. 'Gout', 'Root met goude blom', 'gesmeden ... keten', 'Spiegel' (around the figure, counterclockwise); 'gout', 'blauw voeder', 'root', 'fiol' blom', 'witt groen' (on her dress and skirt). Some of these inscriptions are ornamented, and a few more may be hidden in the hasty scrawls on the girl's dress. Rubens must have been fascinated with the profusion of colours and the general splendour of the exotic costume. Yet there is no trace in his extant work of these studies of oriental figures.

Since Rubens could only have seen De Succa's drawings after his return from Italy, the time of his return is a *terminus post quem* for the London album. Indeed, as De Succa's work was undertaken for Albert and Isabella, Rubens probably saw it only after his appointment as painter at the court in September of 1609 (Génard, 415). No further indications for the date of these drawings can be found. Stylistically, they would seem to fit best into the years between 1610 and 1615, when Rubens collected a good deal of material and when his style was given to precise recordings of details of ornamentation, textures, and local colour.

The 'post-Italian' date for the Costume Book, first proposed by me in 1959, and now generally accepted, was strongly rejected by Burchard-d'Hulst (1963, 12–13), who affirmed that all drawings belong to the pre-Italian period, one group even associated with the period when Rubens served as a page in the household of Marguerite de Ligne (1591)! See also my review of Belkin's book, *The Burlington Magazine*, CXXIV, 1982, 245–6.

70 [Plate 71]

SIX SCENES FROM THE NEW TESTAMENT

c. 1610–1611. Pen and ink, washed. Various dimensions: The Annunciation 53 × 117 mm.; The Visitation 90 × 40 mm.; The Nativity 102 × 38 mm.; The Annunciation to the Shepherds 90 × 38 mm.; The Adoration of the Shepherds 102 × 38 mm.; The Circumcision 46 × 117 mm. (The Annunciation to the Shepherds and the Adoration of the Shepherds have been exchanged in the reproduction for the sake of symmetry.)
New York, J. Pierpont Morgan Library (III, 183).

COLLECTIONS W. Mayor; C. Fairfax Murray.
EXHIBITIONS Cambridge–New York, 1956, No.10.
LITERATURE O. Benesch, *Artistic and Intellectual Trends from Rubens to Daumier*, Cambridge, Mass., 1943, 8–9; Held (in Goris-Held), 1947, Nos.96–101; Burchard-d'Hulst, 1956, under No.48; Held, 1959, under Nos.139 and Add.171; Burchard-d'Hulst, 1963, under No.68; Judson-Van de Velde, *Corpus Rubenianum*, XXI, I, No.7a; II, Pl.50.

Five of the drawings are inscribed P.D.V. and one (the Annunciation) with the full name, P. Del Vaga (Pierino del Vaga (1500–1546/47), which only shows how little previous collectors knew about Rubens' early pen drawings. The Morgan drawings belong to the earliest studies Rubens made for the *Missale* and *Breviarium Romanum*; they were intended to enframe the text of the first page of the Christmas Matins of the Missal published in 1613. The engraver was Theodore Galle, but the prints do not follow the drawings in every detail; the

Annunciation is close to Rubens' drawing, though in reverse; the Nativity and Circumcision are also fairly close, and in the same sense. Major changes were made in the Annunciation to the Shepherds and the Adoration of the Shepherds; and the Visitation was replaced by the Virgin and Joseph turned away from the Inn. On the printed page the four vertical compositions are at the right and the left of the text, with the arched scenes below, the rectangular ones above. The four corners received the images of the four Evangelists, Matthew and Mark at the top, Luke and John below. There is no comment on the design of these four prints in Judson and Van de Velde, but I believe it is safe to say that Rubens was their author, too, though his drawings have disappeared. For his work Theodore Galle was paid 75fl. on September 25, 1612. The payments made to Rubens are not sufficiently itemized to permit us to know what Rubens received, but it was surely a mere fraction of what was paid to the engraver.

Together with the two drawings for the *Vita Beati P. Ignatii Loiolae* (see No.44) the six Morgan drawings for the Roman Missal demonstrate the extraordinary delicacy Rubens was capable of when working on a small scale. Moreover, modest as these small sketches seem to be, they contain, as J. R. Judson has shown in considerable detail, the germs of several later and larger compositions.

Rubens designed one additional border decoration for the *Missale Romanum*, with the Tree of Jesse; the drawing for that border is also preserved, forming part of the large collection of Rubens drawings in the Cabinet des Dessins in the Louvre, Paris (see G.-H. No.71, and Judson–Van de Velde, I, No.6a).

71 [Plate 72] *(1959: No.27)*

STUDIES FOR THE VISITATION

1611 (between March and September; G.-H., 1612–1613). Pen and ink, washed. 265 × 360 mm. On the reverse: Man Holding the Shaft of the Cross (see No.14).
Bayonne, Musée Bonnat (1438).

LITERATURE *Les Dessins de la Collection Léon Bonnat au Musée de Bayonne*, III, Paris, 1926, Pl.22; G.-H.No.75; Evers II, 102, 137, 141; O. Benesch, 'Beiträge zum Werk des Rubens', *Alte und Neue Kunst*, III, 1954, 8ff.; E. Haverkamp Begemann, *Catalogue Exh.* 1953, No.11; A. Seilern, *Catalogue*, 28–29; Burchard-d'Hulst, 1963, No.61; Kuznetsov, 1974, No.36; Jaffé, 1977, 52L.

Inscribed, in Rubens' hand, over the scene in the upper left; 'opus (?) ... adanÿ' (Stradanij); in the lower right corner, by a later hand, 'Rubb:'.

The paper on which this drawing is found was originally more than twice its present size (see Evers, *loc.cit.*). Its original shape can be reconstructed with the help of two other fragments which have been found in recent years. One is now in the Princes Gate Collection, Courtauld Institute Galleries; the other in the Metropolitan Museum (see No.72). On the evidence of the two other drawings we must conclude that the Bayonne section must originally have been at least 20 mm. wider and probably more. It is certain from the figures on the back (see Fig.8) that the three pieces were once part of one large sheet. The studies for the Visitation were made in connection with the left wing of the Triptych of the Descent from the Cross in Antwerp Cathedral (KdK.52). Beside the several Visitation scenes a number of male heads can be seen on the Bayonne drawing (one in the centre, above the head of Elizabeth of the lower group; three or four others in the lower right corner). These heads are so close in style to Rubens' sketches for a Last Supper (see No.18) that they, too, should be dated in the early years of Rubens' stay in Italy—thus contemporary with the drawing on the reverse.

In addition to the Bayonne drawing two oil-sketches exist for the Visitation, one in the Strasbourg Museum, the other in the Princes Gate Collection, Courtauld Institute Galleries (Held, 1980, Nos. 352, 353). It is generally agreed that the Princes Gate sketch is later than the drawing and (with its companion piece of the Presentation in the Temple) is probably the model which Rubens presented to his patrons. The place of the Strasbourg sketch in the development of the composition is less certain. Count Seilern puts it before the Bayonne drawing and he cites Haverkamp Begemann, who had previously taken the opposite view, as now having adopted the same. The Virgin's drapery in the Strasbourg panel and the motif of her hand clasping that of Elizabeth indeed do not recur either in the Bayonne drawing or in the Princes Gate sketch (where the handshake was shifted to Joseph and Zacharias). Yet I would not exclude the possibility of the reverse order. In the early stages Rubens may well have tried out alternate solutions and what he finally adopted was not necessarily always the last in the order of chronology. There is some evidence that this might have been the case here. A careful study of the Bonnat drawing shows that the sequence of groups on the sheet itself is more or less in the order of their size. The earliest group is the one near the upper centre, where Elizabeth appears in a doorway, while the Virgin is only seen in the most general outlines. The idea of a door (or window?) appears once more in the lower left corner but is then abandoned. (It does not figure in the Strasbourg sketch.) The next group, in the upper left, is the clearest of all, and it is this design which Rubens later adopted as the basis for the final work. He continued, however, counterclockwise with trial compositions for the group of the two women in which the scale of the figures grew larger and in which he gave an increasingly urgent and humble attitude to the older woman. While the figure of Elizabeth in these sketches is distinguished by a fluent grace and by an intensity of feeling not found in the scene in the upper left corner, Rubens gave preference in the end to the more statuesque group which he had drawn first. Yet it is not impossible that before he came back to this earlier concept he painted the Strasbourg sketch in which Elizabeth is related to the later studies of the Bayonne drawing.

In January and February of 1614 payments were made for the transport of the finished wings into the Cathedral (R., II, 114–15). All the work on them must therefore have been finished by the end of 1613. However, the artist had already received the commission for the altar on September 7, 1611. In keeping with the custom of the time the commission was probably given only after the sketches had been approved. (The negotiations had begun on March 13 of that year.) Thus—unless one is willing to assume that the original commission referred only to the centre panel, which is not likely, since the triptych is iconographically a well-planned unit (see Evers, I, 132–133)—all the evidence points to spring and summer of 1611 as the period of preparatory work.

There is one additional reason for the early dating of the drawings. Both the drawings for the Visitation and for the Presentation in the Temple (see No. 72) and the Strasbourg sketch make it very likely that originally the dimensions of the altar were planned differently. At the time Rubens made his drawings, the wings evidently did not have the high, narrow proportion which they were finally given and which forced Rubens to introduce rather complex architectural features into his design. It is inconceivable that this uncertainty could have prevailed until after the date of the contract, when Rubens began to work on the central panel. The change in the shape of the panels may well have been responsible for the adoption of the earlier, 'calmer' configuration of the Visitation scene, since the figures were then placed high upon a bridge-like structure.

72 [Plate 73] *(1959: No. 28)*

STUDIES FOR THE PRESENTATION IN THE TEMPLE

1611 (between March and September). Pen and ink, washed. Left section: 214 × 142 mm.; right section: 242 × 238 mm. Left section: *New York*, The Metropolitan Museum of Art. Right section: *London*, Princes Gate Collection, Courtauld Institute Galleries.

COLLECTIONS (left section) J. Scholz; (right section) P. Langerhuizen L^zn.; V. Koch.
EXHIBITIONS (left section) Cambridge–New York, 1956, No. 11; (right section) Amsterdam, 1933, No. 71.
LITERATURE (left section) O. Benesch, *Alte und Neue Kunst*, III, 1954, 8ff., Fig. 1; (right section) L. Burchard in Glück, *Essays*, 382; Evers, II, 102ff., 137, Fig. 10; A. Seilern, *Catalogue*, No. 56; Burchard-d'Hulst, 1963, No. 60.

These two sections originally formed one large sheet with the Bayonne drawing for the Visitation (No. 71); this can be demonstrated by putting them together so that the fragmentary studies on the back are connected into a coherent design (see Fig. 8). For a discussion of the date and the connection of these pieces see Nos. 14 and 71.

Just as he had done for the Visitation, Rubens made several studies for the Presentation in the Temple, which forms the right wing of the triptych of the Descent from the Cross in Antwerp Cathedral. There are three different attempts on the two sheets reproduced here, none of which is very close to the final version or to the oil-sketch in the Princes Gate Collection, which preceded it (Held, 1980, No. 358). In the sketch and in the finished painting Simeon turns towards the right and Joseph is seen almost in profile, not from the back. The drawings are interesting because they show how Rubens experimented on the same sheet simply by reversing the order of figures. There is no denying, however, that the arrangement of the figures as tried out here is much less effective than the one which was finally adopted.

Benesch believed (*loc. cit.*) that the figure of Joseph was inspired by the kneeling figures in the foreground of Caravaggio's Distribution of the Rosary, now in Vienna. For the derivation of this idea one could also point to Caravaggio's Madonna of the Pilgrims in Sant' Agostino in Rome. The connection is not very close, however, in either case. Rubens may have known the Rosary Madonna in Italy; the picture is mentioned in 1607 in a letter written by F. Pourbus to the Duke of Mantua. At any rate, the famous transaction in which Rubens, aided by other Antwerp artists, brought the—perhaps unfinished (see W. Stechow, *The Art Bulletin*, XXXVIII, 1956, 62)—painting by Caravaggio to the church of St. Paul in Antwerp took place only after 1617.

73 [Plate 87] *(1959: No. 30)*

TWO STUDIES FOR ST. CHRISTOPHER

c. 1611–1613. Pen and ink. 267 × 167 mm. The paper has been clipped irregularly in the upper left corner and along the right edge.
London, British Museum (Gg. 2–231).

COLLECTIONS The Rev. C. M. Cracherode.
EXHIBITIONS London, 1977, No. 59.
LITERATURE J. Comyns Carr, *L'Art*, XI, Tome 4, 1877, 265ff.; R., V, No. 1444; Hind, *Catalogue*, No. 14; Muchall-Viebrook, No. 3 (expressing doubts about the authenticity); Burchard-d'Hulst, 1963, No. 43; Keith Andrews, *Adam Elsheimer*, Oxford, 1977, 141.

Hind recognized that this drawing is connected with Rubens' plan for St. Christopher on the outside of the Triptych of the Descent from the Cross in Antwerp; an oil-sketch for that figure is in Munich (Held, 1980, No.359). Without knowing the present drawing, H. Weizsäcker had suggested that in painting that figure, Rubens might have 'remembered' Elsheimer's St. Christopher (*Adam Elsheimer, der Maler von Frankfurt*, Berlin, 1936, 102; *idem*, 2nd part, 1952, 30). That the London drawing has, in fact, a very close relation to Elsheimer's painting was first pointed out by me in the first edition of this book. Sensing in Elsheimer's concept of the Saint's motion (known from a painting and a print by James Heath, 1812) a spatial freedom and vigour unusual for the master—a feeling Weizsäcker, too, had expressed—I proposed a somewhat complicated sequence of events which I find now too hypothetical to repeat. Andrews, however, does minimize the differences between Elsheimer's painting (which he reproduces in three versions) when he speaks of the London drawing as a 'straight copy'. Not only does he overlook the fact that the drawing shows two different poses for the Christ Child, but also very different proportions of the Saint himself. For the influence of Elsheimer on Rubens, first pointed out by K. Gerstenberg (*Zeitschrift für Kunstgeschichte*, II, 1933, 220) Andrews' book, however, provides important insights. Although the Munich oil-sketch and the large version of the Saint in Antwerp depict the action in reverse and introduce an additional narrative element—the reaction of the Christ Child to the light from the hermit's lamp—the link between the drawing and the painted versions has been strengthened by the observation (communicated to me by von Sonnenburg) that X-ray examination of the Munich sketch has shown that originally the Christ Child had both hands on the head of St. Christopher, exactly as Rubens had drawn it on the London sheet.

74 [Plate 75] *(1959: No.81)*

STUDIES OF HEADS AND HANDS

c. 1613. Black and white chalk on greyish paper. 344 × 235 mm. The outlines of the paper are slightly irregular.
Vienna, Albertina (8307).

EXHIBITIONS Zürich, 1946–47, No.83; Paris, 1949, No.83.
LITERATURE R., V.No.1579; F. M. Haberditzl, 1912, 7; G.-H.No.74; A. Seilern, *Catalogue*, 28; Mitsch, 1977, No.9.

All the elements of this drawing can be identified in Rubens' painting of the Presentation of Christ in the Temple, which forms the right wing of the triptych of the Descent from the Cross in Antwerp Cathedral (*KdK*.52). The close correspondence proves that the plan of the composition must have been well advanced when Rubens made these studies from nature. Thus the drawing probably followed the sketch in the collection of Count Seilern (Held, 1980, No.358), now Princes Gate Collection, Courtauld Institute Galleries. (For another drawing, belonging to an earlier stage of the development of the theme, see above, No.72.)
The head seen in the upper half of the drawings was used for Joseph, the lowest figure in the painting; the head below and the pair of hands next to it are studies for Simeon in the painting. The hands in the upper corner are those of the prophetess Hannah.
The work on the wings of the Descent from the Cross seems to have been done mainly during 1613 (they were finished in January, 1614, and delivered in February and March). While the preliminary drawings and the oil-sketches may go back to 1611, the Vienna drawing was surely done only when Rubens was ready to paint the large panel.

75 [Plate 69] *(1959: No.79)*

STUDIES OF ARMS AND LEGS

c. 1612–1615. Black chalk, remnants of white. 350 × 240 mm. *Rotterdam*, Museum Boymans-van Beuningen (V.27).

COLLECTIONS P. H. Lankrink; J. C. Robinson; E. Wauters; F. Koenigs; D. G. van Beuningen.
EXHIBITIONS Amsterdam, 1933, No.119; Rotterdam, 1938, No.344; Brussels, 1938–39, No.36; Rotterdam, 1939, No.28; Antwerp, 1956, No.63; Antwerp, 1977, N.138.

Unlike most of the drawings of single figures or of figure details, this study so far has not been connected with any of Rubens' known compositions, though analogies are found with several of them. The nearest I have been able to find is the use of the hand holding an unidentified object (upper left) in Rubens' Lion Hunt in Munich (*KdK*.154): it is the right hand of the wounded or dead man lying on the ground at the right. In the earlier edition of this book I also referred to the Martyrdom of St. Ursula (Brussels, Held, 1980, No.430) but I realized that the gesture of two hands covering the face in fear or shame belong to the standard formulae of Renaissance art (see Adam in the Expulsion scene of Raphael's Loggie, or Moses before the burning bush of the same cycle). The two legs of a man, seen from the back, with one leg lifted as if walking, or kneeling on steps (?), while nowhere occurring identically, resemble a pose found with a man in the top part of the so-called 'small' Last Judgment in Munich (*KdK*.195) and possibly even earlier with a youth kneeling before St. Ignatius of Loyola in the Vienna picture of the Miracles of the Saint (*KdK*.204).
Stylistically, however, the drawing belongs to the earlier ones of its type. Rubens' concern with details such as the veins standing out from under the skin, and a certain hesitancy in tracing the outlines may be quoted in favour of a relatively early date. In its general character the drawing is related to a study of four hands (Kupferstichkabinett, Dresden, see Freedberg, *Corpus Rubenianum*, VII, 1984, Fig. 97) all of which were used in the Assumption of the Virgin in Vienna, dated *c.* 1613 by Freedberg.

76 [Plate 80]

COMMUNIUM OBJECTORUM COGNITIO

(The Cognition of Common Objects) *c.* 1612. Pen and ink, washed, over black chalk, and heightened with white, stylus marks for transfer. 97 × 146 mm. Watermark: a two-headed eagle with the emblem of Basel, a shield (?) below.
Washington, National Gallery of Art (1982.104.1).

COLLECTIONS Sale Christie's Amsterdam, November 22, 1982 (36) (I am not aware of any previous mention).
LITERATURE Judson-Van de Velde, *Corpus Rubenianum*, XXI, 1978, I, No.13a ('Whereabouts unknown; presumably lost'), II, 453[12]: 'gesneden voor den boeck van Pater Agillion . . . daer hij met een ooghe siet op een stoxken . . .' ('engraved for the book of Father Agillion . . . where he looks with one eye at a stick').

Engraved by Theodoor Galle who received 18 guilders for his work (May 20, 1613).

This is Rubens' model for the third of six vignettes he designed for Franciscus Aguilonius' book on Optics, OPTICORVM LIBRI SEX, Antwerp, 1613, for which he also drew the title-page. It appears at the head of chapter three, which deals with visual and tactile perception. The scholar seated at the left is learning from a children's game that it is difficult to gauge the position and distance of an object (here a small stick held by the foremost of three putti) with one eye closed. The setting—a library with books on shelves and a globe and armillary sphere on a

Fig. 14 Communium Objectorum Cognitio. Engraving for Aguilonius' *Opticorum Libri Sex*, 1613

cabinet—is appropriate for a man of learning, who, at this moment, tries to touch the stick with the index finger of his left hand but, as we might expect, fails in his attempt. (Rubens clearly calculated with the reversal of the design in the print, where in fact both the scholar and the putto extend their right hands.) The engraving follows the drawing closely, with one major change: Rubens had failed to stress the fact that in this experiment, one eye of the observing scholar must be closed. Presumably at Aguilonius' urging, he must have submitted to the engraver another drawing of the old man's head, turned slightly to the front so that one can clearly see that one eye (his left) is closed.

The lion-headed sphinx at the side of the scholar's seat, whose hand rests on the creature's head, symbolizes wisdom or intellectual power. Rubens used a similar form on the throne of Solomon giving his judgment in the case of the two mothers contending over a child claimed by both (Copenhagen, *KdK*.128) and on the throne of Scipio in the picture of the Continence of Scipio, now lost, but known from an engraving by Schelte a Bolswert (V.S. p.140, No.35). In both these compositions the right hand of the wise judge—Solomon and Scipio—is on, or close to, the head of the sphinx, surely a significant idea which Rubens had introduced for similar reasons in the vignette for book III of Aguilonius' Optics.

At present only one other drawing for a vignette in Aguilonius' work is known (see Judson–Van de Velde, *op.cit.*, No.11a, private collection, London). For the relationship of Rubens to Aguilonius in general see C. Parkhurst, 'Aguilonius' Optics and Rubens' Colour', *Nederlands Kunsthistorisch Jaarboek*, XII, 1961, 35–49; M. Jaffé, 'Rubens and Optics: Some Fresh Evidence', *Journal of the Warburg and Courtauld Institutes*, XXXIV, 1971, 362–6; W. Jaeger, *Die Illustrationen von Peter Paul Rubens zum Lehrbuch der Optik des Franciscus Aguilonius, 1613*, Heidelberg, 1976; Held, 'Rubens and Aguilonius: New Points of Contact', *The Art Bulletin*, XXI, 1979, 257–64.

77 [Plate 76] *(1959: No.139)*

THE ADORATION OF THE MAGI

c. 1612–1613. Pen and ink, washed. 295 × 190 mm. Outlines indented with a stylus for transfer.
New York, J. Pierpont Morgan Library (I, 230).

COLLECTIONS J. C. Robinson; C. Fairfax Murray.
EXHIBITIONS Paris–Antwerp–London–New York, 1979–80, No.11; Cambridge–New York, 1956, No.12.
LITERATURE C. Fairfax Murray, I, London, 1905, No.230; G.-H.No.68; Bouchery-Wijngaert, 61, Pl.35–36; Evers, II,

209–10; O. Benesch, *Artistic and Intellectual Trends from Rubens to Daumier*, Cambridge, 1943, 7; Goris-Held, No.102; Judson-Van de Velde, I, 1978, No.8a; Held, 1980, under Nos.322 and 323.

Engraved: Th. Galle (in reverse). Galle was paid 75fl. on February 13, 1613.

Between 1612 and 1614 Rubens furnished eleven full-page illustrations, two designs for marginal (or framing) decorations, and a title-page for a new edition of the *Breviarium Romanum* by the house of Plantin. The earliest drawings were six small scenes to be inserted in a decorative frame (see No.70). Three of the large illustrations were printed in the edition of the *Missale Romanum* of 1613, among them the present one, and all the new designs were included in the edition of the *Breviarium* of 1614. The drawing is a careful piece of work, leaving not much more to the engraver than the design of foliage and the pattern of shading lines. The only conspicuous addition (by the engraver?) is the halo over the Virgin's head. Rubens also considered the inevitable reversal of the design; it is only in the print, for instance, that Christ's right hand meets the right hand of the oldest king.

The composition is still related to a slightly earlier Adoration of the Magi known from a sketch in Groningen and a painting in Madrid (*KdK*.26 and Held, 1980, No.325). The pose and appearance of the Virgin; her position in front of a corner of an imposing ruin with a column on a high pedestal; the shape of the cradle; the motif of a little negro boy holding a vessel with burning coal close to his face, which thus is illuminated from below, are some of the similarities between the two compositions. It is in the group of the Magi and their followers that Rubens made major changes due to the exigencies of the format, and perhaps also in keeping with a growing tendency towards more strictly balanced compositions.

78, 79 [Plates 86, 105]

A YOUNG WOMAN LOOKING UP

c. 1613. Black chalk heightened with white. 374 × 250 mm. On the reverse some light and rather indistinct sketches in black chalk, apparently of a hunt of a wild bull, the attacking stance of which can be discerned twice. It may be connected with a much later composition known from an oil-sketch (Held, 1980, No.226) and several other pieces, done mainly by followers of the master.
Washington, The National Gallery of Art (B30.458).

COLLECTIONS J. Richardson, Sr.; F. Flameng; sale Paris (Petit), May 26–27, 1919 (87). Acquired 1977.
EXHIBITIONS Washington, National Gallery of Art, 1978, No.64.
LITERATURE Burchard-d'Hulst, 1963, No.111; Logan, *Master Drawings*, XVI, 1978, 449; Logan and Haverkamp Begemann, *Revue de l'Art*, XLII, 1978, 92; Freedberg, *Corpus Rubenianum*, VII, 1984, No.37f.

This tender sketch of a young woman is one of six drawings with carefully observed details, intended for the Assumption of the Virgin, now in the Kunsthistorisches Museum in Vienna (*KdK*.206). In the lower centre of that composition are three young women, one of whom looks down at the roses she is uncovering by lifting up a piece of the white linen of the shroud; the next one has picked a few of the flowers as she looks up to call them to the attention of two apostles, one of whom spreads his arms in astonishment; behind her is a third woman who points with her right hand at the roses while turning her head over her left shoulder, though the apostles she is addressing are occupied watching the still greater miracle unfolding above. It is for this young woman that Rubens drew the study now in

Washington; the curved form on which her left hand rests is actually the shoulder of the young woman kneeling directly before her.

Recent research, aptly summed up by Freedberg, assigns to the Vienna Assumption a much earlier date than 1620 which was usually associated with it before. It is, in fact, the first large-scale treatment of the theme, preceded only by the *modello* in Buckingham Palace (Held, 1980, No.375) and a still earlier *modello* for a slightly different theme, the Assumption and Coronation of the Virgin in Leningrad (Held, 1980, No.374), compositions with which the large canvas in Vienna has much in common. Burchard-d'Hulst had dated the large canvas 1614–1615; my date was 1614; and Freedberg has more recently proposed 1613, a date I am now willing to accept too. The several studies for individual figures, or details of hands only (see Freedberg, No.37c, Fig.97) thus take their place chronologically close to the drawings of such details made by Rubens for the two great triptychs of the years 1611–1614—the Raising of the Cross and the Descent from the Cross, both now in Antwerp Cathedral. The work on the Vienna canvas may also have preceded (though not by much) the drawing of the Assumption of the Virgin for the *Breviarium Romanum* (see No.84).

80 [Plate 74] *(1959: No.80)*

STUDY OF A NUDE MAN

c. 1612–1614. Black and white chalk. 570 × 444 mm. Two small pieces of paper added at right.
Stockholm, Nationalmuseum (1926–1863).

COLLECTIONS P. Crozat; Comte C. G. Tessin.
EXHIBITIONS Helsinki, 1952–53, No.34; Stockholm, 1953, No.97; Antwerp, 1956, No.44; Antwerp, 1977, No.134.
LITERATURE G.-H. No.88; Burchard-d'Hulst, 1963, No.72; Kuznetsov, 1974, No.41.

Inscribed below: 'Rubens–Rubnij (?) Cabinet de Crozat 1735'.

Study for the left wing of the triptych of Job formerly in the Church of St. Nicolas in Brussels. The painting, destroyed in the bombardment of 1695, had been ordered by the musicians' guild in June, 1612, and was put on the altar in May, 1613 (R., I, No.129). According to Glück and Haberditzl, the left wing, showing Job attacked by demons and reproached by his wife, was executed in 1614–1615; I do not know on what evidence they made this statement. Rubens was paid in eight instalments between 1613 and 1621. (For the history of the theme of Job as Patron of Musicians see Valentin Denis, 'Saint Job patron des Musiciens', *La Revue Belge d'Archéologie et d'Histoire de l'Art*, XXI, 1952, 253ff.)

The picture was engraved by L. Vorsterman and by two anonymous engravers (V.S.17, 18, 19). A drawing for the engraving (attributed by Lugt to Van Dyck) is in the Louvre (L.1129, Pl.LVIII). If Vorsterman's print and the Louvre drawing are exact renderings of the painting, Rubens must have made considerable changes between the Stockholm drawing and the execution of the painting: in the print, the near arm of Job is raised high, while the far one is extended horizontally; the head inclines further back. Rooses has already stated, however, that Vorsterman's print cannot render the picture correctly, since the proportions of his engraving do not correspond to those of the wing of a triptych.

In the drawing, alternate positions of the limbs are indicated, but none so radical as those mentioned. The left leg was apparently first drawn more vertically, while the beginning of the left arm at this stage was more diagonal. Not having enough paper at the top, Rubens drew the left lower arm and hand separately (in their final pose) at the right edge.

The pose of Job clearly reveals the influence of the Laocoön statue which Rubens had drawn from many angles (see above, Nos.34–36). For the Copenhagen copies after Rubens' drawings of the Laocoön, see Introduction, p.44.

81, 82 [Plates 77, 78] *(1959: No.29)*

SILENUS AND AEGLE, AND OTHER FIGURES

c. 1612–1614. Pen and ink, washed lightly in two tones. 280 × 507 mm.
On the reverse: Studies for several compositions.
Windsor Castle (6417).

COLLECTIONS GR (Royal Collections).
EXHIBITIONS Rotterdam, 1948–49, No.128; Paris, 1949, No.82; Antwerp, 1956, No.41; London, 1977, No.58.
LITERATURE G.-H. No.188; Van Puyvelde, *Windsor Drawings*, No.280; Evers, II, 228–229; E. Kieser, *Zeitschrift für Kunstgeschichte*, XIII, 1950, 135, note 3; Burchard-d'Hulst, 1963, No.51; Kuznetsov, 1974, No.25.

Inscribed at the top, in Rubens' hand: 'Vetula gaud'; this is read as 'Vetula Gaudia' by Van Puyvelde, and probably more correctly as 'Vetula gaudens' (an amused old woman) by Evers; (the other inscription, near the lower edge, 'No.iii. teekeningen' [No.3 drawings], is by a different hand).

There are evidently sketches for several compositions on this sheet, though those of Silenus and a Nymph who is crowning him occupy most of the space; the Nymph, indeed, has been drawn three times by Rubens (the third version almost disappearing underneath the several figures in the upper right-hand corner of the sheet). As L. Burchard and R. A. d'Hulst pointed out (*Catalogue*, Exh. Antwerp, 1956, 52) the literary source for the action was a passage in Virgil's Bucolics (*Eclogues*, VI, 21–24). It tells how Silenus, found drunk and asleep, is fettered by Chromis and Mnasyllos with his own garlands. When he opens his eyes, Aegle, the most beautiful of the Naiads, stains his brow and temples with blood-red mulberries. To the youths he laughingly promises a song, to Aegle, however, another kind of reward. The figure above Silenus in the upper left corner pertains to a different theme, as it is clearly the same as Rubens drew in a very rapid sketch in the collection of L. Burchard (Exh. 1933, No.100) illustrating Meleager's fight with his uncles. The barely outlined man to whom the Nymph in the centre of the Windsor sheet seems to be turning is very similar to an equally sketchy figure (of Meleager) in the same drawing, which thus dates from the same period. Evers noticed that the boy sitting in the centre is also found in a composition of Satyr, Nymph and Leopards, now in the Montreal Museum of Fine Arts (see *Quarterly Review of the Montreal Museum*, VII, 3, 1975, 5–18). He suggests that the group in the upper right corner contains the first ideas for the Four Continents in Vienna (*KdK*.111) and that a head near the centre belongs to Jupiter and Callisto in Cassel (?). The Satyr's head directly over the foremost version of the Nymph is related to a chalk-drawing of a smiling Satyr in Paris (G.-H. No.101). I agree with Lugt, however, in doubting that that drawing is a work by Rubens. Glück and Haberditzl had dated the Windsor drawing '*c.* 1630'; Van Puyvelde, somewhat vaguely, but nearer the truth, dated it 'between 1610 and 1620'. Evers finally dated it *c.* 1611 because of its connection with the Dreaming 'Silenus' (actually a Satyr) in the Vienna Academy (*KdK*.41) which he places in the same year. There are clearly similarities with works belonging to the beginning of the second decade. The long-limbed, svelte body of the Nymph finds her nearest relative in the figure of Victory in the Crowning of the Victor in Munich (*KdK*.56) which is generally dated about 1612.

Although psychologically on a very different level, the interplay between Aegle and Silenus in the drawing is reminiscent of that

between Venus and Adonis in the painting at Düsseldorf (Phaidon *Rubens*, No.102) of *c.* 1610–1612. The temptation of an elderly man by a young woman was rendered by Rubens in the picture of Lot with his daughters in Schwerin (*KdK*.42), dated by Oldenbourg *c.* 1610–1611. Since the graphic style of the Windsor drawing is not too far from such studies as the Bacchanal in Antwerp (No.53) and the David and Goliath in Montpellier (No.63), an early date would seem to be well justified. Kieser (*loc.cit.*) disagrees with Evers only to the extent of placing the drawing after, rather than before, the painting in Vienna. Additional corroboration for an early date is found in the observation that the pose of the man in the upper left corner (known also from the Meleager drawing in the collection of L. Burchard) was adopted in reverse in an early drawing by Jordaens (Louvre, *Catalogue* L.729). The fact that it is poorly integrated with the rest of the composition strongly suggests that Jordaens adopted it from a different context. The drawing has been dated 'before 1615–1616' by R.-A. d'Hulst, *De Tekeningen van Jakob Jordaens*, Brussels, 1956, No.1.

The reverse of the sheet with Silenus and Aegle was discovered when that drawing was examined prior to the 1977 exhibition. In his commentary John Rowlands spoke of a 'startling array of studies' found on the reverse, and said with some justification that it was unusual for Rubens to be 'doing sketches for such diverse subjects on the same sheet'. The group of standing men (one of them turbaned) on the upper left appears to be a first study for the painting of Thomyris and Cyrus, preceding the sketch in the Hermitage, Leningrad (see No.100); the prostrate figure which Rowlands thought was a female saint, may actually be Cyrus who, however, was left out in the later versions, except for his head about to be dipped into a vessel filled with blood. At the right of this group are two figures on horseback (one of them repeated underneath), which Rowlands connected with the painting of the Wolf and Foxhunt at the Metropolitan Museum (*KdK*.112). Since the woman, seen frontally, holds a falcon, the context is a hawking party rather than a wild animal hunt; in fact this group is closely related to a drawing of a Hawking Party formerly (?) in a private collection, Cologne (Burchard-d'Hulst, 1963, No.79); this drawing is connected in turn with an oil-sketch at present known only from a photograph, reproduced by Kristin Lohse Belkin (*The Costume Book, Corpus Rubenianum*, XXIV, 1978, pl.72) which John Smith (III, 1831, No.368) listed as by Van Dyck but as Burchard wrote (1963, 162–3) 'must be associated with Rubens and not with Van Dyck'.

The prostrate figure—drawn twice—at the lower left was linked by Rowlands to the Lamentation of 1614 in the Kunsthistorisches Museum in Vienna (Inv. No.515, see the 1977 exhibition of Rubens' works at the museum, No.11). The same foreshortened view is found, however, also in the study for a Raising of Lazarus (see No.132) and there is reason to link the Windsor drawing to this subject rather than to the Lamentation: whenever Rubens rendered the miracle of the raising of the dead (see the two versions of the Miracles of St. Francis Xavier in Vienna and the three versions of the Miracles of St. Francis of Paola, Held, 1980, Nos.405, 406, 407) he introduced the motif of a sheet of white material removed from, but still partly covering the head, just as it appears in the Windsor drawing and the Lazarus drawing in Berlin.

The two standing male nudes in the lower centre may indeed be studies for the St. Sebastian (Berlin, *KdK*.48) as Logan suggested (*Master Drawings*, 1978, 412–13); I find her connection of the group of figures standing at the right with Boldrini's woodcut after Titian (Rosand-Muraro, *Titian and the Venetian Woodcut*, 1976–1977, No.35) less persuasive.

As we can tell from several other drawings (see Nos. 90, 135, 149, 220), sketches made on one side of a sheet do not necessarily determine the date of those on the other side. Since the Boston painting of Thomyris was hardly begun earlier than

1615, one ought probably to place all the sketches on the verso of the Windsor drawing into the years around the middle of the decade. (While the 'Lazarus' type is at least similar in pose to the Christ of the Vienna Lamentation, the date of 1614 on that picture also reinforces such a chronological placing of the verso of the Windsor sheet.) Nevertheless, a slight shift in the dating of the recto (which I dated 1611–1613 in 1959) might also be in order, see above.

83 [Plate 135] *(1959: No.32)*

BATHSHEBA RECEIVING DAVID'S LETTER

c. 1612–1614. Pen and ink, some wash. 192 × 266 mm.
On the reverse: rapid sketches of five figures in medieval costume.
Berlin, Kupferstichkabinett (5397).

COLLECTIONS R. P. Roupell; A. von Beckerath; acquired 1902.
EXHIBITIONS Antwerp, 1956, No.55.
LITERATURE J. Rosenberg, 1928, 57–58; Bock-Rosenberg, *Catalogue*, 250 (Pl.181); F. Lugt, *Jahrbuch der Preussischen Kunstsammlungen*, LII, 1931, 64; H. Kauffmann, *Oud Holland*, XLVIII, 1931, 196; Burchard-d'Hulst, 1963, No.78; Mielke-Winner, 1977, No.18.

Only Bathsheba and the kneeling woman at the right who delivers David's letter are rendered three-dimensionally by shading. All the other figures are done almost wholly in outline. In front of Bathsheba, near the left edge, is a servant drying her mistress's feet. She belongs to a stage of the drawing in which Bathsheba's legs were sketched in a different position. Bathsheba's right hand, too, is seen in two poses, though it is hard to say which came first. Both Bathsheba and her maid are rapidly drawn again in outlines in the upper left corner. The two other figures on the sheet (one in two positions of the head) appear to be maids, as has been observed by Burchard-d'Hulst, p.131. The Berlin catalogue calls the drawing on the reverse a 'rough sketch for a Baptism of Christ', but there is no reason whatever for this interpretation. The poses as well as the costumes recall some figures in the sketch for the triptych of St. Bavo (London, National Gallery, see Held, 1980, No.400).

Rosenberg pointed out that the pose of Bathsheba is similar to that of Susanna in the painting in Stockholm (*KdK*.75). Since the panel in Stockholm is dated 1614, Rosenberg dated the drawing '*c.* 1615'; Kauffmann chose the date '1614–1615'. It should not be overlooked that there are also similarities with the early Susanna in the Villa Borghese in Rome (*KdK*.19). Yet more slender proportions of the Bathsheba would seem to favour a somewhat later date. The first version of Bathsheba in the Berlin drawing, with the raised left leg, shows a considerable kinship with the Venus (*KdK*.63) and Callisto (*KdK*.62) of *c.* 1613, both in Cassel. All things considered, a date before rather than after 1614 is more likely, particularly as the drawing is stylistically close to those done for the Breviary (see No.77).

No painting of Bathsheba by Rubens is known to exist before the late canvas in Dresden (*KdK*.347). There is no connection between that painting and the drawing in Berlin. Nor so far as I know is there a work by the master for which the figures sketched on the reverse clearly have been intended.

When I wrote this entry for the book of 1959, I was not aware of the connection between this drawing and Giulio Romano's small frescoes of the story of Bathsheba in the *Loggia* of the Palazzo del Te (F. Hartt, *Giulio Romano*, New Haven, 1958, II, plates 334 and 335, according to Hartt painted by Rinaldino). The pose of Bathsheba in the Berlin drawing is particularly close to pl.335 (though in reverse), where David spies upon

Bathsheba. The interpretation of the figures drawn on the verso as the condemnation of Jeanne d'Arc (proposed by Burchard-d'Hulst and accepted by Mielke-Winner) does not seem to me to be likely, even though Jeanne d'Arc appears in one of Rubens' paintings (Raleigh, N.C., Exhibition Antwerp, 1977, No.46).

84 [Plate 79]

THE ASSUMPTION OF THE VIRGIN

c. 1613–1614. Black chalk, pen and brown ink, washed. 298 × 189 mm.
Malibu, J. Paul Getty Museum (83.gg.198).

COLLECTIONS H. Tersmitten (?); T. Philipe; sold Christie's, 12 April, 1983 (155).
LITERATURE Jaffé, *The Burlington Magazine*, CXIX, 1977, Fig.33; Judson-van de Velde, *Corpus Rubenianum*, XXI, 1978, No.27a ('Whereabouts unknown; presumably lost.').

Engraved by Theodoor Galle for the *Breviarium Romanum*, 1614 (p.882).

On April 12, 1614 Theodoor Galle received 260 guilders for the cutting of four plates for the Roman Breviary (each one at 65 guilders) representing the Nativity, Christ's Resurrection, the Pentecost, and the Assumption of the Virgin. The Getty drawing was the model for the latter composition. It was probably drawn during 1613 or very early in 1614.

In his exemplary treatment of the various compositions which Rubens devoted to the Assumption of the Virgin, many of which were done in a relatively short period of time (between 1611 and 1615), David Freedberg paid only passing tribute to this particular design since it had been discussed, though only on the basis of Galle's print, in volume XXI of the *Corpus Rubenianum* dealing with Rubens' book-illustrations and title-pages. Moreover, Burchard-d'Hulst (1963, 44) had already pointed out that there is a fairly close connection between this composition and the *modello* of the Assumption in Buckingham Palace on the one hand and the large canvas of the Assumption in Vienna, on the other. I have pondered the interrelation of all these works (1980, I, 510–12): all three compositions make use of several poses of putti in the *Engelswolke* underneath the Virgin which Rubens himself had derived in part from a fresco—now destroyed—by Pordenone in the Malchiostro Chapel of S. Niccolò, Treviso. (Rubens' drawing is now in the Princes Gate Collection, Courtauld Institute Galleries; see Seilern, *Catalogue I*, 1955, No.50, Plate CI, and Burchard-d'Hulst, 1963, No.24.)
While the basic textual sources for the Assumption of the Virgin are the second-century *Liber de Transitu Virginis* and the Latin text of the *Pseudo-Melito* (Freedberg, 138), later summarized in the Golden Legend, Rubens 'probably consulted Jerome Nadal's popular *Adnotationes et Meditationes in Evangelia...* published in Antwerp by Martin Nutius in 1595 and by the Plantin-Moretus Press in 1607.' (Freedberg 139.) Composition-ally, however, virtually all of Rubens' renderings of the Assumption of the Virgin are indebted to Titian's formulation of the theme in his painting of 1515–1518 in S. Maria Gloriosa de' Frari in Venice. Yet Rubens increasingly abandoned the strict separation between the apostles below and the Virgin on angel-supported clouds above (still used in the present ex-ample), in favour of a closer association of the two spheres in terms of colour and movement. He also invariably introduced three and occasionally more women among the witnesses of the event, as some Netherlandish artists had done before him, since it gave him the opportunity to develop subtle variations in the emotional attitudes of the now numerically larger group of people below. To the women particularly falls the task of discovering the roses on the empty shroud within the sar-cophagus.
The present drawing is the ninth original design by Rubens that has been preserved out of a total of thirteen which Rubens contributed to the Roman Breviary (and the four which had appeared one year earlier in the Roman Missal); this number includes the title-page for the Breviary and the two marginal designs. We also have one of the four missing compositions in what looks like a copy (The Ascension of Christ), in the Herzog Anton Ulrich-Museum in Braunschweig (Fig.54 in Judson-Van de Velde, II). It is not without interest for the economics of engraving versus drawing in Rubens' time that the engraver, Theodoor Galle, received a total of 915 guilders for the thirteen prints, while Rubens' entire stipend, according to the account books of the Plantin-Moretus press, was 132 guilders, just about one-seventh of what the engraver received.

85 [Colour Plate I] *(1959: No.35)*

THE ASSUMPTION OF THE VIRGIN

c. 1614–1615. Pen and ink, washed, on lightly browned paper. 290 × 230 mm. Some parts of the design were executed with the brush.
Vienna, Albertina (8212).

LITERATURE R. II, 184; V. No.1437; O. Benesch, *Festschrift Karl M. Swoboda*, Vienna-Wiesbaden, 1959, 35ff. (Van Dyck); Held, 1959, pp.108–9; Burchard-d'Hulst, 1963, No.73; Kuznetsov, 1974, No.44; Mitsch, 1977, No.8; Held, 1980, 511; Freedberg, *Corpus Rubenianum*, VII, 1984, No.36.

It is surprising that this beautiful drawing was not included in the book by Glück and Haberditzl, who must have been very familiar with it. They evidently did not accept the attribution to Rubens; yet it is difficult to see on what basis they rejected it. The character of the lines, the shading, even the many corrections and changes made on top of a very delicate initial sketch in pen, are all very characteristic of the master. Van Dyck, the only artist near Rubens who could be credited with a drawing of this quality, never had the calm and sure approach to the rendering of extremities that we see here in the design of many hands and feet.
Moreover, the drawing is connected with several of Rubens' compositions of the Assumption of the Virgin, particularly with the sketch in Buckingham Palace (see Held, 1980, No.375), where the Virgin is in a similar standing position with hands raised and palms turned upward. The foreshortened head of the Virgin is an almost literal repetition, though in reverse, of a head in the centre of Rubens' early Circumcision of Christ in Genoa (*KdK.*21). Of the finished pictures the one nearest to the drawing is the Assumption in Vienna (*KdK.*206), which has a similar dense grouping of angels at the Virgin's feet and the same shadowy area in the lower left; there are also analogies in the attitudes of some angels. Some motifs recall the Brussels picture (*KdK.*120), with which Rooses had connected the drawing (the veil above the Virgin's head, for instance), but these recur again later in the Assumption in Antwerp Cathedral (*KdK.*301) and the sketch from the collection of Lt.Col. T. Davies, now in the Mauritshuis (Held, 1980, No.377). The garland-like grouping of the angels recalls the Virgin with Angels in the Louvre (*KdK.*197).
L. Burchard (as quoted by St. Tschudi Madsen, see No.104), dates the Vienna picture 1614–15 and that would also seem to be the best date for the Vienna drawing. (The complex question of the several renderings of the Assumption of the Virgin done between 1611 and 1615 has been fully explored by Freedberg, *op.cit.* pp.138–62.)

86, 87 [Plates 91, 92]

THE RETURN FROM THE FLIGHT INTO EGYPT

1614–1615. Pen and ink on white paper. 301 × 195 mm.
On the reverse: Two studies of the Virgin.
Moscow, Pushkin Museum (1110).

EXHIBITIONS Brussels–Rotterdam–Paris, 1972–73, No.87.
LITERATURE M. Jaffé, 'The Return from the Flight into Egypt,
by Peter Paul Rubens', *Wadsworth Atheneum Bulletin*, Summer
1961, 10–26; Yuri Kuznetsov, *Rubens Drawings*, (Russian)
Leningrad-Moscow, 1965, No.15; *Idem*, 1974, No.46.

Inscribed (recto): 'P. P. Rubens' (lower right); '67' (upper right
corner).

Despite the old inscription, this drawing had been thought to
have come from 'Rubens' school' until Jaffé recognized it as a
study for a painting which exists in two large versions. One is in
the collection of the Earl of Leicester, at Holkham Hall, the
other in the Wadsworth Atheneum at Hartford. Jaffé considers
the Wadsworth canvas to be the earlier of the two, done around
1615, while dating the one at Holkham Hall about five years
later. While this has no bearing on the date of the Moscow
drawing, which surely antedates both paintings, I have the
impression that both paintings belong to the same period, and
that the one at Hartford is more routinely executed than the one
in England (thought the latter suffers from awkward, later
additions).
The Moscow drawing has the three figures walking towards the
right, in reverse to the action of the paintings. The major
difference between the drawing and the final arrangement is in
the child's relationship to his parents: in the drawing each of his
hands is held by one of the hands of each parent; in the paintings
he only holds the Virgin's hand with his left, while carrying a
walking stick in his right.
The reversal of the composition seems to be indicated in the
sketch on the reverse, where the Virgin moves towards the left
as in the painted versions. A second figure, less clearly
connected with the action, is based (as Jaffé recognized) on the
so-called Pudicitia statue in the Vatican.
The style of the Moscow drawing is linked to a number of
drawings which belong to around the middle of the second
decade. The figure of the Virgin (on the recto) has its closest
analogy with the Virgin in the study for a Visitation (No.71),
but the light and sure touch of all the lines also connects it with
drawings such as the two studies for the Continence of Scipio
(Nos.123, 124). The Pudicitia type had of course been used by
Rubens before, in the sketch of 'The Virgin adorned with
Flowers' in the Liechtenstein collection, Vaduz (Held, 1980,
no.369), but it occurred again, and again for the figure of the
Virgin, in the panel with the Three Marys at the Tomb of
Christ, in the Norton Simon Museum, Pasadena, which must
have been painted about the same time.

88 [Plate 83] *(1959: No.78)*

FARM GIRL WITH FOLDED HANDS

c. 1612–1614. Black chalk, pen and ink, washed. 262 × 120 mm.
All four corners cut.
Rotterdam, Museum Boymans–van Beuningen (School of
Rubens, 2).

COLLECTIONS Boymans (1847).
LITERATURE Hannema, 1931, No.9; Kuznetsov, 1974, No.71.

Although apparently little known or appreciated, this drawing
has a simple grandeur and forceful characterization which make
it not only quite convincing as a work of the master, but indeed
one of his most interesting drawings of rural subjects. The chief
problem of the work is its date. The only figure of a peasant girl

in any of Rubens' landscape paintings which looks similar in
pose is the maid at the right in 'Winter' at Windsor Castle
(*KdK*.238) of *c.* 1620. The Rotterdam drawing, however, seems
to belong to an earlier period. Some of the graphic conventions
in shading the face are also found in the drawings for the
Breviary and the Missal (see No.77 and G.-H. No.69). The
heavy shading, if original, is not without parallels in still earlier
drawings. In view of these technical analogies with drawings
between 1610 and 1614, it seems to me worthwhile to point out
that in pose and even physiognomy the figure in Rubens'
oeuvre most similar to the drawing is Sta. Martina on the right
wing of the Resurrection of Christ in Antwerp Cathedral. This
triptych was painted by Rubens between September 22, 1610,
and April 27, 1612 (Bouchery-Wijngaert, 34–35; Fig.18) to
serve as an epitaph for Jan I Moretus, the father of Rubens'
friend and patron Balthasar Moretus, head of the Plantin Press.
It is well known that the drapery of that figure was modelled
after a classical prototype which Rubens also used elsewhere in
his oeuvre (see F. M. Haberditzl, *Jahrbuch der Kunsthistorischen
Sammlungen des allerhöchsten Kaiserhauses*, XXX, 1912, 288); if—
as I suggested in 1959—the saint of the Antwerp triptych was
also based on the Rotterdam drawing, the date of that drawing
would have to be still earlier than is indicated above. The
evidence, however, is insufficient for such a conclusion.

89 [Plate 81]

NIOBE (?)

c. 1614–1616. Pen and ink, and black chalk (by another hand?).
200 × 279 mm.
Inscribed: m (or in?) eternitas (eternitatem?).
Moscow, Pushkin Museum (4574).

COLLECTIONS P. J. Mariette; Marquis de Chennevières;
S. V. Penskii; acquired 1912.
LITERATURE Yuri Kuznetsov, *Risunki Rubensa*, Leningrad,
1965, No.23, Pl.12; *Idem*, 1974, No.90 ('1618–1620').

A kneeling woman, in plain dress, her hair dishevelled, her
mouth open in a scream, flings both her arms upward in a
traditional pose of deep sorrow or despair. Behind her, right
and left, lie lifeless bodies, some human, some animal.
Despite the unusual appearance of a figure from classical
mythology known for excessive pride, the drawing may well
represent Niobe lamenting the death of her children. She had
boasted of her many children (fourteen according to Ovid's
version, Met. VI, 204–312) considering herself superior to
Latona who had only two, Diana and Apollo. Angered by
Niobe's hubris, they killed all her children, Diana the seven
daughters, Apollo the seven sons. Niobe herself was changed
into stone.
The presence of animals can only be explained (as Kuznetsov
has done) by the brief reference to the myth in Apollodorus'
account, according to which the daughters of Niobe were killed
at home, but the sons as they were hunting on Cithaeron (III,
46–47, see *The Library of Greek Mythology*, translated with notes
and indices by Keith Aldrich, Lawrence, Kansas, 1975, 64). The
dead animals hence refer to the victims of the sons' hunting.
The inscription might indicate that the sorrowing Niobe will
forever be a figure of stone.
Stylistically, I associate this striking drawing with such works
as Nos. 88, 90.

90 [Plate 82]

A PEASANT WOMAN, IN TWO VIEWS
(COSTUME STUDY, DONE FROM LIFE)

Before 1620. Pen and ink (bistre) on grey-white paper; water
stains. 233 × 396 mm.

Berlin-Dahlem, Staatliche Museen Preussischer Kulturbesitz, Kupferstichkabinett (12223).

COLLECTIONS Earl of Aylesford; Adolf von Beckerath; acquired 1902.
EXHIBITIONS Antwerp, 1956, No.89.
LITERATURE J. Rosenberg, *Amtliche Berichte aus den Preussischen Kunstsammlungen*, 1926, 86–8; G.-H. Nos.189–90; Bock-Rosenberg, 1930, 252; Burchard-d'Hulst, 1963, 199, 245–6; Mielke-Winner, 1977, No.37.

Inscribed by Rubens himself with notes on the materials and colours of her garments: (at left) *witte halsdoeck; vuyl blauw; vuyl steurse van omber/swart en wit.* (at right) *vuyl blauw; swa(rt); swarte overtrek mantel; canefas; root; vuyle gescheurde veurschoot;* (on the upper figure) *canefas; root.* (on the lower figure) *witte halsdoeck; blauw; cane(fas); blauw;* (two more words still undeciphered).

This is the verso of Studies of Nude Women (see below, No.182). To see the drawing correctly, the recto sheet must not only be turned over but also rotated 90 degrees to the left. No exact equivalent of this drawing can be found anywhere in Rubens' work and should not be expected, since it is clearly a study of a particular peasant costume, done from life. Similar figures occur in several of Rubens' paintings of rural life (Winner, 1977, 104), one of which—the Summer at Windsor Castle—is generally dated in the early 1620s. Most scholars have connected the drawing with the so-called Walk in the Garden in Munich (*KdK.*321) which certainly is a work of the early 1630s. That does not necessarily mean that the drawing must also be of that period. Among the late drawings it would be most exceptional. Its closest analogies are found in the London Costume Book (see our Nos.66–9) though it does not seem to have been part of it. The last Rubens' drawing of this kind that I know is the study of Robin, the dwarf of the Earl of Arundel of 1620 (see No.145). Thus a date before the 1630s must be considered seriously. If that is the case, one might question whether this drawing—preceding the one on the other side of the paper—ought not to be designated 'recto' and the sketch of the nude women 'verso', in recognition of their chronological relationship. At any rate, with the question wide open, I tentatively place the drawing before 1620.

91 [Plate 84] *(1959: No.82)*
STUDY FOR THE FIGURE OF CHRIST ON THE CROSS

c. 1614–1615. Black and white chalk, some bistre wash, on coarse grey paper. 528 × 370 mm. The paper has probably been trimmed on all sides.
London, British Museum (Oo.9–26).

COLLECTIONS R. Payne Knight, Esq.
EXHIBITIONS London, 1977, No.64.
LITERATURE *Rubens Bulletin*, IV, 1896, 291, No.1345[1]; *Vasari Society*, II, 1906–1907, 22; Hind, *Catalogue*, No.9; G.-H. No.87.

The late medieval type of the Crucifixion, in which Christ's arms are held vertically, is found many times in Rubens' work. It made its first appearance in the altar of the Raising of the Cross which was painted for the church of St. Walburgis (*KdK.*36). An image of the Crucified Christ which is no longer known to exist was in the centre of the predella. Its appearance can be reconstructed, I believe, on the basis of a little known but very beautiful and completely authentic panel of the Crucified Christ in the Busleyden Museum in Mechlin. In the Mechlin picture Christ looks down, as he probably did in the lost predella piece. In the Raising of the Cross itself Christ looks towards Heaven and it is this motif which was used later on in many renderings of the Crucified Christ, most of which seem to be studio products. The present drawing is an unusually careful study from the nude. It was probably done rather later than the Raising of the Cross (and the drawings connected with it), being both more precise in its observation and physiologically subtler. A large formal drawing of this type, made as model for an engraving, in which the Crucified Christ is shown as victor over Death and Devil, is in Rotterdam (G.-H. No.140; engraved by P. Pontius, 1631). In this impressive drawing, Rubens apparently did only the very extensive work in body-colour (chiefly lead-white); the preliminary chalk-drawing was done by an assistant.

92 [Plate 85] *(1959: No.85)*
STUDY FOR DANIEL IN THE LIONS' DEN

c. 1614–1615. Black and white chalk, on grey paper. 507 × 302 mm.
New York, J. Pierpont Morgan Library (I, 232).

COLLECTIONS W. Bates; C. Fairfax Murray.
EXHIBITIONS Detroit, 1936, Sec. V, No.4; Worcester Art Museum, 1948, No.44; Cambridge, 1948, No.30; Philadelphia Museum of Art, 1950–1951, No.51; Cambridge–New York, 1956, No.14; London, 1977, No.69; Paris–Antwerp–London–New York, 1979–1980, No.12.
LITERATURE E. Michel, 1899, 190; C. Fairfax Murray, I, No.232; G.-H. No.97; Goris-Held, No.95; H. Tietze, *European Master Drawings in the U.S.*, New York, 1947, No.61; A. Mongan, *One Hundred Master Drawings*, Cambridge, 1949, 70; M. Jaffé, *Bulletin van het Rijksmuseum*, III, 1955, 64–66 (Figs.6 and 8); Burchard-d'Hulst, 1963, No.110; Kuznetsov, 1974, No.63; Jaffé, 1977, 41.

The study was made for the picture of Daniel in the Lions' Den, now in Washington, National Gallery of Art. Rubens referred to the painting in a famous letter of April 28, 1618, when he offered it with other pictures to Sir Dudley Carleton: 'Daniel between many lions done from life, an original entirely by my own hand ... 600 florins' (see *Correspondence*, II, 136). The painting must have been finished in 1617, since it figured in Jan Brueghel's Allegory of Sight, in the Prado (No.1394), which bears that date. M. Jaffé drew attention to another painting by Brueghel, a landscape with many animals in the Wellington Museum, Apsley House, in London, which is dated 1615 and in which may be seen both the standing lion in the centre of the Daniel painting and the foreshortened lioness from the right side. Some studies for the picture thus go back at least to the years 1614–1615.

The motif of the crossed legs, classical in origin, was known to Rubens from Raphael's Jupiter in the cycle of Amor and Psyche of the Farnesina in Rome, and from Caravaggio's first St. Matthew, which he may have seen in Rome in the collection of Vincenzo Giustiniani. A particularly close analogy was pointed out by M. Jaffé (*loc.cit.*, 65–67, Figs. 9, 10). The pose, including the hands folded in prayer, is found in a drawing in the Louvre (Lugt, *Catalogue*, No.1219), there listed as 'school of Rubens', but claimed by Jaffé on good grounds as a drawing by Muziano. It was apparently Muziano's study for a penitent St. Jerome in Bologna; a similar composition was engraved after Muziano by Cornelis Cort and published in 1573. It is very likely that Rubens was familiar with Muziano's figure and chose the model's pose under the influence of the Italian work.

The motif of the crossed legs appears in various other works of the master. He used it for Neptune in the picture of Neptune and Amphitrite (*KdK.*108) formerly in Berlin and now destroyed. (For the subject of this picture see Held, 1980, No.254.) It also appears in the large but little known painting of Pythagoras with three pupils and nymphs, and a still-life by Snyders, in Buckingham Palace, London. Some figures from that painting are among the drawn copies in Copenhagen.

93 [Colour Plate 2] *(1959: No.83)*

A LIONESS

c. 1614–1615. Black and yellow chalk, washed; white body-colour. 390 × 235 mm. Cut irregularly in the upper left corner. *London*, British Museum (N.G.853–o).

COLLECTIONS Sir T. Lawrence; J. Barnard; National Gallery, London.
EXHIBITIONS London, 1835, No.54; London, 1977, No.70.
LITERATURE R., V. No.1428; G.-H. No.99; A. E. Popham, *British Museum Quarterly*, X, 1935, 10ff.; M. Jaffé, *Bulletin van het Rijksmuseum*, III, 1955, 59ff; Kuznetsov, 1974, No.42.

The drawing was made in connection with the painting of Daniel in the Lions' Den, formerly in the collection of the Duke of Hamilton, now Washington, National Gallery of Art (see No.92), where the lioness appears near the right margin. M. Jaffé has pointed out that this drawing was preceded by another, found on the back of a sheet in Amsterdam (G.-H. No.144), which was done in black chalk alone (repr. Jaffé, *loc.cit.*, Fig.2). It shows the same lioness, in reverse. The London drawing differs from the Amsterdam sheet in that, despite the reversal of the pose, it is again the left front paw which is lifted up, while the right one, visible between the hindlegs, is resting on the ground. Yet while there is undoubtedly a greater degree of spontaneity in the Amsterdam drawing, I doubt that it was made from nature. It is exactly the different pose of the forepaws which establishes a contact between the Amsterdam sketch and the Paduan bronze of a lioness that Rubens had drawn in pen in two views (see J. Rosenberg, *Pantheon*, VII, 1931, 105ff., and Mielke-Winner, No.8; a similar study of a lioness, probably also drawn from a bronze, is in the Victoria and Albert Museum in London, D.524 [unpublished]). It can hardly be doubted that Rubens must have made studies of lions from life, since there are many lions in different poses in the painting of the former Hamilton collection. The drawing of a lion in London (G.-H. No.98) may well be such a study from life. The pose of the lioness, however, is too close to that of the Paduan bronze to have been realized independently of that work. This view, first disputed by Jaffé, was fully accepted by him in a paper published 1970 in *Report and Studies in the History of Art 1969*, National Gallery of Art, Washington, 'Some Recent Acquisitions of Seventeenth-Century Flemish Painting', 7–33. Fig.8 of his article reproduces a Paduan bronze in the Galleria Estense in Modena, clearly the model Rubens followed in his drawing in Amsterdam (his Fig.5) as well as (with the changes described) in the magnificent drawing in London.
There are two sheets in the collection of John Nicholas Brown in Providence with drawings of lions, both in red chalk. One shows the five most prominent lions of the left half of the painting of Daniel in the Lions' Den, the other the two snarling ones from the right half. The close correspondence of their arrangement on the sheets to their appearance in the picture, apart from other considerations, makes it likely that they were done from the picture rather than for it. For the date see the comment under No.92.

94 [Plate 92] *(1959: No.84)*

A MAN, STANDING

c. 1614–1617. Black and white chalk, on rough grey paper. 388 × 224 mm.
Munich, Graphische Sammlungen (2871)

COLLECTIONS Counts Palatine of Rhine.
EXHIBITIONS Brussels-Paris, 1949, No.85; Antwerp, 1956, No.65.
LITERATURE K. T. Parker, 1937, 50 (Pl.46); W. Wegner, *Die*

niederländischen Handzeichnungen des 15.–18. Jahrhunderts, Berlin, 1973, No.863.

Inscribed in pen (by a later hand): 'J. Lanfranc.' '57', '1196'. See text to Nos.95 and 121.

95 [Plate 93] *(1959: No.36)*

THREE ROBED MEN

c. 1614–1617. Black and white chalk, on chamois-coloured paper which is foxed and repaired. 281 × 314 mm.
Copenhagen, Kunstmuseet, Kobberstiksamlingen (13235).

COLLECTIONS Anatole France; P. Dubaut.
LITERATURE J. Sthyr, *Kunstmuseets Aarskrift*, XXIII, 1936, 50ff.; L. Burchard and R. H. d'Hulst, in *Catalogue*, Exh. Antwerp, 1956, under No.65; Burchard-d'Hulst, 1963, No.96; Kuznetsov, 1974, No.56.

The two lateral figures are studies for a St. Andrew, both leaning on the characteristic cross of the Saint. This drawing poses an interesting problem of chronology. The figure in the centre was beyond doubt used for Melchisedek in the painting of Abraham and Melchisedek in Caen (*KdK*.110), which Oldenbourg dated about 1615. The figure at the right seems to be connected with the outside of the right wing of the triptych of the fishmongers' guild in Notre Dame au delà de la Dyle at Mechlin (*KdK*.174), which was painted 1618–19. There are two other drawings for this figure: one—the first of the three—in Munich is obviously a study from life with no indication of the role of the figure (No.94); another in the collection of Mrs. G. W. Wrangham (see No.121 reverse), with variations in the position of the right arm, the legs, and the drapery folds, is clearly the last of the three and largely determines the appearance of the finished painting. Burchard apparently considers all three drawings to be studies for the Mechlin picture; as a consequence he assigns the date of 1618 to the painting in Caen, too (*Catalogue*, Exh. London, 1950, under No.53), since the three figures of the Copenhagen drawing must have been done at the same time. There is, however, another possibility. The Copenhagen museum owns a companion piece to the present drawing which shows two other apostles, St. John and St. Simon [?]; it is of about the same height (275 × 210 mm.) and came from the same collections. Thus it is possible that these drawings were made for a project involving several apostles, if not all; whether or not the project materialized we cannot say, though it is likely that it did not. Rubens was thus free to use the figure of St. Andrew for the Mechlin altar. Of the three drawings, it is then only the one from the Wrangham collection which is strictly speaking a study for the work of 1618, and the date of the two others may be advanced. Such a solution is preferable for various reasons. Stylistically the painting in Caen does not agree with works of about 1618: Oldenbourg's date was surely nearer the mark. The same must be said of the drawings in Munich and Copenhagen, in which the figures have less of that broad sense of volume which characterizes similar drawings of about 1618. The nearest parallel, indeed, to the figure at the left of the present drawing is that of St. Paul from the title-page of the *Breviarium Romanum* of 1612–13 (see Judson-Van de Velde, *Corpus Rubenianum*, XXI, II, 1978, Pl.71). Since the drawing shows the figure as it appears in the engraving, Rubens probably made it after Th. Galle had engraved the design, i.e. after the spring of 1614.
The man who posed for the Munich drawing appears here for the first time. He is found later in other drawings, such as G.-H. No.106 (present whereabouts unknown) and possibly G.-H. No.110. Rubens made use of the figure at the right once more at a later date, when he introduced it, in the role of St. Paul standing on a cloud next to Christ, in the painting of the Miracles of St. Benedict in Brussels (*KdK*.302).

96 [Plate 94] *(1959: No.33)*
TWO STUDIES OF A RIVER-GOD

c. 1614–1616. Black chalk, squared. 414 × 240 mm. The paper
has been folded several times.
Boston, Museum of Fine Arts (20.813) (Frances Draper Colburn
Fund).

COLLECTIONS Howard Wicklow; F. T. P.; Henry Adams; Mrs.
Henry P. Quincy.
EXHIBITIONS Fogg Art Museum, Cambridge, 1954;
Cambridge–New York, 1956, No.22; London, 1977, No.82.
LITERATURE J. R. Martin, *Corpus Rubenianum*, XVI, 1972,
No.50b.

Inscribed, in a seventeenth-century hand, but not Rubens':
'Hogde vier ellen ende half'; 'Brede gelijck dese draet' (height
four and a half ells; width the same as this thread); on the
reverse: 'dit is het pastuchen'[?].

Neither of these two figures corresponds exactly to any in
Rubens' work, though general similarities can be observed.
Some analogies can be found in the river-god in the Birth of
Marie de'Medicis in the Louvre (KdK.244) and the sketch of the
Birth of Henry IV (KdK.320). The lifted hand of the river-god
in the latter picture corresponds (in reverse) to the raised hand of
the main figure in the Boston drawing. The pose of the left arm
of this figure, across the urn, is very like that of the river-god in
the Flight of Cloelia, Berlin (see *Nederlandsch Kunsthistorisch
Jaarboek*, III, 1950–1951, 116). The Flight of Cloelia cannot date
from before 1620, since the arms of one of the nymphs are based
on a famous chalk-drawing of that year (see No.128). Despite
these analogies with works of about 1620 and slightly later, it is
likely that the drawing belongs to an earlier period. It lacks the
sweeping grandeur and the anatomical articulation of the
drawings of about 1620. The theme of two river-gods, one
placed behind the other, is found in the Four Continents at
Vienna (KdK.111) and in the painting of Neptune and Amphi-
trite (or Oceanus and Thetis) formerly in Berlin, now destroyed
(KdK.108); for a sketch see Held, 1980, No.254. One of the
river-gods in Berlin is almost a combination of the two in
Boston: he has his arms draped over the urn rather like the one
in front, while he looks at the beholder like the one at the back.
There is, finally, a striking similarity between the head that
looks out of the picture in this drawing and the bearded and
rather portrait-like head of a man in the Vienna drawing of
Heads and Hands (No.56). That drawing dates from about
1610, the Berlin and Vienna pictures from about 1614–1615.
The Boston drawing would seem to fit best into this general
period. A. Mongan points out (see *Catalogue* of the Exhibition
in Cambridge and New York, 1956), that some elements of the
background landscape, particularly the obelisk and the bridge,
are reminiscent of an illustration of Achille Bocchi, *Symbolarum
quaestionum liber secundus*, Bologna, 1574, reprinted in *The Art
Bulletin*, XXIX, 1947, p.171. She also suggests that the drawing
may have been intended for a tapestry. M. Jaffé, as quoted in the
same catalogue, connects the drawing with the study of the
Vestal Tuccia of *c.* 1622 (see No.156).
According to the catalogue of the London exhibition of 1977
(p.77) Burchard connected the drawing with the Arch of the
Mint from the *Pompa Introitus Ferdinandi*, of 1635, an opinion
rejected by Martin, who, however, like Rowlands, places the
drawing in the early 1620s. My own dating in 1959 (1612–1615)
may have been slightly too early.

97 [Plate 89] *(1959: No.34)*
HERCULES STRANGLING THE NEMEAN LION

c. 1613–1616. Black and red chalk, on grey paper.
363 × 498 mm. (The background figure at the left in black
chalk; the one at the right in red; black chalk used almost
exclusively on the lion.)
Antwerp, Cabinet des Estampes (A.XIV.7).

COLLECTIONS Sale: Van der Straelen-Moons-Van Lerius, 1886,
No.268; Clément van Cauwenberghs.
EXHIBITIONS Amsterdam, 1933, No.96; Antwerp, 1946, No.1;
Antwerp, 1956, No.80; Antwerp, Rubenshuis, 1971, No.66.
LITERATURE A. J. J. Delen, 1932, 32; *idem, Catalogue*, No.192;
Delacre, *Van Dyck*, 235, note 2; *idem, Gand Artistique*, VII, 1927,
121ff.; Lugt, *Catalogue*, II, under No.1012; Burchard-d'Hulst,
1963, No.192 ('after 1630').

Besides the many variants of the pose within the main group
(with the result that Hercules has three right and two left legs)
the hero's figure has been drawn twice more in outline at the
right and left. The subject was treated by Rubens in several
works. All of them betray the influence of Giulio Romano's
fresco in the Palazzo del Te (F. Hartt, *Giulio Romano*, New
Haven, 1958, Pl.185) and of the classical formulations which
stand behind it. Rubens was surely also familiar with the
woodcut by Giuseppe Nicolò Vicentino (B.XII, 17, 1). Rubens'
earliest version is preserved in a painting in Sanssouci, which is
generally regarded as the copy by a pupil of a lost original (see
Oldenbourg, 1922, 43, and Evers I, 101, note 89); Oldenbourg
dated this composition *c.* 1605. A much later occupation with
the theme is preserved in a drawing in London (No.217) and in
some sketches (Held, 1980, Nos.227 and 242). The Antwerp
drawing was put into the Italian period by Lugt (*loc.cit*). While
surely not as late as the one in London, it seems to me different
from works done in Italy, while showing similarities to such
drawings as the study of a crouching man for the Caen painting
of Abraham and Melchisedek (G.H. No.92). The squat pro-
portions and the hunched back belong to this period and are not
found later, even in renderings of Hercules (see No.148). A
painting of the same subject at Apsley House, London, men-
tioned in connection with the drawing in the Catalogue of the
exhibition of 1933 has only general similarities, and is at best a
school-piece (see Evelyn Wellington, *A descriptive and historical
Catalogue of Pictures and Sculptures at Apsley House*, London,
1901, I, No.75.).

98 [Plate 98] *(1959: No.37)*

THE ENTOMBMENT OF CHRIST

c. 1615. Pen and ink, washed, over black chalk. 223 × 153 mm.
Amsterdam, Rijksmuseum (A4301).

COLLECTIONS Th. Hudson; Sir Th. Lawrence; Jac. de Vos
Jbzn.; W. Pitcairn Knowles.
EXHIBITIONS Amsterdam, 1933, No.77; Brussels, 1938–39,
No.12; Rotterdam, 1939, No.19; Paris, 1949, No.80; Antwerp,
1977, No.139.
LITERATURE E. W. Moes, *Oude Teekeningen . . . in het
Rijksprentenkabinet te Amsterdam* [s.d.], 29 (as Van Dyck);
Delacre, *Van Dyck*, 220 (as Van Dyck); Evers, II, 139–40, note
12; A. Seilern, *The Burlington Magazine*, XCV, 1953, 380ff.;
idem, Catalogue, 45; Burchard-d'Hulst, 1963, No.38;
Kuznetsov, 1974, No.23; Jaffé, 1977, 58L ('1612').

This important drawing was one of those formerly attributed to
Van Dyck (see Moes, *loc.cit*.); Glück and Haberditzl apparently
shared this opinion. The attribution to Rubens is due to Van
Regteren Altena.
The composition reflects the influence upon Rubens of
Caravaggio's Entombment in the Vatican. Of this work Rubens
had made a free copy (National Gallery of Canada, Ottawa),
which Oldenbourg (KdK.427) dated 1613–15. The dryness of
the Ottawa picture, however, seems to me to indicate a
somewhat earlier date, and if it was not painted—as was

formerly assumed—while Rubens was still in Italy, he probably
painted it soon after (see also p.49, note 20). It is just in
comparison with the Ottawa picture and with drawings done
between 1608 and 1612 that the maturity of the Amsterdam
drawing becomes apparent. One need only compare the pos-
ition of the elderly man at the right with that of David in the
drawing in Rotterdam (see No.62), which at first glance is so
similar, to become aware of the increased precision and control
of the later work. The spatial arrangement surely goes beyond
the stage presented by the Descent from the Cross in Antwerp
and is probably even later than the Burial of St. Stephen in
Valenciennes (KdK.158) (which, according to L. Burchard as
quoted by Seilern, cannot be later than 1614). It antedates,
however, the Entombment of Christ in St. Géry in Cambrai
(see Exhibition, Paris, Le Siècle de Rubens, 1977–78, No.118;
Held, 1980, No.366), where the pose and function of St. John
are rather similar, but where the whole composition has been
expanded and loosened up in an approach towards a High
Baroque solution.

99 [Plate 100]

THE MARTYRDOM OF ST. STEPHEN

c. 1615–1616. Pen and ink on light grey paper. 342 × 323 mm.
Rotterdam, Museum Boymans-van Beuningen (Rubens 2).

COLLECTIONS F. J. O. Boymans (1767–1847); bequeathed to
the city of Rotterdam, 1852.
EXHIBITIONS Antwerp, 1930, No.457; Amsterdam, 1933,
No.89; Antwerp, 1956, No.61.
LITERATURE Burchard-d'Hulst, 1963, No.88 (with list of
earlier literature); Kuznetsov, 1974, No.54.

The subject of this large and dramatic drawing has greatly
puzzled the scholars who studied it, until Burchard and d'Hulst
came up with a suggestion which, though unprecedented in
Rubens' art, at least gives a possible explanation. Since the death
of the central figure is caused by stoning, the logical identifica-
tion of the martyr is obviously St. Stephen, and there are indeed
sufficient analogies with the death of this martyr as depicted in
the great triptych in Valenciennes (KdK.158) to make the
connection plausible. That the martyr seems to be dressed like a
woman does not create a serious problem, since in a rapid
sketch like this one, the characteristic deacon's gown of the saint
might easily be abbreviated to look like a woman's dress; nor
does the long hair by which the figure is pulled militate against
the identification, since in the central panel of the triptych
Stephen's head is surrounded by ample locks. What is disturb-
ing, however, is the presence of what looks like a second
victim. St. Stephen, the first martyr, suffered his death alone.
The explanation offered by Burchard-d'Hulst assumes that the
prone figure is also St. Stephen, whose body was rescued by
Gamaliel and Nicodemus and buried in Gamaliel's plot (The
Golden Legend, December 26).
The two men at the left bending over the prone and probably
lifeless body, look as if they are coming to the aid of the
martyred figure rather than participating in the stoning. The
combination in one scene of two consecutive phases of the same
action, with the concomitant duplication of the main charac-
ter—common in medieval art—is exceptional with Rubens.
Yet since the burial of the saint is also depicted as part of the
Valenciennes triptych (though admittedly in a separate compo-
sition on the right wing), the thesis proposed by Burchard-
d'Hulst seems reasonable. The painting of the Stoning of St.
Stephen in Valenciennes was prepared by Rubens in an oil-
sketch which is preserved (possibly only in a copy) in the Royal
Palace in Brussels (Held, 1980, No.426, Pl.411). The incident of
the rescue of the saint's body is no longer part of the
composition, but instead another sympathetic witness has been

introduced: the youthful Saul, who seems to call out against the
stone-throwers at the left (see also H. Vlieghe, *Corpus
Rubenianum*, Vol.VIII, 1973, pp.152–3).
It is generally assumed that Rubens' chief source was Cigoli's
painting of 1597, also depicting the Stoning of St. Stephen,
originally painted for the church of the Montedomini convent
in Florence, now in the Pitti Palace (see W. Friedländer, in the
Festschrift für Ludwig Heydenreich, Munich, 1964, Fig.18). Yet
Rubens surely also remembered Barthel Beham's engraving of
fighting men, parts of which he had copied in his youth (see
No.3), where one figure clearly anticipates the pose of the chief
stone-thrower.
The date of the Valenciennes triptych is not known, but it most
likely belongs to the years 1616–1618, according well stylistic-
ally with the period in which Rubens was particularly active in
furnishing large altarpieces for churches in Antwerp as well as in
other places.

100 [Plate 96]

THOMYRIS AND CYRUS

c. 1615–1617. Drawn with brush, on brown paper, in bistre and
oil colour (brown, grey, pink, ochre and white). 255 × 385 mm.
Leningrad, Hermitage (5511).

COLLECTIONS Count Ludwig von Cobenzl; Catherine II of
Russia (1768).
EXHIBITIONS Leningrad, 1937, 50; Leningrad, 1940, 10;
Antwerp, 1956, Supplement No.63b; Moscow, 1955, No.637.
LITERATURE M. V. Dobroklonsky, *Zeitschrift für Bildende
Kunst*, 1930–31, 2, 33, 34; Dobroklonsky, *Isskoustvo*, 1935,
No.5; Burchard-d'Hulst, 1963, 316, under No.196 (1616–
1618); Yuri Kuznetsov, *Rubens Drawings* (Russian), Leningrad
1965, No.18, pl.10.

According to Herodotus (I, 204–14), Thomyris, Queen of the
Messagetae, made war upon Cyrus of Persia, who had
threatened to invade her country. When her army had taken
him captive, she had his head plunged into a vessel filled with
blood 'so that he could satisfy his thirst of it'. The Leningrad
drawing, done in a technique unusual for Rubens, is the study
for a large painting, formerly at Cobham Hall (Earl of
Harewood), and now in the Museum of Fine Arts, Boston
(KdK.175). The Boston canvas (203.5 × 358.5 cm.) shows the
action in reverse to the drawing and, being proportionally much
wider, shows a number of armed soldiers and a large greyhound
at the right (behind the officers in oriental garb), presumably
added as an afterthought since it unbalances the fairly symmetri-
cal arrangement of the Leningrad drawing. Rubens may have
enlarged the composition in this way to satisfy a patron, or to fit
the picture into a given space. He apparently tried to equalize
the two sides of the design by giving a grander sweep to the
Queen's robe and allotting more space to the two boys who
hold its train; they were only lightly indicated in the drawing.
(These boys seem to be portraits of Rubens' two sons, Albert
and Nicolas, born in 1614 and 1618 respectively.)
The only major difference between the Leningrad drawing and
the Boston painting concerns the man who dips the head of
Cyrus into the vessel. In the painting he is seen sideways,
kneeling on one knee but in a somewhat ambiguous spatial
relationship to the large blood-filled bowl which appears to be
closer to the foreground. In the Leningrad drawing by contrast,
he stands, bent forward and clearly holding Cyrus' head above
the bowl. Being foreshortened, he appears to be smaller than
the other figures, and hence much less prominent than his
counterpart in Boston. The loss of his subordinate place in the
general action seems to be hardly a gain; but it may have
resulted from the extension of the canvas to the right, since the
larger and more prominent form of the servant in the Boston

picture re-establishes, to some extent, the importance of the compositional centre. However that may be, the pose of the figure as designed in the Leningrad drawing is very similar to two other figures done by the artist earlier: the figure of David, in David and Goliath, in Rotterdam (see above, No.62) and even more similar, and iconographically playing a comparable role, the servant cutting Samson's hair in the drawing owned by J. Q. van Regteren Altena (see above, No.51), there seen, however, in reverse. The fat, turbaned general at the left is obviously modelled on the Portrait of Nicolas de Respaigne in Cassel (KdK.174, left) which was probably painted only a short time before.

For another version of the theme see below under No.230.

101 [Plate 90]

A LION HUNT

c. 1615–1616. Pen and ink, over traces of black chalk.
290 × 48.5 mm. Upper left corner made up.
London, British Museum (1885.5.9.51).

COLLECTIONS P. H. Lankrink; Reynolds; Lawrence; S. Woodburn; R. P. Roupell; P. L. Huart; W. Russell.
EXHIBITIONS London, 1977, No.89.
LITERATURE R. 1417 and 1419; Hind, *Catalogue*, II, 1923, 1; D. Rosand, 'Rubens' Munich Lion Hunt. Its Sources and Significance', *Art Bulletin*, LI, 1969, 31–2; Rowlands, 1977, 82–4; Held, 1980, 407; Freedberg, *Corpus Rubenianum*, VII, 1984, No.52a.

This drawing is on the upper half of a large sheet (574 × 485 mm.), the lower half of which contains studies for the torture of the Damned in Hell; on the reverse are numerous sketches—some rather faint—of the Blessed rising to Heaven. The sheet gives a particularly vivid insight into Rubens' manner of working out a project. (The sheet was originally folded horizontally in the middle. Since it is now unfolded, the sketches for the Lion Hunt appear upside down.)
The dramatic encounter of several men, some on horseback and others on foot, with three lions (one of whom appears only in the drawing) was sketched twice by Rubens on this sheet. The more complete rendering of the action is at the upper right, while its central group was drawn with more detail, and on a larger scale, at the lower left. Both sketches were done by the master in a hasty effort to clarify his thoughts; in this they resemble the most preliminary studies Rubens made for other types of painting (see Nos.104, 135, 140). Moreover, these first drafts can be connected with a composition which was unfortunately destroyed by fire in 1870, when forming part of the museum in Bordeaux; however a good copy has been preserved. Formerly in the collection of E. G. Spencer-Churchill at Northwick Park, this copy was sold in 1965 (Christie's, October 29) and again in 1975 (March); it is reproduced as Fig. 5 in Rosand's study mentioned above. The lost painting belonged to a series of hunts of wild animals painted for the Elector Maximilian I of Bavaria around 1615–1616. I see no reason to disengage, as has been done, the London drawing from the painting formerly in Bordeaux, with which it has virtually everything in common, and change its date from c. 1615–1616 to c. 1620–1621, thus associating it with the great Lion Hunt in Munich done in 1621. The change of date was suggested on the not unreasonable grounds that the studies on the lower half of the sheet—done in the same bold, rapid and almost unruly use of line—are connected with the lowest zone of the Fall of the Damned in Munich, where the 'lion rampant', seen twice in the Lion Hunt, also occurs, threatening the poor souls, as if the other monsters were not enough. Yet there is no reason to think that the plan for the Munich picture does not revert to the earlier period; the date 1621 which Philip Rubens

communicated to Roger de Piles refers almost certainly to the Fall of the Rebel Angels (Munich, KdK.241) since Vorsterman's engraving of that picture bears the date 1621 (which does not necessarily mean that it was painted in that year). The lower strip of the Munich Fall of the Damned itself is problematical—not necessarily in the sense that Rubens' authorship should be questioned (though it has been, for instance by Oldenbourg), but in that both colouristically and compositionally it is none too well integrated with the scene above it. In short, the London drawing of the Lion Hunt, being closely related to a picture done in the years 1615–1616, should also be placed in these years. This is the way Rubens may have begun another painting of this period for which no drawings or oil-sketches have come down—the Battle of Greeks and Amazons, also in the Alte Pinakothek in Munich (KdK.196).

102 [Plate 70] *(1959: No.89)*

STUDIES OF ARMS AND A MAN'S FACE

c. 1616–1617. Black and white chalk. 405 × 310 mm.
London, Victoria and Albert Museum (D.516).

COLLECTIONS The Rev. A. Dyce.
LITERATURE H. Reitlinger, *A Selection of Drawings by Old Masters*, Victoria and Albert Museum, London, 1921, No.71; K. T. Parker, 1929, Pl.23; Kuznetsov, 1974, No.57.

All the arms and hands in this study sheet, with the exception of the hand visible in the upper right corner, are studies for the painting of the Death of Decius Mus (KdK.146). The figure whose face and left arm are seen in the drawing occupies a central position in the painting, as does the man who plunges his lance into Decius' neck. The two arms towards the upper right are the left and right arms of the second assailant, who aims at Decius Mus with a sword. The two left arms with daggers which appear in the drawing near the left edge, though separated by the arm with the lance, are studies for the left arm of the figure lying on his back in the lower right corner of the painting. The horizontal arm at the bottom of the drawing is clearly the same as the one in the painting that crosses, and stays, the arm with the dagger.
The pose of the man with the lance also appears in various hunting scenes, painted between 1615 and 1617 from Rubens' designs, such as those in Rennes, Dresden (KdK.113), and Hartford, Conn.; the latter is probably by Pieter Soutman.

103 [Plate 99] *(1959: No.142)*

THE HOLY FAMILY AND ST. JOHN

c. 1615–1617. Pen and ink, washed, over black chalk, stylus tracings. Diameter 220 mm. The original paper has been enlarged all around by a strip of c. 10 mm.
London, British Museum (1860.16.16.89).

COLLECTIONS P. J. Mariette; Marquis de Lagoy; Sir Thomas Lawrence.
EXHIBITIONS London, 1977, No.67.
LITERATURE R., V. No.1342; Hind, *Catalogue*, No.6; Burchard-d'Hulst, 1963, No.113.

Inscribed on scroll around John's staff: AGNVS. Engraved: M. Lasne (V.S.88, 123).

The enlargement of this drawing must have been made at an early date, as Mariette's collector's mark is on it. (See also Gabriel de St. Aubin's sketch of the drawing on the margin of the Mariette sales catalogue, now in the Museum of Fine Arts at Boston.) Moreover, an old copy of the drawing in the Museum der bildenden Künste at Leipzig (No.NJ.474a, 178 × 176 mm.) is also round and was apparently made even before the

enlargement of 10 mm. that surrounds the London sheet was made. Since Lasne's engraving is rectangular, I had suggested (1959, 149) that Rubens' drawing had had the same shape and was reduced to a circular shape only after it had left Rubens' hands. I agree now with Müller Hofstede, that it was planned to be circular from the beginning—though this is very exceptional in Rubens' work.

Hind claimed that the drawing was also in the collection of the Prince de Conti; indeed, a drawing like this figures in the sale of that collection (Paris 1777) as No.996. In view of the marginal remark quoted before (Introduction, p.9), it is unlikely, however, that the De Conti drawing is identical with the one in the Mariette collection. There is no indication on the London drawing itself that it was ever in the De Conti collection, and the best argument against the identification is found in the prices the drawings fetched: the Mariette drawing was bought by Basan himself (who probably acted as agent for a collector) for 1,300 livres—a record price. Two years later, the De Conti drawing fetched only 152.10 livres—so large a difference that it can only be explained by assuming that there were two different drawings. The men who had pretended (as the Vienna commentator put it) that the De Conti drawing was the original by Rubens and the Mariette drawing a copy (possibly by Van Diepenbeeck) evidently failed to back up their convictions with cash. The De Conti drawing may be identical with the drawing now in Leipzig, mentioned before, or with a copy which is mentioned by Rooses as part of the collection of the Hermitage in Leningrad (Rubens-Bulletin, V, 202)—a drawing which I have not seen.

Another drawing (259 × 204 mm.) of this composition with the figure of St. Elizabeth added at the right, is in the Louvre (L.No.1137); it was engraved by L. Vorsterman (van den Wijngaert, No.722). Lugt thought it to be a Van Dyck, while Burchard and d'Hulst (Catalogue, Exh. Antwerp, 1956, No.85) and M. Jaffé somewhat hesitantly (The Burlington Magazine, XCVIII, 1956, 321) attributed it to Rubens. It is inferior to the London drawing, considerably harder and more pedantic. Lugt, at any rate, accepted the London drawing as an original, as Rooses had done before him. Other modern critics, notably Glück and Haberditzl, rejected this view; Glück thought that Lasne may have been its author. I believe that the only traces left by Lasne on this beautiful drawing are the stylus marks which were made when he transferred the design for the engraving. The stork in the sky, carrying a serpent in its beak, is an emblem of piety, particularly of filial piety (V. Cartari, Emblemata, No.xxx; C. Ripa, Iconologia, Padua, 1611, 427); it occurs, for instance, in an engraving by Philip Galle after Maerten de Vos, which illustrated filial piety with the stories of Aeneas and Anchises and of Cimon and Pero. Rubens himself—or Van Dyck working for him—used it in the drawing of the Return from the Flight into Egypt in the Louvre (L.No.1139) which served for the engraving by Vorsterman. It does not figure, however, in the painting in Hartford (Goris-Held, No.51) which probably preceded the Paris drawing, nor in the seemingly better version in the collection of the Earl of Leicester at Holkham Hall (see Nos.86, 87).

Lasne worked for Rubens between 1617–1620; the latter date thus is a terminus ante quem for works engraved by this master.

104 [Plate 127] (1959: No.40)

THE APOSTLES SURROUNDING THE VIRGIN'S TOMB

c. 1616. Black chalk, pen and ink. 228 × 300 mm.. On the reverse: a little boy, lying on his back (red and white chalk); drawn over it, at an angle of 90 degrees, there is a sketch for a scene of fighting figures.
Oslo, Nasjonalgalleriet.

COLLECTIONS Sophus Larpent.
EXHIBITIONS London, 1950, No.45; Antwerp, 1956, No.58.
LITERATURE L. Burchard, in Catalogue, Exh. 1950; Stephan Tschudi Madsen, The Burlington Magazine, XCV, 1953, 304–305; A. Seilern, Catalogue, 42. (The attribution to Rubens was first made by E. Schilling.); Freedberg, Corpus Rubenianum, VII, 1984, No.39 ('1615–1616').

As a typical worksheet this drawing occupies an interesting position in Rubens' oeuvre. It not only shows the manner of drawing first thoughts in rough outline but also demonstrates Rubens' lack of concern for the appearance of such studies: on the reverse he drew over an earlier drawing (see also No.71). It is the reverse which is thought to give a concrete connection with one of Rubens' works: according to Professor Madsen, the drawing of a little boy is Rubens' study for the figure of young Erichthonius in the painting of c. 1614–1616 in the Liechtenstein collection (KdK.124). This is possible, but—as Count Seilern pointed out—by no means certain. The fighting scene which was drawn over it was connected by Madsen with the Rape of the Leucippidae, which is even less likely. The main figure in this scene is a youth in Roman armour who comes with drawn sword from the left, apparently trying to stop other figures, though neither the nature nor the object of their action is very clear. The youth was drawn a second time in the lower right. A Rape like that of Hippodamia or of the Sabines would fit better what can be seen in this drawing. The pose of the youth, especially as he appears in the lower right, has a close parallel in the almost nude foot-soldier fighting prominently in the centre of the bridge in the Battle of the Amazons (KdK.196)—a picture which Philip Rubens, the artist's nephew, declared to have been painted in 1615 (F. von Reiffenberg, Bull. de l'Académie royale des sciences et belles-lettres de Bruxelles, X, 1837, 15; an English translation was published in the Art Quarterly, IX, 1946, 37). Similar figures also occur in other works, for instance in a much later drawing (done on both sides), Burchard-d'Hulst, 1963, No.191 r. and v.

The apostles surrounding Mary's tomb were surely drawn in connection with a planned Assumption of the Virgin, but they are only loosely related to any of the compositions known to have been made by the master. The arrangement clearly goes beyond the earliest formulation of the theme, that in the Missale Romanum (Madsen Fig.23); the figure with upraised arms has its closest analogy in an apostle in the sketch for the Assumption in the Cathedral at Antwerp of c. 1625 (now in the Mauritshuis, The Hague, see also above, No.85), where the same intense examination of the tomb is found. Yet this emphasis on the sarcophagus is already found in the Assumption in Brussels (KdK.120), which Burchard dates 'c. 1615–16'. The pose of the foremost apostle at the right strikingly resembles that of a man at the right in Count Seilern's drawing of the Conversion of Paul (see No.61). If we try to evaluate the various connections with other work by Rubens and take into consideration the style of the drawing which finds its closest analogies in works done between 1615 and 1620, a date in this period seems to be the most satisfactory.

(In the supplement to the Catalogue of the Antwerp Exhibition of 1956, the authors state that the reclining child, drawn first on the paper, was 'borrowed from a sixteenth-century painting', without naming the alleged source.)

105 [Plate 103] (1959: No.88)

A WOMAN MILKING A COW

c. 1615–1618. Pen and ink, over black chalk. 220 × 174 mm. Besançon, Musée des Beaux-Arts (D.88).

COLLECTIONS J. F. Gigoux.
EXHIBITIONS Antwerp, 1956, No.83.
LITERATURE A. E. Popham, 1938, 26 (Pl.26).

Both the young woman and the cow were drawn first in chalk; while this part of the drawing shows them complete, the pen-lines describe only sections of their bodies, which gives a rather strange effect.

The motif of a girl milking is found several times in Rubens' landscapes, but nowhere more nearly identical with the Besançon drawing than in the Munich landscape with cattle, the so-called 'Polder-landscape' (see KdK.187). The figure occurs again in the landscape with duck-hunter in Berlin, but it is evident that for the 'staffage' of the Berlin landscape Rubens made use of several earlier types.

While the 'Polder-landscape' has been dated around 1618–1620, it is by no means necessary to assign this date to the drawing too; another figure of a seated woman in the same picture goes back to a drawing which Rubens had made a few years before for the picture of Achilles among the daughters of Lycomedes (see No.134). The first occurrence of the motif, though in a slightly different form, is in the painting of the Farm at Laeken at Buckingham Palace (KdK.186); Rubens may have made a series of rural studies when he first became interested in the subject which served as a ready stock of types for later paintings.

The manner of drawing the cow is more closely related to the London drawing of cattle than to the one in Chatsworth. This may be an argument in favour of the originality of the London sheet, though it is hardly conclusive (see also Introduction, pp.13–14). The group of the girl milking a cow was also introduced without change in Jan Brueghel's broad painting of Country Life in the Prado, Madrid (1444).

For this and similar drawings see also Lisa Vergara, *Rubens and the Poetics of Landscape*, New Haven, 1982, pp.75–79.

Fig. 15 A Woman Milking a Cow. Detail. Munich, Alte Pinakothek

106 [Plate 101] *(1959: No.143)*

THE ADORATION OF THE SHEPHERDS

c. 1617–1618. Pen and ink, washed, and some chalk.
359 × 204 mm. (semi-circular top); squared.
Paris, Fondation Custodia, Collection F. Lugt.

COLLECTIONS Mrs. E. John Heidsieck (sale, New York, 1943).
EXHIBITIONS London–Paris–Bern–Brussels, 1972, No.79.

Inscribed (by a later hand): 'P. P. Rubens',
and (in upper left): '99'.

Three men and three women approach in pairs from the left to do homage to the child who is shown to them by the Virgin. Joseph stands behind her and the heads of ox and ass appear in the right foreground. Five angels fly overhead, the two largest ones holding a scroll on which is written GLORIA IN . . . T IN TERRA (Gloria in excelsis et in terra).

The function of the drawing is uncertain. In my book of 1959 I proposed that it was made for an engraving, a view which was accepted by C. van Hasselt in the exhibition catalogue of 1972, but was questioned by Müller Hofstede in his review of my book (*Kunstchronik*, 1962, 136). At any rate, neither an engraving nor a painting corresponding to the design is known and may never have been done. The group of angels was clearly used for the Munich Adoration of the Shepherds which Rubens painted in 1619 for the Elector of Pfalz-Neuburg. The group of shepherds appears similarly in the Adoration of the Shepherds in Rouen (R.I, No.150), a work which was almost certainly done in the studio with little participation on the part of the master. (It is reproduced in Mitsch's 1977 *Catalogue*, Vienna, p.60.) I suspect that Rubens abandoned the composition as a whole because he was no longer satisfied with the action and profile view of the Virgin, which he had used similarly in the Adoration of the Shepherds in Fermo and the Adoration of the Magi in the *Breviarium Romanum* (see above, No.77). (For the various sketches in oil depicting the Adoration of the Shepherds see Held, 1980, Nos.321–4.) The solution he chose in the Munich canvas (KdK.198) for the pose of the Virgin is clearly more graceful and more imaginative than the one seen in the Lugt drawing, and the composition as a whole has more fluidity. Hence it is likely that the Lugt drawing was done at least one or two years before.

For the crouching maid in the foreground Rubens made a study in black and white chalks (380 × 264 mm.), now in Vienna (Mitsch, 1977, No.25).

107 [Plate 102] *(1959: No.141)*

PORTRAIT OF JUSTUS LIPSIUS (1547–1606)

c. 1615. The portrait itself is in black chalk, reworked in black ink. Both the pen-lines and the washes of the decorative frame are in a light bistre. 232 × 185 mm.. A correction on the right side, on a separate piece of paper, was pasted over the first draft.
London, British Museum (1891.5.11.31).

COLLECTIONS S. Woodburn.
EXHIBITIONS Paris, 1954, No.363; London, 1977, No.213.
LITERATURE *Rubens Bulletin*, IV, 1895, 290; R., V. No.484; G.-H. No.80; Hind, *Catalogue*, No.90; Bouchery-Wijngaert, 23, 78, 133–136; *Rubens and The Book* (J. S. Held ed.), Williamstown, Mass., 1977, 177–178 (A. S. Hoch); Judson-Van de Velde, 1978, I, No.30a.

Design for an engraving by C. Galle I which was used for Lipsius' edition of Seneca's works published in 1615 by the Plantin Press. The print is reproduced by Bouchery-Wijngaert, *loc.cit.*, Pl.45. As for all his portraits of Lipsius (the group portrait in the Pitti Palace KdK.45, and the bust at the Musée

Plantin-Moretus, Bouchery-Wijngaert, Pl.14), Rubens had to rely on a painting of Lipsius by Abraham Janssens, lost but known today from an engraving by Pieter de Jode, dated 1605 (rep. *Belgische Kunstdenkmäler*, II, Munich, 1923, Fig.185). Bouchery-Wijngaert stress correctly that Rubens worked from Janssens' original and not from de Jode's print as was maintained by Rooses and A. M. Berryer ('Essai d'une Iconographie de Juste Lipse', *Annales de la Société Royale d'Archéologie de Bruxelles*, XLIII, 1939–1940, Brussels, 1940, 5–71).

The frame, which is Rubens' own invention, is richly charged with emblematic meaning. It consists of a wreath, cornucopia, two torches, winged hat of Mercury, the sun and two lamps. At the left a serpent winds round wreath and cornucopia; at the right its place is taken by a scroll. In his preface to the Seneca edition of 1615 Balthasar Moretus, the editor, explains this difference by saying that the left side symbolizes Prudence, the right Doctrine. In the engraving the scroll is inscribed with references to Lipsius' major works: *POLITICA; CONSTANTIA; PHILOSOPHIA STOICA; MILITIA ROMANA; EPISTOLAE*. On the plinth of the drawing two medallions flank the author's name. Resembling Roman coins, one medallion, showing a helmeted head, is inscribed *ROMA*, the other, with an armed figure holding lance and sword, *VIRTVS* (see also No.133). In the engraving the words *IVSTVS LIPSIVS* were replaced by *MORIBVS ANTIQVIS* and a cartouche was added with a distych comparing the portrait—not too flatteringly—to Timanthes' veil. (The Greek painter Timanthes, who despaired of doing justice to Agamemnon's emotions in the scene of the Sacrifice of Iphigenia, resolved the problem by painting Agamemnon's head veiled; the distych, which incidentally had already accompanied the Lipsius portrait of the 1605 edition of Seneca's works, elaborates on this reference by saying that the sun's brilliance, too, can only be seen safely through a dense cloud.) For a comparison between the frame of the earlier Lipsius portrait of 1605 and that of Rubens, see Bouchery-Wijngaert, *loc.cit.*, 134.

Translated from the original Latin, Balthasar Moretus' address to the reader says this about Rubens' portrait of Lipsius: 'I wish that you be edified and delighted by the Lipsius portrait which is prefixed to the title of Seneca's works. Rubens drew it no less faithfully than elegantly not only according to his own judgment but also that of several other admirers of Lipsius, embellishing it with the most appropriate decoration symbolizing Prudence and Learning. For he believed with me that it was not fitting to make a great effort on the picture of the old sage while neglecting the image of the most eloquent interpreter of that wisdom. Therefore, refreshed by the most pleasant sight of the dignified face let yourself be excited to view the immortal monuments of divine genius and embrace in them willingly the image of all ancient learning and good wisdom, and farewell again.' (For the Latin text see: Bouchery-Wijngaert, 133.)

108 [Plate 110] *(1959: No.86)*
THE REVEREND HENDRIK VAN THULDEN (1580–1617)

c. 1615–1617. Black chalk on light brown paper; the top corners have been cut. 374 × 262 mm..
London, British Museum (1845.12.8.5).

COLLECTIONS J. Richardson, Sr.; T. Hudson; Sir Joshua Reynolds.
EXHIBITIONS London, 1977, No.78.
LITERATURE Hind, *Catalogue*, 64, No.44 (as Van Dyck); Clare Stuart Wortley, *Old Master Drawings*, VI, 1931–1932, 30; M. Delacre, *Le Dessin*, 180–81; Burchard-d'Hulst, 1963, No.109; Kuznetsov, 1974, No.665.

Sketch for the portrait in Munich of Hendrik van Thulden (KdK.140), who was pastor of the church of St. George (St. Joris) in Antwerp from 1613 to his death in 1617. (L. Burchard was the first to determine the correct identity of the sitter.) Another portrait by Rubens, showing Van Thulden in surplice and stole, adoring a small crucifix, was originally placed over the tomb of the cleric. It was sold at Christies in 1926 (see *Catalogue*, Exh. Amsterdam, 1933, No.47).

The Munich portrait corresponds to the London drawing in all essentials except that the *biretta* was omitted from it.

The drawing shows traces of corrections which were caused by a decision to raise the head. Originally it had sat deep inside the broad collar of the gown; the original position of all the main elements from the neck upwards can still be seen. These changes were clearly not made for the sake of greater likeness but in order to stress the impression of dominance and vitality. By raising the head, and by giving the *biretta* greater width and height, Rubens emphasized the ecclesiastical rank as well as the dynamic personality.

Rubens must have made a special drawing of the face alone since the London sketch is primarily one of the pose; the features bear little resemblance to the broad fleshy forms of the pastor.

109 [Plate 108] *(1959: No.87)*

A SADDLED HORSE

1615–1618. Black, red, and white chalk. 400 × 425 mm.. Cut out irregularly (the upper and lower left corners of the sheet are missing) and torn in many places. The right front hoof is restored. Inscribed in the lower left, by a later hand: PPR. The same hand added the signatures on the Bullock (No.110) and on the study of a tree (G.-H. No.184).
Vienna, Albertina (8252).

LITERATURE R., V. No.1582; G.-H. No.139; Phaidon *Rubens*, Fig.90; Kuznetsov, 1974, No.73; Mitsch, 1977, No.18.

Evidently a study from nature. At the left Rubens added, somewhat more sketchily, the breast and front-legs of the same horse in a pose which suggests jumping. The drawing cannot be connected with any definite painting, but its firm, smooth, and plastic style points to those years in the second decade when Rubens not only made similar studies for figures but was also frequently occupied with themes involving horses.

Drawings of horses are surprisingly rare in Rubens' oeuvre. The Oxford sheet showing horses in a stable (G.-H. No.93) is surely—as Parker suggested (*Catalogue of the Collection of Drawings in the Ashmolean Museum*, Oxford, 1938, No.203)—a copy after the painting in Antwerp (KdK.182) and not a sketch for it. Benesch reaffirmed (in my opinion correctly) an old attribution to Rubens of two drawings of farm-horses in the Louvre (*Kunstchronik*, 1954, 201), which Lugt (*Catalogue* Nos.1269 and 1270) had given to a follower of the master. Two more sheets in the collection of P. Dubaut in Paris, also rendering farm-horses, should probably be added to these drawings. (One of them was exhibited in 1948 at the Galerie Charpentier in Paris.) (See also No.197 below.)

110 [Plate 109] *(1959: No.91)*

A BULLOCK

c. 1618. Black and red chalk and wash, on white paper, waterstained at the top; a small hole in the upper centre. 283 × 436 mm..
Vienna, Albertina (8253).

LITERATURE R., V. No.1583; Muchall-Viebrook, No.31; G.-H. No.138; Popham, 1937, 26; Glück, *Landschappen*, 14, 54,

72 (Fig. 1). Inscribed: 'P.P.R.' (by a later hand); Kuznetsov, 1974, No. 72; Mitsch, 1977, No. 30; Vergara, 1982, 75.

The study was used by Rubens in his painting of the Farm at Laeken, Buckingham Palace (*KdK*. 186).

111 [Plate 112] *(1959: No. 94)*

YOUNG WOMAN HOLDING A BOWL

c. 1616. Black and white chalk, on nearly white paper buckled in parts from mounting. 347 × 307 mm. (measured on longest sides).
Vienna, Albertina (8279).

LITERATURE R., V. No. 1568; F. M. Haberditzl, 1912, 5; Muchall-Viebrook, No. 5; G.-H. No. 107; Kuznetsov, 1974, No. 85; Mitsch, 1977, No. 27.

Outstanding on account of its economy of line, this drawing was made during the preparation of one of the least known of Rubens' works, the large Entombment in St. Géry, Cambrai. Rooses indeed, and following him Oldenbourg, in discussing the oil-sketch for this altar, which is in Munich (Held, 1980, No. 366) thought that it was done for a lost altarpiece in Courtrai. It is the Cambrai altarpiece for which the present drawing as well as Nicodemus (G.-H. No. 106) and a St. John (Parker 1929, Pl. 20) were drawn, in addition to the Munich sketch. Parker thought that still another drawing in the Victoria and Albert Museum (*loc. cit.* Pl. 21, Dyce, 523) belonged to the same group as a study for Nicodemus. If so, Rubens changed the figure more than usual; stylistically at any rate the very beautiful drawing clearly belongs to this period. (The Cambrai Entombment, to which I first called attention in 1959, has since then figured prominently in the 1977–78 Paris exhibition, *Le Siècle de Rubens*, No. 118.)

112 [Plate 111] *(1959: No. 41)*

STUDIES FOR A DRUNKEN SILENUS

c. 1616–1618. Pen and ink. 290 × 195 mm. On the reverse: 'Inscribed in Italian with notes on waterworks' (Parker).
Collection of the late Mrs. G. W. Wrangham.

LITERATURE K. T. Parker, 1928–29, 1ff.; Delacre, *Van Dyck*, 236–237, Fig. 104; Evers I, 203 (note 171); Evers II, Fig. 257; *Catalogue*, Exh. Antwerp, 1956, under No. 56.

Silenus appears twice on this sheet, accompanied each time by a Satyr and—in the upper right corner—by a third person. Since the lines of the upper group stop short of the lower, it is the latter which Rubens drew first. This observation supports the placing of this drawing between the Leningrad Bacchanal (*KdK*. 82) and the Munich Silenus (*KdK*. 177) suggested by Evers. In the Leningrad version, Silenus leans backward as he does in the lower group of the drawing; in the Munich version he leans forward as he does in the upper. The 'earlier' position of the body is also connected with other paintings which date from *c.* 1615 or before, such as the Dresden Drunken Hercules (*KdK*. 122, but see also E. Hensler, *Festschrift Paul Clemen*, 1926, 435, for the original version) and the Doubting Thomas in Antwerp (*KdK*. 84). A classical figure which was identified by E. Kieser (*Münchner Jahrbuch der Bildenden Kunst*, N.F., X, 1933, 114, 121, 127) is the source for this pose. A drawing in black and white chalk from a model posing in the same attitude is in Rotterdam (V. 82; Evers II, Fig. 241). An inscription on the back (J. Richardson?) makes reference to the painting 'in the Elector Palatine's collection at D[üsseldorf]'.
It has been correctly pointed out by Parker that the drawing was used in the preparation of the painting in Munich. According to E. Kieser, the Munich picture was painted in two phases

(*Münchner Jahrbuch der Bildenden Kunst*, N.F., XIII, 1938–39, 185); it is most likely that the drawing antedates the earlier and smaller version (see also No. 212).
The forward inclination of Silenus in the upper half of the drawing recalls Rubens' early drawing after a Greek vase then in the Borghese collection (now in the Louvre); Rubens' copy is now in the Dresden Kupferstichkabinett (C. 1967–42; black chalk, 292 × 383 mm. See Jaffé, 1977, 83R, and pl. 289). The drawing figured in an exhibition: *Dialoge: Kopie, Variation, und Metamorphose alter Kunst*, Dresden, 1970, No. 64 (see also No. 36).

113 [Plate 115] *(1959: No. 129)*

FARMYARD, WITH A FARMER THRESHING AND A HAY-WAGON

c. 1615–1617. Black and red chalk (chiefly for the man's jacket), with light touches of blue, yellow, and green. 255 × 415 mm..
Malibu, J. Paul Getty Museum.

COLLECTIONS Bakewell, Chatsworth, Devonshire Collection (sold London, July 3, 1984).
EXHIBITIONS London, 1938, No. 614; Brussels, 1938–39, No. 47; Rotterdam, 1939, No. 45; Helsinki–Brussels, 1952–53, No. 45; Antwerp, 1956, No. 77; London, 1977, No. 202.
LITERATURE Rooses, *Rubens Bulletin*, V, 1900, 204; *Vasari Society*, IV, 1908, No. 21; L. Burchard, *Mitteilungen aus den Sächsischen Kunstsammlungen*, 1913, 8–9; G.-H. No. 94; Glück, *Landschappen*, 28, 72 (Fig. 4); Burchard-d'Hulst, 1963, No. 101; Kuznetsov, 1974, No. 61; Adler, *Corpus Rubenianum*, XVIII, I, 1982, No. 26a; Vergara, 1982, 75.

The wagon which Rubens drew with such care in this drawing appears in three of his paintings. It was used first in the painting of the Prodigal Son in Antwerp (*KdK*. 182); it occurs later in 'Winter' in Windsor Castle (*KdK*. 238), in a strip which Rubens himself added on the left side of the painting (see Glück, *Landschappen*, 26, No. 10). Slightly tilted, the same wagon is found a third time in the Landscape with a Country Wagon in Leningrad (*KdK*. 185). The figure of the man, on the contrary, is not found anywhere in Rubens' paintings of country life.
Rubens must have made many such studies for the Antwerp Prodigal Son alone, but none has come to light. The Oxford drawing of the Horses (G.-H. No. 93) is probably only a copy after the painting. See also comment to the following number.

114 [Plate 114] *(1959: No. 130)*

A COUNTRY LANE

c. 1615–1618. Pen and ink, washed; some black chalk. 312 × 402 mm. (paper joined in centre).
Cambridge, Fitzwilliam Museum (2178).

COLLECTIONS The Rev. Thomas Kerrich; Ch. Ricketts and Ch. Shannon (Bequest Charles Shannon, 1937).
EXHIBITIONS London, 1927, No. 562; London, 1938, No. 610.
LITERATURE Campbell Dodgson, *Old Master Drawings*, II, 1927–1928, 11 (Fig. 12); G.-H. No. 137; A. E. Popham, *The Burlington Magazine*, LXXII, 1938, 19; Glück, *Landschappen*, 35, 72 (Fig. 17); Burchard-d'Hulst, 1963, No. 206; Kuznetsov, 1974, No. 62; Jaffé, 1977, 52r; Adler, *Corpus Rubenianum*, XVIII, I, 1982, No. 72; Vergara, 1982, 79.

Inscribed on the back, in ink: T. Kerrich 1767./M.C.C.

The problem of dating, difficult in Rubens' landscapes in general, is more so in this sheet because it is rather isolated, even among the drawings. Nor has the motif been found in any of the paintings or engravings. The drawing is much harder and more detailed than the reproduction in Glück and Haberditzl

would lead one to expect; its style is nearer Rubens' early conception of nature than his later. The date '1620–25', given in Glück and Haberditzl, seems to be no more than a compromise solution which places the drawing unhappily 'between two stools', as it were—and right at a period in which Rubens was occupied with large commissions. Not only does this time seem to have been unpropitious for such a drawing, but it was just then that Rubens developed his fluid style of composition which tried to eliminate sharp angles—a feature still particularly prominent in the drawing. Thus, an earlier date seems to be more appropriate.

115 [Plate 113] *(1959: No.132)*

LANDSCAPE WITH A FALLEN TREE

c. 1617–1619. Black chalk, pen and ink. 582 × 489 mm.. A small piece of paper has been inserted in the lower right corner.
Paris, Louvre, Cabinet des Estampes (20.212).

EXHIBITIONS Brussels, 1938–1939, No.48; Rotterdam, 1939, No.46; Paris–Brussels, 1939, No.111 (105); Antwerp, 1977, No.143; Paris, 1978, No.14.
LITERATURE R., V. No.1591; Lugt, 1925, 194; Muchall-Viebrook, No.27; G.-H. No.134; L. van Puyvelde, *Pantheon*, XXIII, 1939, 75ff.; Evers, I, 232, note 203; Glück, *Landschappen*, 1945, 19–20, 57, 72 (Fig.6); Burchard-d'Hulst, 1963, No.104; Kuznetsov, 1974, No.59; Adler, *Corpus Rubenianum*, XVIII, 1, 1982, No.18a; Vergara, 1982, 84–6.

It is generally very difficult to establish a connection between the relatively small number of landscape drawings attributed to Rubens and any of his pictures (see on this question A. Seilern, *Catalogue*, 101). The present drawing is an exception since it is clearly connected with the Hunt of the Wild Boar in Dresden (*KdK*.184). That picture has always been dated between 1615 and 1620; this would obviously be the period during which Rubens made the drawing.
Rubens made considerable changes in the forms of the tree and the lay of the land when he transferred the drawing to the picture. The trunk and the branches of the tree were more twisted and gnarled and a new branch was added. Instead of flat ground the painting has a ditch beneath the tree, so that the trunk acts as a bridge. With hounds and hunters jumping and climbing all over it, intent on killing the boar who has been cornered inside its big fork, the tree plays an exciting and important role in the plan of the whole action. Rubens' interest in twisted and gnarled tree-trunks, most noticeable in his early landscapes, has antecedents in Northern art but may actually have been stimulated by his acquaintance with Italian sixteenth-century landscape conceptions. A more than accidental kinship seems to connect the present drawing (and the trees standing at the left in the Dresden painting) with F. Zuccari's stage-design of 1565 (see H. Voss, *Die Malerei der Spätrenaissance in Rom und Florenz*, Berlin, 1920, II, 453, Fig.176).
In the Albertina in Vienna there is a very large drawing (pen and ink over cursory black chalk, 415 × 568 mm.) which is clearly connected with this composition and which has been attributed to Rubens by F. Lugt (*Gazette des Beaux-Arts*, XII, 1925, 195) as a sketch for the Dresden picture. The observation that the composition looks like the record of an intermediate stage in the development of the Dresden picture, half-way between the Louvre drawing of the tree and the finished painting, is favourable to this theory. Like the Louvre drawing the big branch is not yet in the foreground (nor, of course, the two dogs who jump across it). On the other hand, the trunk is more curved and more rapidly foreshortened, and thus it approaches the Dresden painting although it still remains behind it by comparison.

There are serious objections, however, to the attribution of the Vienna drawing to Rubens. The lines of the pen are drawn weakly and rather than create forms seem to trace them. The forms of the animals, especially of the hounds, are at once more finite and less 'understanding' than in authentic drawings. The explanation, I believe, is simply that the pen-lines—the only clearly distinguishable part—follow without much imagination the underlying chalk-sketch which today is almost wholly effaced. Such crude 'tracing' can only be the work of a pupil. Since the composition of the Vienna drawing was engraved by Soutman, it is this artist who should first be considered as its author. The engraving is signed *P. Soutman Effigiavit* and dated 1642 (van den Wijngaert, No.647). Thus it is not impossible that Soutman had Rubens' sketch in his possession after the master's death and traced its faded lines prior to making the engraving. He may also, of course, have had the drawing since the time he had worked in Rubens' studio. The role of Soutman as collaborator and as imitator of Rubens is in need of further clarification.
A washed drawing, by another follower, freely copying the Dresden Hunt of the Wild Boar is in London (Hind, *Catalogue*, No.112).
Since the previous edition of this book was written, the problem of the drawing in the Albertina has been treated extensively by H. G. Evers, 'Zu einem Blatt mit Zeichnungen von Rubens im Berliner Kupferstichkabinett', *Pantheon*, XIX, 1961, 93ff. and 136ff.; by Mitsch, 1977, No.71; and by Winner, 'Zu Rubens' Eberjagd in Dresden (Landschaft oder Historien-bild)', in *Peter Paul Rubens, Werk und Nachruhm*, Augsburg, 1981, 157ff. Fig.32. As I had done, Winner also concluded that the pen work was done by another hand. (Neither Mitsch nor Winner had noticed my entry of 1959.)

116 [Plate 116]

A DEAD TREE COVERED WITH BRAMBLES

*c.*1618–1620. Red and black chalk, pen and ink, and touches of different colour. 345 × 298 mm.
Bakewell, Chatsworth, Devonshire Collection (1008).

COLLECTIONS N. A. Flinck.
EXHIBITIONS London, 1977, No.199.
LITERATURE *Vasari Society*, II. series, pt.VI, No.12; G.-H. No.135; Held, 1959, under No.131; Vergara, 1982, 83–4.

The drawing has a Flemish inscription in three lines, in the corner at the lower right. It reads: 'Abgevallen bladeren ende op sommighe plaetsen schoon gruen gras door kyken'. (Fallen leaves and in some places pretty green grass peeping through.) There is a very similar, though much lighter drawing, done in different colours of chalk only, in the Princes Gate Collection, Courtauld Institute Galleries (Seilern, *Catalogue* 1955, No.63; it, too, was exhibited London, 1977, No.198). When I referred to the Chatsworth drawing in 1959, 145, I expressed my firm conviction that the character of the handwriting is not that of Rubens, when he wrote in Flemish. It is difficult to be sure of such matters when the material on which one has to base such statements is limited but I still feel that in so far as I have evidence about Rubens' 'Flemish' hand, it is different. Yet the drawing is so much in keeping with Rubens' style (see the drawing of the fallen tree, No.117) that his authorship can hardly be doubted. Moreover, its style is clearly different from Van Dyck's who drew a number of delicate renderings of nature (see Vey, 1962, plates 334–60), Van Dyck being the only other artist who could possibly be considered as its author. The nature of the inscription, too (similar to the one on the sheet in the Princes Gate collection), is more characteristic of Rubens than of his great pupil.

117 [Plate 117] *(1959: No.132)*

A FALLEN TREE

c. 1617–1619. Black chalk, light green and brown washes and some sanguine, on white paper. 184 × 310 mm.
Bakewell, Chatsworth, Devonshire Collection (985).

COLLECTIONS N. A. Flinck(?).
EXHIBITIONS Rotterdam, 1948–49, No.130; Paris–Brussels, 1949, No.112; Antwerp, 1956, No.106.
LITERATURE *Vasari Society*, 2. Series, VI, 1925, 12; Clare Stuart Wortley, XI, 1937, 49 (Pl.45); Glück, *Landschappen*, 61 (under No.18), 72 (Fig.7); Burchard-d'Hulst, 1963. No.103; Kuznetsov, 1974, No.60; Adler, *Corpus Rubenianum*, XVIII, I, 1982, No.28a.

This drawing and the sheet in the Louvre (see No.115) show the same fallen tree. Whereas the Louvre drawing, however, was used in one of Rubens' earlier landscapes, the tree of the Chatsworth drawing only occurs in the late painting of Ulysses and Nausicaa in the Pitti Palace (*KdK.354*). Hence the problem as to whether the drawing, too, belongs to the 1630s or whether it was done considerably before that time. No conclusive answer can be derived from the appearance of the tree itself. A tree like this one which evidently still had some roots in the ground (see the thick foliage of the Louvre drawing) can stay alive for a number of years. There is no reason why Rubens should not have gone to the same place at different times to draw a picturesque motif. It is more likely, however, that they were done at the same time. And while the drawings at first glance seem to be very different in style, this difference is more of appearance than of fact. The underlying chalk-sketch in the Louvre drawing, seen near the right edge, is very similar in character to the manner in which the Chatsworth drawing was executed. By contrast, those drawings, which with a high degree of probability can be placed in the 1630s (see Nos.227, 228), have a very different, much softer, style and do not seem to be occupied with the exploration of single objects (see also Introduction, p.34). In the Chatsworth drawing the tree is seen from across a small marsh lying along its edge, parallel to the picture plane. In the Louvre drawing it is seen in a foreshortened view. The elaborate pen-work on the Louvre drawing—which not only adds detail but also strengthens the gnarled and twisted appearance of the forms—makes it clear that at that time Rubens preferred the 'baroque' interpretation of the motif, a tendency which was increased when he incorporated the tree into his picture of the Hunt (see comment on No.115). On the other hand, it is equally significant of Rubens' economy as well as his stylistic development that he made use of the calmer drawing at a time when his conception of landscape had veered from the crowded, dramatic, and agitated compositions of his earlier years to the spacious and becalmed bucolic vistas of his last decade.

118 [Plate 118] *(1959: No.133)*

TWO FARM WAGONS

c. 1618–1620. Black and white chalk, and pen and ink. Touches of light green, yellow, and red chalk on the load of sheaves in the wagons. 225 × 375 mm.
Berlin, Kupferstichkabinett (3237).

COLLECTIONS N. Hone; B. Suermondt.
EXHIBITIONS Antwerp, 1956, No.78.
LITERATURE G.-H. No.95; Bock-Rosenberg, 253 (No.3237); Glück, *Landschappen*, 15, 31; F. Winkler, *Flämische Zeichnungen*, Berlin, 1948, 53, Fig.30; Burchard-d'Hulst, 1963, No.102; Mielke-Winner, 1977, No.32; Adler, *Corpus Rubenianum*, XVIII, I, 1982, No.48b; Vergara, 1982, 79.

The larger of the two wagons was used by Rubens in the lower left foreground of the Return from the Harvest in the Palazzo Pitti in Florence (*KdK.405*). Since that picture surely dates from the 1630s (see also Nos.195, 196), Winkler (*loc.cit.*) suggested a date after 1630 for this drawing. The differences between this drawing and the one in Malibu (No.113)—which must be early—are not enough, however, to warrant the assumption of a great interval of time between them. It is more likely that Rubens employed for his painting in the Pitti a study that had lain for several years without having been used. This is also the opinion of Burchard and d'Hulst (*Catalogue*, Exh. Antwerp, 1956, 74).

119 [Plate 120] *(1959: No.134)*

A WILLOW TREE

c. 1620. Black chalk, on brownish-grey paper. 392 × 264 mm.
London, British Museum (5213–2).

COLLECTIONS W. Fawkener, Esq. (Bequest, 1769).
EXHIBITIONS London, 1977, No.197.
LITERATURE Hind, *Catalogue*, No.81 (as Van Dyck); G. Glück, *Landschappen*, 19, 72, Fig.11; O. Benesch, *Gazette des Beaux-Arts*, 6th series, XXX, 1946, 156–157 (as Van Dyck); Burchard-d'Hulst, 1963. No.73; Kuznetsov, 1974, No.64; Adler, *Corpus Rubenianum*, XVIII, I, 1982, No.73; Vergara, 1982, 82.

Inscribed in pen (by later hands) 'Di Vandik' and 'Rubens', followed by some numerals.

Although not listed in Glück and Haberditzl, the drawing was evidently accepted by Glück as being by Rubens; its style indeed is clearly that of the master, who appears to have liked old willow trees with their gnarled, pitted, and rough-surfaced trunks, and their thin and graceful branches. No exact correspondence with any painted willow tree in Rubens' landscapes can be found, but it is not very likely that such a drawing would have been used without any changes. Glück seems to have connected the drawing with the Leningrad Landscape with a Country-wagon (*KdK.185*). Since the tree in the London drawing has no leaves, a picture such as the 'Winter' in Windsor Castle (*KdK.238*) is brought to mind where there are willow trees too, though none exactly like the one in the drawing. Although there is hardly any criterion by which a drawing like this could be dated, I am inclined to place it with the earlier group of painted landscapes rather than the later ones.

120 [Plate 119] *(1959: No.95)*

A PEASANT GIRL, CHURNING BUTTER

c. 1618–1620. Black and red chalk (the latter on her cheek and her bodice). 335 × 257 mm.
Bakewell, Chatsworth, Devonshire Collection.

COLLECTIONS N. A. Flinck (?).
EXHIBITIONS Antwerp, Van Dyck-Tentoonstelling, 1899, No.116 (as Van Dyck); London, 1938, No.605; Brussels, 1938–39, No.46; Rotterdam, 1939, No.44; Rotterdam, 1948–49, No.44; London, 1950, No.54; Helsinki–Brussels, 1952–53; No.44; Antwerp, 1956, No.120.
LITERATURE Rooses, *Rubens Bulletin*, V, 1900, 204; *Vasari Society*, I, 3rd Series, 1907, No.15; G.-H. No.210; Glück, *Essays*, 181; Burchard-d'Hulst, 1963, No.177; Kuznetsov, 1974, No.108.

Glück and Haberditzl dated the drawing '*c.* 1635', perhaps because of a presumed similarity to the drawing in the Lugt collection (No.199). Burchard and d'Hulst (*Catalogue*, Exh. Antwerp, 1956, 100) suggest that it might have been drawn

about 1631, possibly for one of the paintings Rubens is known to have done about that time in collaboration with C. Saftleven; they repeated this view in their book of 1963. As long as no picture is found for which the drawing was used, it can be only dated on the basis of its style which I feel is different from that of the 1630s. The firm continuous line and the emphasis upon a relatively closed silhouette connect it with rather earlier studies. The application of the red and black chalk on the face is comparable for instance to the drawing of the two monks at Chatsworth (No.136).

121 [Plate 121] *(1959: No.42)*

THE DESCENT FROM THE CROSS

c. 1617–1618. Pen and ink, washed. 346 × 232 mm.
Reverse: St. Andrew, pen and ink, washed.
New York, Eugene V. Thaw.

COLLECTIONS The late Mrs. G. W. Wrangham; Edward Wrangham.
EXHIBITIONS *Drawings from the Collection of Mr. and Mrs. Eugene V. Thaw*, New York, J. Pierpont Morgan Library, 1975, No.11; Paris–Antwerp–London–New York, 1979–1980, No.12.
LITERATURE K. T. Parker, 1928–1929, Pl.1 and 2; *idem*, 1937, 51; Evers II, 137, Pl.45; Burchard-d'Hulst, 1963, under No.96; Held, *Master Drawings*, XII, 1974, 252–3, Pl.28.

This drawing, too, is interesting for the unconcern with which Rubens drew over some of his own lines when he was interested solely in working out a problem of composition. He started with the head of Christ, which is still visible, though now upside down, towards the lower left. Dissatisfied with this beginning (probably because the angle of the head was not right), Rubens turned the paper upside down and began again. (For this practice see also D. Rosen–J. S. Held, *Journal of the Walters Art Gallery*, XIII–XIV, 1950–1951, 77ff.) From the similarity of the heads of Christ, and for other reasons, it would seem that he then drew the group appearing in the upper half of the sheet, consisting of Christ and two women. The last drawing is the scene in the lower right, which consists of three men on ladders in addition to the figures of Christ and the two women. Rubens drew this group on a smaller scale because of the limitations of space, but he gave it higher relief by heavier strokes and deeper shading. The effect of the design is diminished because of the heavy washes of the drawing on the reverse which have penetrated the paper. While Evers connected the drawing only with the Descent from the Cross in Leningrad (KdK.90), Parker correctly referred to the one in Lille also (KdK.89). Since it is exactly the figures done last in the drawings which reappear in the Leningrad version (the two men to the left and right of Christ), while the figure of Christ, which did not change in the three stages of the drawing, is nearer to that of the Lille picture, though in reverse (see also the oil-sketch for the painting in Lille, Held, 1980, No.360), one could conclude that the drawing was done between the two works as a study for the Leningrad picture. The Lille Descent was in progress in March 1617 (see *Catalogue*, Exh. London, 1950, No.51, for further references). The drawing must therefore date from about this period, a theory which is supported by the figure of St. Andrew on the reverse. This St. Andrew is a study for the outside of the triptych of the Miraculous Draught of Fishes in Mechlin (KdK.174) of 1618–19. (For another study connected with this figure, see No.94.) Although it is not unusual that drawings on two sides of the same paper belong to different periods, the character of the pen-work and of the wash in this case is rather similar, so that a date of 1617–18 would be indicated for the studies of the Descent from the Cross. The Leningrad picture has been dated 1613–15 by Oldenbourg; like

the one in Lille it may well be of a somewhat later date, apart from the fact that the major share in it was painted by studio assistants.

The date for the drawing of the Descent from the Cross has implications for two drawings of the Consecration of a Bishop (G.-H. No.77 and No.78), which are very similar in style. They too should be dated about 1617–18, a date which is further supported by their connection with the Last Communion of St. Francis of 1619 in Antwerp (KdK.190), where one of the acolytes resembles a figure of the Berlin drawing in form as well as in function. The previous dates of 1613–14 (G.-H.) or 'before 1615' (Rosenberg, *Berliner Museen*, XLVII, 1926, 85) seem to be too early.

The drawing of a Descent from the Cross (Burchard-d'Hulst, 1963, No.71) at Rennes is clearly of a much earlier date (see also No.12 and Introduction, p.61, note 5).

122 [Plate 122]

THE DESCENT FROM THE CROSS

c. 1617–1618. Pen and brown ink. 357 × 216 mm. Inscribed, in a later hand: P. P. Rubbens Ft. The eye of the kneeling figure at the left (Magdalen) is damaged.
Boston, Museum of Fine Arts.

COLLECTIONS Thomas Hudson (L.2432); Thomas Lawrence (L.2445); Henry Adams; Mrs. Henry P. Quincy. Purchased by the museum in 1920.
LITERATURE Held, *Master Drawings*, XII, 1974, 249–60, Pl.29

Of the compositional sketches on the drawing in the Eugene V. Thaw collection (No.121), the lower and smaller one of the two was the point of departure for this rendering of the subject. The limp pose of Christ is essentially the same, though it is nearer the vertical, and the head dangles less loosely. The bald man is placed nearer to Christ and is thus more effective in his support of the body. The turbaned man has replaced the man leaning across the horizontal bar and his part in the action, previously hardly indicated, is now perfectly clear. (The movement and functional role of this man revert to some extent to Rubens' great painting of the Descent from the Cross in the Cathedral in Antwerp, KdK.52.) The place lower down on the ladder was taken by St. John who earlier had not clearly figured in the action. The Virgin retained the place she had been given in the smaller of the sketches but for her head Rubens returned to the more elaborate and more meaningful design he had given her in the larger scene. The Magdalen's pose, however, is entirely new: in the upper sketch of the Thaw drawing she kneels directly underneath and slightly to the right of Christ's legs; in the lower one Rubens moved her to the left, her body leaning forward in an unstable pose, expressing her ardent affection rather than demonstrating her ability to aid in the difficult undertaking. In the Boston drawing she is given the same place, but she now leans backward, offering an effective counterweight and better support to Christ's body.

While Rubens drew the Boston figures more deliberately and more neatly than those of the Thaw study, he still experimented in a number of ways. The right arm of the turbaned man was first placed on Christ's upper arm rather than his shoulder; the face of St. John was drawn twice, the first version being slightly higher and to the right of the final one, the change resulting in a certain confusion in that area. The curvature of St. John's shoulder, too, had first been delineated in a more sweeping curve similar to that used earlier for the man with the turban. Other changes of plan, more difficult to disentangle, are apparent in the lower part of the Virgin's body.

The reappearance of the Boston drawing in the literature on Rubens permits us to draw all these studies closer to the painting of the Descent from the Cross in Leningrad (KdK.90),

'the most severe and most monumental realization of the subject ... in the whole of Rubens' work' (Jan Bialostocki, 'The Descent from the Cross in Works by Peter Paul Rubens and his Studio', *The Art Bulletin*, XLVI, 1964, 517–18). Nevertheless, Rubens introduced into the final version some new and important ideas. Joseph of Arimathea, less clearly 'turbaned' than before, is now seen from the side, touching Christ's shoulder with his left hand rather than the right. Christ himself is depicted in a more rigid pose than before. The most radical change, however, again concerns the two women whose part in the action Rubens had been studying intensely from the beginning. The Virgin is still standing and the Magdalen kneeling, but they have exchanged places. Rubens had discovered that by slightly increasing the slant of St. John's ladder, a triangular space could be created, ideally suited to receive the kneeling figure. In making this change, he also avoided some crowding and awkward overlapping, considerations which always weighed heavily with Rubens. It is only in the Leningrad canvas, in fact, that the five figures involved in the action surround Christ's body in a harmoniously balanced manner; not even in the Boston drawing had the artist achieved this kind of equilibrium. Yet Rubens was not only concerned with chiefly formal considerations. In all previous phases the Virgin's activity was only a physical one: she extended her arms in an effort to receive and support the body of her son. In the final version, in which Christ is lowered down towards the right, the Virgin is no longer physically engaged. Only now do we perceive that it is out of mental anguish that she stretches out her arms, and embraces Christ's body; and the angle of her vision, which before had only permitted her to see the back of Christ's head, is now clearly directed towards His face.

123 [Plate 123] *(1959: No.38)*

THE CONTINENCE OF SCIPIO

c. 1617–1618. Pen and ink. 236 × 343 mm. The high absorbency of the paper has resulted in spotty ink effects (see also No.230). *Berlin*, Kupferstichkabinett (5685).

COLLECTIONS R. Houlditch; Sir Joshua Reynolds; von Beckerath.
LITERATURE J. Rosenberg, 1928, 58–60 (Fig.4); Bock-Rosenberg, 251; Mielke-Winner, 1977, No.24; E. Hubala (ed.), 'Rubens', *Kunstgeschichtliche Beiträge*, Konstanz, 1979, 162–4; Held, 1980, under No.287.

This drawing and the following one depict the magnanimous action of Publius Cornelius Scipio Africanus who released a captive Spanish bride to her legitimate groom and, in addition, gave him as a dowry the ransom which her family had offered for her. In both drawings Scipio points with one hand to the gifts which he had received so that the theme of his *liberalitas* is clearly joined to that of his continence (Livy, XXVI). In earlier representations of the theme (such as that by Jost Amman, in the Livy edition of Feyerabendt, Frankfort, 1578, 460) the young couple kneel pleadingly before Scipio, who sits on a throne in a noncommittal pose. The bride's father stands behind them with a bag of ransom money in his hand.
The incident of the Spanish bride is quoted three times in the works of Niccolò Machiavelli as a supreme demonstration of statecraft (*The Discourses*, Book III, chaps. XX and XXXIV, and *The Art of War*, Book VI, chap. XVI). '... among all the ways wherewith the people are to be cajoled, nothing goes so far as examples of chastity and justice as that of Scipio in Spain, when he returned a beautiful young lady to her parents and husband untouched, a passage that contributed more than his Arms to the subduing of that Country' (quoted from the English edition, London, 1720, 509). Rubens' interest in the theme was surely connected with its significance as a political exemplar.

The Berlin drawing is the earlier of two which Rubens made for a painting of this subject. The picture was destroyed by fire on March 3, 1836 (see R., IV, 809), but its composition is known from an engraving by Schelte a Bolswert (V.S.140, No.35). It was more elaborate than any of the drawings and a clearer distinction was made between the chief personages and the assisting figures. The bride, particularly, was more prominent and drawn in a more upright position.
In his second drawing, in Bayonne (see No.124), Rubens reversed the composition so that the groom instead of the bride occupies the centre of the stage. In both drawings the young couple join their right hands in the traditional gesture of betrothal, but their movement is more graceful and at the same time more conspicuous in the later drawing. There is in general more experimentation in the Berlin drawing. Yet it illustrates well the high degree of clarity in Rubens' visualization of complex groups, and the economy in the lines he needed to put them down on paper which he had achieved by this time.
For an oil-sketch of this subject which appeared at a sale in 1971, see Held, 1980, No.287. (I assigned to it the date 1618–1620, but now prefer 1617–1619, being aware, of course, of the relativity of such chronological fixations.)

124 [Plate 124] *(1959: No.39)*

THE CONTINENCE OF SCIPIO

c. 1617–1618. Pen and ink on grey paper. 255 × 354 mm. *Bayonne*, Musée Bonnat (1436).

COLLECTIONS J. Richardson, Jr.
LITERATURE *Les dessins de la collection Léon Bonnat au Musée de Bayonne*, II, Paris, 1925, Pl.20; G.-H. No.84; (see also literature listed with the previous number).

Second version of this subject (see No.123). It is more carefully executed than the Berlin drawing and the union of the young couple is more happily expressed in their poses. The young woman at the right, wearing a feather beret, is found in two hunting scenes (New York, *KdK*.112, and Marseilles, *KdK*.115), both of which belong to the years around 1615. The arrangement of the composition corresponds to such pictures as the Judgment of Solomon, Copenhagen (*KdK*.128) which was dated by Oldenbourg *c.* 1615–1617. The pose of Scipio in the Bayonne drawing and of Solomon in Copenhagen are indeed very much alike.
In the collection of P. Wauters (*Catalogue*, Brussels, 1797) there were two drawings of the Continence of Scipio, both done in pen and ink, and wash (Nos.66 and 1062).

125 [Plate 106] *(1959: No.144)*

AN ANGEL BLOWING A TRUMPET

c. 1617–1620. Black and white chalk, pen and ink, squared. 245 × 283 mm. *New York*, J. Pierpont Morgan Library (I, 233).

COLLECTIONS J. Richardson, Sr.; C. Fairfax Murray.
EXHIBITIONS Detroit, 1936, Sec. V, No.3; Cambridge–New York, 1956, No.19; Antwerp, 1956, No.67; London, 1977, No.140; Paris–Antwerp–London–New York, 1979–1980, No.15.
LITERATURE J. Fairfax Murray, I, 1905, No.233; G.-H.128; Goris-Held, No.106; J. S. Held, *The Burlington Magazine*, XCVIII, 1956, 123; F. Baudouin, *Pietro Pauolo Rubens*, Antwerp, 1977, 144–5 and 154.

Companion piece to No.126.

126 [Plate 107] *(1959: No.145)*

ANGEL BLOWING A TRUMPET

c. 1617–1620. Black and white chalk, pen and ink, squared.
251 × 274 mm.
New York, J. Pierpont Morgan Library (1957.1).

COLLECTIONS J. Richardson Sr.; H. S. Reitlinger; Martin B.
Asscher.
EXHIBITIONS London, 1977, No.142; Paris–Antwerp–
London–New York, 1979–1980, No.16.

Inscribed on the back, in Richardson's hand: Ja.43./D D.39/J.
Companion piece to No.125.

These two drawings were made as models for two marble
angels in high relief, to decorate the spandrels above the main
portal of the Church of St. Charles Borromeo at Antwerp (see
Held, 1959, Fig.60). The sculptor followed Rubens' design
precisely, except for one modification. The spandrel into which
he had to fit his figures allowed for less space than Rubens had
assumed in his drawings. Thus instead of the two crossed feet
seen in each of the drawings, the sculptor could only show one
foot. This deprives his angels of the impression of standing
freely. They now look wedged in between the frame of the
spandrel, reclining with their whole weight on the archivolt of
the portal. (In the great garden portal which Rubens built in his
own courtyard he seems to have allowed a broader base to
figures similarly placed; see F. Harrewÿn's engraving of 1684,
and Evers, I, 157.)
The façade is the work of P. Huyssens (see the engraving of J.
de la Barre), but the name of the sculptor does not seem to be
known from documents. Some scholars have connected the
name of Hans van Mildert with some of the sculptures of the
façade of St. Charles (M. Devigne, in Thieme–Becker, XXIV,
1930, 556, and A. J. J. Delen, in *L'Art en Belgique du Moyen Age à
nos Jours* [ed. P. Fierens], Brussels, 1939, 272). Is. Leyssens, in
her thorough study of Van Mildert (*Gentse Bijdragen*, VII, 1941,
128–129), did not accept this theory and in accordance with an
older tradition attributed the work to three members of the De
Nole family of sculptors (Andries the younger, Robrecht, and
Jan). She also, however, called attention to the fact that many of
the original sculptures were destroyed during the French
Revolution and were replaced by modern ones during two
periods of restoration (1820 and 1912). Whether the angels in
the spandrels of the main portal are the originals or more recent
copies I have as yet been unable to determine. L. Burchard and
R.-A. d'Hulst (*Catalogue*, Exh. Antwerp, 1956, 68) attributed
the sculptures first to Van Mildert and in the supplement to
Colijns de Nole. The pose of both angels, ultimately reflecting a
classical prototype, is familiar from many of Rubens' works.
The one at the left has its nearest analogy in the figure of victory
in the Coronation of the Victorious Hero in Munich (*KdK*.56).
The one at the right resembles, in reverse, the figure of Earth in
the Union of Water and Land in Leningrad (*KdK*.109, see E.
Kieser, *Münchner Jahrbuch*, 1933, 114, 121, 127), and even more
closely the sorrowing victory in the frame of the Allegory in
Honour of Charles de Longueval, Comte de Bucquoy, of 1621
(Held, 1980, No.294).
For other drawings by Rubens connected with the façade
decoration of St. Charles, see No.127 and the literature cited
there.

127 [Plate 125] *(1959: No.Additional 172)*

A CARTOUCHE SUPPORTED BY CHERUBS

c. 1617–1620. Black chalk, pen and ink, washed, with white
highlights in body-colour which are now greyish and probably
more transparent than originally. Squared. 370 × 267 mm.

The paper has been cut irregularly at the upper corners and
along the right margin but the missing parts have been replaced
by later restorations. The extent of these additions has been
indicated in our reproduction by a dark line.
London, British Museum (00.9–28).

COLLECTIONS T. Hudson; R. Payne Knight.
EXHIBITIONS London, 1977, No.141.
LITERATURE Hind, *Catalogue*, No.41; Burchard-d'Hulst,
Catalogue, Exh. Antwerp, 1956, under No.67; M. Jaffé, *The
Burlington Magazine*, XCVIII, 1956, 314; Burchard-d'Hulst,
1963, No.117; Kuznetsov, 1974, No.75; Baudouin, 1977, 146–7
and 154.

Hind thought that the drawing might have been made for a
picture containing in the centre an image of the Virgin and
Child but Burchard and d'Hulst pointed out that it is obviously
one of the studies for the sculptural decoration of the façade of
the church of the Jesuits at Antwerp (see also Nos.125 and 126).
Rubens determined here the shape and decoration of the large
central cartouche immediately above the main portal. The facts
that it is squared, and that the finished work follows it closely,
make it clear that the drawing was the final formulation as far as
Rubens was concerned; we know too little about the working
methods of Antwerp sculptors to say whether they could work
directly from such a drawing, or whether scale cartoons were
made first. On the façade proper, the cartouche contains the
monogram of Christ and underneath it three spikes as symbols
of the Crucifixion.
The history of the façade of St. Charles and of the part Rubens
played in its design is still largely conjectural. There were times
when Rubens was credited with the complete design; some
modern authors, such as Hubert Colleye (*Les Eglises Baroques
d'Anvers*, Brussels, 1935, 17) went to the opposite extreme and
denied that Rubens had anything to do with it. It is probably
correct that Rubens had no hand in designing the architecture,
but it becomes increasingly clear that he had much to do with
the figural and ornamental decoration of the façade, precisely as
an unknown eighteenth-century poet had written in the year of
the great fire that destroyed all the ceiling-paintings by Rubens
in the interior (see No.147): '. . . Rubbens . . . heeft in syn tydt
den prael des gevels helpen cieren' (Rubens . . . helped in his
time to embellish the splendour of the façade), quoted by J. H.
Plantenga, *L'Architecture Religieuse dans l'Ancien Duché de Brabant
(1598–1713)*, The Hague, 1926, 101.
Drawings by Rubens for the façade, besides the three repro-
duced here, are in the collections of L. Burchard (Exh. 1956,
No.71) and of M. Jaffé (see *loc.cit.*, footnote). Others have been
attributed to Rubens by both Burchard and Jaffé, the latter
indeed going so far as to believe that several drawings in the
archives of St. Charles were done jointly by the architect and
Rubens, with Rubens adding the decorative elements to the
strictly architectural framework furnished to him by the ar-
chitect. Whether all these attributions will stand up under
scrutiny based on the quality standards established by the
present drawing and the two angels at the Morgan Library
remains to be seen; yet even if they are not all by Rubens' own
hand, it is highly probable that they reflect his ideas for the
decoration.
The date of Rubens' work for the façade is made complex by the
uncertainties that still exist with regard to the actual designer of
the architecture. The original architect of the church of St.
Charles (which until 1779 was actually dedicated to St. Ignatius
of Loyola) was F. Aguilonius (1567–1617), the learned Jesuit
and, since 1613, rector of the Antwerp College of the order. It
was he who on April 15, 1615, laid the cornerstone of the
church. When Aguilonius died on March 17, 1617, P. Huyssens
took over as chief architect. The church was finished in 1621
and solemnly consecrated by Bishop Malderus on the twelfth of
September of that year.

Abbé Thibaut de Maizières (*L'Architecture Religieuse à l'Epoque de Rubens*, Brussels, 1943, 30–32) assumed that most of the plans for St. Charles were made by Aguilonius while Huyssens' part was chiefly that of supervising the actual construction. Plantenga (*loc.cit.*) and S. Brigode (*Bulletin de l'Institut Historique Belge à Rome*, XIV, 1934, 157), among others, minimized Aguilonius' role and credited Huyssens with much of the planning, even during Aguilonius' lifetime. However that may be, it is difficult to see how the design for the façade could be attributed to anyone but Huyssens who is specifically mentioned as its author in the print by de la Barre (see No.126). A drawing for the façade which Plantenga (*loc.cit.* Fig.119) accepted as Huyssens' original project contains the cartouche, just as it was drawn by Rubens in the present sketch, and the two trumpet-blowing angels of the portal; it does not contain the Virgin and the angels of the pediment which were evidently introduced into the project at a somewhat later time. The inference to be drawn from this observation is that Rubens' drawings ought to be placed early in the building period, but I see no reason to date them before the period of Huyssens' activity as chief architect, i.e. not before March 1617.

The sculptures, as has been pointed out before (see No.126), were probably done by members of the de Nole family.

128 [Plate 139] *(1959: No.100)*

A BLIND MAN

c. 1617–1618. Black and white chalk on chamois-coloured paper. 280 × 417 mm. Lower left corner cut off. Sides of irregular length.
Vienna, Albertina (17641).

EXHIBITIONS Zürich, 1946–47, No.90; Antwerp, 1977, No.148.
LITERATURE R., V. No.1381; Glück, *Marées Gesellschaft* No.IV; F. M. Haberditzl, 1912, 2; G.-H. No.120; Evers I, 218; Vlieghe, *Corpus Rubenianum* VIII, 1973, II, No.104d; Kuznetsov, 1974, No.79; Jaffé, 1977, 25R; Mitsch, 1977, No.17.

Study from the model for a blind beggar at the right in the foreground of the Miracles of St. Francis Xavier, Vienna (*KdK.*205); the figure appears in the painting very much as it does in the drawing, while in an oil-sketch in Vienna (see Held, 1980, No.408) his pose had been rather different, with the left arm lower than the right. Rubens changed this arrangement for reasons of perspective. The pose was also used for a figure in the Flight of Cloelia, Berlin (see J. G. van Gelder, *Nederlands Kunsthistorisch Jaarboek*, 1950–51, The Hague, 1951, 116, Fig.6). Abraham van Diepenbeeck, too, borrowed the motif for a scene of charity (see Held, 1959, p.8 and Fig.8).

There are three more drawings known for this painting (G.-H. Nos.121, 122, 123). Rubens probably prepared the huge altars for St. Charles with great care, and many more such studies of single figures must have existed. The paintings were finished by March 29, 1620, when the contract for the ceiling decoration of the Church of the Jesuits was signed, and there is reason to assume that they had been finished by the end of 1618. The pose of the figure may have been inspired by the figure of blind Elymas from Raphael's tapestry, though Haberditzl rightly repudiated Rooses' contention that it was a 'copy' of Raphael's figure. (See also No.129.)

129 [Plate 88] *(1959: No.165)*

THE HEAD OF SENECA, AND OTHER STUDIES

c. 1617–1618. Black and white chalk. 320 × 220 mm.
Leningrad, Hermitage (5454).

COLLECTIONS Count Cobenzl; Empress Catharine II of Russia.

LITERATURE M. Dobroklonsky, *Zeitschrift für Bildende Kunst*, LXIV, 1930/31, 36; idem., *Risunki Rubensa*, Moscow, 1940, No.15; idem., *Risunki flamandskoï shkoly*, Moscow, 1955, No.647; Vlieghe, *Corpus Rubenianum*, VIII, 1973, II, No.115b; Kuznetsov, 1974, No.80.

As Dobroklonsky observed, the old man looking up was taken from the bust believed to be that of Seneca, of which Rubens owned an example (see Introduction, p.32). Whether the profile with a very prominent chin was also inspired by a work of art, such as Leonardo's similarly proportioned 'caricatures', or was taken from life, is hard to decide. The hand below these faces was surely drawn from life.

All the studies in this drawing were made in connection with the large canvas of the Miracles of St. Ignatius Loyola, in Vienna (*KdK.*204). That picture, originally painted for the church of the Jesuits in Antwerp, was finished by March 29, 1620, as we know from a contract made at that date between the artist and the church authorities (see R., I.44). An oil-sketch for the composition, also in Vienna (Held, 1980, No.410), does not contain the head derived from the 'Seneca' bust, so that it is safe to assume that the drawing was done later than that sketch.

In the finished painting the man whose features were taken from the 'Seneca' bust occurs right above the left arm of the woman possessed by an evil spirit. A profile of a woman immediately above her may be connected with the profile in the drawing, all the more so as in the preparatory oil-sketch Rubens had included in that spot *two* profiles, one with a big jutting chin. The study of the hand was made for the man trying to steady the raving woman. (See also No.128.) For a similar drawing after a Roman bust seen greatly foreshortened from below, see J. Byam Shaw, *Catalogue of Drawings by Old Masters at Christ Church, Oxford*, Oxford 1972, No.1372, 'Galba'.

130 [Plate 133]

A MAN IN KOREAN COSTUME (A JESUIT CONVERT?) WITH A SAILING SHIP IN THE BACKGROUND AT THE LEFT

c. 1617–1618. Black chalk with touches of red on mouth, nose, cheeks and ear. 387 × 234 mm.
Malibu, J. Paul Getty Museum.

COLLECTIONS J. Richardson Sr.; Cock; J. Richardson Jr.; R. Willett; Baron A. von Lanna; Christopher Head; Lady Du Cane. Sold London, Christie's, November 29, 1983, lot 135 ('Property of a Lady of Title').
EXHIBITIONS London, Royal Academy, 1953, No.281; ibid., 1953–54, No.522.
LITERATURE R. V., No.1531; Clare Stuart Wortley, *Old Master Drawings*, IX, 1934, 40ff.; Held, 1959, under No.105; Burchard-d'Hulst, 1963, 181, 183, and 231–3 (1618–1619).

Engraved: Capt. W. Baillie, June 17, 1774 (reversed): 'The Siamese Ambassador'.

The drawing belongs to a group of 'Chinese' costume studies—clearly done from life—which were first published by Miss Stuart Wortley who thought they were all drawn in 1622 in Antwerp, on the occasion of the canonization, in that year, of St. Francis Xavier and St. Ignatius Loyola (see No.131). The present drawing, however, is the only one that depicts a true oriental; his headgear is said to be Korean though that may not necessarily mean that he was a Korean himself. A man with a similar headgear (a skull cap inside a transparent cylindrical form) was introduced by Rubens in the centre of his large altarpiece of the Miracles of St. Francis Xavier, now in Vienna (see Vlieghe, *Corpus Rubenianum* VIII, 1973, II, No.104). In the *modello* for that picture, also in Vienna (Vlieghe, 1973, II, No.104a) his place had been taken by a conventionally dressed and turbaned oriental; the 'Korean'—and presumably the drawing from

which he was derived—thus seem to belong to the period between the *modello* and the completed work, that is the later part of 1617 and the beginning of 1618. (See also No.131).

131 [Plate 134] *(1959: No.105)*

A JESUIT MISSIONARY IN CHINESE COSTUME

*c.*1618–1622? Black chalk, with traces of pale green (not blue) on stole and belt. 450 × 244 mm.
New York, J. Pierpont Morgan Library (III, 179).

COLLECTIONS C. Fairfax Murray.
EXHIBITIONS Cambridge–New York, 1956, No.23; Paris–Antwerp–London–New York, 1979–1980, No.18.
LITERATURE Cl. Stuart Wortley, *Old Master Drawings*, IX, 1934, 40ff.; Goris-Held, No.122; Burchard-d'Hulst, 1963, 183.

Inscribed, by a later hand: A. v. Dyck.

This drawing is one of a group of five which, though differing in size, are similar in that they all show men in oriental costume; the four others are: formerly in the collections of Lady Du Cane (now the Getty Museum); L. Burchard; the Right Honourable H. Hobhouse (now private collection, Washington); and the Stockholm Museum. The drawing formerly in the Hobhouse collection appears to be a second version, by Rubens' own hand (?), of the one in Stockholm. It has a Latin inscription in Rubens' writing, in which he compares the dark colour worn by the Jesuits to that of Chinese scholars, stating further that they (the Chinese) may use any colour except yellow which is reserved for the King. The models with one exception all seem to have been Westerners dressed in oriental gowns; only the model of the drawing formerly in Lady Du Cane's collection was a genuine Asiatic. Miss Wortley assumes that they were Western Jesuits who are known to have worn native costumes when doing missionary work in the East; she believes they were all members of one party (perhaps accompanied by a native servant) and that the man of the Morgan drawing, outstanding for his dignity, may have been their leader. (The Morgan drawing is also one of the largest of the group.) The drawing in the collection of Dr. Burchard was engraved in 1774 by W. Baillie with the inscription: 'A Siamese Priest. Arrived at the Court of K. Charles the 1st as an attendant to the Ambassador of his Nation just as Rubens was preparing to leave England, however that Eminent Artist found time to make the above discrib'd Drawing' (V.S.279). According to Dr. Otto Fischer, as quoted in the Catalogue of the Exh. Amsterdam, 1933, No. 120, the costume is Korean rather than Siamese.
Discrediting the tradition that Rubens made the drawings in England, Miss Wortley believes that they were done on the occasion of a three-day festival held between July 23 and 25, 1622, at Antwerp, to celebrate the canonization of St. Ignatius Loyola, St. Francis Xavier, and others. On the second day a large procession was held—in the manner still typical of Antwerp in our own days—in which a group of participants wore Chinese costumes, alluding to the widespread activity of Jesuit missions. Indeed, various Eastern nations were impersonated in this manner. The costumes were worn by students and probably other local people, as is customary in these pageants. Nothing is known about an actual group of Eastern missionaries attending this celebration, and it is not even very likely that they would have taken part in the procession. Thus, while it is possible that the drawings were made at the time of the procession, there is no conclusive evidence that this is so. Miss Wortley also made reference to an oil sketch in Bayonne which she connected with the Triumph of the Eucharist. For that sketch (and a date before 1620) see Held, 1980, No.393. Burchard-d'Hulst, 1963, 232, dated this and three other drawings of that group between 1622 and 1628, but excepted the 'Korean' man (see No.130) which they dated 1618–1619.

132 [Plate 126] *(1959: No.43)*

THE RAISING OF LAZARUS

c. 1618–1619. Black chalk, pen and ink, and wash. 394 × 306 mm.
Berlin-Dahlem, Kupferstichkabinett, 5684.

COLLECTIONS J. Richardson, Jr.; von Beckerath.
LITERATURE Bock-Rosenberg, p.124; F. Lugt, *Jahrbuch der Preussischen Kunstsammlungen*, LII, 1931, p.44 (attribution to Rubens, supported by L. Burchard); Burchard-d'Hulst, 1963, No.87; Mielke-Winner, 1977, No.22.

The first draft of the composition, done with chalk, can only be seen if the paper is turned upside down. It consists of Christ, some apostles near him, and a man pulling the shroud from Lazarus' head. Lazarus himself is more clearly visible than the other figures, since Rubens traced his outlines with the pen. Rubens then turned the sheet round and drew the more elaborate version with greater attention to details and with the addition of some figures, especially towards the left. Lazarus' head was drawn in three different positions, from one in which it is turned away from Christ to one in which he looks gratefully upwards at the Saviour. Christ's head, too, was drawn twice. Wash was used not only to dramatize the scene (it suggests an illumination from the upper right and adds emphasis to the divine intercession) but also to cover up the chalk of the previous sketch. The wash also covers in part the little sketch of the scene which appears, in pen, in the upper right corner. This small repetition of the composition was surely done after the first draft in chalk, since it was made to fit into the area created by the edges of the paper and the outline of Lazarus of that draft. It is more difficult to say whether it precedes or follows the large 'second' draft, unless one accepts the fact that it is covered by the wash as proof of its intermediary position. The concept of the narrative differs markedly from that found in the early painting in Turin (*KdK.*, 1st ed., 457; see also Glück, *Essays*, 22ff. and 376 [L. Burchard]), although the position of Christ still recalls that work. It is also quite different from the later treatment of the theme in the Louvre sketch (Held, 1980, No.338) and the painting formerly in Berlin (*KdK.*217, now destroyed). Considering the greater fluency and maturer interpretation of the subject in the Berlin painting, the drawing probably represents a somewhat earlier phase of Rubens' development; the juxtaposition of groups, especially the marked isolation of the figure of Christ, agrees with compositional patterns found around 1616–1618 (from the Decius-Mus cycle to the Miraculous Draught of Fishes, in Mechlin); for the figure of Lazarus Rubens used a pose which, with minor variations, appears in some Lamentation scenes just prior to this epoch (Liechtenstein Collection, *KdK.*76, and its copy in Antwerp, *KdK.*77); the motif of the lifting of the shroud is found in the Christ à la Paille in Antwerp (*KdK.*160). It also occurs in the large painting of the Miracles of St. Francis Xavier in Vienna of about 1618–19 (*KdK.*205). The wide mantle of Christ is reminiscent of the mantle on one of the men watching the miracle; see also G.-H. No.122. In that painting Rubens used some of the compositional ideas of the Lazarus drawing which he apparently never developed any further. Rubens came back to the pose of Lazarus in his studies of the Miracles of St. Francis of Paula (Held, 1980, Nos.405, 406, 407).

133 [Plate 104] *(1959: No.138)*

VIRTUE AND HONOUR

c. 1618–1620. Red chalk, slightly washed, reinforced in pen and ink. 308 × 210 mm.
Watermark: Crowned eagle over a house mark.
Antwerp, Musée Plantin–Moretus (*TK* 152).

EXHIBITIONS Antwerp (Rubenshuis) 1971, No.62.
LITERATURE F. Van den Wijngaert, *De oude Tekeningen van het Museum Plantin-Moretus* (unpublished) 135/1, as by H. van Mildert.

Inscribed in Rubens' hand: '*Virtus*' '*Honos*' above each figure. Below the figure of Honour: 'dese voeten moeten treden allebeyde op den waeter pas want sy syn alhier in perspective geteekent' (Both these feet must stand on the same level for they are here drawn in perspective.)

This and another drawing, representing 'Doctrina', also in the Musée Plantin (153, 304 × 202 mm.), have hitherto been attributed to H. van Mildert (c. 1580–1638). Three wood sculptures in the Musée Plantin made from these drawings, have also been given to Van Mildert, an attribution ignored by I. Leyssens (*Gentse Bijdragen*, VII, 1941, 73ff.). The drawings, at any rate, are surely from Rubens' hand. (F. Lugt also attributed them to Rubens, in a ms. note at the Institute of Art at The Hague.)
The combination of Virtue and Honour has classical sanction. In Rome a sanctuary in their names was built in such a way that to see the temple of Honour one had to pass through that of Virtue. *Virtus* and *Honos* are combined on coins (see C. Gevartius, *Pompa Introitus Ferdinandi*, Antwerp, 1641, 111; see also Margarete Bieber, *American Journal of Archaeology*, XLIX, 1945, 25). In the Triumphal Entry in Antwerp of Albert and Isabella in 1599, sculptures of Virtue and Honour were placed on pedestals inscribed ISABELLAE VIRTVTI and ALBERTI HONORI (see F. M. Haberditzl, *Jahrbuch des all. Kaiserhauses*, XXVII, 1907–1909, 203, Fig.34). Rubens himself placed *Virtus* and *Honos* as companion pieces on the Arch of Ferdinand (*KdK*.371, and Gevartius, *loc.cit.*108) where they flank the picture of the Triumph at Nördlingen.
Both figures are modelled after Roman types. For *Honos* with wreath, staff, and cornucopia, see Bieber, *loc.cit.* Fig. 10 (coin of Vespasian). For his *Virtus* Rubens followed faithfully the beautiful figure of *Virtus Augusti* of the Trajan relief on the East wall of the main passage of the Arch of Constantine (see Bieber, *loc.cit.* Fig.15) which J. von Sandrart later transformed into a freestanding statue (*Sculpturae Veteris Admiranda*, etc., Nuremberg, 1680, 1). Rubens' figure differs from the Roman one chiefly in the position of the parazonium which is downward in the older piece. Müller Hofstede, *Wallraf-Richartz-Jahrbuch*, XXVII, 1965, 261, suggests that Rubens took the figure from an engraving by Marcantonio Raimondi (B.XIV, 275) which itself, however, was derived from the ancient relief.
Rubens' *Virtus* was engraved (in reverse) by P. Aveline on Pl.XLIII in Jombert's French edition of a Rubens treatise (see p.43 and note 8). For renderings of Honour in Antwerp in the early seventeenth century see also M. Sabbe, *De Gulden Passer*, XIII, 1935, 37/38.
Baudouin proposed a date of *c.* 1620, since in 1622 Van Mildert received payments for unidentified· sculpture for the Plantin publishing house. I had dated the drawing '1612–1615' but admit that it could have been done several years later. It should be remembered, however, that there is no clear connection between the sculptures and Hans van Mildert.

134 [Plate 129] (1959: No.90)

A YOUNG WOMAN CROUCHING

c. 1617–1618. Black and white chalk. 375 × 267 mm. Upper left corner trimmed partly along outline of figure. Chamois-coloured paper.
Vienna, Albertina (8295).

LITERATURE R., V. No.1430; *Rubens Bulletin*, V, 87–88; Schönbrunner-Meder, No.171; G.-H. No.108; Glück, *Landschappen*, 18, 72, Fig.5.; Burchard-d'Hulst, 1963, No.99; Kuznetsov, 1974, No.76; Mitsch, 1977, No.26.

Study from a model whom Rubens drew several times, in different poses. The drawing G.-H. No.114 was probably made in the very same session. The costume suggests a peasant girl, and G.-H. No.114 was indeed used for an Adoration of the Shepherds (see above, No.106). The present study was evidently made—to judge from the position of the hands—for one of the girls in the painting Achilles among the Daughters of Lycomedes, in the Prado (*KdK*.130), a picture which, according to Rubens' letter of April 28, 1618, to Sir Dudley Carleton (*Correspondence*, II, 137), was finished at that date. Rubens also used the same figure for the Landscape with Cows in Munich (*KdK*.187), where she sits at the left, holding a pitcher. Such repeated use of the same study is common in Rubens' work, particularly at the time of his most expanded activity. The drawing G.-H. No.111, to mention another example, was used for the Adoration of the Shepherds in Marseilles (*KdK*.166), where the young girl was changed, however, into an old woman (which caused Glück [*Landschappen*, 15, 72] to refer to the drawing, too, as that of an old woman), and in the Farm at Laeken in Buckingham Palace (*KdK*.186).
The fact that the paper was carefully trimmed away at the upper left suggests that another study, originally on the same sheet, was cut off and thus made into a separate drawing.

135 [Plate 128] (1959: No.44)

THE LAST COMMUNION OF ST. FRANCIS

1618–1619 (reverse: *c.* 1622). Pen and ink. 222 × 310 mm. Reverse: various standing men (pen) and two women (chalk). *Antwerp*, Cabinet des Estampes (A.XIV.5).

COLLECTIONS Clément van Cauwenberghs.
EXHIBITIONS Amsterdam, 1933, 86; Antwerp, 1946, No.6; Paris, 1954, No.417; Antwerp, 1956, No.72.
LITERATURE Delen, 1932, 32, Figs.3 and 4; Delacre, *Van Dyck*, 233–235; Delen, *Catalogue*, No.195; Burchard-d'Hulst, 1963, No.123; Vlieghe, *Saints I, Corpus Rubenianum*, VIII, 1972, No.102a; Kuznetsov, 1974, No.86.

First sketch for the painting of the Last Communion of St. Francis in Antwerp (*KdK*.190). Rubens' receipt for this picture dates from May 17, 1619, which is only a *terminus ante quem*, since payments were often made considerably later than the work itself. Besides the present one, several other drawings can be connected with this commission. A slightly later sketch, done rapidly in black chalk showing the main lines of the painting, including its architecture, is in the collection of L. Burchard (see Exh. Antwerp, 1956, No.75); it is particularly interesting because of its inscription (see Introduction, p.39). A drawing for two of the monks is at Chatsworth House (see No.136). Another drawing of a monk which may conceivably belong to this group was in the collection of Mrs. S. van Berg, New York (Exh. Cambridge–New York, 1956, No.17). The sketches of two women on the back are closely related to figures of women in the Marriage of Constantine from the series of sketches for tapestries (see Held, 1980, under No.39). This would indicate a slightly later date for the reverse than for the front of the drawing.
Burchard and d'Hulst (*Catalogue*, Exhibition Antwerp, 1956, 71) also pointed out a connection between the reverse of the Antwerp drawing and the Constantine cycle; they connect the man, seen from the back and stretching out his arm, with a figure at the extreme right in Constantine's Vision of the Monogram of Christ (*KdK*.231). They also believe that another figure is related to the St. John of the *Coup de Lance* of 1620 (*KdK*.216). Both observations strengthen the theory that the reverse of the drawing is to be dated somewhat later than the front.

136 [Plate 130] *(1959: No.93)*

TWO FRANCISCAN MONKS

c. 1618–1619. Black and white chalk, some red chalk on the faces, on greyish paper. 560 × 403 mm.
Bakewell, Chatsworth, Devonshire Collection.

EXHIBITIONS Brussels, 1938–1939, No.45; Rotterdam, 1939, No.35; Paris–Brussels, 1949, No.90; Helsinki–Brussels, 1953, No.28; Antwerp, 1956, No.73; London, 1977, No.75.
LITERATURE G.-H. No.113; Burchard-d'Hulst, 1963, No.125; Vlieghe, *Saints I, Corpus Rubenianum* VIII, 1972, No.102c; Kuznetsov, 1974, No.96.

Drawing from the model, for the Last Communion of St. Francis in Antwerp (*KdK*.190. See also No.135). The figure stretching out his arms was used in the painting for the monk supporting St. Francis, leaning further forward, parallel to the Saint. The monk with the cowl on his head corresponds to the one in the background, near the right edge of the painting. In a few lines between the two figures Rubens drew some folds and the belt in the back of the upper figure, since this part could not be included on the paper. This proves that the drawing always terminated at the right as it does today.

137 [Plate 136] *(1959: No.45)*

FEMALE NUDES RECLINING

c. 1618–1620. Pen and ink. 200 × 283 mm.
On the reverse: Studies for the Blessed in a Resurrection and for an Adoration of the Magi (see Held, 1959, Fig.48).
London, Princes Gate Collection, Courtauld Institute Galleries.

COLLECTIONS Sir Thomas Lawrence; Sir Thomas Phillipps, Bart.; T. Fitzroy Phillipps Fenwick; Count Seilern.
LITERATURE A. E. Popham, *Catalogue of Drawings . . . in the possession of . . . T. Fitzroy Fenwick*, London, 1935, 194 (No.4); A. Seilern, *Catalogue*, I, 96, No.60; Burchard-d'Hulst, 1963, No.86.

Since the figure leeringly raising a drapery from the nude in the centre obviously has goat legs, the study was probably made for a picture of sleeping nymphs, surprised by satyrs. For a further discussion of the drawing see the following number with which it originally formed one sheet.

138, 139 [Plates 137, 138] *(1959: No.46)*

STUDIES FOR VENUS [?] AND CUPID

c. 1618–1620. Pen and ink. 202 × 280 mm.
On the reverse: Studies for a Last Judgment.
New York, The Frick Collection.

COLLECTIONS Sir Thomas Lawrence; R. P. Roupell; J. C. Robinson; J. P. Heseltine; H. Oppenheimer.
LITERATURE Phaidon *Rubens*, 130; Goris-Held, No.A.99; K. E. Simon, *Jahrbuch der Preussischen Kunstsammlungen*, LXIII, 1942, 113, note 3; Burchard-d'Hulst, 1963, No.85; Freedberg, *Corpus Rubenianum*, VII, 1984, No.49c.

Inscribed at the lower left, by a later hand, in pencil: P.P Rubens. Another word ('Pagan'?) written near the left edge.

When I published this drawing in 1947, the arguments against its authenticity seemed to me stronger than those for it. At that time I was unaware of the drawing in the collection of Count Seilern (see No.137), which is closely related stylistically to the Frick drawing. I now consider both drawings to be genuine works of the master—all the more since the theory I had tentatively put forward in 1947, that the drawings might be the work of Jan Boeckhorst, is surely wrong.

Both the Count Seilern and the Frick drawings must originally have been larger. The Seilern sheet has been cut at the bottom, with the result that the lower figure has lost part of her legs and feet. The New York drawing was trimmed at the top, where now only a pair of crossed feet is visible, with the rest of the body missing. It is tempting to link these feet with the footless body in the Count Seilern drawing, thus connecting the two sheets physically as well as stylistically. The measurements of both drawings are nearly identical and their subjects on both front and back agree perfectly. The paper seems to be identical in structure; a watermark (a cross within a drop-shaped loop ending in two smaller loops) is seen only on the piece in New York.

The connection of the two pieces is clinched, I believe, by the observation that *c.* 10 mm. from the left edge of both sheets there runs an old vertical crease, clearly visible even in reproduction. It is inconceivable that two sheets which agree perfectly both in style and subject matter should also share such a physical condition without actually having been physically connected. The combined sheet thus reconstructed measured at least 410 mm. in height (making allowance for a small loss between them) which is well within the normal size of Rubens' drawing paper.

The connection with Titian's painting of the Andrians, to which Count Seilern pointed for the figure on his part of the drawing, is even closer in the lower figure of the New York drawing, especially the legs. Copies of Titian's Children's Bacchanal and probably the Andrians are listed in Antwerp inventories (Denucé, 121, 122, 126), where one is identified as the work of 'Paulo Franchyon' (Franck? or Franchoys?; see also E. Tietze-Conrat, *La Critica d'arte*, VIII, 1949–1950, 435). Yet both sheets are evidently quick compositional sketches for which Italian paintings may have furnished some general ideas, but no concrete models.

There is no exact correspondence in Rubens' other work for any of the reclining nudes in either the Frick or the Count Seilern drawings, although there are points of contact with the earlier Sleep of Diana in Hampton Court (R., III, No.600) and the later Sleeping Angelica (*KdK*.220). The manner of drawing would seem to fit best into the years around 1620, though more likely before than after that date. This agrees with the date given by Count Seilern to the sheet in his own collection, which is all the more welcome as he arrived at it by a different method of reasoning.

The figures on the reverse were used for the upper part of the so-called Small Last Judgment in Munich which Oldenbourg considered the work of Jan Boeckhorst (1922, 169ff.). That part of the painting, however, is now widely accepted as Rubens' own work (see Freedberg, 1984, *Corpus Rubenianum*, VII, 210–11). That their invention must be Rubens' I had claimed in this entry in 1959.

140 [Plate 97]

THE CRUCIFIXION

1619–1620. Pen and ink. 206 × 164 mm.
Rotterdam, Museum Boymans-van Beuningen (Rubens 4).

COLLECTIONS F. J. O. Boymans (1767–1847); bequeathed to the city of Rotterdam.
EXHIBITIONS Antwerp, 1930, No.403 (Van Dyck); Amsterdam, 1933, No.74; Rotterdam, 1933, No.13; London, 1950, No.41; Antwerp, 1956, No.91; Antwerp, 1977, No.150.
LITERATURE Burchard-d'Hulst, 1963, No.118 (with record of earlier literature); Kuznetsov, 1974, no.95; Held, 1980, 485, under No.352.

This is the first sketch for the Crucifixion in the Antwerp Museum (the 'Coup de Lance', *KdK*.216). Since several of the

ideas tried out here no longer appeared in the grisaille oil sketch in London (Held, 1980, No.352) it is very likely that other drawings, done even before the sketch, did once exist, but none has come to light. (See also No.141.)

The main action of the finished painting and the London grisaille—the piercing of Christ's side by the lance of Longinus—is only vaguely indicated by lances that come from the right (not, as in the painting, from the left) and a figure with an upturned face, in the centre; nor is there any indication of horses. The man on the ladder, about to break the legs of the bad thief with a stick, occupies the same area, with several different poses of his arms; he is drawn a second time, clearly seen from the back, at the right. (In the oil sketch, and the large painting, he is seen behind the thief, and more from the front.) Another figure, also drawn twice, may be the Magdalen who—as she also does in the final version—stretches out her arms, though she is seen here moving to the right while in the later versions she moves towards the left. Only the figures of Christ and of the bad thief anticipate to some extent their appearance in the London sketch and the Antwerp canvas.

Rubens drew the figure of Christ a second time, on the back of this sheet, and indicated one of the thieves with a few rapid outlines.

141 [Plate 141] *(1959: No.99)*

A YOUNG MAN CARRYING A LADDER

c. 1619–1620. Black and white chalk. 346 × 272 mm.
Vienna, Albertina (8298).

EXHIBITIONS Antwerp, 1977, No.151.
LITERATURE Schoenbrunner-Meder, No.870; Muchall-Viebrook, No.16; Burchard-d'Hulst, 1963, No.120; Kuznetsov, 1974, No.84; Mitsch, 1977, No.22.

This strong drawing has had little attention; it was not reproduced by Glück and Haberditzl and had apparently never been exhibited. One of the reasons for this neglect may have been the fact, already mentioned in J. Meder's brief commentary to his publication, that no such figure could be identified in Rubens' work ('energische Kreidezeichnung, deren Verwendung nicht nachweisbar ist'). Yet the figure does occur in a Rubens composition. It can clearly be seen in the centre of the oil-sketch for the 'Coup de Lance' in the London National Gallery (on loan from the Victoria and Albert Museum, *Catalogue*, 1929, No.1865; 'School of Rubens'). G. Glück (Van Dyck, *KdK*.1931, 519, item 19) attributed that sketch unequivocally to Van Dyck. This attribution was questioned by Horst Vey (*Bulletin, Musées Royaux des Beaux-Arts*, Brussels, 1956, 174) in connection with a study on Van Dyck's oil-sketches, but it was once more upheld by Burchard-d'Hulst, 1963, 190 ('erroneously attributed to Rubens').

It is hard to see on what grounds the London sketch can be taken away from Rubens and given either to an anonymous pupil or to Van Dyck. First of all, it certainly is a sketch for the 'Coup de Lance' and no other painting; nor is there any indication that it is not a preliminary work. It differs from the finished canvas in ways characteristic of preparatory sketches, but not found in later copies. Indeed, the presence in the sketch only of the man carrying a ladder is one of these features. He was eliminated from the finished version when the master had decided for the sake of clarity to turn the horse of the centurion with the lance more toward the Cross. Nor is the sketch wanting in quality. This is particularly evident if we compare it with the copy made of it that has been ceded by the Kaiser-Friedrich Museum to the Städtische Museen, Aachen (No.442, 'Rubens-werkstatt', see R., II, 98, No.296 bis). The Aachen sketch (reproduced as Fig.51 in the first edition of this book) is a typical copy slavishly following the London sketch and thus

revealing the superior quality of the latter. To attribute the London oil-sketch to Van Dyck is tantamount to attributing the invention of the 'Coup de Lance' to Van Dyck, too. This no one has done yet, though some scholars have thought of detecting Van Dyck's hand in part of the execution. There are indeed sound historical reasons why at least the invention of the 'Coup de Lance' must be credited to Rubens, Rubens was mentioned as its author in the inscription placed on the altar for which it was painted, an altar commissioned by Rubens' friend and patron Nicolas Rockox (R., II, 97); it was engraved in 1631 by Boetius à Bolswert as Rubens' work (V.S., 48, 333). There is a first sketch for it, by Rubens' hand, in the Museum at Rotterdam (see No.140). The Vienna drawing of the man with the ladder offers an additional argument in favour of reclaiming the London oil-sketch for Rubens. The drawing is so clearly Rubens' work that one would have to assume a very complex manner of collaboration (such as Rubens making studies from nature for a composition sketched by Van Dyck) if the London sketch were indeed Van Dyck's work. (For this question see now also Held, 1980, No.352.)

It is only fair to add that Meder, when first publishing the drawing, suggested that it may have been made for a Crucifixion, an opinion which has now been fully vindicated.

142 [Plate 140] *(1959: No.97)*

A MAN FALLING FROM A HORSE

c. 1618–1620. Black and white chalk. 325 × 308 mm. (made up of two pieces of paper).
London, British Museum (Oo.9–18).

COLLECTIONS P. H. Lankrink; R. Payne Knight, Esq.
EXHIBITIONS London, 1977, No.87.
LITERATURE Hind, *Catalogue*, No.12, and 158; G.-H. No.91; W. Pinder, *Münchner Jahrbuch der Bildenden Kunst*, N. F., V, 1928, 359–60; E. Kieser, *ibid.*, N. F., X, 1933, 124, note 32; Kuznetsov, 1974, No.81.

The hand which appears on the separate piece of paper in the upper left is the left hand of the falling man. It is not very probable that Rubens himself should have inserted it in this way; the piece was probably cut off by a later owner who fitted it carefully into the empty space, and by this operation made the drawing more compact, though ruining its original shape and impairing its effect. Despite this mutilation, the drawing is still one of the most impressive pieces of its kind in Rubens' oeuvre. It belongs to the studies from the model which he made for hunting and battle scenes; he must have been fond of this particular type for he used it not only in the Munich Lion Hunt (*KdK*.154) and the sketch in the Cholmondeley Collection (Introduction p.30), but also in the sketch of the conquest of Tunis by Charles V in Berlin of about 1638–1639 (Held, 1980, No.288). Pinder and Kieser have pointed out the classical origin of the idea of a man falling from a horse. A more direct source of inspiration may have been an engraving by Philip Galle, after Stradanus' *Mediceae Familiae Gesta*, of 1583 (Wurzbach, I, 567), where the head of the falling man is illuminated in a similar fashion. For the date of the Munich Lion Hunt see No.143.

143 [Plate 142] *(1959: No.96)*

A TURBANED MAN THRUSTING WITH A LANCE

c. 1620. Black chalk. 297 × 362 mm. Paper torn and repaired, especially along right edge.
Berlin-Dahlem, Staatliche Museen Preussischer Kulturbesitz, Kupferstichkabinett, (26383).

COLLECTIONS Glasgow, Sir Archibald Campbell, Bart.
LITERATURE K. T. Parker, 1930–31, 69, Pl. 52; Mielke-Winner, No. 29.

The movement which Rubens studied in this drawing is linked to his plans for the Lion Hunt in Munich (*KdK*. 154). With minor variations it appears in all the studies which have been connected with that work. Despite the extreme abbreviation of all forms it can be made out in the drawing in the Princes Gate Collection (A. Seilern, *Catalogue*, No. 65, verso, see text to No. 220); it appears in the sketch in Leningrad (Held, 1980, No. 299)and also in that of the collection of the Marquess de Cholmondeley (Held, 1980, No. 300).
Of these, the sketch in the Cholmondeley collection I hold to be the last; it is certainly later than the Seilern drawing. Count Seilern hesitated to draw this conclusion because the Cholmondeley sketch lacks the figure of a 'rider cutting down a lion' which dominates the centre in both the drawing and the Munich picture. This argument loses its force if we realize that this figure was not newly invented for the Lion Hunt but belonged to an old stock of figural types. It first occurs in the very early painting of St. George in Madrid (*KdK*. 22) and later, for instance, in the Augsburg Hunt of Crocodiles and Hippopotami. The composition of the drawing, on the other hand, is basically so different from both that of the Cholmondeley sketch and the Munich picture that it must precede both— unless one disassociates it from the whole group and dates it later, more or less contemporaneous with the *recto* of the sheet, a late Bath of Diana. I follow Count Seilern in turning down this possibility.
A more serious difficulty lies in the relationship of the Seilern drawing to the Leningrad sketch which is nearer the finished picture than the Seilern drawing, since it already has that grand diagonal design which gives distinction to the final version. It is therefore surprising to see that it shows the man falling from his horse in the centre of the composition in a very different pose from that adopted eventually by Rubens, while that final position is already clearly indicated in the Seilern drawing. (For this pose see also No. 142.) On the other hand, the horse from which he falls was drawn in the Count Seilern example in a very decorative but conventional upright position, one that Rubens had used many times before (in the earlier Lion and Tiger hunts, *KdK*. 113, in the Defeat of Sennacherib, *KdK*. 156, the Death of Decius Mus, *KdK*. 146, and elsewhere), while the Leningrad sketch has the very dramatic and violent contrapposto which is also found in the Munich picture. It seems that the upright position of the horse was still considered by Rubens when he drew the few hurried lines in the lower half of the Cholmondeley sketch. Thus, all things considered, it would appear that the chalk-sketch in Count Seilern's collection was the first thought for the picture after all.
On the reverse of the Cholmondeley panel is a sketch for the Marriage of Marie de Médicis which Rubens could not have painted before 1622. Assuming that both sides of the panel must date from about the same time, Burchard also assigned the date 1622 to the Munich Lion Hunt and its sketches (*Catalogue*, Exh. London, 1950, 20). He demonstrated at the same time that the Munich Lion Hunt is not the picture which is referred to in the famous letter to Sir Dudley Carleton of April 28, 1618 (*Correspondence*, II, 136–137). While this fact appears to be incontestable, it does not follow that the picture must date from 1622. Rubens could well have made his sketch for the Médicis cycle on the back of a sketch a few years older. The style of the drawings in Berlin-Dahlem and London at any rate is more closely related to the style of the second decade than to that of the 1620s.

144 [Plate 156] *(1959: No. 98)*

PORTRAIT OF A LITTLE BOY (Nicolas Rubens [?] 1618–1655)

c. 1619. Red, black, and some white chalk; pen and ink on eyes, mouth, and pearl necklace. White paper, 252 × 202 mm. Two restored areas on cheek.
Vienna, Albertina (394).

EXHIBITIONS Zürich, 1946–47, No. 88; London, 1948, No. 69; Brussels–Paris, No. 100; Antwerp, 1977, No. 152.
LITERATURE R., V. No. 1520; Muchall-Viebrook, No. 18; G.-H. No. 116; E. Kieser, *Münchner Jahrbuch der Bildenden Kunst*, 3. Folge, I, 1950, 222; Burchard-d'Hulst, 1963, No. 126; Kuznetsov, 1974, No. 97; Mitsch, 1977, No. 35.

Inscribed: 'P. P. Rubbens' in pen, in lower right; traces of an inscription in lower left, of which only 'No. 5' and '1621' are readable.

The identification of the model with Nicolas Rubens (b. March 3, 1618), the master's second son, rests on probability rather than exact evidence. There is, first, some physiognomic similarity to the drawing No. 163, which is a portrait of Nicolas, at the age of about seven. Secondly, Rubens used the drawing for the head of the Christ-child in the picture of the Virgin with the Penitent Sinners in Cassel (*KdK*. 129), where St. John, standing next to the Virgin and protected by her, has the features of a rather older boy taken from another drawing in Vienna (G.-H. No. 117), which could be a portrait of Albert Rubens, born in 1614. (He was christened on June 5, 1614.) There are other drawings of a similar character (G.-H. Nos. 105, 117, 118; the latter has been reworked, but No. 117 is entirely by Rubens' own hand, contrary to the statement of Glück and Haberditzl). It is likely that all these drawings were studies made of Rubens' own sons, but the identification of the individual models— whether Albert or Nicolas—is not certain in all cases. Unfortunately, the Cassel painting is not dated. Oldenbourg, who credited Van Dyck with its execution, but neglected the connection with the Vienna drawings, dated it 1615–1617; Glück and Haberditzl, identifying the children with Albert and Nicolas and guessing the ages of the children to be five and one, respectively, dated the drawings 1619 and the painting accordingly about the same time.
Another author to discuss the drawing, E. Kieser, believes it to represent Albert Rubens and to have been done in 1615. He claims that it was used for two of the angels in the Munich painting of the Virgin in a wreath of flowers (*KdK*. 138). This I cannot see and I prefer to follow the identification suggested by Glück and Haberditzl.
The inscription 'P. P. Rubbens' is found similarly on a number of drawings in Vienna (G.-H. Nos. 42, 86, 131, 159, 162, 165, 180, 194, 195); Glück and Haberditzl suggested—without giving any further explanation—that Rubens' name may have been written on these drawings while they were still part of his estate. Since the inscriptions appear on drawings which were certainly cut out from larger sheets (G.-H. Nos. 194, 195), this fragmentation must presumably have been made at that time.

145 [Plate 144] *(1959: No. 101)*

ROBIN, THE DWARF OF THE EARL OF ARUNDEL

1620 (before July 17). Black, red and white chalk and pen and ink, on light grey paper. 408 × 258 mm.
Stockholm, Nationalmuseum (1913–1863).

COLLECTIONS P. Crozat (Cat. 1741, No. 841); Comte C. G. Tessin.
EXHIBITIONS Brussels, 1938–39, No. 26; Rotterdam, 1939, No. 42; Rotterdam, 1948–49, No. 120; Paris–Brussels, 1949,

No.94; Helsinki, 1952–53, No.40; Stockholm, 1953, No.100; Antwerp, 1956, No.89; Antwerp, 1977, No.153.
LITERATURE R.,V. No.1498; G.-H. No.133; Evers, II, 339; W. Burke, *Rubens' Handzeichnungen*, Zürich, 1948, Pl.13; Burchard-d'Hulst, 1963, No.127; Kuznetsov, 1974, No.101.

Inscribed (by a later hand); P. P. Rubens 1722 (see also Nos.10, 11). Colour-notes in Rubens' own hand (starting in upper left): 'Het Wambuys vermach wesen root sattyn ende de broeck root flouwell'; 'Tannoyt flouwel' (twice); 'root'; 'Geel'; 'root'; 'swart'; 'geel vudringhe'; ('The mantle may be red satin and the pants red velvet; brown velvet; red; yellow; red; black; yellow lining'). The wording of the first part is not certain. Red chalk was used for shading in the face, the mantle (all shaded parts), for the ribbon near the knee and for shoelaces; white for the highlights in the face, on the collar, sleeves and cuff, and the pants. The pen lines were added last.

This drawing was made for the portrait of the Countess of Arundel in Munich (KdK.200), where a hunting falcon sits on Robin's raised and gloved right hand.
For the history of this commission see Introduction, p.32.

146 [Plate 143]

PORTRAIT OF PIETER VAN HECKE (?)

c. 1620–1622. Black chalk. 413 × 345 mm.
On the reverse: Studies for a St. Cecilia.
London, British Museum (1885-5-9-48).

COLLECTIONS J. Richardson Sr.; T. Hudson; J. Thane; R. Cosway; W. Russell
EXHIBITIONS London, 1977, No.81.
LITERATURE Hind, *Catalogue* No.91; Glück, *Van Dyck, des Meisters Gemälde*, London–Stuttgart, 1931, 530 (under S. 106–107); Rüdiger Klessmann, 'Rubens's Saint Cecilia in the Berlin Gallery after cleaning', *The Burlington Magazine*, CVII, 1965, 550–9; Jan Kelch, *Peter Paul Rubens*, Berlin–Dahlem, 1978, 56.

This drawing is a prime example of the difficulty of keeping certain Rubens drawings apart from those of Van Dyck, particularly at the period when Van Dyck worked in closest contact with his master. The portrait of this staid burgher (who may have been the husband of Clara Fourment, an older sister of Helène Fourment) is almost certainly a study for a portrait formerly in the collection of Baron Edmund de Rothschild in Paris, accompanied there by a portrait of his wife. These portraits had been listed as Rubens' work in the fourth volume of Rooses's oeuvre catalogue (1890, Nos.934 and 966), but had been given to Van Dyck independently by Bode and Glück (1905) and were also included in Glück's Van Dyck volume (KdK.1931, pp.106, 107). I was given the opportunity to study these paintings closely in July 1983 and concluded that they were indeed by Rubens; they were published as Rubens' work by Michael Jaffé in the following year (*Apollo*, CXIX, 1984, 274–81, together with other works).
It is evident that the attribution of the painting firmly determines that of the drawing as well; as a consequence Glück gave both to Van Dyck. Glück also made the less than fortunate effort to interpret the study of an arm and hands on the reverse as a preliminary sketch for the hands of the (supposed) Clara Fourment. As Klessmann reiterated strongly, they can only be understood as studies for Rubens' late paintings of St. Cecilia in Berlin, quoting J. Müller Hofstede (in footnote 15) in support of that view. John Rowlands, too, in his 1977 exhibition catalogue, came out strongly for Rubens as the author of the drawing.
It is indeed not only the reverse which argues in favour of the Rubens attribution. The drawing of the man holding a hat (the hand apparently resting on the back of a chair)—irrespective of

the attribution of the painting for which it is the study—has a much closer connection with Rubens' manner of drawing than Van Dyck's. (I may mention in passing that it was not included in H. Vey's catalogue of Van Dyck's drawings.) Van Dyck is rarely as economical—without suppressing precision and detail—as is seen here. And the strong fleshy hands, with the upturned finger tips (seen at the model's left hand) are virtually signatures of the master. Van Dyck's hands are almost never individualized; the same slim hand with elongated and rather un-articulated fingers served for most of his models.
One delicate question remains. While the recto of the drawing, as well as the painted portrait, can hardly be dated other than to the years around 1620, the St. Cecilia in Berlin for which Rubens utilized the studies on the verso is generally, and rightly, placed to the last years of Rubens' life. Klessmann actually pleaded for a date of 1640 or the year before. He also, however, realized that Rubens had enlarged and partly altered an earlier version more centred on the Saint herself, though for technical reasons no X-rays had been taken. Is there not a possibility that Rubens may have had such a picture planned at a much earlier date, and that the London drawing is the record of such an earlier project? The pose of the hands is clearly one assumed by a woman playing a keyboard instrument; yet they are held differently from those seen in the Berlin painting and the sleeves are much less loosely draped around the arm. Whatever the answer, it seems to me more likely that recto and verso in this case belong more or less to the same period than that they are about twenty years apart.

147 [Plate 146] *(1959: No.47)*

ST. GREGORY NAZIANZENUS

1620. Black (and traces of white) chalk. 411 × 476 mm.
Cambridge (Mass.), Fogg Art Museum.

COLLECTIONS Sir Thomas Lawrence; John Hay; Clarence L. Hay.
EXHIBITIONS Cambridge–New York, 1956, No.20; London, 1977, No.148.
LITERATURE Martin, *Corpus Rubenianum* I, 1968, No.25a; Held, 1980, 60, under No.36.

This brilliant drawing was made in connection with Rubens' plans for the decoration of the *plafonds* of St. Charles, the church of the Antwerp Jesuits. The large paintings of that decoration were destroyed by fire in 1718. Their appearance is known, however, from several sets of painted and engraved copies and—at least for the majority of them—from painted sketches which Rubens prepared in accordance with the contract he signed on March 29, 1620, with Jacob Tirinus, the prefect of the Antwerp Jesuits (see Rooses, I, p.43, and Van Puyvelde, p.25). Hardly any drawings of this project, however, have been known until now, though twelve of them are listed in the Catalogue of the P. Wauters collection (*Catalogue*, Brussels, 1797, p.214, No.70 'à la pierre noire rehaussées d'un peu de blanc'). A drawing for the figure of St. Athanasius (KdK.208) is in the Hermitage (Dobroklonsky, 1930, 36, No.5). Its quality, though somewhat inferior to that of the New York drawing, is worthy of Rubens. (In the supplement of the catalogue of the Antwerp Exhibition, 1956, No.101, b, this drawing is thought to be a '*ricordo*, perhaps by Rubens himself', done several years later.) The drawing of St. Gregory is important for its intrinsic beauty, as well as for the fact that it provides an interesting example of Rubens' working methods (see Introduction, p.56). The corresponding oil-sketch still exists; formerly belonging to the Gotha Museum, it is now in the Albright-Knox Art Gallery in Buffalo. It differs from the drawing in several respects. Its design is much simpler. Rubens eliminated the large angel at the left and the bigger of the two demons; the second demon was

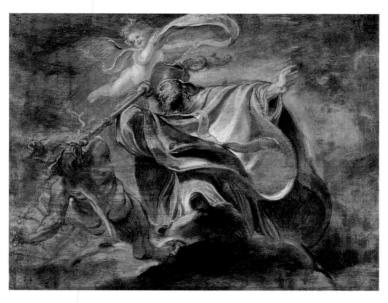

Fig. 16. St. Gregory Nazianzen. Oil-sketch. Buffalo, Albright-Knox Art Gallery.

moved up and into a more prominent position. The fountain was also excluded from the painted sketch. The putto overhead had been drawn with two bodies, flying in opposite directions, although the head and pair of arms were the same. Rubens decided in favour of a movement towards the right, for obvious compositional reasons.

Rubens may have omitted the larger devil because he had decided to make use of him in the large painting of the Miracles of St. Ignatius which he did for the high altar of St. Charles (now Vienna, *KdK*.204). There he appears with only minor variations, in the background. Rubens had used this figure before, in the Fall of the Damned, Munich (*KdK*.194). The pose of the angel at the left in the New York drawing is similar to that of the angel in the Flight into Egypt (see No.235) and to Mercury Descending (see No.157).

148 [Plate 145] *(1959: No.48)*

HERCULES STANDING ON DISCORD, CROWNED BY TWO GENII

c. 1621. (G.-H. '*c.* 1608'; Hind '1600–1608'). Red chalk (with corrections in black chalk near the eyes), on white, foxed paper. 475 × 320 mm.
London, British Museum (1900, 8.24, 138).

COLLECTIONS J. Barnard; Sir Thomas Lawrence; J. W. Brett; H. Vaughan.
EXHIBITIONS London, 1835. No.18; London, 1977, No.72.
LITERATURE *Vasari Society*, II, 1906–07, 24; Hind, *Catalogue*, No.22; Glück, *Die Graphischen Künste*, 1924, 74; G.-H. No.56; L. Burchard, *Catalogue*, Exh. London, 1950, under No.8; Haverkamp-Begemann, *Catalogue,* Exh. Rotterdam, 1935, under No.16; Burchard-d'Hulst, 1963, No.188.

Glück and Haberditzl interpreted the subject of this drawing as 'Hercules Victorious over Queen Hippolyta of the Amazons'. The correct interpretation was given by L. Burchard who did not, however, discuss the date of the drawing.

This drawing is another instance of the use Rubens made of his studies of the Hercules Farnese; while in Italy he made several drawings of the famous marble (Held, 1982, 99). A pen-drawing of the head of Hercules (Exh. Cambridge–New York, 1956, no.24 [original?]) and an oil-sketch of the head (Exh.

Rotterdam, 1953, No.7) are additional proofs of this interest. For the popularity of the Hercules Farnese in Antwerp in the seventeenth century see L. Burchard (*loc.cit.* under No.25). Burchard also emphasized the fact that Rubens employed the forms and the pose of the Hercules Farnese for other themes that required a 'strong man', such as St. Christopher. (It has not yet been observed that Rubens used the head alone, which he had drawn in black and white chalk [Seilern, *Catalogue,* No.53 r°], for the commander on the right wing in the Raising of the Cross [Phaidon *Rubens,* p.218].) The works with which the present drawing has the closest iconographical correspondence are a sketch in Rotterdam (Held, 1980, No.243) and the oil-sketch for an engraving by L. Vorsterman, dedicated to the memory of Charles de Longueval, Comte de Bucquoy (Held, 1980, No.294). No certain date is known for the former: it was dated 1615–18 by Burchard, 1612–15 by Chr. Norris (*Burlington Magazine,* XCIII, 1951, 7); the latter was probably painted in 1621, shortly after the death of Longueval. The London drawing differs from both to such an extent that it cannot with any degree of certainty be considered a sketch for one or the other; it could have been drawn independently of either work. There is one feature of the drawing, however, which might favour a connection with the sketch for the Longueval portrait. The two putti overhead who hold a laurel-wreath also occur in the sketch of 1621, where instead of holding the wreath over Hercules they bestow this honour on the eagle in the top centre of the composition. The somewhat unusual side-view of Hercules could be more readily explained if we assume that Rubens already thought at this stage of a connection with an architectural setting; the severe, almost tragic expression of the face would be fitting in the context of the Longueval composition, where all the figures express grief at the untimely death of the military hero.

Stylistically, the drawing has its closest analogies with works which belong to the years 1618–22 (see Nos.147, 157). Thus from the point of view of style nothing militates against a connection with the project of 1621—in which, admittedly, the figure of Hercules was considerably changed from that of the London drawing.

149 [Plate 154] *(1959: No.103)*

PORTRAIT OF ISABELLA BRANT, RUBENS' FIRST WIFE (1591–1626)

c. 1622. Black, red, and white chalk, and pen and ink (in the eyes), lightly washed, on light brown paper. 381 × 292 mm.
London, British Museum (1893.7.31.21).

Verso: An elegant Pair and a Child (Rubens and Hélène Fourment?). Red and black chalks.

COLLECTIONS P. H. Lankrink; J. Richardson, Sr.; J. Thornhill; Lord Clive; Earl Spencer; R. S. Holford.
EXHIBITIONS Flemish Drawings of three centuries, London, British Museum, 1954; London, 1977, No.154.
LITERATURE *Rubens Bulletin,* IV, 294; R., V. No.1500; *Onze Kunst,* XII, 1907, 42; *Vasari Society,* Vol. V, 1909–10, No.20 (S. Colvin); Hind, *Catalogue,* No.92; G.-H. No.160; Burchard-d'Hulst, 1963, No.135; Kuznetsov, 1974, No.103.

Inscribed on the reverse, on an attached slip: 'No.27. Given me by Sr. Ja: Thornhill. Oct. 1724 JC' [Clive?].

Hind thought—not without reason—that the drawing was connected with the portrait of Isabella, now in the National Gallery in Washington. He considered that painting, however, to be a work of Rubens, while it is now generally accepted as a painting by Van Dyck. Van Dyck may of course have painted it on the basis of a drawing, not necessarily this particular one, by Rubens. Glück and Haberditzl apparently connected the draw-

ing with the portrait of Isabella in the Uffizi (*KdK.*282), the last portrait Rubens painted of her, and dated it consequently 'Ca.1625'. Actually, the London drawing was probably made a few years earlier and seems to have served for the portrait of Isabella which is now in Cleveland (Goris-Held, No.1). The face is less puffy than in the Uffizi portrait, the hair more tightly combed back towards the knot. Altogether she looks younger and healthier even though her smile seems somewhat forced.

The London drawing is the only portrait of Isabella Brant preserved in this medium. For a much later drawing of her see Goris-Held, A90.

The drawing on the reverse, discovered in a remounting, was first published by Jaffé (*Burlington Magazine*, 1965, 381 and Fig.46). Its style points to the 1630s and there is a possibility that it is linked to the self-portrait with Hélène Fourment and the young Peter Paul in the Metropolitan Museum of Art. Admitting such a link, Liedtke (1984, 182) nevertheless doubts that it was a study for that painting.

150 [Plate 131] *(1959: No.52)*

STUDIES FOR A ROMAN TRIUMPH

c. 1622. Black chalk and pen and ink. 278 × 385 mm. Another drawing (?) and inscriptions are on the reverse, but only faintly visible, since at present they are covered by a backing paper. *Berlin*, Kupferstichkabinett (4249).

COLLECTIONS P. H. Lankrink; J. Richardson, Sr.; J. C. Robinson.
LITERATURE J. Rosenberg, 1928, 58; Bock-Rosenberg, 251; Mielke-Winner, 1977, No.30.

Formerly attributed to Van Dyck.

As a 'working sheet' for a large composition this drawing is particularly interesting. It shows the beginning, in a few lines quickly drawn in chalk, of the general distribution of the main compositional elements. The trophies at the right and lower left and some (flying?) figures in the upper centre belong to that first stage. Over this design Rubens drew with a fine pen, occasionally changing the position of an arm or a head as he went along, but most of the time giving a remarkably sure and final outline to all figures and objects. Each stroke at this stage is much more controlled, and evidently put down slowly after careful thought.

The subject is not known in any finished work. A seated statue is seen in the upper centre, near which an eagle flaps his wings. Before this figure a young warrior stands with his left foot on a globe, his right hand holding some wreaths over the heads of three men who kneel before him in homage. His left arm is drawn twice, once raised and once lowered; in the latter pose a thunderbolt can clearly be distinguished in his hand. Thus, the inscription '*habet fulmen*' (transcribed in Bock-Rosenberg as '...t fuhnen'), which is near the left shoulder of the seated figure, probably refers to the youthful warrior. Two figures can be made out behind the warrior, one on either side; one is probably a goddess of victory as she holds a wreath over the youth's head. In the preliminary chalk drawing she was winged and stood on the other side. The group further towards the left of a man holding a horse is clearly derived from the Dioscures of Monte Cavallo (see Lafreri's print of 1546, reprinted in *Jahrbuch der Preussischen Kunstsammlungen*, LXI, 1940, 165). There is a drawing (III–22) in the Copenhagen collection of copies after one of the Dioscures, probably going back to a drawing made by Rubens while he was in Rome. In addition there is a figure holding trophies and one playing a woodwind instrument. The lower part of the composition is occupied by a Roman sacrifice: an ox whose throat has just been slit lies behind an altar in the centre; a priest points to it as he turns

towards some figures approaching from the left; one of them plays a musical instrument, another holds a burning torch, a third carries a load on his shoulder. Some of these figures are cut off at the lower edge in such a manner as to suggest that the composition was originally larger at the bottom. It must have been cut at an early date, since the collector's marks of Lankrink and Richardson are near the present edge. There are a few more words inscribed which are hard to make out; one seems to be '*cornuc[opia]*'. Near the right edge '*varia ar[ma]*' can be read which refers to arms lying beneath the high structure of trophies.

The scene of the sacrifice is reminiscent of the interpretation of the Victim from the Decius Mus cycle (*KdK.*143). The style of the drawing, however, points to a somewhat later date. The next major project in which Rubens dealt with a Roman subject was the cycle of Constantine, of 1622; it is tempting to connect the drawing with that work. The scene for which it could have been a first project is *Roma Triumphans* at the Mauritshuis, The Hague (see Held, 1980, No.51) and the Vienna drawing (below, No.151). The elements of the composition correspond in many respects. A seated figure with an eagle in the centre (the eagle, indeed, is very like the one in the later sketch); trophies on either side; a youthful victor who holds a thunderbolt in one hand; a winged victory holding a wreath; all these figures are found in both compositions, even though their individual forms and placing are different. Indeed, the kneeling men at the left correspond much more to the text of Tardieu's engraving, which mentions representatives of the Roman Senate freed by Constantine's victory, than the figures which are seen in the Vienna drawing and the sketch at The Hague. Thus it is possible that this is a first conception of Constantine's triumph, later superseded by a more condensed version in which *Roma* became more prominent and the sacrifice was completely omitted.

While there is thus reason to connect the drawing with the cycle of Constantine of 1622, its genesis leads indeed back to the earlier cycle of Decius Mus. When Rosenberg first published the drawing he briefly called attention to a tapestry of *Roma Triumphans* in the Liechtenstein collection then in Vienna. That tapestry renders only a single figure of *Roma*, but there is also a painting in the same collection showing two large figures, one a winged Victory with wreath and palm-branch, the other a helmeted *Roma* with lance and short sword, her left foot resting on a globe (see R. Baumstark, *Liechtenstein, The Princely Collections*, New York, 1985, No.216; the canvas measures 287 × 271.5 cm.).

It is easy to see that Rubens must have had that earlier picture in mind when he began making sketches for the Triumph of Constantine. The central figure in the Berlin drawing, indeed, is still very similar to that of *Roma* in the Liechtenstein canvas who is also armed and helmeted and has also the left foot on the globe. Rubens may actually have planned to treat the scene completely allegorically, without the presence of Constantine; since the seated figure with the eagle in the centre is probably an image of Jupiter, the sacrifice would have been meant for him, whereas *Roma*, standing in the middle, would have been crowned by Victory while herself freeing prisoners.

This complex plan apparently gave way later to the simpler arrangement first sketched in the Vienna drawing (No.151), followed by the oil-sketch in The Hague. The sacrifice was completely eliminated, along with the statue of Jupiter; Constantine himself was introduced instead, and the thunderbolt was now given to him. As a matter of fact, even this was not enough to give prominence to the emperor (who may be a disguise for Louis XIII): in the finished series Rubens included a much changed composition showing the emperor himself in triumph, standing before a magnificent array of trophies, and being crowned by a graceful goddess of victory (Held, 1980, No.44).

In the catalogue of the 1985 exhibition of the Liechtenstein

collection in New York Baumstark argued that the figure in the large canvas, hitherto generally interpreted as *Roma*, should be identified more broadly as *Virtus*.

151 [Plate 132] *(1959: No.49)*

ROMA TRIUMPHANS

1622. Pen and ink, washed. 219 × 303 mm.
Vienna, Albertina (8643).

Inscribed in the lower right corner, by later hands: 'Rubb . . .' (in ink) and 'Rubens' (in pencil).

COLLECTIONS Prince de Ligne.
EXHIBITIONS Vienna, Albertina, 1974–1975, No.33; Vienna, 1977, No.36.
LITERATURE O. Benesch, 1929, 81; Held, 1959, No.49; Burchard-d'Hulst, 1963, No.133; Held, 1980, under No.51.

The pen-lines are as delicate as in the Berlin sketch for a Roman Triumph (No.150), but the somewhat coarse wash gives the drawing a very different character. In this case, the connection with the series of scenes from the Life of Constantine is very obvious. The drawing prepares the oil-sketch of the Triumph of Rome (never made into a tapestry) now in the Maurits-huis at The Hague (Held, 1980, No.51). Compared with the Berlin drawing, which may have preceded it, the Vienna drawing represents a drastic reduction of the programme; it was apparently too simple, for Rubens again added some figures in the oil-sketch. The essential parts of the composition of the oil-sketch, however, are present in the Vienna drawing: *Roma*, resting her arm on a globe is seated in the centre; a victory goddess stands (or flies) behind her. (For this group Rubens drew on an earlier rendering of *Roma* in the title-page of J. Biaeus, *Numismata Imperatorum Romanorum*, Antwerp, 1617, see G.-H. No.102, which in turn had been inspired by a classical statue of *Roma* in the Cesi collection, now in the Capitoline Museum in Rome, which was reproduced from a design by Rubens himself, in Ph. Rubens, *Electorum Libri II*, Antwerp, 1608, 67; see also Kieser, *Münchner Jahrbuch für Bildende Kunst*, 1933, 136, note 55). Constantine stands at the right with a thunderbolt in his right hand. Two fettered prisoners are crouching on the ground before him. The two men at the left, judging by the analogy of the oil-sketch, are barbarian prisoners. (Their design, too, is reminiscent of classical types of prisoners, such as the black marble figures of the former Cesi collection, now also in the Capitoline Museum.) The outlines of the Roman she-wolf and the children Romulus and Remus below the figure of *Roma* are barely recognizable in the drawing; they were apparently done in two versions, one on the spot now occupied by the two seated prisoners, the other further to the left.

The figure of Constantine leads into an interesting filiation of motifs. It has very likely been derived from the figure of a soldier standing in the right foreground of Veronese's painting of Esther before Ahasuerus in S. Sebastiano in Venice, a picture of which Rubens had just made use a year or two before, for one of his compositions for the ceiling of the Jesuit church in Antwerp (see Held, 1980, No.14). The figure of Constantine, as it appears in the oil-sketch in the Mauritshuis, in turn served as the model for Van Dyck's famous painting of Charles I in the Louvre. Van Dyck took over not only the attitude of the prince but of the horse and attendants as well. For this question see Held, 'Le Roi à la "Ciasse"', *The Art Bulletin*, XL, 1958, 139ff; reprinted, Held, *Rubens and His Circle*, Princeton, 1982, 65–79. Another drawing of this theme, though different in size and technique, was in the collection of Sir Thomas Lawrence, Exh. London, 1835, No.10: 'Roma Triumphant. A female seated with captives at her feet, emblems of war, etc., etc., Red chalk.

17″ × 15‴'. This drawing is now in the British Museum, see Exhibition, 1977, No.85 (its dimensions are 380 × 429 mm.). The attribution to Rubens is very doubtful; moreover, a freer version is in Besançon as 'école de Rubens', 370 × 408 mm. A painting closely related to these two drawings was sold at Sotheby's, May 30, 1979 (128) as by Jacques Reatta.

152 [Plate 150] *(1959: No.146)*

DESIGN FOR THE TITLE OF FRANCISCUS HARAEUS' (FRANS VAN DEN HAER) ANNALES DUCUM BRABANTIAE

Before April 5, 1622. Pen and ink, washed and heightened with white. 286 × 175 mm.
London, British Museum (1895.9.15.1058).

COLLECTIONS Sir T. Lawrence; J. C. Robinson) J. Malcolm.
EXHIBITIONS London, 1977, No.215; Antwerp, *P. P. Rubens als Boekillustrator*, Museum Plantin-Moretus, 1977, No.17a (as by Cornelis Galle).
LITERATURE *Rubens Bulletin*, IV, 290; R., V. No.1276; Hind, *Catalogue*, No.38; G.-H. No.155; Bouchery-Wijngaert, 79, Pl.57, 58; Evers, II, 179, Pl.91; Judson-Van de Velde, *Corpus Rubenianum*, XXI, 1, 1978, No.51a and b (as by 'Cornelis Galle or a member of his workshop').

Engraved: C. Galle the Elder. Galle received 75 fl. on April 5, 1622, for his work.
The full title of the book was engraved on the plinth in the centre: FRANCISCI HARAEI ANNALES DVCVM SEV PRINCIPVM BRABANTIAE TOTIVSQ. BELGII. TOMI TRES: *Quorum Primo solius* BRABANTIAE, *secundo* BELGII *vniti* PRINCIPVM *res gestae*; *Tertio* BELGICI TVMVLTVS, *vsque ad* INDVCIAS *anno* M.DC.IX. *pactas, ennarantur. Cum* DVCVM *seu* PRINCIPVM *Imaginibus, et breui rerum per omnem* EVROPAM *illustrium narratione.*

The figure seated on top of the plinth is History, with book, torch, and the globe; two putti on one side of her hold an open scroll (which remained bare even in the engraving); on the other side a putto is holding a serpent biting its tail, the symbol of Eternity, while another blows the trumpet of fame. The two figures confronting each other in the middle are War and Peace, the latter with caduceus and a torch which burns the armour of war (a motif which Rubens used again soon after in The Conclusion of Peace of the Medici Cycle [KdK.261] and much later in one of the scenes of the Whitehall Ceiling [see Held, 1980, No.140]). Below Peace sits Belgia, with a walled crown and the Belgian Lion, while a River-god (the Scheldt?) holding a cornucopia sits opposite her. In the engraving the cartouche between these figures was filled with the printer's address. The book was published jointly by B. Moretus and J. Meursius. The Haraeus title is the most harmoniously balanced book title which Rubens designed. The change toward loosening up of figural motion and greater freedom of composition, which appears in Rubens' art during the years he worked on the Medici Cycle (1622–25) can also be noticed in the titles which follow that of Haraeus' work. It is very likely that Rubens was influenced in this design by recollections of Italian 'Sacra Conversazione' patterns, all the more so as the personification of History at the top was clearly derived from Correggio's Virgin in the painting of the Virgin with St. George and other Saints in Dresden, of which Rubens had drawn a copy (Vienna, Inv. No.8229 (8), see Mitsch, 1977, No.58). Rubens also designed the title page of the second volume of Haraeus' work (containing the third book); his drawing is now in Windsor Castle (see Judson-Van de Velde, 1978, 1, No.52). It was engraved by Vorsterman who was paid on Feb. 10, 1623. (The attribution of this beautiful drawing to Cornelis Galle, the engraver, I consider to be without merit.)

153 [Plate 148]

GEMMA TIBERIANA. (THE APOTHEOSIS OF GERMANICUS)

1622. Pen in brown ink, washed, heightened with white. 327 × 270 mm. Inscribed (by another hand) *Gemma Regis Franciae* (above); *Petri Pauli Rubenij manu* (below). Watermark: two Cs across each other surmounted by a cross. *Antwerp*, Stedelijk Prentenkabinet (109).

COLLECTIONS E. Calando; J. Q. van Regteren Altena.
EXHIBITIONS Amsterdam, 1933, No. 110; Helsinki–Brussels, 1952–1953, No. 50; Antwerp, Rubenshuis, 1956, No. 93; Antwerp, Rubenshuis, 1971, No. 64; Rotterdam–Paris, 1974, No. 97.
LITERATURE R., V. 1220; Delen, 1938, No. 194; Bouchery-van den Wijngaert, 1941, 113; Christopher Norris, 'Rubens and the Great Cameo,' *Phoenix*, III, 1948, 177–88; H. Ladendorf, *Antikenstudium und Antikenkopie*, Berlin, 1958, 85; Burchard-d'Hulst, 1963, No. 132; W. Stechow, *Rubens and the Classical Tradition*, Cambridge, Mass. 1968, 16–18; H. M. van der Meulen-Schregardus, *Petrus Paulus Rubens Antiquarius*, Alphen aan den Rijn, 1975, 142–4 (and *passim*).

The so-called Gemma Tiberiana (Paris, Bibliothèque Nationale, Cabinet des Médailles), a sardonyx of unusually large size (31 × 26.5 cm.) had been preserved in the Sainte-Chapelle since it had come, presumably from Constantinople, in the middle of the thirteenth century. The first to examine it archaeologically was Nicolas Fabri de Peiresc with whom Rubens soon thereafter established a close relationship and a regular correspondence. It was Peiresc who established the interpretation according to which the helmeted figure in the central section is Germanicus. Some other interpretations have been proposed in modern times but Mrs. Van der Meulen-Schregardus, who has dealt with the entire material in the most thorough and learned manner still followed the old theory about the subject.
Rubens saw the Cameo in Paris in 1622, where he had gone to negotiate his work for the Luxembourg Palace. While he may have made a sketch of the ancient sculpture when he saw the original, he made the careful drawing listed here from plaster-casts which had been sent to him. He also painted a large canvas of the cameo as a gift for Peiresc now in the collection of Christopher Norris at Polesden Lacey.
Both Peiresc and Rubens planned a publication of the major cameos known at the time, in part in collaboration with Girolamo Aleandro, a scholar living in Rome. Rubens was to take care of the drawings and the engravings, Peiresc of the commentary. Nothing eventually came of that venture (its story has been painstakingly reconstructed by Van der Meulen-Schregardus, 36–72) but prints of the two major cameos (the Gemma Tiberiana and the Gemma Augustaea) were published in a posthumous collection of the archaeological writings of Rubens' son Albert, accompanying two *dissertationes* by Albert on these carvings. (ALBERTI RVBENIJ PETRI PAVLO F(ILIUS) DE RE VESTIARIA VETERVM PRAECIPVE DE LATO CLAVO LIBRI DVO, Antwerp, 1665). Albert Rubens had died in 1657.
In his drawing of the cameo Rubens had to make up some damaged parts at the lower right. Two of the barbarian prisoners that fill the lowermost zone had no heads and may have been damaged in other parts too. One of the figures had a pose Rubens knew well: its best known example is the relief believed to represent *Dacia Captiva* (Dacia—a Roman province) today in the Palazzo dei Conservatori; her pose is echoed in one of Rubens' most tender sketches, The Victims of War, Vaduz, Liechtenstein Collection (Held, 1980, No. 270).

154 [Plate 149]

THE TRIUMPH OF LICINIUS

c. 1622. Pen and brown ink, washed. 188 × 250 mm. Inscribed, inside an oval line at the lower left, in Rubens' own hand: Grandezza della Pietra. At the lower right, (by another hand?) P P Rubbens fecit.
Watermark: Eagle with wings outstretched (Briquet 1386 or 1387).
London, British Museum, (1919-11-11-22).

COLLECTIONS G. E. Bullen.
EXHIBITIONS London, 1977, No. 95.
LITERATURE R., V. 1223; Hind, II, No. 53; N.T. de Grummond, *Rubens and Antique Coins and Gems*, Diss. University of North Carolina, Chapel Hill, 1968; H. M. van der Meulen-Schregardus, *Petrus Paulus Rubens Antiquarius*, Alphen aan de Rijn, 1975, 51–52, 150; Jaffé, 1977, 84R.

When Rubens made this drawing he—like Peiresc and other scholars—was convinced that its model, a cameo now also in the Cabinet des Médailles of the Bibliothèque Nationale in Paris, was of Roman origin. Modern scholars suspect that it was done in the sixteenth century, though before 1650 when it was listed in the inventory of Fontainebleau. (For a good reproduction of the cameo see Jaffé, 1977, pl. 312). Contrary to the elaborate technique Rubens used for his copy of the Gemma Tiberiana (No. 153), he drew the Triumph of Licinius entirely with a fine pen, applying only a minimum of shading. He probably drew it from a cast. The engraving (showing the drawing in reverse) is unsigned; it has been given to Pontius (Hymans) as well as Vorsterman (Van der Meulen-Schregardus). Calling it a *quadriga triumphante*, Rubens sent the engraving to M. de Valavez, brother of Peiresc, on July 3, 1625 (*Correspondance*, III, 372). In his letter he singled out as particularly remarkable the two figures with orbs and torches to either side of the triumphator (sun and moon). Actually they are subordinate characters; the main figures (besides 'Licinius') are the four horses, and the two Victories on either side. They are walking rough-shod over the bodies of six fallen foes, one of whom tries to protect himself with a shield. It is instructive to see how closely Rubens followed the overall arrangement of the composition as he saw it on the stone—and how completely he altered it in every detail. Strictly speaking, the cameo is a clumsy piece of work; the horses are dwarfed by the triumphator and the victories are most ungainly females. There is hardly any distinguishable expression on the faces of the men so unceremoniously trampled on. What Rubens made of this unprepossessing model is wholly admirable—as if he had tried to recapture for it a distinction which he was convinced had informed all major works of antiquity, but suspected of having been lost or debased in a small copy, remarkable mainly for technical, and perhaps iconographic reasons. The proportions of all humans, but also of the horses, are elongated, their movements graceful, their expressions animated. The unfortunate soldiers at the bottom are recognizable individuals, one of them, whose head is seen upside down, reminiscent of the drawing of a man falling from a horse (see above, No. 142).
The delicacy with which Rubens handled the pen in this drawing is not unusual in copies which he made of relics of antiquity; small sculptures and coins as well as cameos. Admittedly, there is a certain range in the strength of his lines, dependent, not least, on the kind of pen he chose. Yet there are a great many drawings still given to Rubens of a coarseness which I believe ought to condemn them as works of followers. There were no less than eight such drawings in the London exhibition of 1977, that also contained the present drawing (Nos. 100, 102, 103, 104, 107, 109, 111, 113); another dubious group, borrowed from the Copenhagen 'cantoor'-drawings was exhibited as authentic in Cologne, 1977 (Nos. K44a, b, c, d, [so marked in

the reproductions although listed as K44c, d and e in the text] and K45. Nos.42a, 43, and 44d and e [listed in the text 44a and b], however, are authentic).

The third drawing after one of the major cameos, known as Gemma Augustaea (belonging to the Kunsthistorisches Museum in Vienna), is in the St. Annen Museum in Lübeck. Praised by Stechow for its 'wonderful spontaneity', the drawing in Lübeck was less admired by Van der Meulen-Schregardus (159–60) who felt that the basic work in chalk was not done by the master himself. I have never seen this drawing.

155 [Plate 152] (1959: No.166)

THREE CARYATIDS (after Primaticcio)

c. 1622–1625. Red chalk, largely worked over in red watercolour with a fine brush; white body-colour (now yellowed). 269 × 251 mm. Pieced in the lower left corner and above the head at the left.
Rotterdam, Museum Boymans-Van Beuningen (V.6).

COLLECTIONS Chanoine J. Ph. Happaert; P. H. Lankrink; F. Koenigs; D. G. van Beuningen.
EXHIBITIONS Amsterdam, 1933, No.108; London, 1950, No. 50; Rotterdam, 1952, No.67; Helsinki–Brussels, 1952–53, No.41; Antwerp, 1956, No.100.
LITERATURE Constantin Huygens, jun., *Journal*, Utrecht 1881, 103, 106, 238; J. Q. van Regteren Altena, *The Burlington Magazine*, LXXVI, 1940, 194; L. Burchard-R.-A. d'Hulst, *Catalogue*, Exh. Antwerp, 1956, 88–89; M. Jaffé, *The Burlington Magazine*, XCVIII, 1956, 318; idem, 1977, 19 L–R, 45R.

An inscription in the lower centre—not by Rubens—can no longer be made out.
On the reverse: A Woman in fantastic dress, sitting on an elephant, in profile towards the left; in the upper right and left corners: two crouching cupids and another figure.

In this drawing Rubens copied, with some variations, stucco figures by Primaticcio in the chamber of the *Duchesse d'Etampes* in Fontainebleau (now the *Escalier du Roi*). The two figures at the left correspond in general to the two caryatids at the left of one of the groups over the doorways (see L. Dimier, *Le Primatice*, Paris, 1928, Pl.VI). The main difference consists in the more fully proportioned shape of Rubens' figures, the absence of any cover, and—in the figure at the extreme left— the different pose of the head. (This last change, however, might have been made by Rubens somewhat later, since that head is heavily reworked in body-colour.) The decorative elements are also derived from Primaticcio's decoration, but Rubens left out the Satyr-herm which in Fontainebleau appears between the legs of the figures. The figure nearest the left margin occurs a second time in a group of two caryatids between the windows. The third figure, at the right on Rubens' sheet corresponds closely with one that belongs to a group directly opposite that containing the first two nudes. This is the caryatid at the far right, near the window, as one mounts the stairs. They only differ in that Rubens' figure has her left leg in front of her right one while in Primaticcio's stucco it is the right leg that crosses the left. The position of the legs chosen by Rubens does occur, however, elsewhere in the room. (I am indebted to Miss Julie Misrahi for having verified these facts in Fontainebleau.) Although Van Regteren Altena suggested that the copy was taken from a lost drawing by Primaticcio, it is probable that Rubens' drawing was made in front of the original sculptures. Thus the drawing must date from one of Rubens' visits to Paris, the likeliest being those he made in 1622, 1623, and 1625 in connection with the cycle of pictures for the Palais du Luxembourg (see Nos.156, 158–60). It is surprising that at this time he should still have been interested in figures as

typically mannerist as those of Primaticcio. Rubens' interest in Primaticcio, however, lasted still longer as evidenced by his copying around 1630 compositions by Primaticcio or reworking drawings made after that master (see Exh. Antwerp, 1956, Nos.111–113).

The assumption that the copy was made on the spot is perhaps reinforced by the fact that the sheet on which Rubens drew contained a French drawing of the school of Fontainebleau—by Primaticcio himself?—which Rubens could easily have acquired in Paris. It is related to a series of similar drawings of masks and allegorical pageants (see Dimier, *loc.cit.* Pl.XXXVIII and XL). The figure probably signifies Eternity (see G. du Choul, *Discours de la Réligion des Anciens Romains*, Lyon, 1581, 141–142).

M. Jaffé (1956) stated that the drawing was reworked by a different hand (possibly Lankrink's). I have been unable to see this alleged transformation.

156 [Plate 151] (1959: No.50 recto)

THE VESTAL TUCCIA

c. 1622. Black chalk and pen and ink. 227 × 315 mm.
On the reverse: Louis XIII comes of Age (No.159).
Paris, Louvre, Cabinet des Dessins (20.199).

COLLECTIONS St. Maurice.
EXHIBITIONS Antwerp, 1956, No.97; Antwerp, 1977, No.154; Paris, 1978, No.21.
LITERATURE R., V. No.1774; F. Lugt, 1925, 185, 193; G.-H. No.154; E. Kieser, *Zeitschrift für Kunstgeschichte*, X, 1941, 312; Lugt, *Catalogue*, No.1015; Burchard-d'Hulst, 1963, No.129; Kuznetsov, 1974, No.91.

Upper right corner torn. Inscribed in lower left, by a later hand: 'P.P.Rub...'

The Vestal Tuccia, who had been accused of incest, proved her innocence by carrying water from the Tiber in a sieve (Livy, *ep.* XX, Valerius Maximus, VIII, 1, 5; Pliny, N. H. XXVIII, 12; Dionysius, II, 69, 1–3). She is shown in the centre, aided by the river-god himself, who reclines in the foreground. The subject had been treated before by Polidoro da Caravaggio and Maturino on a façade on Montecavallo, near Sant'Agata (Vasari, V, 146); by G. A. Figino in drawings for a picture apparently lost (A. E. Popham and J. Wilde, *The Italian Drawings at Windsor Castle*, London, 1949, No.326, 74, 75, 92); and in two engravings after Stradanus, one by the Th. Galle, the other by P. Furnius. (One Stradanus drawing is in the Albertina, Vienna, see Benesch, 1928, No.175.) Rubens was surely acquainted with some of these versions of a theme which owed its popularity to its marianic significance (see W. Molsdorf, *Christliche Symbolik der mittelalterlichen Kunst*, Leipzig, 1926, p.147, No.907).

No other work of Rubens dealing with this subject is known to exist. Lugt as well as Glück and Haberditzl dated the drawing 1622 since the sketch on its reverse is likely to date from that year. While we know from other examples (see Nos.135, 220) that the front and back of one sheet need not necessarily date from the same period, the argument in this case is meaningless since the drawings, though apparently front and back of one sheet, were actually drawn on different pieces of paper pasted together at a later date. Nevertheless the drawing would seem to date from this period. The river-god reappears rather similarly in the Birth of Marie de Médicis (KdK.244), where the figure of Lucina seems to contain an echo of that of Tuccia in the drawing. Tuccia's movement itself is related to a soldier with a standard in a sketch for the Cycle of Constantine ('Constantine and the Labarum', see Held, 1980, No.41). The women behind the river-god recall the women at the right of the double-

wedding of that same cycle (Held, 1980, No.39) as well as the group of the Three Graces in the Education of Marie de Médicis (KdK.245). The figure of the priest, however, still echoes that of Melchisedek from the Caen painting of Abraham and Melchisedek of c. 1614–1615 (KdK.110).

E. Kieser (loc.cit.) connected the Tuccia drawing with a composition which Rubens planned but never executed for the cycle of Marie de Médicis. He suggested that it is an allegorical defence of the Queen whom rumour had implicated in the murder of Henry IV, and that it is this composition to which Rubens and Peiresc refer in their correspondence under the name 'Flamineo' (Pontifex Maximus; the figure standing at the left). If this was indeed its meaning, it is easy to see why the design was rejected.

157 [Plate 153] (1959: No.102)

STUDY FOR MERCURY DESCENDING

c. 1622. Black and white chalk. 480 × 395 mm. All four corners have been cut, the lower ones to a considerable degree, and along a curved line.
London, Victoria and Albert Museum (D.517).

COLLECTIONS P. H. Lankrink; Earl Spencer; The Rev. A. Dyce.
EXHIBITIONS London, 1977, No.152.
LITERATURE M. Rooses, Rubens Bulletin, IV, 1895, 217; G.-H. No.141; K. T. Parker, 1929, 18, note 1; Kuznetsov, 1974, No.89.

This splendid study has hitherto been called 'an angel descending', on account of the theory that it was a study for an angel in the Munich Fall of the Rebel Angels of 1622 (KdK.241). Parker pointed out that such figures of Angels occur in earlier works too, such as the Munich Nativity (KdK.198). Similar poses are in fact found as early as 1608 (see No.43), again in 1614 and later in the various versions of the Flight into Egypt (see No.235). It has not been observed, however, that by far the most striking analogy is to be found in the figure of Mercury descending in the painting of The Education of Marie de Médicis in Paris (KdK.245). This connection has probably been overlooked because the movement in the Paris painting is in reverse. That Rubens had not decided exactly which position he should choose when he drew the figure can be deduced from the fact that he equipped it with three pairs of legs, to test out several possibilities. While we cannot be dogmatic about the master's reasons for reversing the pose in the finished picture, it may well have been done because in a painting of good auguries it was preferable for Mercury to carry the caduceus with his right hand. It is also possible that the whole composition was originally planned in reverse. Such an inversion was not unusual in Rubens' work, as evidenced by the drawings for the Scipio story (Nos.123, 124). In the Médicis series itself the composition of the Coronation of Marie de Médicis was originally sketched in the reverse of the final solution, the whole action being oriented towards the left (see Held, 1980, No.67). The scene of Louis XIII Coming of Age was also first drawn in the opposite direction (see No.159).

A good deal of the beauty of the drawing lies in the verve with which Rubens sketched the drapery. In the painting the drapery swirls around Mercury; and he has in addition the obligatory helmet on his head. The light falls on the figure exactly as it does in the drawing.

The Médicis series was begun in 1622 and the drawing surely belongs to the early phases of the work. Since it may also have been used for the Fall of the Rebel Angels of that year (though it was almost certainly not made for it), the date assigned to it by Glück and Haberditzl can still be maintained.

158 [Plate 158] (1959: No.51 verso)

HENRY IV CARRIED TO HEAVEN, AND OTHER FIGURES

c. 1622. Pen and ink, and a few brush marks. 175 × 171 mm. (slightly, rounded at the bottom).
Formerly: Bremen, Kunsthalle (658). The drawing was evacuated during the war and has disappeared since. On its verso No.160.

LITERATURE G.-H. No.148; J. Thuillier-J. Foucart, Rubens' Life of Marie de' Medici, New York, 1967, 84, under No.14; Fig.71.

Inscribed in pen, apparently in Rubens' own hand: 'Quelque di[e] me[u]neras a Leschange d[e] espouss' and (in the lower right corner) 'paulo Jud (?) . . .'. Elizabeth McGrath informs me (in literis) that a better reading might be: 'qualquè dio marino a l'Eschanges d'espouss . . .' ('a maritime deity—to the exchange of the brides').

It is evident from the many figures cut by the frame that this is only a section of a larger study sheet. Whoever dismembered the sheet must have considered the drawing on the back the more important, thus sacrificing the evidently more disconnected sketches on this side in order to preserve the compositional integrity of the other.

The large figure in the lower left is probably the first draft of the pose of Henry IV for the scene of the Apotheosis of the King after his murder by Ravaillac, forming the left half of the eleventh picture in the cycle of the Life of Marie de Médicis (KdK.253). Besides this drawing, two oil-sketches exist for this composition, one in Leningrad (Held, 1980, No.69) and another in Munich (Held, 1980, No.70). The large canvas in the Louvre originally formed the centre piece of the whole decoration, placed as it was against the narrow end of the gallery opposite the entrance (see von Simson, loc.cit., 33). The Leningrad sketch still shows the King with the left arm raised and the right lowered, as he appears in the present drawing, although the attitude of his body approaches that seen in the Munich sketch, where the movement of the arms is reversed, just as the gods assisting in the apotheosis are exchanged. The drawing substantiates the evidence, from an exchange of letters between Rubens and Peiresc (see again von Simson, p.336), that there had been doubts in Rubens' mind whether the King should be rendered in a gilded classical armour, as he indeed is in the finished canvas. Von Simson stressed correctly the compositional and iconographic connection between the King and the personified planets above, alluding to the ancient theme of the translation of the dead hero into the starry sky; he quotes, not inappropriately, Bedford's line from the but slightly earlier Henry VI, I, I: 'A far more glorious star thy soul will make, than Julius Caesar. . . .'

Rubens, however, was surely aware of an image that could easily be associated with his theme. This is the engraving Virtus Immortalis, which is No.14 in Otto van Veen's Quinti Horatii Flacci Emblemata, Antwerp, 1607 (reprinted in 1612). It shows Virtue soaring towards heaven, aided by Learning and Valour. The latter indeed is seen from the back like the figure of Time in the later stages of the development of Rubens' Apotheosis of Henry IV.

The two angels in the upper left corner of the Bremen drawing were associated by Glück and Haberditzl with the 'angels' holding the portrait of Marie de Médicis for King Henry in the fourth painting of the cycle (KdK.246). Lugt, and following him Evers, connected them with the cupids who help to loosen the fetters of the princess in the Berlin version of Perseus and Andromeda (KdK.225). Neither view can be substantiated sufficiently to be acceptable; indeed, it is impossible to establish a clear connection between the other figures in this sheet and any of Rubens' paintings. The kneeling man remotely evokes

the figures of kneeling nobles (in the right half of the Apotheosis of King Henry) who profess their loyalty to the Queen. Yet Rubens may well have drawn him with a very different theme in mind.

Even the inscription poses a problem that has not been solved satisfactorily. Lugt, as well as Glück and Haberditzl, saw a reference in it to the fourteenth picture of the series, the Exchange of the two princesses Anne of Austria and Isabelle of France (*KdK.256*). Contending that 'épouses' could not very well apply to the two young girls, Evers sees a reference to the exchange of the rulers of France after Henry's murder, Marie de Médicis taking the place of the King; he sees this very exchange represented in the painting of the Apotheosis of Henry, where Marie dominates the right half of the canvas just as the King does the left. McGrath's reading with its reference to a 'dio marino' (marine god) would seem to strengthen the connection with the exchange of the Princesses, since that picture does include a rivergod—the Bidassoa, near Hendaye.

159 [Plate 157] *(1959: No.50 verso)*

LOUIS XIII COMES OF AGE

c. 1622. Pen and ink. 218 × 216 mm. On the reverse, but not on the same paper: The Vestal Tuccia. Inscriptions (see below) in Rubens' hand.
Paris, Louvre, Cabinet des Dessins (20.199).

EXHIBITIONS Antwerp, 1956, No.97.
LITERATURE R., V. No.1471; F. Lugt, 1925, 180; G.-H. No.147; O. Gg. von Simson, *Zur Genealogie der weltlichen Apotheose im Barock*, Strasbourg, 1936, 367; Evers II, 304; Lugt, *Catalogue*, No.1016; Burchard-d'Hulst, 1963, No.129; Kuznetsov, 1974, No.92; Held, 1980, under No.75.

This and two other drawings (Nos.158 and 160) are the only sure examples of first drafts for the Médicis Cycle, a series of twenty-one large paintings, that have been preserved. The Louvre drawing is very different from the oil-sketch in Munich, as well as from the painting in the Louvre. It shows Louis XIII and Marie de Médicis in the centre; at the left are Prudence ('prudentia') trimming the sails and Constancy and Strength ('constanza', 'forza') rowing; at the right stands the 'Kingdom of France' ('Regnum Galie') with sceptre and globe while two figures ('fama'), flying nearby, blow trumpets. The words in the lower right are probably 'Govern[o] G[alie?]' (surely not 'honos', as von Simson read), referring to the rudder which Louis XIII holds with his left hand, while in the Munich sketch and the large canvas in Paris he, more properly, holds it with his right. In that painting four, instead of two, allegorical figures row the boat, which was turned in the opposite direction. France now stands near the mast, in the centre, and Marie de Médicis has been moved nearer the rudder so that the gesture of her right hand assumes a more specific meaning—that it is she who willingly turns the rule over to her son.

160 [Plate 159] *(1959: No.51 recto)*

MARIE DE MÉDICIS RECEIVES THE OLIVE BRANCH OF PEACE

c. 1622. Pen and ink. 175 × 171 mm. (slightly rounded at the top).
Formerly: *Bremen*, Kunsthalle (658v°). Verso of No.158.

COLLECTIONS Kunstverein in Bremen.
LITERATURE F. Lugt, *Gazette des Beaux-Arts*, LXVII, 1925, 2, 186; G.-H. No.149; O. Gg. von Simson, *Zur Genealogie der weltlichen Apotheose im Barock*, Strasbourg, 1936, 373; Evers, II, 271, 303–304; Kuznetsov, 1974, No.93.

Inscribed later, in ink, '658' and 'van dijk', by different hands.

This sketch is clearly a first thought for the eighteenth picture of the Cycle of Marie de Médicis, now generally called The Treaty of Angoulême (*KdK.260*). Whereas in the painting in the Louvre the Queen is seated at the left, in the drawing she approaches from the right, accompanied by a Cardinal and by an allegorical figure who also stands by her side in the finished canvas. This figure, which Félibien (*Entretiens sur les vies et les ouvrages des plus excellens peintres*, London, 1705, 322) called 'Diligence' but which, on Nattier's evidence (*La Gallerie du Palais du Luxembourg peinte par Rubens, Dessinée par les S^s. Nattiers*, Paris, 1710), is now generally interpreted as Prudence, was derived from a Roman figure, the so-called 'Thusnelda' in the Loggia dei Lanzi (see Lugt, *loc.cit.*). Rubens must have been particularly fond of this marble, as may be seen from the frequent use he made of it in his work.

The Cardinal is La Rochefoucauld, and the event to which the scene alludes is the agreement of Angoulême of 1619, not the peace of Angers of 1622 (see von Simson, *loc.cit.*). It is uncertain whom Rubens had in mind at this early stage as the person offering the olive branch. In the painting in the Louvre it is Mercury; von Simson thought that there might have been some indecision about this figure. He hints that the rôle could have been reserved for Cardinal de Richelieu, who is known to have played an active part in the negotiations at Angoulême.

161 [Plate 161] *(1959: No.104)*

PORTRAIT OF SUSANNE FOURMENT (1599–1643)

c. 1622–1625. Black, red, and white chalk, on light brown paper. 388 × 280 mm.
Rotterdam, Museum Boymans-van Beuningen (V.58).

COLLECTIONS Mrs. L. M. Bancroft; F. Koenigs; D. G. van Beuningen.
EXHIBITIONS Düsseldorf, 1929, No.87; Amsterdam, 1933, No.123; Rotterdam, 1938, No.346; Brussels, 1938–39; No.19; Rotterdam, 1939, No.21; Rotterdam, 1948–49, No.131; Paris–Brussels, 1949, No.101 (97); Rotterdam, 1952, No.68; Antwerp, 1956, No.101.
LITERATURE *Vasari Society*, 2, series, VIII, 1927, 10; G.-H. No.161; A. J. J. Delen, 1950, No.6, Kuznetsov, 1974, No.117.

As late as 1928, when this drawing appeared in a sale at Sotheby's (May 16, 1928, No.51), a slip, now gone, was attached to it, inscribed in a hand of the late seventeenth or early eighteenth century: 'Mademoiselle Forment soeur de la seconde femme de Rubens. P. P. Rubbens fecit.' For the portraits of Susanne Fourment see Glück, *Essays*, 133ff. Of the portraits listed by Glück, the one in the Louvre (Collection Schlichting, Fig.85) comes nearest to the present drawing, despite the fact that there Susanne is shown in profile. Another portrait drawing of Susanne Fourment, inscribed in red chalk 'Suster van Heer Rubbens' is in Vienna (G.-H. No.162).

Susanne Fourment was married to R. del Monte in 1617 and, after his death, to A. Lunden in 1622. Rubens painted several portraits of her, the most famous being—G. Glück's doubts notwithstanding—the picture known as 'Le Chapeau de Paille' in London (see Evers, II, 275ff.).

162 [Colour Plate 3] *(1959: No.106)*

PORTRAIT OF A YOUNG GIRL (Clara Serena Rubens [?] 1611–1623)

c. 1623. Black, white, and red chalk; pen and ink touches on the eyes and between the lips. 350 × 283 mm.
Vienna, Albertina (8259).

EXHIBITIONS Antwerp, 1930, No.445; Vienna, 1930, No.206; Brussels, 1935, No.522; Zürich, 1946–47, No.95; Paris–Brussels, 1949, No.106.
LITERATURE G. Glück, *Marées Gesellschaft*, No.V; G.-H. No.165; Evers, I, Pl.III; Delen, 1950, No.7; Burchard-d'Hulst, 1963, No.137; Kuznetsov, 1974, No.104; Mitsch, 1977, No.38.

Inscribed at the top, in red chalk: 'Sael dochter [G.-H. read 'doegter'] van de Infante tot Brussel' (Lady-in-waiting of the Infanta at Brussels). Similar inscriptions, by the same hand, are found in G.-H. Nos.143, 152, 156, 157, 162, 164. These inscriptions, while surely quite early, must be later than 1630, since Susanne Fourment (G.-H. No.162), who is called 'Suster van Heer Rubbens' (Sister of Mr. Rubens) could have been referred to in this manner only after his marriage to Hélène Fourment. For the inscription 'P. P. Rubens' in pen and ink in the lower right see No.163. It seems to me likely that the inscriptions in red chalk were written by the hand that inscribed the word 'biblioteek' on a portrait of a cleric in Berlin (Bock-Rosenberg, No.5498, repr. F. Lippmann, *Zeichnungen alter Meister im Kupferstichkabinett*, Berlin, 1910, II, 247). Since writing and drawing are evidently by the same hand in that work, the author of the Vienna inscriptions must have been an artist. Could it have been Erasmus Quellinus? The model in the Vienna drawing must have been the subject of an oil-sketch by Rubens which is known to us from two versions, neither of them original; one is in the Diocesan Museum in Liège, the other was in the collection of Charles U. Bay in New York (Goris-Held, No.A11). In the paintings the girl wears a much simpler dress, but the identity of the features is unquestionable; whoever was the model in the sketch must also be reproduced in the drawing. Indeed, contrary to the doubts expressed on this score by E. Haverkamp Begemann (*Catalogue*, Exh. Rotterdam, 1953, No.43), I believe that the—lost—sketch was actually based on the Vienna drawing. The same person appears once more, seemingly somewhat older, in a painting in Leningrad (M. Varshavskaya, *Rubens' Paintings in the Hermitage Museum*, Leningrad, 1975, No.28). The originality of the Leningrad painting, however, is highly questionable. It may well be a later work, based also on the drawing in Vienna. There is, finally, a portrait of a young girl of perhaps six or seven years in the Liechtenstein collection (*KdK.*135) which looks very much like a picture of the same model at an earlier age. Since such a repeated portrayal of a child speaks for a close personal contact between artist and model, and since Rubens had a daughter, Clara Serena, who died at the age of twelve and a half in the fall of 1623, both the Liechtenstein portrait and the oil-sketches have been identified several times with this girl (see R. Baumstark, *Masterpieces from the Collections of the Princes of Liechtenstein*, New York, 1980, No.44). A portrait on panel of Clara Serena is recorded in the estate of Jan Brant, Rubens' father-in-law and grandfather of the girl (Denucé, *Inventories*, 54). The girl in the Vienna drawing looks as if she were not much more than twelve years old, allowing for the effect of the rather formal dress.

While it remains puzzling that the inscription does not mention Clara Serena's name, the fact that it calls her a 'saeldochter' of the Infanta does not by any means contradict the identification. Rubens himself had been a page to a Countess de Lalaing. The Infanta might well have accepted the daughter of her favourite artist to be educated at her court, as a special sign of her grace, particularly as the child had been given her own name.

163 [Plate 162] *(1959: No.108)*

PORTRAIT OF RUBENS' SON NICOLAS (1618–1655)

c. 1625. Black and white chalk, on light brown paper. 227 × 180 mm.
Vienna, Albertina (17.648).

EXHIBITIONS Brussels, 1963, No.350.
LITERATURE R., V. No.1523; Glück, *Marées Gesellschaft*, No.XI; G.-H. No.159); Burchard-d'Hulst, 1963, No.138; Mitsch, 1977, No.42.

Inscribed (pen) by a later hand: P. P. Rubbens (see No.162). The drawing may have been cut from a larger sheet.

This drawing was made in connection with the double portrait of Albert and Nicolas, the sons of Rubens and Isabella Brant (Liechtenstein Collection, Vaduz, *KdK.*281). The painting follows the drawing faithfully; when Rubens drew his son, he must have known precisely how he wanted him to appear in the painting. There Nicolas watches, with rather grim intentness, the fluttering of a bird which he holds by a string as a living toy. There must also have been a drawing of Albert Rubens for this picture, and it probably looked like the drawing G.-H. No.158. That study, however, is surely only a copy; Glück and Haberditzl's generous assumption that it is the original, disfigured by a later reworking in pen, is hardly tenable, particularly as the so-called 'self-portrait' G.-H. No.191, in which there is not a trace of Rubens' own work, was doubtlessly drawn and inscribed by the same hand. Inscriptions in the same style of handwriting are found on some of the Copenhagen drawings (see Introduction, p.42)—a fact which suggests that both G.-H. No.158 and No.191 are the works of one of the Copenhagen copyists.

The Liechtenstein double portrait must have been painted after the death of Clara Serena (1623; see No.162) and probably before that of Isabella Brant (1626). The date generally given for it, 1625, is probably correct; the boys were then eleven and seven years old respectively.

164 [Plate 163] *(1959: No.109)*

PORTRAIT OF RUBENS' SON NICOLAS

c. 1625–1626. Red, black and white chalk. 292 × 232 mm.
Vienna, Albertina (8.266).

EXHIBITIONS Zürich, 1946–47, No.94; Antwerp, 1977, No.157.
LITERATURE R., V. No.1524; G.-H. No.163; Burchard-d'Hulst, 1963, under No.126; Mitsch, 1977, No.41.

Glück and Haberditzl dated the drawing *c.* 1626–27, on the assumption that the boy looks about eight or nine years of age. This seems to be too old, though he does look slightly older than in the drawing. No.163. No picture for which this moving study was used has so far been found.

165 [Plate 160] *(1959: No.107)*

PORTRAIT OF GEORGE VILLIERS, DUKE OF BUCKINGHAM (1592–1628)

1625. Black, red, and white chalk; ink (applied with brush) on the eyes; white paper, torn at lower left corner. A small repaired spot on the left cheek, right above beard. 383 × 266 mm.
Vienna, Albertina (8256).

LITERATURE R., V. No.1501; Muchall-Viebrook, No.15; G.-H. No.156; Glück, *Marées Gesellschaft*, No.VII; Charles Richard Cammell, *The Connoisseur*, XCVIII 1936, 127 (No.V); Kuznetsov, 1974, No.106; Mitsch, 1977, No.39.

Inscribed in red chalk: 'Hertoeg van Bockengem [not "Bochengem"] P. P. Rubbens F' by a hand which inscribed several drawings in Vienna in this manner (see No.162).

Rubens met the Duke of Buckingham in Paris in 1625 when the latter came after the marriage by proxy of Charles I of England

to Henrietta of France to escort the young queen to London. Rubens was present in the French capital to deliver the Médicis cycle. Besides starting—at Buckingham's initiative—the negotiations which led to the sale of his private collection to the Duke for the sum of 100,000 florins, Rubens also made drawings of both ⌐he Duke and Catherina Manners, the Duchess of Buckingham (G.-H. No.157). Two portraits of the Duke were subsequently painted from this drawing. One, half-length, is in the Pitti Palace in Florence (*KdK.* 1st ed., 257. Oldenbourg called it a copy, but it was exhibited in Paris in 1952, No.75, as original, which it may very well be). The second was a large allegorical equestrian portrait of the Duke in the collection of the Earl of Jersey, Osterley Park (*KdK.*267), destroyed by fire in 1949. (For the painting of Catherina Manners at Dulwich and the various theories about the origin of Rubens' drawing of the Duchess see G. Glück, *The Burlington Magazine*, LXXVI, 1940, 174, and F. Grossmann, *Les Arts Plastiques*, 1948, 52 ff.) Both drawings have suffered from rubbing which is more disturbing in the portrait of the Duchess who, from the beginning, was only thinly drawn. Of Buckingham Rubens wrote on December 26, 1625: 'When I consider the caprice and arrogance of Buckingham I pity this young king who through bad counsel throws himself and his Kingdom into such extremity without any need' (*Correspondence*, III, 412). The passage refers to Buckingham's ill-conceived expedition against Cadiz; in 1626 Buckingham was impeached for it in the House of Commons, but he escaped conviction. Two years later, on the eve of his second expedition to relieve La Rochelle, he was assassinated. See also the sketch for the equestrian portrait of the Duke, now at the Kimbell Art Museum, Fort Worth, Texas (Held, 1980, No.292).

166 [Plate 166]

THE VIRGIN WITH THE CHRIST CHILD AND ST. ANNE

c. 1624–1626. Pen and ink. 199 × 150 mm. Inscribed, lower left: 'Dyck'.
Darmstadt, Hessisches Landesmuseum (AE. 504 'Van Dyck').

EXHIBITIONS Darmstadt, *Peter Paul Rubens und sein Kreis*, 1977, No.21 (catalogue by Rainer Schoch).
LITERATURE Burchard-d'Hulst, 1963, No.131; Logan, *Master Drawings*, XVI, 4, 1978, 447 (Van Dyck?).

In addition to the main group, Rubens sketched the heads of the Virgin and the Christ Child a second time in the lower half of the paper. The face at the upper right, drawn only schematically, may be for St. Joseph, as suggested tentatively by Burchard-d'Hulst. This striking, and still little known drawing has no exact equivalent in Rubens' work. The nearest analogy of the tender embrace of his mother by the infant Jesus is found in a painting in the Prado (1418) where the Virgin is seen in an elongated octogonal in the centre, surrounded by elaborate wreaths of flowers, fruits and vegetables, and a number of animals, all painted by Jan Brueghel the Elder (d. 1625). The connection with a painting in the Walker Art Gallery in Liverpool (*KdK.*342, right) seems to be less close than Burchard-d'Hulst maintain.

The source of the athletic pose of the Christ Child seems to be Michelangelo's Medici Madonna in the Sagrestia nuova of San Lorenzo in Florence, though it is here seen in reverse. Michelangelo's child turns its head still further towards the Virgin, suggestive of nursing, but in all other respects it is almost a mirror image of that model; the Virgin's hand, too, is similarly placed.

It is hazardous today to state with any degree of certainty how Rubens could have become acquainted with that work, though he may have actually seen it *in situ*. Since his visits to Florence,

however, never seem to have been prolonged, it is more likely that he knew it through other sources, or possibly from a cast. Dating such a slight study, too, is difficult. Burchard-d'Hulst opted for 1624–1627, and the middle of the 1620s seems indeed the most likely time-span for it. That would imply, however, that it was not done for the painting in the Prado mentioned before, unless one would assume that the central part of the picture was added only after Jan Brueghel's death.

167 [Plate 164] *(1959: No.147)*

THE ANNUNCIATION

c. 1625. Pen and ink, washed, over black chalk which is visible in many places as greyish spots. Much of the shading has been done with the brush. Stylus marks, for transfer. 297 × 197 mm. *Vienna*, Albertina (8205).

EXHIBITIONS De Madonna in de Kunst, Koninklijk Museum voor Schone Kunsten, Antwerp, 1954, No.337.
LITERATURE R., V. No.1289; Muchall-Viebrook, No.13; G.-H. No.168; Evers, II, 207–208, and 353, note 11; Jaffé, *Burlington Magazine*, 1977, 622; Mitsch, 1977, No.68; Logan, *Master Drawings*, 1978, 406–7.

This drawing served as the model for an engraving included in the 1627 edition of the *Breviarium Romanum*, published 'apud societatem Librorum Officii Ecclesiastici' (Joh. Keerbergen and H. Verdussen). For the history of this publication which appeared in competition with the Plantin edition see Rooses, *L'Oeuvre*, etc. V, 103, and Evers, II, 197. Evers was probably correct in pointing out that Rubens is not likely to have furnished a design to a publisher who encroached on B. Moretus' privileges. Yet since other prints of that publication are clearly derived from Rubens' compositions, the use of the Vienna drawing does not necessarily argue against its authenticity. Evers' depreciation of the quality of the drawing seems to me unjustified. At the present state of our knowledge, there is no pupil of Rubens' whose manner of drawing resembles that of the Vienna sheet, nor does its style differ seriously from that of Rubens. Its quality is certainly not unworthy of the master. Some of the motifs of the drawing (the pose of the angel, the inclusion of the sewing basket) are found also in the large Annunciation which Rubens painted in Spain in 1628–1629 (now Rubens-Huis, Antwerp, on loan from the Dulière Collection, see Goris-Held, No.41). The technique with its many parallel brush-strokes is found, amongst others, in Rubens' copy after Primaticcio (No.155) and in his drawing of the bust of Julius Caesar (G.-H. No.100). The latter might well belong to the 1620's, too, since the design of the armour is related to Rubens' drawings for the title of H. Hugo's *Obsidio Bredana* of *c.* 1625–1626 (G.-H. No.166). (Burchard and d'Hulst in the *Catalogue* of the Antwerp Exhibition, 1956, No.99, assign the date 1624 to the Caesar drawing.) Despite Mitsch's and Logan's doubts. I still believe this to be an original drawing by Rubens, a view that Jaffé, too, has defended.

168 [Plate 165] *(1959: No.58)*

VENUS ANADYOMENE AND TWO NEREIDS

c. 1628. Pen and ink, on light brown paper (watermark: Elephant), 273 × 251 mm.
On the reverse: Dance of (Italian) Peasants.
London, British Museum (1920, 10.12.1).

COLLECTIONS Fairfax Murray.
EXHIBITIONS London, 1977, No.177.
LITERATURE Hind, *Catalogue* 59, No.25, as Van Dyck; G.-H. No.229 (reverse: No.221); K. Feuchtmayr, in Glück, *Essays*, 399; Delacre, *Van Dyck*, 225–227 (as Van Dyck); L. Burchard,

in *Catalogue*, Exhibition 1950, under No.16; Burchard-d'Hulst, 1963, No.149; Karl Feuchtmayr, Alfred Schädler, Norbert Lieb, Theodor Müller, *George Petel, 1601/2–1634*, Berlin, 1973, 100.

Hind kept the former attribution to Van Dyck while admitting that the drawing might be by Rubens. The attribution to Rubens was made by Glück and Haberditzl, and following them, Van Puyvelde (*Esquisses*, No.61). These authors, however, connected the drawing with a sketch for a silver tray (Held, 1980, No.265) although Glück himself had already published the work for which it had really been done: an ivory salt-cellar now preserved in the Swedish Royal collection in Stockholm (Glück, *Essays*, 193 ff., Fig.110). Glück also demonstrated that a sketch formerly in the collection of the Duke of Portland (Held, 1980, No.266) served as a model for the carving. He attributed the ivory carving—which Rubens himself had owned, since it is described in the inventory of his possessions drawn up in 1640 (see Denucé, *Inventories*, 70)—to Lucas Faid'herbe; but Arvid Julius (*Jean Cavalier*, Uppsala and Stockholm, 1926) and more precisely K. Feuchtmayr (*loc.cit.*) proved that it is a work of Georg Petel (1601/02–1634). Feuchtmayr also saw that the group on the salt-cellar agrees more closely with the corresponding London drawing than with the sketch. Whereas in the sketch the nymph who follows Venus looks forward and up, in both the London drawing and the Stockholm ivory she looks backward over her left shoulder. Contrary to Feuchtmayr's original opinion, which I had taken over in the first edition of this book, dating the salt-cellar 1631–32, it is now generally agreed that Petel's work dates from 1628, as indeed Burchard had first maintained. That means that the connection of the work with Rubens' marriage of 1630 to Hélène Fourment, proposed by Feuchtmayr, also has to be dropped. Not accepted, for good reasons, is the opinion expressed by Burchard-d'Hulst, that the oil sketch (Held, 1980, No.266, now owned by Lady Anne Bentinck) was made as a model for the engraving by Peter de Jode and was copied by Rubens from Petel's ivory. It was surely part of the preparation of Petel's work.

Burchard drew also the conclusion, which was again repeated in Burchard-d'Hulst, that the drawing for a 'Dance of Italian peasants' on the back of the London drawing (see No.169) and the painting based on it, must also have been done in 1627–1628, rather than, as generally believed, in the early 1630s. Recto and verso, as Burchard-d'Hulst themselves admit, must not always be of the same date. Hence I see no reason to separate this group of works from other scenes of rustic life, of the period of *c.* 1630–1632.

169 [Plate 167] *(1959: No.58)*

DANCE OF (ITALIAN) PEASANTS

*c.*1630–32. Verso of No.168.

LITERATURE Burchard-d'Hulst, 1963, 236 (under No.149). *London*, British Museum.

While the painting in the Prado in Madrid known as *A Dance of Italian Peasants* (KdK.407) is one of the master's most popular works, surprisingly little attention has been given to the only drawing that can be connected with it. Being on the verso of the study for Petel's salt cellar, it is generally discussed only briefly at the end of commentaries on the recto of the sheet. One of the reasons for this neglect may be found in the fact that it deals only with the left half of the painting; no one has even raised the question of whether the London sheet is only a fragment of a larger one on which Rubens may have worked out the entire composition. Seeing a quick trial sketch at the lower left of the sheet (a pair of arms and two [?] heads), Burchard-d'Hulst

explain its presence as Rubens' effort to continue a figure cut off at the right which had to remain fragmentary because 'the sheet was not large enough'. (I do not think one can take seriously the thought, somewhat diffidently added, that this figure may have been continued at the top of the sheet with seventeen dancing couples, our No.194.) It is surely a strange idea that Rubens should have noticed too late, after having drawn parts of a figure, that there was no more space on the paper to do the rest of it; the only sensible explanation must assume that the paper was indeed considerably larger, and was cut up at a later date. In fact, it is not very difficult to account for such a mutilation. The drawing on the recto contains only one of the groups that appear on Petel's ivory carving. Rubens may well have drawn the group of the Triton and the nymph riding on his back separately on the right half of the sheet. There is some evidence that Rubens had drawn in a manner similar to the way he drew the group on the London sheet the group of the nymph riding on the back of a triton. The same draughtsman who copied the nereid looking back (Copenhagen collection V.15) drew also, and in the same manner, the nereid on the back of the triton (ibid. V.22), which means that a drawing similar to the one discussed here must have existed for that group too.

It must have been very tempting for a later owner—dealer or collector—to cut the sheet in half and thus obtain two separate drawings. Such carving up of some of Rubens' large sheets was not uncommon (see Nos.61, 72, 219). It should be noted, incidentally, that in order to draw on its back, Rubens did not turn the sheet sideways as one turns the pages of a book, but vertically, so that right and left are the same for both recto and verso. It can be seen even in the reproduction of the drawing with the dancing peasants that the drawing on the other side is 'upside down'—but of course right side up as soon as the sheet is turned vertically.

The missing half of the sheet of the dancing peasants deprives us of the pleasure of watching Rubens develop one of the truly humorous inventions in his 'popular' subjects. The basic idea of the dance is simple enough—and indeed still familiar today: six pairs of dancers, holding hands, move around in a large circle, while two couples, with the help of kerchiefs held in their hands form an arch or bridge under which the others have to pass. We may assume that gradually other pairs will take over the forming of the arches so that all of them will successively pass under them and partake in the freewheeling dance. Since it is proper in such a dance that the man leads the girl, Rubens gave us an opportunity to analyse the various attitudes and relationships of the dancers by the simple device of 'breaking' the chain at the upper right. There the young man turns eagerly to the left to catch again the outstretched hand of the girl before him; in doing so, he runs in the opposite direction to that of his own partner, who is still moving towards the right. The youth whose hand *she* holds, while also moving to the right, looks backward and notices, hardly with pleasure, that *his* partner is caught in a backward motion that brings her mouth dangerously close to a sturdy fellow with a large hat. He, in turn, thus occupied with a not unpleasant twist of the dance, leaves his own partner far behind, who is now approached by a nearly nude man sporting a wreath, very much to the visible chagrin of the young woman who is *his* partner. And this playful separation of the couples who really belong together is even continued in the following pair where it is actually the four arms of the bridge that keep the youth at a distance from the young girl whose hand he still holds. Even the last of the dancing partners, running as fast as they can, fail to be closely related; and here it is in fact a large tree that seems to prevent their faces from coming too close to each other. There can be no question that Rubens enjoyed mixing up and keeping apart the couples, not unlike the fun Puck—and Shakespeare—had with some young lovers in *A Midsummer-Night's Dream*. The idea was evidently not yet fully developed in the London drawing: the

heads of the couple that just emerges from the bridge are still close to each other, but the pair ahead of them is already far apart, though with no indication of the displeasure the woman shows in the painting. It would have been interesting to see how Rubens at this stage conceived the couples at the right. Nevertheless, the London fragment catches well the gaiety and spirited motions of the intricate choreography at the left of the composition.

170 [Plate 168] *(1959: No.113)*

YOUNG WOMAN LOOKING DOWN

c. 1627–28. Black, red, and white chalk, a few lines in pen and ink on the eyes. 414 × 286 mm.
Florence, Uffizi (1043 E).

EXHIBITIONS Antwerp, 1956, No.109.
LITERATURE R., V. No.1570; G.-H. No.173; Martin Freeman, *Peter Paul Rubens* (Master Draughtsmen, No.3), London, 1932, No.2; Burchard-d'Hulst, 1963, No.148; Kuznetsov, 1974, No.122.

This lovely study was used for the St. Apollonia in the painting on the high-altar of the church of the Augustines at Antwerp (*KdK*.305, see also No.171). The drawing is later than all the known oil-sketches for the picture, though it probably followed soon after the one in Berlin in which the final composition was almost completely developed. Rubens made use of this study again for one of the young Roman ladies on the estrade at the left in the Rape of the Sabines in the National Gallery, London (*KdK*.379).
The drawing is remarkable in that it represents a type generally believed to appear only in the last decade of Rubens' life and to be connected with Rubens' marriage to Hélène Fourment. M. Freeman, indeed (*loc.cit.*) published the drawing as a 'Portrait of Hélène Fourment'. Rather than speculating on Rubens' demonstrable contact with the Fourment family long before he married Hélène (who had several older sisters), it seems more appropriate to see here the projection of the artist's own concept of beauty—a concept which may well have influenced him in his portrayals of Hélène herself.

171 [Plate 169] *(1959: No.53 recto)*

THE VIRGIN ADORED BY SAINTS

c. 1627–1628. Black chalk, pen and ink, washed in grey and brown. 561 × 412 mm.
On the reverse: Studies for the Virgin and for St. George.
Stockholm, Nationalmuseum (1966–1863).

COLLECTIONS Comte C. G. Tessin.
EXHIBITIONS Brussels, 1948–9, No.14; Rotterdam, 1939. No.38; Stockholm, 1953, No.102; Antwerp, 1956, No.108; Antwerp, 1977, No.159.
LITERATURE F. Lugt, 1925, 200; G.-H. No.172; Van Puyvelde, *Esquisses*, 83; P. Bjurström, *The Art Quarterly*, XVIII, 1955, 27 ff.; F. Grossmann, *The Burlington Magazine*, XCVII, 1955, 337; Burchard-d'Hulst, 1963, No.145.

Inscribed in the lower right 'Rubb.ˢ'; in the lower left, on an added piece of paper, 'A. Vandick'.

This large drawing is one of the studies for the great altar-piece which in July 1628 was placed on the high altar of the church of the Augustines in Antwerp (*KdK*.305). Besides this drawing, four oil-sketches are known, two for the whole composition and two for just two figures (Held, 1980, Nos.382–5). After passing for a long time as a work by Van Dyck, this drawing was first claimed for Rubens by Lugt, whose attribution has

only been challenged once (by Van Puyvelde), though without any foundation. The recent discovery of the drawings on the reverse has given additional interest to the sheet, besides dispelling any possibility of doubt. The brown layer of wash, however, is somewhat disturbing and might have been added by another hand.
The sketches of the Virgin on the reverse were evidently made first. St. Catherine, who kneels before Christ and who remained prominent in all the subsequent stages of the composition, was not yet envisaged in that place when Rubens drew these pen-sketches. Her place, here, is taken by little St. John, whose pose was used on the front for one of the angels below the Virgin. The group of Christ embracing the Virgin, drawn in chalk in the upper right corner of the recto of the paper, is foreshadowed by one of the groups on the verso. It is difficult to read all the different layers of the drawing which show the gradual crystallization of a complex compositional idea (for a more detailed discussion see Bjurström, *loc.cit.* and Held, 1980, 519–21).

172 [Plate 170] *(1959: No.53 verso)*

UPPER HALF: STUDIES FOR THE VIRGIN ON THE HIGH ALTAR OF THE CHURCH OF ST. AUGUSTINE. LOWER HALF: STUDIES FOR ST. GEORGE AND THE DRAGON, Buckingham Palace (*KdK*. 311).

Pen and ink (upper half), washed (one figure in lower half); the other figures in black chalk.

The sketches in chalk show the princess Cleodolinde, her train held by a child (in the finished painting the child was replaced by a lamb), a woman standing behind her (who in the painting was first included in the same place but later completely painted out and replaced by two tall trees), and the man on horseback who, in the painting, is seen in the lower right corner. The kneeling woman with arms outstretched is also found in the painting. The sketchy lines near the right margin are evidently studies of the buildings in the background of the painting which have been identified by E. Croft-Murray (*The Burlington Magazine*, LXXXIX, 1947, 89 ff.) as 'interpretations' rather than portrayals of Lambeth Palace, St. Mary Overy, the Banqueting House, and Westminster Abbey. What Rubens intended to do with the pen-lines in the lower right is not clear.
The drawing was preceded by a large sheet in Berlin (No.177). For the discussion of the whole project see the comment under that number. Since the preparation of the painting must have taken place in London, Rubens surely carried with him the sketchbook in which he had drawn the studies for the Antwerp altar the year before. That he had even taken it to Spain, as Bjurström thinks, is not likely; he almost certainly had had enough time between the two trips to pick up a sketchbook in Antwerp.

173 [Plate 173] *(1959: No.111)*

PORTRAIT OF KING PHILIP IV OF SPAIN (1605–1665) (?)

c. 1628 (October–November?). Black and red and some touches of white chalk, and pen and ink. 383 × 265 mm. Upper left corner cut.
Bayonne, Musée Bonnat (1439).

COLLECTIONS J. P. van Suchtelen.
LITERATURE *Les Dessins de la Collection Léon Bonnat au Musée de Bayonne*, II, Paris, 1935, Pl.21; G.-H. No.177; Huemer, *Corpus Rubenianum* XIX, I, 1977, No.32.

Rubens is known to have painted five portraits of the King during his stay at the court of Madrid between September, 1628, and the end of April, 1629 (F. Pacheco, *Arte de la Pintura*, Seville, 1649, I, 132; see also C. Justi, *Velázquez*, Zürich, 1933, 246). A half-length portrait of the King is known from several school versions (Munich, *KdK*.306); an example which was in the London art market in 1925—perhaps identical with a picture that was part of the Ružička-Stiftung, Kunsthaus, Zürich, but was destroyed in 1985—has been claimed as the original. An excellent full-length portrait of the King is in the Galleria Durazzo-Giustiniani in Genoa (see A. Morassi, *Catalogue*, Mostra della Pittura del Seicento e Settecento in Liguria, Milan, 1947, No.5). The most formal composition, showing the King on horseback, is known from a copy in Florence (*KdK*.446). Rubens himself owned a portrait of the King which is described in his inventory 'Un pourtrait du Roy, le chapeau sur la teste, sur toile' (Denucé, *Inventories*, 61, No.123). Glück and Haberditzl connected the present drawing with the composition listed in Rubens' inventory, probably on the strength of the observation that in the drawing, too, the King wears his hat. There was a painting by Rubens in the collection of the Marquis de Léganès (Inventory of 1655, see *Rubens Bulletin*, v, 1900, 169), showing the King 'de medio cuerpo . . . armado, sombrero con plumas blancas'—which unfortunately leaves open the question whether the hat with white feathers was on the King's head or elsewhere in the picture.

Compared with the King's portraits that are preserved in the original or in copies, the drawing in Bayonne is unusually informal. Its very casualness is underscored by the hat—which is probably normally worn during the cold winter months—but which in the more formal portraits of the King by Velázquez and also by Rubens (except for the equestrian ones) is shown on a table or in the King's hand. Evidently quickly drawn, it is more a study of a pose than of the features of the face (see Introduction, p.33). For that very reason one cannot be entirely certain that it is a portrait of Philip IV at all. Since Rubens' model wore the simplified form of the order of the Golden Fleece, he must have been a member of the royal family and not a 'stand-in'. The possibility cannot be completely excluded that it was Don Carlos, the King's younger brother (1607–1632), who was also portrayed by Rubens in half-length, according to Pacheco (*loc.cit.*); a portrait of this prince by Velázquez in Madrid (Prado, No.1188) does not help, since its own identification is contested.

The strongest argument for the identity of the model with King Philip IV lies in the observation that at the chin the lines drawn by Rubens with the pen make a very noticeable correction to those done in chalk, thus considerably reducing the size of the chin. It is known that Philip IV had a very large and prominent chin; the pen-strokes, thus, would represent a conscious modification of the King's features in keeping with Rubens' tendency to idealize his portraits.

174 [Plate 172] *(1959: No.170)*

GOD THE FATHER

c. 1628–1629. Black chalk, washed, heightened with white. 410 × 368 mm. The lower corners are cut, the top is rounded and made up of three pieces of paper, with some modern additions. Squared for transfer.
London, Victoria and Albert Museum (Dyce 514).

COLLECTIONS Ch. Rogers; the Rev. Alexander Dyce.
EXHIBITIONS London, 1977, No.183.
LITERATURE H. Reitlinger, *A Selection of Drawings by Old Masters*, Victoria and Albert Museum, London, 1921, No.72; K. T. Parker, 1929, No.4; Held, 1980, I, p.444.

Inscribed at the lower left: Taddeus Zuccarus; at the lower right: a; 514.

The technique and function of this drawing are somewhat puzzling. Rubens was not in the habit of making drawings in such an elaborate wash technique as studies for his paintings. The technique is more familiar from his reworking of pupils' drawing before they were given for transfer to the engraver (see No.235). Yet because this figure was not self-sufficient, it was surely not meant to be engraved. It is therefore most likely that the impressive sheet belongs to that group of works in which Rubens 'edited' other artists' drawings, and that the basic design (in chalk, perhaps even including the squaring) was done by somebody else, possibly—as Parker has already suggested—by Zuccari, whose name appears on the sheet in an early hand.

It seems, however, that—once reworked—Rubens used the drawing like any of his own studies from the model. There is a close analogy between this figure and that of God the Father in the allegorical Annunciation sketch in the Barnes Foundation in Merion (*The Incarnation as Fulfilment of all the Prophecies*, see Held, 1980, No.319). The only major difference between the two figures can be seen in the right arm, which in the drawing is raised while in the sketch it is lowered, with a sceptre in the hand. All the other details, particularly the drapery, are so similar that the two works seem to belong together.

The allegorical Annunciation—with Prophets and Sibyls—may have been painted during Rubens' stay in Spain in 1628–1629. Whether the ambitious plan was ever carried out in a large picture we do not know; it is quite possible that it was never developed beyond the preparatory stage and that the more conventional Annunciation now in the Rubens House in Antwerp, on loan from the Dulière collection took its place. A confirmation of the theory that the plan was conceived in Spain may be seen in the only reflection of Rubens' composition. This is a large painting by Claudio Coello decorating the high altar of the church of S. Placido in Madrid; it was supposedly painted around 1663 (see A. L. Mayer, *Geschichte der Spanischen Malerei*, Leipzig, 1922, 467). The picture shares not only the theme of Rubens' sketch, the Annunciation with Prophets and Sibyls, but has some undeniable compositional analogies.

The iconographic theme of the Barnes sketch goes back to a lost fresco by Federico Zuccari, painted for the Jesuit Church of Santa Maria Annunciata, Rome, known from an engraving by C. Cort (reproduced Held, 1980, I, Fig.13). At the top of that composition God the Father is seen in half-length, emerging from clouds, his right hand raised in a gesture of blessing, his left supporting a globe. Since in Rubens' drawing he strikes a similar pose (though Zuccari's figure is seen entirely frontally) and since there is this close iconographic link between the entire composition and Zuccari's fresco the old reference to 'Taddeo Zuccari', Federico's brother, on the London sheet may have some documentary value after all.

175 [Colour Plate 5]

SIX STUDIES OF WOMEN, AFTER TITIAN

c. 1628–1629. Black and red chalk. 448 × 286 mm. At the lower right a triangular piece of paper has been cut away.
Malibu, The J. Paul Getty Museum (82.6B.140).

COLLECTIONS P. H. Lankrink; Dr. Gollnow, Stettin; Dr. A. Schrafl, Zurich; Christie's December 9, 1982 (78).
LITERATURE Muchall-Viebrook, 1926, No.4; G.-H. No.3; Held, 1959, I, 123, under No.64; Burchard-d'Hulst, 1963, No.158; Jaffé, 1977, 33; Held, 'Rubens and Titian,' in *Titian, His World and his Legacy*, (ed. D. Rosand), New York, 1982, 306 (said—due to a mixup—to be in the Albertina).

It is known, thanks to Pacheco, Velázquez's father-in-law, that Rubens copied 'all' the paintings of Titian in the Spanish royal collections during the seven and a half months of his stay in Madrid, 1628–1629. Yet there are very few drawings by the

master that can be connected with his stay in Madrid and more specifically with that grand undertaking. The Getty drawing, done perhaps before he had decided to proceed with large-scale copies of entire compositions, can best be described as a 'sampler' of some of Titian's goddesses and nymphs taken from three different paintings: the head at the bottom of the sheet is that of Venus pleading with Adonis to tarry, as she fears for his life, from Titian's painting of 1554, still in the Prado. The head and raised arm directly above her, and the nude bending down at the top, are taken from Diana and Actaeon, of 1559, now at the National Gallery of Scotland, Edinburgh (on loan from the Duke of Sutherland Collection), the head being Diana's own; the nymph leaning forward is occupied in Titian's canvas with drying the goddess's right leg. The remaining three heads are from the Discovery of Callisto's Pregnancy, also of 1559, and it, too, is now in Edinburgh, on loan from the same collection. The profile head at centre right and one below, seen in lost profile, are of two nymphs to the right, the first one embraced by Diana's left arm, the other sitting on the ground below her. The head seen sideways—being the only one done in black chalk alone—appears to be the nymph at the right, lifting up a large arrow with her left hand. Her face is in the shade, which may explain Rubens' choice of the medium.

One may ask what it was that induced Rubens to concentrate on these six heads, since he included the body of only one of the figures, to the extent that it could be seen in Titian's canvas. What appears to have fascinated him are their fanciful hairdos, braided, beribboned, and interlaced with chains of pearls. In fact there are numerous examples in Rubens' later works where he provided goddesses and nymphs with variations of the hairdressings he had so assiduously studied in Titian's poesie.

I believe one can reconstruct at least approximately the sequence in which he drew the different figures. He may have begun with the nude nymph at the top; the next figure, done on a larger scale than any of the others, is Venus below, looking up. It is certain that her head was on the paper before Rubens drew the two heads directly above her, since he clearly stopped continuing with them wherever they approached, and would have overlapped, her form. The other two heads probably came last, being fitted into the available space. What is suggested by this sequence (which could be only slightly modified) is that the three paintings from which Rubens took the different heads must have hung close to each other and almost certainly in the same room, since it is most unlikely that Rubens would have wandered around, and returned again, to obtain this sampling. Its very beauty lies in the impression conveyed of sustained spontaneity and lightness of touch. Nowhere did Rubens come closer to Watteau's magic drawings than in this sheet.

176 [Plate 147] *(1959: No.167)*
ECCE HOMO (after Titian)

c. 1625–1630. Pen and ink (in two shades) over black chalk, lightly washed. 330 × 415 mm.
New York, Collection Mrs. Jacob M. Kaplan.

COLLECTIONS Crozat (?); London, Victor Koch.
LITERATURE Held, 'Rubens and Titian', in *Titian, His World and His Legacy*, New York, 1982, 324–5, Fig. 7.36.

This little known drawing renders a portion of Titian's Ecce Homo in Vienna (H. Tietze, *Titian*, London, 1950, No. 139) but it is far from being a faithful copy. The changes are so numerous, indeed, that they cannot be listed singly. Taken together, they show a more continuous and more dynamic movement from the lower right to the upper left.

There cannot be any doubt that all the pen-work is by Rubens himself. It is more difficult to say whether the underlying drawing in chalk is also by the master. If it is, one would still

have to determine whether or not it is of the same date as the reworking of the pen. It is chiefly these pen-lines, at any rate, which give the drawing a distinctly 'late' appearance, reminiscent of the gouache sketches which Rubens painted about 1630 of Primaticcio's Gallery of Ulysses (see No. 155).

Since the reworking was probably done at a time when Rubens did not have the original by Titian before his eyes, it is only of academic interest where the painting was at that time. It so happens that about 1620 it had been sold to the Duke of Buckingham. Rubens may have known it when it was still in Venice, and he could of course have seen it again in 1629–30 in England. There is reason to assume that he was familiar with the composition before this trip to England, since recollections of the picture are clearly distinguishable in the Mystic Marriage of St. Catherine of 1628 (*KdK.*305), a painting which Rubens had finished before he left for Spain and England. Titian's painting existed in two school-versions (information given by Mrs E. Tietze-Conrat), and surely also in print, but we should remember, too, that Rubens kept draughtsmen busy copying all the famous works in Italy for him (see Introduction, p.43). (For some interesting details of the purchase of Titian's original—for the sum of £275—and its shipment to England via Turin, Lyons, and Paris, while a newly ordered frame was sent by sea, see I. G. Philip, *The Burlington Magazine*, XCIX, 1957, 155–56.) A drawing is listed in the Crozat collection (*Catalogue*, 1741, No.813) as 'le Christ montré au peuple du Titian'; it came either from the collection of Antoine Triest or of Jabach. It is no longer possible to say whether the New York drawing is identical with that of Crozat's collection, but it is significant that the Crozat sheet is listed among drawings 'dessiné ou retouché' by Rubens.

177 [Plate 171] *(1959: No.54)*

STUDIES FOR ST. GEORGE AND THE PRINCESS

c. 1629 (near the end of the year). Black and red chalk, pen and ink, washed. 348 × 496 mm. The drawing has probably been trimmed at the top. On the reverse of the right half of the paper: Four heads of children, (red chalk, heightened with white, 248 × 348 mm.).
Berlin, Kupferstichkabinett (3997).

LITERATURE Michel, *Rubens*, 429 (reproduced in reverse); J. Rosenberg, 1928, 62; Bock-Rosenberg, *Catalogue*, 252 (Pl. 183–184); L. Burchard, *Catalogue*, Exhibition of the King's Pictures, 1946–1947, 102; *Catalogue*, Exh. London, 1953, No.84; E. Croft-Murray, *The Burlington Magazine*, LXXXIX, 1947, 89–93; P. BJURSTRÖM, *The Art Quarterly*, XVIII, 1955, 27 ff; Burchard-d'Hulst, 1963, No.146; Mielke-Winner, 1977, No.35.

The drawing is a study for the allegorical painting of St. George and the Princess which Rubens painted in London before March 5, 1630 (probably late in 1629). (For another study see No.172.) The painting, which is now in Buckingham Palace (*KdK.*311), was sent to Antwerp by Rubens and was only later acquired from the painter by Endymion Porter, who in turn either gave or sold it to King Charles I.

The genetic history of the painting is complex and has not yet been satisfactorily explained, despite Bjurström's painstaking and sagacious discussion of the evidence. The painting not only has pieces of canvas added at the top and the left, but also has unusually extensive *pentimenti*. The two trees at the left were painted over the figures of a woman and a small child; the same woman can be seen in the Stockholm drawing, which then, clearly, must belong to the first stage of the plan. From the observation that the horseman seen from the back in the Stockholm drawing agrees more closely with the horseman in the picture in London than does the one in Berlin, the conclusion that the Berlin drawing preceded the one in Stockholm is justified.

The two horsemen in the Berlin drawing, one of them repeated on the left half of the sheet, were first drawn in chalk; the other figures in the upper right corner were done directly in pen and ink without any other preparation. In the finished painting the horsemen appear in the same place and similarly related to each other, while the curious onlookers are considerably changed, placed much higher up and in a different order. Bjurström believes that Rubens originally intended the man on horseback to be St. George and that the figure of Charles I as St. George was inserted only later when the artist made the sweeping changes mentioned before; this, Bjurström thinks, happened after Rubens' return, under the influence of the honours which had been bestowed upon him before his departure. The theory does not seem to be very likely; it is based upon a very literal reading of the configuration of the Stockholm drawing; the Berlin drawing, which is still earlier, shows the horseman in question much too concerned for a St. George with whatever horrible sight makes the horses shy, and he is far away from the princess. I believe, therefore, that the 'real' St. George was always meant to be in the place which he occupies today. Bjurström also seems to squeeze too much evidence from the first mention of the picture in a letter by Joseph Mead on March 6, 1630. The expression 'drawing with his pensil' is perfectly compatible in the seventeenth century with the idea of a painting in oil; and the identification of the two main figures with Charles I and Queen Henrietta Maria, first introduced into the literature by Roger de Piles, if at all true, is by no means so striking that Mead would have had to mention it, instead of calling the picture an allegory 'in honour of England and of our nation'. I take the changes in the composition to have been made for purely artistic reasons and not because of a change in the basic meaning of the painting.

The four heads of children (three taken from the same model) were used by Rubens for The Blessing of Peace in the National Gallery, London (see Burchard-d'Hulst, 1963, 229–30; see also Mielke-Winner, 1977, 99–100). The models most likely were children of Balthasar Gerbier, in whose house Rubens lived while in London. (See also No. 178 and 179.)

178 [Plate 175] (1959: No.112)

PORTRAIT OF A YOUNG GIRL

c. 1629–1630. Black, red and white chalk, some accents done in pen and ink on the eyes. 335 × 232 mm. The paper is badly yellowed and the drawing has suffered much from abrasion. Leningrad, Hermitage (5432).

COLLECTIONS Count Cobenzl.
EXHIBITIONS Leningrad, 1940, No.19; Antwerp, 1956, No.110a.
LITERATURE R., V. No.1569; G.-H. No.181; M. Dobroklonsky, 1940, No.23. Burchard-d'Hulst, 1963, No.173; Kuznetsov, 1974, No.121.

The model for this charming drawing was apparently a daughter of Balthasar Gerbier; there is a considerable similarity between the features of the girl in the Leningrad drawing and the daughter of Gerbier who appears at the extreme right in the group of children in the London Allegory of War and Peace (KdK.312), which was painted in 1629–1630. The main difference (and difficulty) is the age of the girl, who looks older in the drawing than in the painting; Rooses, indeed, called the drawing the portrait of a young woman. Since the style of the drawing fits into the period of the London painting, we retain the traditional identification. Balthasar Gerbier (1592–1667), a miniature painter and an adventurer by profession, first met Rubens in 1625 in Paris where he had gone as the agent of the Duke of Buckingham (see No.165). For several years the contact between the two men was fairly close, especially when

Gerbier was employed to represent the English king in secret diplomatic negotiations in which Rubens, too, was involved. During his visit to London, Rubens 'was lodged' in Gerbier's house (Correspondence, V, 62). Yet Gerbier's career declined quickly; his record as diplomat is blackened by opportunism and venality. He travelled much and for a period lived in French Guiana where he had gone on a colonial speculation to recoup his fortunes. It was here that one of his daughters, Catherine, was killed, and another wounded. His surviving daughters ended their lives in deep poverty. (See M.G.de Boer, Oud Holland, XXI, 1903, 129 ff., and R. Oldenbourg in Thieme-Becker's Künstler-Lexikon, XIII, 1920, 444.)

179 [Plate 174]

A WOMAN SEEN FROM THE BACK (DEBORAH KIP?)

c. 1629–1630. Black chalk, heightened with white. 394 × 226 mm. Berlin–Dahlem, Staatliche Museen Preussischer Kulturbesitz, Kupferstichkabinett (KdZ.3236).

COLLECTIONS B. Hausmann, Hannover; acquired 1875.
LITERATURE Bock-Rosenberg, 1930, 254; Mielke-Winner, 1977, No.33.

In the entry he dedicated to this delightful drawing, Winner was fully justified when he removed the doubts about its origins to which Bock and Rosenberg's catalogue had given official sanction. As an informal study from life—perhaps, as Winner thinks, to study the costume more than the model herself—it still lacks a recognizable connection with a larger project. Winner concludes that it may belong to the first studies made for the Garden of Love (Madrid, Prado, KdK.348) possibly for the young woman at the left, for whom Rubens made a much more elaborate study now in Frankfurt (see No.205). Yet he appears to realize that it might have been slightly earlier since his date for the Garden of Love, including all of the preparatory works (Vorarbeiten) is 1631–1633, while this drawing is dated c. 1630 on his caption under the plate. I should like to extend the time-span to a still earlier date, to separate the drawing more decisively from the studies for the Love Garden which I place into the years 1632–1635. In doing this I should like, as Winner did, to call attention to a small detail of fashion. The woman wears a collar which reaches high up at the neck where it is actually touched by the hair. The same kind of collar is worn by the young girl in the drawing in Leningrad (No.178) who is generally assumed to have been one of Balthasar Gerbier's children. Moreover, it is the same kind of collar—though covered by an additional piece of clothing, buttoned in front—that Deborah Kip, the wife of B. Gerbier herself, is wearing in the family portrait in Washington (see W. Stechow, Studies in the History of Art, National Gallery of Art, 1973, 6–22). We know that Rubens stayed with the Gerbiers during his visit to London, 1629–30. Might not the Berlin drawing be a quick sketch of Deborah Kip herself? It has the character of informality which a close domestic association might encourage. Even physiognomically there is enough similarity between the head in the drawing and the one of the group portrait in Washington. Though seen in complete profile, the woman of the Berlin drawing has a similar sharp nose, and the one visible eye is as heavy-lidded as those of the woman in Washington. Moreover, one must not forget that in 1629, when the group portrait presumably was painted, Deborah Kip—though the mother of four children—was still a young woman, having been born in 1601 (Stechow, loc.cit. p.9). Some of the tenderness that Rubens projected into the formal portrait of his twenty-eight-year-old hostess indeed seems to reverberate also in the graceful sketch of the Berlin drawing.

180 [Colour Plate 4]

THOMAS HOWARD, SECOND EARL OF ARUNDEL (1585–1646)

c. 1629–1630. Brush and brown ink, washed, heightened with white body colour; some touches of red. 460 × 355 mm.
Williamstown, MA., Sterling and Francine Clark Art Institute (990).

COLLECTIONS Unidentified 17th century collector;
J. Richardson, Sr. Th. Hudson; sale London, March 24, 1770 (69); Lord Selsey; sale London, June 20–28, 1872; Robert P. Roupell; sale London, July 12–14 1887 (1120); Private Collection, London. Acquired 1926.
EXHIBITIONS Sterling and Francine Clark Art Institute, 1960, No.427; The Tate Gallery, London, 1972, No.44.
LITERATURE G.-H. No.178; Burchard-d'Hulst, 1963, No.170; E. Haverkamp Begemann, S.D. Lawder, C.W. Talbot Jr., *Drawings from the Clark Art Institute*, New Haven-London, 1964, I. No.22; Huemer, *Corpus Rubenianum* XIX, I, 1977, No.5a.

This powerful drawing is a study for the Portrait of the Earl of Arundel in the Isabella Stewart Gardner Museum, Boston (*KdK*.288, there mistakenly called Portrait of Count Henry van den Bergh). Rubens had painted Arundel's wife, Aletheia Talbot, in 1620 (see No.145), her portrait now being in Munich (*KdK*.200). He visited Arundel House in August 1629 and may have drawn the Earl at that time. This may be the pen and ink drawing over black and red chalk (280 × 190 mm.) formerly in the Duchastel-Dandelot collection in Brussels (G.-H. No.226, see also Huemer, *loc.cit.* No.4a). Charles Davis, as quoted by Huemer, believes that that drawing is 'an inked-over counter-proof of a lost chalk drawing', made in preparation of a painting now in the London National Portrait Gallery (Haverkamp Begemann, *loc.cit.* Fig.27). This does not seem to me likely but since the drawing has not surfaced for a long time the question cannot be decided. From the reproduction in Glück-Haberditzl I should prefer to think that it was Rubens' original sketch precisely because of its informality; nor do I see any reason for dating this portrayal '*c.* 1636' as Glück-Haberditzl have done. The Clark drawing, at any rate, is surely not 'a rapid study from life' (Burchard-d'Hulst, p.263) but a compositional sketch made in preparation of the Boston painting.

Another drawing, in Weimar (Huemer, Fig.54) may indeed be a copy after the portrait in the National Portrait Gallery, as has been suggested by Jaffé, but the re-working in ink may have been done by Rubens himself.

For the compositional arrangement of the Williamstown drawing and the Boston painting Rubens was probably inspired by Titian's portrait of Francesco della Rovere, Duke of Urbino, in the Uffizi, Florence (see Held, 'Rubens and Titian', in D. Rosand (ed.) *Titian, His World and his Legacy*, New York, 1982, 283 ff.).

181 [Plate 177]

SERMON IN A BARN

c. 1630. Black chalk with watercolour and gouache; some outlines reinforced with the point of the brush in brown and red. While in parts still unfinished, the drawing has suffered from minor abrasions in others. 422 × 573 mm.
London, Private Collection.

COLLECTIONS Count Nils Bark; Thibaudeau (sale Paris, 1857).
EXHIBITIONS London, 1977, No.203 (not illustrated).
LITERATURE Rooses, V. No.1441. Renger, *Kunstchronik*, XXXI, 1976, 136 ('doubtful').

Although the free use of watercolour, as seen here, is unusual with Rubens, it is not unique. He used it, for instance, in copies

Fig.17. Pieter Angillis (1685–1734): Sermon in a Barn (67.5 × 89 cm). Coll. Professor P. O. Kristeller, New York

he made of Primaticcio's scenes from the life of Ulysses (see Burchard-d'Hulst, 1963, No.163, where six such drawings are listed) and in two other such compositions (now in the Prado, see M. Diaz Padrón, *Dibujos de Rubens en el Museo del Prado*, Madrid, 1977). In terms of its subject matter, however, the drawing stands alone in the master's oeuvre.

In a barn-like structure a congregation, separated by sex—the men at the left, the women at right—appears to be listening to a sermon offered by a pot-bellied minister standing on a pulpit attached to the right wall, with a sound-board placed over his head. The members of the congregation are rendered in various degrees of attention as they stand, sit on benches, or even on the floor. The men—more crowded together than the women—have removed their hats. Several of the women wear broad-rimmed hats (either of straw or felt) though most of them have the head covered with plain white kerchiefs; two dogs stand in the foreground at the left.

The meeting takes place in what clearly is an improvised setting. While the minister wears a beret, he is not dressed in any recognizable ecclesiastic garb. Nor are there any indications that would permit us to recognize the particular denomination of the people here assembled; they are obviously not Roman Catholics. It is not likely that Rubens could have observed a meeting of a protestant sect in Flanders. Since in the 1630s he was only very briefly in Holland (and one trip was in the deep of winter) the most likely country that might have offered Rubens such an opportunity is England, where he arrived in June 1629. The style of the drawing is certainly compatible with such a date. I must leave it to others to investigate whether any details—above all the costumes—bear out such a theory.

Rubens' drawing formed the basis for a painting by Pieter Angillis (1685–1734) in the collection of Professor Paul-Oskar Kristeller in New York (canvas 67.5 × 89 cm.). The painter greatly enlarged the composition by adding middle-class characters standing at the right and left, as if watching the proceedings; there is also what looks like a group of beggars at the right. The setting is more grandly developed, with a vaulted ceiling, an attached column and part of an epitaph (?) on the wall at the right (see Fig.17).

An escutcheon is over the door at the back. The minister is bareheaded, with long curly hair, and his gown is more formal

COLLECTIONS P. H. Lankrink; J. W. Böhler; F. Koenigs.
EXHIBITIONS Amsterdam, 1933, No.124; Rotterdam, 1938,
No.349; Brussels, 1938–39, No.18; Rotterdam, 1939, No.22;
Paris–Brussels, 1949, No.105; Antwerp, 1977, No.167.
LITERATURE G.-H. No.207; Burchard-d'Hulst, 1963, No.174;
Kuznetsov, 1974, No.132.

A particularly tender drawing with a happy distribution of the
colours; all flesh parts are drawn in red chalk, but eyebrows,
pupils, and some shadows near the mouth are in black chalk. By
contrast some red chalk has been used in the hair, which is
preponderantly black. The drawing was dated 1632–1635 by
Glück and Haberditzl and 1632–1634 by Delen; the latter
considered it to be a work from the time of the Garden of Love
(see Nos.205–9). There is, however, a much greater probability
that it was made in connection with the Ildefonso altar
(KdK.325), which Rubens painted between 1630–1632. Even in
the finished version the young saint standing at the left in the
central panel has a very similar position of body and head,
though the hands are different; in the Leningrad sketch,
however, the same woman, seen from the side, holds her hands
in front of her body, the left hand crossing the right as it does in
the drawing. It is therefore likely that Rubens made the
Rotterdam drawing after the sketch, when he had decided on a
frontal position, but before he had adopted the *Pudicitia* motif
for her right hand. (For other drawings surely made for the
Ildefonso altar see G.-H. Nos.194–196—all of which were cut
out from larger sheets. This may have been done at an early
date.)

193,194 [Plates 184, 185 and frontispiece] *(1959: No.57)*

STUDIES FOR A KERMESSE

c. 1630–1632. Black, and a few traces of red, chalk, reworked in
pen and ink. 502 × 582 mm.
On the reverse: Dancing Peasants.
London, British Museum (1885.5.9.50).

COLLECTIONS J. Richardson, Sr.; Sir Thomas Lawrence [?]; W.
Russell.
EXHIBITIONS London, 1977, No.178.
LITERATURE R., V. No.1488; Hind, *Catalogue*, No.33; G.-H.
No.236, 237; Delacre, *Van Dyck*, 223–224; Evers, I. 244–248,
note 209; Burchard-d'Hulst, 1963, No.150; Kuznetsov, 1974,
Nos.110, 111, 112.

Inscribed near the lower centre: 'Hier ghebreken Bedelaers
mede . . . vrouwen mans ende Kinderen' (Here lack beggars
with . . . women, men, and children); Hind read the two words
after 'Bedelaers': 'daer comen' (there come) which does not
seem to be borne out by the evidence. Above the head of the
man in the upper right corner: 'vrolyk'[?] (gay); near, and on,
some figures in the upper right: twice 'root' (red), once 'blauw',
'geel', 'viol' (blue, yellow, purple).

The drawings on both sides of the sheet are studies made in
connection with the Flemish Kermesse in the Louvre
(KdK.406). (For good details of that painting see J. Dupont,
P. P. Rubens, La Kermesse Flamande, Brussels–Paris, 1938). The
relationship of these drawings to the finished picture has been
discussed by Evers (*loc.cit.*) and by H. Robels (*Rubens und die
Tradition*, unpublished dissertation, Cologne). Evers' presenta-
tion suffers from his insistence on a date of 1620–1623 for both
the drawings and the painting. The Louvre painting admittedly
has some puzzling aspects for a painting of the last decade,
particularly as regards the landscape; yet the treatment of the
landscape is difficult to associate with Rubens' manner of
painting at any time, and though it may be strange in a
composition to which Rubens evidently gave much thought,
the possibility that parts of it were painted by an associate

should not be rejected lightly. Glück seems to have thought of
Saftleven in connection with this picture (*Essays*, 94), although
he does not say outright that it was he who might have painted
the still-life in the foreground. The connection with Saftleven
has been strengthened by the discovery (made by L. Burchard)
of a painting of farm life in which Rubens and Saftleven
collaborated—as we know they had done, from the inventory
of Rubens' estate (see Exh. Rotterdam, 1953, No.80; a repro-
duction in colour was in *The Burlington Magazine*, XCVI, 1954,
Plate I; see also No.184). Whatever the facts of the case, the date
of 1620–1623, given by Evers, seems to me untenable as far
as the figures are concerned; they are painted in a broad pictorial
style, with bold, yellow highlights for which there is no
analogy in works so early. The very late date, however, which
has traditionally been given to the Louvre painting (1635–1638)
is equally questionable; there is still too much solidity in the
figures and compactness in the composition. A date around or
soon after 1630 would seem best to fit the facts of the case; it is
perhaps not without significance that Rubens' contacts with
Saftleven appear to have taken place just about that time.
The London drawing is a typical working sheet in which
Rubens sketched individual figures and groups without regard
to their place in the ultimate composition. Thus he drew the
dancing group twice in the lower half; the man sprawling on the
ground appears near the upper left as well as towards the centre
right edge. There are also two studies of peasants helping a
seated man to stand. The main motif of the sheet is a table
placed diagonally. It appears first in the upper left corner, where
the preliminary chalk lines remained visible; a second time it
was drawn further down on the same side of the sheet, now
surrounded by many figures. The rather dense arrangement of
tables in the upper right half is probably Rubens' third thought,
most of which was again abandoned when he painted the
picture. In the drawing all the figures, as Evers correctly
observed, are seen much more from above 'as if drawn from the
upper floor of an inn, rather similar to the old Bruegel' (*loc.cit.*,
246). In the painting the viewer is more or less on the same level
with the frolicking crowd.
Nevertheless, a number of poses and groups of the drawing
were taken over into the Paris picture: the dancing group seen in
the foreground of the London drawing reappears with only
minor changes far back at the right in the Louvre painting. The
two men in the lower left who shake hands while one gives the
other a tall tankard were moved further inward, and the receiver
of the drink was changed into an elderly man. Rubens kept in
the composition the men who slump over the table and a group
of three seated figures who, in the drawing, are seen to the left
behind a [pregnant?] woman standing alone in the right upper
half of the sheet. He also introduced in the background, near the
entrance to the inn, the man who leans away from the table to
offer a drink in his outstretched right hand to an approaching
figure a few paces away.
Some of the dancing couples on the reverse were also incor-
porated into the design by Rubens, in a free order. The two
pairs whose movements he sketched twice in the lower left
corner of the drawing appear in the centre of the painting,
below the musicians, but their sequence is reversed. The couple
following them at the right in the Louvre panel was derived
from the sixth pair in the upper right of the drawing. The pair
next to them near the right edge of the drawing became the
most prominent group of dancers in the painting, above the
foraging dog. Other dancers in the drawing recur with vari-
ations in the painting, but Rubens without doubt must have
drawn at least one other such study sheet, and possibly several.
There are too many figures and groups in the painting for which
there are no equivalents in the London drawing, such as the
group of beggars and the passionate lovers in the foreground,
and several dancers.
The London drawing and the Louvre painting anticipate, in

some of their pairs, the three dancing couples from the Feast of Venus Verticordia in Vienna (KdK.324). The central pair in that canvas was developed from the dancers in the lower left corner of the drawing and its equivalent in the Paris painting. The group of the Satyr lifting a nymph into the air is found at the left end of the row of dancers in the Paris picture, though nowhere in the drawing. The idea for the third pair is roughly outlined in the first pair of the drawing, but it may have been further developed in a drawing no longer preserved.

Many authors have observed that Rubens was indebted to Bruegel for individual ideas of the picture, if not the very subject itself. Yet other influences seem to have been absorbed into the Louvre picture. Some figures can be traced back to German woodcuts of the Renaissance, especially H. S. Beham, as has been noticed by Miss Robels (loc.cit.) and, independently, by Miss E. Hering. Miss Hering also observed a striking connection with a lost painting by Brouwer that Rubens owned (Denucé, Inventories, 68, No.283), the design of which has been preserved in a copy by M. van den Bergh (E. Bock–J. Rosenberg, Catalogue, 82, No.133, Pl.66). As long as the date of the Kermesse is uncertain, it is difficult to say which of the two pictures came first. A date ante quem for Rubens' painting, to which Rooses called attention, is not very helpful in this particular problem. Rooses (Vol. I, 129 ff.) mentioned that 'two Flemish weddings' by Rubens were listed in an inventory of 1636. Since the Louvre painting was referred to as 'Noce de Village' in 1684 (R., IV, 71), it is quite possible that it was one of the two pictures mentioned in 1636, and must, therefore, have been painted before that date. The London drawing—or one like it—may be identified with a drawing listed in the inventory of the estate of Erasmus Quellinus (March 22, 1679, see Denucé, Inventories, 286) as 'Boeren ende Boerinnen, crab-belinge, Rubbens' (peasants and peasant-women, quick sketch, by Rubens).

195,196 [Plates 186, 187] (1959: No.60)

WOMEN HARVESTING

c. 1630–1635. Two sheets in black, red, and white chalk, the outlines of one figure in each leaf gone over in pen and ink. (a) 216 × 257 mm.; (b) 181 × 207 mm.
Edinburgh, National Gallery of Scotland (R. N. 1490 and 1500).

COLLECTIONS P. H. Lankrink (a); P. Sandby; D. Laing.
EXHIBITIONS London, 1938, No.588; Rotterdam, 1948–49, No.137; Brussels/Paris, 1949, No.104, (109); Leicester, October, 1952; Antwerp, 1956, Nos.102–103; London, 1977, Nos.193, 194.
LITERATURE One drawing (b) reproduced The Burlington Magazine, XCI, 1949, 139, Fig.15; Burchard-d'Hulst, 1963, Nos.153, 154; Kuznetsov, 1974, Nos.142, 143; W. Adler, Corpus Rubenianum, XVIII, 1, 1982, Nos.78, 79; K. Andrews, Catalogue of Netherlandish Drawings in the National Gallery of Scotland, I, 1985, 70–1.

The larger drawing (a) inscribed in pen, by a later hand, 'Rubens'. On the smaller drawing (b) also a later inscription, 'Rubens', and above the figure of a woman bending down, the word 'blauw' (blue), probably written by Rubens himself.

There are eight women on the larger drawing, four on the smaller one. They all are occupied in various ways with the preparation of sheaves, presumably of wheat. Most of them have a few stalks which they twist in their hands so as to make a primitive 'rope' with which they tie the sheaves. One woman in the lower right of (a) is actually tying a sheaf, while others pick up the bundled sheaves and carry them away.

The studies in these drawing give the impression of having been made from life, perhaps for a painting of a harvest scene. Rubens may have known Bruegel's Harvest (Metropolitan

Museum, New York), where a figure rather similar to the one in the lower right of (b) can be seen, and he may have planned a painting like that. It can be inferred that he knew another of Bruegel's series of months (Castle Raudnitz), from his Return from the Harvest in the Pitti Gallery, Florence (KdK.405). (This picture has a very interesting pentimento of a big hay-wain in the centre of the composition which was replaced by a herd of sheep moving in the opposite direction.)

The only paintings known to me that contain similar figures—if only small in the background—are the Landscape with Castle Steen in London (KdK.404) and the Return from the Harvest in Florence. In the latter there is indeed one woman picking up a sheaf of wheat, whose pose is almost identical with that of the woman in the upper right of (b), though in reverse. Since both these paintings belong to the 1630's, a date of after 1630 is suggested for the drawings. Burchard-d'Hulst (Catalogue, Exhibition Antwerp, 1956) dated the drawings c. 1627–1628; in 1963 they, too, seem to have considered a later date.

197 [Plate 190]

FARMHORSE WITH RIDER

1630–1635. Black and white chalk on greyish paper; some red chalk on face and hand. 263 × 348 mm.
Copenhagen, Kongelige Kobberstiksamling (256) (Tu 59, no.11).

COLLECTIONS J. C. Spengler.
LITERATURE Held, Master Drawings, XII, 3, 1974, 256–7.

Although classified—with a question mark—as by Saftleven, both J. Q. van Regteren Altena and J. van Gelder had noted on the mat that the drawing might be Flemish. The drawing, indeed, is comparable to the many studies of single figures that occupy such a central place in Rubens' oeuvre. It shares with them the assured concept of form, the energetically and quickly drawn layers of shading, and the economic handling of outline. The left hand of the rider, to mention one detail, is drawn with a few firm lines which nevertheless record accurately how the reins are held between index and middle finger. The trappings are drawn without hesitation, with an understanding of their function that bespeaks the draughtsman's familiarity with such things.

Dating the Copenhagen drawing, nevertheless, is not easy. In so far as we know Rubens' oeuvre at present, the study was not used in any of the master's paintings of rural subjects. Nor is there any other study completely analogous to it. Although some aspects of the drawing are reminiscent of the earlier group of Rubens' studies from life—mainly from between 1615 and 1620—I favour a date in the 1630s when Rubens' curiosity in things rural was kindled again. I find its loose, relaxed style, the almost casual and yet beautifully controlled manner of drawing, more akin to the few drawings of country subjects from the 1630s (Nos.195, 196, 198) than to the earlier ones (Nos.105, 109, 110, 111, 113–120), with their tighter definition of form and their tendency to dramatize these subjects. Rustics astride horses are indeed encountered fairly frequently in late land-scapes, and they generally sit on the same kind of primitive saddle we see here. The best known examples are found in the Landscape with Castle Steen (London, KdK.404) and the Return from the Fields (Florence, Pitti Palace, KdK.405). These horse-men always carry a rod or a short whip, as does the model in the Copenhagen drawing.

198 [Plate 189] (1959: No.117)

A PEASANT WOMAN, WALKING

c. 1630–35. Black and red chalk, on light brown paper.
266 × 144 mm. (The red chalk only appears on the skirt, where it is not covered by the apron.)
Florence, Uffizi (Santarelli 8439).

COLLECTIONS E. Bouverie; J. C. Robinson; E. Santarelli.
EXHIBITIONS Antwerp, 1956, No.105.
LITERATURE E. Santarelli, *Catalogo della Raccolta de Disegni Autografi Antichi e Moderni*, Firenze, 1870 (p.561 'Figura di donna in piedi'); M. Jaffé, *The Burlington Magazine*, XCVIII, 1956, 321; Burchard-d'Hulst, 1963, No.152; Kuznetsov, 1974, No.109.

Although not very large as Rubens drawings go, this little known sheet is of striking monumentality. There are not enough drawings of this kind known to allow a precise dating. Nor is there a figure exactly like this in any of Rubens' paintings or engravings. The nearest in pose is a figure of a woman near the right edge in the landscape 'Winter' at Windsor Castle (*KdK.*238), which was probably done around 1620. The connection is not close enough, however, to establish the drawing as a study for that picture. Its style, at any rate, with its seemingly coarse and bold lines and its summary treatment of detail is more comparable to drawings of the 1630's. See also No.197.

199 [Plate 192] *(1959: No.116)*

A YOUNG WOMAN HOLDING A TRAY

c. 1630–1633. Black, red and white chalk. 468 × 300 mm.
Paris, Fondation Custodia, Collection Frits Lugt.

COLLECTIONS J. de Vos Jbzn.; P. Langerhuizen (not E. Wauters, as in G.-H.).
EXHIBITIONS London, 1927, No.560; Amsterdam, 1933, No.127; Brussels, 1939, No.58; Rotterdam, 1939, No.54; London–Paris–Bern–Brussels, 1972, No.84; Antwerp, 1977, No.162.
LITERATURE G. Glück, *Die Graphischen Künste*, XLVII, 1924; 1; G.-H. No.212; Glück, *Essays*, 178 and 398 (L. Burchard); Burchard-d'Hulst, 1963, No.176.

Glück (*loc.cit.*) observed that this figure appears in a composition which we know from three painted versions, and from a mezzotint by R. Earlom of one of them. The history of this composition, however, is more interesting than Glück assumed. The first stage is represented by a sketch in the collection of Baron E. Descamps, Brussels (Held, 1980, No.301). It shows a kitchenmaid, and a boy on a table, at the left, and a man, perhaps a cook, at the right. The centre is left free, to be occupied by a large still life by Snyders. It is quite possible that the sketch was made to give Snyders a general idea of the position and pose of the figures, so that he could go ahead and paint the main subject, the figures to be added later. Before that stage, Rubens made the present drawing to give the figures the precision that comes from the study of a living model. In the end two pictures were painted with still lives by Snyders, one using as staffage the boy and the maid at left, the other the man at the right. Of the latter composition one version is in the Hermitage in Leningrad; another was sold in Paris, June 6, 1952. Whether Rubens himself painted the figures into the first version of Snyders' painting (the one rendered in Earlom's print, which was last in the collection of the Marquis of Bute), I cannot say, since I have never seen the painting. Neither Glück nor Burchard apparently thought so; Glück attributed the figures in this as well as in the version formerly belonging to Count Hemricourt de Grunne in Brussels (now in the collection of the Marquis du Parc Locmaria) to Jan Boeckhorst. The third version is now at the Getty Museum in Malibu; the figures are almost certainly by Boeckhorst.

The pose of the maid in the drawing is rather different from the one in the sketch; the whole figure is more monumental and more dignified. These changes were still further stressed in the paintings, where the young woman was given a lace cap and a

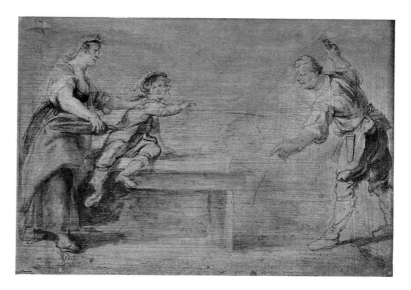

Fig.18. Kitchen Scene. Oil-sketch. Coll. Baron E. Descamps, Brussels

kerchief over her shoulders. Even within the drawing one can distinguish two stages, especially noticeable in the design of the right sleeve.

200 [Plate 191] *(1959: No.114)*

HÉLÈNE FOURMENT, RUBENS' SECOND WIFE (1614–1673)

c. 1630–1632. Black, red and white chalk, pen and ink, washed. 612 × 550 mm. The paper has been cut along the outlines of the figure.
London, Princes Gate Collection, Courtauld Art Galleries.

COLLECTIONS Prince Charles de Lorraine; Comte de Cuypers; Schamp d'Averschoot; Robert Stayner Holford; Sir George Lindsay Holford; Count A. Seilern.
EXHIBITIONS Burlington Fine Arts Club, London, 1921–22, No.28; London, 1927, No.570; London, 1977, No.155.
LITERATURE G. F. Waagen, *Treasures of Art in Great Britain*, London, 1854, II, 204 ('animatedly and cleverly conceived, and grandly sketched'); A. M. Hind, *Vasari Society*, 2. series, III, 1922, No.8; G.-H. No.234; A. J. J. Delen, 1950, No.20; A. Seilern, *Catalogue*, 102, No.64; Burchard-d'Hulst, 1963, No.201; Kuznetsov, 1974, No.105; H. Braham, *The Princes Gate Collection*, London, 1981, No.147.

According to the Catalogue of the Holford Sale (Christie's, May 17–18, 1928, No.3), a strip of paper is attached to the back of the drawing with this inscription: 'Hélène Fourment, fille de Daniel et de Claire Stappaert, deuxième femme du fameux Pierre-Paul Rubens, laquelle épousa en seconde noce Jean-Baptiste Brouchover, dont ample posterité. Petrus P. Rubens Fecit'.

While holding a little prayer-book in her left, gloved hand, with the right Hélène removes a mantle, the so-called 'heuke' from the high pompon of her skull-cap. The action of the right hand is a free variation on a classical motif ('Pudicitia') which Rubens used and varied many times throughout his career.

The costume resembles that worn by Hélène in the Munich portrait (*KdK.*328); she wears the skull-cap in the portrait of the A. de Rothschild collection, now in the Louvre, in Paris (*KdK.*425), a picture probably done several years later (see Evers, I, 446 ff.). The chain and brooch (with its single square stone) are very much like those worn by Susanne

Fourment, Hélène's sister, in the full-length portrait in the Gulbenkian collection (*KdK*.329), which dates from the same period.

The portrait in the Princes Gate Collection is the most elaborate drawing of this kind by Rubens known to me. The artist may have done it without any painting in mind as an 'independent work of art' (Count Seilern); yet it is nevertheless likely, that the genesis of the De Rothschild portrait is linked with it. Since it has been shown that the latter was originally planned as a half-length figure (Evers, *loc.cit.*), the connection with the Seilern drawing becomes even more striking. Count Seilern dates the drawing 1635–1638, judging from the 'apparent age of the sitter'; this seems to me too late.

201 [Plate 193] *(1959: No.115)*

PORTRAIT OF HÉLÈNE FOURMENT

*c.*1630-1632. Black, white, and a little red chalk, on foxed paper. 488-320 mm. (charcoal on collar?). Mounted on thick paper.
Rotterdam, Museum Boymans-van Beuningen (V.45).

COLLECTIONS G. Huquier; Graf Moriz von Fries; Sir T. Lawrence; J. P. Heseltine; F. Koenigs; D. G. van Beuningen.
EXHIBITIONS London, 1835, No.38; Antwerp, 1927, No.3; Amsterdam, 1933, No.121; Brussels, 1938–1939, No.17; Rotterdam, 1938, No.348; Rotterdam, 1939, No.20; Paris–Brussels, 1949, No.104.
LITERATURE *Rubens Bulletin*, V, 329, No.1505; G.-H. No.193, Evers, I, note 460.

Study for the so-called 'Portrait of Hélène Fourment in her Bridal Gown' in Munich (*KdK*.328). The Munich portrait has all the characteristics of a formal portrait, but there is no reason to assume that it is a record of Hélène's appearance at the wedding. The changes which Rubens made from the drawing to the painting are instructive with regard to the creation of official portraiture. Without sacrificing the impression of informality, Rubens gave dignity and weight to the figure. Both arms spread farther sideways, resting on the arms of the chair (in the drawing the chair is armless); the dress was enriched by a brocaded pattern, and instead of the soft, plain collar of the drawing, in the painting there is a stiff, semi-circular lace collar which acts as a splendid foil for the head; the flower in the hair, the jewelled pendant, and the gold chain, as well as the conspicuous display of the ostrich feather, correspond to the sumptuous setting with its columns and balustrade, the carpet and the curtain; and instead of the girlish wistfulness of expression which marks Hélène's features in the drawing, she appears in the Munich painting as a mature, nubile young woman.

202 [Plate 197]

A YOUNG WOMAN SEATED

c. 1630–1635. Black and red chalk. 509-410 mm.. Inscribed at bottom: P. P. Rubbens delin.
Present Location unknown.

COLLECTIONS Sir John Leslie Bt.; F. Koenigs. (Sold during World War II and since disappeared.)
LITERATURE G.-H. No.102; Evers I, note 460.

Glück-Haberditzl believed that this drawing, like the previous number, was a study for the Munich portrait of Hélène Fourment 'in her bridal gown'. Evers questioned this view, as I believe correctly, but he, too, thought that it portrayed Hélène. Even this identification, however, seems to me to be questionable. The frail beauty of the model and her slender proportions preclude it from being one of the later portraits of Hélène, who

seems to have developed very quickly in her marriage the sensuous expression and large proportions known from many pictures. Nor does it seem likely that it is a drawing of her at the time of her marriage—or possibly even shortly before—since the features are hardly those of a girl fifteen or sixteen years old. Th. Bodkin (*Catalogue of the Paintings, Drawings and Miniatures in the Barber Institute of Fine Arts, Birmingham*, Cambridge, 1952, 192) indeed calls the model for this drawing Susanne Fourment, though this view is also unconvincing. The drawing was used by Rubens, together with the drawing G.-H. No.201 and a much reworked one of a girl with a hat in Birmingham for a grisaille sketch, now in the collection of A. de Meester, Hoeleden, Belgium (see Held, 1980, No.334, Plate 332). The sketch was engraved anonymously (V.S. p.69, No.39, in the Albertina, Vienna VII, fol.54) and by Maria Cosway (R. V, 325).

203,204 [Plates 195,196]

THREE YOUNG LADIES ACCOMPANIED BY PUTTI

c. 1630–1635. Black and red chalk, washed in brown, 282 × 250 mm.
The sheet is irregularly damaged along the left side.
On the reverse: Several studies for a group of the *Three Graces*, done in the same technique.
Warsaw, Print Room of the University Library (zb.d.451)

COLLECTIONS Society of the Friends of Science, Warsaw.
EXHIBITIONS Antwerp, 1956, No.144; Antwerp, 1977, No.172.
LITERATURE Z. Batowski, *Zbior graficzny w Universytecie Warsjawskim*, Warsaw, 1928, 15, 37, 44, 55, 87, Pls.40–41; Burchard-d'Hulst, 1963, No.205; M. Jaffé, 'Rubens Drawings in the Warsaw University Library', *Bulletin du Musée National de Varsovie*, XVII, 1976, 83–97; S. Sawicka and M. Mrozińska, ed., *Rysunki szkól obcych w zbiorach polskich*, Warsaw, 1976, No.58, 28; Held, 1980, 412 (under No.302); Julius Chróścicki, 'Rubens w Polsce', *Roznik Historii Sztuki*, XII, 1981, 197–9.

While there is obviously a close connection between the triad of young women on the recto of this sheet and the traditional theme of the *Three Graces* on the verso, one cannot automatically transfer the meaning of the latter to the configuration of the former, unless metaphorically. That there is an analogy of which Rubens was surely conscious need hardly be emphasized. The context in which the recto of the drawing ought to be read is made still clearer in an oil sketch for which the Warsaw drawing served as a first formulation. That sketch is in the Museo d'Arte Antica at the Castello Sforzesco in Milan (Held, 1980, No.302, Pl.302). It also depicts the three elegantly dressed young ladies, accompanied and apparently led by three putti, while a fourth one, flying in front, pulls at the veil of the nearest to him, and another, hovering above, holds a wreath over the head of the one in the centre. The one in the middle seems indeed to be favoured slightly over her companions, in the Warsaw drawing as well as in the Milan sketch. Yet the suggestion, made by Burchard and d'Hulst (p.328) that the subject 'may well be Psyche and her sisters' 'whom the putti (symbols of Cupid) try to tear away' (!) is clearly way off base, and has been rejected by me in 1980 in my commentary on the Milan sketch: 'The gist of the story of Psyche and her sisters as told by Apuleius, is the single-minded envy and hatred felt for Psyche by her two sisters, who are bent on ruining her, and her happiness. In Rubens' drawing, and even more so in the Milan sketch, the entire stress is on harmony and mutual trust, and the cupids are equitably distributed among them. It is inconceivable that Rubens would ever have so completely missed the character of a story.'

The conscious use of contemporary, and clearly fashionable dress of the young ladies, while surely excluding a mythological subject, links these works to the theme of the Garden of Love which occupied Rubens in the early 1630s (see also Nos.205-9). Its best-known formulation is the canvas in the Prado (*KdK*.348) where three elegant young ladies, also accompanied by putti but not associated with any cavalier, sit in the centre; moreover, there, too, one of them—looking out of the picture—is clearly favoured over the two others, hardly a surprising fact since she is the only one in the entire painting who can reasonably be claimed to be a portrait of Hélène Fourment, Rubens' young wife (see No.205).

For the Three Graces on the verso Burchard and d'Hulst developed an elaborate genetic scenario which contributes little to our understanding and fails to consider that the sheet may have been originally much larger, especially to the right. They correctly, however, linked the drawing to the painting of the *Three Graces* in the Prado (*KdK*.434) where the Grace seen from the back corresponds closely to the same figure in the Warsaw drawing. The same pose, though in reverse, also appears in the fragmented sketch of the *Three Graces* on a sheet of paper which Mars tramples underfoot in the painting known as *The Horrors of War* in the Pitti in Florence, a detail the significance of which I first pointed out in 1959 (see above, p.25 and Fig.4). For the meaning of the theme of the *Three Graces* in Rubens' work, see Held, 1980, 328, under No.240.

205 [Plate 198]

A YOUNG WOMAN STANDING, SEEN IN PROFILE

c. 1632–1633. Black and red chalk, heightened with white. 563 × 317 mm. The original sheet has been cut close to the figure and laid down on a larger piece of paper.
Inscribed on that sheet, with ink; P. P. Rubens.
Frankfurt, Städel'sches Kunstinstitut (846).

LITERATURE R. V. 1481; G.-H. No.197; Glück, *Essays*, 105, Fig.58; Burchard-d'Hulst, 1963, 282, under No.181.

This is one of the magnificent group of nine large studies for individual figures of the Conversation à la Mode (the so-called Love-Garden) in the Prado in Madrid (*KdK*.348) and possibly the first one Rubens made, intended for the young woman at the extreme left whom her gallant leads gently to join the company. It would seem natural that Rubens began with this figure before he studied the relationship to the young man, worked out in the following drawing. Moreover, all the other figures, in so far as drawings have been preserved, seem to be sketched somewhat more boldly and expansively, as if the master had loosened up in the course of the work. In the painting in Madrid Rubens turned the figure slightly more inward and made some changes in her costume, but he followed the drawing somewhat more closely when he drew the same group in the large sheet for the woodcut by Christoffel Jegher (see below Nos.210, 211).

Except for the woman in the centre, seated on a low stool and looking at the beholder and the one singing behind her at the right, there is a drawing for each of the principal figures; there are even two for the woman seated on the ground, who rests her elbow and hand on the leg of a cavalier. Four of the nine drawings are in the Museum Fodor in Amsterdam (three of them illustrated here: Nos.206, 208, 209); two are in the Louvre (No.207) and one in Berlin (G.-H. No.200). The ninth, formerly in the F. Koenigs collection in Rotterdam (G.-H. No.203) has been sold and its present whereabouts is unknown. While the Love-Garden theme surely reflects a range of reflections and feelings engendered in Rubens during the early years of his marriage to Hélène Fourment, I see no reason to assume—as some authors have done (for instance Lugt, Evers

and Delen)—that Hélène posed for every one of the women in the Prado canvas. Least of all can I accept the frequently found assertion that the young woman at the left, prepared in the Frankfurt drawing, is a portrait of Hélène (and that Rubens himself is the man next to her). There is however a good possibility that the young woman sitting in the centre and looking out at the beholder (and also, we should keep in mind, at the painter who was engaged in the work) is a portrait of Hélène (for this identification see below, Nos.210, 211, and Held, 1980, under No.296).

In 1956 (*Catalogue*, Exhibition Antwerp, No.102 ff.) Burchard and d'Hulst assigned the date of 1631 to the Madrid painting and by implication to all the drawings made for it. However, in 1963 they rejected this view and claimed that the large studies in chalk were made in the preparation for the woodcut by Jegher (see Nos.210, 211) and that the work for the woodcut preceded that of the canvas in the Prado. Going still further, they also expressed their conviction that the Garden of Love of the James Rothschild collection at Waddesdon Manor, Bucks (*KdK*.349) was Rubens' first version and undoubtedly an original from his hand, dating from 1630–1632. Since they expressly state that the preparatory drawing for the woodcut dates from 1632–1633 (which must then be approximately the date also for the single studies made for that work); they arrive at the incomprehensible position that after Rubens had painted most of these figures in his 'first' version (Waddesdon Manor) he still felt compelled to make large single drawings for most of them to be used for a woodcut. Although opinions about the Rothschild Garden of Love differ (there have been as many adverse opinions as positive ones) what should be undeniable in my view is that neither that picture nor the one in Madrid could have been painted prior to the nine drawings here discussed, and that studies of that size, technical complexity and colouristic wealth were invariably made in the preparation of paintings and never of prints.

206 [Colour Plate 6] *(1959: No.120)*

A YOUNG COUPLE

c. 1632. Black, red and white chalk on light brown paper (Watermark: Elephant). 322 × 300 mm.
Amsterdam, Fodor Collection, Gemeente Musea (185).

COLLECTIONS T. Hudson; Sir Thomas Lawrence; King William II of Holland; C. J. Fodor.
EXHIBITIONS London, 1835, No.46; Amsterdam, 1933, No.128; Brussels, 1939, No.37; Rotterdam, 1939, No.55; Paris, 1949, No.91; Antwerp, 1956, No.122; Antwerp, 1977, No.164.
LITERATURE R., V. No.1486; G.-H. No.198; Glück, *Essays*, 104–105; A. J. J. Delen, 1950, No.13; Burchard-d'Hulst, 1963, No.181; Kuznetsov, 1974, No.129.

Study for the couple standing at the left in the *Conversation à la Mode* in the Prado in Madrid (cf. Nos.207–9). The young man who appears beardless in the drawing is bearded in the painting, but the identification of the painted figure with Rubens himself, supported by Glück, Evers, and others, is not convincing. For a possible connection with Holbein see above, No.2.

207 [Plate 201] *(1959: No.118)*

A YOUNG WOMAN WITH OSTRICH FAN

c. 1632. Black, red, and white chalk; a few ink lines on dress; paper darkened from exposure. 538 × 347 mm.; a piece cut off at upper right.
Backed.
Paris, Louvre, Cabinet des Estampes (20.196).

COLLECTIONS J. Barnard.
EXHIBITIONS Brussels, 1938–1939, No.42; Rotterdam, 1939, No.60; Paris, 1978, No.25.
LITERATURE R., V. No.1477; Michel, 436, Pl.xxxv; Glück, *Essays*, 106, Fig.64; G.-H. No.204; Mme. J. Bouchot-Saupique, *De Kunst der Nederlanden*, 1930, I, 88; Lugt, *Catalogue* No.1023; Burchard-d'Hulst, 1963, No.182; Kuznetsov, 1974, No.131.
Engraved (facsimile): Alphonse Leroy, in F. Reiset and F. Villot, *Collections de Dessins originaux*, No.71.

Study for the last woman at the right in the *Conversation à la Mode* in the Prado in Madrid (*KdK*.348). Lugt has already noted some of the differences (the absence of the collar in the painting and the fan raised higher), but there are others of equal importance: in the painting the woman's head is lifted higher and turned into a completely profile view; moreover, her features and her hair-style are greatly altered; they accord with a head in the collection Schlichting in the Louvre (Glück, *Essays*, 139, Fig.85) in which Glück recognizes a portrait of Susanne Fourment.

208 [Plate 199] *(1959: No.121)*

A YOUNG WOMAN, KNEELING

c. 1632. Black, red, and white chalk on light brown paper. 403 × 474 mm.
Amsterdam, Fodor Collection, Gemeente Musea (184).

COLLECTIONS Sir Thomas Lawrence; King William II of Holland, C. J. Fodor.
EXHIBITIONS Amsterdam, 1933, No.133; Brussels, 1938–1939, No.40; Rotterdam, 1939, No.57; Helsinki–Brussels, 1953, No.37; Antwerp, 1956, No.125.
LITERATURE R., V. No.1479; G.-H. No.201; Glück, *Essays*, 105 (Fig.61) and 386; A. J. J. Delen, 1950, No.16; Burchard-d'Hulst, 1963, No.184; Kuznetsov, 1974, No.130.

Study for the young woman crouching at the left near the seated cavalier in the *Conversation à la Mode* in the Prado, Madrid (cf. Nos.205, 206, 207, 209). Rubens drew the figure a second time in a more upright position (G.-H. No.202). He seems to have been very fond of this particular pose as it appears repeatedly in his work, for instance in the Rape of the Sabines, London (*KdK*.379), in an Entombment which is known from three versions, none of them authentic (see Held, 1980, No.367) and from an engraving by Witdoeck (v.d. Wijngaert, No.761). A young man in a very similar pose also appears in Otto Van Veen's Calling of St. Matthew, Antwerp, Musée Royal des Beaux Arts, No.480. Yet the invention of the rather coy pose should probably be credited to Rubens, since he used it in a painting that was almost certainly painted before that of Van Veen, the Massacre of the Innocents, Brussels, Musées Royaux des Beaux-Arts, No.682. This picture, long attributed to Sallaert, was ascribed to Rubens by G. Glück (*Annuaire des Musées Royaux des Beaux-Arts de Belgique*, I, 1938, 151 ff.) but declared to be a studio replica by Norris (1940). It belongs to Rubens' first works and dates, if not from the period before his trip to Italy, at least from the first years of his stay there.

209 [Plate 202] *(1959: No.119)*

A YOUNG MAN, WALKING

c. 1632. Black, red and white chalk on light brown paper (Watermark: Elephant). 561 × 415 mm.
Amsterdam, Fodor Collection, Gemeente Musea (183).

COLLECTIONS Sir Thomas Lawrence; King William II of Holland; C. J. Fodor.
EXHIBITIONS London, 1835, No.47; Amsterdam, 1933, No.129; Brussels, 1938–1939, No.43; Rotterdam, 1939, No.61;

Paris, 1949, No.92; Antwerp, 1977, No.166.
LITERATURE R., V. No.1483; Muchall-Viebrook, No.21; G.-H. No.205; Glück, *Essays*, 106, Fig.65.

Study for the young man at the extreme right in the *Conversation à la Mode* in the Prado (see Nos.205–8). He was not used in Jegher's woodcut nor in the drawing for it (Nos.210, 211).

210, 211 [Plates 203, 204] *(1959: No.152)*

THE GARDEN OF LOVE ('CONVERSATION A LA MODE')

c. 1632–1634. Pen and ink, washed, touched up with indigo, green, and white, over black chalk. On two sheets of paper, each 480 × 710 mm.
New York, Metropolitan Museum of Art (58.96.1; 58.96.2).

COLLECTIONS J. Ph. Happart(?) (both sheets); De Thiers (one sheet); P. Crozat (one sheet); P. J. Mariette; Jan Gildemeester; H. van Eyl-Sluyter, Earl of Aylesford; J. C. Robinson; Lord Leverhulme; Lady Lever Art Gallery, Port Sunlight.
EXHIBITIONS London, New Gallery, 1899–1900; London, 1950, No.46–47; Antwerp, 1956, No.128; London, 1977, No.172.
LITERATURE Mariette, *Abecedario*, v, 135; C. Josi, *Collection d'imitations de dessins*, London, 1821; R., V. No.1322; H. Hymans, *Gazette des Beaux-Arts*, 1894, 84; Rooses, *Rubens Bulletin*, v, 1900, 199; Rooses, 1904, 335, 589; Glück, *Essays*, 115; 386 (L. Burchard); *Catalogue, Lady Lever Art Gallery, Port Sunlight*, 1928, Nos.257–258; L. Burchard in Cat. Exh. London, 1950, 53–55; Ch. Norris, *Burlington Magazine*, XCII, 1951, 8–9; Burchard-d'Hulst, 1963, No.180; Mary L. Myers, 'Rubens and the Woodcuts of Christoffel Jegher', *Bulletin, The Metropolitan Museum of Art*, XXV, 1966, 7–23; Kuznetsov, 1974, No.135; J. Bean, *100 European Drawings in the Metropolitan Museum of Art*, s.d., New York, No.81 (right half); Renger, *Kunstchronik*, XXXI, 1978, 137–40.

Three drawings by Rubens each consisting of two pieces were listed in 1686 in the collection of Canon J. Ph. Happart of Antwerp Cathedral (Denucé. *Inventories*, 336; see also No.61). The present drawings are likely to have been amongst them. Separated from each other they were reunited again in Mariette's collection (who received one part from M. de Thiers as a gift). They figure as No.994 in the sale catalogue of the Mariette collection of 1775.
The left half of the composition (Pl.203) has been enlarged by strips of paper on either side. In contrast, however, to the statement made in the catalogues of the London exhibition of 1950 (L. Burchard) and the Antwerp one of 1956 (Burchard and d'Hulst), there are no such additions on the right hand sheet (Pl.204). Nor is there any reason to accept the theory, proposed there also, that Rubens himself made the additions. They are certainly due to a different hand as they have not been made very intelligently. The larger strip, along the right edge, contains a part of a rusticated column on a high base which has no connection with the rest of the architecture on either sheet. The waterjets in the added strip are drawn very lamely; they become wider towards the point from which they emerge. The most important evidence, however, in support of the view that this strip is not original lies in the position of the inscriptions '27' and 'Petro Pauolo (?) Rubbens' in the lower right corner of the sheet. They remain completely within the 'original' sheet and clearly mark its corner. Had the sheet already been larger at that time, the choice of this corner would have been very strange indeed. (J. C. Robinson's mark was indeed put on the added strip.) Since 'Rubbens' suggests a Flemish hand, I draw the inference that it was Canon Happart who put Rubens' name on the sheet and that the additions date from after 1686.
Gabriel de St. Aubin made a rapid sketch of the two sheets on the margin of a copy of the Mariette auction catalogue of 1775

that is now in the Boston Museum of Fine Arts; it may be purely accidental, but it looks as though the left half of the composition was at that time still without the additions.

The drawing was made by Rubens as a model for a woodcut by Christoffel Jegher (1596–1652/53). There are considerable differences between the drawing and ´he woodcut (the woodcut is reproduced in Glück, *Essays*, 116–117); both have been described, with minor inaccuracies, in the catalogue of the Exh. London, 1950. Most of the changes are found in the right half of the composition (the left half of the woodcut, which shows the composition in reverse). The cupid hovering near the figure seated on a low stool is absent in the woodcut; so is the cavalier with a feathered hat. The young woman who in the drawing turns her head in surprise and apparent indignation, looks down in the woodcut in the direction of the lady with a hat near the centre of the group. The fountain with the three Graces is not found in the print, where the right edge comes close to the last figure. The heads of a man and a woman turning to each other in the drawing have clearly been reworked with body-colour; this could conceivably have been done later, by another hand. Despite the possible interference with Rubens' original design, the drawing remains an unusually fine and important example of its category, i.e., models for prints. Burchard (*loc.cit.*) was fully justified in calling attention to the praise that these sheets have received in the earlier literature, climaxing in the unqualified enthusiasm of Rooses, who said: 'C'est le plus beau dessin de Rubens que nous connaissions, un vrai chef-d'oeuvre de grâce, de sûreté de main et de délicatesse de touche' (*Bulletin Rubens*, V, 1910, 199). A less favourable view was expressed by some critics of the eighteenth century, as may be seen from a marginal note in the Mariette Catalogue (see *Abecedario*, V, 135, note 1); in modern times Christopher Norris has found weaknesses in the drawing which he attributes to a 'substructure' by Christoffel Jegher. It should also be remembered that the drawing was not included in the book by Glück and Haberditzl, even though Glück (*loc.cit.*) admitted that its 'outlines' might be Rubens' work.

The composition represents Rubens' second version of the theme; the first is the famous painting in the Prado, known as The Garden of Love, though referred to in early records as a 'Conversation of Young Ladies' (Een Conversatie van Joffers) or 'Conversation à la Mode' (see also Nos. 205–9). Many of the figures of the Prado painting are found also in the present drawing, but the composition as a whole is very different. It is extended horizontally, but has less depth. Thus the six figures inside the building who play only a secondary rôle in the painting in Madrid are now much more prominent. Their action, puzzling to some interpreters who looked only at the painting, is easy to understand in the drawing and the print. While one couple looks on in amusement, the four other figures try to protect themselves as best they can from the water-jets which seem to have opened on them quite suddenly. Such wet surprises were not uncommon features of early garden-architecture; one is known to have been a special attraction of Marmirolo near Mantua, with which Rubens was surely familiar. It was the work of Giulio Romano (see E. Gombrich, *Jahrbuch der Kunsthistorischen Sammlungen in Wien*, N.F. IX, 1935, 126) and was described thus: 'Evvi etiando un luogo, nel quale volendo il Governatore del detto, incontinente alla sproveduta escono e saltano tante acque per alcuni secreti cannoni et con tanta prestezza da ogni lato, che non e possibile fuggire, che da dette acque non siano bagnati quei, che quindi so ritroveranno. Inverno ella e un opera d'un grandissimo, e bellissimo artificio, e di non minor piacere, e massimamente ne'tempi dell'esta onde se possono rinfrescare i riscaldate' (F. Leandro Alberti, *Descrittione di Tutta Italia*, Venice, 1553, 353v°). Whether or not the architecture of Rubens' pavilion with its 'bearded' columns and cyclopic proportions reflects Giulio Romano's actual pavilion of Marmirolo is difficult to

say, since no trace of that building, not even in an engraving, seems to have come down to us. It would seem more likely, however, that Rubens' building was designed by the artist himself. The water-jets are also found in the Madrid painting, but there they cannot be seen as clearly as in the drawing and the woodcut, which may explain Evers' reference to the activity of the figures as a 'game'. (A similar 'Wasserscherz' from the early seventeenth century has survived into our own times in Schloss Hellbrunn, near Salzburg. Others are known to have been installed in grottoes by Buontalenti and Tribolo.)

The meaning of the subject has been discussed chiefly by Glück and with several corrections of Glück's analysis—by Evers (I, 339 ff.). While the figures wear contemporary costumes it is almost certain that the picture is primarily an allegory in the tradition of the old love-gardens. In keeping with the respectability of the figures Rubens included prominently—in the painting—attributes that have emblematic reference to matrimony (torch, yoke, turtle-doves; see also No. 219). Indeed, there is general agreement among scholars that the happiness of the first years of Rubens' marriage to Hélène Fourment pervades the whole picture. To see in it, however, a 'fröhliches Beisammensein mit sympathischen Schwägerinnen und Geschwistern' (M. Eisenstädt, *Watteaus Fêtes Galantes*, Berlin, 1930, 142) goes perhaps too far. Nor can I agree with those scholars who felt that Hélène was the model for every single woman in the picture (see No. 205). She can be recognized in the woman in the centre of the composition who sits on a low chair and looks at the beholder; she may also have served as the model for the one at the right who turns towards a cavalier sitting on the ground. The man with a broad-brimmed hat at the left has occasionally been considered a self-portrait of Rubens, though without any good reason. Neither the Prado painting nor the New York drawing nor Jegher's woodcut should be interpreted too narrowly as autobiographical. Despite the contradictions of some authors, they are intermediaries between the bucolic allegories of the Venetian painters of the early sixteenth century and the Fêtes Galantes of Watteau.

The connection between Rubens and Jegher seems to have been especially close at about 1633–1635 (see Bouchery–Wijngaert, 99–101). A proof-print of the left half of Jegher's woodcut, retouched by Rubens, is in the Cabinet des Estampes, Bibliothèque Nationale, Paris.

In their publication of 1963, Burchard-d'Hulst introduced a scenario vastly different from the one they had proposed seven years before (see also above No. 105). They now suggest that Rubens first formulated the theme of the Garden of Love in the painting at Waddesdon Manor (National Trust), which Glück and Oldenbourg (*KdK*.349) had rejected, the latter calling it a clever combination by an imitator. This was followed, according to this theory, by the New York drawings and the Jegher woodcut, while the painting in the Prado came last. Some scholars (as did for instance John Rowlands in the 1977 exhibition catalogue), accepted this view, while others, among them Renger in his review of that exhibition, strongly rejected it. Without going into this problem at great length, I can only say that I see no reason for changing my mind on the sequence of events as presented above. Renger, however made the interesting suggestion that Rubens drew the right half of the drawing first and may have intended it alone at first to serve as the model for a woodcut. That might explain, he reasons, the differences in the line work that can be observed in the two halves of the composition.

212 [Plate 218] *(1959: No.155)*

MARCH OF SILENUS

c. 1633–1635. Pen and ink, corrections in oxidized body-colour. 368 × 335 mm.
Paris, Louvre, Cabinet des Estampes (20.288).

COLLECTIONS E. Jabach.
EXHIBITIONS Paris, 1978, No.110.
LITERATURE R., V. No.1320 (Pl.380); K. T. Parker, *Old Master Drawings*, 1928–29, 3; Delacre, *Etudes*, 69–70; L. Burchard, *Catalogue*, Exh. London, 1950; 55; Lugt, *Catalogue*, II, No.1157.

This drawing was used for the woodcut by Christoffel Jegher (V.S. p.135, 139) which reproduces the composition in reverse. It was considered to be a work of Rubens when it came to the Louvre from the Jabach collection, and Rooses, Delacre, and Burchard accepted the old attribution. Glück and Haberditzl excluded the drawing and their negative judgment was shared by Parker. Lugt compromised by claiming the retouches and corrections for the master. This would seem to be the least likely solution, since there is no stylistic difference between the line-work in the retouched areas and that done before. The drawing must either be accepted or rejected as a whole.

Since it cannot be doubted that the drawing formed the model for the woodcut by Jegher, the question is whether Jegher or Rubens was the responsible draughtsman. The decision is simplified since the case has a perfect parallel in the drawings in the Metropolitan Museum (Nos.210, 211) and the National Museum in Poznan (Rest on the Flight into Egypt, Exhibition Antwerp, 1956, No.129). The Louvre Silenus is closely related to those drawings; it is certainly their equal in quality. There is no evidence for crediting Jegher with more than a fine ability to transfer a design into woodcut: to attribute to him drawings of the undeniable grandeur of the Louvre Silenus and of the New York Garden-Party would make him one of the major draughtsmen of the Flemish school.

While the drawing has the methodical line-work which characterizes the models for graphic media (see Introduction, pp.35–6), it is nevertheless clearly connected with some later drawings by Rubens, such as the Venus Anadyomene of the British Museum (No.165), which have been accepted by even the more sceptical critics. The few thin lines that accompany the contour of the man at the left are probably the first rapid notes which Rubens drew before proceeding to the more detailed design.

For the composition Rubens relied upon ideas that go back to a much earlier period. The faun leaning forward and regarding Silenus with a leer is connected with the figure of a Negress in the Leningrad Bacchanal (KdK.82). Silenus himself comes from the Munich painting of the March of Silenus (KdK.177). But whereas in the Munich version he is a man who, though beyond his prime, still possesses great strength and vitality, here he is rendered as a very old man indeed. With his sagging flesh and faltering gait (his right leg was significantly corrected so as to appear more 'trailing') he is almost helpless in his intoxication. Yet more than ever before Rubens gave him an expression of spiritual dignity in striking contrast to the sinister associations evoked by his companions (see also Evers, I, 203).

213 [Plate 219] *(1959: No.151)*

TITLE-PAGE FOR THE WORKS OF LUDOVICUS BLOSIUS (LOUIS DE BLOIS, 1506–1566)

1631. Black chalk, pen and ink, washed, with a great deal of white body-colour; 305 × 214 mm.
London, British Museum (1895.9.15.1042).

COLLECTIONS P.J. Mariette (Cat.1775, No.1011); Van Maarseveen; Sir Thomas Lawrence; J. Malcolm.
EXHIBITIONS London, 1835, No.61; Paris, 1954, No.327; London, 1977, No.221.
LITERATURE *Rubens Bulletin*, IV, 288 (R.1246); *Correspondence*, V.431, Hind, *Catalogue*, No.39; G.-H. No.183; Bouchery-Wijngaert, 81, 123, 139; Evers, II, 184; Catalogue, Exh. Paris, 1954, No.327; Judson-Van de Velde, *Corpus Rubenianum* XXI, 1, 1978, No.61b, as by Cornelis Galle (?).

Inscribed in the lower right corner: '69'.
Engraved: Cornelis Galle (in reverse); Galle was paid 95 fl. on August 12, 1631.

The drawing was made in 1631 for the Plantin edition of 1632 of the works of Blosius, the famous Benedictine mystic and friend of Charles V. The full title—which was engraved on the pages of the book held by four allegorical figures—reads: VENERABILIS PATRIS D. LVDOVICI BLOSII MONASTERII LAETIENSIS ORDINIS S. BENEDICTI IN HANNONIA ABBATIS OPERA, CVRA ET STVDIO R.D. ANTONII DE WINGHE ABBATIS ET MONACHORVM EIVSDEM MONASTERII AVCTA ORNATA ILLVSTRATA.
There are a few small differences between Rubens' drawing and Galle's print. In the print the angel at the top holds not only a wreath but also—in his uplifted left hand, which in Rubens' drawing is not visible—a very ornate necklace. The little angel nearest the Virgin carries a somewhat differently shaped box, with open cover, and—in his raised right hand—a small object which could be a key. Blosius himself, who is beardless in Rubens' drawing, has a short beard in Galle's print. Finally, in the print there are designs on the armorial shields lying on the platform on which the four allegorical figures stand or kneel. The four women who assist Blosius in offering his works to Christ and to the Virgin are the four monastic virtues: the pious contemplation of mystic theology (standing at the left, her head veiled); the benevolent gentleness of manners (the woman with the lamb); the abject humility of the soul (the woman looking down, nearest to Blosius); the prudent (discerning?) mortification of the body (the woman with the whip). (The identification of these figures is contained in the Latin preface to the book.) The seven angels hold objects which refer allegorically to the main works of the author (not to the chapters, as maintained by Evers, who also mistook the editor for the author; see Bouchery-Wijngaert, 139, note 65): *Psychagogia seu Animae recreatio* [Violin]; *Sacellum animae fidelis* [chapel]; *Brevis Margaritum spirituale* and *Monile spirituale* [necklace?]; *Facula illuminandis et ab errore revocandis haereticis*, and *Divini amoris Igniariolum* [torch]; *Speculum spirituale* and *Speculum Monachorum* [mirror]; *Corona spiritualis* [wreath]; *Scriniolum spirituale* [shrine].
Antonius de Winghe, who edited Blosius' works criticized—as an error committed by the engraver—the place of the Virgin at Christ's right. In his answer, Balthasar Moretus laid the blame for this 'error' at Rubens' door, but he proceeded to point out that it was not an error at all since it is expressly said: 'Adstitit Regina a dextris eius' (Ps.44:10). This correspondence took place in September, 1631; as the engraving was certainly finished by August 12, it is likely that Rubens' drawing was made in the middle of that year.

214 [Plate 220]

TITLE PAGE FOR SILVESTER PETRASANCTA'S DE SYMBOLIS HEROICIS LIBRI IX

c. 1633. Pen and bistre, washed, over black chalk, heightened with white. 190 × 140 mm. Traced for transfer.
Paris, Fondation Custodia, Collection F. Lugt. (1971.T.2).

COLLECTIONS P. J. Mariette; Mlle de Chaumont (?); J. P. van Suchtelen; E. Calando; Private Collection Paris; acquired 1971.
LITERATURE R., V. No.1292; C. van Hasselt, *Fondation Custodia, Collection Frits Lugt, Acquisitions récentes de toutes époques*, Paris, 1974, No.67; Adrian S. Hoch, in *Rubens and the Book* (J. S. Held ed.) Williamstown, Mass. 1977, 141–4; Judson-Van de Velde, *Corpus Rubenianum*, XXI, 1, 1978, No.69a ('Copy').

Engraved by Cornelis Galle who received 38 florins for the job, see Judson-Van de Velde, II, 471, [73].

Silvester Petrasancta (1590–1647) was an ardent member of the Jesuit order; his main work is a three-volume defence of the 'true religion' against the 'perfidy of the sectarians'. The book for which Rubens drew the title page, however, is a basically non-political collection of 264 *imprese* illustrated with a large number of small emblematic prints.

In the centre of Rubens' design stands an antique altar (on which in Galle's engraving the author's name and the title of the book are inscribed); two sphinxes are symmetrically attached to the two visible corners of the altar. They symbolize the combination of prudence and strength (see Gevartius, *Pompa Introitus Ferdinandi*, Antwerp, 1641, 161). A woman with four breasts and a floral crown, the personification of Nature, stands at the left; Mercury holding the pen and brushes of art in his left hand is at the right. He is about to hand over these tools to a butterfly-winged genius (Ingenium) emerging from clouds in a burst of light. (Butterfly wings, as Rubens explained elsewhere 'denote the eternity of . . . glory.') The three figures are linked to each other through the interlocking of hands and attributes. Mercury places the caduceus held in his right hand through a laurel wreath Nature holds in her left. A second linking of 'Nature' and 'Art' is established by the Genius who in his left hand receives the artist's tools, while placing his right hand around the neck and shoulder of Nature where it meets and holds the fingers of her right hand. (In the printed title page, as one would expect, right and left are reversed; the only major change, however, concerns the small wings protruding from the Genius's head in the drawing; they were left out in the engraved title.)

Rubens received 12 florins for his design (see Judson–Van de Velde, II, 448–449). His design was apparently finished before the text of the volume was completed, since a polite phrase about the title was included on p.480: '*Id quod in Operis vestibulo, summi artificis penicillo descripta effigies eleganter monet*' ('This is taught elegantly in the beginning of the book through an image made by a most skilful pencil').

Judson–Van de Velde recognized a stylistic similarity (mainly in the strength of the lines done with the pen) between this drawing and the title of Cardinal Barberini's *Poemata*, published in the same year (see here No.216). Since they reject that drawing as an original by Rubens, they extended the same judgment to this one, too. I see no reason to question the originality of either one of these drawings.

215 [Plate 221] *(1959: No.153)*

POETRY AND VIRTUE

1633 (or before?). Pen and ink. 120 × 170 mm.; paper irregularly torn at the left.
Antwerp, Museum Plantin-Moretus (389).
EXHIBITIONS Antwerp, 1946, No.14; Paris, 1954, No.379; Antwerp, 1956, No.134; Antwerp, Museum Plantin-Moretus, 1977, No.24b.
LITERATURE R., V. No.1241; G.-H. No.217; Bouchery–Wijngaert, 73, 119, 140, 155 (Pl.73, 74); Evers II, 188, Fig.10; Held (ed.), *Rubens and the Book*, Williamstown, 1977, No.4; Judson–Van de Velde, *Corpus Rubenianum*, XXI, 1978, No.63a.

Engraved: C. Galle the Elder or K. de Mallery; copperplate paid for December 10, 1633.

Inscribed (by Rubens himself): '*Habes hic Musam sive Poesim Cum Minerva seu Virtute forma Hermatenis Coniunctam nam musam pro Mercurio apposui quod pluribus exemplis licet, nescio an tibi meum Commentum placebit ego certe mihi hoc Invento valde place[o] ne dicam gratulor*' ('You have here the muse of poetry with Minerva or Virtue joined in the shape of a Hermathene. I have placed there the muse instead of Mercury which is permissible on the basis of several examples. I do not know if you will like my

idea, I myself am quite pleased with it and almost compliment myself for it'). On the left margin: '*nota quod Musa habeat Pennam in Capite qua differt ab Apolline*' ('Notice that the muse should have a feather on her head by which she is distinguished from Apollo').
The head of Athena was drawn a second time, outside the design proper.
Design for the frontispiece of BERNARDI BAVHVSII ET BALDVINI CABILLAVI E SOC. IESV EPIGRAMMATA. CAROLI MALAPERTII EX EADEM SOC. POEMATA, published by Balthasar Moretus in 1634. The first edition of Bauhusius' epigrams of 1616 and the second of 1620 had appeared without figured title-page, despite the author's request to have one designed by Rubens. In 1617, he had suggested Parnassus, the Muses, Mnemosyne and Apollo as appropriate subjects for such a title (see Bouchery–Van den Wijngaert, 140). When the third edition was contemplated, Rubens was probably informed about the author's ideas, although Bauhusius himself had died a year before the second edition.

The inscription, surely intended for Balthasar Moretus, gives an interesting insight into the part that Rubens played in planning the programme of such commissions. His design was accepted without any further change, and he received 5 fl. for his part in the work. The engraving was formerly attributed to C. Galle the Elder; Van den Wijngaert, No.434, and following him Evers, claim that it was by K. de Mallery (1571–after 1635). De Mallery was paid 2 fl. on December 10, 1633, for *the lettering* of the title. If anything, this document speaks against rather than for the attribution of the print to De Mallery. The engraving of the figural part may have been done for an edition planned before 1633. There is nothing in Rubens' drawing which would militate against a somewhat earlier date, but unless better evidence is found it is preferable to accept the date of 1633.
A real Hermathene (Hermes and Athena combined) was drawn by Rubens as model for a work 'in iron, or ivory, or electrum' [alloy of gold and silver]; see Hind, No.57, Pl.VIII. Evers translated 'commentum' with 'Entwurf' (design) and accounted for Rubens' pleasure by his having used the profile in both figures. Actually, it was the replacement of Mercury by a muse which seems to have been the cause of Rubens' satisfaction.

216 [Plate 222] *(1959: No.154)*

SAMSON AND THE LION

1633–1634. Black chalk and pen and ink. 179 × 138 mm.
Antwerp, Museum Plantin-Moretus (389).
EXHIBITIONS Brussels, 1938–39, No.55; Rotterdam, 1939, No.52; Helsinki–Brussels, 1952–53, No.52. Paris, 1954, No.377; Antwerp, 1956, No.136; Antwerp, Museum Plantin-Moretus, 1977, No.28b ('copy').
LITERATURE R., V. No.1285; G.-H. No.215; Bouchery–Wijngaert, 81, 96, 115, 123, 125, 140 (Pl.71, 72); Evers II, 81, 188, Fig.114; Burchard-d'Hulst, 1963, No.200; Kuznetsov, 1974, No.133; Held (ed.), *Rubens and the Book*, Williamstown, 1977, No.3; Judson–Van de Velde, *Corpus Rubenianum*, XXI, 1978, No.68a and b ('Cornelis Galle or a member of his shop'). Renger, *Kunstchronik*, XXXI, 1978, II (Rubens).

Engraved (in reverse): C. Galle the Elder; 60 fl. were paid for the engraving on February 3, 1634. Rubens received 12 fl. for his drawing.

Design for the title-page of MAPHAEI S.R.E. CARD. BARBERINI NVNC VRBANI PP. VIII. POEMATA published by the Plantin Press in 1634. The poems of the Barberini pope issue from the mouth of the lion in the form of bees—the heraldic emblem of the Barberini. The image alludes to Samson's discovery of bees in the carcass of the lion that he had killed, and the riddle he proposed about it, 'Out of the eater came forth meat, and out of the strong came forth sweetness' (Judges, XIV, 5–14).

Since it can be dated with fair accuracy, this drawing is important in the study of the late pen drawings (see Nos.219, 220, 229, 230, 232).

Another drawing of Samson and the Lion, in circular format, and inscribed 'DVLCIA SIC MERVIT' is in the collection of F. Lugt. A pose which is also known from the Lion Hunt composition engraved by Soutman (Van den Wijngaert, 646) was used for the figure of Samson in that drawing. The function of the drawing in the Lugt collection may have been either to serve for a medal or a printer's mark. (Samson and the Lion seems to have been used as a signet in books of the Cologne publisher Quentel.)

The rejection of this and a number of other drawings for title pages by Judson, and in some cases also by Logan, is disturbing since it is founded on a judgment of quality; where—as in this drawing—I see great freedom, strength, and originality, they apparently see the hesitant hand of a copyist. Since most of my commentaries were formulated about thirty years ago, it may be proper for me at this moment to reaffirm my complete confidence in the originality of these drawings.

217 [Plate 216] *(1959: No.61)*
STUDIES FOR THE EXPLOITS OF HERCULES

c. 1630–1635. Red chalk; one group reinforced in pen and ink. 300 × 457 mm.
On the reverse: Two sketches for a Visitation, with faint indications of architecture, in black and red chalk.
London, British Museum (1897.6.15.12).

COLLECTIONS P. H. Lankrink; J. Richardson Sr.
EXHIBITIONS London, 1977, No.184.
LITERATURE Hind, *Catalogue*, No.23; G.-H. No.145; L. Burchard, *Exhibition*: New York, 1951, under No.17; Burchard-d'Hulst, 1963, No.190; Kuznetsov, 1974, No.120.

In the top row there are three sketches of Hercules and Antaeus, two of Hercules carrying the globe, and between these two groups a head which might be that of Antaeus but is more likely that of Hercules trying to free himself from the burning gown of Dejanira. This identification is suggested by the great similarity of this head to the reverse of a drawing in the Louvre (Lugt, *Catalogue,* No.1228, Pl.LXXIV), where Hercules was drawn twice in this action. (The theme was already treated in antiquity, see K. Jex-Blake, *The Elder Pliny's Chapters on the History of Art,* London, 1896, p.79 and note 11.) In the bottom row there are three versions of Hercules strangling the lion, and one—reinforced in pen and ink—of Hercules and Antaeus. Originally the sheet was probably larger since some of the figures are cut off awkwardly at the edge. In 1951 Burchard associated the drawing with the sketch of Hercules and the Lion, then in the collection of Charles L. Kuhn, which he dated *c.* 1620. (For this sketch see now Held, 1980, No.227.)
Hind and Evers had dated it still earlier. Glück and Haberditzl suggested a date of after 1620, but they did not accept the reverse as genuine, calling it the work of a pupil, such as Van Thulden. I see no compelling reason for doubting the authenticity of the reverse. It is close in style and technique to the drawing of the Adoration of the Magi and the Annunciation in Besançon (No.221). The Louvre drawing mentioned before, is another that seems to belong to this group. Lugt admittedly gave this drawing to a pupil because of 'weaknesses' and because he saw Rubens' hand in the word 'buono' inscribed on it twice; Benesch (*Kunstchronik*, VII, 1954, 199) concurred in this adverse criticism. Even if Rubens wrote this word—a contention which is as hard to prove as to deny—it would not necessarily follow that the drawing could not be by him. It is connected with Rubens' work in many ways, besides the two instances mentioned by Lugt. One of the figures at the left in

L.1227 occurs in a composition of Susanna and the Elders (engraved by P. Pontius in reverse; see also L.1130 and 1131, Pl.LIX); the pose of the woman with uplifted arms near the right edge is related to the figure of Andromeda (*KdK*.390); finally, the woman at the left of the Susanna type is also found in several variants in a drawing in Leningrad, on the reverse of St. Athanasius (Dobroklonsky, 1930, No.5; see also Nos.47 and 63).

In my entry of 1959 I not only accepted the drawing as Rubens' work but contrary to all earlier opinions placed it in the 1630s. In 1963 Burchard-d'Hulst accepted this view, dating both sides of the sheet 'after 1630' (p.301).

218 [Plate 215] *(1959: No.124)*
A YOUNG WOMAN WITH RAISED ARMS

c. 1635. Black, white, and red chalk. 480 × 285 mm.
On yellowed paper. Inscribed below, by a later hand, 'Rubens'.
Paris, Louvre, Cabinet des Estampes (20.198).

EXHIBITIONS Paris, 1978, No.29.
LITERATURE Michel, 1900, Fig.XXXVII, 494; G.-H. No.224; Lugt, *Catalogue*, No.1025; Burchard-d'Hulst, 1963, No.203.

This is a moving study for the Massacre of the Innocents in Munich (*KdK*.378). It proves that Rubens occasionally reverted to making detailed studies in chalk from the model even for his very late pictures. Contrary to the remarks found in the literature, however, it appears to be a study not for one figure but for two. Rubens used the head and the body, including the shoulders, for the crazed woman who embraces her dead child (see Evers, I, 415/16); he gave the raised arms and hands to the unhappy mother who stands directly in front of her. This woman, finding herself cruelly separated from her child, in vain implores the pity of a nude executioner from whose brutal grasp the little one tearfully stretches out his hands towards her.
No other study for this painting has come to light so far, although it is almost certain that Rubens prepared its complicated group actions and figural movements (which so impressed Delacroix) in drawings and in oil-sketches.

Fig.19. Nymph and Satyr, verso of Venus and Cupid (Plate 217)

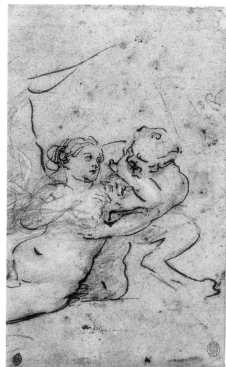

219 [Plate 217] *(1959: No.65)*

VENUS AND CUPID; on the reverse: NYMPH AND SATYR (Fig.19)

c. 1635. Black, red and white chalk, reinforced with pen and ink. 277 × 161 mm.
Berlin–Dahlem, Kupferstichkabinett (12222).

COLLECTIONS Chambers Hall; Ch. Scarisbrick.
EXHIBITIONS Antwerp, 1956, No.141.
LITERATURE J. Rosenberg, 1926, 88 ff.; G.-H. No.223 (reverse: No.222); Bock-Rosenberg, *Catalogue*, 250; Burchard-d'Hulst, 1963, No.198; Müller Hofstede, 'Zeichnungen des späten Rubens', *Pantheon*, XXIII, 1965, 175–7; Kuznetsov, 1974, No.137; Mielke-Winner, 1977, No.39.

Inscribed in the upper right (in Rubens' own hand): 'Cupido Captivus'.

Since figures on both sides of the paper are senselessly cut off at the edges, it is certain that the size of the paper was originally considerably larger, especially at the sides. The woman who is seated on a chair behind Cupid and appears to reproach him, while holding on to his wings, is probably Venus; she is shown again in the upper left corner, gesturing in an admonishing manner, and a third time, roughly outlined in chalk and with two positions of the hand, in the upper right. Cupid's profile, in pen and ink, is seen near her at the paper's edge.
The figure of Cupid is nearly identical with the boy standing at the right in the so-called 'Garland of Fruits' in Munich (*KdK*.132). Yet Rosenberg was probably right in dating the drawing late. The coarse lines in chalk and pen are characteristic of Rubens' later drawings (see Nos.230, 232). The head of the nymph on the reverse is closely related in pose and in proportion to that of Pero in Roman Charity in Amsterdam (*KdK*.359) and of Venus in The Horrors of War in Florence (*KdK*.428), both late pictures.
The themes treated on the *recto* and *verso* of this sheet could conceivably belong together; yet whereas the subject of Satyrs attacking Nymphs is frequently found in Rubens' work, the punishment of Cupid appears only—in a rather different form—in the Garden of Love in the Prado (*KdK*.348). For the connection between the theme of Cupid fettered and allegories of chastity, see E. Panofsky, *Oud Holland*, L, 193 ff., and *Studies in Iconology*, New York, 1939, 126 and 166. In his commentary on P. Scholiers' *Sermonum familiarum libri III* (Antwerp, 1683, 146), A. Le Roy explained 'amor captivus' as a traditional figure of speech for 'conjugium' (= love of a single partner, as opposed to one roaming freely). Considering the 'untamed' love alluded to on the reverse, it is likely that Rubens had the same reference in mind when he inscribed his drawing with 'Cupido captivus'. L. Burchard and R. A. d'Hulst (*Catalogue*, Exh. Antwerp, 1956, 114) expressed the opinion that the figure of Cupid was derived from a classical (?) sculpture which Rubens, on the evidence of some copies in the Copenhagen material, appears to have drawn several times and may even have owned.
The assumption that the Berlin sheet was only a small fragment of a larger drawing has been verified surprisingly quickly by Müller Hofstede (1965) who found the missing part in the Musée Condé, Chantilly. The Chantilly piece measures 270 × 300 mm. so that the entire sheet was—at least— 277 × 461 mm. (I suspect that it was still larger since these proportions are unusual) (see Fig.8 and text to No.101). For some modifications of Müller Hofstede's analysis (particularly the identification of the main figure in the bacchic scene with Hercules rather than Silenus) see Winner, in Mielke–Winner, pp.111–113.

220 [Plate 210] *(1959: No.64)*

DIANA AND HER NYMPHS, SURPRISED BY ACTAEON

1632–1636. Pen and ink. 291 × 509 mm.
Reverse: Study for a hunt of wild animals (lions?). Red and black chalk. Inscribed at the top 'dese dry vraukens(?) half ghecleurt (?) door van den Broeck'. (These three women (?) half-coloured (?) by van den Broeck). (Quoted from A. Seilern's Catalogue.)
London, Princes Gate Collection, Courtauld Institute Galleries.

COLLECTIONS P. H. Lankrink; J. Richardson, Jr.; R. Adam Ellis; A. Seilern.
LITERATURE Seilern, *Catalogue*, No.65; Burchard-d'Hulst, 1963, No.159; Kuznetsov, 1974, No.119.

This drawing was made for the painting of Diana and Actaeon, bought by Cardinal Richelieu from Rubens' estate. Damaged by fire, the painting is preserved only as a fragment in the Museum Boymans (*KdK*.350). The left half of the painting, containing the figures of Actaeon and of three bashful nymphs hastily and ineffectually trying to cover themselves, is lost but can be reconstructed in its general appearance on the basis of a small painted copy, now also in Rotterdam (A. Seilern, Fig.58), and an engraving of 1787 (not 1781) by P. Spruyt.
The group of which Diana is the centre—occupying the left half of the drawing (and evidently derived from Tintoretto's painting of Susanna in the Louvre, see H. Tietze, *Tintoretto*, London, 1948, Fig.59)—originally formed the right half of the picture; it is now the only part preserved. Diana herself was little changed. The nymph in front of her was changed into an old woman, but her movement remained virtually intact. The nymph who in the drawing crouches before Diana and puts a slipper on her left foot was replaced in the painting by a crouching figure in profile (slightly reminiscent of the sitting figure near the right edge in the drawing) drying Diana's foot with a towel. The two figures standing behind Diana in the drawing underwent the greatest change. Instead of concentrating their attention on their mistress, they now look with dismay and indignation at the intruder. It is obvious that this change became necessary when Rubens decided to move the group with Diana to the right side of the composition.
To what extent the drawing represents a plan for a complete composition remains problematical. A. Seilern (*loc.cit.*) maintained that 'the drawing is not so much a composition study as a set of variations on the principal group'. In this view, I think, he goes too far, though it is quite evident that in the drawing the group of nymphs at the right is far from being compositionally integrated with the Diana section at the left. Yet Rubens clearly envisaged a unified setting, organized by a pillar in the centre, from which springs an arch on either side—a setting anticipating in a rudimentary form the one adopted in the painting. Furthermore, it is practically certain that Diana herself does not occur anywhere in the group at the right, which thus forms a separate compositional and narrative element apart from the actions centering on the goddess. The apparent absence of Actaeon, added to these observations, gives rise to the question of whether Rubens planned to render a Bath of Diana and her Nymphs without giving much prominence to the Actaeon incident.
The weightiest argument against such a view is found in the fact that many of the ideas of the drawing were derived from a painting by Titian which dealt specifically with the Actaeon story: the well-known canvas at Bridgewater House (O. Fischel, *KdK*.161). Rubens took from that picture the pose of Diana and the idea of a woman standing behind her to help her dress. Titian's painting, too, has an arch and a post near the middle, with a figure peeping from behind it. There are still other, though rather more tenuous, points of contact. Rubens'

interest in Titian's painting in Bridgewater House can be seen from yet another drawing, the lovely sheet with various heads of women—all of them copies from Titian—formerly in the collection of Dr. Gollnow in Stettin, now in the Getty Museum in Malibu (see No.175). It was thought by Glück and Haberditzl to have been drawn during Rubens' stay in Italy but it seems more likely that it dates from the master's visit to Madrid in 1628–29, when he could have seen, in one place, the three paintings from which the individual figures were copied.

Count Seilern's drawing is of interest because it throws some light on a curious drawing in Berlin (Bock-Rosenberg 252, No.2234; G.-H. No.186–187). On one side of the sheet there is a kind of Nymphaeum with fountains and bathing women, on the other similar sketches of women dressing or undressing, though without any indication of the setting. There are a number of analogies between the figures of Count Seilern's sheet and those in Berlin; in particular the woman in the centre who pulls a shirt over her head (a figure which Rubens also used in the finished painting) appears in the Berlin drawing in several versions. The Berlin drawing was accepted as Rubens' work by Glück and Haberditzl; Bock and Rosenberg appear to have had some doubts though they sum up with a 'wohl echt'. Kauffmann, in a review of Glück and Haberditzl, questioned one side, and denied Rubens' authorship for the other. The similarity to the Seilern drawing seems to me to add weight to the attribution of the Berlin sheet to Rubens. For a discussion of this question see Mielke-Winner, No.38.

The question of the date of the whole group remains. A. Seilern dated the drawing in his collection 'c.1635–40'. Glück and Haberditzl dated the Berlin sheet 'about 1630'. Roger de Piles, who gave a long description of the painting of Diana and Actaeon when it was in the collection of the Duc de Richelieu, claimed that Rubens painted it in Spain under the direct impression of Titian's masterpieces (cf. R., III, 83–84, No.601). This would move the date of the drawings to about 1628–1629. Despite de Piles' authority (which may well reflect an oral tradition, see Introduction, p.10), stylistic evidence seems to favour a later date, though perhaps not as late as A. Seilern thought. There are contacts with such drawings as G.-H. No.189 and the sketches for the Kermesse (No.193), which belong to the early thirties. The painting, too, shows its greatest analogies with pictures of these years; Oldenbourg, indeed, dated it 1632–1635, and this would seem to be the most likely date for the drawing.

The sketch on the reverse, for a hunting scene, is discussed above, under No.143.

221 [Plate 211] *(1959: No.63)*

THE ADORATION OF THE MAGI

c. 1633. Black and red chalk. 279 × 432 mm.
On the reverse: Two studies for an Annunciation (black and red chalk).
Besançon, Musée des Beaux-Arts (D.94).

COLLECTIONS J. Gigoux.
LITERATURE Held, 1980, under No.330.

Inscribed on the gown of the old king: 'root flou[weel]' (red velvet). There is a three line inscription in the upper left which I have been unable to make out. Both inscriptions seem to be in Rubens' hand.

This unpublished drawing, previously brought to my attention by Dr. E. Schilling, is a good example of the very summary and deceptively 'coarse' style of Rubens' late drawings; it has the advantage of a fairly precise date. It seems to be the first idea for the Adoration of the Magi which Rubens painted for the Church of the convent of the *Dames Blanches* in Louvain about 1633 (R., I, No.176). A sketch for this picture is in the Wallace Collection in London (No.521); the painting itself was in the Collection of the Duke of Westminster and is now in King's Chapel, Cambridge. The drawing precedes the sketch; the figure of the old king was apparently the first to reach its final form and there is a close correspondence here between drawing and sketch. Originally a horizontal composition was planned; the change to a vertical composition must have occurred between drawing and oil-sketch, necessitating a general shifting of figures. Although the Christ child remained almost the same the Virgin was made taller and placed higher. The painting did not gain by these changes.

The first outlines were made in black chalk but some of the figures were drawn so thinly (notably Christ, Joseph and the old king, except for his head) that they now seem to have been done completely in sanguine.

The figure of the old King, and perhaps some general ideas of this composition, appear to have been derived from Pordenone's fresco of the Adoration of the Magi in the Cappella Malchiostro in the Cathedral of Treviso (see G. Fiocco, *Giovanni Antonio Pordenone*, Udine, 1939, Pl.74). That pose appears, in fact, in an earlier Adoration of the Magi (perhaps done from Rubens design by Van Dyck, as Müller Hofstede suggested, *Zeitschrift für Kunstgeschichte*, 1964, 84), a painting now in the Bildergalerie in Potsdam Sanssouci; see G. Eckardt, *Peter Paul Rubens*, Berlin, 1973, pl.30.

The Besançon drawing may well act as a catalyst for a number of drawings which have been leading a 'marginal' existence, accepted as Rubens' work by some scholars, rejected by others. The sheet with studies of Nymphs and, on the reverse, of Hercules in the Louvre (Lugt, *Catalogue*, Nos. 1227–1228) may be one of them; the reverse of St. Athanasius in Leningrad another (see M. Dobroklonsky, *Zeitschrift für bildende Kunst*, LXIV, 1930, 31, No.5). (This latter drawing was exhibited at Antwerp, 1956 [see Supplement to the catalogue, No.101b] and its inclusion in Rubens' work fully vindicated. See also under Nos.147 and 217.)

222 [Plate 212] *(1959: No.127)*

PORTRAIT OF FRANS RUBENS (1633–1678)

c. 1636. Black, red and faint traces of white chalk, on light greenish paper. 291 × 200 mm. All four corners cut.
Rotterdam, Museum Boymans-Van Beuningen (V.1).

COLLECTIONS J. Richardson; T. Hudson; F. Koenigs; D. G. van Beuningen.
EXHIBITIONS Antwerp, 1927, No.4; Amsterdam, 1929, No.271. ('Oude Kunst', Rijksmuseum); Amsterdam, 1933, No.114.
LITERATURE J. Bouchot-Saupique, *Hélène Fourment*, Paris, 1947, Fig.6.

Study for the portrait of Hélène Fourment with three of her children (see also No.128) in the Louvre (*KdK.*383). Frans Rubens, then about three years old, sits on his mother's lap, turning to the beholder very much as in the drawing, though his head is slightly more tilted.

The Museum Boymans has another drawing showing the child in reverse (V.62) which, although classified as 'contre-épreuve' of the present one, actually is a reversed copy. Another drawing of Frans Rubens, showing him more *en face*, but with the same feathered tocque as he is wearing in the Rotterdam drawing, is preserved in the collection of the Earl of Ellesmere at Bridgewater House (200 × 149 mm.) (ex. coll. Sir T. Lawrence; R. Cosway; engraved by L. Schiavonetti; exh. London, The Royal Academy of Arts, 1938, No.581). For still another drawing of Frans Rubens see No.223.

223 [Plate 214] *(1959: No.125)*

HEAD AND FEET OF A CHILD (Frans Rubens?)

c. 1635. Black, red and white chalk, on light brown and foxed paper. 285 × 210 mm. Pasted on a white sheet of paper.
Besançon, Musée des Beaux-Arts (D.91).

COLLECTIONS J. F. Gigoux.
EXHIBITIONS Antwerp, 1956, No.79; Antwerp, 1977, No.140.
LITERATURE K. T. Parker, 1934–35, p.15; Burchard-d'Hulst, 1963, No.75; Kuznetsov, 1974, No.47.

Marked, in pencil, in lower right: '100'.

Technically, this drawing is of interest because the white chalk which generally has been rubbed off Rubens' drawings is unusually well preserved here. Rubens began the sketch with black chalk, working the red freely into it, and finishing it with the white highlights.

Parker, who found and published the drawing, dated it *c.* 1615–1620, suggesting that it might be a portrait-study of Rubens' son Nicolas (b.1618). Burchard-d'Hulst (*Catalogue*, Exh. Antwerp, 1956 and 1963) believe that Albert (b.1614) was the model, which implies a date of *c.* 1615–16. However, for stylistic as well as iconographic reasons, the drawing must be dated much later. The subtlety of the colour and the softness of the interplay of light and shade point to the 1630's. Physiognomically, the child in the drawing has a striking resemblance to Rubens' son Frans, the second child of his marriage to Hélène Fourment (b. July 12, 1633), as he appears in the Munich and Paris portraits with his mother (*KdK.* Nos.346 and 383) and in the drawings in Dresden (G.-H. No.213) and Rotterdam (see No.222). The feet, though closer together, correspond to those of one of the little boys (St. John?) playing with a lamb in the Holy Family with Saints in the Prado (*KdK.*345).

224 [Plate 213] *(1959: No.128)*

A SMALL CHILD (Rubens' daughter, Isabella Hélène, 1635–1652)

c. 1636. Black, white and red chalk, on light brown paper. 398 × 287 mm. The upper corners cut. Red chalk only on hands, mouth, and a few lines in hair.
Paris, Louvre, Cabinet des Estampes (20.197).

COLLECTIONS J. Richardson, Sr.; J. Barnard.
EXHIBITIONS Brussels, 1938–1939, No.21; Rottterdam, 1939, No.40; Rotterdam, 1949, No.135; Paris–Brussels, 1949, No.107 (103); Paris, 1954, No.419; Paris, 1978, No.30.
LITERATURE R., V. No.1525; Muchall-Viebrook, No.23, Glück, *Essays*, 123, Fig.76; G.-H. No.227; Evers, I, Fig.254; J. Bouchot-Saupique, *Hélène Fourment*, Paris, 1947, Fig.9; Lugt, *Catalogue*, No.1026.

The identification of this child with Isabella Hélène (b. May 3, 1635) is suggested by the observation that the same pair of outstretched hands that we see in the drawing appears, outlined rather sketchily, in the portrait of Hélène Fourment with her two older children, Clara Johanna (b. Jan. 18, 1632) and Frans (b. July 12, 1633) in the Louvre (*KdK.*383). Rooses had overlooked this connection and assumed that the drawing was done for the portrait of Rubens and Hélène Fourment, with a little child walking in front of them, formerly in the collection of Baron Edouard de Rothschild, now in the Metropolitan Museum of Art, New York (see Liedtke, 1984, 176 ff.). Glück and Haberditzl as well as Sterling (Exh. Rubens et son Temps, Paris, 1936, No.78) suggested that Rubens had planned an addition to the Paris panel which was never made, but in view of the clearly unfinished state of the whole painting, Lugt's (and others') theory that a larger painting was planned from the beginning is more likely. If so, the plan must have included a figure holding the reins of the little child, most likely to have been a nurse. This part of the picture was probably only lightly sketched and cut off at a later date. The same child appears in a watercolour by Ph. Fruytiers (reproduced in a mezzotint by P. J. Tassaert, see J. G. van Gelder, *Nederlandsch Kunsthistorisch Jaarboek*, 1950–51, The Hague, 1951, 148, Fig.31).

225 [Plate 207] *(1959: No.123)*

SELF-PORTRAIT

c. 1633–1635. Black and white chalk on coarse yellowed paper. 461 × 287 mm. Backed. On the reverse, still covered with an old mounting paper, figures of people apparently fighting can be made out; at the left a man with his arms lifted over his head. These figures are drawn in ink, which has eaten through the paper and caused the dark spots visible on the front.
Paris, Louvre, Cabinet des Estampes (20.195).

COLLECTIONS J. Richardson, Sr.; T. Hudson, J. Barnard.
EXHIBITIONS Brussels, 1938–1939, No.20; Rotterdam, 1939, No.39; Paris–Brussels, 1949, No.108; Antwerp, 1977, No.173; Paris, 1978, No.31.
LITERATURE R., V. No.1530; Muchall-Viebrook, No.19; G.-H. No.235; Mme. J. Bouchot-Saupique, *De Kunst der Nederlanden*, 1930, 86; Lugt, *Catalogue*, II, No.1017; Burchard-d'Hulst, 1963, No.202; Kuznetsov, 1974, No.1.

Engraved: Simon Watts, 1768 [while in coll. of Th. Hudson], published in C. Rogers, *Collection of Prints in Imitation of Drawings*, 1778.

This and the drawing in Windsor (No.236) are the only authentic self-portrait drawings by Rubens which have been preserved. Both are from the late period of the master; the Paris drawing, in contrast to the English one, is a formal rendering, which served for the painted Self-portrait in Vienna (*KdK.*427). Rubens faces the beholder in three-quarter view; his right hand, gloved, holds the left glove in a typical 'chevaleresque' arrangement. In the painting Rubens added the sword, which he was entitled to wear, resting his left hand on it. Other differences have been well described by Lugt and I agree with his opinion 'que le dessin est plus poignant par sa simplicité et par sa plus grande vérité'. It is customary to date the Vienna portrait in the last years of the master's life, a date which has also been accepted by Glück and Haberditzl ('*c.*1636–40') and by Lugt ('Rubens était sexagénaire') for the Paris drawing. There is neither any evidence that the drawing is that late, nor—admittedly—that it is not. However, a comparison with the Windsor drawing seems to me to suggest a somewhat earlier date, since Rubens looks definitely more aged in the latter. Such a date is also preferable for the Vienna painting.
A copy of this drawing, possibly by Van Dyck, is in London (Hind, *Catalogue* No.123). See also Lugt's note on it in the Louvre catalogue.

226 [Colour Plate 7] *(1959: No.135)*

TREES AT SUNSET

c. 1635. Black, red, and white chalk. 273 × 454 mm.
London, British Museum. (Gg.2–229).

COLLECTIONS J. Richardson, Sr.: C. M. Cracherode.
EXHIBITIONS London, 1977, No.195.
LITERATURE Hind, *Catalogue*, No.108; G.-H. No.171; Glück, *Landschappen*, 35, 72 (Fig.16); Van Puyvelde, *The Burlington Magazine*, LXXVIII, 1941, 188, 191; Evers, I, 434; Th. Bodkin, *Catalogue of the Paintings, Drawings, and Miniatures in the Barber Institute of Fine Arts, University of Birmingham*, Cambridge, 1952, 89; Held, 'Rubens and Aguilonius: New Points of Contact', *The Art Bulletin*, 1979, 257 ff.; Adler, *Corpus Rubenianum* XVIII, 1982, No.77.

Inscribed in Rubens' hand: 'de boomen wederschyn[en] In het Waeter bruynder ende veel perfecter In het Waeter als de boomen selve.' This has been freely translated by an English, eighteenth-century hand underneath: 'Thee Shadow of a Tree is greatter in ye watter and more parfect then ye treess themselves, and . . . darker.' Actually it reads: 'The reflection of the trees in the water is browner [darker?] and more perfect [clear?] in the water than the trees themselves.'
This rapid sketch, charming in itself, gains in interest on account of its inscription. Here Rubens reveals his keen observation and an inclination toward theoretical problems. No exact correspondence with any of his painted or engraved landscapes has been found, yet reflections in water of just such feathery trees are seen in the Sunset landscape in London, in the so-called Landscape near Malines in Birmingham (see Th. Bodkin, loc.cit.), and in the moonlight landscape in the Princes Gate Collection, Courtauld Galleries. These connections make it clear that the drawing must belong to the late period of the master, though Van Puyvelde (loc.cit.) dates the Birmingham painting and apparently the drawing in London between 1610 and 1620. I have pointed out more recently (loc.cit.) that the inscription, apparently reflecting a spontaneous observation, may well allude also to a passage (De umbris, pp.423–443) in F. Aguilonius's book on Optics (OPTICORVM LIBRI SEX Antwerp, 1613).

227 [Plate 225] (1959: No.136)

LANDSCAPE WITH A WATTLE FENCE

c. 1635–1638. Black chalk (in two tones) and red chalk (chiefly on the tree at right and on the fence); grey, foxed paper. 353 × 514 mm.
London, British Museum (1854.6.28.7).

COLLECTIONS P. H. Lankrink; J. Richardson, Sr.; T. Hudson.
EXHIBITIONS London, 1977, No.196.
LITERATURE Rubens Bulletin IV, 298 (No.1587³); Vasari Society, II, 1906–1907, 25; Hind, Catalogue, No.109; G.-H. No.211; Glück, Landschappen, 1945, 35, 72, Fig.15; Burchard-d'Hulst, 1963, under No.207; Adler, Corpus Rubenianum, XVIII, 1982, No.75.

Like the similar sketch in Oxford (No.228) this beautiful drawing probably dates from the last years of Rubens' life when his ownership of Castle Steen brought him into close contact with nature. The prevailing flatness of the land, the lightness and softness of the forms diffused in light are characteristic of the master's late style in the rendering of landscapes.
Another drawing—in gouache—in Leningrad (M. V. Dobrok-lonsky, Zeitschrift für Bildende Kunst, LXIV, 1930, 36–37 and idem, Risunki Rubensa, Moscow, 1940, rep. in colour) is less convincing and seems to stand closer to a group of gouache landscapes often given to Van Dyck. In contrast to this opinion is that of Burchard and d'Hulst (Catalogue, Exh. Antwerp, 1956, Supplement, No.138a) who not only accepted that drawing but called it indeed one of Rubens' most important landscapes.

228 [Plate 200] (1959: No.137)

WOODLAND SCENE

c. 1635–1638. Black, red and white chalk, on stone-coloured paper. 383 × 499 mm.
Oxford, Ashmolean Museum (201).

COLLECTIONS P. H. Lankrink; Chambers Hall.
EXHIBITIONS London, 1927, No.567; London, 1938, No.579; Brussels, 1938–39, No.49; Rotterdam 1939, No.47; London, 1950, No.57; Antwerp, 1956, No.138.

LITERATURE P. Buschmann, Onze Kunst, XXIX, 1916, 42–43; Vasari Society, 2 series, II, 1923, 12; Muchall-Viebrook, No.30; G.-H. No.170; K. T. Parker, Catalogue of the Collection of Drawings in the Ashmolean Museum, Oxford, 1939, No.201; Glück, Landschappen, 5, 19, 35, 72 (Fig.14); Burchard-d'Hulst, 1963, No.207; Adler, Corpus Rubenianum, XVIII, 1982, No.75.

Glück and Haberditzl dated the drawing 'ca.1625–30'; Parker stressed its connection with the London Landscape with a Wattle Fence (No.227), which would indicate a later date. The light touch and the transparency of the foliage is indeed more in keeping with the landscape style of the 1630's than that of any period before. A little bridge, not unlike the one in the drawing, surrounded by slender trees, is seen at the approaches of Castle Steen, at the left of the large landscape showing Castle Steen in the London National Gallery (KdK.404).

229 [Colour Plate 8] (1959: No.66)

HERCULES AND MINERVA FIGHTING MARS

c. 1635–1637. Gouache, over black chalk, on light brown paper. (There is no reason to assume, as did Glück-Haberditzl and Burchard-d'Hulst, that oil-colour was used.) 370 × 539 mm.
Paris, Louvre, Cabinet des Dessins (20.183).

EXHIBITIONS Antwerp, 1930, No.443; Antwerp, 1956, No.115; Antwerp, 1977, No.169; Paris, 1978, No.28.
LITERATURE R., V. No.1475; R., IV, under No.826; G.-H. No.182; Lugt, Catalogue, No.1014; Burchard-d'Hulst, 1963, No.169; Kuznetsov, 1974, No.140; R. Baumstark, 'Ikonographische Studien zu Rubens Kriegs-und Friedensallegorien', Aachener Kunstblätter, 45, 1974, 163–5; Held, 1980, under No.244.

The theme of war and peace was close to Rubens' heart from the time he had taken an active part in the negotiations for peace between Spain (the power which ruled his own country) and England. In several allegorical compositions he expressed his hatred of war, and his deep longing for peace. The brilliant gouache in Paris—as has always been observed—has connec-tions with the painting of Minerva defending Peace in London (KdK.312; see also No.178) and the similar one in Munich (KdK.313). For that reason it has generally been dated about 1630. In its compositional pattern, with its increasingly urgent movement towards the right, its long diagonal chain towards the upper right corner, and the motif of the tumbling figures in the lower right, it is related even more closely to the great Allegory of War in the Palazzo Pitti (KdK.428; see Introduction p.16). It may well represent a stage in the development of that painting. If so, it is significant of Rubens' growing pessimism in view of current events; whereas in the gouache the powers of peace and of war are still fairly evenly matched, and the ultimate triumph of Minerva and of Hercules is strongly suggested, the painting in the Pitti seems to express the melancholy idea that no power is strong enough to stop the fatal drift to war.
The Paris gouache clearly approaches the effects of Rubens' sketches in oil. More specifically, it aligns itself with the sketches which Rubens made in the middle of the 1630's and shortly thereafter for the large projects which occupied him at that time. The Hercules is reminiscent of the figure of Mercury in Mercury and Argus, of the Torre de la Parada series (KdK.391). The Woman who is dragged along by Mars is very similar, though in reverse, to the figure of Hippodamia in the Abduction scene of the same cycle (KdK.385, above). Thus a date close to these works, and not too far from the Pitti canvas, seems to be indicated.
After the publication of this book in 1959 a very important oil sketch turned up (Held, 1980, No.244, then owned by Edward Speelman & Co., London) which appears to have been done before the Paris gouache. Despite the differences between the

two works, which I tried to describe, the basic programme of both works is the same. There may have been special reasons for Rubens to take up the theme again, and to do it in the unusual technique of the gouache, so that the work could be considered an end in itself.

230 [Plate 205] *(1959: No.67)*

THE FEAST OF HEROD

c. 1637–1638. Black and red chalk and pen and ink, on coarse paper. 272 × 467 mm.
On the reverse: Thomyris, queen of the Messagetae, orders Cyrus' head to be dipped into a basin of blood, a symbolical punishment for his refusal to give up Thomyris' captured son.
Cleveland, The Cleveland Museum of Art (54.2).

EXHIBITIONS Cambridge–New York, 1956, No.26; Antwerp, 1956, No.131.
LITERATURE L. Burchard, *The Burlington Magazine*, XCV, 1953, 383; Held, *The Burlington Magazine*, XCVI, 1954, 122; Henry S. Francis, *The Bulletin of the Cleveland Museum of Art*, XLI, 1954, 124; Held, *The Burlington Magazine*, XCVIII, 1956, 123–124; Burchard-d'Hulst, 1963, No.196; Kuznetsov, 1974, No.148.

Inscribed (r°): 'den Herodias meden hoofte' and 'den stoel . . . Caesar(?)'; (v°): 'plus spatij'. All the inscriptions are in Rubens' hand. Both sides suffer from the heavy inking coming through from the reverse. An old copy is in the printroom in Amsterdam, 1940: 633.

Variants of the figures done in pen are sketched in red chalk in the upper half of the drawing. The drawing is connected with a painting which belongs to Rubens' last years and may indeed never have been finished by him. Rediscovered by L. Burchard in the Lady Lever Art Gallery, Port Sunlight, Cheshire, it is now in the National Gallery of Scotland, Edinburgh. This large painting (201.9 × 265.4 cm) has thirteen full-length and life-size figures and differs in many respects from the drawing which has only six half-length figures. One of the main differences in the actios of the figures concerns Salome, who does not hold the salver with John's head as she does in the painting, but only lifts its cover with her left hand. Another striking difference is seen in Herodias' costume: she wears a fashionable small feathered tocque in the painting, while her head is bare in the drawing. The drawing thus represents the first draft for a composition which must have gone through several stages before it reached its final form in the Edinburgh picture. It is not likely, however, that there was ever a stage between the two works resembling the composition which Burchard called a 'second' version, and which had many more figures than the painting in Edinburgh. The Thomyris and Cyrus composition on the reverse is connected with a painting now in the Louvre (R., IV, No.792). Contrary to an earlier version where she stands (Boston Museum, *KdK*.175, see No.100), Thomyris is seated on a throne. At the left a man stands in a striking frontal pose. It occurs more than once in Rubens' work (e.g. the Adoration of the Magi in Lyon [*KdK*.162, engraved by Vorsterman 1621]; an Adoration of the Magi formerly in a private collection in New York [Goris-Held No.49]; and in the portrait of a Man in Oriental Dress [Cassel, *KdK*.174]). This figure, however, is ultimately derived from one drawn by Gentile Bellini and twice used by Pintoricchio in his frescoes in the Vatican. For the late date of the drawing, see Held, *loc.cit.*, 1954. The Edinburgh picture, despite its rather different subject, may have been among the sources for Jordaens' 'moralistic meal-scenes' which begin just at the time this work was painted.

231 [Plate 209]

COMBAT OF TWO ARMOURED MEN

c. 1635–1638. Pen and brown ink over black chalk.
On the reverse: a small dog, done in black chalk only.
New Haven, Yale University Art Gallery (1968.78).

LITERATURE 'New Acquisition', *Yale University Art Gallery Bulletin*, XXXII, 1969, 44; Anne-Marie Logan, 'Two Armored Soldiers Fighting', *Yale University Art Gallery Bulletin*, XXXIV, November, 1972, 16–18; Held, 1980, 388 (under No.288).

Their heads protected by helmets, the two foot soldiers in half-armour are wielding their swords in close hand-to-hand combat. Each one tries to stay with his left hand the right one of his opponent which is extended backwards for greater force in driving the weapon home.
Before he reinforced the main outlines with pen and ink, Rubens had sketched some of the limbs in different position in black chalk, changes described in detail by Logan. Logan also realized that the drawing belongs to the later years of Rubens' activity and associated it stylistically—and convincingly—with the drawing of the Lansquenets Carousing (see No.232). To the analogies cited by her I added (1980) a reference to the Berlin sketch of The Conquest of Tunis by Charles V, though no exact correspondence can be established with that composition. The style of the armour shown in the New Haven drawing does point to the early sixteenth century.

232 [Plate 208] *(1959: No.68)*

LANSQUENETS CAROUSING

c. 1638. Pen and ink, over black chalk. 272 × 355 mm.
On the reverse: Rapid sketches (pen and ink, over chalk) of a shepherd playing a recorder, a seated woman, and a third figure.
Paris, Fondation Custodia, Collection F. Lugt.

COLLECTIONS P. H. Lankrink; J. Richardson, Sen.; Sir Joshua Reynolds; E. Wauters.
EXHIBITIONS Amsterdam, 1933, No.134. London–Paris–Bern–Brussels, 1972, No.85.
LITERATURE G.-H. No.219; F. Lugt, *The Art Quarterly*, 1943, 107–108; Evers II, 317; Burchard-d'Hulst, 1963, under No.196; Kuznetsov, 974, No.150.

Inscribed in Rubens' hand: 'met een groot slecht landschap' (with a large flat landscape).

The paper appears to have been cut at the left side where parts of a crouching woman, including her left arm, are still visible. As it is, the drawing renders the right half of a composition about which we are fairly well informed even though it is uncertain whether or not the original painting by Rubens is still preserved. The first record of this subject is an entry in the inventory of Rubens' estate (No.90, see Denucé, *Inventories*, 60 and 75): 'A troop of Swiss who force the peasants to give them money and set the table, on canvas'. It was sold for 880 florins. It may be identical with a painting listed in the estate of E. Quellinus in 1678–1679 (Denucé, *Inventories*, 289) as 'De soldaten beklimmen thofken' (The Soldiers take the farm). F. van de Wijngaerde engraved this composition (Van den Wijngaert, No.777). Fragonard drew it in 1761 when he saw a version of it in the Colonna Collection in Rome. His drawing was last in the collection of Dr. Tobias Christ in Basel. When part of the collection of the Colonna Palace was sold, the painting passed into the collection of A. Gordon in Edinburgh. Copies of the composition are known to be in Munich, Budapest, and the collection of Baron Jean de Becker-Remy. A version of the composition, framed elliptically, appears in the painted gallery known as 'Rubens' Studio' by de Baellieur (?) in the Pitti Palace (reproduced in Denucé, *Inventories*, Pl.2).

The drawing in the Lugt collection might be identical with one listed as 'een plunderincxken' (a pillaging) in the estate of Joannes Philippus Happart, Canon of the Cathedral of Antwerp, of 1686 (Denucé, *Inventories*, 337).

Lugt thought that the composition was derived from Holbein or an artist of that generation such as Urs Graf; the name of Jan Lys has also been mentioned (K. Steinbart, *Johann Liss*, Berlin, 1940, 77). Marauding soldiers were painted in the early seventeenth century by Vinckeboons (Amsterdam); what must have been a sixteenth-century version of the theme—and possibly the very source of Rubens' interest in the subject—appears in the inventory of Oct.15–21, 1642, of the estate of H. de Neyts of Antwerp: 'Een affsetterye vanden ouden Cleeff, wesende soldaterye die de lantlieden affsetten' (A plundering, by Old Cleef, showing soldiers who hold up farmers; Denucé, *Inventories*, 95). Thus it is clear that the subject was by no means new when Rubens occupied himself with it, but his picture—as Evers emphasized—is nevertheless a very original treatment of the theme. In view of the fact that the costumes are clearly 'old fashioned', Evers' theory that Rubens aimed at contemporary conditions must be taken with caution.

Glück and Haberditzl, as well as Evers, dated the drawing 1632–1635. L. Burchard, in a ms. statement, suggested 1635–1640. There is a reason for giving preference to the later date. On August 17, 1638, Rubens wrote a brief note from his country seat Steen to Lucas Faid'herbe in Antwerp, who apparently took care of Rubens' house in the master's absence. In this letter (*Correspondence*, VI, 222) Rubens asked Faid'herbe to send him a panel on which he had painted three heads in life size. One was of an angry soldier in a black cap, the other of a crying man, and the last of a man laughing. Since three of the main figures in the painting of the marauding soldiers correspond to this description, it seems plausible to assume that Rubens asked for the study-heads because he was working, or intended to work, on a picture for which he could make use of them.

The figures appearing on the reverse are rough sketches of shepherds for the Landscape with Rainbow in the Hermitage (Glück, *Landschappen*, No.34).

233 [Plate 224] *(1959: No.168)*

YOUNG WOMAN HOLDING A SHIELD

c. 1625–1635. Pen and ink, washed, heightened with white, ochre, and some light green. 261 × 210 mm.
Bakewell, Chatsworth, Devonshire Collection.

COLLECTIONS N. A. Flinck.
LITERATURE *Vasari Society*, V, 1909–1910, 29 'School of Holbein'; F. Thöne, 1940, 64; Lugt, 1943, 108; E. Schilling, 1950, 251.

Thöne was the first author who mentioned Rubens' name in connection with this drawing, though, not having seen the original, he was uncertain whether it was an unfinished earlier work which Rubens had finished or an outright copy by Rubens. Lugt correctly stated that it had been reworked by Rubens and Schilling followed him, with the added comment that the original was a work by D. Hopfer's. None of these authors specified exactly the extent of the reworking, which was considerable. Of the original drawing nothing remains visible except the architecture, the plumes of the hat, the sleeve of the right arm, and the pattern on the undergarment. The rest of the figure is completely reworked, and in some parts extensive changes have been made. Originally the woman wore a cap under the feather hat, from which barely a hair escaped. All the visible hair is Rubens' work, done with the brush. All flesh-parts have been thoroughly reworked, and the shape of both hands has been altered. The most far-reaching change has

been made in her relationship to the shield. In the original drawing, the woman stood behind the shield, which was completely visible. The old outline of the shield can still be seen: it coincides with the long fold running from the girl's right hand obliquely towards her left foot. Her right hand originally held a loop, which was attached to the shield. Thus the whole part of the figure which is now in front of the shield is Rubens' own addition; but other parts of the dress, for instance the left sleeve, were so completely redone that they too show nothing but Rubens' work. A few highlights on the pilaster at the left were also added by him, as were the 'horn' and the 'curl' of the shield. It hardly needs saying that the demure smile of the girl and the soft modulation of her face are all—and typically—Rubens'.

In its present shape, therefore, the Chatsworth drawing is essentially a work by Rubens. It is an important example of Rubens' interest in works of the early sixteenth century. In view of the almost complete reworking of the earlier drawing it seems hazardous to attribute that drawing to any definite master. It is equally difficult to say at what time Rubens might have done this reworking. It does look like a relatively late work, though it is probably wiser not to confine too narrowly the date for a drawing of this kind.

Photos taken at my request with infra-red and ultra-violet light largely confirmed the observations made from the original drawing. In addition it allows to make out clearly the armorial design on the shield (two pitchers and a housemark) but I have been unable to identify it. It now seems likely that the original is the work of a Swiss artist working under Hans Holbein's influence.

234 [Plate 227] *(1959: No.169)*

A GARDEN PARTY

c. 1625–1635. Pen and ink and water-colour (brown, blue-grey, green, body-white), on blue-tinted paper. 207 × 434 mm.
Vienna, Albertina (149S).

EXHIBITIONS Vienna, Albertina, 1974–75, No.23.
LITERATURE O. Benesch, *Alte und Neue Kunst*, III, 1954, 18 (Fig.11); Mitsch, 1977, No.64.

This interesting drawing was formerly ascribed to Giorgione; Franz Wickhoff thought it was a copy after a lost painting of Romanino. According to Benesch, the reworking of the drawing by Rubens was already noted in an inventory made about 1800.

Benesch has the merit of having discovered the drawing among those of the Venetian School; he not only recognized the fact that Rubens reworked it extensively, but he also succeeded in identifying the original draftsman. On the basis of an etching, preserved in only one impression in the Albertina in Vienna (reproduced as Fig.10 in Benesch's article), it is safe to ascribe the original drawing to J. C. Vermeyen (a portrait by whom Rubens copied in the powerful image of Mulay Ahmad in Boston [see *The Art Quarterly*, 1940, 173 ff.]). The etching shows not the same but a very similar scene, both perhaps records of a lost wall-decoration.

Rubens did not touch the lovers at the extreme left nor the reflections in the water, except the one below the man behind the tree. He put highlights on foreheads, cheeks, and especially the hands of figures; his most radical changes were made in the three figures on the right. The young couple near the edge was originally sitting behind a round table and therefore visible only to the middle. The action of their hands is all Rubens' work. The figure behind the tree in Vermeyen's drawing stretched out his hand toward the couple at the right; his hands and his head, and naturally their reflections in the water, are also—as was already observed by Benesch—almost completely due to Rubens' intervention.

Such a striking similarity in the nature of the theme exists between Vermeyen's etching and Vermeyen's drawing that a close connection must be assumed. That similarity must have been even greater before Rubens' reworking of the drawing, when there was in both compositions a round, foreshortened table at the right, with a couple sitting behind it, and with an arm of another figure extended toward them. It is possible, though one can no longer be certain, that the woman sitting behind the table was originally old-looking in the drawing as she is in the etching. Nevertheless, the drawing can never have been a study for the etching, but must have been an alternate version of the same theme. Vermeyen apparently made two designs; the etching, not only giving as it does more details of the fountain and the trees, but also revealing a more successful grouping and perspective, probably preserves the version that was executed on a larger scale.

As in No.233, a relatively late date seems to me more likely than an early one.

235 [Plate 226] *(1959: No.150)*

THE FLIGHT INTO EGYPT

c. 1630–1635. Black chalk, reworked with gouache in black and grey, heightened with white. 365 × 465 mm. Stylus marks for transfer.
London, British Museum (Gg.2–234).

COLLECTIONS The Reverend C. M. Cracherode.
EXHIBITIONS London, 1977, No.171.
LITERATURE *Vasari Society* II, 1906–1907, 23; R., I. No.178; Hind, *Catalogue*, No.7; Burchard-d'Hulst, 1963, No.193.

Although Hind saw the differences between this drawing and the painting of 1614 in Cassel (*KdK.*78) on the one hand, and its close correspondence with the engraving by Marinus van der Goes (V. S. p.24, 102; R., I, Pl.61) on the other, he nevertheless called the drawing a 'study for the picture.' Actually, it was clearly made (and used) for Marinus' engraving and is only in part Rubens' work. The basic work in chalk betrays the hand of a pupil, following in a rather dull manner the sketch in the Gulbenkian collection, Lisbon (Held, 1980, No.333). The pupil's work was gone over by Rubens himself, with solid washes in various shades of grey. In some sections (especially in the figure of the Virgin) this reworking was so extensive that the present surface is largely Rubens' own. The drawing thus resembles those cases where Rubens reworked drawings by older masters (see Nos.233, 174), or where he corrected proofs of engravings and woodcuts.

That the Gulbenkian sketch is later and represents a more mature solution of the theme than the Cassel picture was plain to Glück (*Landschappen*, 6, 9), who dated it about ten years after the painting in Cassel. The central group of Virgin and child is the object of much more effort and tender care: the angel guiding the ass scans the fields instead of looking down; the one flying overhead points forward to safety, while illuminating the road with his torch; a third angel, not found in Cassel at all, covers up the flight by pushing clouds between the Holy Family and its pursuers, and Joseph himself raises his right hand in an eloquent gesture of concern. Even the two willow trees at the right help to create a protective screen. By contrast, some typical early motifs (the Elsheimer-like reflection of the moon, and the exaggerated foreshortening of the flying angel) have been eliminated. The original inspiration for this composition may have come from Elsheimer; see Rubens' letter to Dr. Johannes Faber of January 14, 1611, where the master expresses a keen interest in Elsheimer's painting of the Flight into Egypt (*Correspondence*, VI, 327–329).

Since Marinus was active in Antwerp only in the 1630's, it is logical to assume that a drawing engraved by him was not done much earlier. A drawing retouched by Rubens in a similar way is the Martyrdom of St. Andrew in London (Hind, 13) which must belong to the late 1630's.

The drawings by pupils to which Rubens gave the final touches prior to their being engraved are so numerous that it is impossible to quote them all. I should like to mention, however, the Crucifixion of St. Peter in Basle which was apparently never engraved in the seventeenth century, and the Lamentation of Christ in the Louvre (Lugt, *Catalogue*, No.1141). The drawing of two prisoners in the Musée Pincé at Angers, which was exhibited as an original at Antwerp (*Catalogue*, Exh. Antwerp, 1956, No.92) is clearly another case where only the reworking in leadwhite can be credited to the master himself. The two figures were copied from a fresco by Salviati (Burchard-d'Hulst, 1963, No.93).

236 [Plate 206] *(1959: No.126)*

SELF-PORTRAIT

c. 1635–1640. Black and white chalk, some fragments of pen and ink sketches, on light brown paper. 200 × 160 mm. Minor pieces torn off off at the top; some waterstains.
Windsor Castle (6411).

EXHIBITIONS London, 1977, No.223.
LITERATURE Leo van Puyvelde, *The Flemish Drawings in the Collection of His Majesty the King at Windsor Castle*, London, 1942, No.281.

When the drawing was remounted prior to the exhibition of 1977, a sketch in black chalk was uncovered on its back. It depicts a man (?) embracing a nude woman; below her is the number 25 (?) or 29 (?). The configuration is reminiscent of the group at the right in a drawing in Rotterdam, rendering Callisto embraced by Jupiter in the guise of Diana. There is no such openly amorous action in the Prado painting (*KdK.*381) to which Logan referred (*Master Drawings*, XV, 1977, No.4, 414). The eyes were drawn twice (in the final version a fraction higher than before), a type of correction which is not unusual with Rubens (see No.108). The head was evidently cut out of a larger paper on which Rubens had sketched various compositions in pen and ink; in the upper left an arm can still be made out, while the lines at the lower right seem to be part of a drapery.

Van Puyvelde tentatively connected this drawing with the Munich painting of Rubens and Hélène Fourment in the Garden (*KdK.*321) and dated it 'about 1630'. Apart from the fact that Evers expressed doubts (II, 336–41) about the Munich picture there is every reason to dissociate the drawing in Windsor from the portrait which served for the Munich painting. The large, somewhat flabby, profoundly serious and almost tragic face of the Windsor drawing has nothing in common with the ingratiating, elegant, and youthfully trim face that looks at us from the Munich panel. The Munich portrayal of Rubens is closely allied to a drawing in Vienna (G.-H. No.191), which is certainly the work of a copyist (see Introduction, p.15).

Liedtke (1984, 181) made the interesting suggestion that the Windsor self-portrait was drawn in connection with the large painting, now in the Metropolitan Museum of Art, of Rubens, his wife Hélène Fourment, and their son Peter Paul. The position of the head seems to correspond indeed to the first version of Rubens' head in that painting (now only seen in the X-ray photograph, Liedtke, I, Fig.38). If this is the case, the drawing must belong to the last two years of the artist's life, since his son Peter Paul was born on March 1, 1637.

1 (Cat. 1) The Knight, drawing after Holbein's *Dance of Death*. Before 1600. 100 × 73 mm. Amsterdam, Mrs. H. D. Pfann

2 (Cat. 2) The Noblewoman, drawing after Holbein's *Dance of Death* Before 1600. 104 × 76 mm. Amsterdam, Mrs. H. D. Pfann

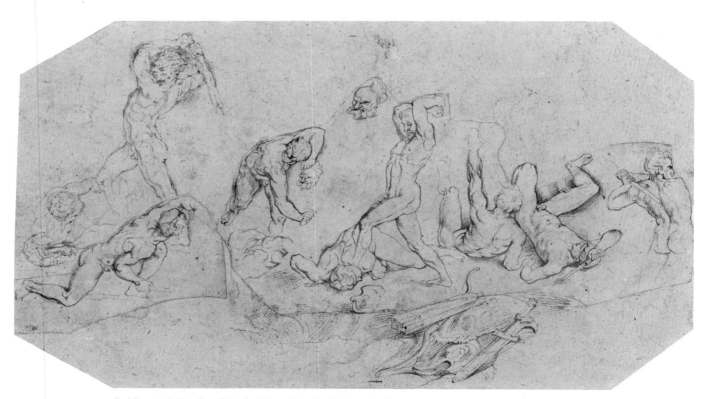

3 (Cat. 3) A Battle of Nude Men, after B. Beham. Before 1600. 142 × 252 mm.
Washington, National Gallery of Art (Julius S. Held Collection, Ailsa Mellon Bruce Fund)

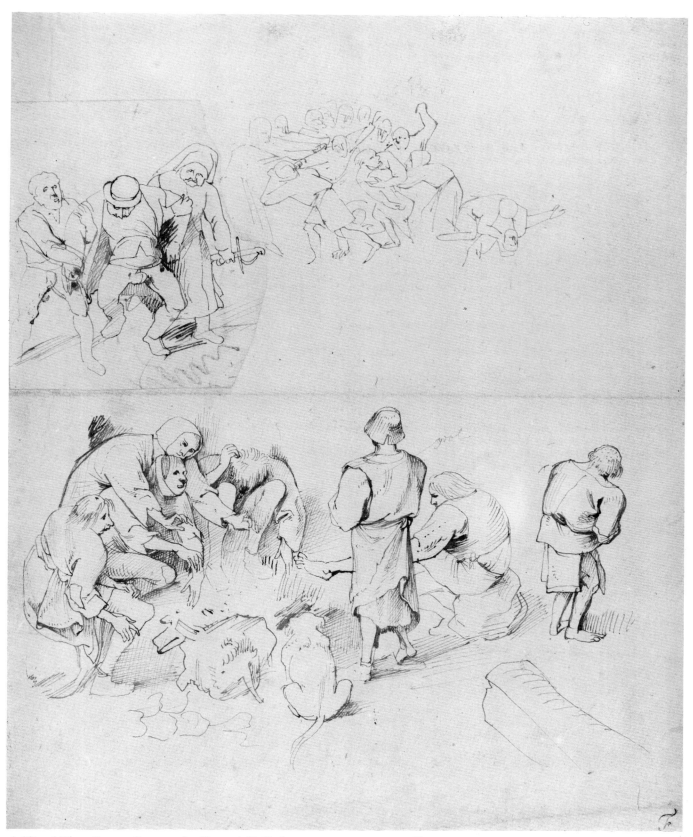

4 (Cat.4) Three Peasant Scenes, after Bruegel (?). Before 1600. 247 × 198 mm. Chatsworth, Trustees of the Devonshire Collection

5 (Cat. 5) Two copies after Tobias Stimmer. Before 1600.
188 × 127 mm. New York, J. Pierpont Morgan Library

6 (Cat. 6) Nine Figures, after Tobias Stimmer. Before 1600.
187 × 127 mm. Hilversum, Private Collection

7 (Cat. 7) Sketchbook Sheet, with Figures after Raphael and Holbein
and notes from Quintus Curtius Rufus's *Historiae*. Before 1600 (?) 202 × 159 mm.
Berlin–Dahlem (Kupferstichkabinett)

8 (Cat.8) The Discovery of Callisto. Before 1600. 179 × 139 mm. Berlin–Dahlem (Kupferstichkabinett)

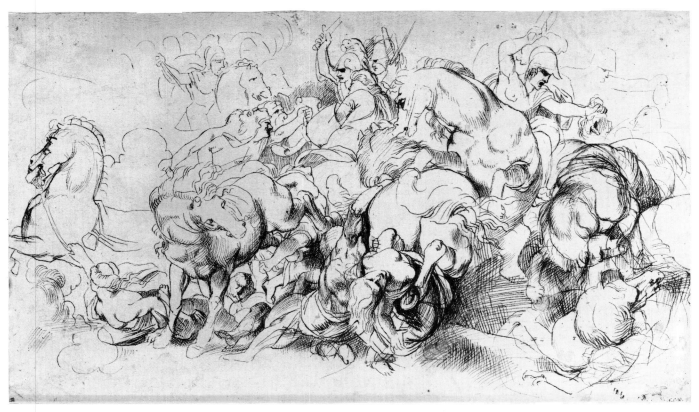

9 (Cat.9) A Battle of Greeks and Amazons. 1600–2. 252 × 430 mm. London, British Museum

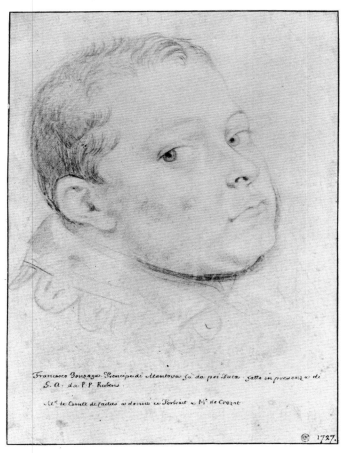

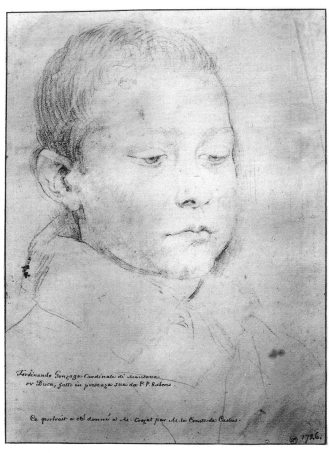

10 (Cat.10) Portrait of Francesco Gonzaga. *c.* 1601–2. 226 × 161 mm. Stockholm, Nationalmuseum

11 (Cat.11) Portrait of Ferdinando Gonzaga. *c.* 1601–2. 224 × 160 mm. Stockholm, Nationalmuseum

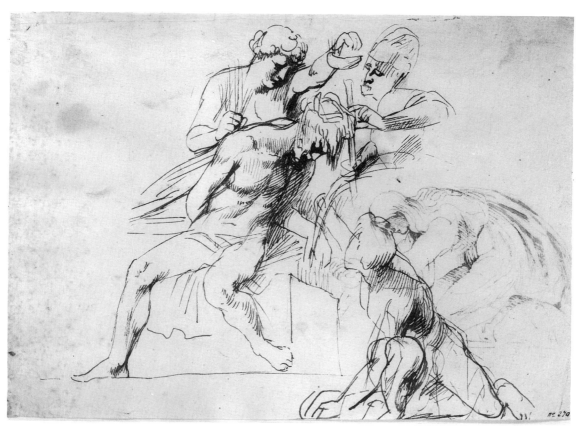

12 (Cat. 13) Christ Crowned with Thorns. *c.* 1601. 208 × 289 mm. Brunswick, Herzog Anton Ulrich-Museum

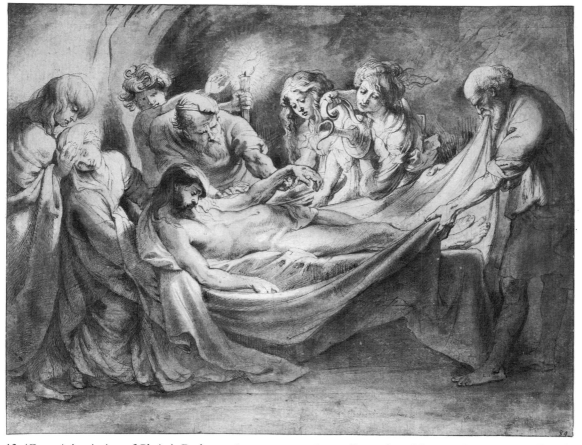

13 (Cat. 12) Anointing of Christ's Body. *c.* 1600–2. 324 × 408 mm. Rotterdam, Museum Boymans–van Beuningen

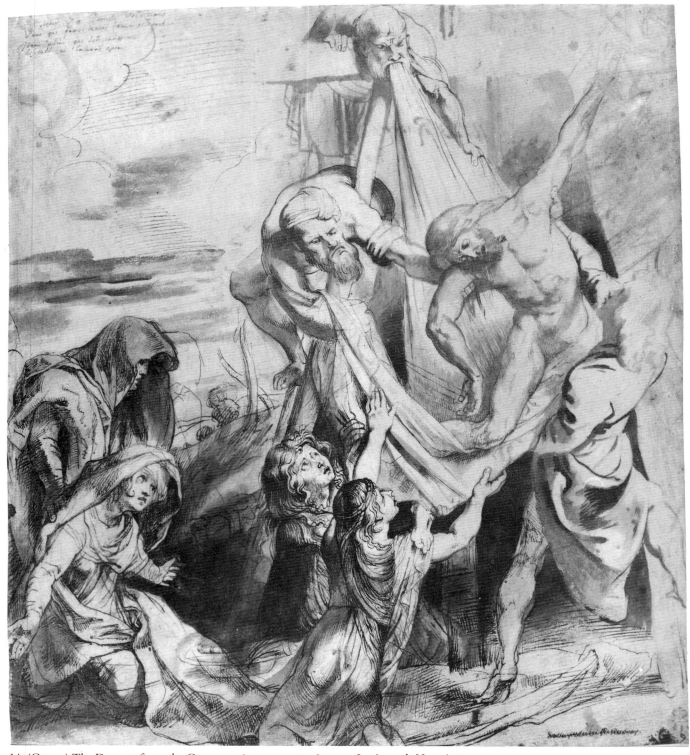

14 (Cat. 15) The Descent from the Cross. *c.* 1600–2. 437 × 380 mm. Leningrad, Hermitage

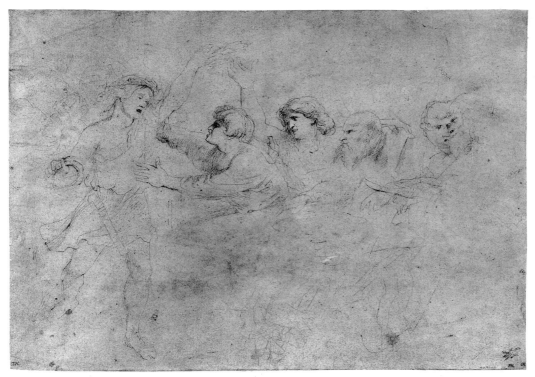

15 (Cat. 17) Alcibiades Interrupting the Symposium. *c.* 1601–2. 260 × 350 mm. New York, Metropolitan Museum of Art

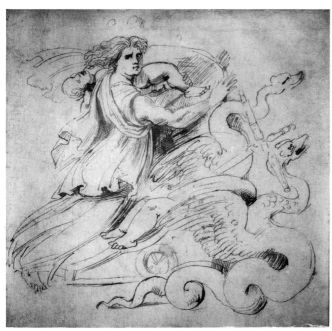

16 (Cat. 16) The Flight of Medea. 1601–2.
157 × 157 mm. Rotterdam, Museum Boymans–van Beuningen

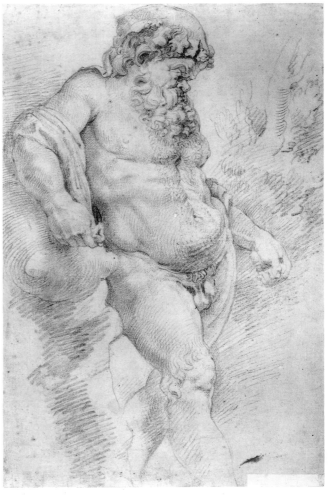

17 (Cat. 37) Silenus. *c.* 1605–8. 413 × 262 mm.
London, British Museum

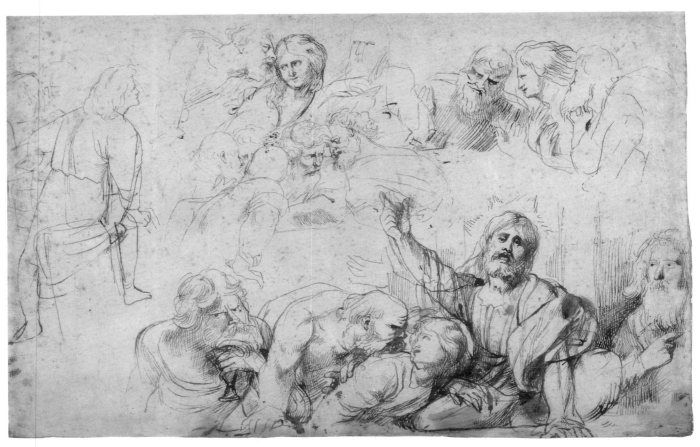

18 (Cat. 18) Studies for a Last Supper. *c.* 1600–4. 283 × 444 mm. Chatsworth, Trustees of the Devonshire Collection

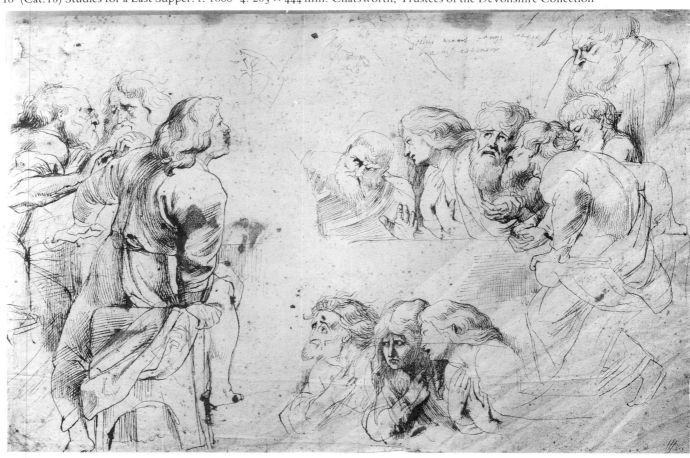

19 (Cat. 19) Studies for a Last Supper. *c.* 1600–4. 293 × 435 mm. Malibu, J. Paul Getty Museum

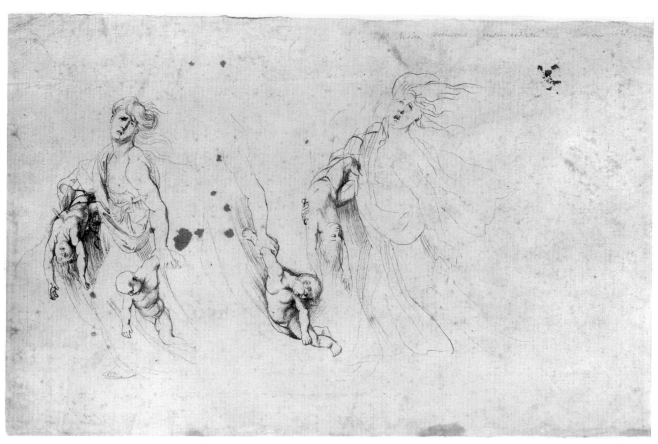

20 (Cat.20) Medea and her Slain Children. 293 × 435 mm. Malibu, J. Paul Getty Museum

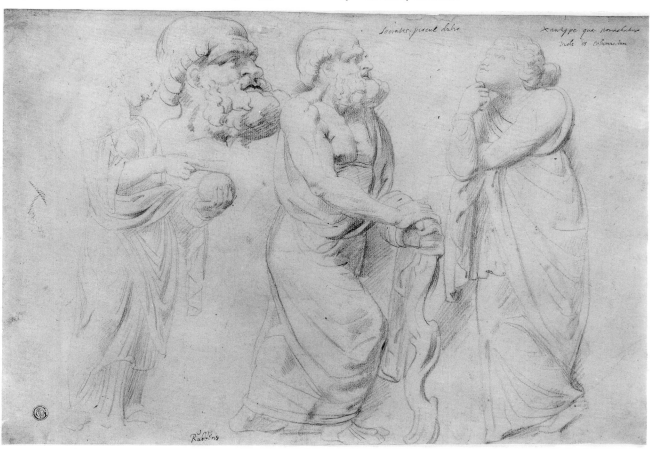

21 (Cat.21) Three Figures from a Roman Sarcophagus. 1601–5. 281 × 416 mm.
 Chicago, The Art Institute (Leonora Hall Gurley Memorial Collection)

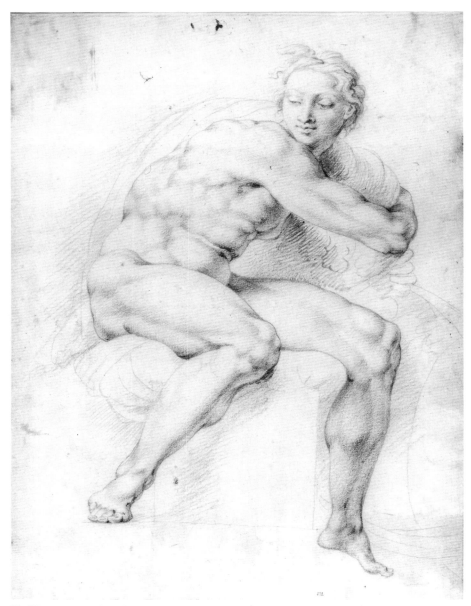

22 (Cat. 22) Ignudo, after Michelangelo. 1601–5. 387 × 277 mm. London, British Museum

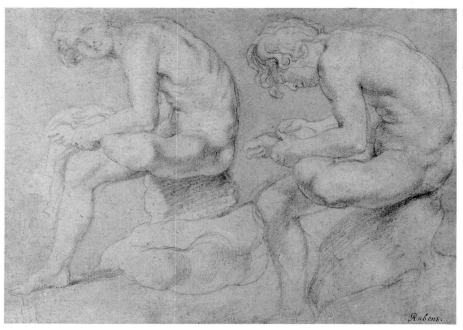

23 (Cat. 39) A Youth in the Pose of the Spinario. *c.* 1605–8. 260 × 360 mm.
 London, British Museum

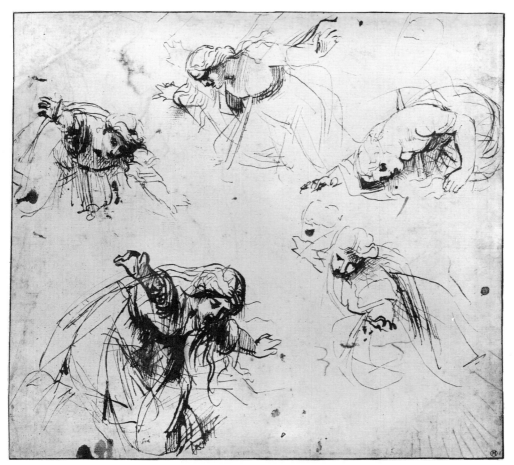

24 (Cat.24) Studies for the Suicide of Thisbe. 1602–5. 193 × 208 mm.
 Paris, Louvre, Cabinet des Estampes

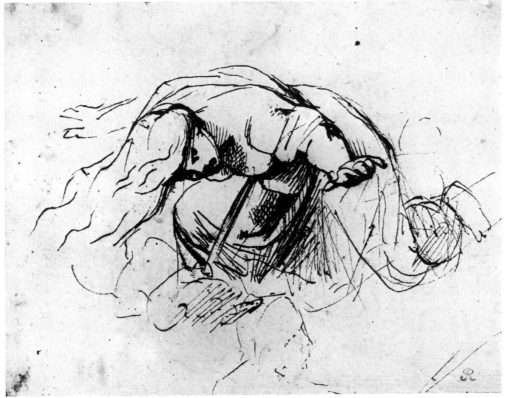

25 (Cat.25) Thisbe Committing Suicide. *c.* 1602–5. 95 × 115 mm.
 Brunswick (Maine), Bowdoin College Museum of Art

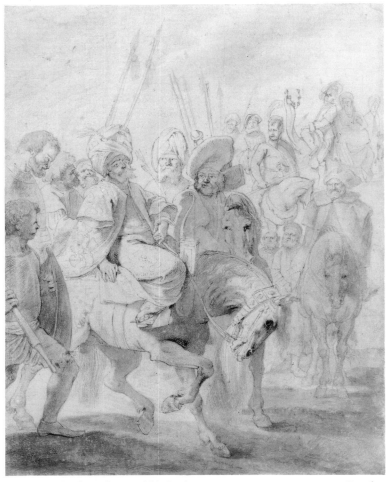

26 (Cat. 31) The Sultan and his Retinue. *c.* 1606–8. 271 × 213 mm. London, British Museum

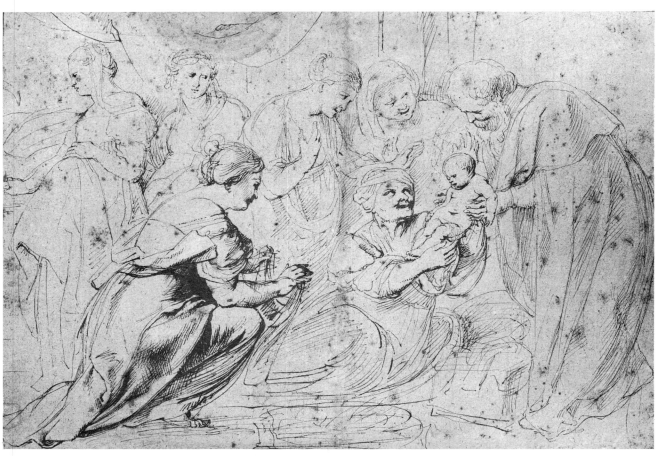

27 (Cat. 23) The Birth of the Virgin. *c.* 1602–6. 253 × 365 mm. Paris, Petit Palais (Dutuit Collection)

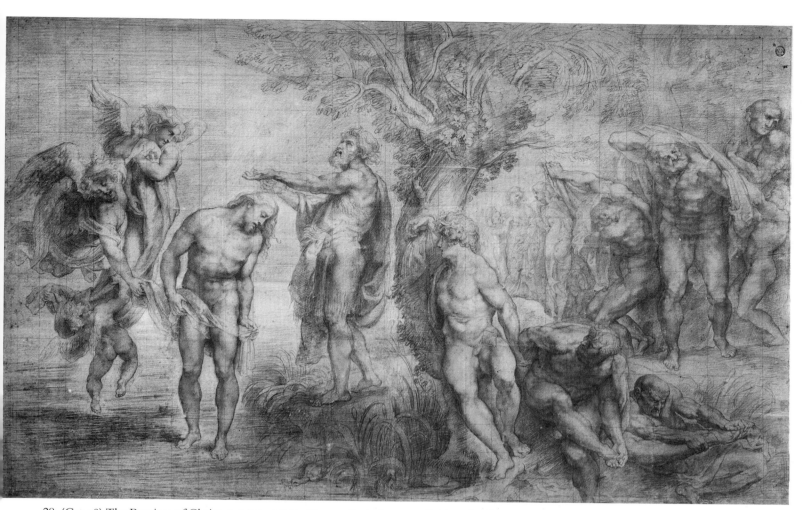

28 (Cat. 28) The Baptism of Christ. *c.* 1604. 477 × 766 mm. Paris, Louvre, Cabinet des Estampes

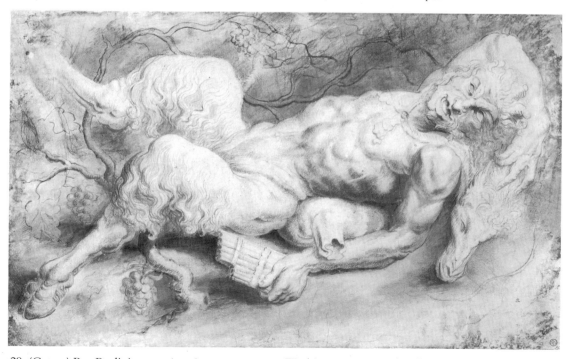

29 (Cat. 40) Pan Reclining. *c.* 1605–8. 309 × 493 mm. Washington, National Gallery of Art (Ailsa Mellon Bruce Fund)

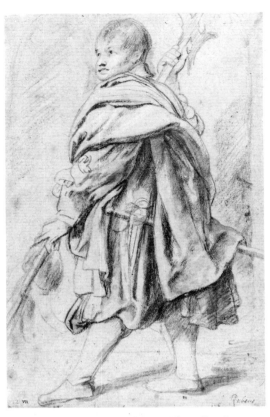

30 (Cat. 27) A Young Soldier with Halberd. 1604.
404 × 258 mm. Brussels, Cabinet des Estampes

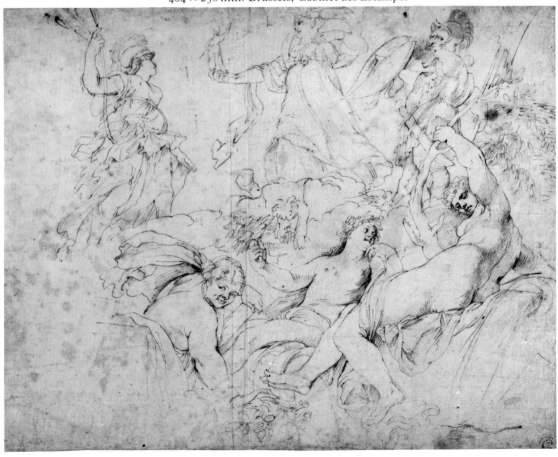

31 (Cat. 30) Allegory of Brescia, after Titian. 1605–8. 316 × 384 mm. London, British Museum

Plates

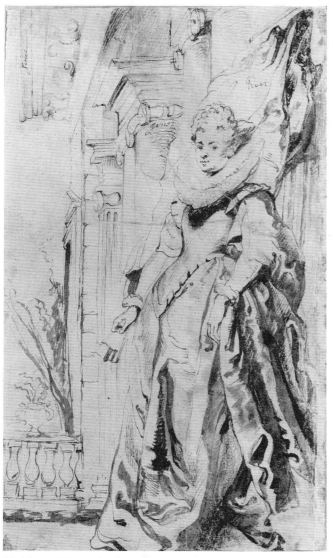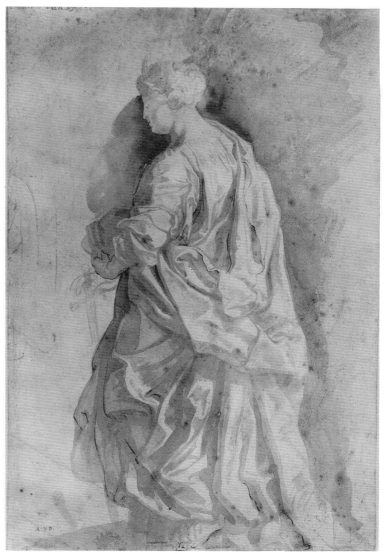

32 (Cat.29) Portrait of a Lady. *c.* 1606.
315 × 185 mm. New York, J. Pierpont Morgan Library

33 (Cat.32) St. Catherine. 1606–7.
470 × 315 mm. New York, Metropolitan Museum of Art (Rogers Fund)

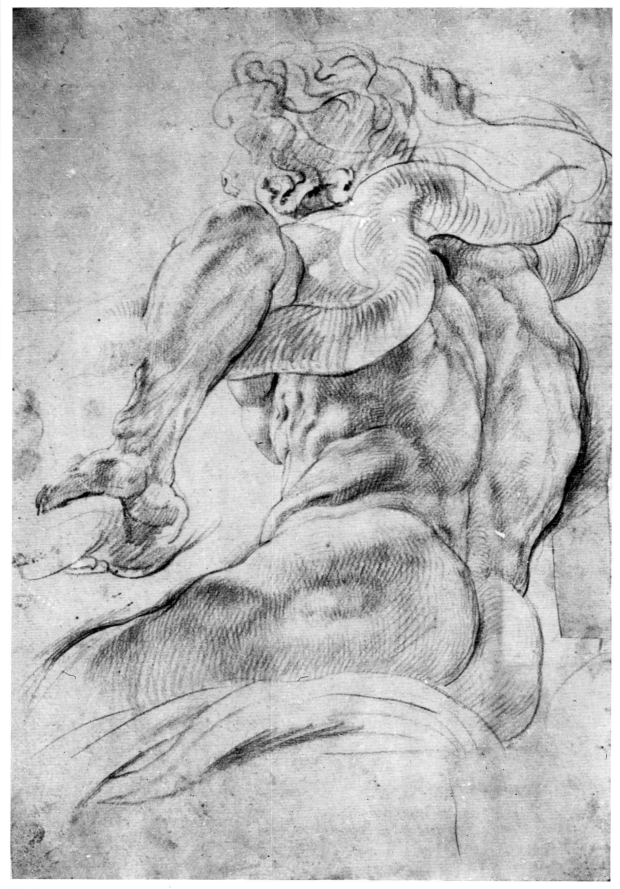

34 (Cat. 34) Laocoön, Seen from the Back. *c.* 1605-8. 440 × 283 mm. Milan, Biblioteca Ambrosiana

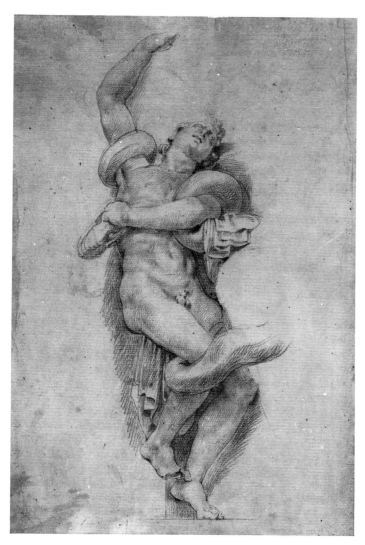

35 (Cat. 35) Laocoön's Younger Son, Seen from the Front.
c. 1605–8. 411 × 260 mm. Milan, Biblioteca Ambrosiana

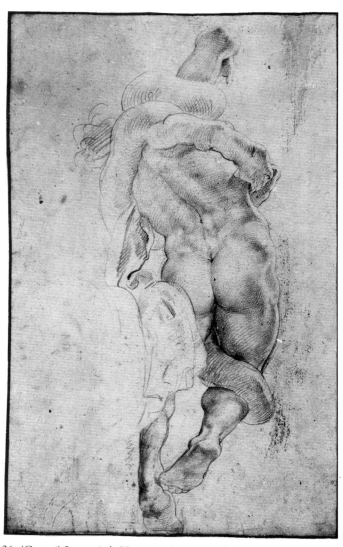

36 (Cat. 36) Laocoön's Younger Son, Seen from the Back.
c. 1605–8. 443 × 265 mm. Milan, Biblioteca Ambrosiana

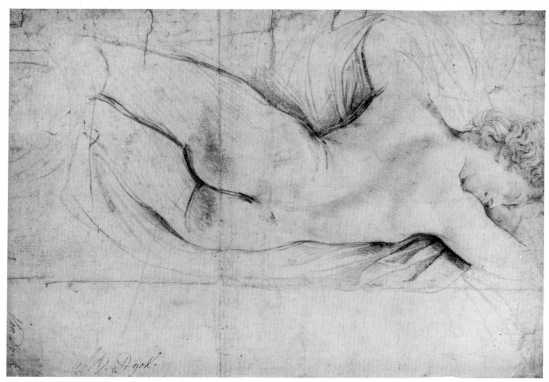

37 (Cat. 38) Sleeping Hermaphrodite. *c.* 1608. 310 × 437 mm. London, British Museum

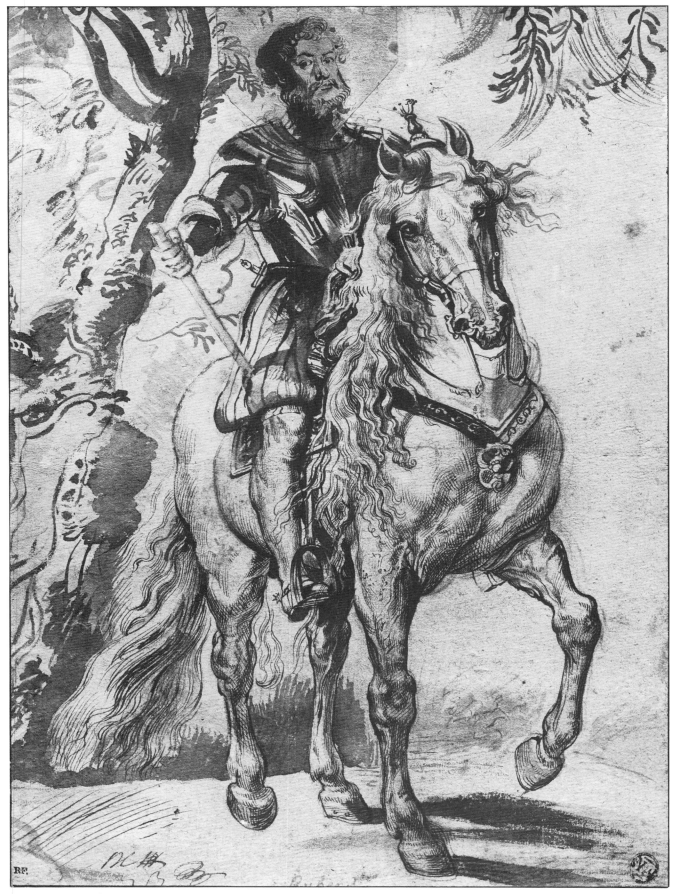

38 (Cat. 26) A Gentleman in Armour on Horseback. 1603. 300 × 215 mm. Paris, Louvre, Cabinet des Estampes

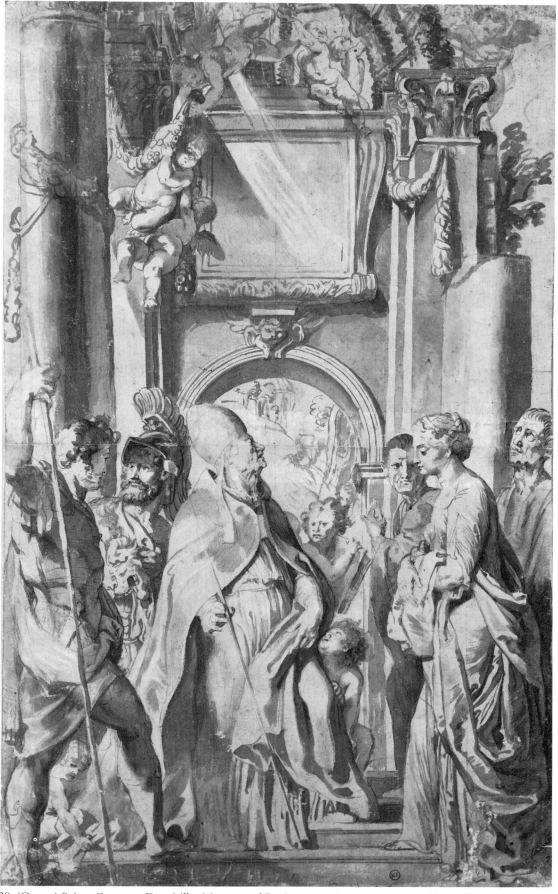

39 (Cat. 33) Saints Gregory, Domitilla, Maurus and Papianus. 1608. 735 × 435 mm. Montpellier, Musée Fabre

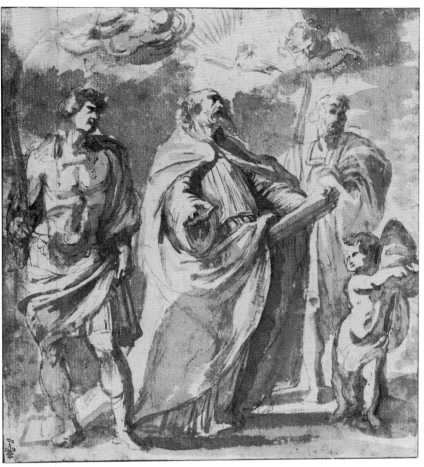

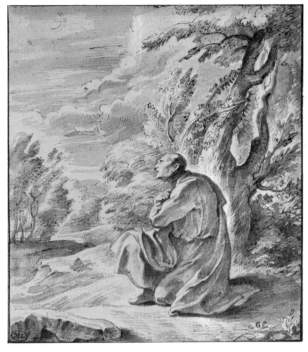

40 (Cat.41) St. Gregory, St. Maurus and St. Papianus.
1608. 158 × 140 mm.
Chantilly, Musée Condé

41 (Cat.44) St. Ignatius of Loyola
Contemplating the Heavens. *c.* 1606–8.
114 × 98 mm. Paris, Louvre, Cabinet des Estampes

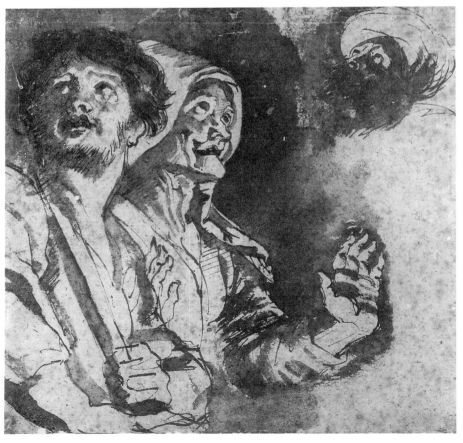

42 (Cat.43) Two Shepherds and a Man with Turban. 1608. 139 × 150 mm.
Amsterdam, Gemeente Musea (Fodor Collection)

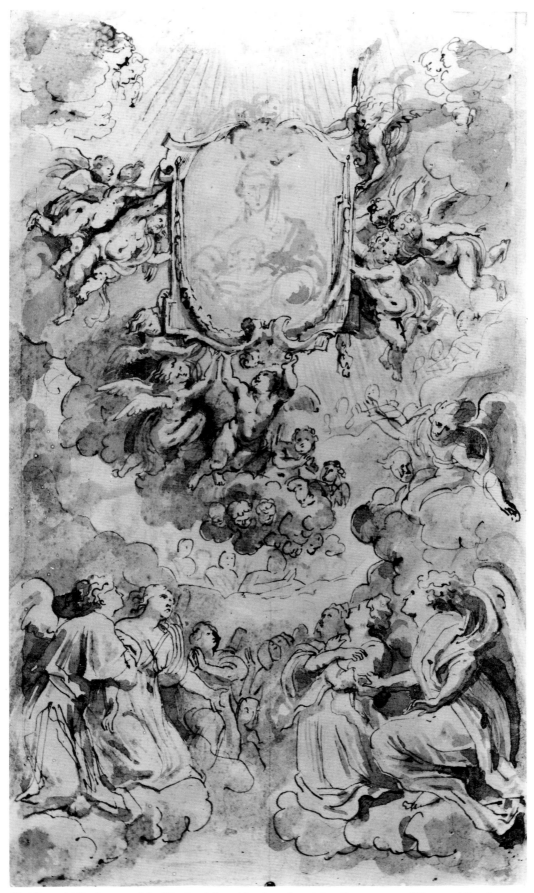

43 (Cat.42) The Image of the Virgin, Adored by Angels. 1608. 268 × 152 mm. Vienna, Albertina

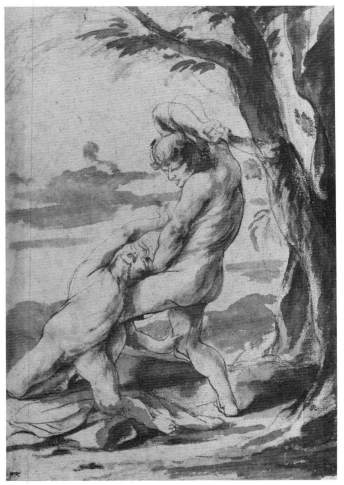

44 (Cat.45) Cain Slaying Abel. *c.* 1608–9.
267 × 184 mm. Amsterdam, Gemeente Musea
(Fodor Collection)

45 (Cat.46) Samson Slaying the Philistines (?). 1608–9.
267 × 184 mm. Amsterdam, Gemeente Musea
(Fodor Collection)

46 (Cat.59) The Death of Creusa. *c.* 1608–10. 224 × 281 mm. Bayonne, Musée Bonnat

47 (Cat.47) The Battle of Lapiths and Centaurs. 1608–10. 159 × 182 mm. Amsterdam, Rijksmuseum

48 (Cat.48) Judith Killing Holofernes. *c.* 1608–10.
205 × 160 mm. Frankfurt, Städelsches Kunstinstitut

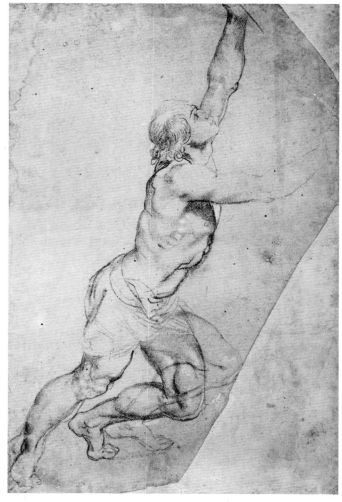

49 (Cat. 55) A Nude Man with Raised Arms. *c.* 1610.
488 × 315 mm. The Hague, Koninklijk Huisarchiv

50 (Cat. 49) The Fight for the Standard, after Leonardo. 1612–15. 452 × 637 mm. Paris, Louvre, Cabinet des Estampes

Plates

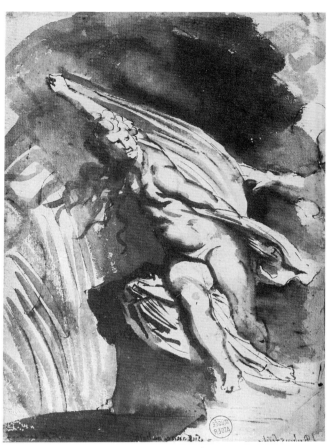

51 (Cat. 53) A Bacchanal. *c.* 1608–10.
140 × 125 mm. Antwerp, Cabinet des Estampes

52 (Cat. 52) Susanna. *c.* 1608–12. 215 × 158 mm.
Montpellier, Bibliothèque Universitaire (Collection Atger)

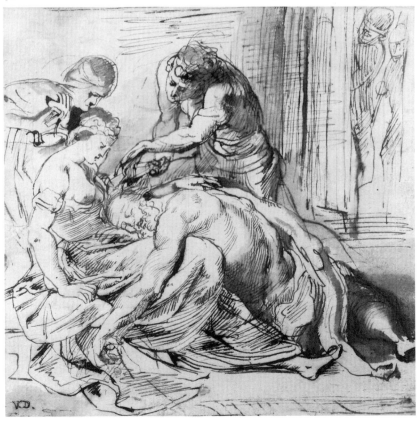

53 (Cat. 51) Samson and Delila. *c.*1610. 164 × 162 mm.
Amsterdam, Collection J. Q. Van Regteren Altena

187

54 (Cat. 50) Design for a Tomb. *c.* 1609. 272 × 171 mm. Amsterdam, Rijksprentenkabinet

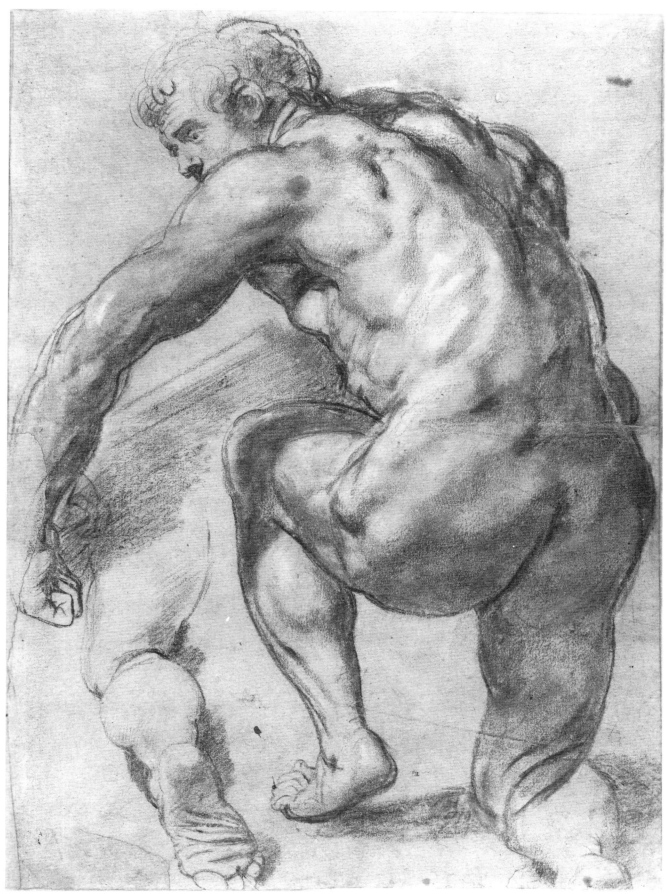

55 (Cat. 54) A Nude Man, Kneeling, *c.* 1609. 520 × 390 mm. Rotterdam, Museum Boymans–van Beuningen

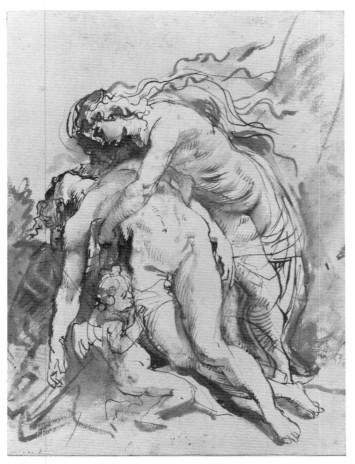

56 (Cat.57) Venus Lamenting Adonis. c. 1608–12.
217 × 153 mm. London, British Museum

57 (Cat.58) Venus Lamenting Adonis. c. 1608–12.
305 × 198 mm. Washington, National Gallery of Art

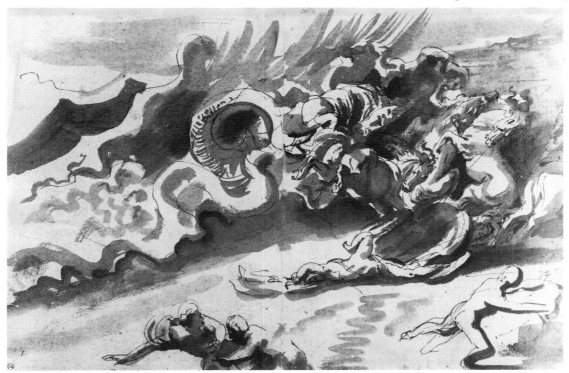

58 (Cat.60) The Death of Hippolytus. c. 1610–12. 220 × 321 mm. Bayonne, Musée Bonnat

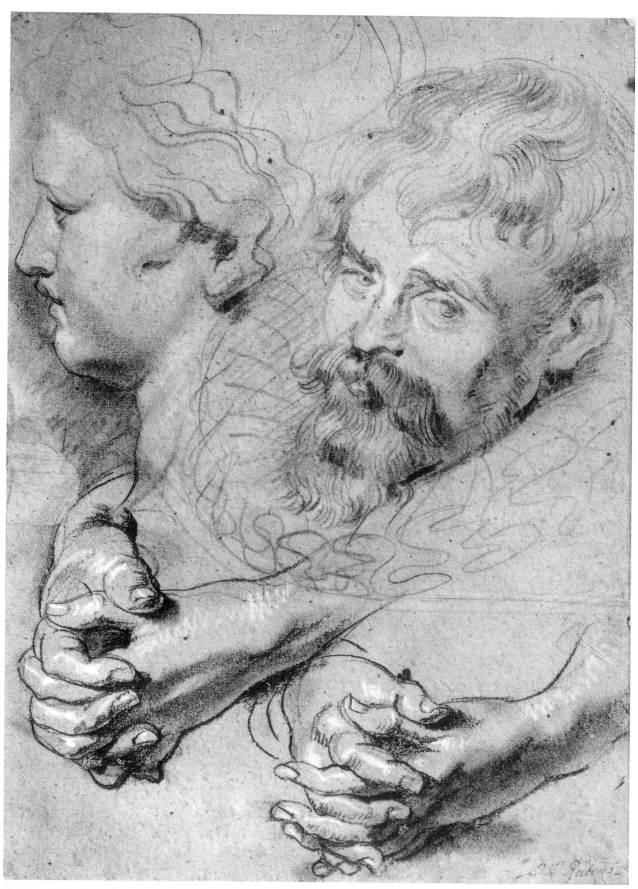

59 (Cat. 56) Studies of Heads and Hands. *c.* 1610. 392 × 269 mm. Vienna, Albertina

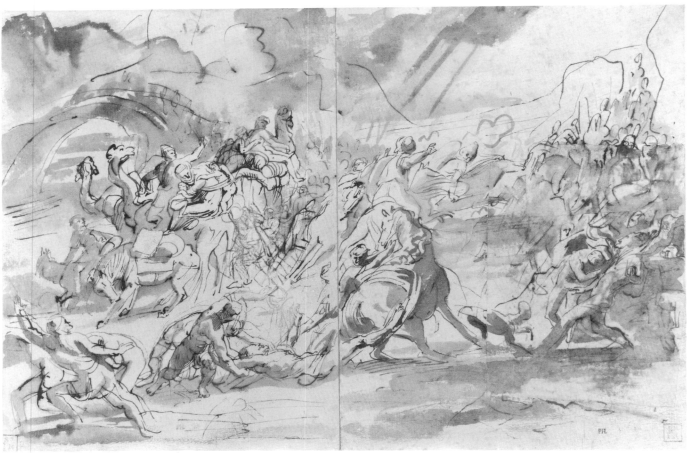

60 (Cat.61) The Conversion of St Paul. *c.* 1610–12. 222 × 329 mm. London, Courtauld Institute Galleries (Princes Gate Collection)

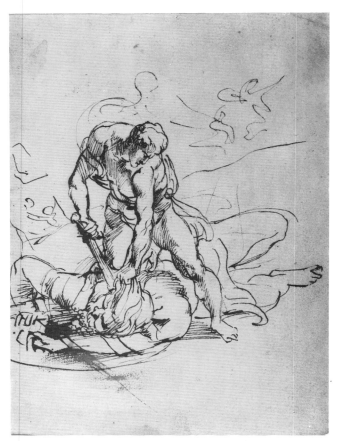

61 (Cat.62) David and Goliath. *c.* 1610–12. 219 × 164 mm. Rotterdam, Museum Boymans–van Beuningen

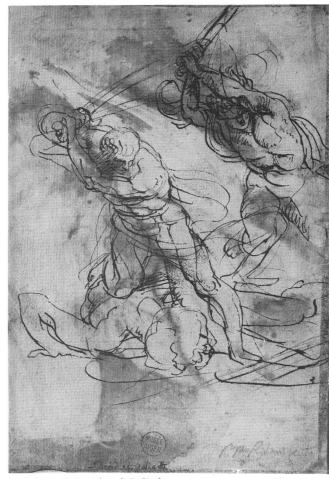

62 (Cat.63) David and Goliath. *c.* 1610–12. 215 × 158 mm. Montpellier, Bibliothèque Universitaire (Collection Atger)

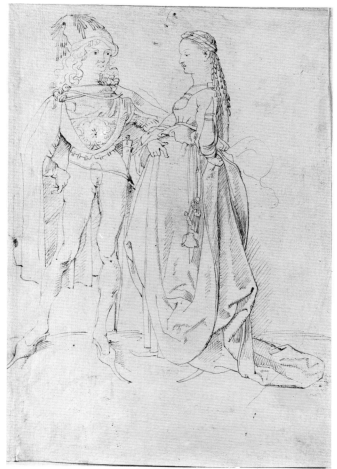

63 (Cat.65) A Young Couple. 1608–12.
199 × 139 mm. Berlin–Dahlem, Kupferstichkabinett

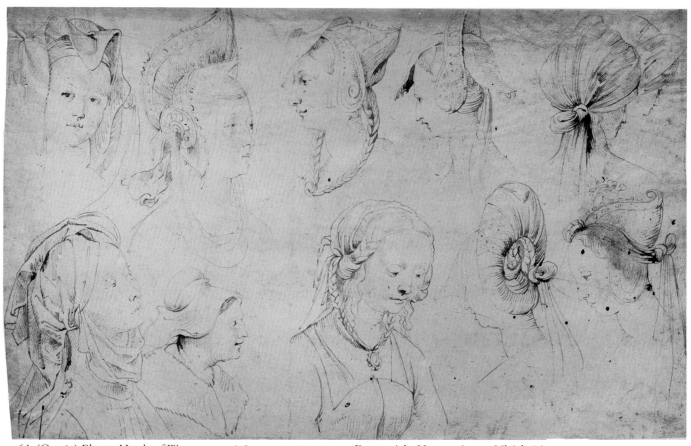

64 (Cat.64) Eleven Heads of Women. *c.* 1608–12. 203 × 313 mm. Brunswick, Herzog Anton Ulrich-Museum

65 (Cat. 66) Several Studies of Sixteenth-Century Armour. *c.* 1610–14. 232 × 336 mm. London, British Museum

66 (Cat. 67) Yolande de Barbançon, Guillaume de Jauche and Three Other Figures.
1610–11. 304 × 105 mm. London, British Museum

67, 68 (Cat.68, 69) Four Figures in Oriental Dress. 1610–14. 308 × 388 mm. London, British Museum

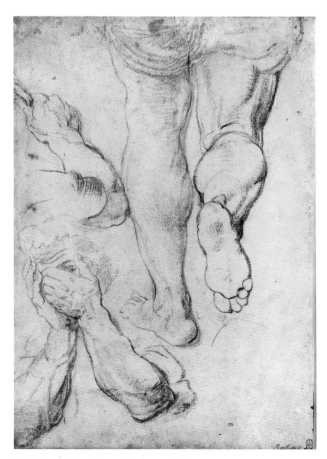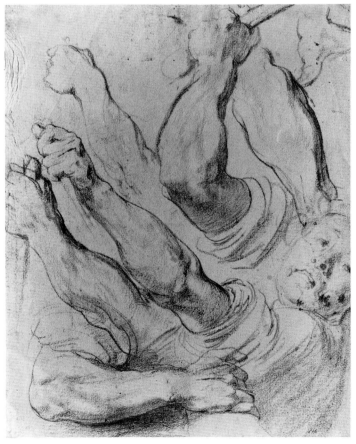

69 (Cat.75) Studies of Arms and Legs. c. 1612–15.
350 × 240 mm. Rotterdam, Museum Boymans–van Beuningen

70 (Cat.102) Studies of Arms and a Man's Face. c. 1616–17.
405 × 310 mm. London, Victoria and Albert Museum

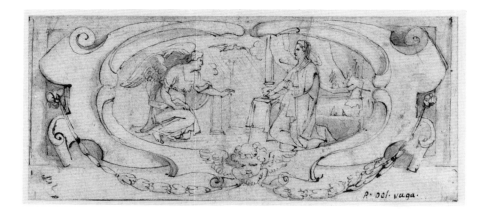

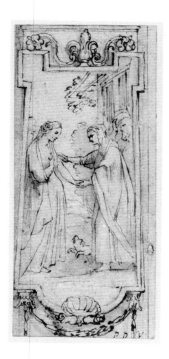

71 (Cat. 70) Six Scenes from the New Testament. *c.* 1610–11.
New York, J. Pierpont Morgan Library

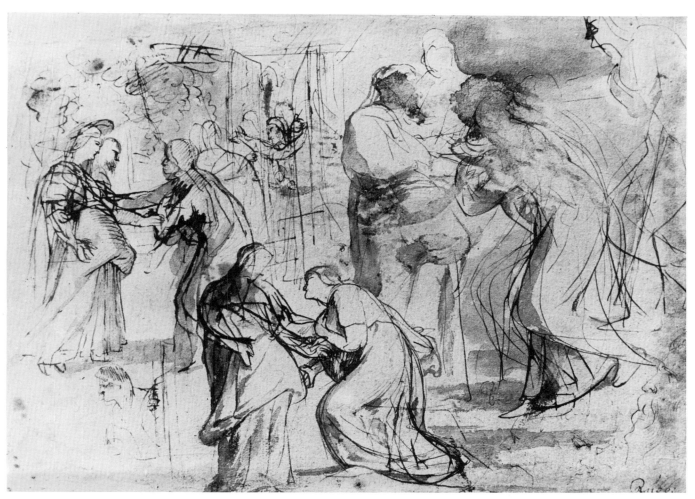

72 (Cat.71) Studies for the Visitation. 1611. 265 × 360 mm. Bayonne, Musée Bonnat

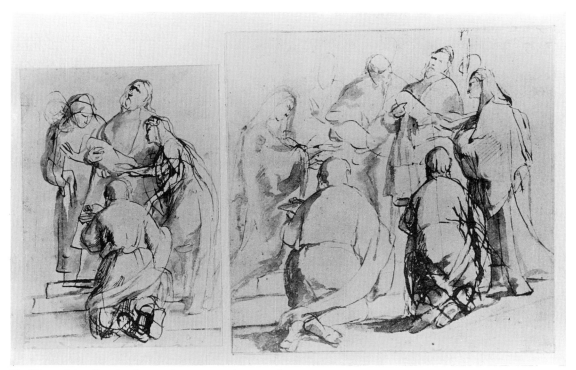

73 (Cat.72) Studies for the Presentation in the Temple. 1611.
Left Section: 214 × 142 mm. New York, Metropolitan Museum of Art. Right section: 242 × 238 mm.
London, Courtauld Institute Galleries (Princes Gate Collection)

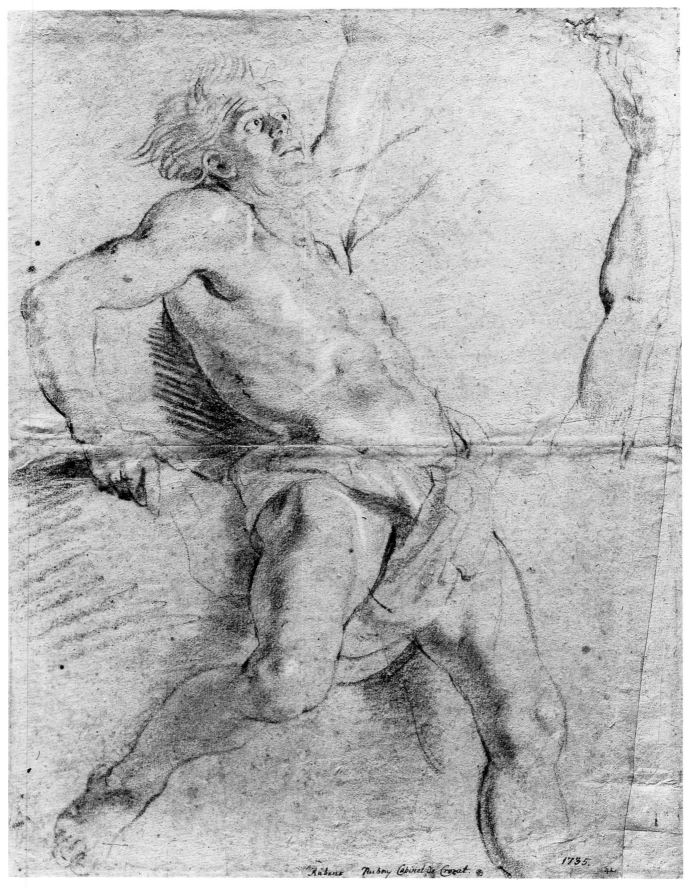

74 (Cat. 80) Study of a Nude Man. *c.* 1612–14. 570 × 444 mm. Stockholm, Nationalmuseum

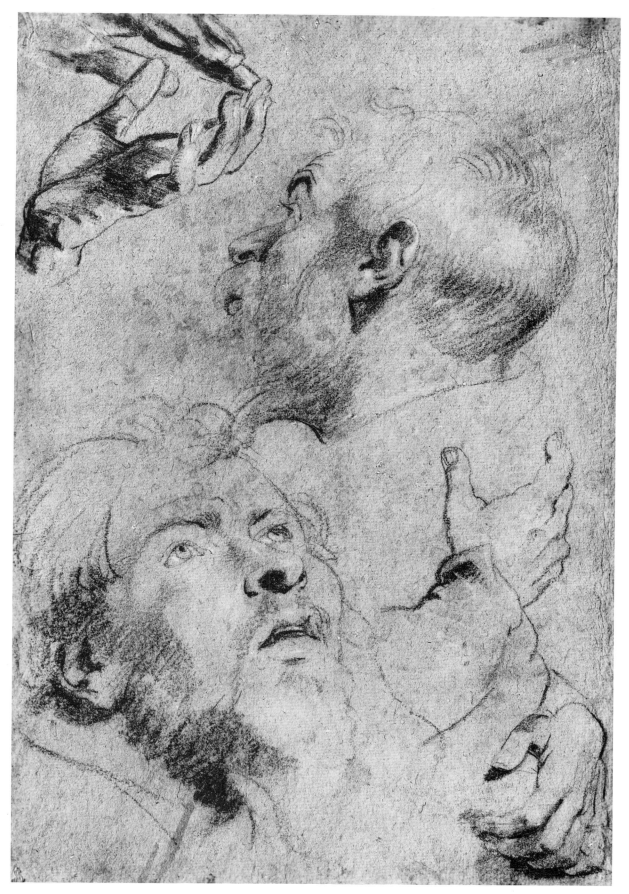

75 (Cat.74) Studies of Heads and Hands. *c.* 1613. 344 × 235 mm. Vienna, Albertina

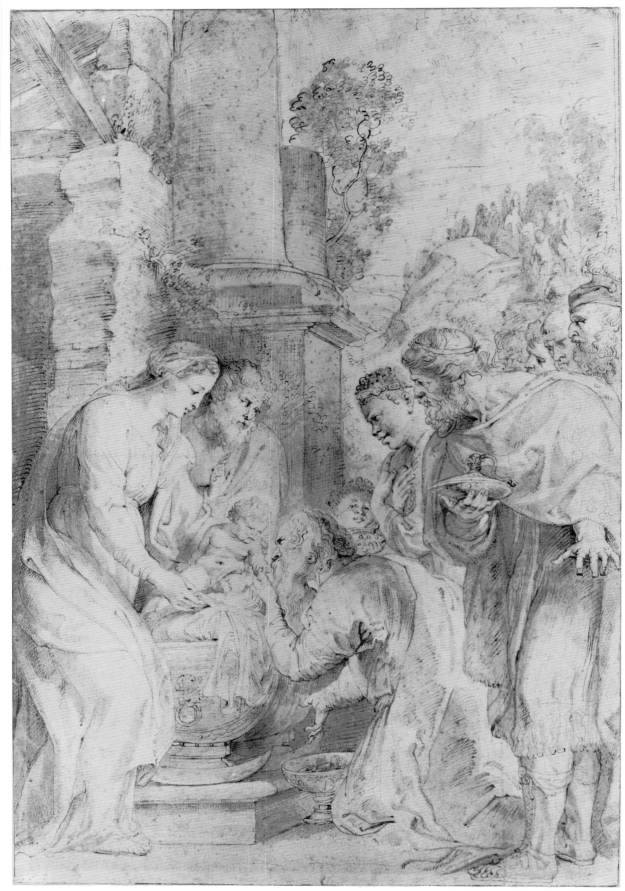

76 (Cat. 77) The Adoration of the Magi. *c.* 1612–13. 295 × 190 mm. New York, J. Pierpont Morgan Library

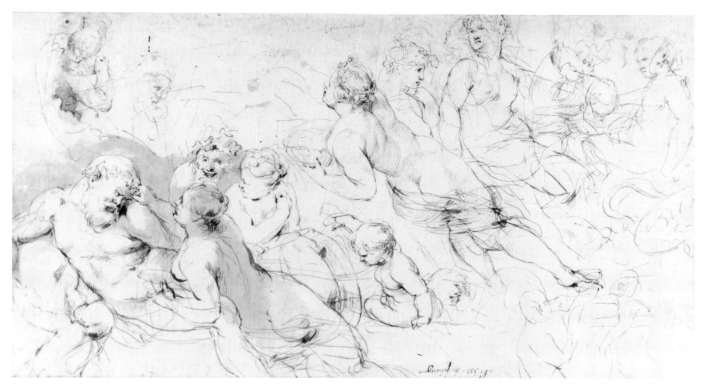

77 (Cat.81) Silenus and Aegle, and Other Figures. *c.* 1612–14. 280 × 507 mm. Windsor Castle

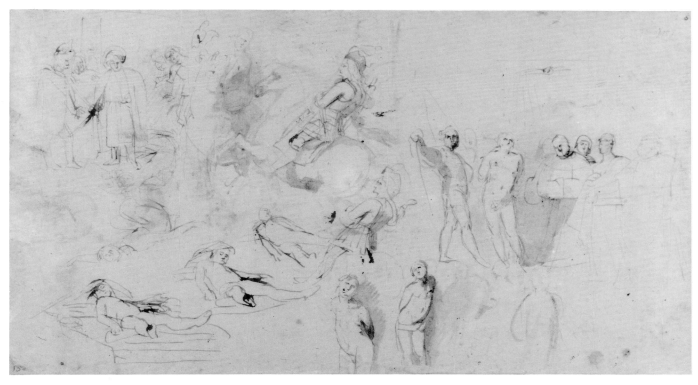

78 (Cat.82) Studies for Several Compositions. *c.* 1612–14. 280 × 507 mm. Windsor Castle

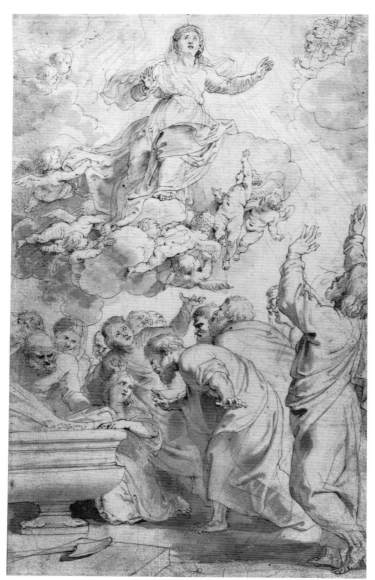

79 (Cat.84) The Assumption of the Virgin. *c.* 1613–14.
298 × 189 mm. Malibu, J. Paul Getty Museum

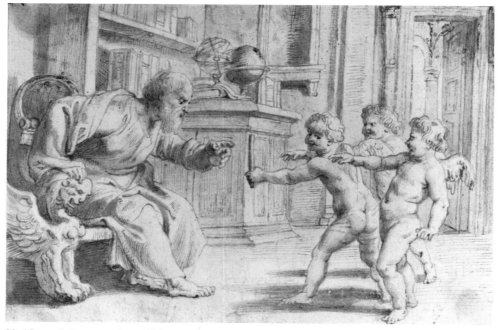

80 (Cat.76) Communium Objectorum Cognitio. *c.* 1612. 79 × 146 mm.
Washington, National Gallery of Art

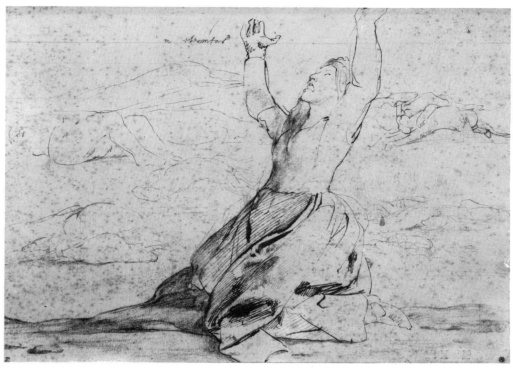

81 (Cat.89) Niobe (?). *c.* 1614–16. 200 × 279 mm. Moscow, Pushkin Museum

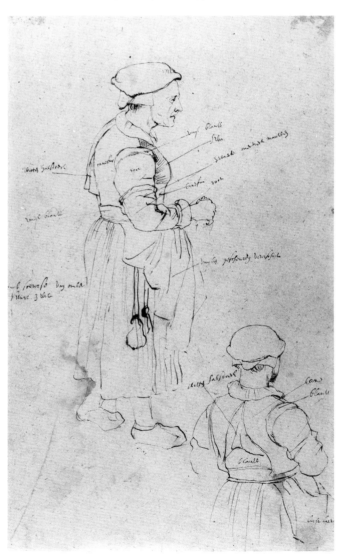

82 (Cat.90) A Peasant Woman, in two views
(Costume study, done from life). Before 1620.
233 × 396mm. Berlin–Dahlem, Kupferstichkabinett

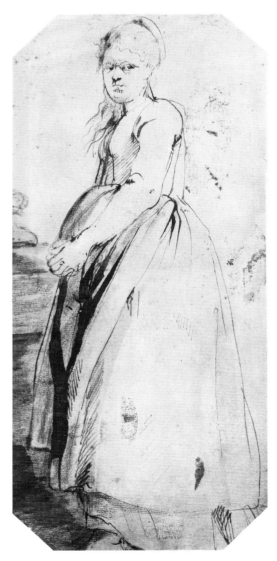

83 (Cat.88) Farm Girl with Folded Hands.
c. 1612–1614. 262 × 120 mm.
Rotterdam, Museum Boymans–van Beuningen

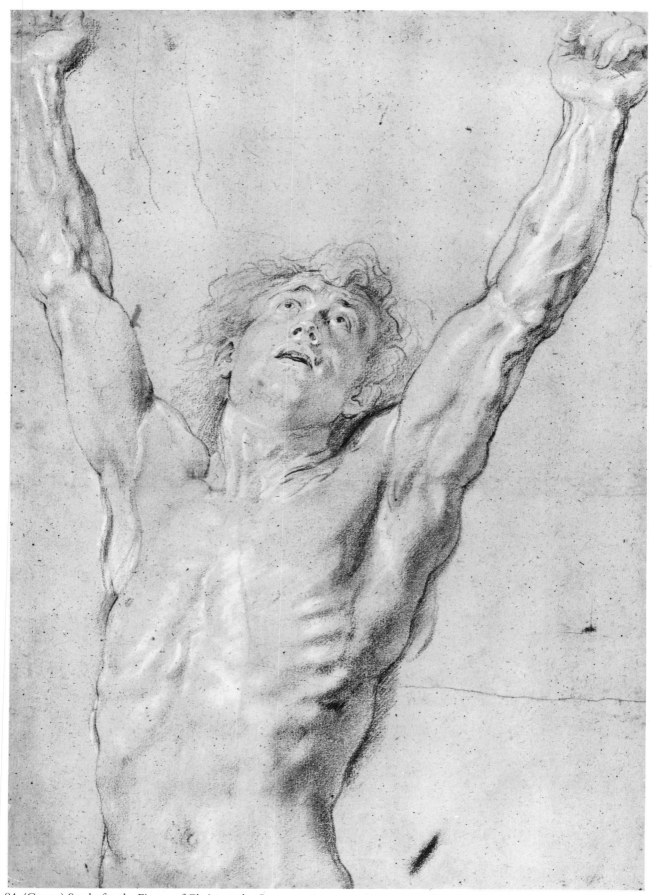

84 (Cat.91) Study for the Figure of Christ on the Cross. *c.* 1614–15. 528 × 370 mm. London, British Museum

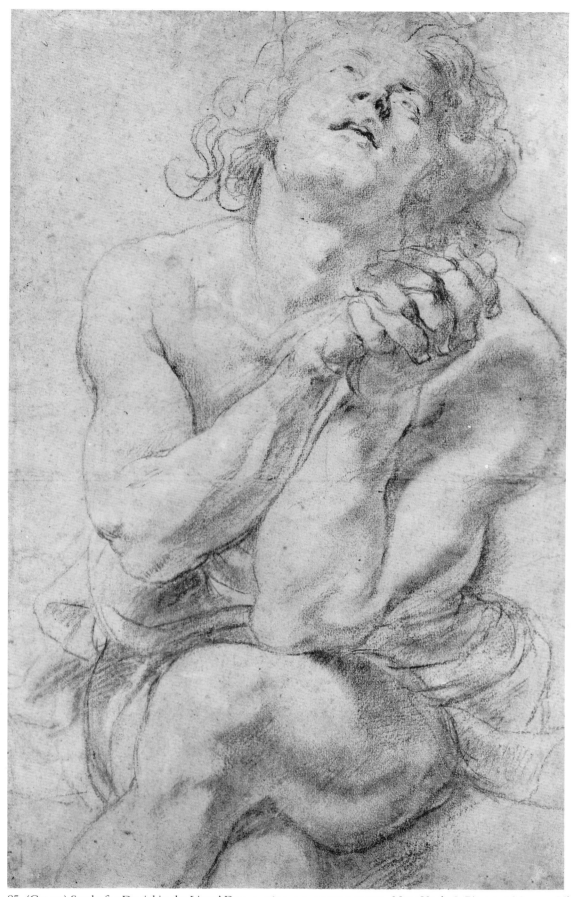

85 (Cat.92) Study for Daniel in the Lions' Den. *c.* 1614–15. 507 × 302 mm. New York, J. Pierpont Morgan Library

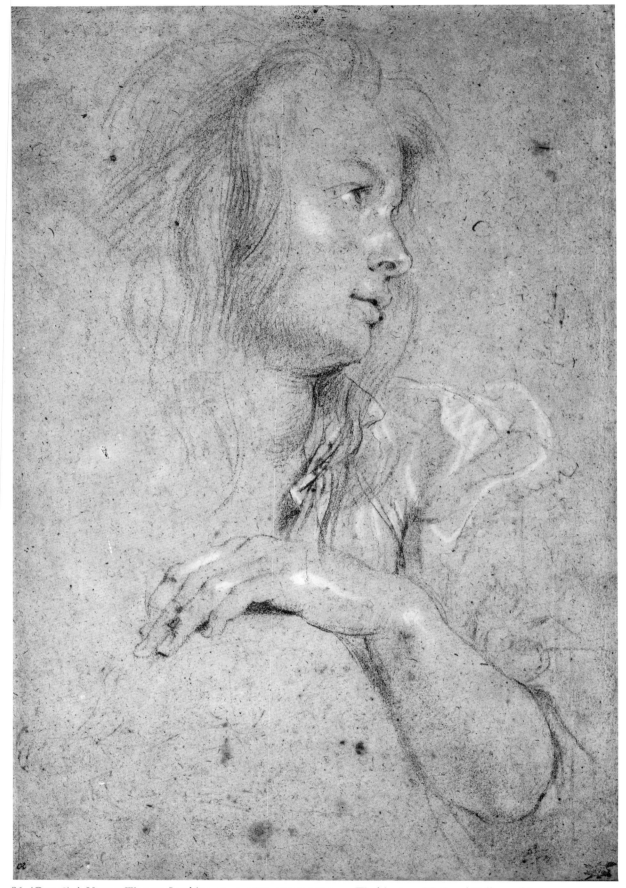

86 (Cat. 78) A Young Woman Looking up. *c.* 1613. 374 × 250 mm. Washington, National Gallery of Art

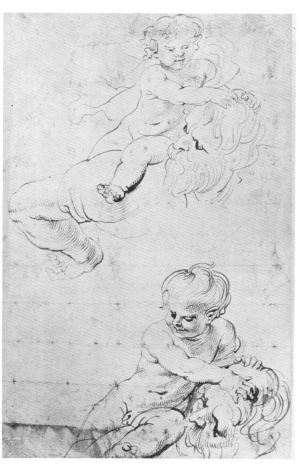

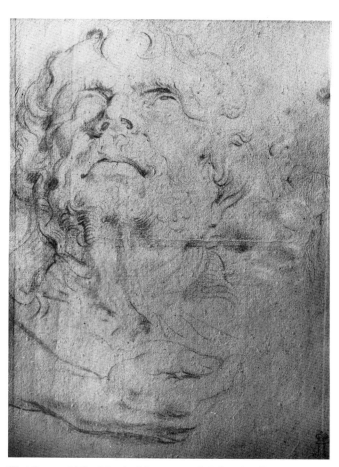

87 (Cat. 73) Two Studies for St. Christopher. *c.* 1611–13. 267 × 167 mm. London, British Museum

88 (Cat. 129) The Head of Seneca, and Other Studies. *c.* 1617. 320 × 220 mm. Leningrad, Hermitage

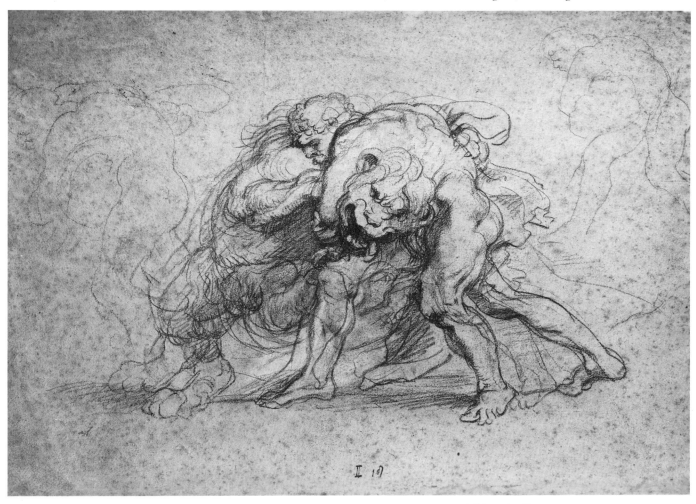

89 (Cat. 97) Hercules Strangling the Nemean Lion. *c.* 1613–16. 363 × 498 mm. Antwerp, Cabinet des Estampes

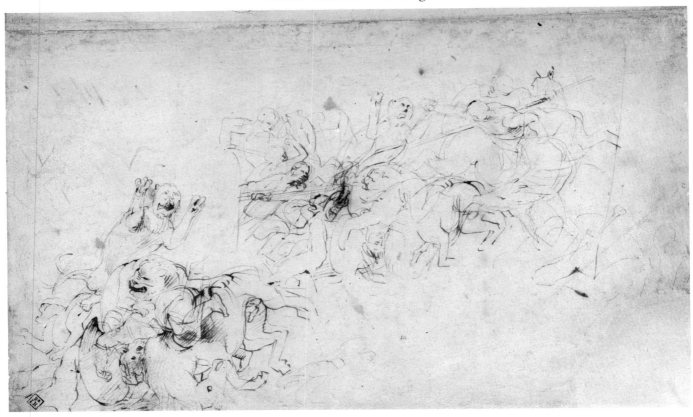

90 (Cat. 101) A Lion Hunt. *c.* 1615–16. 290 × 485 mm. London, British Museum

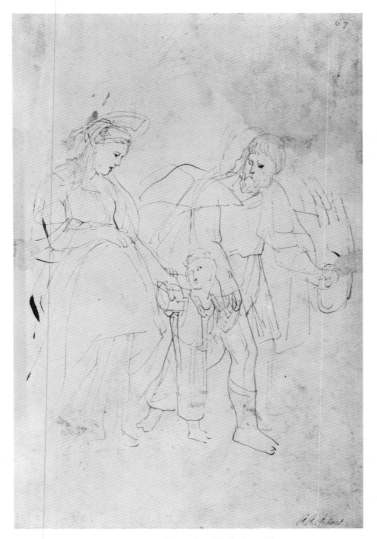

91 (Cat. 86) The Return from the Flight into Egypt. 1614–15. 301 × 195 mm. Moscow, Pushkin Museum

92 (Cat. 87) Two Studies of the Virgin. 1614–15. 301 × 195 mm. Moscow, Pushkin Museum

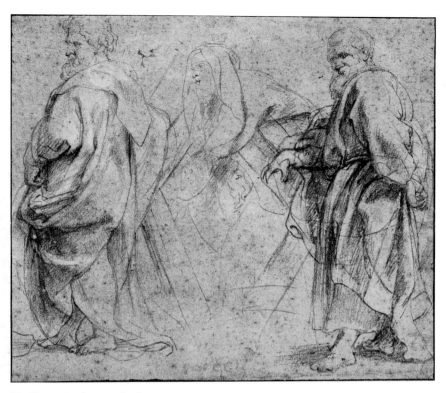

93 (Cat.95) Three Robed Men. 1614–17.
281 × 314 mm. Copenhagen, Kunstmuseet, Kobberstiksamlingen

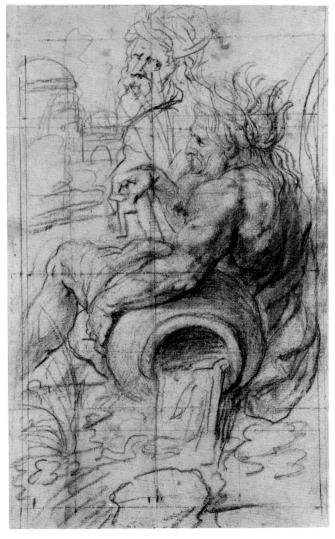

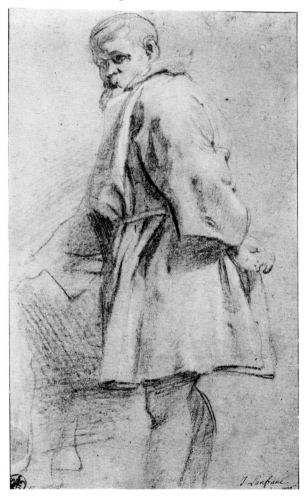

95 (Cat.94) A Man, Standing. *c.* 1614–17.
388 × 224 mm. Munich, Graphische Sammlungen

94 (Cat.96) Two Studies of a River-God. *c.* 1614–16.
414 × 240 mm. Boston, Museum of Fine Arts

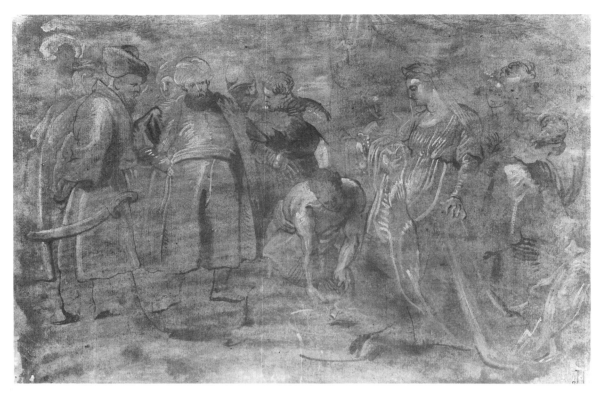

96 (Cat. 100) Thomyris and Cyrus. *c.* 1615–17. 255 × 385 mm. Leningrad, Hermitage

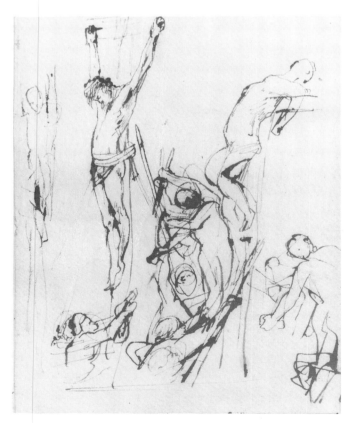

97 (Cat. 140) The Crucifixion. 1619–20.
206 × 164 mm. Rotterdam, Museum Boymans–van Beuningen

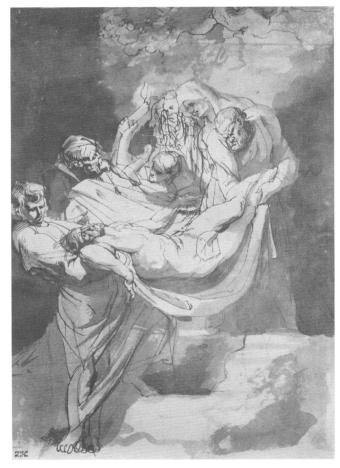

98 (Cat. 98) The Entombment of Christ. *c.* 1615.
223 × 153 mm. Amsterdam, Rijksmuseum

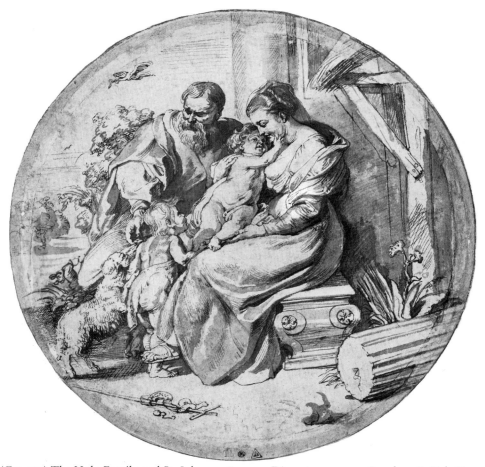

99 (Cat.103) The Holy Family and St. John. *c.* 1615–17. Diameter 220 mm. London, British Museum

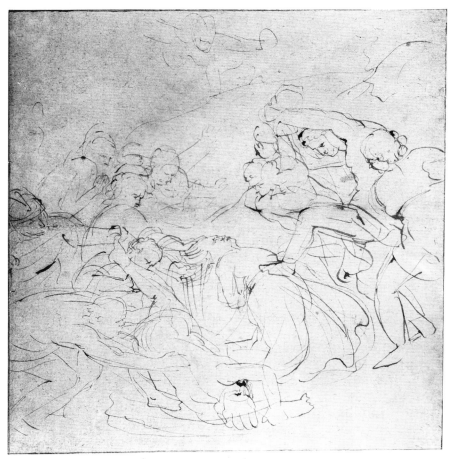

100 (Cat.99) The Martyrdom of St. Stephen. *c.* 1615–16.
342 × 323 mm. Rotterdam, Museum Boymans–van Beuningen

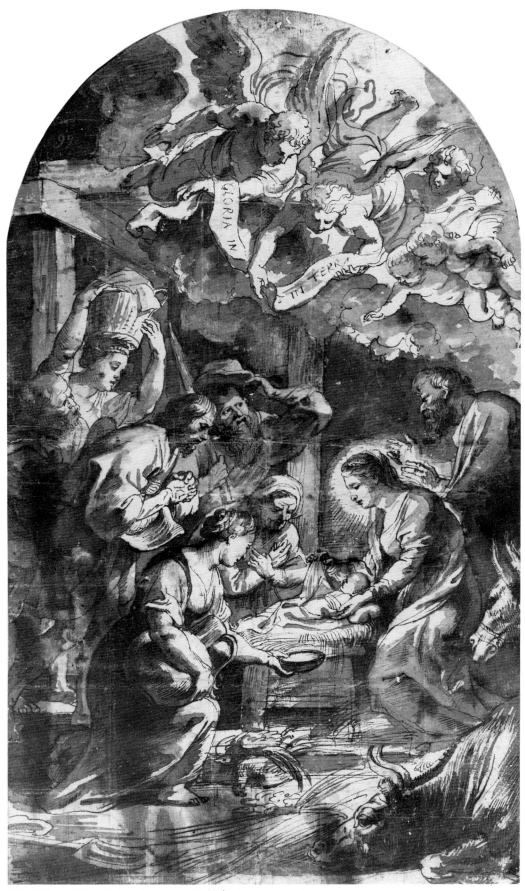

101 (Cat. 106) The Adoration of the Shepherds. *c.* 1617–18. 359 × 204 mm.
Paris, Fondation Custodia, Collection F. Lugt

102 (Cat. 107) Portrait of Justus Lipsius. *c.* 1615. 232 × 185 mm. London, British Museum

103 (Cat. 105) A Woman Milking a Cow. 1615–18.
220 × 174 mm. Besançon, Musée des Beaux-Arts

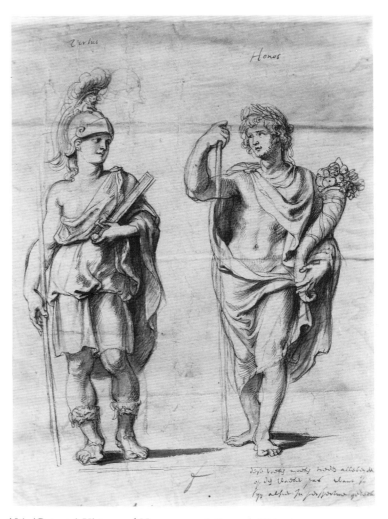

104 (Cat. 133) Virtue and Honour. c. 1618–20. 308 × 210 mm.
Antwerp, Musée Plantin-Moretus

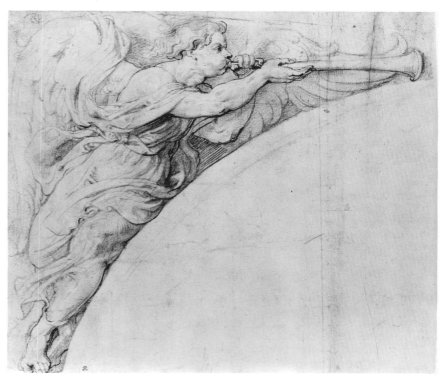

106 (Cat. 125) An Angel Blowing a Trumpet. c. 1617–20.
245 × 283 mm. New York, J. Pierpont Morgan Library

105 (Cat. 79) Hunt of a Wild Bull. *c.* 1613. 374 × 250 mm. Washington, National Gallery of Art

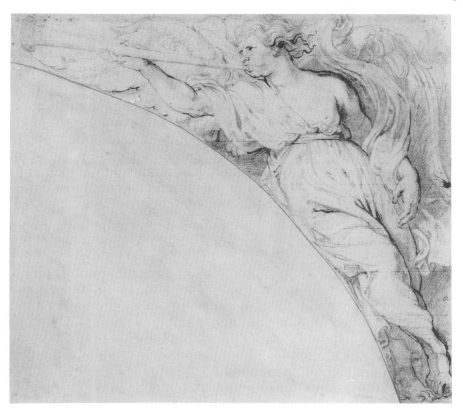

107 (Cat. 126) An Angel Blowing a Trumpet. *c.* 1617–20.
 251 × 274 mm. New York, J. Pierpont Morgan Library

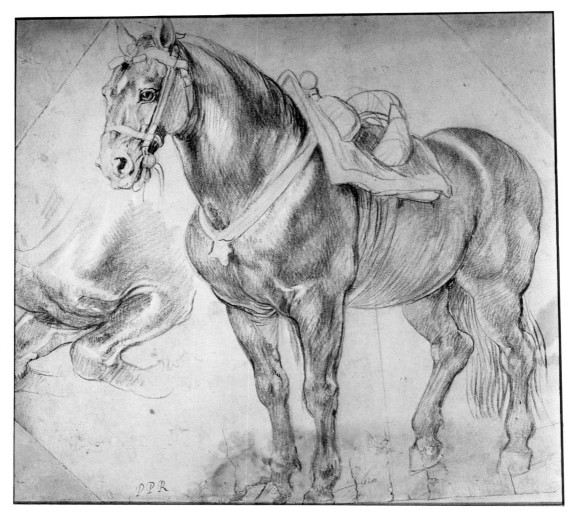

108 (Cat. 109) Saddled Horse. 1615–18. 400 × 425 mm. Vienna, Albertina

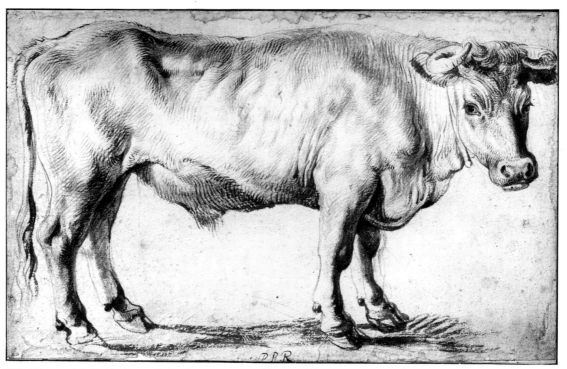

109 (Cat. 110) A Bullock. *c.* 1618. 283 × 436 mm. Vienna, Albertina

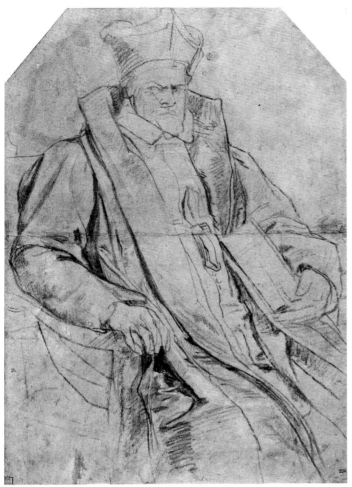

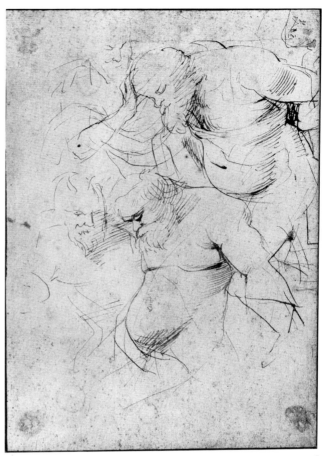

110 (Cat. 108) The Reverend Hendrik Van Thulden (1580–1617). *c.* 1615–17. 374 × 262 mm. London, British Museum

111 (Cat. 112) Studies for a Drunken Silenus. *c.* 1616–18. 290 × 195 mm. Collection of the late Mrs. G. W. Wrangham

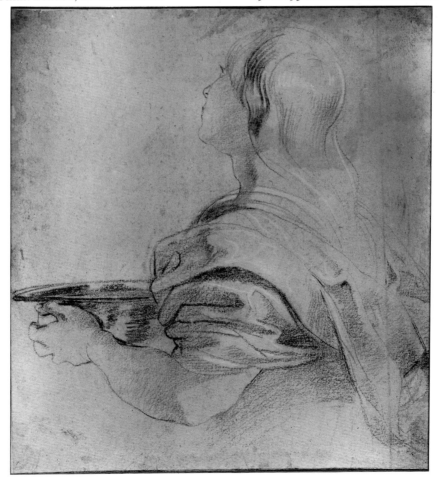

112 (Cat. 111) Young Woman Holding a Bowl. *c.* 1616. 347 × 307 mm. Vienna, Albertina

113 (Cat. 115) Landscape with a Fallen Tree. *c.* 1617–19. 582 × 489 mm. Paris, Louvre, Cabinet des Estampes

114 (Cat. 114) A Country Lane. *c.* 1615–18. 312 × 402 mm. Cambridge, Fitzwilliam Museum

115 (Cat. 113) Farmyard, with a Farmer Threshing and a Hay-Wagon. *c.* 1615–17. 255 × 415 mm. Malibu, J. Paul Getty Museum

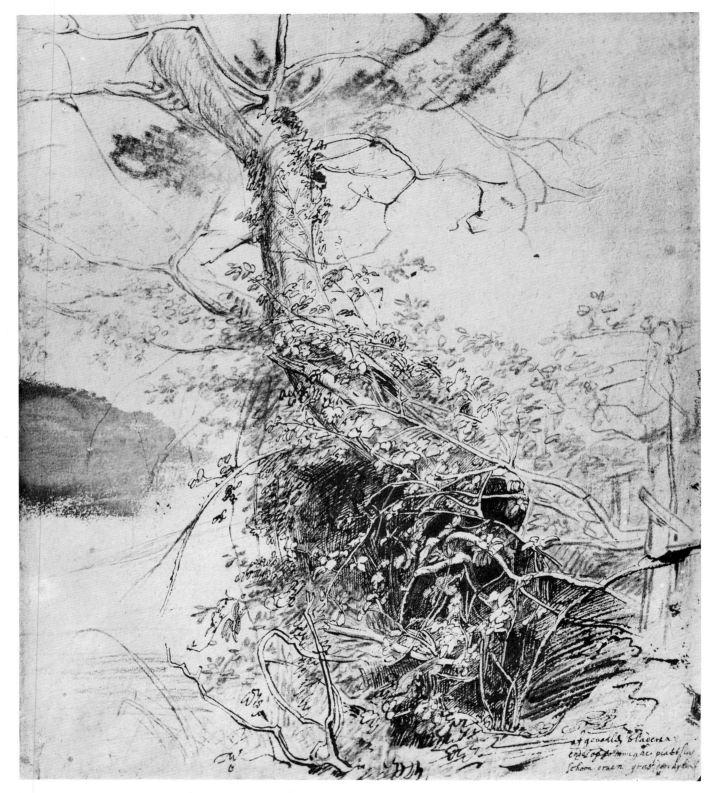

116 (Cat. 116) A Dead Tree Covered with Brambles. 1618–20. 345 × 298 mm. Chatsworth, Trustees of the Devonshire Collection

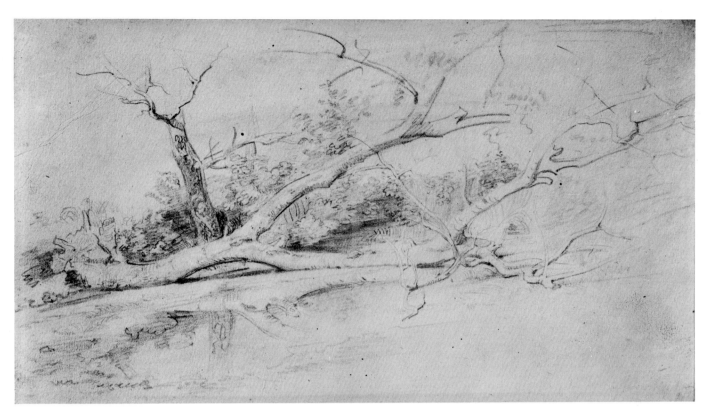

117 (Cat. 117) A Fallen Tree. *c.* 1617–19. 184 × 310 mm. Chatsworth, Trustees of the Devonshire Collection

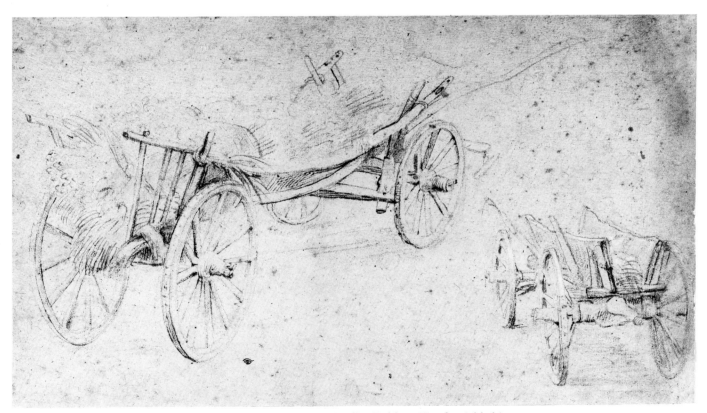

118 (Cat. 118) Two Farm Wagons. *c.* 1618–20. 225 × 375 mm. Berlin–Dahlem, Kupferstichkabinett

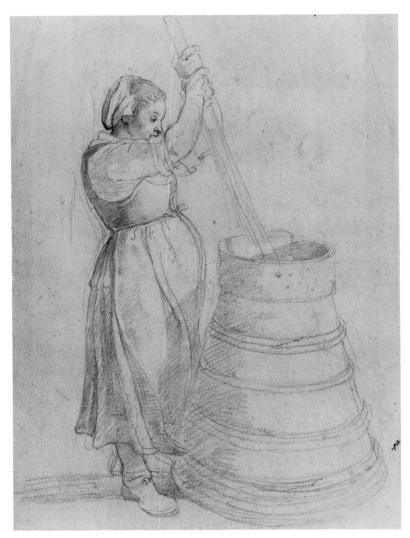

119 (Cat. 120) A Peasant Girl, Churning Butter. *c.* 1618–20.
335 × 257 mm. Chatsworth, Trustees of the Devonshire Collection

120 (Cat. 119) A Willow Tree. *c.* 1620.
392 × 264 mm. London, British Museum

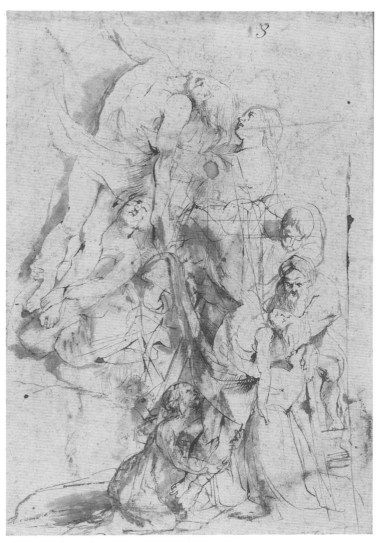

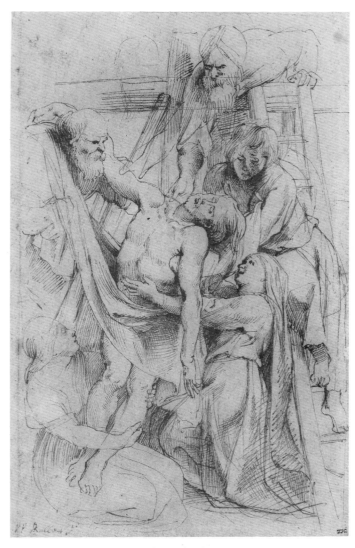

121 (Cat. 121) The Descent from the Cross. *c.* 1617–18.
346 × 232 mm. New York, Eugene V. Thaw

122 (Cat. 122) The Descent from the Cross. *c.* 1617–18.
357 × 216 mm. Boston, Museum of Fine Arts

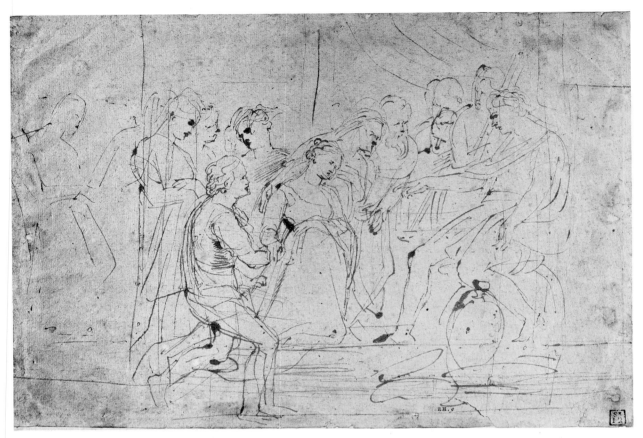

123 (Cat. 123) The Continence of Scipio. *c.* 1617–18. 236 × 343 mm. Berlin–Dahlem, Kupferstichkabinett

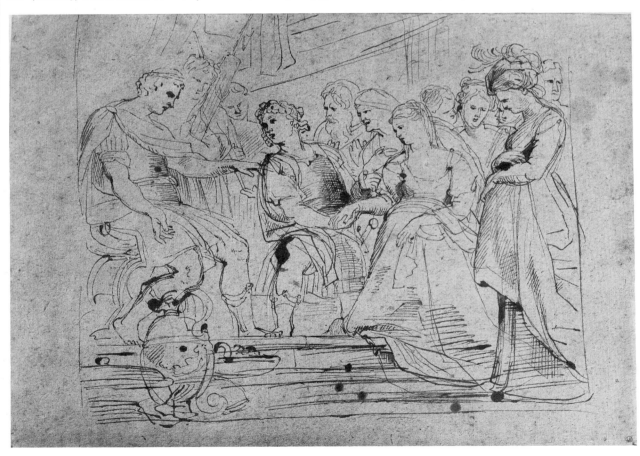

124 (Cat. 124) The Continence of Scipio. *c.* 1617–18. 255 × 354 mm. Bayonne, Musée Bonnat

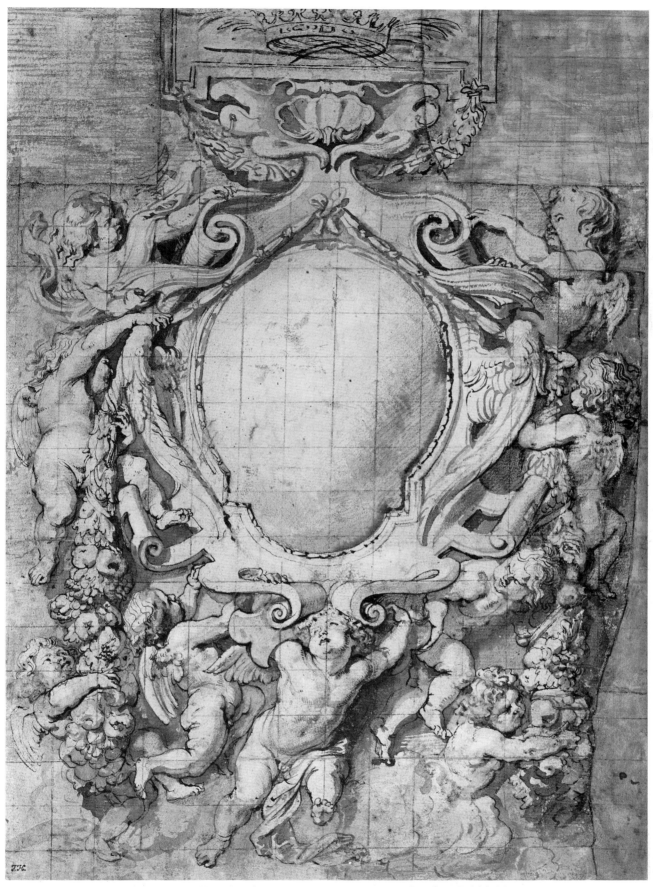

125 (Cat. 127) A Cartouche Supported by Cherubs. *c.* 1617–20. 370 × 267 mm. London, British Museum

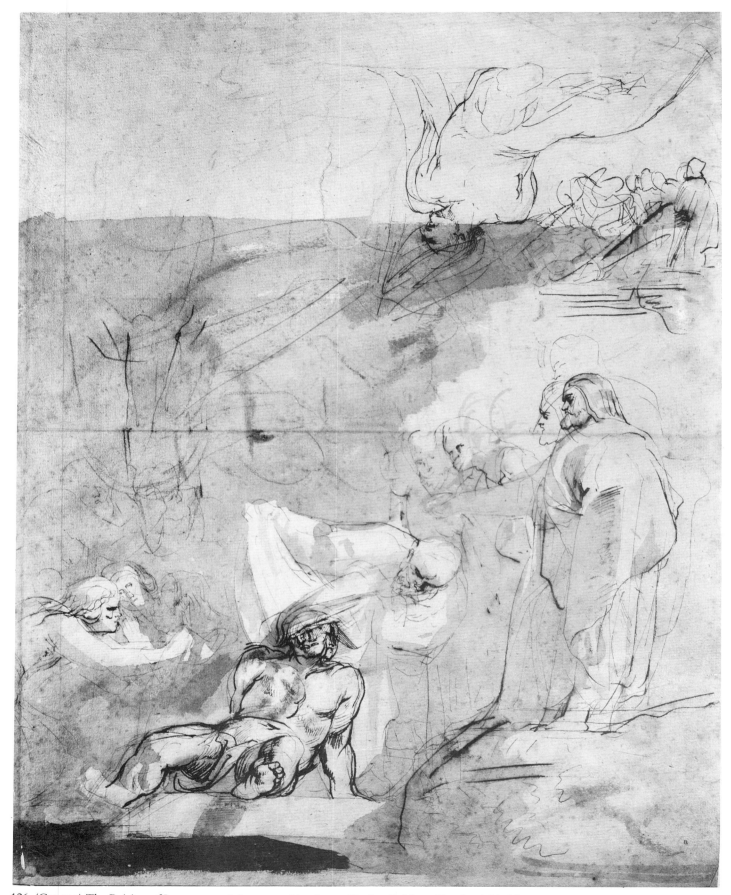

126 (Cat. 132) The Raising of Lazarus. *c.* 1618–19. 394 × 306 mm. Berlin–Dahlem, Kupferstichkabinett

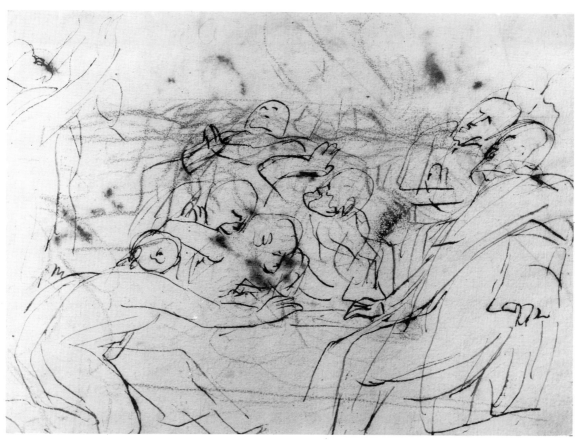

127 (Cat. 104) The Apostles Surrounding the Virgin's Tomb. *c.* 1616. 228 × 300 mm. Oslo, Nasjonalgalleriet

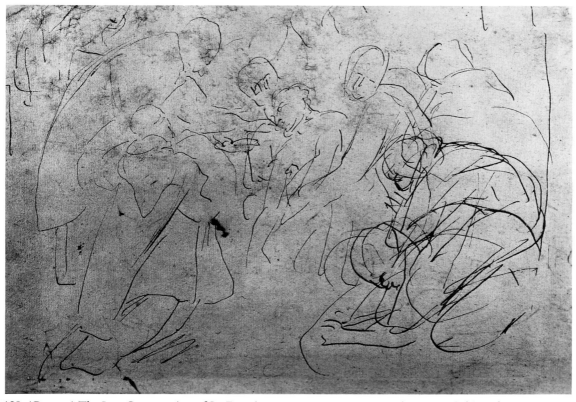

128 (Cat. 135) The Last Communion of St. Francis. 1618–19. 222 × 310 mm. Antwerp, Cabinet des Estampes

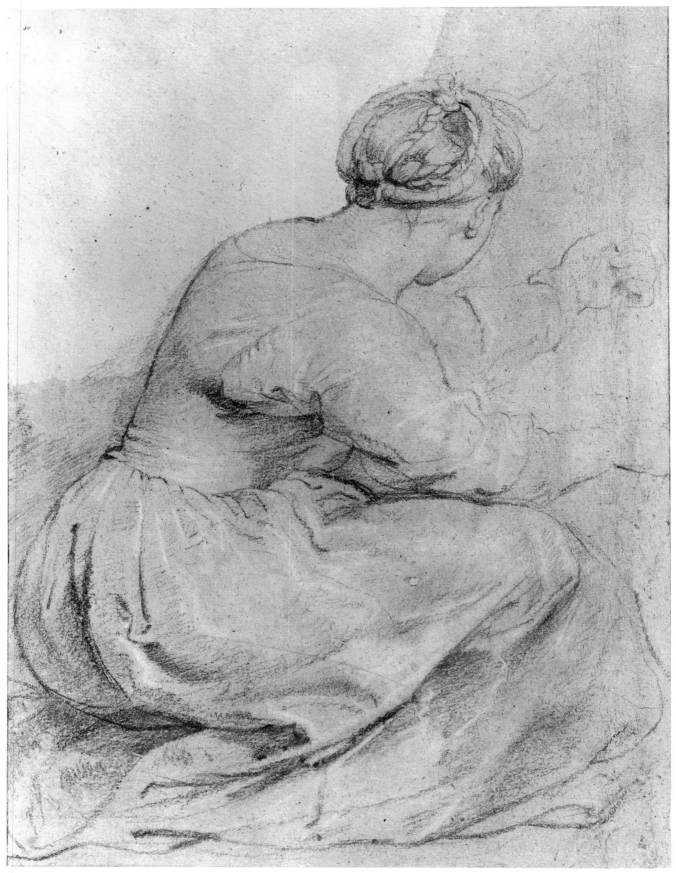

129 (Cat. 134) A Young Woman Crouching. *c.* 1617–18. 375 × 267 mm. Vienna, Albertina

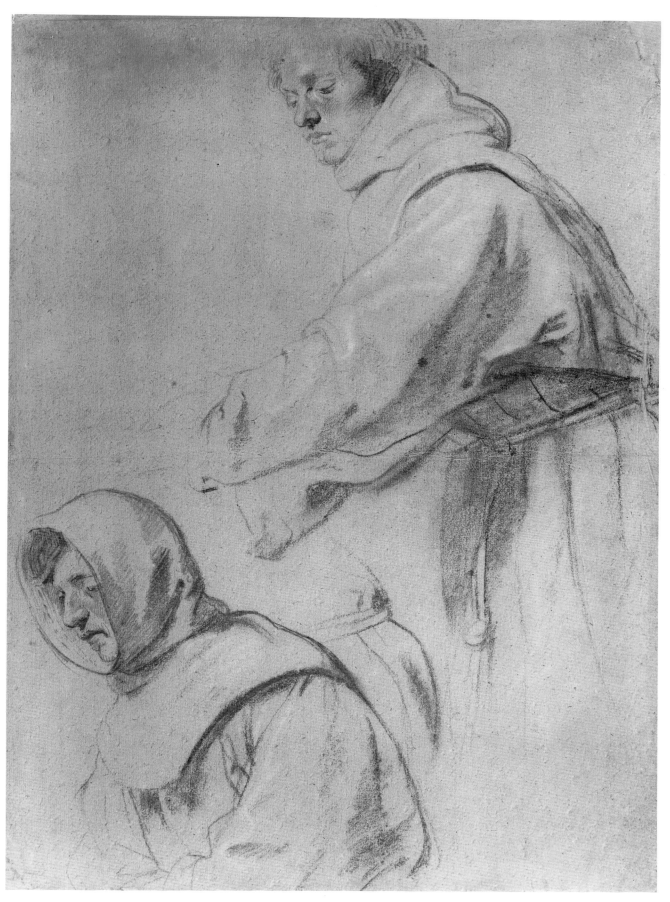

130 (Cat.136) Two Franciscan Monks. *c.* 1618–19. 560 × 403 mm. Chatsworth, Trustees of the Devonshire Collection

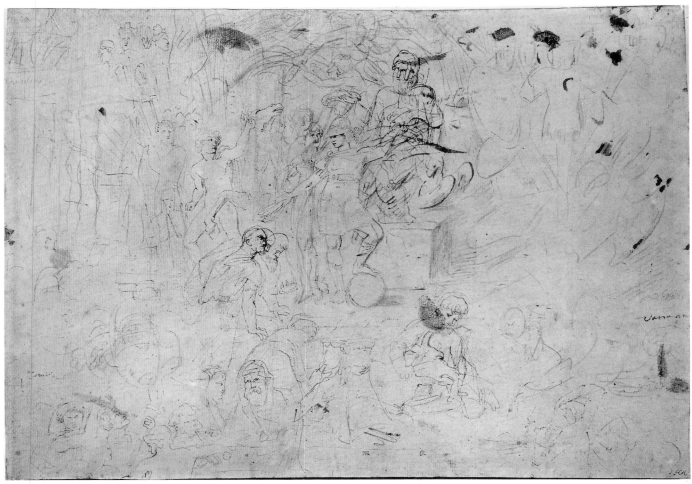

131 (Cat. 150) Studies for a Roman Triumph. *c.* 1622. 278 × 385 mm. Berlin–Dahlem, Kupferstichkabinett

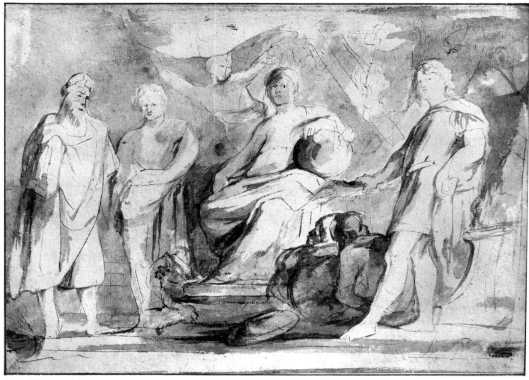

132 (Cat. 151) Roma Triumphans. 1622. 219 × 303 mm. Vienna, Albertina

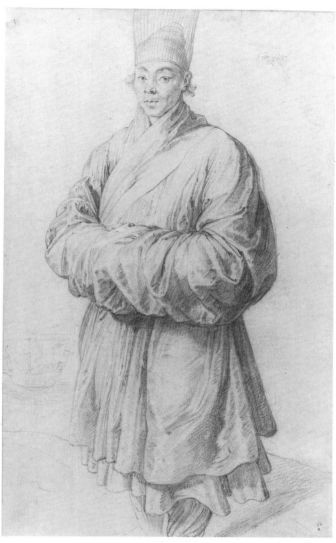

133 (Cat. 130) A Man in Korean Costume (a Jesuit Convert?)
c. 1617–18.
387 × 234 mm. Malibu, J. Paul Getty Museum

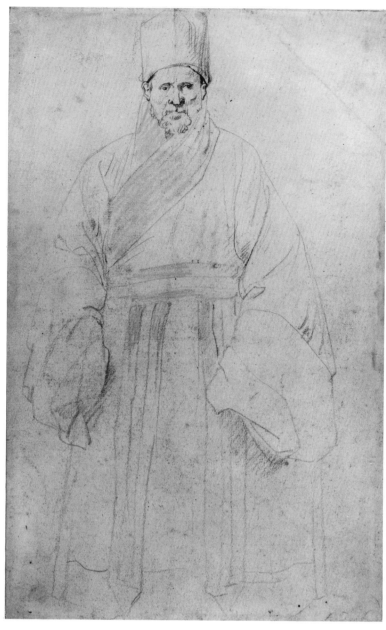

134 (Cat. 131) Jesuit Missionary in Chinese Costume. 1618–22?
450 × 244 mm. New York, J. Pierpont Morgan Library

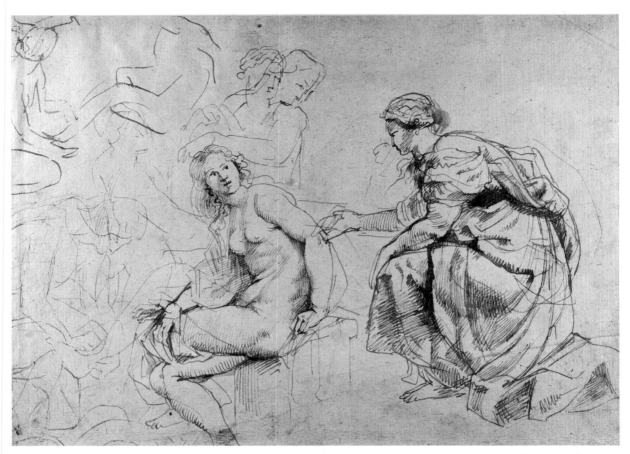

135 (Cat.83) Bathsheba Receiving David's Letter. *c.* 1612–14. 192 × 266 mm. Berlin–Dahlem, Kupferstichkabinett

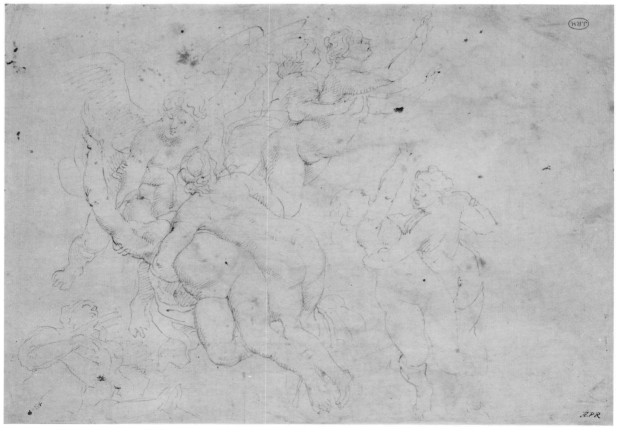

136 (Cat.139) Studies for a Last Judgment. *c.* 1618–20. 202 × 280 mm. New York, The Frick Collection

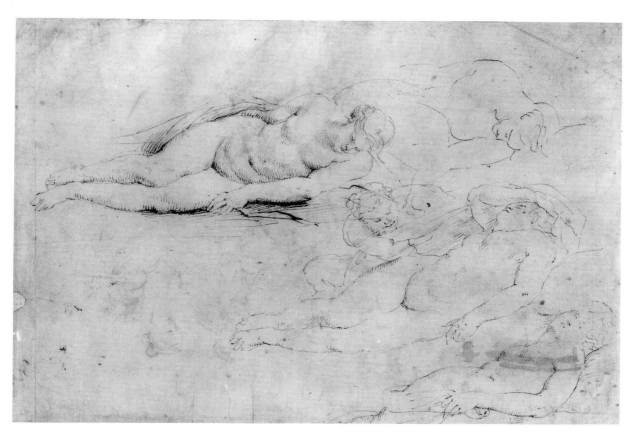

137 (Cat. 137) Female Nudes Reclining. *c.* 1618–20. 200 × 283 mm. London, Courtauld Institute Galleries (Princes Gate Collection)

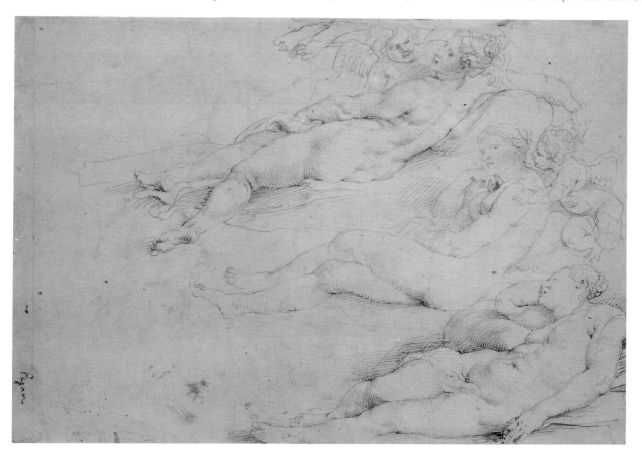

138 (Cat. 138) Studies for Venus (?) and Cupid. *c.* 1618–20. 202 × 280 mm. New York, The Frick Collection

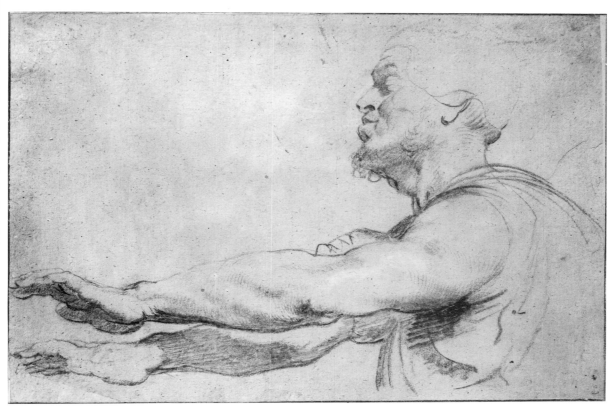

139 (Cat. 128) A Blind Man. *c.* 1617–18. 280 × 417 mm. Vienna, Albertina

140 (Cat. 142) A Man Falling from a Horse. *c.* 1618–20. 325 × 308 mm. London, British Museum

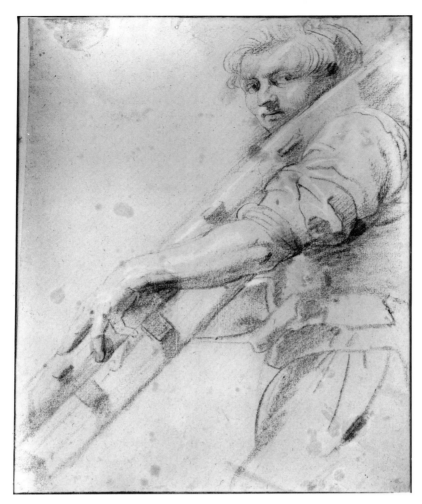

141 (Cat. 141) Young Man Carrying a Ladder. *c.* 1619–20.
346 × 272 mm. Vienna, Albertina

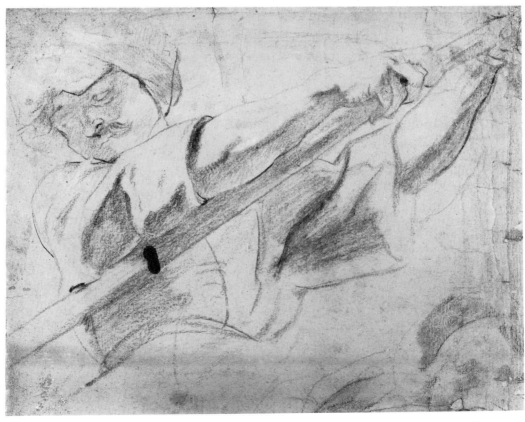

142 (Cat. 143) A Turbaned Man Thrusting with a Lance. *c.* 1620. 297 × 362 mm. Berlin–Dahlem, Kupferstichkabinett

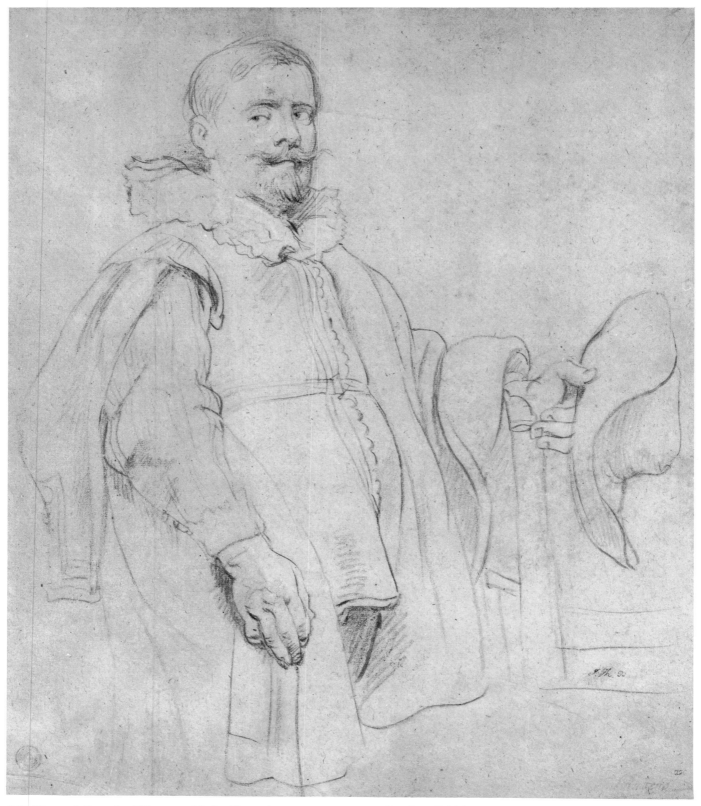

143 (Cat. 146) Portrait of Pieter van Hecke (?). *c.* 1620–22. 413 × 345 mm. London, British Museum

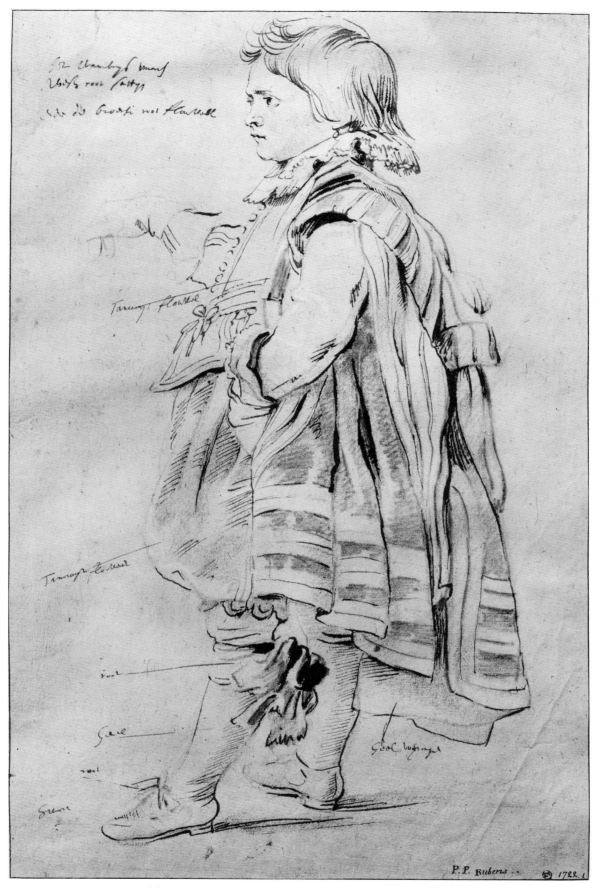

144 (Cat. 145) Robin, the Dwarf of the Earl of Arundel. 1620. 408 × 258 mm. Stockholm, Nationalmuseum

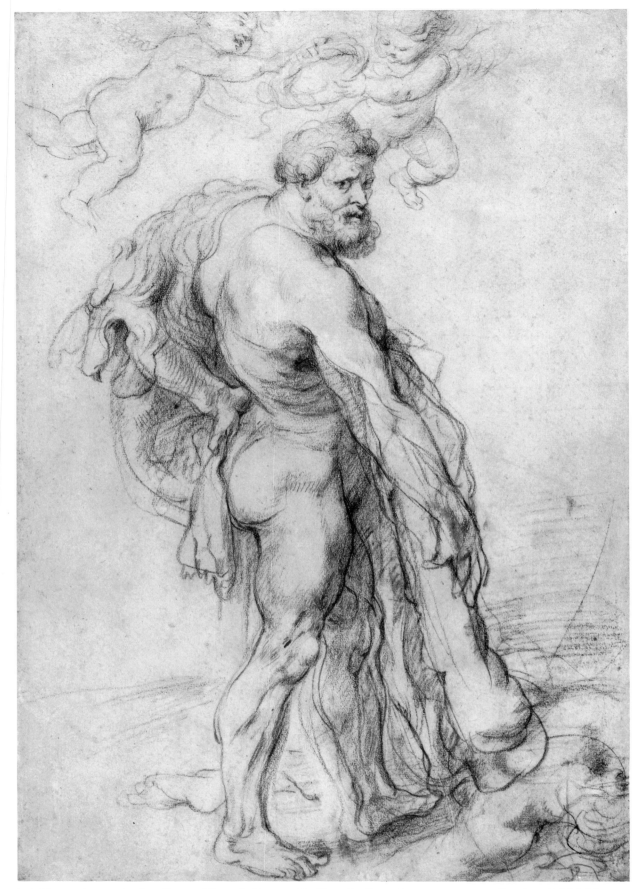

145 (Cat. 148) Hercules Standing on Discord, Crowned by Two Genii. *c.* 1621. 475 × 320 mm. London, British Museum

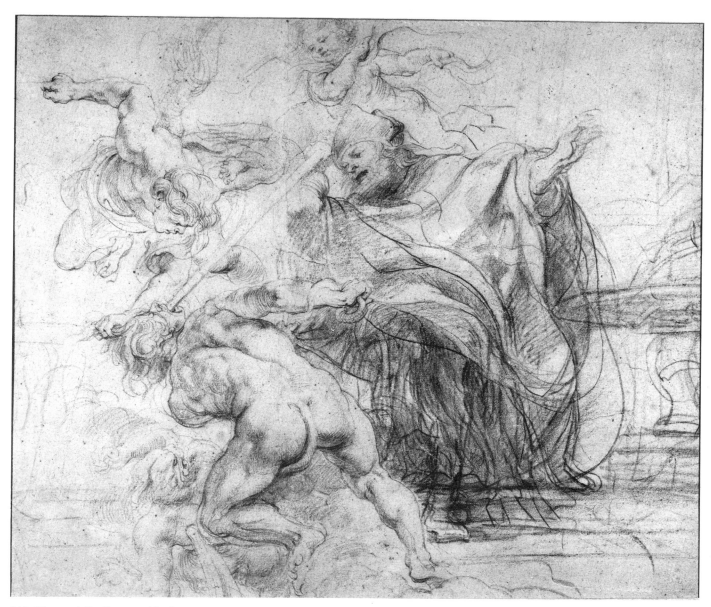

146 (Cat.147) St. Gregory Nazianzenus. 1620. 411 × 476 mm. Cambridge (Mass.), Fogg Art Museum

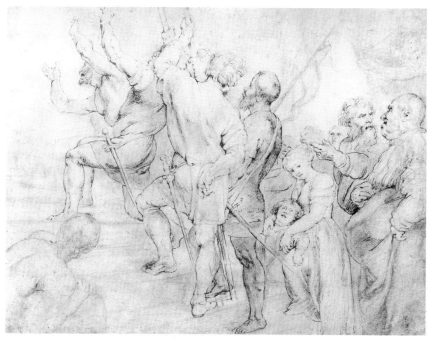

147 (Cat.176) Ecce Homo (after Titian). *c.* 1625–30.
330 × 415 mm. New York, Collection Mrs. Jacob M. Kaplan

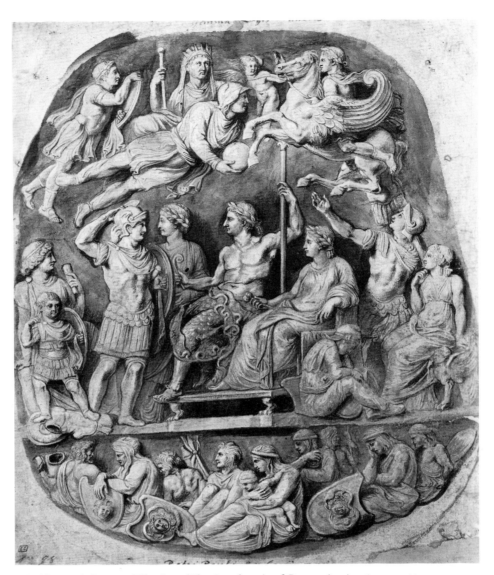

148 (Cat. 153) Gemma Tiberiana (The Apotheosis of Germanicus). 1622. 327 × 270 mm. Antwerp, Stedelijk Prentenkabinet

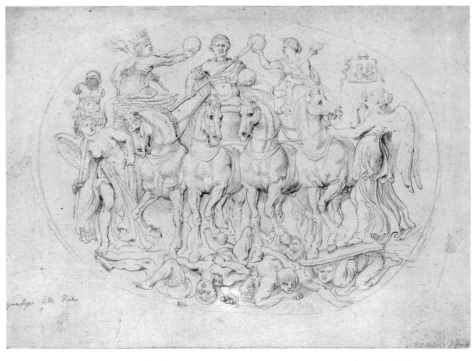

149 (Cat. 154) The Triumph of Licinius. c. 1622. 188 × 250 mm. London, British Museum

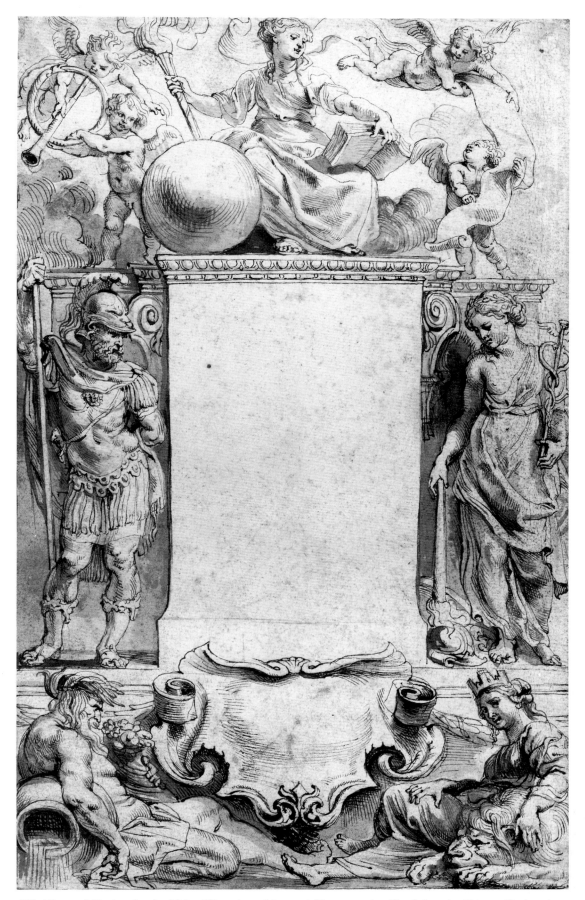

150 (Cat. 152) Design for the Title of Franciscus Haraeus' (Frans van den Haer) Annales Ducum Brabantiae.
Before April 5, 1622. 286 × 175 mm. London, British Museum

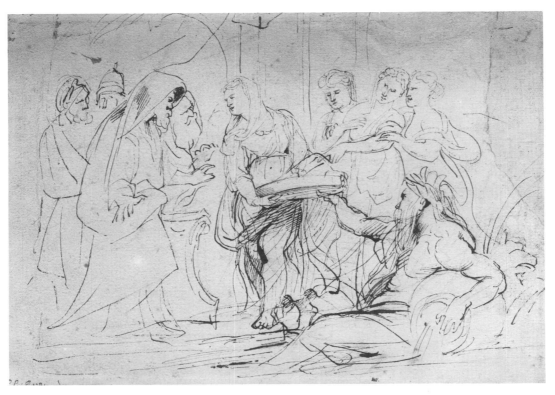

151 (Cat. 156) The Vestal Tuccia. *c.* 1622. 227 × 315 mm. Paris, Louvre, Cabinet des Dessins

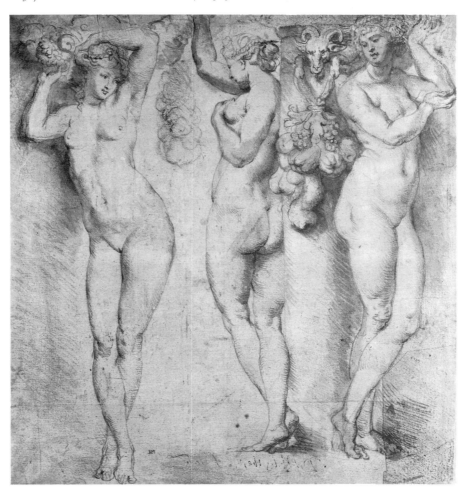

152 (Cat. 155) Three Caryatids. *c.* 1622–25. 269 × 251 mm.
Rotterdam, Museum Boymans–van Beuningen

153 (Cat. 157) Study for Mercury Descending. *c.* 1622. 480 × 395 mm.
London, Victoria and Albert Museum

154 (Cat. 149) Portrait of Isabella Brant, Rubens' First Wife (1591–1626). *c.* 1622. 381 × 292 mm. London, British Museum

155 (Cat. 189) Head of St. Francis. *c.* 1633.
141 × 105 mm. Frankfurt, Städelsches Kunstinstitut

156 (Cat. 144) Portrait of a Little Boy (Nicolas Rubens (?) 1618–55).
c. 1619. 252 × 202 mm. Vienna, Albertina

245

157 (Cat. 159) Louis XIII Comes of Age. *c.* 1622. 218 × 216 mm. Paris, Louvre, Cabinet des Dessins

158 (Cat. 158) Henry IV Carried to Heaven, and Other Figures. *c.* 1622. 175 × 171 mm. Formerly Bremen, Kunsthalle

159 (Cat. 160) Marie de Médicis Receives the Olive Branch of Peace. *c.* 1622. 175 × 171 mm. Formerly Bremen, Kunsthalle

160 (Cat. 165) Portrait of George Villiers, Duke of Buckingham (1592–1628). 1625. 383 × 266 mm. Vienna, Albertina

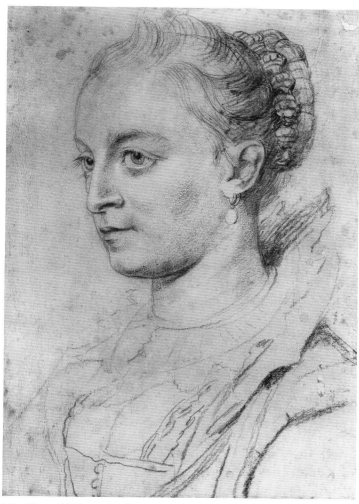

161 (Cat. 161) Portrait of Susanne Fourment (1599–1643). *c.* 1622–25. 388 × 280 mm. Rotterdam, Museum Boymans–van Beuningen

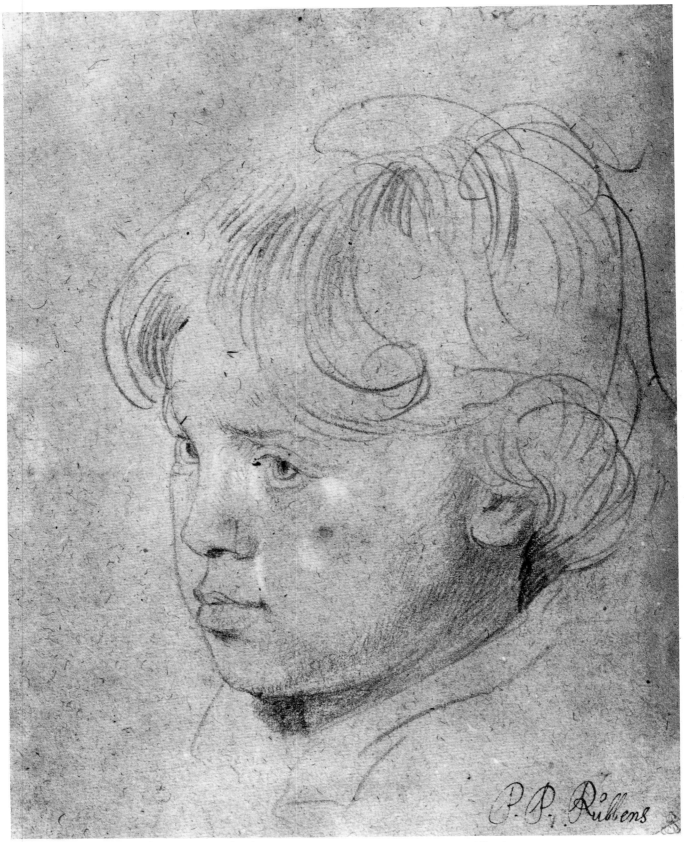

162 (Cat. 163) Portrait of Rubens' Son Nicolas (1618–55). *c*. 1625. 227 × 180 mm. Vienna, Albertina

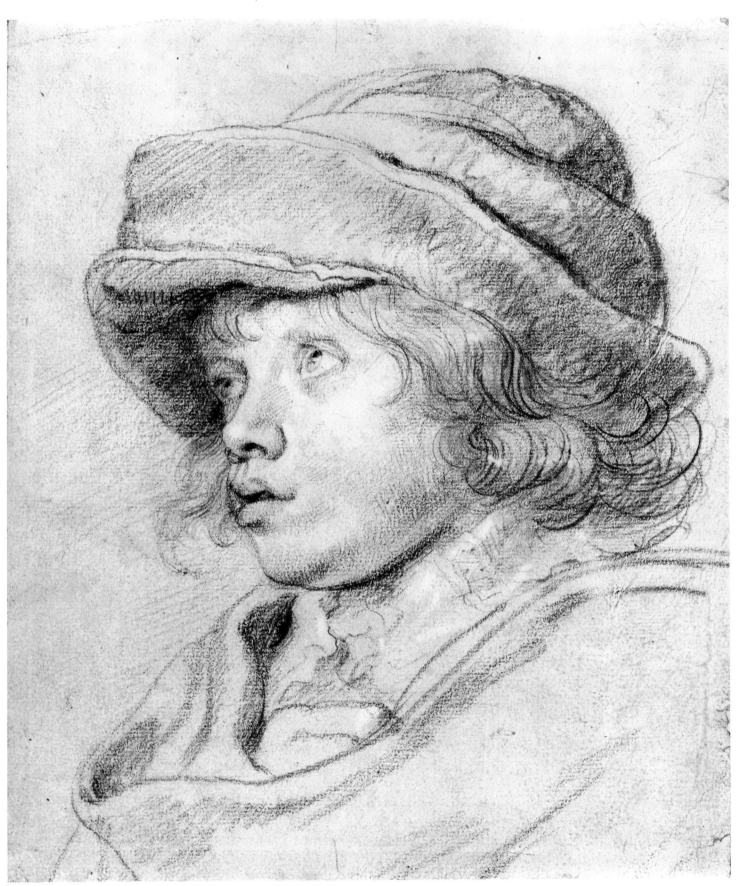

163 (Cat. 164) Portrait of Rubens' Son Nicolas. *c.* 1625–26. 292 × 232 mm. Vienna, Albertina

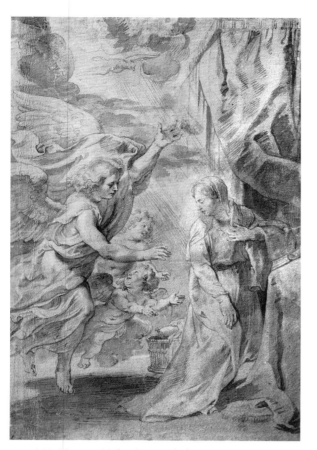

164 (Cat. 167) The Annunciation. *c.* 1625.
297 × 197 mm. Vienna, Albertina

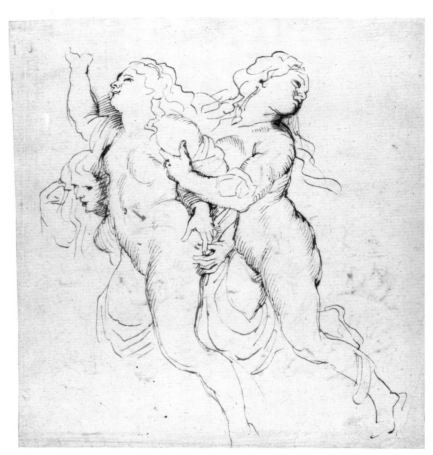

165 (Cat. 168) Venus Anadyomene and Two Nereids. *c.* 1628.
273 × 251 mm. London, British Museum

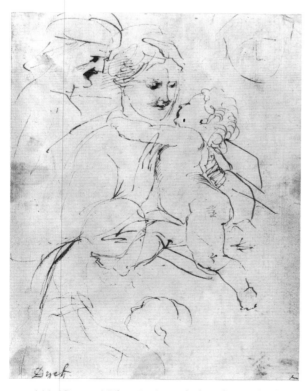

166 (Cat. 166) The Virgin with the Christ Child and
St. Anne. *c.* 1624–26. 199 × 150 mm.
Darmstadt, Hessisches Landesmuseum

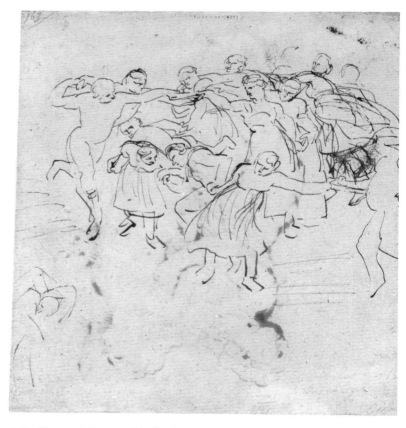

167 (Cat. 169) Dance of (Italian) Peasants. 1630–32.
London, British Museum

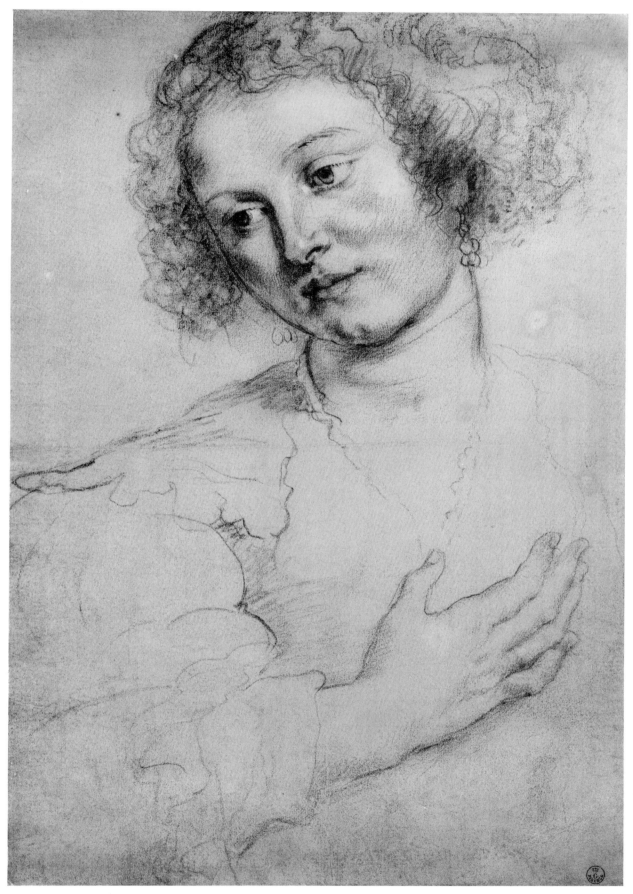

168 (Cat. 170) Young Woman Looking Down. *c.* 1627–28. 414 × 286 mm. Florence, Uffizi

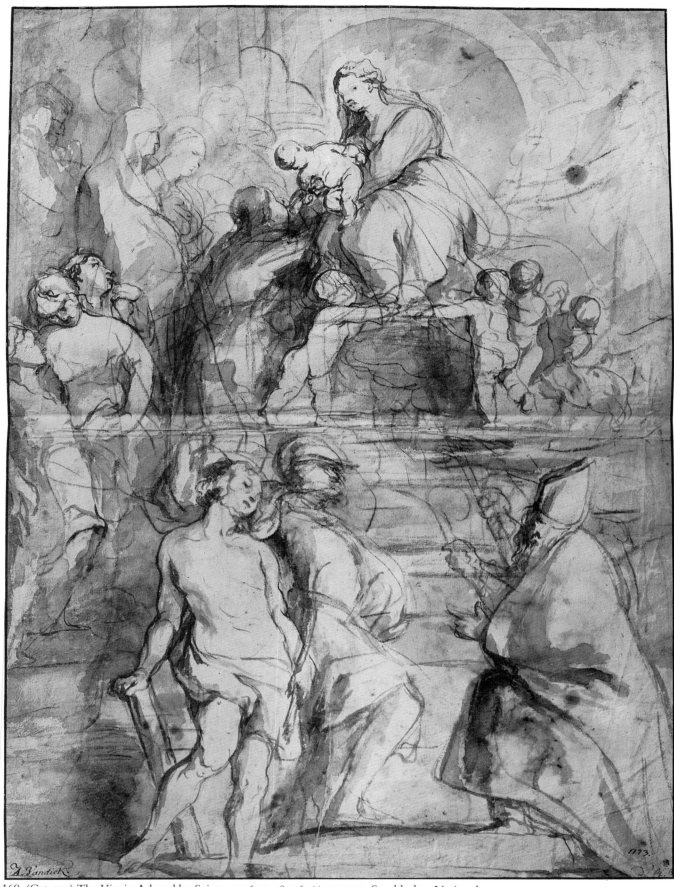

169 (Cat. 171) The Virgin Adored by Saints. *c.* 1627–28. 561 × 412 mm. Stockholm, Nationalmuseum

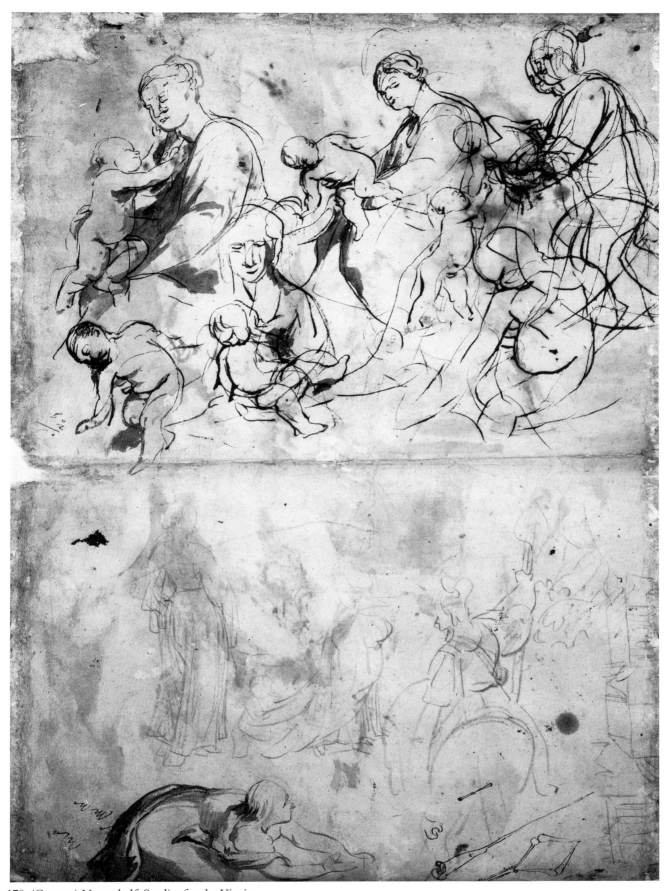

170 (Cat. 172) Upper half: Studies for the Virgin.
Lower half: Studies for St. George and the Dragon. Stockholm, Nationalmuseum

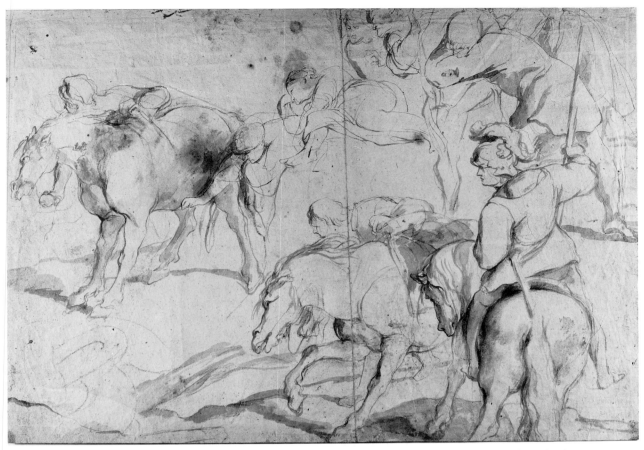

171 (Cat. 177) Studies for St. George and the Princess. *c.* 1629. 348 × 496 mm. Berlin–Dahlem, Kupferstichkabinett

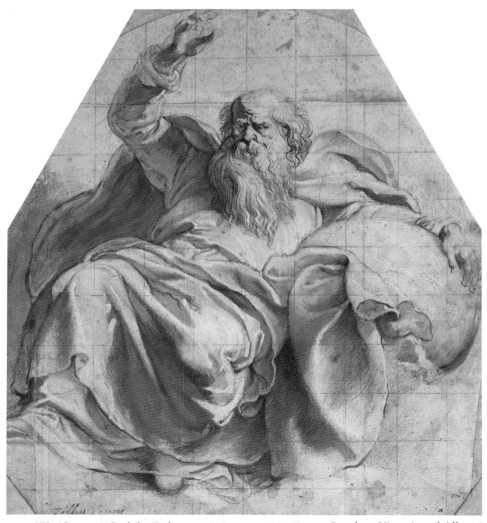

172 (Cat. 174) God the Father. *c.* 1628–29. 410 × 368 mm. London, Victoria and Albert Museum

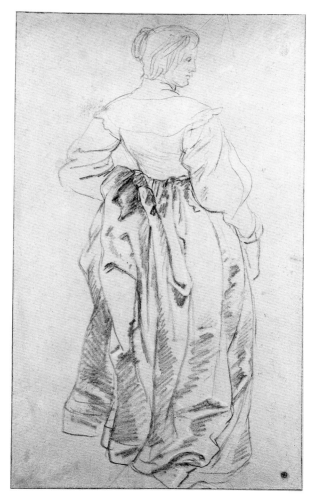

174 (Cat. 179) A Woman seen from the Back (Deborah Kip?). *c.* 1629–30. 394 × 226 mm. Berlin–Dahlem, Kupferstichkabinett

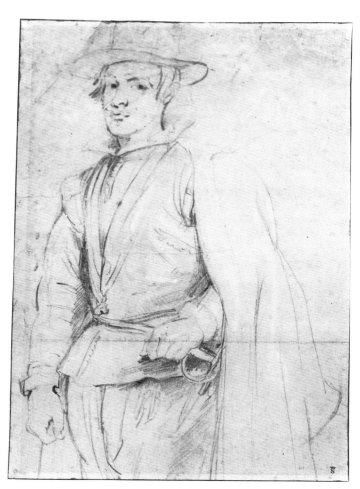

173 (Cat. 173) Portrait of King Philip IV of Spain (1605–65) (?). *c.* 1628. 383 × 265 mm. Bayonne, Musée Bonnat

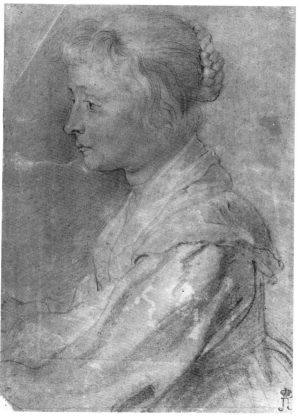

175 (Cat. 178) Portrait of a Young Girl. *c.* 1629–30. 335 × 232 mm. Leningrad, Hermitage

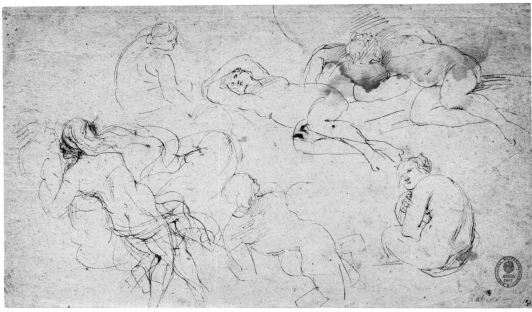

176 (Cat. 182) Studies of Nude Figures, mostly of Women. *c.* 1628–32.
233 × 396 mm. Berlin–Dahlem, Kupferstichkabinett

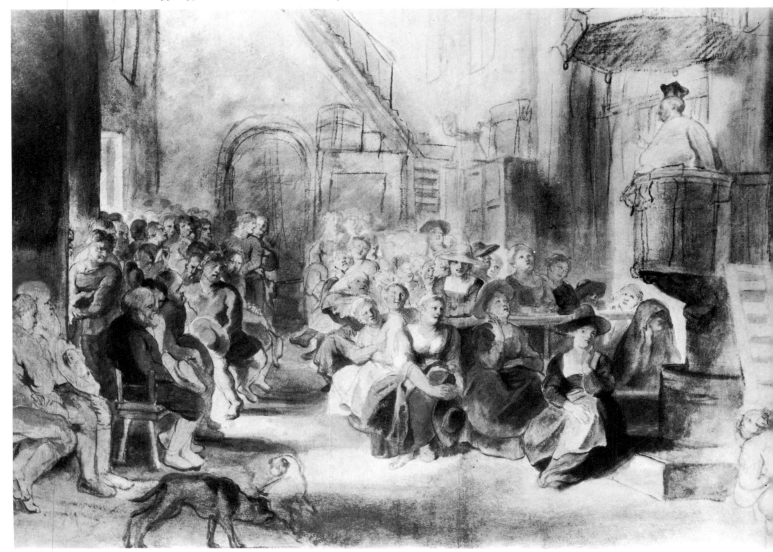

177 (Cat. 181) Sermon in a Barn. *c.* 1630. 422 × 573 mm. London, Private Collection

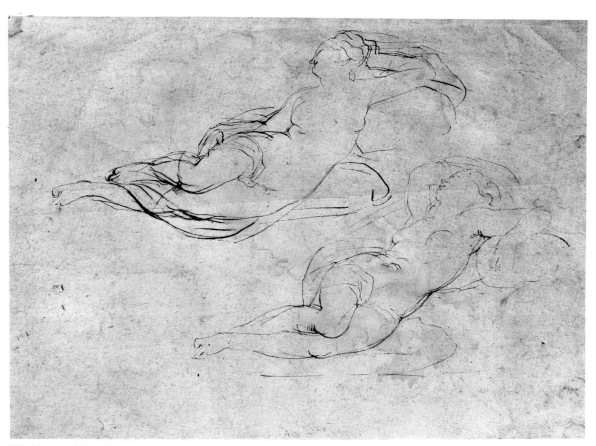

178 (Cat. 183) Female Nudes Reclining. *c.* 1628–30.
262 × 348 mm. London, Courtauld Institute Galleries (Princes Gate Collection)

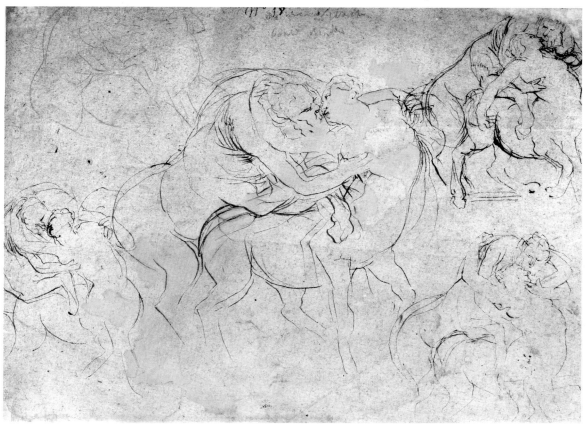

179 (Cat. 184) Centaurs Embracing. *c.* 1628–29. 262 × 348 mm. London, Courtauld Institute Galleries (Princes Gate Collection)

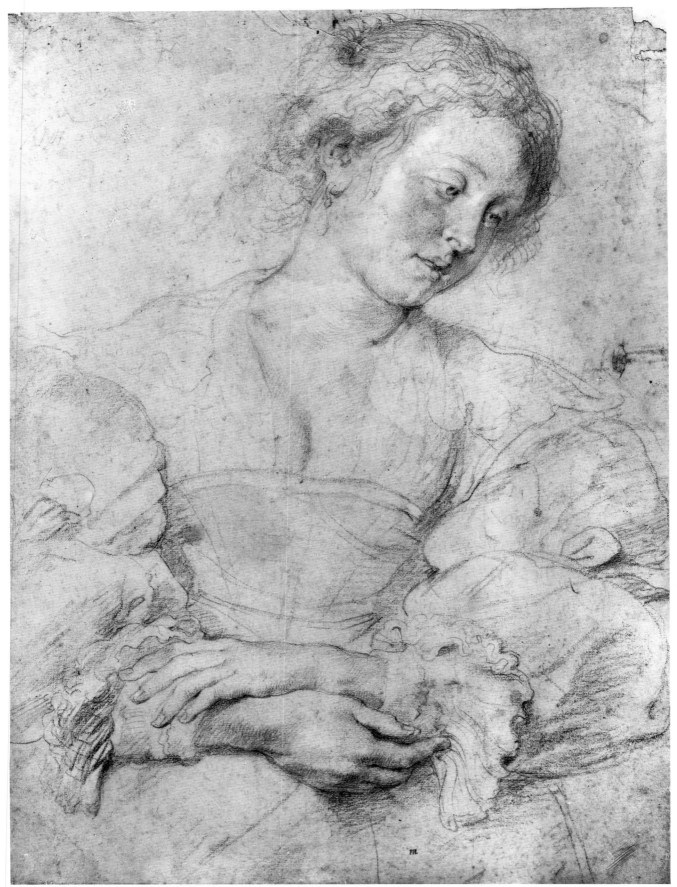

180 (Cat. 192) A Young Woman with Crossed Hands. *c.* 1630. 473 × 354 mm. Rotterdam, Museum Boymans–van Beuningen

181 (Cat. 186) The Emblem of the Plantin Press. *c.* 1629–30. 206 × 277 mm. Antwerp, Museum Plantin–Moretus

182 (Cat. 190) Archduke Albert with his Patron Saint Albert of Louvain. *c.* 1630–31.
 203 × 97 mm. Philadelphia Museum of Art
183 (Cat. 191) Archduchess Isabella Clara Eugenia, with her Patron Saint Elizabeth of Hungary. *c.* 1630–31.
 200 × 78 mm. Philadelphia Museum of Art

184 (Cat. 193) Studies for a Kermesse. *c.* 1630–32. 502 × 582 mm. London, British Museum

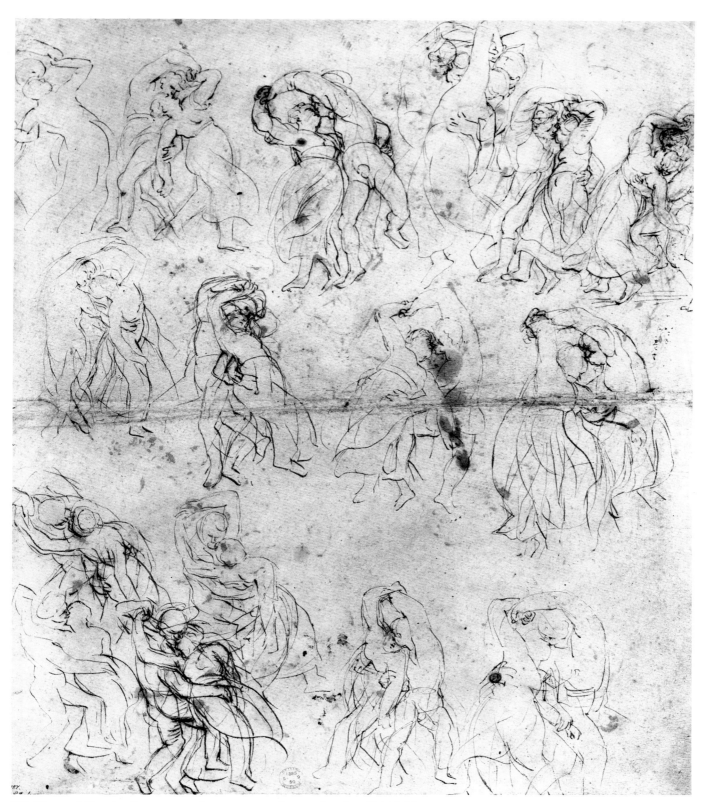

185 (Cat. 194) Dancing Peasants. *c.* 1630–32. 502 × 582 mm. London, British Museum

186 (Cat. 195) Women Harvesting. *c.* 1630–35. 216 × 257 mm. Edinburgh, National Gallery of Scotland

187 (Cat. 196) Women Harvesting. *c.* 1630–35. 181 × 207 mm. Edinburgh, National Gallery of Scotland

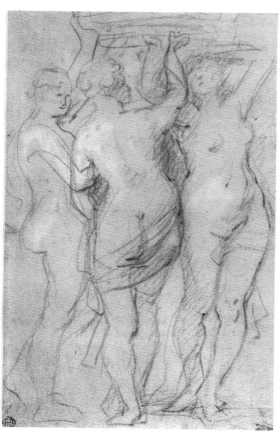

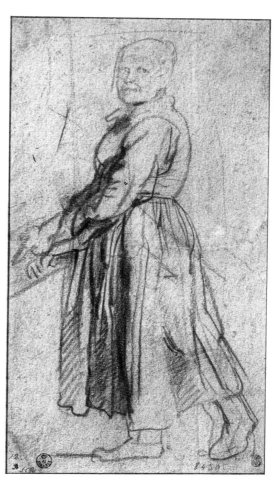

188 (Cat. 188) The Three Graces. 1628–31.
267 × 170 mm. London, Courtauld Institute
Galleries (Princes Gate Collection)

189 (Cat. 198) A Peasant Woman, Walking. *c.* 1630–35.
266 × 144 mm. Florence, Uffizi

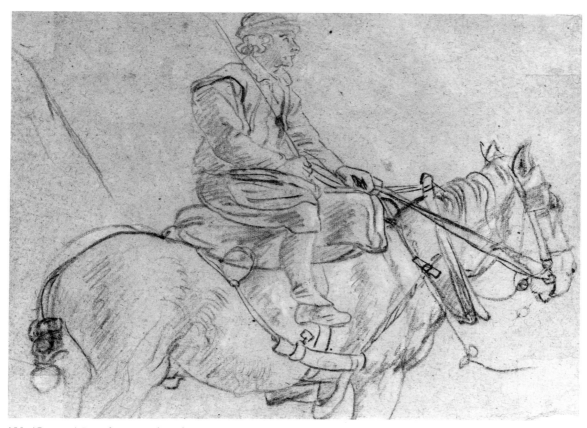

190 (Cat. 197) Farmhorse with Rider. 1630–35. 263 × 348 mm. Copenhagen, Kongelige Kobberstiksamling

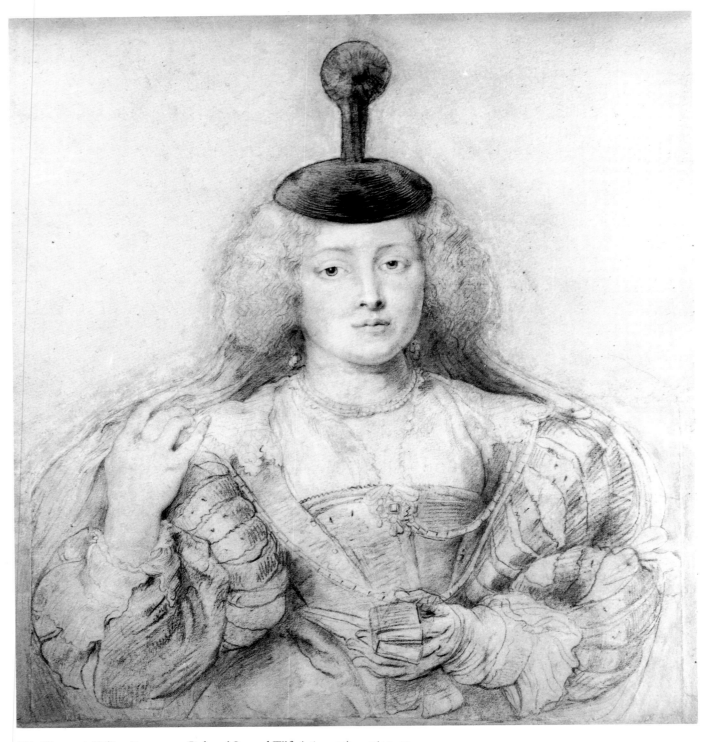

191 (Cat. 200) Hélène Fourment, Rubens' Second Wife (1614–73). *c.* 1630–32.
612 × 550 mm. London, Courtauld Institute Galleries (Princes Gate Collection)

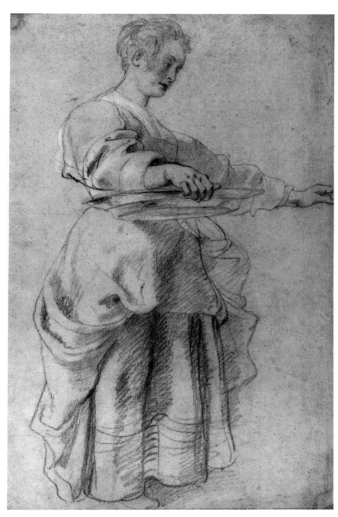

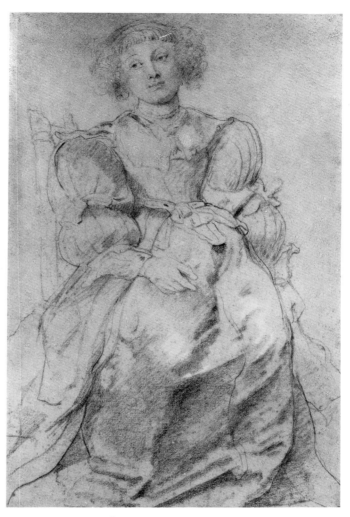

192 (Cat. 199) A Young Woman Holding a Tray. *c.* 1630–33.
468 × 300 mm. Paris, Fondation Custodia, Collection Frits Lugt

193 (Cat. 201) Portrait of Hélène Fourment. *c.* 1630–32.
488 × 320 mm. Rotterdam, Museum Boymans–van Beuningen

194 (Cat. 185) A Nymph Asleep (Diana?). *c.* 1628 32. 90 × 222 mm. Rotterdam, Museum Boymans–van Beuningen

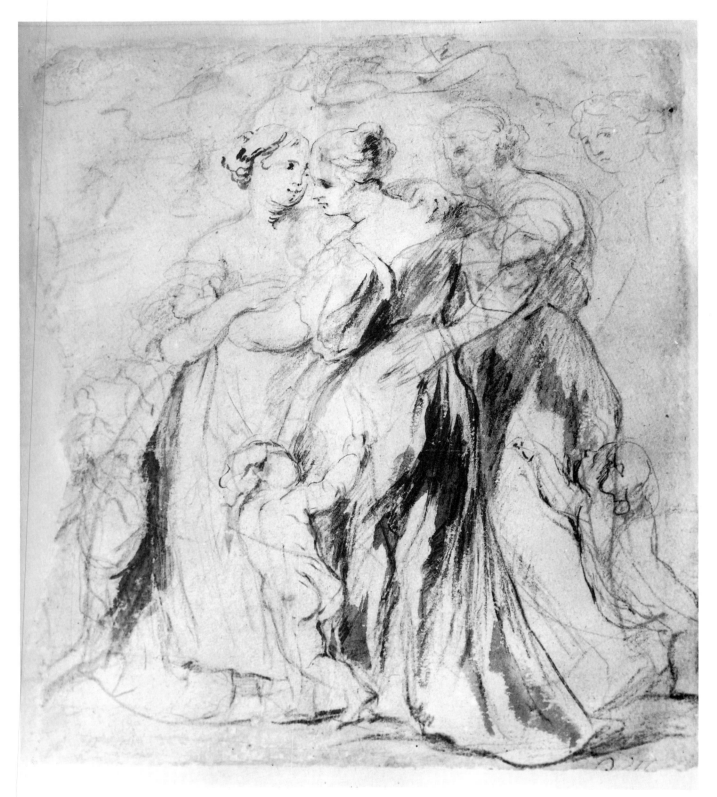

195 (Cat. 203) Three Young Ladies Accompanied by Putti. *c.* 1630–35. 282 × 250 mm. Warsaw, Print Room of the University Library

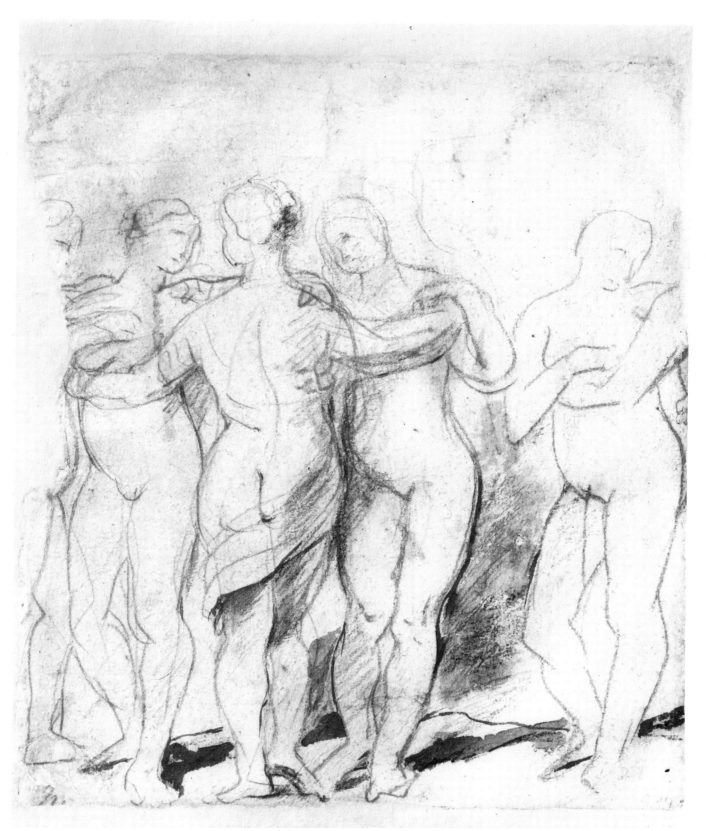

196 (Cat.204) Several Studies for a group of the Three Graces. *c.*1630–35. 282 × 250 mm. Warsaw, Print Room of the University Library

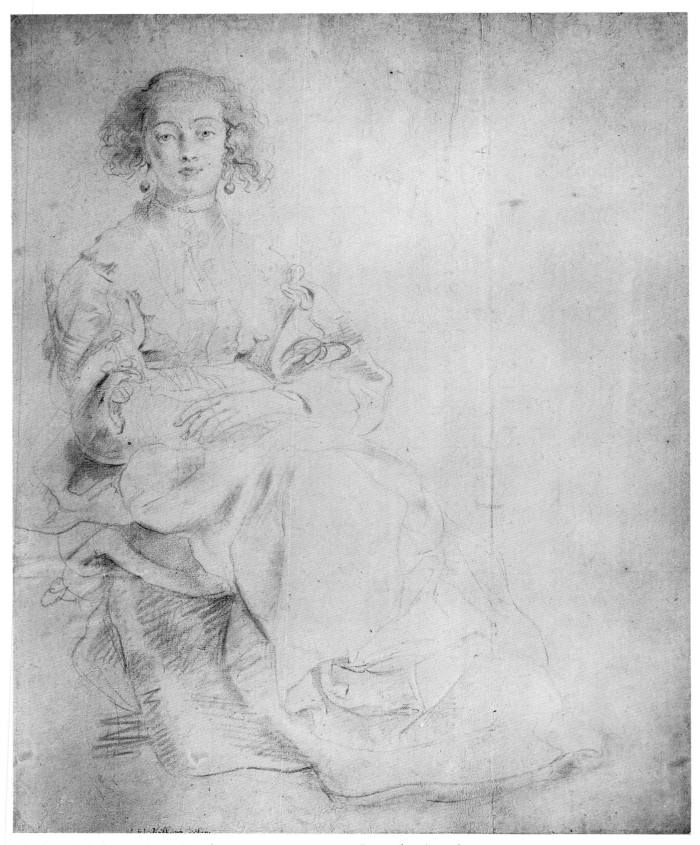

197 (Cat.202) A Young Woman Seated. *c.* 1630–35. 509 × 410 mm. Present location unknown

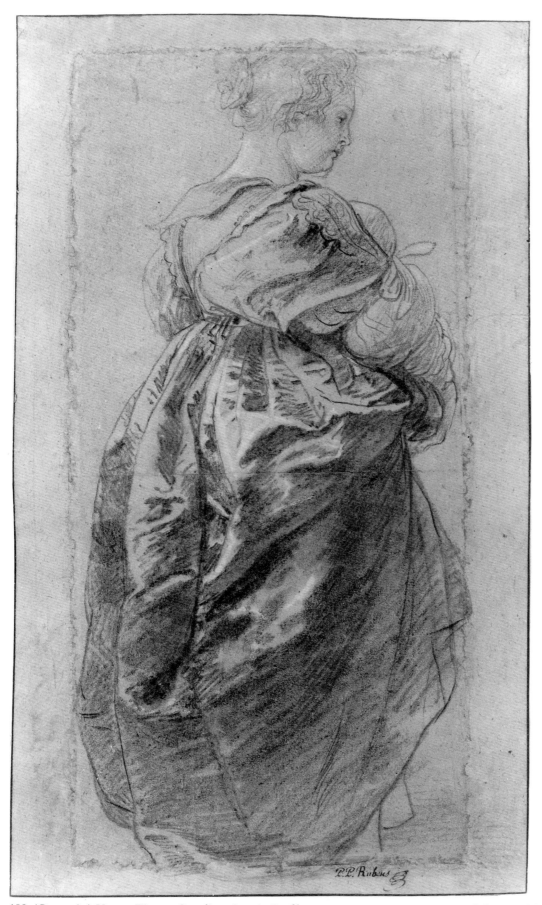

198 (Cat.205) A Young Woman Standing, Seen in Profile. *c.* 1632–33. 563 × 317 mm. Frankfurt, Städelsches Kunstinstitut

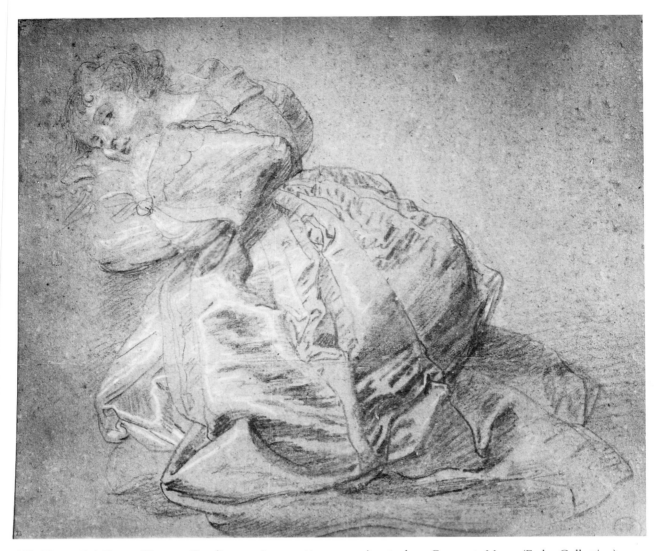

199 (Cat. 208) A Young Woman, Kneeling. *c.* 1632. 403 × 474 mm. Amsterdam, Gemeente Musea (Fodor Collection)

200 (Cat. 228) Woodland Scene. *c.* 1635–38. 383 × 499 mm. Oxford, Ashmolean Museum

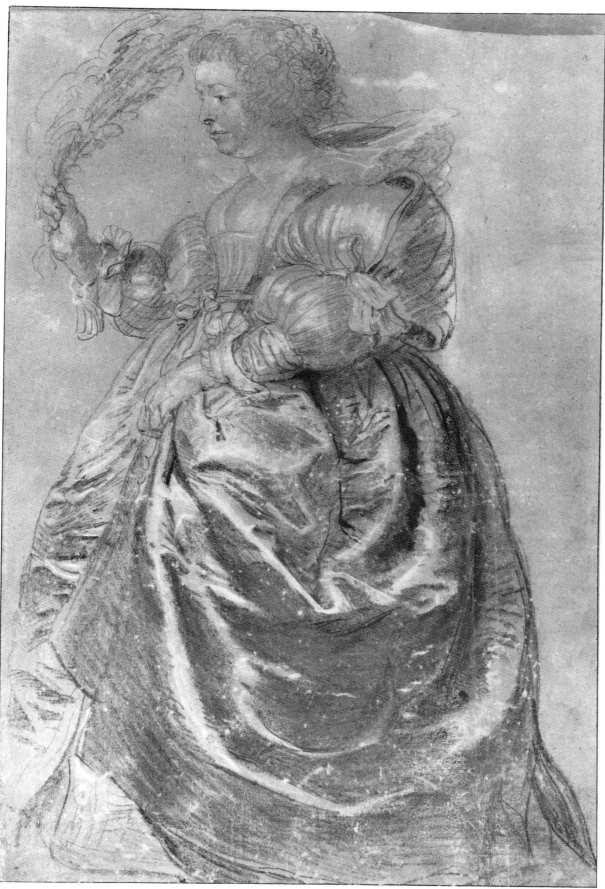

201 (Cat. 207) A Young Woman with Ostrich Fan. *c.* 1632. 538 × 347 mm. Paris, Louvre, Cabinet des Estampes

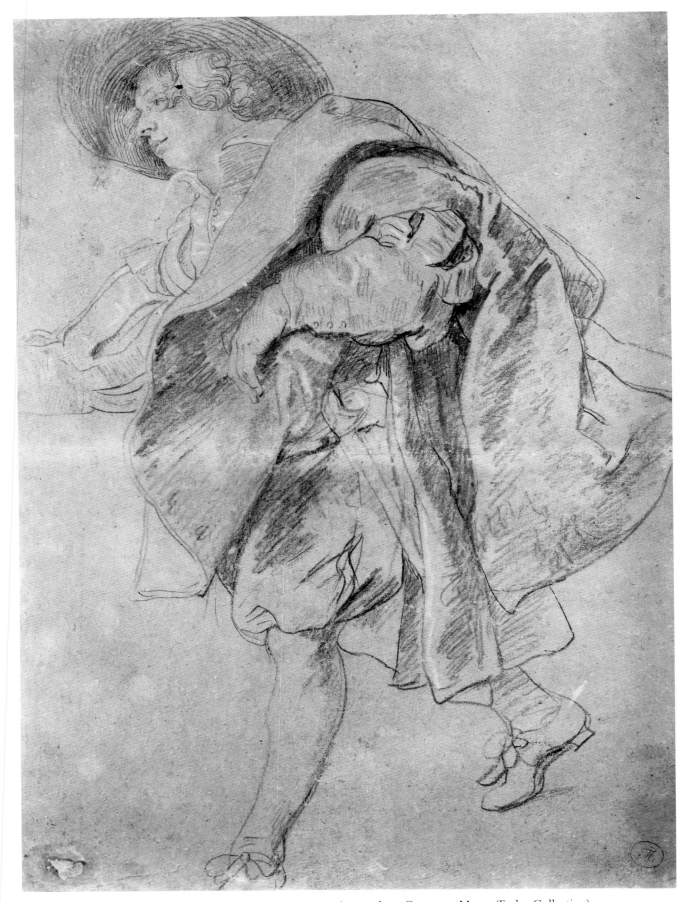

202 (Cat.209) Young Man, Walking. *c.* 1632. 561 × 415 mm. Amsterdam, Gemeente Musea (Fodor Collection)

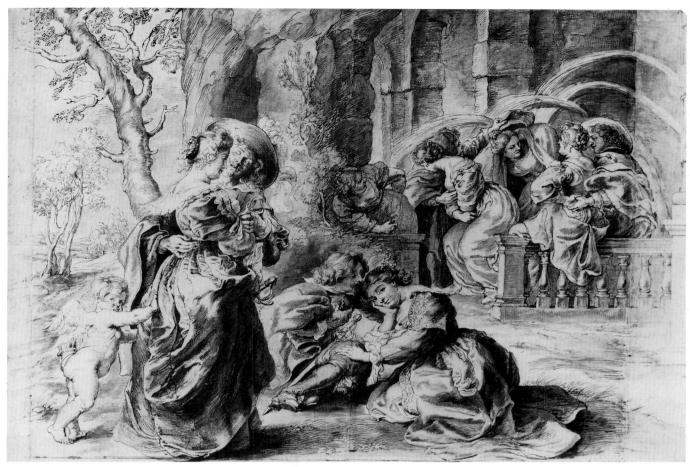

203, 204 (Cat. 210, 211) The Garden of Love ('Conversation à la Mode'). *c.* 1632–34. 480 × 710 mm.
New York, Metropolitan Museum of Art

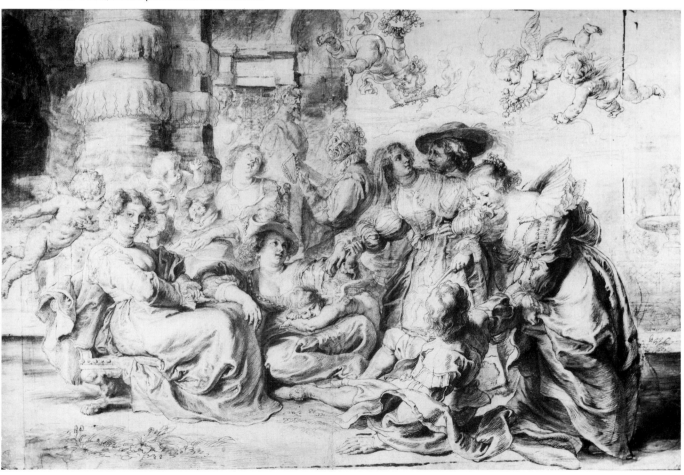

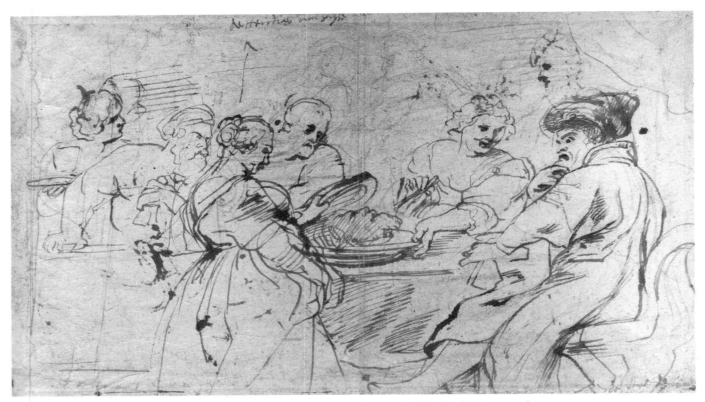

205 (Cat. 230) The Feast of Herod. *c.* 1637–38. 272 × 467 mm. Cleveland, The Cleveland Museum of Art

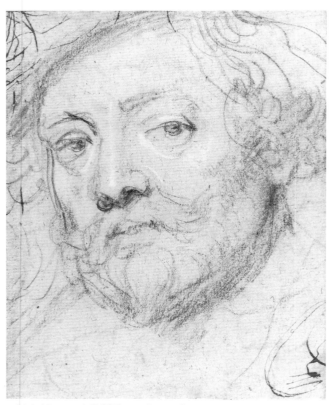

206 (Cat. 236) Self-Portrait. *c.* 1635–40.
200 × 160 mm. Windsor Castle

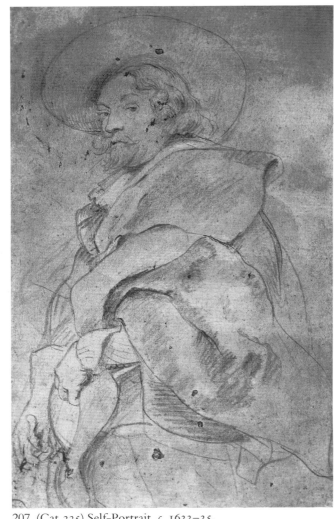

207 (Cat. 225) Self-Portrait. *c.* 1633–35.
461 × 287 mm. Paris, Louvre, Cabinet des Estampes

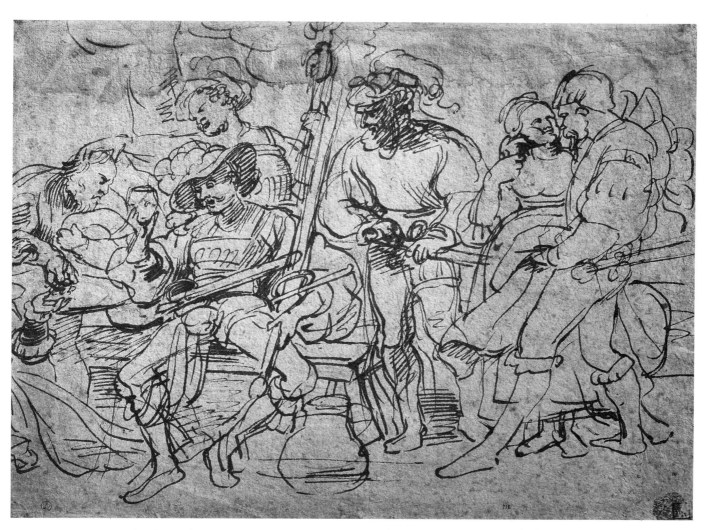

208 (Cat. 232) Lansquenets Carousing. *c.* 1638. 272 × 355 mm. Paris, Fondation Custodia, Collection F. Lugt

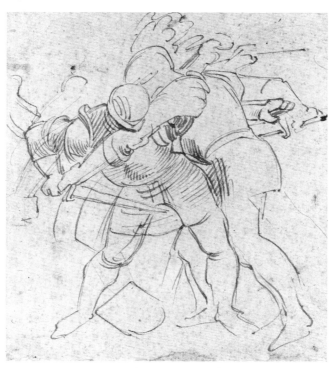

209 (Cat. 231) Combat of Two Armoured Men. *c.* 1635–38.
New Haven, Conn., Yale University Art Gallery

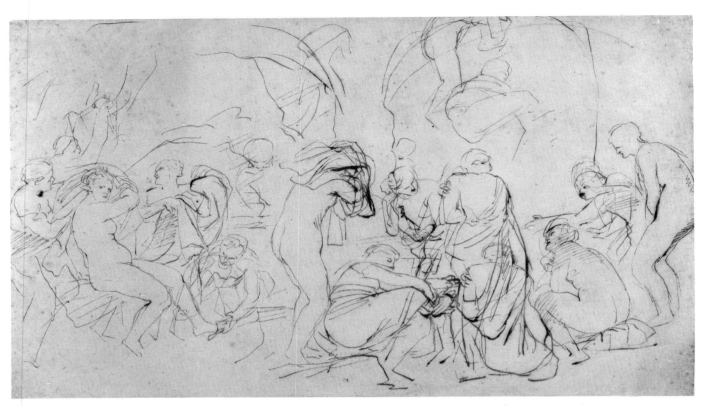

210 (Cat. 220) Diana and Her Nymphs, Surprised by Actaeon. 1632–36. 291 × 509 mm. London, Courtauld Institute Galleries
(Princes Gate Collection)

211 (Cat. 221) The Adoration of the Magi. *c.* 1633. 279 × 432 mm. Besancon, Musée des Beaux-Arts

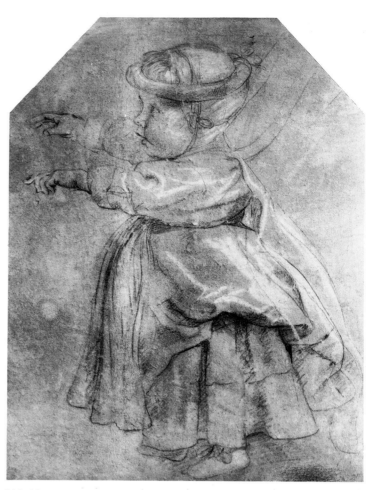

212 (Cat. 222) Portrait of Frans Rubens (1633–78). *c.* 1636.
291 × 200 mm. Rotterdam, Museum Boymans–van Beuningen

213 (Cat. 224) A Small Child (Rubens' daughter, Isabella Hélène, 1635–52).
c. 1636. 398 × 287 mm. Paris, Louvre, Cabinet des Estampes

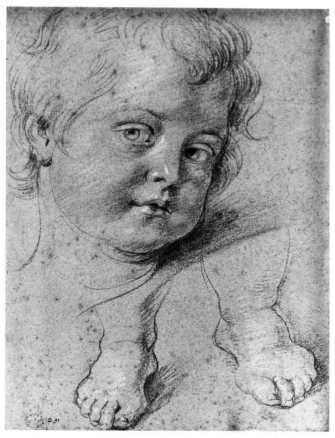

214 (Cat. 223) Head and Feet of a Child (Frans Rubens?). *c.* 1635.
285 × 210 mm. Besançon, Musée des Beaux-Arts

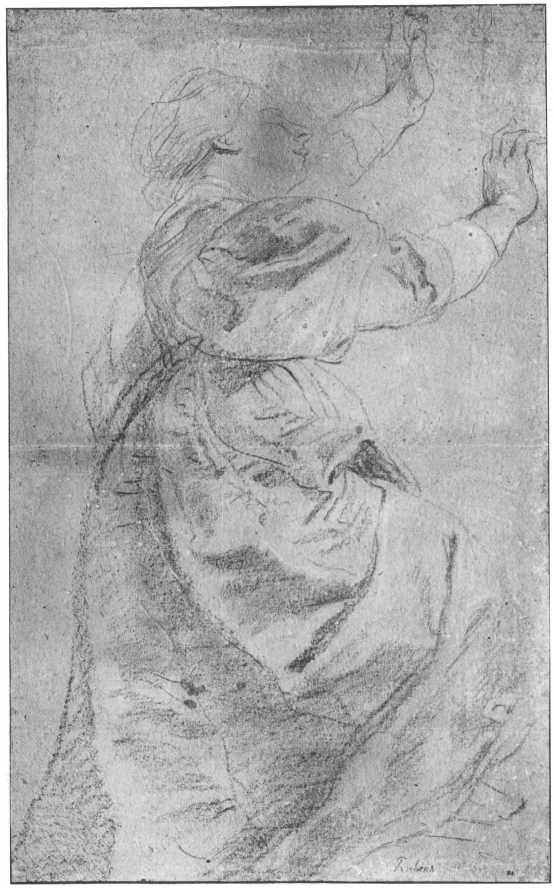

215 (Cat. 218) A Young Woman with Raised Arms. *c.* 1635. 480 × 285 mm. Paris, Louvre, Cabinet des Estampes

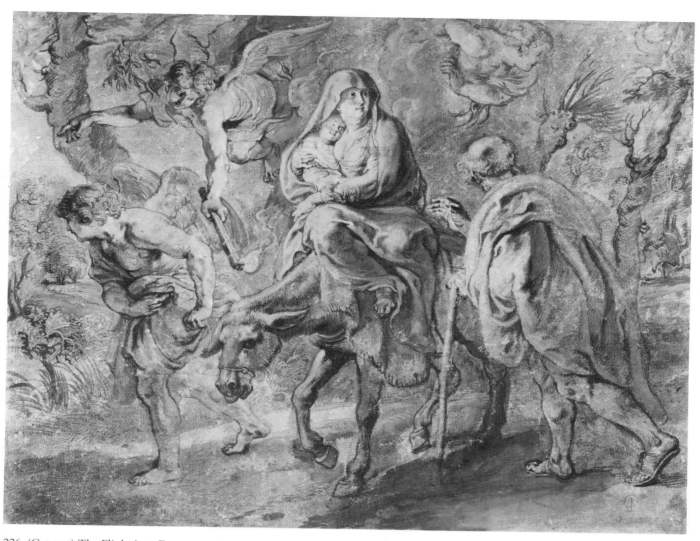

226 (Cat. 235) The Flight into Egypt. *c.* 1630–35. 365 × 465 mm. London, British Museum

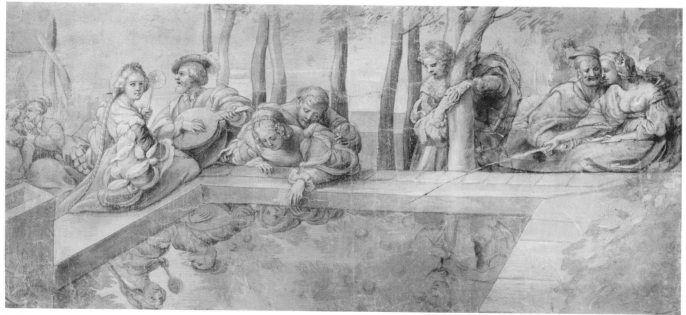

227 (Cat. 234) A Garden Party. *c.* 1625–35. 207 × 434 mm. Vienna, Albertina

ABBREVIATIONS AND BIBLIOGRAPHY

This list contains only the most frequently mentioned publications. Other abbreviations are used throughout the volume but they should not present any difficulties to students familiar with art-historical literature. For the many and important reviews of books and exhibitions written during and following the Rubens-year 1977 the reader may want to consult the volumes IV, V, and VI of RILA (Répertoire International de la Litterature de l'Art – International Repertory of the Literature of Art).

B. A. Bartsch, *Le Peintre Graveur*, Vienna, 1803–1821

BAUDOUIN, 1977 Baudouin, F., Pietro Pauolo Rubens, Antwerp–New York, 1977

BOUCHERY-WIJNGAERT H. F. Bouchery and Fr. Van den Wijngaert, *P. P. Rubens en het Plantijnsche Huis*, Antwerp, 1941

BURDHARD-D'HULST, 1963 Burchard, ludwig and R.-A. d'Hulst, *Rubens Drawings*, Brussels, 1963

CORPUS RUBENIANUM *Corpus Rubenianum Ludwig Burchard* (individual volumes listed alphabetically by authors)
 Adler, W. *Landscapes and Hunting Scenes, I*, London-Oxford, 1982 (vol. XVIII)
 Belkin, K. L., *The Costume Book*, London–philadelphia, 1978 (vol. XXIV)
 Freedberg, D., *The Life of Christ after the Passion*, London–Oxford, 1984 (vol. VII)
 Huemer, F., *Portraits, I*, Brussels, 1977 (vol. XIX)
 Judson, J. R. and C. van de Velde, *Book Illustrations and Title-Pages*, London–Philadelphia, 1978 (vol. XXI)
 Vlieghe, H., *Saints*, London–New York, 1973 (vol. VIII)

CORRESPONDENCE Ch. Ruelens and M. Rooses, *Correspondence de Rubens et Documents Epistolaires*, 6 vols., Antwerp, 1887–1909

EVERS I H. G. Evers, *Peter Paul Rubens*, Munich, 1942

EVERS II H. G. Evers, *Rubens und sein Werk*, Neue Forschungen, Brussels, 1943

DENUCÉ, *Inventories* J. Denucé, *De Antwerpsche 'Konstkamers'*, Antwerp, 1932

GLÜCK, *Landschappen* G. Glück, *Die Landschappen von Peter Paul Rubens*, Antwerp–Amsterdam, 1940

G.-H. G. Glück and F. M. Haberditzl, *Die Handzeichnungen von Peter Paul Rubens*, Berlin, 1928

HELD, 1980 Held, Julius S. *The Oil Sketches of Pieter Paul Rubens*, Princeton, 1980

HELD, 1982 Held, Julius S. *Rubens and his Circle*, Princeton, 1982

HIND, *Catalogue* A. M. Hind, *Catalogue of Drawings by Dutch and Flemish Artists . . . in the British Museum*, II, London, 1923

JAFFÉ, 1977 Jaffé, Michael, *Rubens and Italy*, Oxford, 1977

KDK R. Oldenbourg, *P. P. Rubens, Des Meisters Gemälde*, 4th ed., Stuttgart–Berlin, (1921)

KDK, 1st ed. A. Rosenberg, *P. P. Ruben, Des Meisters Gemälde*, 1st ed., Stuttgart–Leipzig, 1905

KUZNETSOV, 1974 Kuznetsov, Yuri, *Risunki Rubensa*, Moscow, 1974

LUGT, *Catalogue* F. Lugt, Musé du Louvre, *Inventaire General des Dessins des Ecoles du Nord, Ecole Flamande*, Paris, 1949

MIELKE-WINNER, 1977 Mielke, Hans and matthias Winner, *Peter Paul Rubens: Kritischer katalog der Zeichnungen*, Staatliche Museen Preussischer Kulturbesitz, Berlin, 1977

MITSCH, 1977 Mitsch, Erwin, *Die Rubenszeichnungen der Albertina*, Vienna, 1977 (Exhibition Catalogue)

MÜLLER-HOFSTEDE, 1977 Müller Hofstede, Justus, *Peter Paul Rubens 1577–1640*, Cologne, 1977 (Exhibition Catalogue)

MUCHALL-VIEBROOK T. W. Muchall-Viebrook, *Flemish Drawings of the Seventeenth Century*, London, 1926

PHAIDON *Rubens* Rubens, *Paintings and Drawings*, with an introduction by R. A. M. Stevenson, London, 1939

R. (followed by no. of volume) Max Rooses, *L'Oeuvre de P. P. Rubens*, Antwerp, 1886–1892

ROOSES Max Rooses, *Rubens: Sa Vie et ses Ouevres*, Paris, 1903

ROWLANDS, 1977 Rowlands, John, *Rubens, Drawings and Sketches*, London, 1977 (Exhibition Catalogue)

Rubens-Bulletin Bulletin-Rubens, *Annales de la Commission Officielle instituée par le Conseil Communal de la Ville d'Anvers pour la publication des documents relatifs à la vie et aux oeuvres de Rubens*, Antwerp–Brussels, 1882–1910

A. SEILERN, *Catalogue* (A. S.) *Flemish Paintings and Drawings at 56 Princes Gate, London, S.W.7*, London, 1955

SÉRULLAZ, 1978 Arlette Sérullaz, *Rubens; ses maîtres, ses élèves; dessins du musée du Louvre*, Paris, 1978 (Exhibition Catalogue)

VAN DEN WIJNGAERT Frank van de Wijngaert, *Inventaris der Rubeniaansche Prentkunst*, Antwerp, 1940

VERGARA, 1982 Vergara, Lisa, *Rubens and the Poetics of Landscape*, New Haven, 1982

Quotations from letters sent by, and addressed to Rubens have been taken from the monumental and indispensble edition of Rubens' correspondence by Ruelens and Rooses (cited as 'Correspondence'). All translations have been made by myself from the original texts published there. I gratefully acknowledge, however, many valuable suggestions regarding the interpretation and formulation of Rubens' own letters, derived from the excellent English translation of Rubens' letters by Ruth Saunders Magurn, Cambridge, 1955.

Index of Names

285

Index of Works

Index

Index